Seeing America

PAINTING AND SCULPTURE

FROM THE COLLECTION OF THE

MEMORIAL ART GALLERY

OF THE UNIVERSITY OF ROCHESTER

 Memorial Art Gallery
OF THE UNIVERSITY OF ROCHESTER

500 University Avenue, Rochester, New York 14607, mag.rochester.edu

Editor-in-Chief: Marjorie B. Searl
Editor: John W. Blanpied
Project Coordinator: Cynthia L. Culbert
Designer: Kathy D'Amanda / MillRace Design Associates
Printer: Monroe Litho, Inc., Rochester, New York

This publication was produced with the support of:

Henry Luce Foundation
National Endowment for the Arts
Gallery Council of the Memorial Art Gallery
Herbert W. Vanden Brul Fund of the Memorial Art Gallery
Thomas and Marion Hawks Memorial Fund of the Memorial Art Gallery
Nancy Turner
The Elizabeth F. Cheney Foundation
Monroe Litho, Inc.
Contributions made in memory of Florence Macomber, Eleanor McQuilkin, and Eleanor Searl

NATIONAL
ENDOWMENT
FOR THE ARTS

An online version of this book is available at mag.rochester.edu.

 Printed on FSC-certified Chorus Art paper which, in addition to being acid free, is 50% recycled—
25% post-consumer waste and elemental chlorine free.
Cert. no. SCS-COC-00635
©1996 Forest Stewardship Council A.C.

Library of Congress Cataloging-in-Publication Data
University of Rochester. Memorial Art Gallery.
 Seeing America: painting and sculpture from the permanent collection
 of the Memorial Art Gallery of the University of Rochester / edited by
 Marjorie B. Searl.
 p. cm.
 Includes index.
 ISBN 1-58046-244-8 (hardcover : alk. paper)—ISBN 1-58046-246-4
 (pbk. : alk. paper)
 1. Painting, American—Catalogs. 2. Sculpture, American—Catalogs.
 3. Painting—New York (State)—Rochester—Catalogs.
 4. Sculpture—New York (State)—Rochester—Catalogs.
 5. University of Rochester. Memorial Art Gallery—Catalogs.
 I. Searl, Marjorie B., 1947– II. Title.
 ND205.U55 2006
 708.147'89—dc22
 2006009153

Distributed by University of Rochester Press, 668 Mt. Hope Avenue, Rochester, New York 14620, USA, www.urpress.com
and Boydell & Brewer Limited, PO Box 9, Woodbridge, Suffolk IP12 3DF, UK, www.boydellandbrewer.com

Contents

Contents

Contents

Director's Foreword

I became aware of the exceptional collection of American art at the Memorial Art Gallery some thirty-five years ago. As a Kress Fellow at the National Gallery of Art, I was helping to organize the centennial exhibition of the work of John Sloan and, after making a quick trip to Rochester in 1970, realized that the Gallery not only owned two of Sloan's finest city genre paintings but possessed an exemplary collection of American painting and sculpture that spanned three (and now four) centuries. The publication of *Seeing America* underscores both the quality and the breadth of our collection of American art. We are delighted to be able to share these treasures with a wider audience.

The Memorial Art Gallery, from its founding in 1913, has been an ardent advocate for the exhibition and acquisition of American art. Six of the first seven paintings to enter the permanent collection were by American artists, including Jonas Lie's *Morning on the River*, given in memory of James G. Averell, son of Gallery founder Emily Sibley Watson. And it is no coincidence that the Gallery's first director, George Herdle, was a practicing artist whose ambitious exhibition program for MAG brought work by emerging as well as established Americans to Rochester. Within the first five years of the Gallery's existence, no fewer than sixty-two American artists were invited to exhibit at MAG, and several group exhibitions were held—12 Contemporary American Artists in 1916 and, two years later, Collection of Paintings Selected From the Leading American Exhibitions of the Season of 1917–1918. Over the past ninety-three years the Gallery has continued to enhance its American collection. That the first entry in this book is devoted to a painting by the eighteenth-century master John Singleton Copley and the last to photography by contemporary African American artist Lorna Simpson underscores MAG's rich and expansive journey of acquisition.

Though the first catalogue of the art collection of Oxford University was apparently written by the janitor of the Bodleian Library, we have relied on the expertise and insights of many scholars who, in the words of our chief curator Marjorie Searl, "represent some of the most brilliant minds working in this field." To them, our heartfelt thanks, and particularly to Michael Kammen, Newton C. Farr Professor of History, Cornell University, whose introduction sets the collection against the broader background of the American narrative. Marjorie Searl has directed the planning of the catalogue from the beginning and, indeed, has contributed several key essays. In addition, she also worked closely with editor John Blanpied and designer Kathryn D'Amanda, dear friends and most valuable contributors to this project. Without their respective leadership skills and dedication, this publication would not have been possible.

I want to thank the many generous underwriters who have made it possible to share the insightful essays written about the MAG collection with students of American art everywhere. The beneficence of the Henry Luce Foundation has truly enriched our understanding of the field by its significant encouragement of research, exhibitions, and publications. We are most grateful for their interest in this publication as we are for their support of other Gallery initiatives pertaining to our American collection. Our thanks also go to the National Endowment for the Arts for its encouragement and generosity. I personally want to thank the Gallery Council of the Memorial Art Gallery for its special and meaningful contribution to this project made in honor of my twenty years as director. The use of the Herbert W. Vanden Brul Fund, established by our late Gallery president who loved and collected American art, seems most appropriate, as does the use of funds from the Thomas and Marion Hawks Memorial Fund established by two individuals who spent their lives

Isabel Herdle (1905–2004), associate director and curator, standing; Gertrude Herdle Moore (1896–1993), director, seated

supporting and enhancing the arts in Rochester. Other gifts were provided by Nancy Turner, The Elizabeth F. Cheney Foundation, Monroe Litho, Inc. Finally, contributions were made in memory of Gallery friends Florence Macomber, Eleanor McQuilkin, and Eleanor Searl.

On behalf of the board of managers and staff of the Memorial Art Gallery, we dedicate this book to the memories of Gertrude Herdle Moore and Isabel Herdle, who devoted themselves to the Gallery for over fifty years. Their vision, passion, and insight informed every aspect of this institution, including its remarkable collection of American art.

Grant Holcomb
The Mary W. and Donald R. Clark Director of the Memorial Art Gallery

Preface

Seeing America is a journey in space and time. It is, to begin with, a tour through the pride of the Memorial Art Gallery: the collection of American art the museum has been championing for almost one hundred years. But (with a nod to the cover) the book is also a kind of packet-boat tour of America, with some of her most outstanding artists as guides. The artists are uniquely equipped for the job: they see with such compelling immediacy that we now are "pulled across the room"* to a different time and place. Their tour ranges from Colonial times to the twenty-first century, from Maine to Florida to the far West, from mighty historical subjects to intimate byways, from august figures and events to the humblest and most anonymous. The huge diversity of American experience is on display here, but as Michael Kammen shows in his Introduction, distinctive themes of American history also emerge from this tour.

Seeing America is also a running commentary on the art by knowledgeable and thoughtful contemporary scholars and artists writing on eighty-two works. Each essayist was charged with observing his or her subject closely and freshly, defining and answering questions generated by the work and its relationship to the spirit of its times, and ultimately presenting a new, deeper, and more authentic viewpoint that will enhance the reader-viewer's understanding and appreciation of the object. In so doing, the writers have helped to fulfill the goal of the Henry Luce Foundation's American Collections Enhancement (ACE) initiative, awarded to MAG in 1999 as part of an effort "to highlight American art collections that are not widely known, but deserve greater attention."

This book also documents the Memorial Art Gallery's commitment to building an outstanding collection of American art. From the acquisition in its opening year, 1913, of a masterpiece by John Twachtman (*The White Bridge*), to the acquisition in 2005 of the iconic *Pittsford on the Erie Canal* (the painting featured on the cover of this volume), the museum has been in the business of promoting and acquiring American art. While the significant 1951 purchase of fourteen paintings from the Encyclopedia Britannica Collection of Contemporary American Painting has been hailed over the years, a little-known aspect regarding the development of the American collection surfaced during the research for this publication. In 1941, ten years before the Britannica purchase, MAG had established a Lending Library of American Art "in an effort to bring contemporary American art closer to the American public in this grave period of national emergency and to promote the sale of excellent average-priced paintings by artists." Ninety artists were asked to contribute paintings, including Charles Burchfield, John Steuart Curry, and Rockwell Kent, and a selection of their work entered the permanent collection as a result of this patriotic gesture.

The creation of *Seeing America* has also been an illuminating professional journey in the company of outstanding colleagues. I am profoundly grateful to the fifty-one distinguished, often brilliant scholars and artists who gave their time, intelligence, and expertise to the essays, sometimes putting aside current projects to meet our deadlines. To the staff at MAG, particularly Grant Holcomb, The Mary W. and Donald R. Clark Director, I owe my deepest appreciation for their belief in me and in this project. Christine Garland has worked side by side with me through the years to obtain the necessary funding. Cynthia Culbert labored over this publication but also managed to bring into the world two beautiful little girls while the book was gestating, spelled by Jessica Marten and Emily Pfeiffer. Lu Harper and Susan Nurse managed research materials and images. MAG staff members Cynthia

* The phrase is from Dr. Virginia Mecklenberg, senior curator at the Smithsonian American Art Museum.

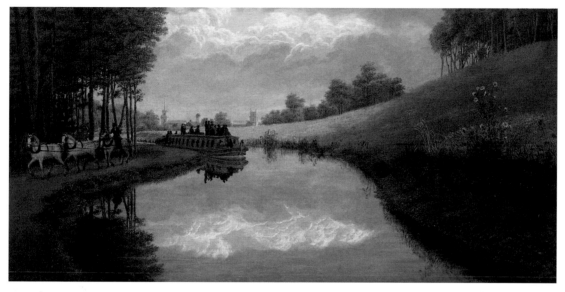

George Harvey,
1800–1878
Pittsford on the Erie Canal–
A Sultry Calm, 1837 (detail)
Oil on panel, 17¹/₂ x 23⁵/₈ in.
Gift of the Margaret M.
McDonald Memorial Fund,
2005.33

Culbert, Susan Dodge-Peters Daiss, Marlene Hamann-Whitmore, Grant Holcomb, Jessica Marten, Nancy Norwood, Susan Nurse, and Marie Via contributed insightful essays. John Blanpied's wise editing and cheerful spirit has made this project a joy, and Kathy D'Amanda, who designs all things beautiful, has contributed her inimitable sense of style. Donald Strand worked his magic to turn the publication into a website. The choice of Monroe Litho and the related choice of paper are rooted in our strong desire to have an American publication printed in America, and most happily in Rochester, by a company certified by the Forest Stewardship Council—an organization that contributes to the retention of beautiful American landscapes like the ones depicted in this volume.

And of course, my gratitude goes out to my family, for whom this catalogue has become a condition of family life. They have done research and accompanied me on quixotic quests, and Scott in particular has provided technical support so that information, images, and essays could fly through the ether. To my parents, grandparents, and great-grandparents, who imbued me with a deep love of "Seeing America," my thanks.

Marjorie B. Searl
Chief Curator, Memorial Art Gallery

Introduction

Michael Kammen

"Now ye'd think seein' that he made his money in this counthry, he'd pathro-
nize American art...."

"Well," said Mr. Hennessy, "perhaps a bum Europeen pitcher is betther thin
a good American pitcher."

"Perhaps so," said Mr. Dooley. "I think it is so."

—Peter Finley Dunne, Observations by Mr. Dooley[1]

As the Memorial Art Gallery approaches its centennial, it is a propitious time to consider the notable qualities of its American collection. First and foremost, I believe, has been the museum's receptiveness to American art, which so many counterpart institutions snubbed until at least the 1930s, and more often until well after World War II, in favor of works from Europe and East Asia. (The attitude of people running those museums is epitomized by the pithy dialogue between Mr. Dooley and Mr. Hennessy.) The Memorial Art Gallery's inaugural exhibition in 1913 followed by a few months the legendary Armory Show in New York City, which introduced European modernism to the United States. MAG's very first display featured art by contemporary American painters, including George Bellows, Winslow Homer, and George Inness, and during its initial five years, it acquired the beginnings of a respectable native collection with paintings by John Twachtman, Jonas Lie, and Willard Metcalf, among others. It did not hurt, of course, that the founding director, George Herdle, was American (not common at that time) and a painter himself, and that he was succeeded for many decades by his daughter, Gertrude, with yet another keen-eyed daughter, Isabel, as associate director and curator.[2]

Memorial Art Gallery, 1913
building designed by Foster
and Gade

It is impossible to overestimate the role women played in shaping and contributing to the collection generally, not merely as curators and major benefactors, but as active members of MAG's Women's Council (now the Gallery Council). The founder and first benefactress was Mrs. Emily Sibley Watson, whose generosity funded construction of the original building. And a major bequest from Hannah Durand Gould in 1938, in memory of her daughter Marion, provided the first endowed fund, which made possible a very important coup: the 1951 acquisition of work from the Encyclopedia Britannica collection by American artists, including such paintings as Thomas Hart Benton's *Boomtown* (1928), Georgia O'Keeffe's *Jawbone and Fungus* (1931), and Stuart Davis's *Landscape with Garage Lights* (1931–32). This purchase was truly a landmark moment in MAG's history, providing the backbone for its significant twentieth-century holdings.[3]

Emily Sibley Watson (1855–1945), founder of the Memorial Art Gallery; James G. Averell (1877–1904), her son, in whose memory the Memorial Art Gallery was founded

One of MAG's most distinctive dimensions from a historical perspective—possibly its *most* distinctive—is that it was created in conjunction with a university so that it would function within a scholarly milieu, yet at the same time was intended to be a community museum and asset emphasizing public outreach and service to an extended urban area. Some other art museums eventually moved in the direction of such a double mission, but MAG is preeminent in seeking to fulfill both functions from the outset. Hence the important role, for example, of Howard S. Merritt, a professor of fine arts at the University of Rochester, in writing catalogues for exhibitions of American art and providing counsel in matters concerning connoisseurship and acquisitions.

The particular mix of mission and municipal participation in MAG's history also means that, in distinction from some other museums, its holdings do not reflect the taste or lengthened shadow of a dominant individual, such as W. W. Corcoran, Isabella Stewart Gardner, or Duncan Phillips. Input, guidance, suggestions, and direct support have come from diverse groups and individuals who hoped to improve the collection without wishing to shape it according to their personal preferences. Among the many who have donated major holdings are George Eastman, Charles Rand Penney, and Dr. and Mrs. James Lockhart, Jr.

The museum's inventory of American art can be contemplated in various ways. Is it suitably comprehensive and representative of the most significant phases of development and change? Are the paintings by important artists strong and distinctive examples of their work? Looked at along such customary lines, the Memorial Art Gallery's collection certainly distinguishes itself with flying colors.

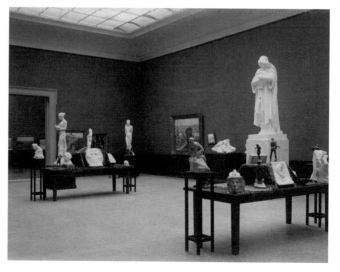

If we consider the collection from a cultural and historical perspective, however, we can use a less obvious set of criteria: How well does the ensemble reflect changes in American tastes, enthusiasms, and social concerns? Specifically, what sort of national narrative do these images, taken together, suggest? Taken on these terms, the Memorial Art Gallery's holdings are no less worthy. Indeed, because of their particular strengths, and owing to their breadth, MAG's American works provide an engaging window for viewing significant developments and changes in American life.

Hall of Casts, ca. 1914, dominated by William Ordway Partridge's *Memory*

The most fundamental "story line" for the history of the nation's culture concerns an essential conflict, even a contestation, between the desire to be cosmopolitan and avoid provincialism on one hand, and the quest for a distinctively *American* art and literature on the other.[4] As Ralph Waldo Emerson put it in his widely influential essay titled "The American Scholar" (1837): "We have

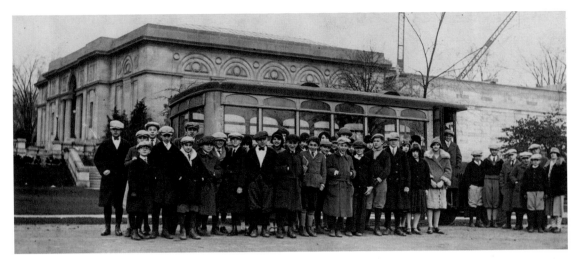

School group, 1926, arriving at the Gallery for a visit. Construction of the 1926 addition is visible on the right

listened too long to the courtly muses of Europe.... We will walk on our own feet; we will work with our own hands; we will speak our own minds." That impulse is readily visible in MAG's diversified collection and manifest in exemplary works that we might notice from the pre-Civil War era right through the mid-twentieth century and beyond.

Let us then consider the national narrative conveyed by MAG's American collection. To begin, we might recall that during the middle third of the nineteenth century Americans liked to regard their country as "Nature's Nation" because they believed the United States was unsurpassed for natural beauty, whether that meant geological wonders or landscapes that had been "improved" by human hands. Writers, artists, and architects referred almost obsessively to the "American picturesque." MAG has important works by Thomas Cole, John F. Kensett, and George Inness—members of the Hudson River School of painting who celebrated the majesty of New York and New England's wilderness places. One of the finest examples from this phase is *Genesee Oaks* (1860) by Asher B. Durand. Its motif is no dramatic mountain or valley scene, but a brace of stately oaks near Geneseo, New York. Because the subject is familiar and not exotic, we can understand how "Nature," to the Hudson River School painters, was more than merely a romantic spectacle, but an occasion for immanence. Durand would have known the seventeenth-century Dutch landscape masters, such as Albert Cuyp; but unlike Cuyp, whose cows were constantly so prominent and dominant, Durand "shrinks" the cows and gives priority to the mighty oaks, emblematic of stability and endurance.

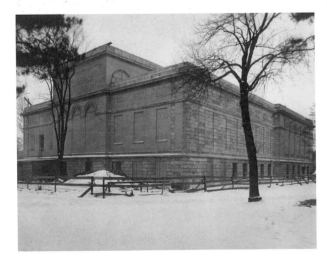

Construction of 1926 addition designed by McKim, Mead and White

Political maturity and stability would soon be sorely challenged, however, by the darkest chapter in the nation's history. Two pieces in the collection exemplify in distinctive ways how that conflict was viewed by anxious contemporaries and then subsequently in national memory. *The Night Before the Battle* (1865) by James Henry Beard owes much to a very rich tradition of European allegorical art dating back to the later Middle Ages—hence the presence of the grim reaper ambiguously manning the cannon in the middle ground and the slumbering, bone-weary soldiers awaiting their fate, symbolized by emblems of chance—the cards—in the brightly lit foreground. We immediately think of those haunting moonlit scenes by the greatest German romantic painter, Caspar David Friedrich. The shadow of Old World art remained strong.

By contrast, George Grey Barnard's noble bust of *Abraham Lincoln* (ca. 1918) captures the contemplative melancholy of a beardless Lincoln, also brooding through a dark night of the soul but in the plaintive austerity of a ravaged republic. Because Barnard telescoped the life of a rural lawyer turned commander-in-chief into a single

image, his work was initially controversial. Americans idealized Lincoln in various ways, especially following the centennial of his birth in 1909. Hence some called the work an "atrocity" and a "calamity" while others regarded it as "the image of a saint," and eventually "something like a mirror of Lincoln's soul." The latter view has prevailed, of course.

In the aftermath of the Civil War the specificity of place increasingly intrigued many Americans. In literature, "local colorism" or regionalism infused such popular novels as Sarah Orne Jewett's *Country of the Pointed Firs* (1896) and the best-selling tale of upstate New York by Edward Noyes Westcott, *David Harum* (1898). In painting, several extraordinary holdings by the Memorial Art Gallery illuminate this intense passion for the particular. John Henry Twachtman maintained a very tight focus on the seventeen acres of his home on Round Hill Road near Greenwich, Connecticut. *The White Bridge* (late 1890s) shows his selective use of French impressionist techniques brought to bear upon a very particular and familiar New England subject. Winslow Homer for many years painted Adirondack mountain scenes, and spent the last two and a half decades of his life repeatedly painting the Atlantic in all seasons and weathers from his solitary spit of land at Prout's Neck, Maine. For Homer, however, meteorology meant more than elemental science. It was a manifestation of God's inscrutable will, a view shared by most of his American contemporaries.[5]

Abraham Lincoln would serve as a symptomatic symbol during the early twentieth century for numerous reasons, but especially because he seemed to transcend the constraints of class. A great many Americans had long clung to the myth that theirs was virtually a classless society (especially by comparison with Europe), and consequently explicit acknowledgment of class, race, and ethnicity emerged only gradually and at first subtly in American art. But the motif grew steadily in importance, as we can see in *Peeling Onions* (ca. 1852) by Lilly Martin Spencer, George Luks's *Boy with Dice* (1923–24), and Robert Gwathmey's *Non-Fiction* (1943). Moreover, the perception that justice in America better serves the affluent classes than the poor is closely related. That is clearly what David Gilmour Blythe had in mind when he painted *Trial Scene (Molly Maguires)* (ca. 1862–63) and numerous works like it, usually incorporating a potent dollop of ironic humor. The contentious and polemical nature of our democracy is vividly illustrated in *The Opposition* (1942) by William Gropper, a member of the radical left throughout the Depression and World War II years and an impassioned defender of civil liberties.

Meanwhile, the United States had quite rapidly begun to urbanize, a phenomenon that avant-garde artists responded to in engaging ways. Consider Everett Shinn's *Sullivan Street* (1900–1905), John Sloan's *Chinese Restaurant* (1909), and later on Jacob Lawrence's *Summer Street Scene in Harlem* (1948). They are significant for several reasons: because of their innovative attention to the increasing role and importance of ethnicity and racial diversity in American life, and because their aesthetic modernism is so decidedly American. Witness, for example, Gwathmey's and Lawrence's deliberately *flat* cubism.

MAG's collection is notably well-represented by the Ashcan school (initially fostered by Sloan and Robert Henri) and by the regionalist emphasis associated with

Thomas Ridgeway Gould's *West Wind* overlooks the American collection installed in the 1913/26 building

Thomas Hart Benton, John Steuart Curry, and Grant Wood. What these two iconoclastic movements shared, spanning the years from 1908 through the end of the Great Depression, is an emphasis upon the "American Scene" (a phrase frequently invoked during the 1920s and 1930s), unglamorous common folk and familiar landscapes characterized by refreshing, distinctly unromantic candor. The oft-recognized entrepreneurial spirit of America (including its ruthless aspect), accelerated by manifest forms of industrialization, is supremely well illustrated by the contrasting

styles yet complementary motifs of Benton's energetic *Boomtown* (1928) and Charles Sheeler's serenely surreal *Ballet Mechanique* (1931), the latter actually commissioned by Henry Ford as an idyll of his River Rouge plant.

Sheeler felt equally at home, however, depicting colonial Americana in Williamsburg, Virginia, along with rustic structures from an earlier era in eastern Pennsylvania. His work along those lines coincided with a renewed interest in American folk art, which the Memorial Art Gallery pioneered in displaying. The first exhibition devoted to this genre occurred as early as 1931, when few individuals and even fewer museums were competing for items now regarded as native treasures. Collecting in this long-ignored field began in earnest during the 1950s at MAG—hence the immediate visual impact and appeal of weathervanes, larger-than-life cigar store Indians, *Pierrepont Lacey and His Dog Gun* (1835–36) by M. W. Hopkins, Thomas Chambers's *View of West Point* (after 1828), and especially Ammi Phillips's exquisite *Old Woman with a Bible* (ca. 1834). This American nationalism infused with nostalgia for simpler times of yesteryear gave new meaning to neglected artists and works like *Articles Hung on a Door* (after 1890) by John F. Peto.

Modernism emerged in American art with particular force fairly soon after the Armory Show (and MAG's opening) in 1913. Aaron Copland's music and the choreography of Isadora Duncan and Martha Graham had their counterparts in the visionary images of (among those in MAG's collection) Georgia O'Keeffe (*Jawbone and Fungus*, 1931), Stuart Davis (*Landscape with Garage Lights*, 1931–32), and Arthur Dove (*Cars in a Sleet Storm*, 1938). And yet, although Americans have invariably affirmed Progress as a prominent part of their cultural ethos, they have been notably ambivalent in their attitudes to modernism in the plastic and graphic arts. In Rochester, however, the more positive reception may be the result of a commitment to modernism by James Sibley Watson, Jr., son of the Gallery's founder and a member in his own right of the American avant-garde, as well as the sophisticated tastes of director Gertrude Herdle Moore and her sister, associate director Isabel Herdle.

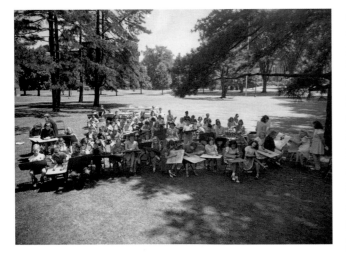

1941 Creative Workshop summer class on the back lawn

Although World War II would prove to be a transitional time in American art, that event prompted important works that perpetuated the contrasting approaches of native-born and European painters. George Grosz, for example, who fled Nazi Germany for the United States in 1933, took refuge in a country that he idealized. But the style and vision that haunt his work called *The Wanderer* (1943) are unmistakably Old World, born of tradition and personal experience. As he remarked right after the war: "The old man is the eternal human spirit—here he walks once again through a dark world—through an apocalyptic landscape."[6] By contrast, Norman Rockwell's *Soldier on Leave* (1944) seems sentimentally chin-up, and intimately more hopeful. It conveys a sense of sociability rather than solitude, dry and polished shoes rather than wet and muddy boots, optimism rather than despair. Consequently we are reminded of Samuel Isham's remark in his *History of American Painting* (1905) that the fundamental characteristic of American art is its overall impression of wholesomeness.

In the years directly following the war, uncertainty about new developments in American painting, particularly abstract art, was manifest in many ways. Between 1947 and 1950 negotiations broke down among the major New York City museums—the Metropolitan Museum of Art, the Museum of Modern Art, and the Whitney Museum—over possible mergers or spheres of dominant activity in the accession and exhibition of work by contemporary artists. The Met did not establish a Department of American Art until 1952. In 1949 Robert Goldwater organized a symposium called "The State of American Art" for the *Magazine of Art*, which he edited. Among the sixteen contributors, all but one, Clement Greenberg, agreed that the best painting of the day originated in Paris.

That consensus would very swiftly undergo a dramatic change, one that is well illustrated by two abstract works in MAG's collection, both from 1950.

The completely nonobjective *Untitled (Relational Painting)*, by Russian-born immigrant Ilya Bolotowsky, reflects the obvious influence of Mondrian's color and space relationships as well as Russian constructivism. Here we have the international style, also clearly associated with the prewar Bauhaus, transmitted to the United States. In contrast we have Jackson Pollock's elegant, almost lyrical work simply titled *Red*. It is fluid, free, and accentuates movement—in that sense almost a parallel work to Andrew Wyeth's famous *The Young American* (also 1950), a realist's vision of a young man riding his bicycle through the wide-open landscape. The American watchwords at mid-century

were freedom, not enclosure, liberty rather than constraint. That is why Pollock's *Red* is such a harbinger, both of Pollock's enormous influence at home and abroad, and of a dominant trend in American art and thought for years to come.[7]

Within less than a decade a new consensus emerged that New York rather than Paris was the art capital of the world. The quest for a distinctively American aesthetic had not only been achieved, it received international acceptance. Indeed, its influence received the ultimate compliment of imitation. In 1958–59 the Museum of Modern Art proudly organized a huge exhibition titled New American Painting, and sent it abroad. The cultural hegemony of Europe had been overcome at last. American art stood on an equal footing with any other, and some even insist that primacy had been achieved.

As if in anticipation of this "equal footing," it is safe to say that the Memorial Art Gallery has, from the beginning, collected the best of American art as an essential part of its mission to "promote the appreciation, understanding, and interest in art and the arts." This publication does more than refute Mr. Hennessy's comment that "a bum European pitcher is betther thin a good American pitcher." It reminds us that the best American art is inextricably bound up with essential truths of American experience.

Cutler Union tower and main entrance, 1968 addition. Cutler Union (1932) was designed as the University of Rochester Women's Student Union by the Rochester firm of Gordon and Kaelber and built with funds donated by Rochester architect James Goold Cutler, also remembered for being the inventor of the Cutler Mail Chute. The 1968 addition was designed by Waasdorp, Northrup and Kaelber.

Looking from the entrance of the 1987 addition, designed by Handler and Grosso, through the allée of trees designed by landscape architect Fletcher Steele, toward the steps of the 1913 building

Michael Kammen is the Newton C. Farr Professor of American History and Culture, Cornell University.

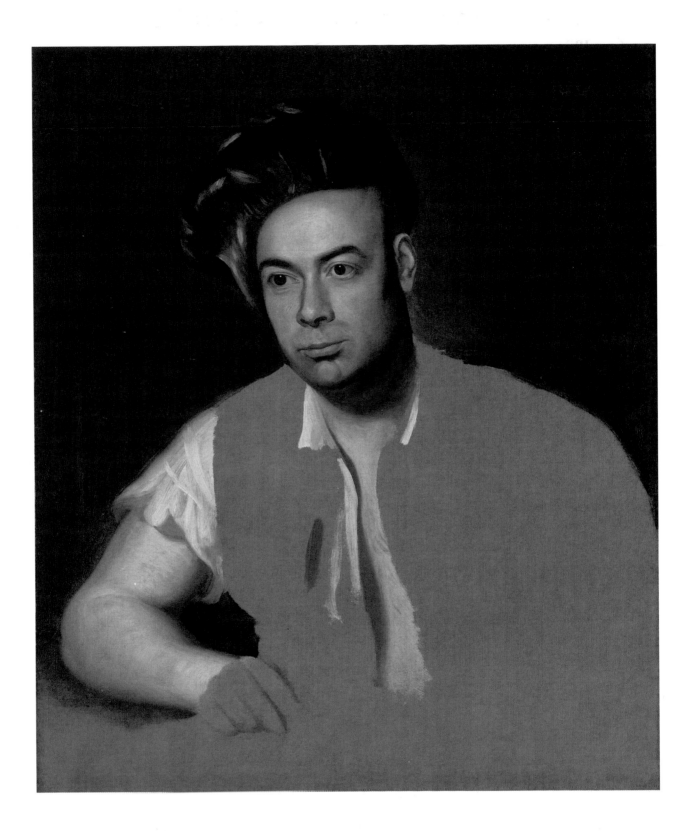

1: John Singleton Copley *Unfinished Portrait of Nathaniel Hurd* (ca. 1765)

Marjorie B. Searl

*V*isitors standing in front of the Memorial Art Gallery's unfinished portrait of Boston silversmith Nathaniel Hurd ask important questions. Why didn't the artist complete the job? Does the painting have any value? Why did it survive? Why hang an unfinished painting in a museum?

The question of value is easily answered. Because MAG's portrait was painted by one of America's finest painters, John Singleton Copley, it is significant as part of the record of his distinguished career.[1] For scholars, its lack of finish yields new information about Copley's painting techniques and helps to better establish the date of this work and perhaps others. And because a finished portrait of Hurd, also by Copley, does exist, we might be able to learn why Copley didn't finish the job and why the unfinished painting survived.[2]

In the 1760s, Boston was a thriving city of around 16,000 people, one of the "big three" in the British colonies, along with New York and Philadelphia.[3] With a monied class that could afford to surround itself with luxuries—and indeed felt entitled to them—artists and artisans had patrons among the British and the colonists alike. One of the best known was the silversmith and engraver Nathaniel Hurd, son of the master silversmith Jacob Hurd. Hurd's upbringing was a traditional one for a mid-eighteenth-century boy—a few years of schooling at Boston Latin School, followed by apprenticeship, most likely to his father. He set up his own shop in the vicinity of the Old State House, easily accessible to many of the leading families of colonial Boston. Some of his most significant commissions were pieces for the distinguished Hancock, Mather, and Hutchinson families. While Hurd's name is not as well known as that of his fellow silversmith, Paul Revere (1734–1818), his engraving was sought after by Revere and other silversmiths, earning him the sobriquet "Hurd the engraver." Hurd had numerous engraving commissions; bookplates and currency bore his designs, which live on in the seals for Harvard College and Phillips Exeter Academy. We can assume his status as a respected citizen, since he held appointed positions such as fire ward, clerk of the market, and "scavenger." He served on the grand jury that was charged with investigating the death of Crispus Attucks, the first casualty of the Boston Massacre. Hurd never married, and died in middle age. His few possessions at the time of his death were distributed among friends and family members.

In spite of his renown among his fellow Bostonians, Hurd was not as affluent nor as socially prominent as those successful colonial "aristocrats"—by birth or self-styling—who sat to have their portraits painted by John Singleton Copley. Copley, whose early years were spent on the Boston wharves where his mother ran a tobacco shop, had traveled far in station if not in geographical terms. His native skill at capturing likenesses propelled him into the premier place as portrait artist in Boston. His marriage to Susannah Clarke, whose father was a tea merchant, positioned him even higher in Boston society. By the 1760s, Copley was commissioned to paint Boston's finest, including Mrs. and Mrs. John Hancock and Mercy Otis Warren.[4]

While artists were paid well for their individual oil and pastel portraits, those works took up a fair amount of time and brought a one-time compensation. Always looking for additional markets, painters like Copley recognized that an engraved image of a particularly popular or important individual could be printed and sold many times over. Rev. Joseph Sewall (1688–1769), pastor of Boston's Old South Church, fit this bill. He presided over the church in the years preceding the American Revolution, and endeared himself to the Patriot community because he permitted the

John Singleton Copley,
1738–1815
Unfinished-Portrait
of Nathaniel Hurd, ca. 1765
Oil on canvas, 29³/₈ x 24⁵/₈ in.
Marion Stratton Gould Fund,
44.2

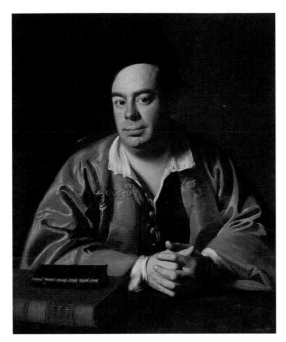

John Singleton Copley,
1738–1815

Nathaniel Hurd, ca. 1765

Oil on canvas, 30³/₈ x 25³/₈ in.

©The Cleveland Museum of

Art, 1994, Gift of the John

Huntington Art and Polytechnic

Trust, 1915.534

church to be used for anti-British political gatherings. Copley had already painted his portrait by 1764, but in a pre-photography era, an engraving was the only means by which the general public could remember him.

After first approaching British engravers with no success—colonial arts were considered inferior—Copley turned to fellow Bostonian Nathaniel Hurd for assistance with this project.[5] We can assume that the two prodigies were known to each other, as Boston was a relatively small community, and the two counted several of the same families as patrons. Family tradition suggests that Hurd's brother, Benjamin, studied painting with Copley, and there is speculation that Hurd may have learned engraving from Copley's stepfather, Peter Pelham.[6] But the definitive proof of a relationship is the existence of a miniature Copley portrait of a younger Nathaniel Hurd.[7]

Written documentation of their relationship is virtually nonexistent. Copley mentions in a 1764 letter that he has contacted Hurd to do the Sewall engraving, but there is no description of the terms. We may speculate that the two made a trade—Hurd's engraving for a Copley portrait. But there is a mystery. Aside from the miniature, two portraits of Hurd painted by Copley survive. One is the unfinished painting in the collection of the Memorial Art Gallery. The other is a finished portrait in the collection of the Cleveland Museum of Art. Here we come to more of our initial questions. Which portrait came first? Why was one left unfinished? What is the relationship between the two, and what is their significance in Copley's work?

Neither painting is dated by the artist.[8] Neither is documented by Copley or Hurd in any letters or ledgers. Again, we are in the realm of speculation. However, it would be logical to assume that the unfinished portrait was the earlier one, and that for some reason, either for the artist or the subject, it was unsatisfactory and therefore abandoned in favor of the one that was completed. So, the question is, what made the earlier version less acceptable, and to whom?

To judge from surviving paintings by Copley, his portrait of Hurd is his first attempt to paint an artisan in workclothes. He would go on a few years after finishing that portrait to paint one of his most brilliant works, the portrait of Paul Revere (ca. 1768, Museum of Fine Arts, Boston) dressed in work attire, holding a piece of silver. It may be that it was Hurd himself who was dissatisfied. If this was, in fact, his payment for preparing and printing an engraving for Copley, he probably wanted to be paid with a work in Copley's best style, rather than in an experimental version whose expanse of exposed flesh might be viewed as scandalous. Hence the finished portrait in the collection of the Cleveland Museum depicting Hurd dressed in a silk banyan and a turban, with a book of heraldry at his elbow. This was a portrait that would link Hurd, visually, with the merchants and scholars who were his patrons, elevating his status to that of a professional rather than a working-class artisan. Carrie Rebora Barratt links this portrait with fifteen others that depict men in fashionable *turquerie*, costumes that reflect the eighteenth-century craze for things Turkish and Oriental. She concludes that "Hurd's image, if we pursue this line of thinking, cleaves him from his artisanal colleagues and aligns him socially and economically with his elite clientele, such as Nicholas Boylston."[9] And, in reality, the role of the silversmith straddled class distinctions. Since patrons typically brought in their silver coins to be melted down and reused in the form of spoons, canns, and salvers, a silversmith like Hurd was charged with determining weights and values of coinage, putting him in a position not unlike a banker in terms of handling significant amounts of money and calling for a high degree of trustworthiness. Presumably, his portrait needed to reflect his professional success. Even his facial expression in the finished portrait has a more corpulent, well-fed appearance, in contrast to the wistful, introspective, and possibly anxious look of the unfinished portrait.

If the abandoned canvas was *not* perceived as the preferred pose or the artist's best effort, then what is its value within the context of Copley's oeuvre? First, as mentioned previously, it represents Copley's developing interest in the informal portrait of the working artisan, which was in itself a revolutionary, anti-aristocratic idea. But beyond the iconography, the painting is a visual demonstration of Copley's working method. The gray underpainting, normally covered, is left revealed. "Dead color" was used to prime the canvas in order to enhance the colors being used to paint the subject. Also, a very close look at the portrait in the area of Hurd's fingers reveals the underdrawing Copley used as he sketched his subject on top of the ground before applying layers of colors.[10]

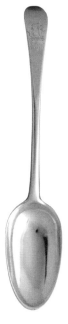

Nathaniel Hurd
1730–1777
Exchange Table, undated
Engraving, 4 x 5³/₈ in.
Courtesy of American
Antiquarian Society

The lives of the two men, reaching their professional prime when this painting was done, would diverge significantly. Hurd remained in Boston, a town that was to suffer greatly during the American Revolution. As taxes and boycotts increased in number, Hurd's sources of income declined. The tax on paper reduced his engraving commissions, and when tea was boycotted, it effectively eliminated commissions for the silver tea accoutrements that were needed by his customers. Money was scarcer in general, and many wealthy families fled the region for safer ground. In addition, Hurd seems to have been unable to fulfill governmental commissions after a time; in November 1776, it was ordered that "the committee appointed to cut plates for a new emission of money, take from Mr. Hurd the plates he began to engrave, and deliver the same to Mr. Revere, to be completed."[11] His will indicates that he had a terminal illness for which he required the care of one Polly Sweetser, and he acknowledged her "Kindness and Tenderness to me in my Sickness."[12] He was buried in the Granary Burial Ground in Boston, not far from the monument to Paul Revere.

Copley, on the other hand, left for Europe to study paintings of the Old Masters. His wife and family stayed behind but as the political situation deteriorated, it soon became necessary to send for them. That move marked the end of Copley's relationship with Boston, the city that exalted him as an honored son. He remained in Europe for the rest of his life, died in 1815, and was buried at Highgate Cemetery in London, England, with other notables like authors Charles Dickens, George Eliot, and Karl Marx.

Both portraits remained in the Hurd family for many years. That the unfinished portrait came down through the Hurd/Furnass family may indicate its value to family members from the beginning, perhaps as the more realistic depiction of a revered ancestor. Its provenance began with Hurd's sister Ann. Might she have prevailed upon her brother to keep the portrait? She seems to have been, of the four sisters, the one closest to Nathaniel. She named one son after her brother, and her other son, John Mason Furnass, inherited from his uncle a printing press and some tools, "in consideration for the Love I bear to him & the Genius he discovers for the same Business which I have followed & to which I intended to have brought him up."[13]

As for the final unanswered question—why would a museum exhibit an unfinished portrait? In addition to the scholarly, historical, and anecdotal value of this painting, there is an additional and perhaps fundamental dimension: beauty. This may have been the quality most highly prized as the painting was handed down through the generations and as the original connection with the beloved brother and uncle became attenuated. After nearly two hundred and fifty years, the tender and shadowy contours of Hurd's face and the softness of his eyes and mouth have become parts of an aesthetic whole, perhaps all the more satisfying for the hint of mystery it imparts to its subject.

Nathaniel Hurd,
1730–1777
Spoon, ca. 1760
Silver, 8³/₄ x 1¹¹/₁₆ in.
Maurice R. and Maxine B.
Forman Fund, 2001.22.1

Marjorie B. Searl is Chief Curator, Memorial Art Gallery.

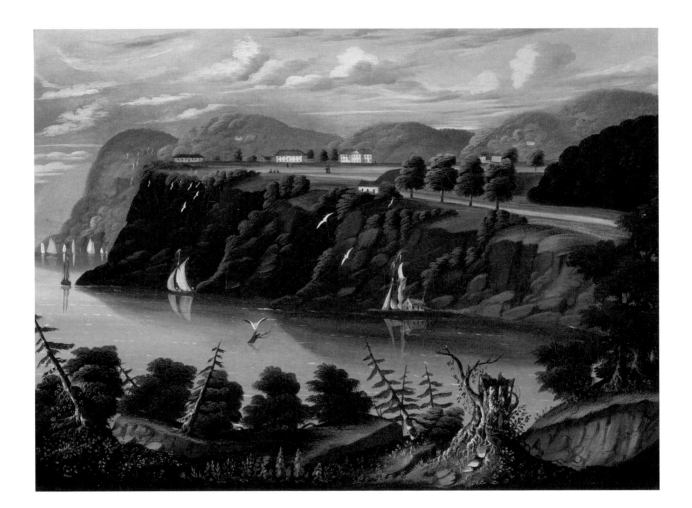

2: Thomas Chambers *View of West Point* (after 1828)

Peter Ogden Brown

West Point is romantically situated on the west bank of the Hudson River, 52 miles from New York and 93 miles from Albany....No place in the Union exceeds [it] in beauty of location and the stirring incidents connected with its early history, [and in its present role as] the residence and school of the future defenders of the Union.[1]

The manner and style of natural adornment that is presented by the face of the grounds and rocks attached to this national domain...cannot fail to impress the traveler, when he observes the formation of the fantastic rocks, wild moss covered crags, luxuriantly-garlanded pillars and creeping shrubs, and the cottages and hamlets perched on the slopes, terraces, and crags, in most admired confusion....[2]

It is little wonder, with ease of transportation and unabashed promotion of the American heritage and landscape by guide books like those excerpted above, that Hudson River sites became popular images for artists to paint or to copy. Thomas Chambers, a self-taught British artist who immigrated to America, was one of the most prolific of these. While he painted many American scenes, including Niagara Falls and the Genesee Falls in Rochester, he seemed to specialize in the Hudson River. A search of the Smithsonian Institution's Inventory of American Art database yields a variety of descriptive titles, including *Looking North from Kingston, View on the Hudson,* and *View Near Fishkill, Hudson River.* Of his many near-identical views of West Point, one, his unsigned *View of West Point,* was a gift to the Memorial Art Gallery from Elsie McMath Cole in 1943, only a few months after Norman Hirschl and Albert Duveen brought the previously unknown painter to national attention. The two dealers assembled eighteen works, only one of which was signed, which they attributed to the artist in a show at New York's Macbeth Gallery ambitiously titled: "T. Chambers: First American Modern."

Subsequently, through the determined work of Nina Fletcher Little and Rochester's Howard Merritt, the artist's life in America was limned in and the identification of his extant paintings expanded to include some sixty-five works, examples of which are now owned by many major art museums.[3] Little, a student and collector of Chambers's work, published three articles about him in *Antiques* magazine between 1948 and 1951.[4] In them she made use of early municipal almanacs, directories, and census records to establish Chambers's places of residence and occupations. Born in England in 1808, he immigrated to New Orleans in 1832. In 1834 he is described in a New York directory simply as an artist and, later, as a landscape and marine painter. By 1843 he was living in Boston, occupied again as an artist and then as a portrait painter. He moved to Albany in 1852, and returned to New York in 1861. Chambers's wife and fellow Briton, Harriett Shellard, died there three years later, at age fifty-five, and the artist, himself, sometime after 1866.[5]

Professor Merritt of the University of Rochester was also a collector of Chambers's work. In a 1956 article about the artist, he noted (as had Little) the painter's evident reliance on published views by other artists, such as Asher B. Durand, William H. Bartlett, and Jacques Gérard Milbert, for much of his subject matter.[6] He broke Chambers's work down into forty-five landscapes, fifteen marine paintings (five of which constitute his only signed works), and five paintings of foreign subjects. (No portraits have yet been attributed to the artist.) Of these oils, twenty measure 20 x 30 inches, the dimensions of the Gallery's work. Merritt traced the inspiration for a second Chambers landscape owned by the Gallery, *View of the Delaware Water Gap,* to a Durand print of the subject published in 1830.[7]

Thomas Chambers,
1808–after 1866
View of West Point, after 1828
Oil on canvas, 22¼ x 30⅛ in.
Gift of Elsie McMath Cole in
memory of her parents,
Mr. and Mrs. Morrison H.
McMath, 43.43

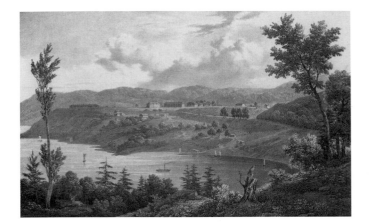

Laurent Deroy, French,
1797–1886, after Jacques
Milbert, French, 1766–1840
*General View of the Military
School, West-Point (Vue générale
de l'école militaire de West Point),*
1828–1829
Lithograph, ca. 7¹¹/₁₆ x 11¹/₈ in.
Courtesy of Emmet Collection,
Miriam and Ira D. Wallach
Division of Art, Prints and
Photographs, The New York
Public Library, Astor, Lenox,
and Tilden Foundations

View of West Point can, likewise, be tied back to a painting by Jacques Gérard Milbert from the early 1820s, subsequently reproduced as a lithograph in his *Itinéraire pittoresque du fleuve Hudson...*, published in Paris, 1828–29.[8] Milbert, born in Paris in 1766, was trained as a naturalist and geographical illustrator. Illness prevented him from joining Napoleon's expedition to Egypt, but in 1815 he seized on an opportunity to travel to the New World. He spent nine years in America, drawing, painting, conducting scientific inquiries, and even consulting on the route of the Erie Canal.[9]

The oldest continually occupied military post in North America, West Point was purchased in 1790 by Congress as a defensive position. In 1794 the government began to train engineers and artillerymen on the site, a level bluff two hundred feet above the west bank of the Hudson. Milbert painted the view from a position on the east side of the river, probably the projection known as Constitution Island. He included the North and South Barracks, the Academy building, with its pedimented front, and the Cadet Mess Hall.[10] The lightning-blasted stump in the right foreground of Milbert's painting, with its new south side growth echoing the tilt of the adjoining trio of wind-bent pines, also appears in Chambers's depiction, together with the larger trees which frame the right and left sides of the composition.

But Chambers cannot be dismissed as a copyist. He developed a distinctive palette and style that separate his works from those of other Hudson River School artists and make them so readily identifiable. Variously described as pioneering ("First American Modern"), essential, or naïve, in *View of West Point* he juxtaposes the rotund color masses of the rocks, leafy trees, and wooded bluffs against the angular shapes of the straggly pines, sailing ships, and soaring gulls to energize his impression of the outlook. Brilliant orange light contends with the cerulean blue of a hazy sky and distant Hudson promontory, while the white accents of the sails and birds contrast against the deep greens and earth tones of the shaded foreground and point. Although relatively small, the Academy buildings and sailing craft on the river are rendered in accurate detail, a feature of the artist's marine paintings.

Thomas Chambers is thought to have painted this subject between ten and twelve times, making it one of his most popular views, and one seen personally by the thousands of Americans and European visitors who followed the pleasant water route offered by the Hudson River and Erie Canal through the eastern heartland of the new nation.[11] Charged with Revolutionary War history, patriotic fervor for the new military establishment sited there, and the natural drama of one of the lower Hudson's most attractive reaches, West Point offered a perfect opportunity for the creation of visual souvenirs of the American "grand tour." As one of the many contemporary guide books put it, "No place in the Union, probably, exceeds West Point in beauty of location and the stirring incidents connected with its early history...."[12]

Thomas Chambers,
1808–after 1866
View of West Point (detail),
after 1828
Oil on canvas, 22¹/₄ x 30¹/₈ in.
Gift of Elsie McMath Cole in
memory of her parents,
Mr. and Mrs. Morrison H.
McMath, 43.43

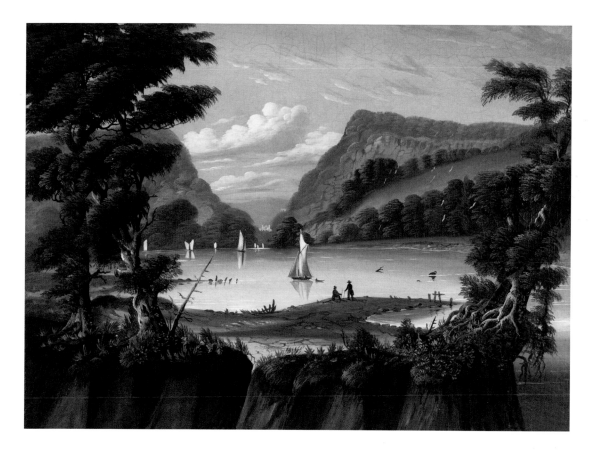

Thomas Chambers,
1808–after 1866
View of the Delaware Water Gap,
ca. 1850
Oil on canvas, 23 x 30½ in.
Marion Stratton Gould Fund,
47.16

And we know that Chambers, living at various times in New York and Albany, must have passed the spot himself on at least one occasion, yet, as with his painted views of other popular natural sites, some of which he may not personally have witnessed, such as the Delaware Water Gap, Niagara Falls, and Rochester's own Genesee Falls, the artist still preferred to rely on other artists' popular prints when formulating his paintings. Combined with the paucity of information regarding his life, this has led to great difficulty in dating his work (the Memorial Art Gallery's *View of West Point,* taken from the 1828–29 publication of Milbert's work, could theoretically have been painted at any time between that event and Chambers's death, some time after 1866). It also raises the question, given his unique use of dramatic shapes and color masses, as to why the artist did not trust his own hand to compose these popular views.

The answer may lie in the strong likelihood that Chambers was self-taught and realistic in his own appraisal of his abilities. The evidence of so many multiple copies in his oeuvre, together with the limited opportunities for learning to paint outside of the academy,[13] suggest that this artist was very much a creature of the marketplace, with his "modernist" tendencies resulting as much from his freedom from the constraints of academic convention, as from any deliberate, creative divergence from contemporary form.

Yet, whatever its derivation, the repetition in Thomas Chambers's work also suggests that the fresh stylistic approach and color liberation struck a responsive chord in his patrons. Being himself an immigrant to these shores, Chambers created dynamic impressions of the young nation's natural and historic attractions that proved very much in keeping with the new spirit of its people.

Peter Ogden Brown chairs the Art Committee of the Memorial Art Gallery and the board of the Rochester Historical Society.

3: Unknown American Artist *Portrait of Colonel Nathaniel Rochester* (before 1831)

Peter Ogden Brown

The Memorial Art Gallery's portrait of Nathaniel Rochester (1752–1831) conveys the strength and character of this tough-minded real estate developer in his seventies. Colonel Rochester, the founder of the city that bears his name, is depicted in three-quarter view as a vigorous gentleman wearing glasses (with fashionable reading lens attachments) and dressed in a black, double-breasted coat, a white shirt, and a cravat.[1] Though unsigned, the portrait has long been attributed to the great naturalist John J. Audubon (1785–1851), owing to the inscription on its backing: "Nathaniel Rochester painted by J. J. Audubon."[2]

But this attribution, however tantalizing, turns out to be open to question. On stylistic grounds alone the work appears to be that of a far more accomplished portrait painter than Audubon. One of the artist's descendants, Lucy Winters Durkin, of the Memorial Art Gallery's Education Department, has pointed out that, although Audubon supported himself in his early years through portraiture, most of his successful renderings were done in crayon and chalk. Around 1822, he converted to oils in order to generate more revenue from his work, but his real skill lay in drawing, and he was never able to achieve the same level of accomplishment in the new medium. Indeed, there are few if any firmly attributed Audubon oil portraits from this period that would lend weight to the case for the Rochester work. Eventually he abandoned portraiture to devote his full time to nature studies. Working with a talented engraver and printer, he produced the epic *Birds of America*, upon which his reputation now lies.[3]

Unknown American Artist
Portrait of Colonel Nathaniel Rochester, before 1831
Oil on canvas, 30 x 25 in.
Gift of Thomas J. Watson, 34.1

The case for Audubon cannot flatly be ruled out. His diary indeed places him in Rochester for a few days in August 1824, during a trip on the recently completed Erie Canal:

> *Rochester, August 22: Five years ago there were but few buildings here and the population is now 5000; the banks of the River are lined with mills and factories. The beautiful falls of the Genesee River, about eighty feet high and four times as broad, I have visited, and made a slight sketch of them. August 24th: Took passage for Buffalo.*[4]

So it is possible that during those two days in Rochester the Colonel sat for his portrait by Audubon. But if so, Audubon doesn't mention it in his journal, and there is no hard evidence that it ever happened.

Descendants of Rochester and students of Audubon have also long disputed the attribution to Audubon, which is based upon family tradition and on the written endorsement on the back of the canvas. At least one Rochester family member, Miss Helen Rochester Rogers, firmly believed that the inscription was in her distinguished ancestor's hand.[5] But in 1969 another Rochester descendant, Charles Shepard, challenged both the attribution to Audubon and the identity of the subject as Rochester.[6] Any doubt about the sitter's identity was dispelled in 2003 when a fourth-generation descendant of the Colonel, Wilson Rood, produced a miniature of the Memorial Art Gallery painting (also unsigned).[7] If we then conclude that the Memorial Art Gallery's portrait is indeed that of Colonel Rochester, the question remains as to whether it was Audubon's work or that of another talented portraitist.

That question may never be definitively answered. But if the family belief is correct that Audubon did paint a likeness of Nathaniel Rochester, is there then a case to be made for its being a portrait other than MAG's? Until quite recently that seemed to be so. A matching pair of portraits of Rochester and his wife Sophia, the originals of which are in the possession of their descendants and copies of which are in the Rochester Historical Society, thought to have been executed around 1822 (yet depicting a Rochester obviously older than that of MAG's), were considered likely candidates for attribution to Audubon. But new information has scuttled that hypothesis.[8]

There is one other intriguing candidate for an Audubon attribution, however. An anonymous pastel done when Rochester was a much younger man (now hanging in the Campbell-Whittlesey House owned by the Landmark Society of Western New York) hung for years in the offices of the Hagerstown (Maryland) Bank, of which Rochester was the first president (1807–09).[9] A partially visible notation on the back of the pastel suggests that it depicts the Colonel in his thirty-seventh year (1789), when Audubon would have been only four. But there is reason to doubt the accuracy of any written information appended to the various Rochester portraits, since all the notations were very likely made years after the sittings.

In 1822, the year of Colonel Rochester's seventieth birthday (and a plausible date for MAG's oil portrait despite the inscription of 1824) the new Bank of Rochester was to be opened. As in the earlier situation at Hagerstown, the bank would have wanted a strong portrayal such as MAG's to inspire the confidence of its depositors, perhaps even entailing some "artistic license." As it happened, the bank did not open its doors until 1824, at which time it could have laid claim to the commissioned portrait to hang in its lobby. As its organizers had feared, the Bank of Rochester did not long survive the Colonel's death in 1831, its charter quietly expiring in 1840. At this juncture Nathaniel Rochester's portrait would logically have been returned to his widow, Sophia, who outlived her husband by many years, dying in 1846.[10] By then Audubon was nationally renowned, and it may be that Sophia's executors, in labeling the unsigned portraits for family distribution, and believing that their father had sat for the artist on some occasion (perhaps for the Hagerstown Bank's pastel, if that work's inscription about Rochester's age is also incorrect), mistakenly attributed the stronger painting to that artist.[11]

Audubon cannot flatly be ruled out as the painter of the MAG portrait, but the technical skill displayed is not apparent in any other portrait attributed to him. But then who? Interesting cases can be made for both Grove S. Gilbert and Horace Harding,[12] both competent period portraitists with Rochester connections, as well as for the fine contemporary painter Rembrandt Peale (1778–1860) and a number of others.

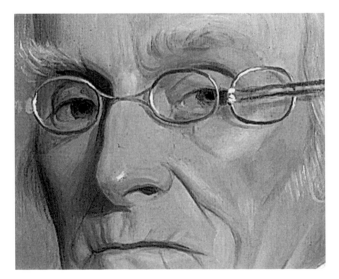

In 1822, the same year in which Nathaniel Rochester was elected to the New York legislature, Peale moved his studio from Philadelphia to New York City in search of new portrait commissions. He painted Governor DeWitt Clinton and other notables, frequently traveling out of the city to accomodate his sitters. Rochester Historical Society

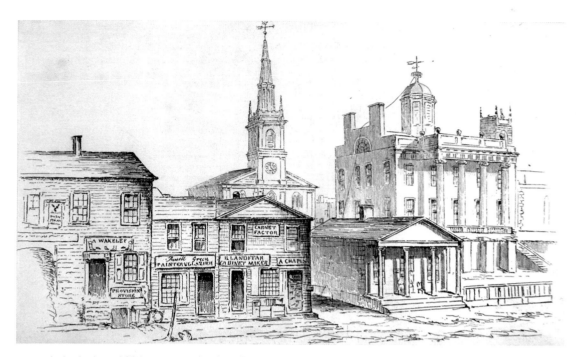

William Home Lizars
1788–1859
The Village of Rochester,
from the book *Forty Etchings*
from Sketches Made with the
Camera Lucida, in North America,
in 1827 and 1828,
by Captain Basil Hall,
(Edinburgh, London, 1829)
Etching, 6$^{7}/_{16}$ x 9$^{5}/_{8}$ in.
Gift of Dr. and Mrs. Frank
W. Lovejoy Jr., 84.36

The step-gabled building on the
right is the first Monroe County
Courthouse, built in 1822.
The steepled church topped
by a weathervane is the First
Presbyterian Church, and St.
Luke's Church, where the
Rochester family worshipped,
is to the right of the court-
house building.

records include a 1936 communication from a Mrs. Russell of New York City describing "a very fine portrait of Colonel Rochester done by Peale and given to (Rochester) Mayor Chas. Carroll," which was owned by her family.[13] Certainly the MAG portrait of Rochester, with its three-quarter pose, clarity of features, technical skill in depicting glasses, monochromatic background, and humorless portrayal of the sitter's character, closely resembles Peale's earlier Philadelphia portraits, such as those of himself, Richard Peters, and William Tilghman.

Nevertheless, the case for Peale as the painter, as for the other candidates, is not entirely persuasive, and so the story of the painting's creation remains unfinished until further information comes to light. Yet even if we never learn the identity of the painter of this classic early nineteenth-century American portrait, its strength and posture of vigorous rectitude, so appropriate to its subject as well as the period, will always be arresting for contemporary viewers.

Peter Ogden Brown chairs the Art Committee of the Memorial Art Gallery and the board of the Rochester Historical Society.

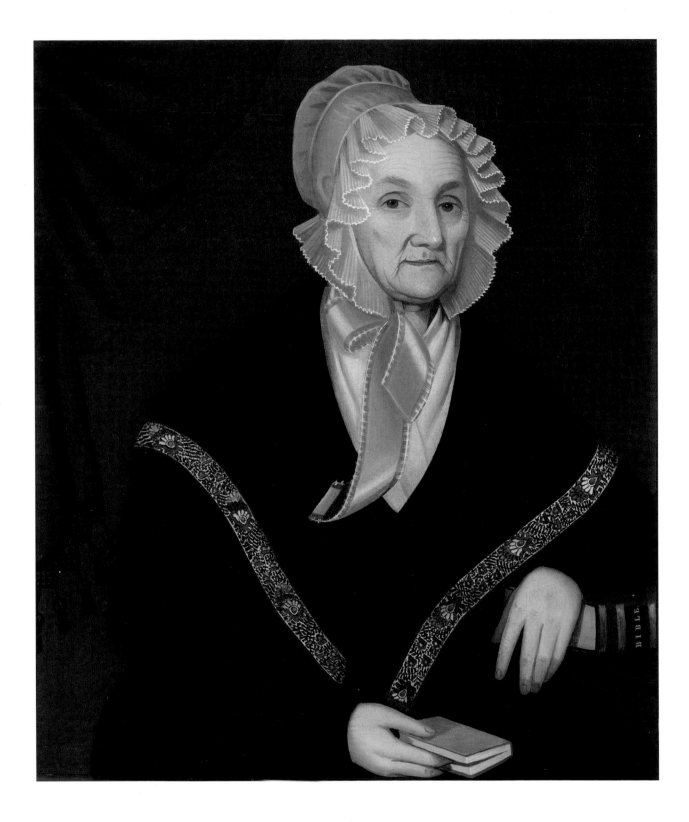

4: Ammi Phillips *Old Woman with a Bible* (ca. 1834)

Susan Nurse

Tugged by nationalism and nostalgia for a simpler past, under assault by wars, brute industrialization, and European modernism, Americans in the early twentieth century discovered a taste for their own folk art, much of which had been relegated to family attics. The portraits of Ammi Phillips have often been included in that category.[1] And indeed, what could be plainer and more reassuring than the quiet, staunch, finely dressed old woman in MAG's portrait, a small book in her hand and her elbow resting with full familiarity on the family Bible?

This new interest in folk art was institutionalized in 1930 when Holger Cahill of the Newark Museum mounted a groundbreaking exhibition: American Primitives. In June 1931, the Memorial Art Gallery became one of the first museums in the country to host the traveling exhibition.[2] Although MAG in the following decades made good on its early appreciation of American folk art, continuing to collect and exhibit it, not until 1984 did it add one of Ammi Phillips's notable paintings—*Old Woman with a Bible*—to its collection.[3]

But is it "folk art," when, unlike many "pure" folk artists, Phillips was well known, was non-itinerant at the peak of his career, often knew and identified his sitters (many of them prominent people), and though probably self-taught, was aware enough of artistic trends and confident enough in his own talent to periodically adjust his style in response to changing tastes, his sitters' wishes, and his own evolving skill and experience? Phillips has been variously categorized as a folk, naïve, or primitive artist, but even if his work is similar in some respects to that conventionally so described, to insist on any of these terms blunts our understanding of his real talent and fails to acknowledge the compelling strength of his mature paintings like *Old Woman with a Bible*.

Phillips was born in 1788 in Colebrook, Connecticut, and given the Old Testament name "Ammi."[4] Early scholarship had attributed his work before 1820 to the "Border Limner" and the mature work to the "Kent portraitist," but thanks to the diligent efforts of Barbara and Lawrence B. Holdridge in the 1960s, Phillips was shown to have been the sole painter involved.[5] Obviously he was highly successful in his craft (by 1994 over six hundred of his portraits had been identified).[6] Anyone wanting to see his work had only to look to neighbors or friends. Phillips's only advertisements occurred in 1809 and 1811, quite early in his career.[7] While no paintings have been found dating from this time, his subsequent success in securing commissions to support himself and his family without further need for published advertisement indicates his ability to provide portraiture that people wanted.

His marriage in 1813 to Laura Brockway from Schodack, New York, set in motion a pattern of living that was unusual for those considered to be folk artists, who generally led the itinerant life seeking out commissions. Phillips himself had done so early in his career, primarily working the border regions of New York, Massachusetts, and Vermont in search of patrons, but in 1817 he and Laura purchased property in Troy, New York, near Albany, a region that would be booming in response to the building of the Erie Canal, where there would be great interest among the landed gentry for portraits of themselves and their families.[8] Phillips began concentrating his travels to the upper Hudson Valley between Troy and nearby Albany. He became known to his neighbors and aware of local tastes, and thus was the obvious choice when the need or wish arose for a portrait.

Ammi Phillips,
1788–1865
Old Woman with a Bible, ca. 1834
Oil on linen, 33½ x 28 in.
Beatrice M. Padelford Trust,
84.22

Phillips's early works (in the "Border Limner" style) were large, light, subtly colored, delicately painted "dreamlike" impressions.[9] But beginning in the 1820s, and peaking in the 1830s (the "Kent portraitist" period) the work underwent a striking change to a darker palette and stylized, reductionist, background and costume features, albeit with the same and possibly stronger attention to the face and general likeness of the sitter. Mary Black has shown that this change of style coincides with Phillips's residence in Troy, part of the region dominated by the academically trained portrait painter Ezra Ames.[10] Ames, Black notes, certainly became a strong influence on Phillips, who adopted Ames's three-quarters poses about this time as well as a number of other specific features of his style, without, however, ever rivaling Ames as a modeler of form. Phillips's painting at its best eschews effects of volume, his figures remaining largely flat, silhouetted, and in some ways reminiscent of twentieth-century modernists in their approach to the figure. As Anderson and Black suggest, this reductionist style owes as much to Phillips's limitations as a draughtsman as to his need to increase his output and fulfill his clients' expectations; however, it is also true that from these conditions he synthesized a highly original style, quite evident in the arresting power of *Old Woman with a Bible*.[11]

Ezra Ames,
1768–1836
Portrait of Gideon Granger,
before 1822
Oil on canvas, 29½ x 23 in.
Bequest of Antoinette Pierson
Granger, 30.54

In *Old Woman with a Bible,* the background gives no indication of depth or location of the sitter except for the dark maroon drapery filling the upper left corner and revealing a bit of wonderfully detailed crocheted and knotted fringe border below. The drapery, typical of many early American and European portraits, is an unusual touch for Phillips, who uses it to reinforce the sitter's right-leaning pose. Unlike the stiff, straight-ahead poses of many folk-art portraits, the old woman's slight lean seems to set her weight onto the arm that rests on the Bible. Her other hand, resting in her lap, holds a small book (a prayer book? a devotional?) in which she is keeping her place with her finger, and so adding an element of spontaneity and animation to the work. This is a classical European motif that found its way to America in the nineteenth century and that Phillips used throughout his career, both with male and female subjects.[12] Pretty clearly, the imagery of a book other than the Bible—rather than other "domestic" icons popular in female genre portraits—is intended to convey both the subject's literacy and a certain level of affluence.

Furthermore, our attention is drawn to this hand by the colorful border of red and green embroidery on the shawl angling down from her shoulders. These garments were modeled on the cashmere shawls, with the embroidered paisley trim, that became popular in London about 1786, woven on power looms in Paisley, Scotland, in imitation of expensive hand-made Indian originals.[13] In turn, the American version, like that depicted by Phillips, was probably not imported English cashmere, but rather a homespun imitation with a detachable border (to facilitate laundering) either woven by the subject herself, or kept in the artist's stock of studio props. Phillips had made use of the shawl at least since ca. 1820.[14] But as Patricia Anderson makes clear, it is from Ezra Ames that he derived the practice of folding the shawl to display both edges of the decorative embroidered trim, a motif he used in his female portraits for the rest of his career.[15]

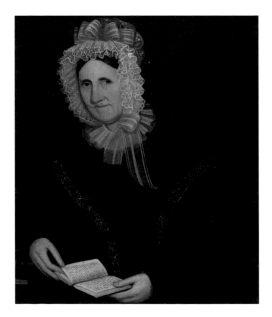

Ammi Phillips,
1788–1865
Woman with Black Paisley Shawl
(Mrs. Zachariah Flagler),
undated
Oil on canvas, 32 x 27 in.
Princeton University Art
Museum. Gift of Edward Duff
Balken, Class of 1897
Photograph by Bruce M. White
Y1958–60

These colorful borders show off most effectively against the black dresses worn by many of Phillips's older sitters. While black or deep blue was the color

Ammi Phillips,
1788–1865
Old Woman with a Bible (detail),
ca. 1834
Oil on linen, 33½ x 28 in.
Beatrice M. Padelford Trust,
84.22

of mourning clothes, many older women regularly chose conservative styles of solid, dark colors. Here the dress is an area of flat black with no visible creases or body weight underneath. However, Phillips has lavished much time and attention on the woman's sheer muslin day-cap with its ruffles around the face and the satin bow with exquisitely trimmed sides. The white day-cap, however fine, signals inside-the-house apparel, as opposed to the fancy "bonnet" she would wear when going out. Even indoors, however, the conservative older woman keeps her hair covered.[16] Phillips has turned the head slightly in order to show the woman's ear peeking through the gauze-like fabric, though by doing so the angle of ear to face is slightly off. Even so, while her face is one of well-earned age, her hands are, typical for Phillips, soft, almost limp, with long fingers, and more appropriate to a younger woman than the sitter.

Is Ammi Phillips a "naïve" artist? Is *Old Woman with a Bible* "folk art"? One value of folk art is its documentary specificity, affording us a more-or-less unvarnished look at the mundane life of a particular time in our history. Phillips's painting seems to serve that function. But Patricia Anderson also draws our attention to its "timeless immediacy and the formal beauty," qualities that certainly transcend merely "naïve" art. She tips her hat to Holger Cahill who, in his pioneering American Primitives exhibition, recognized "the formal sophistication of paintings previously regarded as mere family documents or quaint pictures of a by-gone era."[17] According to Cahill,

> The best of the portraits have the same purity of line, the clear color, the incorruptible honesty which gives distinction to the early work of such men as Copley and Ralph Earl....[18]

Perhaps the primary question for a painting is not "the whats and wherefores of how or when it was created," in the words of the Smithsonian's Virginia Mecklenberg, "but whether it pulls you in across the room."[19] *Old Woman with a Bible* certainly does that.

Susan Nurse is Visual Resources Coordinator, Memorial Art Gallery.

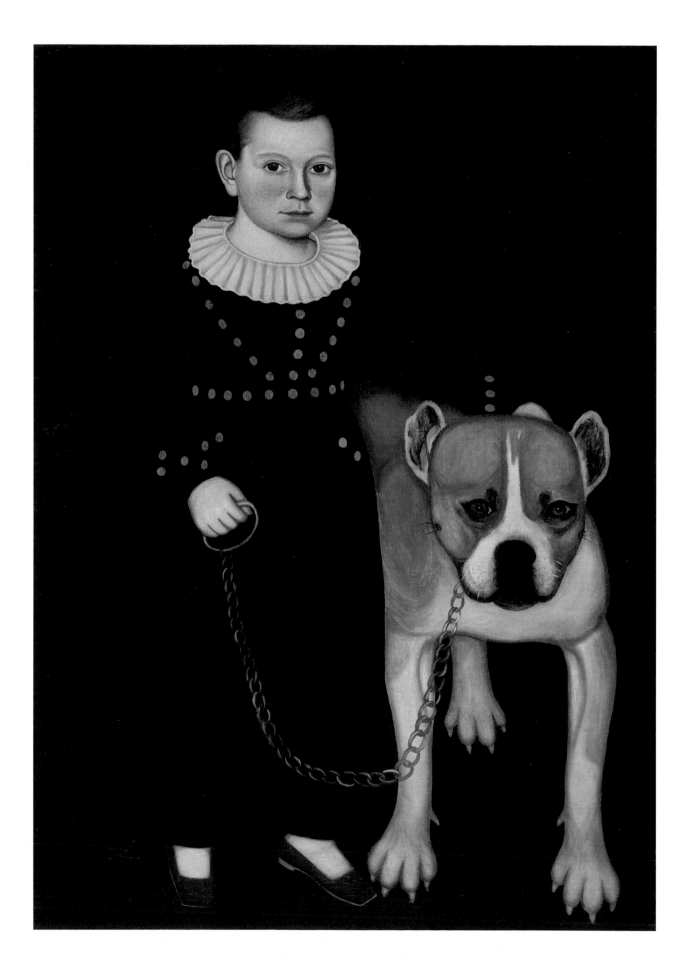

5: Milton W. Hopkins *Pierrepont Edward Lacey and His Dog, Gun* (1835-36)

Jacquelyn Oak

*F*olk artist and social activist Milton W. Hopkins worked in the Rochester area painting portraits in a plain, linear style from 1824 until about 1836. The portrait of Pierrepont Edward Lacey is one of his most successful and has become an American folk art icon. Owned by the family for over 140 years, the portrait was given to the Memorial Art Gallery by collateral descendents of the sitter in 1978.

Born in 1832 in Chili, New York, Pierrepont Edward Lacey was the son of Allen T. and Ann Gennett Pixley Lacey. The family moved to nearby Scottsville, south of Rochester, in 1835 and it was there that Hopkins painted this portrait and those of Pierrepont's mother and younger sister, Eliza. Allen T. Lacey, a prosperous farmer and businessman, was active in the anti-Masonic movement and Whig politics, as was Hopkins, and it is likely that they became acquainted through these associations.[1]

Milton W. Hopkins,
1789–1844
Portrait of Ann Gennett Pixley Lacey (1809–1841), 1835–36
Oil on canvas, 30 x 25 in.
Gift of Mr. and Mrs. Robert H. Dunn in memory of Ruth Hanford Munn and James Buell Munn, 78.187

After the death of Ann Gennett, Allen Lacey remarried and, in 1847, the family moved west to Marshall, Michigan. There they joined other members of the Lacey family who had established farms in the Calhoun County area. Pierrepont apparently finished school in Marshall and, like his father and cousins, engaged in farming. In 1858, he married Agnes Antoinette McClure and the couple had one son, Henry Alden, in 1860. Pierrepont died in 1888 and is buried with his wife in the Austin cemetery, northwest of Marshall.[2]

The portrait of Pierrepont, nearly full-size, is one of the most ambitious and engaging likenesses taken by Hopkins. Solid and sturdy, the young boy, dressed in his best suit and red shoes and bolstered by his huge mastiff dog, looks out candidly at the viewer. The portrait exhibits characteristics typical of Hopkins's style: the facial features include a slightly oversized "C" shaped inner ear, salmon-colored lips, broad arching of the eyebrows, indented temples, soft modeling of the eye socket, highlights in the pupil and inner corner of the eye, and shading on the side of the nose. Like many other folk painters, Hopkins paid particular attention to costume details: Pierrepont wears a "tunic suit," complete with a round, ruffled collar and military-style gold buttons—a type of outfit very common for young boys in the 1830s. His dog "Gun," probably a restless subject, was depicted in realistic detail with brown and white markings typical of the breed. Unlike other animals included in folk paintings that may have been products of the artist's imagination or based on popular illustrations, "Gun" was a real pet. According to a family history, the Laceys raised mastiffs when they lived in Scottsville.

(Facing page)
Milton W. Hopkins,
1789–1844
Pierrepont Edward Lacey and His Dog, Gun, 1835–36
Oil on canvas, 42 x 30⅛ in.
Gift of Mr. and Mrs. Robert H. Dunn in memory of Ruth Hanford Munn and James Buell Munn, 78.189

Pierrepont's portrait is one of a group of six showing children, full-length, dressed in their finest clothes, often accompanied by their dogs. Of the six portraits, three (including that of Eliza Lacey) were painted in the Rochester

area and three were done by Hopkins after he moved to Ohio. All of the sitters were children whose parents were connected to Hopkins through their activities in reform movements or politics.

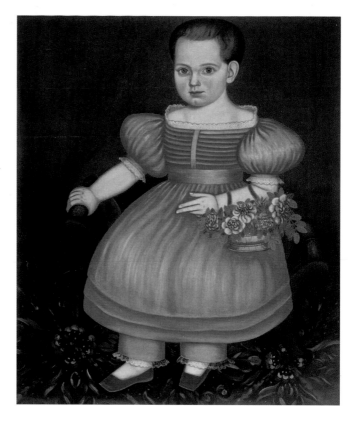

For many years, the Lacey portraits were attributed to Hopkins's student, Noah North (1809–1880), a native of Genesee County, New York. In the 1980s, the discovery of a portrait nearly identical to those by North, but signed and dated "M. W. Hopkins 1833" prompted a reevaluation of the entire body of work.[3]

Milton W. Hopkins,
1789–1844
Eliza Pixley Lacey (1834–1839),
1835–1836
Oil on canvas, 30 x 25 in.
Gift of Mr. and Mrs. Robert H.
Dunn in memory of Ruth
Hanford Munn and James Buell
Munn, 78.188

In 1823, Hopkins moved with his family from Jefferson County, New York, to Albion, then the westernmost terminus of the Erie Canal, twenty-five miles west of Rochester. During his thirteen-year stay in Albion, Hopkins pursued a variety of occupations: his advertisements indicate that he was a portrait artist and teacher, chairmaker, gilder, "house, sign and fancy" painter, and canal boat captain. The social activism that characterized his later years in Ohio began in western New York. In 1826, Hopkins renounced his own Masonic affiliation and became a spokeman for the anti-Masonic movement that originated in nearby Batavia in Genesee County. By 1830, he was a leading spokeman for the Orleans County Temperance Society, traveling and speaking widely throughout the Rochester area. It is likely that his increasing involvement in the abolition movement prompted him to leave western New York and settle in Ohio about 1837. Until his death in 1844, Hopkins was an important supporter of the underground railroad in Cincinnati and Columbus and it appears that his portrait commissions from this time supported his participation in abolitionist activities.[4] Like most of Hopkins's sitters, the Laceys were active participants in a flourishing, rural society that was a focal point for many reform movements of the nineteenth century. Many such members of the middle class became supporters of temperance, anti-Masonry, and abolitionism. Through his highly visible participation in all of these movements, Hopkins established a clientele who subsidized his artistic endeavors and shared his progressive outlook.

A museum and fine arts consultant, Jacquelyn Oak has been a researcher for the Shelburne Museum in Vermont and registrar of the National Heritage Museum in Lexington, Massachusetts.

6: George Harvey *Pittsford on the Erie Canal—A Sultry Calm* (1837)

Marjorie B. Searl

Low bridge, everybody down!
Low bridge for we're comin through a town!
And you'll always know your neighbor,
You'll always know your pal,
If you've ever navigated on the Erie Canal.[1]

When *Pittsford on the Erie Canal* came up at auction at Sotheby's in May 2005, the Memorial Art Gallery was determined to be the winning bidder and, thanks to a generous patron, the painting has come home to Rochester. The luminous oil, which had hung in three temporary exhibitions at the Memorial Art Gallery since the 1940s, now holds a distinguished place in the permanent collection.

Apart from the canalside village of Pittsford being home to many Gallery visitors, the Erie Canal itself is a significant subject for an art museum wishing to tell the story of landscape painting in nineteenth-century America. In its time, the Erie Canal was deemed one of the wonders of America, if not of the world. When it opened in 1825, the celebration cascaded from the Great Lakes to New York Harbor, with cannons, bell ringing, fireworks, and illuminated barges accompanying the final ceremony of the pouring of Lake Erie water into the Atlantic Ocean.[2] In the words of American Studies scholar David Nye, the Erie Canal represented the "technological sublime"—both a part of the "preservation and the transformation of the natural world" and a component of a "moral machine" that "ensured not only prosperity but also democracy and the moral health of the nation."[3] While MAG's landscape collection celebrated the natural sublime with work by Bierstadt, Durand, and Kensett, *Pittsford on the Erie Canal* provides a link to Benton's *Boomtown* and Colin Campbell Cooper's *Main Street Bridge* (all represented by essays in this volume), paintings that extol the industrial landscape. In fact, because of the Erie Canal, Rochester itself was considered America's original boomtown.[4]

Originally Seneca land, the Rochester region was populated by waves of New England and downstate New York emigrants who moved to the upstate frontier following the Revolutionary War. The subsequent building of the Erie Canal and the railroad boosted the economy of nearby towns and villages, and Pittsford became a transportation hub for riders between Rochester and Canandaigua and those journeying by stage coach, rail, or canal boat between Albany and Buffalo.[5] Related businesses prospered, among them mills and inns. Canal boats pulled by horses or mules moved along the water at a stately pace, and church steeples nestled under a backdrop of sky and clouds. The canal is still a busy place in Pittsford, but used now for recreational rather than commercial purposes. On many summer days, voluminous and light-edged clouds appear in the Pittsford sky exactly as George Harvey described them in his painting. The scene has been located at what is currently called "King's Bend," just outside the village. In the 1820s, the skyline, while not exactly as Harvey painted it, would have included the Presbyterian Church, the Methodist Church, and step-gabled buildings at the Four Corners, one of which, the Phoenix Building, stands today.[6]

George Harvey was an enterprising man whose energies were well matched to his times.[7] A Briton who came to America in 1820 to seek his fortune, he gamely tried his hand at a variety of métiers—writing poetry and owning a marble quarry, among other things. In his preface to *Harvey's Scenes in the Primeval Forests of America,* he reminisced:

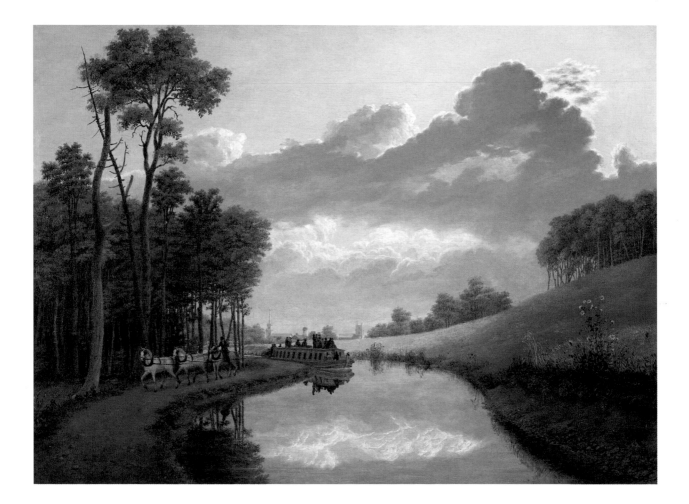

It was one of the earliest dreams of my school-boy days that...caused me to become an Artist: a student of the form and poetry of nature: and in these my after years, it has been my highest delight to ramble uncontrolled in search of the picturesque.[8]

The newly established National Academy of Design recognized Harvey's talents by electing him Associate Academician by 1828, only eight years after his arrival from England. In Boston, he excelled in painting portrait miniatures but, on his doctor's advice, he moved to "the country," to the east side of the Hudson River, in Hastings, New York.[9] In 1835, he began a series of landscape watercolors intended to be engraved and sold by subscription. Entitled *Atmospheric Landscapes*, the series was to convey "to the nations on the other side of the Atlantic ideas of scenery which could never have entered into their imaginations, and convictions of American enterprises and improvements which description could hardly bring home to general belief."[10] It is likely that he used sketches from his earlier travels as subjects for the more finished work. Among his watercolors was *A Sultry Calm. Pitsford* [sic], *on the Erie Canal* (Fenimore Art Museum, Cooperstown, New York; the painting is now titled *Pittsford on the Erie Canal*). Harvey recounted in an 1850 publication:

The cumulous cloud, from which the sketch was taken, rose with great suddenness. At noon the weather was very oppressive and sultry, and not a cloud to be seen; at two o'clock the sky was in commotion, and at three a most terrific thunder storm burst upon the country. The little village in the distance is near to Rochester, a great place for flour mills. The principal trade of Pitsford [sic] is the purchase of grain for other markets; it is situated in one of the most productive agricultural districts in the Union.[11]

While the subscription project failed, Harvey reused the Pittsford subject in an oil painting that he exhibited at the National Academy of Design in 1837, *Dead Calm, Afternoon View Near Pittsford, on the Erie Canal* (original title of the MAG painting). A critic for *The Knickerbocker* wrote about the painting when he first saw it at the exhibition: "[It was] really a very clever picture, although we have puzzled ourselves in vain to account for the patches or dabs of white on the water in the foreground."[12] Those are, of course, the reflections of the clouds overhead; up close, they do appear to be "dabs of white," but at a distance, the brushstrokes coalesce and create a coherent and compelling effect. Whether dead or sultry calm, Harvey suggested the stillness of the water with painstaking reflections of the sky, boat, trees, and even horses.

George Harvey,
1800–1878
*Pittsford on the Erie Canal–
A Sultry Calm* (detail), 1837
Oil on panel, 17½ x 23⅝ in.
Gift of the Margaret M.
McDonald Memorial Fund,
2005.33

Harvey's views of nature were also illustrations of a personal utopian vision. He predicted the settling of America by

a multiplicity of races, who will become fused into one people, like the English in the present day, by a common language; whose laws and literature, and even religion, will probably receive an impress in unison with some general type of humanity, whereby a glorious future will bless, not only ourselves, but mankind....[13]

He continues:

Providence has doubtless ordained this action and reaction, this interchange of physical and moral benefits, for the perfecting of humanity whereby, in the fulness of time, the world is to witness the millennium foretold in the Scriptures.[14]

(Facing page)
George Harvey,
1800–1878
*Pittsford on the Erie Canal–
A Sultry Calm*, 1837
Oil on panel, 17½ x 23⅝ in.
Gift of the Margaret M.
McDonald Memorial Fund,
2005.33

Harvey was not alone in his "second creation" view of America, to adopt another phrase of David Nye's.[15] Hudson River School painters Thomas Cole and Asher B. Durand, for instance, were similarly mindful of the American landscape's Edenic qualities. Harvey's philosophical writings make a case for a "millennial" reading of the Rochester painting: the canal boat, a symbol of Adam in the new Eden, is pulled westward along a manmade waterway, securely protected between the steeples of Christian churches, with the divine light of Providence shining upon the scene. Its passengers share a common destination and are safely protected from any dangers lurking in the dark forest nearby.[16]

George Harvey,

1800–1878

Pittsford on the Erie Canal,

ca. 1837

Watercolor on paper,

8¼ x 13¾ in.

Fenimore Museum,

Cooperstown, New York

Diaries of canal travelers vary in their expressions of harmony and well-being, however.[17] Voyages on the canal tended to be rough and uncomfortable, as Fanny Trollope, the mother of the British novelist Anthony Trollope, described in 1832: "I can hardly imagine any motive of convenience powerful enough to induce me to imprison myself again in a canal boat under ordinary circumstances."[18] On the other hand, for some, the trip was a luxurious cruise, as this anonymous writer suggests:

> [T]hese boats are about 70 feet long, and with the exception of the Kitchen and bar, is occupied as a Cabin, the forward part being the ladies Cabin, is separated by a curtain, but at meal times this obstruction is removed, and the table is set the whole length of the boat, the table is supplied with everything that is necessary and of the best quality with many of the luxuries of life....[T]hese Boats have three Horses, go at a quicker rate and have the preference in going through the locks, carry no freight, are built extremely light, and have quite Genteel men for their Captains, and use silver plate.[19]

Nathaniel Hawthorne's ironic description of his canal trip, published in 1835, belies the contented scene that Harvey depicted:

> Behold us, then, fairly afloat, with three horses harnessed to our vessel, like the steeds of Neptune to a huge scallop-shell, in mythological pictures. Bound to a distant port, we had neither chart nor compass, nor cared about the wind, nor felt the heaving of a billow, nor dreaded shipwreck, however fierce the tempest, in our adventurous navigation of an interminable mud-puddle— for a mud-puddle it seemed, and as dark and turbid as if every kennel in the land paid contribution to it. With an imperceptible current, it holds its drowsy way through all the dismal swamps and unimpressive scenery, that could be found between the great lakes and the sea-coast. Yet there is variety enough, both on the surface of the canal and along its banks, to amuse the traveller, if an overpowering tedium did not deaden his perceptions.[20]

Harvey died in 1878, only a few years following another failed attempt to publish prints based on his paintings, this time scenes of Florida. While *Seeing America* is the title of this publication, it could aptly have been used to describe George Harvey's lifelong efforts to celebrate the beauties of the American landscape and to promote their allure and significance internationally. The newly acquired Pittsford scene takes its rightful place alongside Asher B. Durand's *Genesee Oaks* and Thomas Cole's *Genesee Scenery*. The triad makes a powerful statement about the allure of the Rochester region for nineteenth century artists who sought fitting subjects to depict the "discourse of Manifest Destiny."[21]

Marjorie B. Searl is Chief Curator, Memorial Art Gallery.

7: Asahel Lynde Powers *Portrait of a Dark-haired Man Reading the "Genesee Farmer"* (ca. 1839)

Jessica Marten

The New England itinerant portrait painter Asahel Lynde Powers rarely recorded the names of his sitters. As is common with many American folk portraits, the identity of the man in *Portrait of a Dark-haired Man Reading "The Genesee Farmer"* remains a mystery. A handsome young man appears to be sitting in his study on an Empire settee. Large, amiable brown eyes gaze out at the viewer. The meticulous depiction of his delicately proportioned nose and lips contrasts with the rudimentary treatment of his hands and ear. His face contains a range of tones; gray-green underpainting is visible below the pale flesh where the light strikes his forehead, ruddy reds flush his cheeks, bright white highlights flash on the tip of his nose and along the line of his upper lip. His fashionable suit speaks of prosperity—a black frock coat with a high, generous collar and black cravat, a crisp white shirt and green vest with black embroidery. Fine, brown hair ends in curving wisps that frame his face. In the background, a curtain swag on the right echoes the shape of his collar and shoulder; on the left, a drop-front secretary with an opened bookshelf displays a number of fine, leather-bound books. The newspaper in the sitter's hands, the most conspicuous element of the portrait, is an issue of the early Rochester publication *The Genesee Farmer*, dated October 12, 1839.

The Genesee Farmer was a weekly agricultural journal published in Rochester from 1831 to 1839 by Luther Tucker (1802–1873), editor of the *Rochester Daily Advertiser*.[1] Intended to spread the collective wisdom of the region gained through the experience of "cultivating Scientifically the soil…so lately reclaimed from the wilderness & prepared for the highest state of Agriculture," the first issue proclaimed, "No part of the world is more richly blessed with soil and climate…than the western part of the state of New York—that part called OLD GENESEE."[2] Indeed, early settlers to western New York were drawn to the promise of Rochester's geographic amenities: the agricultural abundance of the Genesee River Valley, the shipping potential of the Genesee River, and the High Falls destiny as a milling center. With the opening of the Erie Canal in 1825, Rochester became a major agricultural and trade center in western New York.

Five years prior to the inception of *The Genesee Farmer* in 1831, a visitor described the vitality of the city:

> It is difficult to begin a sketch of such a place as Rochester. The place is in such motion….It may be referred to as standing proof that the wilderness may be made to vanish almost at a stroke, and give place in as little time to a city! It is like a hive; and the apertures every where around it, are full of bees, pressing into it….The country round about is fertile beyond any idea you can form of it….Who has not heard of the Genesee country? And of its proverbial fertility?[3]

Rochester's agricultural prowess had come to define the city. By the 1820s Rochester earned the nickname "Flour City" due to the quality and quantity of its flour production. By mid-century, the city's nickname changed to "Flower City" to reflect the booming nursery and seed businesses of Ellwanger & Barry and James Vick.

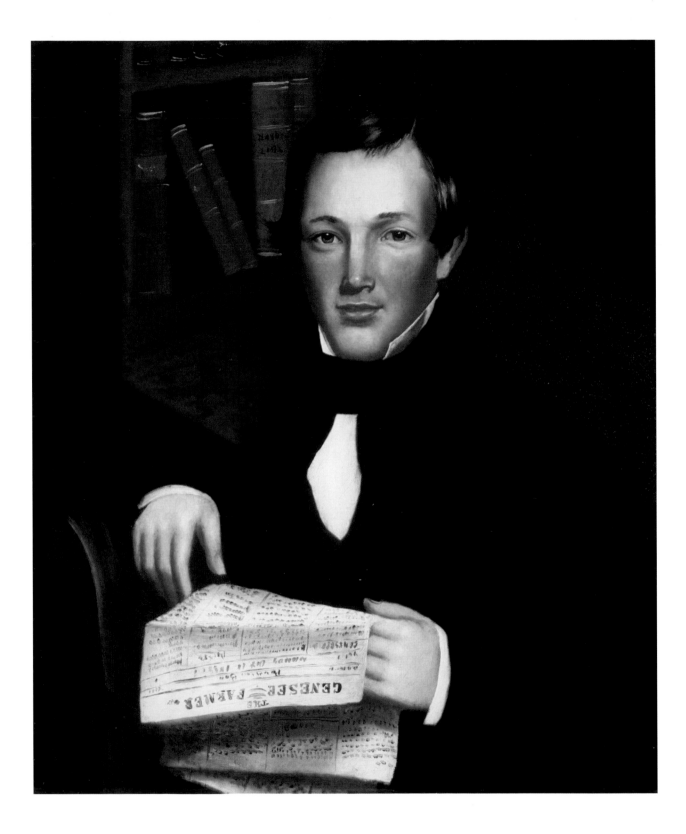

It was in the fecund climate of this young, spirited city that *The Genesee Farmer* was conceived. Despite its regional title, *The Genesee Farmer* became a national publication, spreading its progres-

sive and scientific agricultural spirit throughout the country. Its popularity was based on the diverse array of technical and practical information provided for all facets of agrarian life. Some of the topics in the October 12, 1839 issue (the issue in this portrait) include tips on how to free land of wire worms and field mice, the proper time to harvest wheat and dig potatoes, the best method for propagating apples, and the superior quality of ground bones as crop fertilizer (including a chemical analysis of different bone compositions).

Asahel Lynde Powers,
1813–1843
Portrait of a Dark-haired Man Reading the "Genesee Farmer"
(detail, inverted), ca. 1839
Oil on canvas, 30 x 25 in.
Virginia Jeffrey Smith Fund,
2001.1

Letters to the editor were frequently published in response to particular articles so that *The Genesee Farmer* came to serve as a sounding board for shared experiences, failures, and successes among American farmers. An excerpt from the October 12th issue proclaims, "The man who takes an agricultural journal, profits by the experience of hundreds; while he who takes none, can profit alone from his own, and from that of perhaps a few neighbors. The adage teaches, that two heads are better than one, the world over."[4] This communal spirit fostered responsible, scientific agricultural practices. A man who read *The Genesee Farmer* allied himself with the progressive future of American farming. Hence, this gentleman's reading material helps to illuminate, if not his name, then certainly a clear sense of the image this man wished to embody.

Asahel Lynde Powers was particularly adept at including in his portraits specific accessories of personal or public importance to his sitters—a watch fob, painter's palette, bank notes, texts on botany and geometry, and even an ear trumpet for one hard-of-hearing young lady. As the eldest of seven in a farming family, Powers would have been familiar with the status of *The Genesee Farmer* as the premier publication for the progressive-minded gentleman farmer. Surely expected to take over the family farm, Powers chose instead to follow a dramatically different path, and by the age of eighteen was making a living painting portraits in and around his hometown of Springfield, Vermont.[5]

Powers's early portraits are known for their intensity, due in part to the crisp, lively delineation of facial features, crude handling of anatomy, and lack of perspective and modeling. These characteristics are common in the work of self-taught itinerant portrait painters in eighteenth- and nineteenth-century America. What is exceptional

(Facing page)
Asahel Lynde Powers,
1813–1843
Portrait of a Dark-haired Man Reading the "Genesee Farmer,"
ca. 1839
Oil on canvas, 30 x 25 in.
Virginia Jeffrey Smith Fund,
2001.1

about Powers is the striking development in his technical abilities midway through his brief career (ca. 1831–41). Whether his shift in style was due to an apprenticeship with another artist or to self-education, it is apparent that Powers was studying the European academic style and incorporating it into his portraits.[6]

Asahel Lynde Powers, 1813–1843
Dr. Joel Green, 1831
Oil on canvas, 50 x 36½ in.
framed
Springfield Art & Historical
Society, Springfield, Vermont

In *Portrait of a Dark-haired Man* Powers's evolving style is evident. The artist delights in capturing the subtleties of light falling across a face by carefully modeling this man's delicate features—a self-conscious rejection of his earlier linear style. Sketches found on the verso of the canvas are illustrative of an artist energized by new technique and eager to practice his skills.[7] In addition to a couple of loosely drawn profiles, two evocative sketches of the same face from different angles are sensitive studies in chiaroscuro, point-of-view, and anatomy. Yet the portrait of the dark-haired man on the recto of the canvas remains essentially "folk" in Powers's ongoing naïveté in handling perspective and anatomy. An incomplete understanding of perspective results in the awkward positioning of the furniture in the background. Anatomical inconsistencies include a crudely painted ear and hands and the physical impossibility of a missing shoulder.

Asahel Lynde Powers,
1813–1843
Portrait of a Dark-haired Man
Reading the "Genesee Farmer,"
(verso), ca. 1839
Oil on canvas, 30 x 25 in.
Virginia Jeffrey Smith Fund,
2001.1

During this transitional time, sometime between 1839 and 1840, the artist moved from Vermont to live and paint in Franklin and Livingston Counties in upstate New York. Accompanying his simply worded advertisement, "A. L. Power, Portrait Painter. Room at John Nichols' Hotel," in the November 7, 1840, issue of the *Plattsburgh Republican* are the encouraging words of the editor: "If you want your Portrait taken, call on Mr. Power....We have seen some of his work; and were particularly struck with his skill in transferring the 'human face divine' to canvass....[E]xamine his work, and patronize him if you can—he deserves it."[8] Powers's academically influenced portraits clearly appealed to the aesthetic and practical sensibilities of his prospective clients in Plattsburgh.[9]

In the last years of his career (ca. 1839–1841), Powers's success as a portraitist lay in his ability to capture his clients in a fashion connoting health and prosperity. His mature style was reflective of the larger trend in portraiture away from the linear, humble, folk style embraced by earlier Americans and towards the more realistic, yet idealizing style of European academic portraits. The impulse to flatter a sitter's appearance is evident in Powers's late portraits, in which softened lines and pleasantly rounded features combine to create flush, healthy-looking individuals. Well-appointed interiors complement these hale and hardy figures. *Portrait of a Dark-haired Man Reading "The Genesee Farmer"* is a fascinating document of a provincial artist's determined attempt to move away from the naïveté of his early style towards a more worldly academic style. The result is this charming portrait of a young, educated, successful American farmer of his time.

Jessica Marten is Assistant Curator, Memorial Art Gallery.

8: DeWitt Clinton Boutelle *The Indian Hunter* (1846)

Marlene Hamann-Whitmore

Where are the blossoms of those summers!—fallen, one by one: so all my
family departed, each in his turn, to the land of the spirits. I am on the hill-
top, and must go down into the valley; and when Uncas follows in my foot-
steps, there will no longer be any of the blood of the Sagamores, for my boy
is the last of the Mohicans.[1]

So concludes an impassioned proclamation by Chingachgook, a Mohican chief, about the fate of his people and his son, Uncas, early on in James Fenimore Cooper's *The Last of the Mohicans*. First published in 1826, Cooper's epic tale can be viewed as a direct source for DeWitt Clinton Boutelle's painting *The Indian Hunter*, completed in 1846. Boutelle's lush and dense landscape is a visual realization of Cooper's prose.

Both Boutelle and Cooper sought to define and encapsulate the plight of the Native American in the wake of European settlement and westward expansion. The population of the United States almost doubled between 1830 and 1850, and the effect this had on the already stressed Native American culture was cataclysmic.[2] The portrayal of the disappearing or "doomed" Indian became a popular topic across the arts, and visual artists and writers frequently responded to each other's work.[3] When Boutelle exhibited *The Indian Hunter* in New York at the annual exhibition of the National Academy of Design in 1846, the catalogue entry for the painting was accompanied by the following poem, written by Eliza Cook:

Oh! Why does the white man follow my path,
Like the hound on the tiger's track?
Does the flush on my dark cheek waken his wrath?
Does he covet the bow of my back?
He has rivers and seas, where the billows and breeze
Bear riches for him alone;
And the sons of the wood never plunge in the flood
Which the white man calls his own.
Then, why should he come to the streams where none
But the red skin dare to swim?
Why, why should he wrong the hunter, one
Who never did harm to him?[4]

In addition to the literary influences of Cooper and Cook, Boutelle would almost certainly have been aware of the work of the American poet William Cullen Bryant. In the last two stanzas of Bryant's narrative poem, "An Indian at the Burial-Place of His Fathers" (1824), the Native American narrator speaks with melancholy, with a voice that echoes in Boutelle's painting:

Before these fields were shorn and tilled,
Full to the brim our rivers flowed;
The melody of waters filled
The fresh and boundless wood;
And torrents dashed and rivulets played,
And fountains spouted in the shade.

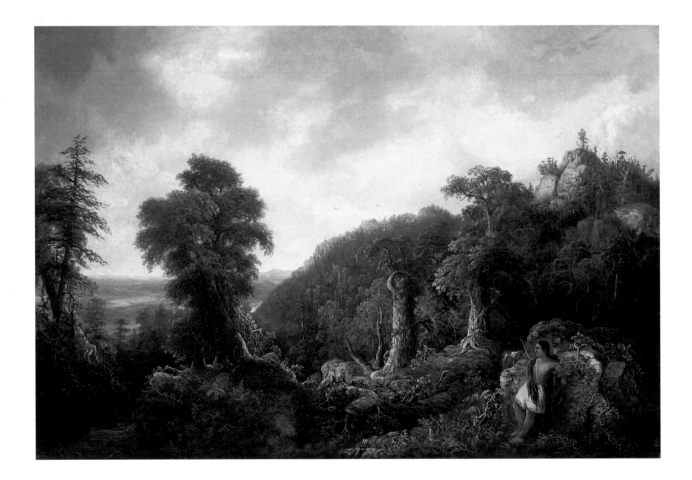

Those grateful sounds are heard no more,
The springs are silent in the sun;
The rivers, by the blackened shore,
With lessening current run;
The realm our tribes are crushed to get
May be a barren desert yet.[5]

As topical as these nineteenth-century literary references may seem to our twenty-first-century sensibilities, all were produced within a framework of nostalgia and romantic historicism. Boutelle was also working with the benefit of historical perspective, and composed *The Indian Hunter* through a similar lens. The first government-sponsored Indian reservation was organized in the Northeast in 1794, after the signing of the Treaty of Canandaigua. The six member nations of the Iroquois Confederacy—the Oneida, Onondaga, Mohawk, Cayuga, Tuscarora, and Seneca—were granted land in western New York that had been ceded by a previous treaty. By 1800 it was clear to most native people, and nearly everyone else, that the indigenous Native American way of life would soon be extinct.

Born in Troy, New York, in 1820, Boutelle was named for DeWitt Clinton, the first governor of New York and the main force behind the construction of the Erie Canal.[6] Boutelle never attended art school and was largely self-taught. However, he was successful enough in his day to maintain a studio in New York City from 1846 through 1855. From New York, Boutelle made sketching trips up and down the Hudson River, throughout the Catskills and New Jersey, and on the Susquehanna River. By 1857, he had left New York for Philadelphia. In 1859 he settled in Bethlehem, Pennsylvania, where he continued to paint until his death in 1884.[7]

Like many artists of his generation, Boutelle was greatly influenced in scope and composition by the early paintings of Thomas Cole, the work of Asher B. Durand, and other artists active in the Hudson River School.[8] *The Indian Hunter* employs several compositional devices frequently used by Cole. Most notable is the panorama of trees in every conceivable stage of the lifecycle. By following Cole's example, Boutelle utilized the landscape as a metaphor for the passage of time and the constancy of change.

Even though *The Indian Hunter* does not depict a specific place, the painting reflects the topography and local history of the region surrounding Boutelle's native Troy. Once home to the Mohawks, these densely wooded hills and ravines are still evident in New York State's capital region. Although he was a convincing landscape painter, Boutelle's lack of formal training is apparent in the stylized tree forms and the simplified figure of the hunter. Yet he ably leads the viewer through the canvas with his sophisticated manipulation of line, scale, and value.

Boutelle's painting engages us on many levels, but it is primarily a painting of opposites and opposing agendas: light and dark; life and death; future and past; settler and native; victor and vanquished.

Here Boutelle's "doomed Indian" has been relegated to the margins of a world that was once entirely his. He surveys the once-familiar landscape from the lower right-hand side of the composition, dejectedly leaning against an outcropping of rocks, as he gazes forlornly into a valley in the far distance. Following his gaze, we see a newly minted European settlement barely visible through the clearing. It is evident that the newcomers have taken some of the best land—riverside—and have already completed a church with a towering steeple.

DeWitt Clinton Boutelle,
1820–1884
The Indian Hunter (detail), 1846
Oil on canvas, 32⅝ x 47⅛ in.
Marion Stratton Gould Fund,
84.47

The parallels between art and literature bring us back to James Fenimore Cooper. In a sentiment again expressed visually by Boutelle's lone Indian hunter, Cooper concludes his novel with a resigned Tamenund, the aged and wise chief of the Delawares:

> *Why should Tamenund stay? The palefaces are masters of the earth, and the time of the red men has not yet come again. My day has been too long. In the morning I saw the sons of Unamis happy and strong; and yet, before the night has come, have I lived to see the last warrior of the wise race of the Mohican.*[9]

Marlene Hamann-Whitmore is Curator of Education for Interpretation, Memorial Art Gallery.

9: Thomas Cole *Genesee Scenery* (ca. 1846-47)

Marlene Hamann-Whitmore

This exquisitely intimate oil sketch, one of the Memorial Art Gallery's gems, might surprise the viewer who knows Thomas Cole only for his large-scale paintings celebrating the majestic grandeur of the nineteenth-century American landscape. The works for which he is most famous—dramatic and encyclopedic vistas filled with rocky cliffs, dazzling skies, and spectacular foliage—served as artistic accounts of specific places, as well as metaphors for the spirited sense of American independence and the presence of an omnipotent God.

Although he was born in England, Cole is often referred to as the patriarch of American landscape painting and a founder of the Hudson River School. The seventh of eight children, he and his family immigrated to the United States in 1819. After arriving in Philadelphia, and moving several times, they eventually settled in New York City in 1825. Between 1819 and 1825, the young Cole traveled to the West Indies, worked with his father designing wallpaper patterns in Steubenville, Ohio, and floor-cloths in Pittsburgh, and wrote poetry and painted whenever possible.[1]

Though trained as an engraver, Cole was self-taught as a painter. Living on Greenwich Street in New York with his family, and painting on his own, he placed his finished works in the shop window of an acquaintance. There they attracted the attention of John Trumbull and Asher B. Durand, who quickly helped spread the word of Cole's talent.[2]

By 1827 Cole had taken up residence in the Hudson River town of Catskill, New York, 125 miles north of New York City, where he would live for the rest of his life. He traveled to Europe in 1829, married in 1836, and began his famed "Voyage of Life" series in 1839. That same year, Cole traveled to western New York at the invitation of Samuel B. Ruggles, then Canal Commissioner of New York State.[3] Ruggles invited Cole to paint a view of the gorge of the Genesee, in what is now Letchworth State Park. The commission was timely, as the gorge was targeted for blasting in order to make way for the proposed Genesee Valley Canal.

The impetus behind the Genesee Valley Canal—an ambitious and extended public works project—was the desire to build on the cultural and financial success of the Erie Canal. By connecting the existing east-west canal (which opened in 1825) to a north-south appendage, financiers and farmers alike sought to build "a waterway capable of accessing the forests of the Genesee Valley, the coal fields of Pennsylvania, and major river routes to the south and west."[4] The plan was to construct 107 miles of canal, stretching from Rochester south to Olean, through the Valley of the Genesee, extending the possibilities of transporting natural resources and finished goods, not to mention consumers, throughout the region. Construction began in Rochester in 1837 and the first section opened in Mount Morris, forty-five miles south, by 1840.[5]

For Ruggles, Cole's commission had two chief purposes: to preserve a view that would possibly be altered forever with the construction of the new canal, and to provide a wonderful presentation piece to then-New York Governor William Seward. In fact, the commission would ultimately generate not one but two large-scale paintings, as well as MAG's oil sketch and several preparatory pencil sketches.

Cole set off from Catskill to Geneseo in late July. "The Valley of the Genesee has heard of your promised visit," Ruggles wrote, "and rejoices in the anticipation—I need not say that I honor their judgment."[6] On August 3 Cole wrote his wife, Maria, from nearby Canandaigua: "We have traveled through a great deal of very beautiful agricultural country: but after all, there are no Catskill Mountains....To-morrow we shall proceed to Geneseo."[7]

From Geneseo, Cole would probably have traveled to Portageville, where he and Ruggles were most likely guests at Hornby Lodge, the home of Elisha Johnson. Johnson, a former mayor of Rochester, an extremely capable man, and the resident engineer for this section of the canal, had

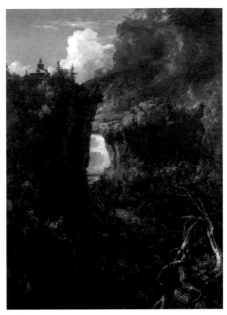

constructed Hornby Lodge in 1837–38, and it was by all accounts a unique and beautiful structure.[8] Cole himself described it as a "Log Building Erected on a romantic spot near the Falls of the Genesee near Portage" and made several sketches of and from Johnson's home as it overlooked the gorge.[9] One such sketch, *On the Genesee*,[10] became the basis of the commissioned painting, *Portage Falls on the Genesee*. Another pencil sketch, together with MAG's *Genesee Scenery* oil sketch, led to a second large painting, *Genesee Scenery (Mountain Landscape with Waterfall)* in 1847.[11]

The first painting, *Portage Falls*, was completed in 1839, presented to Governor Seward, and currently hangs in the Seward House in Auburn, New York.[12] A dynamic combination of gorge and fall foliage (even though the sketches were completed in August), it is a testament to artistic license and Cole's devotion to the creation of the sublime. Hornby Lodge is clearly visible as it crowns the cliff on the left, the Genesee River barely emerges from the cover of autumn trees below, and Deh-ga-ya-soh Creek appears as a trickle on the far right cliff between an outcropping of rocks.

Deh-ga-ya-soh Creek increases in volume and importance as it takes center stage in Cole's 1839 pencil sketch, *Looking Across the Genesee River from Hornby Lodge,* which is a direct source for MAG's painting. This lovely line drawing records the falls of Deh-ga-ya-soh Creek as they cascade beneath a gathering of small buildings that were once part of an active milling operation on that site.[13]

In MAG's *Genesee Scenery* Cole has made several important changes to the pencil sketch. The focus has shifted from a general view with a visible home base on the opposite cliff to a closer examination of Deh-ga-ya-soh Creek and the surrounding hillside. He has eliminated some of the outbuildings in order to draw attention to the mill and the cascading waters. The waterfall has increased in intensity and drama, as has the backdrop of the hillside. He has kept the wooden footbridge, along with the suggestion of two figures enjoying the view. The birds in flight in the upper right—perhaps a reference to the turkey vultures that still glide over the gorge—offer the viewer a subtle but lovely invitation to travel beyond the picture plane.

Although currently dated ca. 1846–47, MAG's painting bears all the hallmarks of an oil sketch done on site—thus the temptation to date the piece to August 1839. *Genesee Scenery* is of a size and medium that was easily transportable by artists in the field. It was evidently painted quickly, with more regard given to impression than carefully rendered detail. And yet there are more compelling reasons to keep the date fixed at ca. 1846–47.

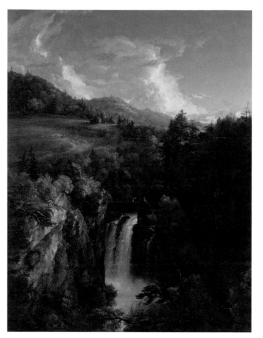

Although Cole did sometimes paint *en plein air,*[14] his correspondence makes it clear that it was not his preferred method of working.[15] Instead, he preferred to make oil sketches once he returned to the studio. These sketches, as is the case with *Genesee Scenery,* often acted as the bridge between an on-site pencil sketch and a large-scale studio painting. And in fact, the composition of MAG's *Genesee Scenery* more closely resembles the large finished painting than the original sketch. Thus, a pencil sketch completed in 1839 was resurrected as a studio oil sketch many years later, as Cole contemplated the additional opportunities presented by an earlier view of the gorge from Hornby Lodge.

It was not unusual for Cole to return to sketches at a later date as the basis for one or more new paintings. A finished painting by Cole was often a composite of several sketches, dramatic lighting, and the artist's imagination. He also considered the delay between drawing on site and painting in the studio to be beneficial, as he wrote to his good friend and fellow landscape painter Asher B. Durand:

> *Have you not found?—I have—that I never succeed in painting scenes, however beautiful, immediately on returning from them. I must wait for time to draw a veil over the common details, the unessential parts, which shall leave the great features, whether the beautiful or the sublime dominant in the mind.*[16]

Genesee Scenery indeed bridged the gap, both in time and the artist's vision, between Cole's visit to the Genesee Valley in 1839 and the design and completion of the large-scale oil on canvas. The finished painting of 1847 retains the color palette, the mill, and the footbridge introduced in MAG's oil sketch. However, the large version offers a dramatically expanded panorama. Cole extended and embellished the background to produce the illusion of a never-ending view from his vantage point at Hornby Lodge. By this convention, used repeatedly in his grand landscape paintings, he entices the viewer's eye and imagination to travel well past the hard and fast edges of the canvas. Cole also introduced several additional figures, small and subservient to their natural surroundings, in the finished large painting.

To be sure, MAG's miniature captures an intimacy and freshness absent from the large painting. The scale of the gorge present in the oil sketch is truer to Cole's original pencil sketch and, based on the contemporary view, a much truer version of the scene as it once appeared. Whether that makes for a better painting can of course be debated. Yet this much is certain: one visit to the Genesee Valley inspired Cole to complete several paintings over a span of eight years. The falls of Deh-ga-ya-soh Creek, pictured here, are less dramatic, but still visible today. Long gone are the wooden bridge, the two tiny figures, and the red wooden building that once served as a mill. However, in his intimate sketch, Cole captured a sense of place, and the true essence of one small but stunning view of the Genesee.

Marlene Hamann-Whitmore is Curator of Education for Interpretation, Memorial Art Gallery.

10: Lilly Martin Spencer *Peeling Onions* (ca. 1852)

Elizabeth L. O'Leary

When Lilly Martin Spencer painted *Peeling Onions* in the early 1850s, she had just begun a distinctive series of domestic genre scenes. At the time, the thirty-year-old artist was negotiating the demands of the New York art market and the challenges of making her way in a profession traditionally dominated by men. Initially finding little patronage for her preferred allegorical and literary subjects, Spencer turned to themes of American home life: toddlers at play, loving parents dandling babies, and cooks preparing the staples of the family meal. Over the next decade—the most successful of Spencer's long career—these sentimental and sometimes humorous images resonated with an audience that prized views of domesticity and the carefully rendered details of a familiar physical world.[1]

The cook depicted in *Peeling Onions* wipes away tears with the back of her hand.[2] She wears a gray pleated bodice; three dressmaker's pins pierce the fabric at the shoulder, hinting at the continuous and varied nature of household labor. Arranged in the foreground is an elaborate still life of utensils, fruit, and an unplucked chicken. The painting's even light, linear contours, and highly finished surface reveal Spencer's absorption of the Düsseldorf style that prevailed in contemporary American genre. At the same time, the image's sharply focused naturalism and trompe l'oeil effects—in particular the spoon that juts forward into the viewer's space—attest to the artist's study of seventeenth-century Dutch art.[3]

It was, however, Spencer's first-hand knowledge of household labor that informed the painting's narrative content—as did her singular understanding of women's work and working women. The artist presents the cook in a demeanor of both vulnerability and power. Tears come from the stinging vapors of the cut onion, yet the woman's soft weeping acts as a reminder—or perhaps a parody—of the sort of tender sensibilities ascribed to females in this period. The sleeves of the cook's dress have been rolled to reveal muscular forearms. She grips the onion and knife firmly and carefully; her strong, sure hands suggest a force that can wring life from a chicken. Despite a momentary weakness, the woman maintains a determined, competent control of her task.

Lilly Martin Spencer,
1822–1902
Peeling Onions (detail), ca. 1852
Oil on canvas, 36 x 29 in.
Gift of the Women's Council
in celebration of the 75th
anniversary of the Memorial
Art Gallery, 88.6

Spencer's own working career echoed this ambiguous blending of vulnerability and power. She made her way into the center of the New York art world at a time when a woman's role in society was becoming increasingly restricted. In the second quarter of the nineteenth century, the concept of a distinct "woman's sphere" was put forward in a deluge of popular literature. It fostered a specific set of gender roles by equating woman with home and private life and man with work and the public arena.[4] The artist, however, led a life that was far from conventional.

Daughter of liberal French émigrés and educators, Angélique Marie Martin—known as Lilly—grew up in rural Ohio. Her parents—who helped establish a commune following the theories of Charles Fourier—devoted themselves to an agrarian life, sharing and rotating labor. They also advocated social reform including abolition, temperance, and women's suffrage—the last being a favorite cause of the artist's mother.[5] Young Lilly, exhibiting a precocious talent for drawing, taught herself to paint. With the blessings of progressive parents and small grants from philanthropist Nicholas Longworth, she left home at age nineteen to pursue professional training in Cincinnati.[6]

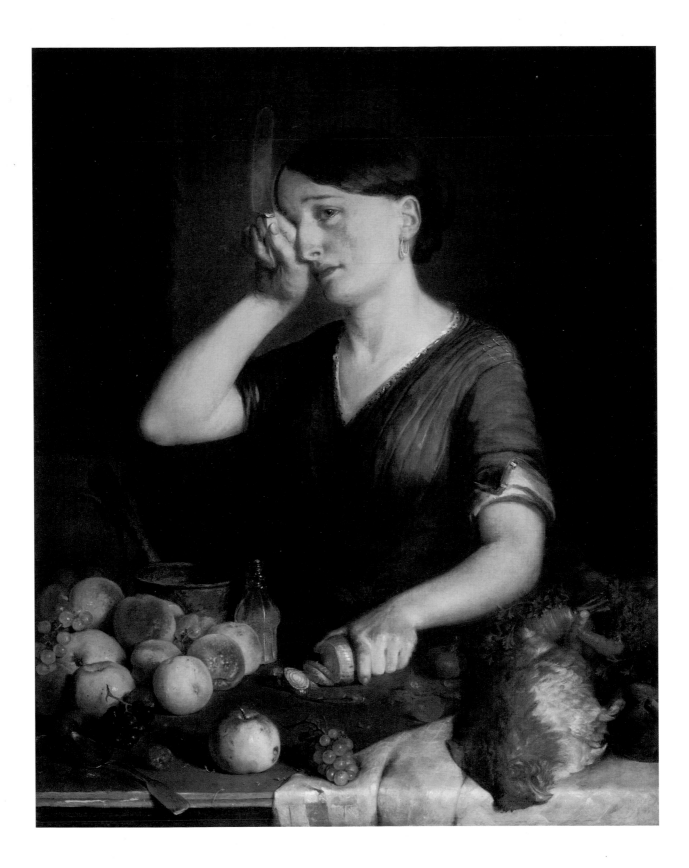

In 1844, Lilly Martin married tailor Benjamin Spencer. Within a few years, her husband, plagued by lay-offs and illness, became his wife's business manager and studio assistant. When Spencer's painting became the principal source of income for her growing family (in time she would give birth to thirteen children, seven of whom would survive infancy), the family relocated to New York City. There, the artist embarked on a period of intense work, producing paintings by day while attending courses at the National Academy of Design at night.[7] Art unions and associations helped generate a clientele for Spencer by marketing her genre paintings and prints to the general public—the primary vehicle for her burgeoning notoriety at mid-century.[8] By 1859, writer Elizabeth Ellet could claim that "Mrs. Spencer's high position among American artists is universally recognized in the profession."[9] Spencer sent her parents the wry rejoinder: "Fame is as hollow and brilliant as a soap bubble, it is all colors outside, and nothing worth kicking at inside."[10]

Lilly Martin Spencer,
1822–1902
Peeling Onions (detail), ca. 1852
Oil on canvas, 36 x 29 in.
Gift of the Women's Council
in celebration of the 75th
anniversary of the Memorial
Art Gallery, 88.6

The artist approached her career with grim determination in the face of an inflated cost of living and stiff competition. The taste for scenes of everyday life was firmly established among painters and collectors in the United States. Well-known practitioners such as William Sidney Mount and George Caleb Bingham laid the groundwork for the surge of interest in genre painting in previous decades. In the 1850s, Spencer managed to garner attention with her compelling kitchen scenes: a laughing washerwoman, a cook greeting the viewer with a doughy hand, a young wife preparing her first stew, and a kitchen maid weeping over onions. However, the artist was not unique in her production of domestic scenes of women, children, and maidservants. On occasion, her antebellum male counterparts—including Eastman Johnson, Tompkins Matteson, Jerome Thompson, and even National Academy of Design president, Francis Edmonds—also approached similar themes with success.[11]

Struggling mightily to balance roles of wife, mother, homemaker, and artist, Spencer encountered ongoing difficulty in finding time to create and market her paintings. Economic need compelled her to produce canvases for sale as quickly as possible; parental duties and societal attitudes toward women restricted her to the household. Turning to scenes at hand, she used her husband, children, herself, and her servants as models.[12]

The skillful cook pictured in *Peeling Onions* is a portrait of Spencer's own live-in maid, one of a series of workers who performed various duties in the Spencer home—cooking, cleaning, sewing, and child care—regularly freeing the artist from these chores so that she could work at her paintings. Spencer, in turn, painted her servant at these tasks.[13] It is not clear how many different women filled the position over time, but Spencer's paintings and drawings give evidence of at least two who worked for the family in the early 1850s. Surviving letters suggest that the artist's relationship with her employees during her early years in New York appears to have been companionable. Over time—and as maids were hired and fired with frustrating frequency due to the Spencers' dwindling household budget—the artist's congenial kitchen scenes came to an end.

(Facing page)
Lilly Martin Spencer,
1822–1902
Peeling Onions, ca. 1852
Oil on canvas, 36 x 29 in.
Gift of the Women's Council
in celebration of the 75th
anniversary of the Memorial
Art Gallery, 88.6

In the remaining decades of the nineteenth century, Spencer maintained an active production of paintings—although the public's decreasing taste for genre seems to have prompted a shift in her concentration to still life and portraiture. Slipping slowly into obscurity, she continued to depend on the income from sales right up until her death at age seventy-nine in 1902. A century later, American art historians have come to recognize Lilly Martin Spencer as one of the premier genre artists of her generation.

Elizabeth L. O'Leary is Associate Curator of American Arts, Virginia Museum of Fine Arts.

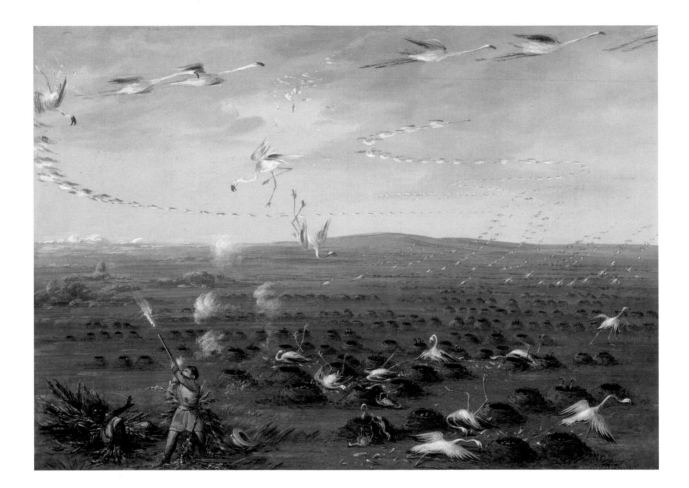

11: George Catlin *Shooting Flamingoes* (1857)

Peter Ogden Brown

George Catlin, said the *New York Morning Herald* in 1837, was "destined to be the Audubon of the Indians,"[1] and in the twenty-first century it is for his work on Indians that he is most remembered. But twenty years later, after his original now-famous "Indian Collection" had been rescued by a friend from his creditors and warehoused in Philadelphia,[2] he was painting scenes on commission from Colt's Patent Firearms, of which *Shooting Flamingoes* was one of ten.[3]

The scene shows Catlin himself discharging the company's unique revolving cylinder rifle into a huge flock of flamingos rising from a salt lake (the Grand Saline) on the Rio Salado, south of Buenos Aires.[4] Catlin published a detailed account of the event in 1868, describing how he and a native guide crept up on the nesting birds. The artist was struck by the intense, contrasting colors of the flamingo, noting that "its chief color is pure white, with parts of its wings the most flaming red and another portion jet black." He also described the nest-building techniques of these "beautiful birds," combining grass and weeds with mud to form open cones about a foot in height and spaced two to three feet apart. He observed that, while in winter the nests were inundated by the rising waters of the lake, in summer, with the water's evaporation, they would reemerge and be restored by the birds in order to provide homes for new broods.[5]

Proud of his repeating rifle, which he had nicknamed "Sam" after its maker, Samuel Colt, he acknowledged that

> I had no chance to sketch, as Sam was before me in both hands and motions would have been imprudent; but I had the most perfect chance to see and to study (to sketch in my mind) every attitude and every characteristic....[6]

Once disturbed, the flamingos rose in formation, allowing Catlin to rake them with shot. He emptied his first cylinder and loaded and discharged a second before realizing that in his excitement, he had struck his young companion on the temple with the gun, knocking the boy down in fear of his life.[7] In the painting the two still bear on their backs the bundles of cut green branches they had used to disguise their advance on the unsuspecting birds. The artist's preference for strong colors and patterns is evident in the painting. A companion picture, *Ambush for Flamingoes,* depicting the more peaceful scene only a few minutes before, can be found in the collection of Pittsburgh's Carnegie Museum of Art.

George Catlin (1796–1872) and Samuel Colt (1814–1862) were good friends, with many parallels in their lives. They were both largely self-taught in their occupations, highly inventive, strong marketers, but subject to financial instability and wanderlust. As a sixteen-year-old, Colt developed his first idea for a percussion revolver while serving as a crewman on a Boston clipper ship bound for Calcutta, using his spare time to carve out prototype parts from wood. After his trial model exploded, he financed his continuing experiments by touring the country in 1832 in medicine shows as "Dr. Coult," promoting the surprising effects of nitrous oxide (laughing gas) on an unsuspecting public. Three years later he received a comprehensive patent for his cylinder weapons, but his factory was bankrupt by 1842. Securing a governmental contract to supply revolvers for the Mexican War in 1847, his reputation as a reliable and successful arms-maker was well established by the time he outfitted Catlin.[8]

George Catlin,
1796–1872
Shooting Flamingoes, 1857
Oil on canvas, 19 x 26½ in.
Marion Stratton Gould Fund,
41.25

George Catlin,

1796–1872

Ambush for Flamingoes,

ca. 1856–1857

Oil on canvas, 19 x 26½ in.

Carnegie Museum of Art,

Pittsburgh; Howard N.

Eavenson Memorial Fund for

the Howard N. Eavenson

Americana Collection, 72.7.2

Born in Wilkes-Barre, George Catlin practiced law in Pennsylvania before turning to art. In Philadelphia he became accepted as a miniaturist and portrait painter, despite little formal training.[9] The appearance there in 1829 of a Native American delegation on their way to Washington inspired a six-year undertaking on his part to capture their vanishing culture in writings and on canvas. He assembled the hundreds of resulting works into an "Indian Gallery," but ultimately failed in his plan to sell the collection to the United States government for the handsome reward which he intended.[10]

Showmanship for Catlin was the ingredient necessary to make his somewhat unrefined art commercially rewarding. In 1839 he and his family moved to England, where he continued to operate his Indian Gallery, though with only marginal success despite surprise appearances by the Catlin clan disguised as Native Americans. It was not until he imported real Indians for this purpose that his venture began to flourish, culminating in a royal audience at Windsor in 1843.

But Catlin's fortunes continued to be uneven as he wore out his audiences and tried unsuccessfully to promote ideas for a "Floating Museum" in 1851 and a life-saving "steam raft" in 1860.[11] In between, driven first by rumors of lost gold mines and later influenced by the German naturalist Alexander von Humboldt,[12] he traveled extensively in both South and North America, Alaska, and Siberia, primarily exploring and documenting indigenous cultures and, along the way, executing Samuel Colt's commission. Other paintings in the series, most of which were turned into commercial lithographs for advertising purposes by Colt, included depictions of the artist demonstrating the repeating rifle to a council of South American Indians, scaring off a pair of jaguars from his Brazilian camp, and saving a colleague from wild boars, as well as scenes of hunting buffalo and rheas from the saddle.[13]

In the 1860s, separated by creditors from his first Indian Collection, Catlin, now working in Belgium, recreated many of the paintings from early sketches, adding the depictions from his more recent expeditions in what has come to be known as the "Cartoon Collection." Eventually transferred to the American Museum of Natural History in New York, the Cartoon Collection was later largely deaccessioned.[14] The Smithsonian continues to prize 445 paintings from the original Indian Collection given to them by Catlin's widow.[15] Thus, although Catlin's desire to inform the world about the already fast-disappearing native cultures of the Americas was often frustrated by the difficulties he encountered in marketing his work for what he believed to be necessary personal gain, the great corpus was ultimately preserved to provide an irreplaceable record of those societies.

George Catlin and Samuel Colt enjoyed a friendship based upon a shared love of adventure and entrepreneurialism, for which the young nation supplied opportunities in abundance. Their kindred spirits were perfectly suited for mutual benefit, with Colt commissioning Catlin's paintings for popular reproduction of exotic hunting scenes demonstrating the efficacy of Colt's patent firearms. While such an image of indiscriminate slaughter as *Shooting Flamingoes* makes us cringe today, it should be viewed as the artistic record of an exciting event of a different time with very different popular values.[16]

Peter Ogden Brown chairs the Art Committee of the Memorial Art Gallery and the board of the Rochester Historical Society.

12: Rubens Peale *Still Life Number 26: Silver Basket of Fruit* (1857-58)

Susan Nurse

The Memorial Art Gallery's *Still Life* by Rubens Peale is one of over 130 paintings produced by this member of America's "First Family of Artists" during the last years of his life. Like Anna Robertson "Grandma" Moses in the twentieth century, Peale did not begin to paint until his seventy-first year and he did not approach painting as a profession but for the pure joy of creating.

Rubens Peale was the fourth of seventeen children of Charles Willson Peale (1741–1827),[1] an energetic artist, philanthropist, and zoologist. Of Charles's large family at least ten became painters, including a brother, four sons (all named for famous painters), several nieces, and a nephew.[2] Thus Rubens was early and often exposed to art and the art of observation. Having a fragile physical nature in early childhood and hampered throughout his life with poor eyesight, he was not given formal artistic training like his famous brothers Raphaelle and Rembrandt but was trained to run another of the father's enthusiasms, the family museums. Charles Willson Peale's Philadelphia museum was a mixture of portraits and paintings by family members, curiosities of nature, both fauna and flora, art exhibits of "old masters" borrowed from prominent friends, and a venue for lectures.[3] To his role as head of two family museums and then his own in New York City,[4] Rubens brought his exactitude for observation, taxidermy skills, and showmanship—aided by special glasses he himself invented.[5]

Facing enforced retirement in his middle fifties, Rubens turned to his wife's family, who provided the Peales with "Woodland Farm" in Schuylkill County, Pennsylvania. There he successfully brought to farming his early love of botany and his museum training as an intense, inquisitive observer of natural forms. His sons did much of the heavy labor, but Rubens supervised the crops and animals, and tended all the gardens, both vegetable and flower. With this success, he was able to send his only daughter, Mary Jane, to Philadelphia to study painting with her uncle Rembrandt.

On October 22, 1855, at the age of seventy-one, Rubens began a daily detailed journal of the life of the farm, including his newfound hobby, painting.[6] It may have been the return of Mary Jane to the farm to help take care of her parents that began the process. Her enthusiasm and encouragement apparently helped Rubens overcome his reluctance to test his artistic abilities against his much more famous and talented family members. In fact, many of the paintings that he made as gifts were met with surprised enthusiasm, not only for his long hidden talent but also for his courage at producing works of art at his age.

The fidelity to life Peale brings to the fruits in MAG's *Still Life Number 26* hardly seems the work of an amateur. His memory of the specimens had to be very keen for him to produce a painting whose fruit looks fresh enough to eat. It certainly appears to have been done with the fruit sitting in front of him, but in fact, since he had no private space in the farmhouse for a studio, the opportunities for setting up his homemade "ezel" and paint box could easily be disrupted by visiting family or friends, sometimes for weeks at a time.[7] His first priority was always his responsibilities on the farm.

Under these circumstances, it is all the more surprising that Rubens was able, in the last ten years of his life, to produce over 130 works, of which 95 were still lifes. Only five were produced on tin, like MAG's painting. In a practice carried over from his museum days, he gave specific numbers rather than names to each work. The number 26 duly appears in the front right corner of MAG's

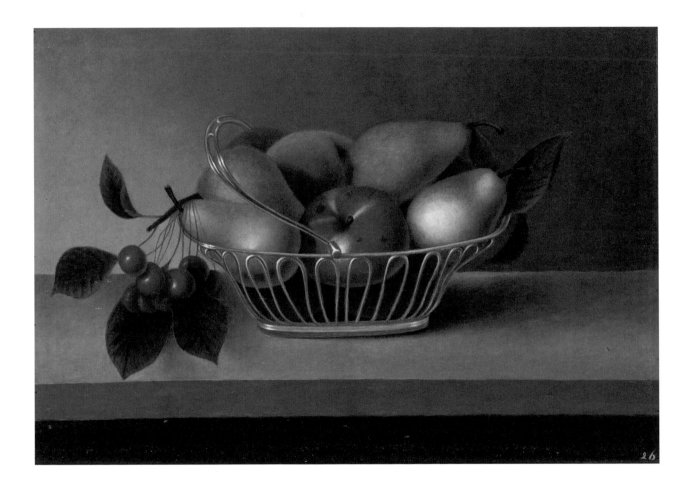

Still Life. We know from Rubens's journal that his son George prepared the tin for the final painting by putting in the ground of brown and green.[8] Rubens may have made for George a preliminary drawing of the placement of the objects, or he may have drawn on the tin itself. In either case, the details of the fruit must have been executed from memory, with typically careful attention to blemishes and skin coloration.

There is no wild profusion of fruits as in many still lifes traditionally—no clusters of grapes, for instance, overflowing onto the table. Indeed all the fruit is contained in the basket: respectable, solidly modeled, carefully individuated all-American standards, a central apple surrounded by pears and a peach, plus a sprig of cherries drooping somewhat rakishly off to one side. This cool simplicity—or perhaps modesty—plus the lack of all background details, allows the silver basket itself to dominate the scene.

The surface on which the basket sits seem tipped forward, but the basket itself is seen straight on. The light comes from the front and the left side, to judge by the highlights on the fruit and the shadows cast by the basket. Curiously, no shadows are cast by the cherries, which Rubens perhaps added later without making any changes in the basket. It is true that he used paint sparingly, adding thin layers to enhance the shading. (When receiving lessons on landscape painting he was shocked at the amount of paint applied by the artist and then scraped off again for effect.)[9]

The basket is of particular interest. Rubens sometimes copied works by other members of the Peale family as a way of learning painting. He was particularly drawn to the works of his uncle James and his brother Raphaelle. The same silver basket was painted by James in a painting called *Fruit and Grapes* (ca. 1820, private collection), which was owned by Rubens's eldest son, Charles Willson,[10] and which Rubens copied in another of his paintings, *Basket of Peaches with Ostrich Egg and Cream Pitcher* (1856–59, private collection).[11] It is almost identical to the oval wire bread basket made by British silversmith Matthew Boulton in 1788.[12] The design is based on forms made popular by Robert Adam deriving from antiquity with its clean lines and fine proportions. While the "Adam style" was hugely popular and influential in England and America from the 1760s on, it was out of fashion by the time Rubens Peale used it. By the 1850s, America's taste in still lifes was changing to much larger and more elaborate works, reflecting the increasing affluence and refinement of American homes and the influence of European training on American artists.[13] Peale's relative isolation on the farm screened him from these changing tastes, with the result that his works, like this one, retain an unusual freshness and simplicity.

(Facing page)
Rubens Peale,
1784–1865
Still Life Number 26: Silver Basket of Fruit, 1857–58
Oil on tin, 13 x 19 in.
Gift of Miss Helen C. Ellwanger,
64.40

Still Life Number 26 descended in the Peale family until given to Miss Helen Ellwanger, the donor to the Memorial Art Gallery. Miss Ellwanger was the daughter of George Ellwanger, co-founder in Rochester of the Ellwanger & Barry Nursery, the most prolific producer of seeds and horticultural supplies in the world at the time. It is fitting that the work of Rubens, a studier of seeds and planting and an observer of nature, should have been donated by a descendant of the famous nineteenth-century nurseryman.

Susan Nurse is Visual Resources Coordinator, Memorial Art Gallery.

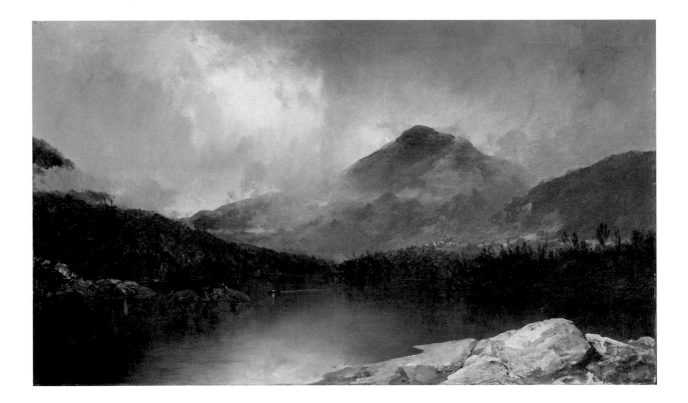

Seeing America: Painting and Sculpture from the Collection of the Memorial Art Gallery

13: John Frederick Kensett *A Showery Day, Lake George* (ca. 1860s)

Caroline M. Welsh

Running almost due north-south, Lake George, the largest lake in the Adirondack mountain region of upstate New York, has been a major thoroughfare for centuries. It has long been praised for its natural beauty and historic significance. Extraordinary geologic and glacial forces along with abundant springs and subterranean water sources combine with a limited watershed to make the water unusually transparent and the terrain picturesque.

The earliest visitors were amateur and professional naturalists, members of religious orders, and sportsmen. Isaac Jogues, Jesuit martyr and the first European to see the lake (in 1646), called it Lac du Saint Sacrament. Swedish naturalist Peter Kalm detailed the topography, flora, and fauna in 1749. Jacques Gérard Milbert, French naturalist and artist, collected natural history specimens between 1815 and 1818 and made innumerable drawings of Lake George, the Adirondacks, and other places in New York State for his *Itinéraire Pittoresque du Fleuve Hudson* (Paris, 1828). Milbert was but the first of many artists to be attracted to the lake.

In 1826 English-born artist Thomas Cole visited Lake George and the ruins of Fort Ticonderoga, important in the French and Indian War and the American Revolution. Engravings after Cole's sketches of these sites were published in several editions of John H. Hinton's *History and Topography of the United States* beginning with the London edition of 1830.[1] Another Englishman, William Henry Bartlett, traveled to Lake George at this time to make illustrations for Nathaniel P. Willis's book *American Scenery*.[2] Two years later Cole returned to the Adirondacks with his wife and his friend Asher B. Durand. They went to Schroon Lake, northwest of Lake George. Cole's and Durand's pioneering forays in search of the picturesque along the Hudson River and in the Adirondacks drew other artists to the northern wilderness by 1837.[3]

Commercial steamboats had begun trafficking the lake in 1817, inaugurating Lake George's heyday as a summer resort. The first of Winslow Homer's many Adirondack subjects was a wood engraving, *On the Road to Lake George*, published as the cover of the July 24, 1869, issue of *Appleton's Journal of Literature, Science and Art*. The editor noted: "These little summer scenes, like that of Mr. Homer's sketch, are necessarily abundant all through the season. Everywhere—by the lake-side, on the mountain, at the sea-shore—the country is dotted with pleasure-seekers, and artists find no lack of pleasing groups for their sketch-book."[4]

Yet few artists found Lake George as felicitous a subject as John Frederick Kensett. Durand's letters to his son on June 22 and July 2, 1848, record Kensett's first visit to the region: "Despite difficulties with baggage left behind, Kensett, [John William] Casilear and Durand took a steamer to Albany, a stage to Whitehall, a boat up Lake Champlain and finally debarked at Essex. From here they journey [*sic*] to Elizabethtown where despite extremely hot weather they made some good sketches, did some 'trouting' and after a week went on to New Russia, a few miles to the south. Plans, as of July 2, were to spend another week or two in Elizabethtown and then go to Keene to finish the month of July."[5] The next year Kensett was again "touring in the Adirondacks" with Casilear,[6] and in 1853 he visited Lake George for the first time, and other sites in the region. Lake George, like Narragansett and Newport, Rhode Island, was a repeated theme for Kensett. Each time he painted the lake he captured different views at different seasons and times of day, always sensitive to the mood produced by the effects of light, color, and atmosphere. He wrote to his uncle, J. R. Kensett, about his experience:

John Frederick Kensett,
1816–1872
A Showery Day, Lake George,
ca. 1860s
Oil on canvas, 14⅛ x 24⅛ in.
Marion Stratton Gould Fund,
74.29

John Frederick Kensett,
1816–1872
A Showery Day, Lake George
(detail), ca. 1860s
Oil on canvas, 14⅛ x 24⅛ in.
Marion Stratton Gould Fund,
74.29

ALSO IN THE MAG COLLECTION:
Jacob Ward,
1809–1891
Outlet of Lake George,
before 1840
Oil on canvas, 21¾ x 30 in.
Marion Stratton Gould Fund,
47.19

I directed my course towards that sheet of water which has a name par excellence among our American inland seas—Lake George....I selected a little unobtrusive spot called Bolton where there was a quiet inn upon the lake...where green hills swept boldly down to the water's edge. Twenty or thirty islands of varying size lay around....It was among these islands with a light boat fortified with my basket of provisions & my painting materials that I spent the greater part of the day....I had some of the most delightful and unobtrusive hours of the summer.[7]

A Showery Day, Lake George is an unsigned study sold with the contents of the artist's studio in 1873 and is related by site and format to his masterpiece, *Lake George* (1869, The Metropolitan Museum of Art).[8] Kensett's characteristic spare and precise delineation reveals the textures and forms of rocks, pine-covered slopes, and water in this atmospheric view of the entrance to the Narrows with Black Mountain in the distance to the north. The artist's allegiance to the picturesque is seen in the framing of the scene with the natural elements of rocks and trees; to the dramatic or sublime, in the wildness of the mountains and weather; and to the beautiful, in the quiet harmony of the scene. The rocks are rendered in the detailed manner of truth to nature promoted by Durand and John Ruskin, while the atmospheric treatment of the mountains and sky presages the luminism and abstraction seen in Kensett's later work.

During the 1860s Kensett based himself in Elizabethtown, in the eastern Adirondacks, and took trips to the Saranacs, Lake Placid, and Keene Valley to sketch and paint with his artist friends.[9] He is recorded at Lake George again in the fall of 1869 and in his last summer, 1872. The large number of paintings and drawings with Adirondack or Lake George titles suggests that Kensett was in the region more times than can be documented.[10]

When Kensett died at fifty-six in December 1872, his art was considered by many of his contemporaries to epitomize landscape painting with religious and moral content. Kensett's paintings, like Cole's and Durand's, were influenced by the transcendentalist belief in the unity of all creation. As George W. Curtis, Kensett's friend and editor of *Harper's Magazine,* said at his funeral: "His love of nature was as simple as it was deep, and his interpretation was pure and reverend and beautiful."[11] *A Showery Day, Lake George* is one of Kensett's reverend interpretations.

Caroline M. Welsh is Chief Curator, Curator of Art, and Director of Operations at The Adirondack Museum in Blue Mountain Lake, New York.

14: Leonard Wells Volk *Life Mask and Hands of Abraham Lincoln* (1860/1886)

Grant Holcomb

"Abraham Lincoln, sixteenth President of these United States, is everlasting in the memory of his countrymen." So notes composer Aaron Copland in the narration to his acclaimed composition "Lincoln Portrait" (1942). Indeed, for many, Lincoln remains the quintessential American hero who, born and raised in the most humble of circumstances, became a prairie lawyer, president, Great Emancipator, and martyr. Beloved by generations of Americans, his life and legacy remain a deep and enduring presence upon the national memory. He was Walt Whitman's "powerful, western, fallen star!"[1] and, for over 150 years, American artists (painters, poets, sculptors, and composers) have been captivated by this "common man whom no other man resembles."[2]

The artistic reputation of Leonard Wells Volk rests primarily on his sculptural portraits of Abraham Lincoln. His 1860 life casts of Lincoln's face and hands earned him immediate and enduring fame, as most, if not all, later sculptors used his casts while trying to capture the Lincoln likeness.

Born in Wellstown (now Wells), New York, Volk's early interest in sculpture began in his father's marble-cutting workshop in Pittsfield, Massachusetts. As a young man, he established studios in Buffalo, St. Louis, and Galena, Illinois, before traveling to Italy in 1855 in order to study, first-hand, the masterpieces of ancient and Renaissance sculpture. Upon his return two years later, he set up a studio in Chicago where he established himself as a sculptor and a prominent figure in the city's art community. In fact, he was one of the founders of the Chicago Academy of Design (later the Art Institute of Chicago) and served as its president for eight years.

Volk first met Lincoln in Chicago in 1858 when the Springfield attorney and aspiring Republican candidate to the United States Senate was debating Stephen A. Douglas, "The Little Giant," throughout the state of Illinois. Always in search of new models (especially of rising politicians), Volk asked Lincoln if he would pose for him sometime in the future. An accommodating Lincoln agreed and, two years later, was reminded of the conversation when he found himself back in Chicago serving as counsel for the defense in a land-dispute case. Lincoln kept his promise and, after breakfast on the morning of March 31, 1860, walked to the artist's studio to pose. Volk remembered a man with a rugged face, a broad and pleasant smile, and a memorable sense of humor.[3]

In an 1881 article describing the making of the first portrait bust of Lincoln, Volk notes that "He sat naturally in the chair and saw every move I made in a mirror opposite...."[4] After cutting holes for the eyes and placing quills in the nostrils that enabled Lincoln to breathe, Volk applied the plaster mold and, after one hour, removed it from Lincoln's face. "It clung pretty hard," he recalled, but Lincoln "bent his head low and took hold of the mold, and gradually worked it off...; it hurt a little, as a few hairs of the tender temples pulled out with the plaster and made his eyes water."[5] The sitter found the experience disagreeable and, when the plaster began to harden on his face, even frightening. But after a positive image of the face was made by pouring liquid plaster into the mold, Lincoln could declare, "There is the animal himself."[6] And Lincoln's friends agreed. For example, John Hay (later Lincoln's private secretary in the White House), described the portrait as "a face full of life, of energy, of vivid aspiration."[7]

Whether due to serendipity, good timing, or keen ambition, Volk found himself in Springfield shortly after Lincoln received word that he had been nominated the Republican candidate for President. "I went straight to Mr. Lincoln's unpretentious little two-story house," Volk wrote. "His face looked

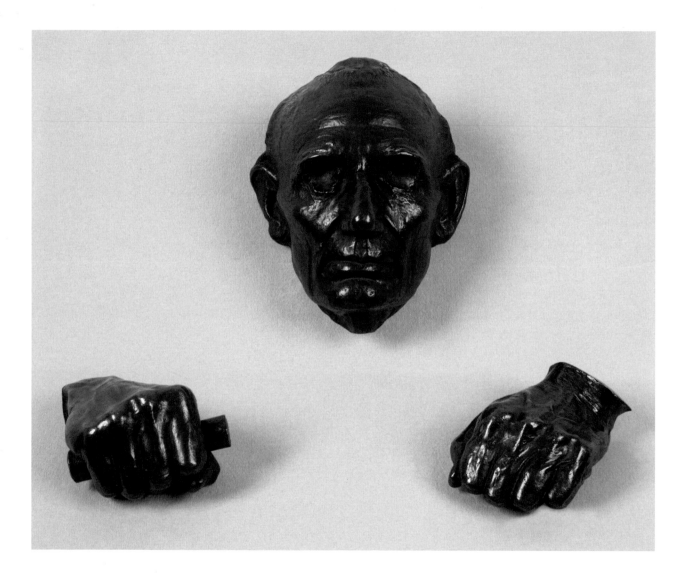

radiant. I exclaimed: 'I am the first man from Chicago, I believe, to have the honor of congratulating you on your nomination for President.' Then those two great hands took both of mine with a grasp never to be forgotten."[8]

Volk had envisioned a full-size statue of Lincoln and, as such, wanted to have casts of his hands as well as his face. Lincoln obliged and, the day following Volk's arrival, sat for the artist once again. When Volk asked him to hold a round stick in his right hand (which was swollen, Volk noticed, "on account of excessive hand-shaking the evening before"), Lincoln went to the wood-shed, fetched the sawn-off handle of the family broom, and began to whittle it. "I remarked to him that he need not whittle off the edges. 'Oh, well,' said he, 'I thought I would like to have it nice.'"[9] (Mary Lincoln was apparently not pleased with Lincoln's solution.) Volk then proceeded to cast the left hand while hearing Lincoln tell the story of the scar on his thumb: "You have heard that they call me a railsplitter," he said, "Well, it is true that I did split rails, and one day while I was sharpening a wedge on a log, the axe glanced and nearly took my thumb off, and there is the scar, you see."[10]

Leonard Wells Volk,
1828–1895
Soldiers' and Sailors' Monument,
Washington Square Park,
Rochester, NY, dedicated 1892
Photograph from the Albert
R. Stone Negative Collection,
Rochester Museum & Science
Center, Rochester, New York

The cast hands have a startling emotional power. In their simple rough realism—the scar, the fierce grip of the swollen right hand, the prominent veins, the bony knuckles—we are looking, after all, at the "actual" hands that swung the axe and would, in the next few years of their life, write the Gettysburg Address and sign the Emancipation Proclamation. In their intensely physical actuality they embody, here and now, much of our diffuse feelings for this complicated man.

Many artists have used the Volk casts in their monuments of Abraham Lincoln, from Augustus Saint-Gaudens's acclaimed *Standing Lincoln* in Chicago (1887), to George Grey Barnard's portrait bust (ca. 1918; see essay 46 in this volume), to Daniel Chester French's heroic *Lincoln Monument* in

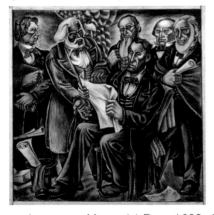

Washington, D.C. (1922). African American painter Hale Woodruff seems to have been influenced by the bronze casts in his depiction of Lincoln's clenched hands in his 1942-43 mural study, *Frederick Douglass and Abraham Lincoln Discussing Emancipation*.[11] Volk himself used them to create his monumental tribute to Lincoln in Washington Square in Rochester, New York. Standing nine feet tall atop a forty-three foot high column, Lincoln faces north with a copy of the Emancipation Proclamation in his right hand. Below, four bronze figures represent the branches of the military; on the base, bronze plaques depict significant Civil War battles and events. Over one hundred thousand people attended the unveiling of the sculpture on Memorial Day, 1892. On hand with the artist and his wife were President Benjamin Harrison, Frederick Douglass, and New York State Governor Preston Flowers.

Hale Woodruff, 1900–1980
Frederick Douglass and Abraham
Lincoln Discussing Emancipation,
1942–43,
Tempera on masonite,
11¼ x 11 in.
Marion Stratton Gould Fund,
2002.20
©Estate of Hale Woodruff/
Elnora, Inc., Courtesy of
Michael Rosenfeld Gallery, LLC,
New York, New York

Over the next quarter-century Volk's original plaster casts passed from Volk to his son Douglas, and then into the care of a fellow artist, Wyatt Eaton, before the renowned sculptor Augustus Saint-Gaudens saw them and recognized their historic and artistic significance.[12] Saint-Gaudens and his friend Richard Watson Gilder then set out to raise money to have bronze replicas made and sold in order that the originals could be acquired by the Smithsonian Institution, where they reside (in the Museum of American History) today. The Memorial Art Gallery's bronzes apparently date from this 1886 venture. From that time forward, innumerable artists, known and unknown, have utilized the bronze casts in order to capture the spirit as well as the likeness of Abraham Lincoln. "To gaze upon his face," one sculptor wrote, "is like beholding the grandeur of a rugged mountain."[13]

(Facing page)
Leonard Wells Volk,
1828–1895
Life Mask and Hands
of Abraham Lincoln, 1860/1886
Bronze, 9¾ x 8⅛ x 5⅝ in.
Gift of Thomas and
Marion Hawks, by exchange,
98.37.1-2a-b

Grant Holcomb is The Mary W. and Donald R. Clark Director of the Memorial Art Gallery.

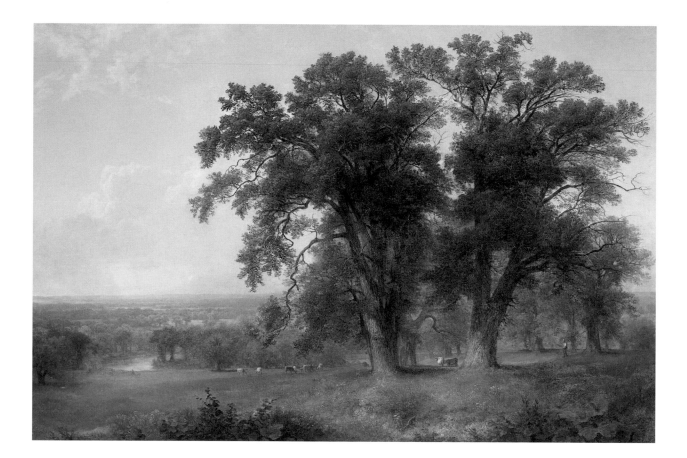

15: Asher B. Durand *Genesee Oaks* (1860)

Marlene Hamann-Whitmore

*I*n this bucolic landscape, Asher B. Durand clearly demonstrates his mastery of a favored nineteenth-century art form. Capturing a view held by wealthy landowner James S. Wadsworth of Geneseo, New York, *Genesee Oaks* combines a fairly faithful record of a specific site with Durand's artistic and philosophical vision. Following in the footsteps of other nineteenth-century artists and poets, Durand—with Thomas Cole, an originator of the Hudson River School of landscape painting—viewed the natural world in all its beauty and grandeur as proof of and a blessing from a benevolent God.[1] By incorporating figures into this landscape, Durand presents a pastoral, almost biblical view of a unified coexistence between man and nature.

In a formula typical of many of his landscapes from this period, Durand divides *Genesee Oaks* quite distinctly in two, offering an extended long-range view on the left and a meticulously rendered foreground on the right. The shallow mid-ground extends the length of the composition as it plays host to a trinity of characters: a meandering herd of cows; a solitary wanderer, and the true protagonists —a gathering of stately oak trees.

The hills of the surrounding Genesee Valley, evident in the left of the composition, remain clearly visible today, almost 150 years after Durand painted *Genesee Oaks*. And the Genesee River, seen here as it makes one of its many twists and turns, remains a vibrant asset to the beauty of the valley as it flows northward from Pennsylvania to the falls of Rochester before joining the waters of Lake Ontario. Geneseo is located in Livingston County, which has retained its strong ties to farming, and herds of grazing dairy cattle remain a common sight in the region.

Durand has given special prominence to his depiction of the oaks. These grand and eloquent trees are a symbol of pride and longevity for the region. With an impressive lifespan of 150 to 300 years, the white oak (shown here) achieved an iconic status among the indigenous Seneca people, a status that was recognized and respected by the early European settlers as well. The constant ebb and flow of stability and change affects all cultures, and the steadfast nature of the white oak, in addition to its impressive size, has remained a constant in this area for centuries. The landscape and culture of this part of the Northeast began to change rapidly in the late 1700s as western New York opened for settlement, and for many the oaks provided (and still do) a much sought-after connection to the land and to the past.

Asher B. Durand,
1796–1886
Genesee Oaks (detail), 1860
Oil on canvas, 28¼ x 42 in.
Gift of the Women's Council in
honor of Harris K. Prior, 74.5

In *Genesee Oaks*, the figure entering from the right is alone—and yet perfectly at home—in this wild pasture. The peaceful rambler is a figure common to many of Durand's landscapes. Here he provides us with a sense of scale, further impressing us with the grandeur of the oaks.[2] The figure also provides a human access point, allowing us to enter this new Eden as he has done. He is an active participant in this gently unfolding narrative, yet he is dwarfed by the quiet majesty of the natural world. He strolls forward at an unhurried pace, his left arm holding a staff or perhaps a fishing pole. It is through our identification and assimilation with this kind stranger that we can most fully appreciate the beauty of the valley on a summer day.

(Facing page)
Asher B. Durand,
1796–1886
Genesee Oaks, 1860
Oil on canvas, 28¼ x 42 in.
Gift of the Women's Council in
honor of Harris K. Prior, 74.5

Durand presents a combination of the general and the specific beauty of this particular place. His careful recording of the vegetation in the foreground displays an array of identifiable plants, such as yarrow and common burdock, both still found in the area.[3] The trees surrounding the bend in the river are cottonwoods, identifiable by their round, billowy crowns and the fact that then, as now, they seek out and flourish near sources of water, such as the Genesee River.[4] A winding river and a grove of trees are standard fare in landscape painting, and contemporary viewers might be tempted to dismiss these elements as generic compositional devices rather than an artist's rendering of a particular place. It is true that Durand was not beyond inserting his brand of artistic license into a painting. However, he had very strong feelings on what was permissible for artistic intervention and what was to be recorded as faithfully as possible:

> There can be no scene worthy of being painted, that does not possess certain characteristic features, which constitute its interest. These features are obvious at a glance, and must be preserved inviolate: there are others more or less subordinate—such should receive attention according to their relative importance....Now, the artist is not only licensed, but enjoined to modify, or entirely omit all these subordinate details, whenever they detract from the beauty or other interest of predominant features;...but the elevations and depressions of the earth's surface composing the middle ground and distance...may not be changed in the least perceptive degree, most especially the mountain and hillforms. On these God has set his signet, and Art may not remove it....[5]

View of the Genesee River Valley from Hartford House, 2005
Photograph by the author

This being said, there is certainly enough evidence to suggest that *Genesee Oaks* is Durand's truthful depiction of a specific view—the view held by James S. Wadsworth (1807–1864) as he looked west from behind Hartford House, his home in Geneseo. Hartford House occupies a large tract of land—a combination of woods, gardens, pastures, and meadow—north of the village of Geneseo.[6] The specific character of this landscape is indebted in part to James Wadsworth (1768–1844), father of James S. Wadsworth.

James Wadsworth, along with his brother William, arrived in the Genesee Valley in 1790 and soon founded the village of Geneseo.[7] Together, brothers James and William purchased two thousand acres of rich but densely forested farmland along the Genesee River. By 1800, James Wadsworth alone owned 34,500 acres.[8]

Inspired by visits to England and the beauty of various managed and manicured English estates and meadows, the elder James was determined to preserve the original wooded character of much of his Livingston County plantation, in addition to leasing out large tracts for farming.[9] These seemingly contradictory agendas were married by an unusual legal clause, contained in the leases signed by all of Wadsworth's tenant farmers:

Tenants are not to destroy, nor suffer to be destroyed, any shade tree, to leave growing on such lands as are to be cleared off, at the rate of one shade tree to every two acres, and occasionally a clump of shade trees; and in case such Lessees shall destroy, or suffer to be destroyed, any shade trees, they shall pay to the Lessor the sum of ten dollars for each and every shade tree so destroyed, as stipulated damages therefor.[10]

This unique and stern proclamation was successful in producing the desired aesthetic effect. Wadsworth land became well known and easily recognizable by the mature and handsome oaks holding court throughout the countryside.

At his father's death, James S. Wadsworth inherited one of the largest estates in the country. Wadsworth was an influential and generous individual, and his stately home reflected his stature in the area. It seems most fitting that he would commission Durand to capture the view of which he would have been most proud—the view of the valley as seen from the site he chose for his homestead. Durand traveled to Geneseo during the summer of 1859. He made several studies of trees while in the area, most inscribed on their lower margin "Geneseo," with dates ranging from June 24, 1859, through July 27, 1859.[11] In a letter to his son John, dated August 7, 1859, Durand stated:

Asher B. Durand,
1796–1886
Pencil sketch, 1859
13¹⁵/₁₆ x 9¹⁵/₁₆ in.
Collection of the New-York
Historical Society, 1918.159

With all my troubles I believe I have learnt more of the management of colors in the painting of trees than by all my previous practice altho' I have never produced so little in the same span of time, not having made but 4 studies in five weeks.[12]

Durand may have been frustrated by his progress, but the resulting work, *Genesee Oaks*, was completed and exhibited at the National Academy of Design in 1861.[13] It hung at Hartford House, remaining in the Wadsworth family, until the early 1970s.[14]

The Genesee River still bends west of Hartford House as Durand has pictured it, and several legendary groups of oaks still stand on the property. Without a doubt, Durand has compressed the northern and southern parameters and shortened the distance from house to river. However, the view of the valley in the background, "especially the mountain and hill forms,"[15] remains virtually unchanged from Durand's visit.

Marlene Hamann-Whitmore is Curator of Education for Interpretation, Memorial Art Gallery.

16: Martin Johnson Heade *Newbury Hayfield at Sunset* (1862)

Marjorie B. Searl

The world lies east: how ample, the marsh and the sea and the sky!
—Sidney Lanier: The Marshes of Glynn, 1878

Martin Johnson Heade's genius reveals itself in his meticulous studies of the natural world. Distinguishing himself from his nineteenth-century predecessors and peers whose canvases celebrated the enormous breadth of creation, he narrowed his focus, like a scientist pursuing microscopic truths. After experimenting and growing dissatisfied with the results of traditional landscape painting, Heade found himself drawn to subjects that were remarkable in their specificity and prototypical nature. In his floral paintings—like *Giant Magnolias on a Blue Velvet Cloth* reproduced on a United States postage stamp in July 2004—leaves and petals seduce our senses with their fragile perfection.

He described himself, for example, as a "monomaniac" about hummingbirds, and traveled to Brazil to study and paint them beginning in 1862. He even went so far as to dissect one to learn more about the bird that he included over and over again in his work, including the Memorial Art Gallery's painting *Hummingbird, Cattleya and Dendrobium Orchid,* circa 1890.[1]

Closer to home, Heade developed a passion for the salt marshes of the Atlantic Coast. In 1859 a Boston critic complimented Heade's "meadow scene in Newburyport, taken at sunset…[with a] stream that runs through the meadow," anticipating the Memorial Art Gallery's 1862 painting of the same subject, *Newbury Hayfield at Sunset.*[2] Decades before French impressionist painter Claude Monet began his haystack series, this rural subject first appeared in Heade's work, and recurred in nearly one-fifth of his oeuvre.[3] Sketches of haystacks from 1858 suggest that he spent time hiking through the marshes, stopping to observe, document, and record, and then used these images again and again as the starting points for paintings through the course of his life.[4]

Why would Heade paint marsh scenes for nearly forty years? To begin to answer this question, consider how the peripatetic Heade first encountered the coastal Atlantic landscape. He visited New England as early as 1855 *(Rocks in New England,* Museum of Fine Arts, Boston), and by 1856 he was known to be living in Providence, Rhode Island. In 1861, when he was living in Boston, he painted his first dated marsh scene. From Boston, where he remained through 1863, it was a train ride of about forty miles to Newburyport, an active shipbuilding and mercantile center just inland from the coastal marshes.[5] Several of Heade's friends had Newburyport connections, and may have recommended a visit to see the picturesque countryside dotted with conical stacks of hay.[6]

To Heade, who spent his childhood in Lumberville, Pennsylvania, on the Delaware River, the ecology of the salt marshes must have had great appeal. While the marsh might appear to be a static subject in comparison to a swiftly flowing river, it is actually, to paraphrase Theodore Stebbins, an intermediate landscape that lies between wilderness and pastoral, churning ocean and domesticated fields. It both conceals and reveals continuous activity and, in short, is emblematic of nature's complexity.[7] While the exact location of many of Heade's marsh landscapes is uncertain, the date of the Memorial Art Gallery's painting and its similarity to other works of this period provide strong evidence that it was, in fact, inspired by the coastal landscape north of Boston, most likely between the Merrimack and the Parker Rivers.

(Facing page)
Martin Johnson Heade,
1819–1904
Newbury Hayfield at Sunset,
1862
Oil on canvas, 11¼ x 25³⁄₁₆ in.
Gift of Jacqueline Stemmler
Adams in memory of
Mr. and Mrs. Frederick
M. Stemmler, 75.21

Martin Johnson Heade,
1819–1904
*Hummingbird with Cattleya
and Dendrobium Orchids,* ca. 1890
Oil on canvas, 22¼ x 14³⁄₈ in.
Harris K. Prior Memorial Fund,
76.3

The Gallery's painting depicts a complex and dynamic environment whose transient qualities proved particularly compelling to the artist. Sunset's warm pink and yellow light ignites the entire scene in a single moment before the end of day, a fleeting effect of the earth's daily rhythm of rotation. Meanwhile, beneath this pageant, the ebb and flow of the tides nurtures the abundant growth of the marsh hay and the resulting haystacks. The apparent calm of the scene belies the drama percolating under the surface of the water and the grasses, as well as the tremendous human activity involved in "marshin'," or harvesting the salt grass. Over fifteen thousand acres of salt marsh make up the Massachusetts "Great Marsh," which extends from Rockport to Salisbury. Marsh hay, consisting of varieties of *Spartina*, grows in the spring and summer, and was traditionally harvested in August when the tide was low. At least one scholar has suggested that a tiny group of figures and a wagon can be seen just to the left of center in the painting, perhaps a farmer out checking his haystacks.[8] According to a Salisbury resident, whose family had harvested hay for centuries, the whole process took approximately two and a half months.[9] The cut hay was left to dry on the marsh before it was brought in, massed on wooden stakes, or staddles, that lifted it above the level of the water at high tide. In MAG's painting, a few broken staddles appear in the foreground on the left. When the ground hardened with the coming of cold weather, teams of horses or oxen pulling wagons and sleds retrieved the hay from the marshes; alternatively, a boat called a gundalow—a flat-bottomed barge that had been in use for centuries—pulled the hay in.

If you look down on the marsh from a bird's-eye view, the ground is penetrated by snake-like salt-water estuaries, whose winding tendrils lead the viewer's gaze through the receding haystacks. Heade composed these elements with precision. The painting is almost exactly bisected horizontally by an implied line extending from the *cumulis lenticularis*, or French bread cloud, at the left to its counterpart on the right. It is bisected vertically by a distant haystack reached by following the path of the tidal river. The river and the clouds move the viewer's gaze from one side of the canvas to another; the river also establishes, with the haystacks, the relationship between the foreground and background of the scene. And, by following the recession of space in the canvas from largest to smallest haystacks, the eye is repeating the curving meanders of the water—the manmade forms falling in step with the naturally created ones, integrated so seamlessly with the natural landscape that it implies Heade's valuing of the balance between man and nature—a balance that today's stewards of the marshes are valiantly attempting to reclaim.

While Heade's marsh paintings present a variation of a nineteenth-century farming landscape, some critics, including John Wilmerding, believe that his choice reflected not simply his interest in light and space but also his concerns about the impending national crisis of the Civil War: "Essentially flat expanses, they exemplified the luminist vision of spacious beauty. At the same time, their dual nature and constant flux also spoke to an America in the 1860s and 1870s of increasingly uncertain change and transformation."[10] Whether or not this interpretation is convincing—and some critics do resist it—we should also remember that the second quarter of the nineteenth century was a fertile time in American culture and philosophy. Heade could hardly have avoided the lectures and writings of New Englanders Henry David Thoreau and Ralph Waldo Emerson, the transcendentalists who emphasized the relationship—in fact, the unity—of the natural and the sacred. In the 1850s, living and working in Boston, Heade may well have read their words or heard Emerson lecture; his paintings parallel some of Emerson's writings, and suggest that, like the Sage of Concord, his choice of subject may have had more to do with finding personal meaning in the natural world.

Over two centuries before Emerson, Thoreau, and others speculated about the relationship between the natural and metaphysical realms, the Great Marsh region was said to be controlled by the Pawtucket sachem Masconomo, dubbed by Governor John Winthrop "the Sagamore of Agawam."[11] By the 1630s, English colonists were creating permanent settlements and pushing the Native Americans out of the way, dividing the property into common land and individually owned parcels. Historically, the marshland was significant enough to be mentioned specifically in wills and inventories. For example, in 1666, nearly two hundred years before Heade "claimed" the marshes

in his paintings, Thomas Smith of Newbury left to his two sons, in addition to pastureland, "that parsell of land that is called the lower pasture and a four acre lot at plumb Iland of salt marsh & two acres of salt marsh land at plumb Iland River below pine Iland..."[12] Settlers and their descendents used the salt marsh hay in a multitude of life-sustaining ways, including feed and bedding for livestock, insulation, and roofing. From earliest times, the region's clean water supported fishing, shellfishing, and farming, although this was generally taken for granted, and as the settlement expanded, the significant human impact on this miraculously self-sufficient natural resource set in motion a downward spiral of deterioration. Over the centuries, for example, marsh pests like mosquitoes were treated with poisonous chemicals as well as wholesale drainage of water. As the population increased large numbers of acres of marsh were filled in for development. Sewage was dumped into the marsh, making life impossible for many species within

the region. Because of the delicate symbiotic relationship of the food chain, these alterations had broad-reaching effects that have only within the past several decades been addressed in meaningful ways through protective legislation. By the 1930s, the use of marsh hay for feed declined and, with changes in architectural technology, the hay was no longer used in construction. Currently, the hay is marketed as mulch.

In his book *Alongshore,* landscape historian John Stilgoe has observed that, with the deterioration of the marshes as well as the onset of photography, interest in them as a subject for the visual arts declined. What had been in Heade's time an activity that spoke of prosperity, productivity, and abundance, became, in a few decades, a problematical endeavor, possibly due to the adoption of poor land management practices.[13] In Stilgoe's estimation, not until the first quarter of the twentieth century, when wealthy individuals recognized the marshes' great potential for scenic views, did interest in the region grow. He quotes landscape architect Charles Downing Lay (1877–1956): "Nowhere...is there greater beauty of line than in their curving creeks and irregular pools."[14]

With increasing recognition of their aesthetic and ecological importance, Newbury marshes are now included in an area called Eight Towns and the Bay, which has been designated by the state of Massachusetts as an ACEC (Area of Critical Environmental Concern). Within this ecosystem, wildlife is remarkably diverse. Many types of fish and shellfish spend at least part of their life cycle in the salt marshes. Birds, including piping plovers and least terns, nest there during breeding and migration cycles, and the area is considered an Important Bird Area by international birding organizations. It is located along the Atlantic Flyway, a North American migratory route.[15]

Heade expressed early on the concerns of contemporary conservationists. Writing letters to *Forest and Stream* magazine with titles like "The Plume Bird Traffic," "Disappearing Ducks," and "Save the Woodcock," he indicated his sustained belief in man's responsibility for the natural world, a belief that began and was reinforced, perhaps, as he traversed the marshes.[16] Taking advantage of twenty-first-century transportation, we can easily to travel to Newbury and recreate his experience. The smells, sounds and sights are, in the main, the same ones that he knew almost 150 years ago. The captivating and thrilling views of earth, sea, and sky reveal more than words ever can why he revisited this subject over the course of his life. Its stark beauty as well as its peaceful isolation confirm to contemporary visitors that the marshes were an aesthetic as well as psychological touchstone for Heade.

Marjorie B. Searl is Chief Curator, Memorial Art Gallery.

17: David Gilmour Blythe *Trial Scene (Molly Maguires)* (ca. 1862-63)

Kerry Anne Morgan

*I*n a dark and shabby room a motley assortment of men have assembled. Although some of them smoke pipes, play cards, and whittle away at sticks, most watch and listen attentively to a loutish man who stands ranting before them, his mouth wide open and right arm upraised and fisted. Directly behind the standing man sits a shackled prisoner who is separated from the other men by a wood railing. Even though rifles rest in the hands of some of these oafish-looking spectators and revolvers and knives lie about, the real threat of punishment lurks in the shadows near the two card players in the form of a pail and sack, labeled "tar" and "feathers," respectively. The scene resembles a court in session, but the law being enforced is clearly not one of lawyers, judges, and jurors. Extra-legal violence will most likely result if the virulent speech succeeds in inflaming the passions of the mob. Who exactly are these ruffians and what particular message might this painting have imparted to a mid-nineteenth-century audience?

Although the painting's indeterminacy is a part of its appeal, the miscreants most likely represent members of the Molly Maguires, an allegedly secret Irish miners' society active in the anthracite or hard coal region of northeastern Pennsylvania in the 1860s and 1870s. The Molly Maguire reference accompanied the painting when the Memorial Art Gallery acquired the work in 1941 from the New York art gallery M. Knoedler & Company. The painting then bore the long, awkward title: "Trial Scene, possibly of a feud such as the 'Molly Maguires' affairs in Pennsylvania." Based on what is known about the painting's creator, David Gilmour Blythe, and the Molly Maguires, the accuracy of the first part of the title is open to debate. As Blythe scholar Bruce Chambers has noted, "It is not in all probability even a trial which is being conducted (although one of the criminals is still shackled), but a harangue by the Maguires' leader prior to a night of guerilla terror."[1]

David Gilmour Blythe,
1815–1865
Trial Scene (Molly Maguires)
(detail), ca. 1862–1863
Oil on canvas, 22¼ x 27 in.
Marion Stratton Gould Fund,
41.24

Blythe spent much of his peripatetic life in Pennsylvania before his death in 1865, and he was undoubtedly familiar with the mayhem that erupted between 1862 and 1864 when the "Mollies" were blamed for violent work stoppages and resisting the Civil War draft.[2] Indeed, the artist shared the same political ideology as the man who first employed the term "Molly Maguire" in the Schuylkill County newspaper, the *Miners' Journal,* in 1857. In reference to a political election scandal, the newspaper's owner and editor, Benjamin Bannan, claimed that the inspectors indicted for fraud "were Irishmen, belonging no doubt to the order of 'Molly Maguires,' a secret Roman Catholic association, which the Democracy is using for political purposes."[3] Both Blythe and Bannan had been Whigs and became staunch supporters of the Republican Party. As proponents of "free labor," they blamed Irish Catholics for supporting pro-slavery Democratic candidates. Their antipathy toward this particular new immigrant class was also based on a certain stereotype of the Irish character—poor, drunk, and lazy, and prone to criminality, insanity, idolatry, and political corruption. Neither artist nor newspaperman would have had sympathy for the Irish mine laborers whose illicit activities were seen as no less than treasonous during the Civil War.[4]

(Facing page)
David Gilmour Blythe,
1815–1865
Trial Scene (Molly Maguires)
ca. 1862–1863
Oil on canvas, 22¼ x 27 in.
Marion Stratton Gould Fund, 41.24

Blythe's decision to portray the Molly Maguires on canvas was unique for a mid-century artist, but not out of character for Blythe himself.[5] In the mid-1850s he stopped taking portrait commissions of respectable citizens and began painting those whom he thought were jeopardizing American democracy—ignorant immigrants, greedy politicians, and corrupt lawyers and judges. Even when other genre painters addressed some similar themes, such as the injustices that plagued the legal system, none of them

did so with such cynicism and sardonic wit.[6] Like the English eighteenth-century graphic artists William Hogarth, James Gillray, and Thomas Rowlandson whose political cartoons influenced him, Blythe employed techniques of exaggeration to satirize human depravity. Vicious caricature and parody play a vital role in Blythe's work, as paintings like *Trial Scene (Molly Maguires)* attest. Painted in a coarse, unfinished style, the Molly Maguires are heavy-jowled low-lifes who have adopted the machinations of judicial practice for extra-legal purposes. And if the democratic system can be mimicked so easily, who is to say the process provides any guarantee that right or justice will prevail?

In an effort to explain Blythe's cynicism, biographers have emphasized the Scottish Presbyterian upbringing that instilled in him a fierce appreciation of individual rights, freedoms, and responsibilities. Blythe's outlook dimmed over his lifetime as he saw these values continually compromised and as he weathered several personal misfortunes.[7] The self-taught artist was born to emigrant parents in East Liverpool, Ohio, in 1815, the fourth of six sons. He left home and moved to Pittsburgh at age sixteen to work as an apprentice to a well-respected woodcarver and cabinetmaker. Three years later Blythe completed his apprenticeship and soon after joined the navy. In 1840 he returned to his hometown and over the next decade and a half worked as an itinerant portraitist and woodcarver. The death of Blythe's young wife in 1850 after just two years of marriage led the artist to despair. Over the next two years he also endured his father's passing away and the failure of an ambitious moving panorama of the Allegheny Mountains that he had financed with two partners. In 1854 he again returned to East Liverpool where for two years he continued painting portraits and began to depict

David Gilmour Blythe,
1815–1865
Trial Scene (Molly Maguires)
(detail),
ca. 1862–1863
Oil on canvas, 22¼ x 27 in.
Marion Stratton Gould Fund,
41.24

genre subjects. By the time he made Pittsburgh his home base in 1856, Blythe was no longer interested in the commercial side of art making and turned all of his energies to humorous genre paintings. He refused to sell his paintings himself and instead left them with his dealer J. J. Gillespie, who hung them in his shop window. Many of the works that Blythe completed over the last nine years of his life were sold in this fashion.[8]

Blythe's disinterestedness in seeking public approval gave him the freedom to create wholly unique paintings like *Trial Scene (Molly Maguires)*. The fact that his work found local buyers who likely shared the artist's disillusionment with certain American institutions did not seem to influence him. When Blythe died of complications resulting from alcoholism at just fifty years of age, he no longer believed in the promise of democracy in America; it was too easily compromised and corrupted.

David Gilmour Blythe,
1815–1865
Trial Scene (Molly Maguires)
(detail),
ca. 1862–1863
Oil on canvas, 22¼ x 27 in.
Marion Stratton Gould Fund,
41.24

Kerry Anne Morgan is Galleries and Exhibition Coordinator, Augsburg College, Minneapolis.

18: James Henry Beard *The Night Before the Battle* (1865)

Susan Dodge-Peters Daiss

The annual exhibition of the National Academy of Design in 1865 opened in a new building days after the ending of the Civil War. Both events were celebrated in the May 13th review in *Harper's Weekly* as the dedication of "a temple of art…in the soft dawn of returning peace." The reviewer remarks on the paucity of "works inspired by the war, which is so profuse of romance, tragedy and comedy." One of the first works cited, however, is a war-based painting: James Henry Beard's *The Night Before the Battle*. It is "a solemn and striking picture," declares the critic. "The soldiers lie sleeping around the guns; one of the men has just been writing a letter home; the sentry paces along the parapet; the cold moonlight gleams upon a gun which Death, the skeleton, is sighting." The painting's chilling commentary, the critic concludes, "makes the spectator glad that peace is come."[1]

In the spring of 1865, the military details of *The Night Before the Battle* were all too familiar to artist and audience alike. Rendered with the accuracy of a field reporter and the daring of a social commentator, Beard's painting was hardly a triumphant celebration of the Northern victory. The "solemn and striking" figure of Death is perhaps the most authentic detail of all, draped in a pall, with his scythe handily placed behind him. Beard must have painted this during the last months of the war when Northern victory was finally, but only very recently, assured. The painting's evident power then and now comes from an understanding of the enormous cost of this conflict that Lincoln had mourned the previous summer as a "terrible war," which "carried mourning to almost every home, until it can be said that the 'heavens are hung in black.'"[2]

The Beard family was intimately acquainted with the war on many fronts. All the eligible men enlisted, including James Henry Beard, who was close to fifty when he joined the Union army, commissioned as a captain in General Lew Wallace's division.[3] James's youngest son Daniel, who was born in 1850 and saw the war from home, later recalled his father's wartime activities. "When General Lew Wallace was in command of the Union forces, stationed in and around Covington, he had a unique and remarkable staff, composed of poets, artists and literary men….All of the staff were wont to meet at our house, of which they made a sort of social headquarters."[4]

The Night Before the Battle is embedded with a wealth of details. Where had Beard observed fortifications made using gabions—woven baskets filled with dirt—and sandbags?[5] Where had he learned about the sighting of a cannon through the embrasure in a fortified wall, or the distinguishing profiles of different cannons?[6] And where did he see the cannon's iron carriage, with its distinctive triangular base, and massive bolts defining its side?[7] The most likely source of Beard's exposure to all of these faithfully rendered details may be the fortifications in and around the cities of Cincinnati, Covington, and Newport. Beard may well have been among the twenty-two thousand Union soldiers and fifty thousand militia who manned these forts on September 2–12, 1862, when the Confederate Army planned its attack and were deterred by the scope of the cities' defenses.[8]

To the audience in 1865, the soldiers in the painting would be immediately identified as belonging to the Union forces. Especially distinctive are the overcoats with outer capes, particularly visible on the soldier who is resting, propped against the side of the cannon carriage; the kepi caps worn by several men; and the artillery soldier's shell jacket with red piping and the three chevron insignia of a sergeant worn by the foreground soldier.[9] The bowler hats worn by two of the huddled soldiers closest to the fire were not, however, standard-issue caps, but rather civilian wear at the height of fashion. Had these soldiers lost their original headgear, replacing it with whatever was readily available? Or, were they perhaps newly come from civilian ranks, serving among the hundred-day recruits at the end of the war?[10]

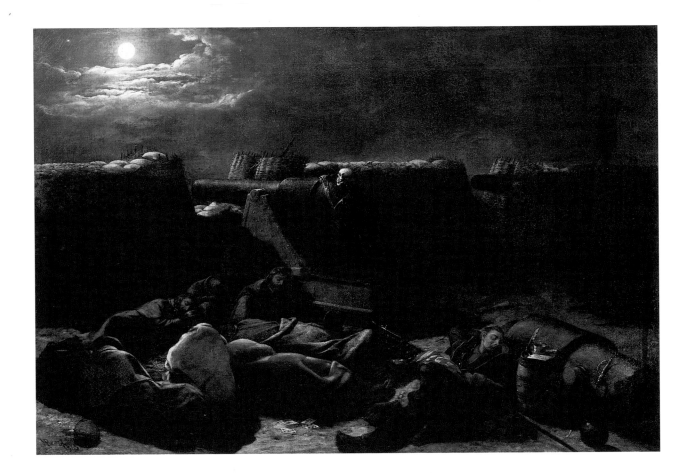

The flag of the United States of America is prominently draped over the body of the sleeping soldier in the foreground. From the opening battle of the war—the rebel attack on Fort Sumter—the flag became the galvanizing symbol of the Union. In 1880, George Henry Preble chronicled how the flag was ceremoniously displayed throughout the country as never before. "Cincinnati, after the fall of Sumter, was fairly iridescent with the red, white, and blue....The Queen City gave ample tokens that the mighty Northwest was fully aroused to the perils that threatened the republic, and was determined to defend it at all hazards."[11] Indeed, Beard was among those who decorated the city in bunting. In his autobiography, Daniel Beard recalls, "Shortly after

Sumter, Father came home and said, 'Caroline [Beard's wife], war has been declared. The President has called for seventy-five thousand men and I must answer the call.' Father forthwith raised a company of one hundred men at his own expense, and offered them to the President. It was then that he brought home the big flag. It covered the whole front of our house, a three-story building."[12]

By the flag-bearer's side on the powder-cask are the signs of a soldier's life: an inkwell, with feather quill, an envelope with the hint of a red stamp, an extinguished candle, a cup, and a small tan object that might be the remains of a twist of tobacco.[13] In the foreground, illuminated by the light of the moon, is an abandoned hand of cards. Whatever the game (which may be Four-Card Monte, one of the most popular card games during the war),[14] nineteenth-century viewers would have instantly recognized that the soldiers had been playing a game of chance—a powerful metaphor for the entire painting, evoked by the figure of the skeleton. Death in tomorrow's battle is certain; the only question is the identity of the victims. Are the eleven soldiers in the foreground doomed to die? Or could they be sleeping peacefully, safe in the care of Death, who has pointed the cannon toward the distant and invisible enemy? Or is the painting a memorial to all the war's dead? Whoever was to die in tomorrow's battle, by war's end, the grim reaper was the most fitting personification of the horrific carnage that many by then had likened to "a harvest of death."[15]

By the 1840s, Beard was exhibiting regularly in the annual exhibition of the National Academy. Beyond his portraits—including one of President William Henry Harrison and another of future President Zachary Taylor—the paintings that first gained Beard national recognition were his politically and socially charged genre scenes. *The Long Bill, North Carolina Emigrants: Poor White Folks,* and *Last of the Red Men* attracted critical attention to the artist as an astute observer of human nature and a controversial interpreter of contemporary issues. Unlike many of his contemporaries, Beard did not idealize or romanticize western expansion in his work.[16] His willing depiction of hard truths is revealed over a decade later when he painted *The Night Before the Battle.*

Yet even as Beard reflected the country's exhaustion, his painting may also reflect a sense of relief—even triumph—at the war's ending, as conveyed in a popular song in 1865: "The Night Before the Battle." The song begins with a description that might easily fit the painting:

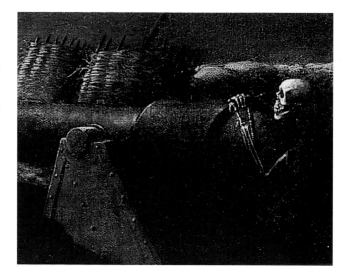

James Henry Beard,
1814–1893
The Night Before the Battle
(detail), 1865
Oil on canvas, 30½ x 44½ in.
Gift of Dr. Ronald M. Lawrence,
78.15

*'Twas night before the battle/
The moon was beaming bright,/
But death's red storm would rattle/
With morning's early light.*

And in the final verse it concludes:

He fought as fight the fearless,/'Twas often hand to hand,/And when the day was over,/His name rang through the land/And she who sat in silence,/Each breath in tremor drew;/But see, He comes the victor,/All hail! the tried and true./ But see, He comes a victor,/All hail! the tried and true.[17]

Illustration by Frank Beard for
Jesse Bowman Young's book,
*What a Boy Saw in the Army:
A Story of Sight-Seeing and
Adventure in the War for the
Union,* published by Hunt and
Eaton, New York, ca. 1894,
illustration no. 100

Perhaps these soldiers are not doomed to die in the morning, but coming home after all.

The first audience for *The Night Before the Battle,* for whom this song may have been quite fresh, was clearly impressed by the painting, which, reviewers exclaimed, was "[s]tartlingly wild, [and] original," "solemn and striking."[18] But its message in the end may be its ambiguity. It is at once a paean to victory and a biting commentary. In the face of overwhelming death that visited, as Lincoln said, nearly every home, victory was a welcome relief, but at what cost?

PEACE AND LIBERTY BORN FROM THE MOUTH OF THE CANNON.

Nearly three decades later, Frank Beard, James Beard's son who had served in the war as an artist correspondent,[19] illustrated a book intended for young readers by Jesse Bowman Young, *What a Boy Saw in the Army: A Story of Sight-Seeing and Adventure in the War for the Union* (1894). The final illustration celebrates "the good" that came of the war. Emerging from the cannon's smoke is a beautiful young woman—a nineteenth-century version of Botticelli's Venus or Primavera?—holding a dove in one hand and a laurel wreath in the other. In the background are idealized scenes of returning soldiers, lovers, and families reuniting. The drawing is titled *Peace and Liberty Born from the Mouth of the Cannon.*[20]

"In the soft dawn of returning peace," James Henry Beard first exhibited a painting that contemporary viewers singled out for praise and recognition. They saw its historic accuracy. They recognized its psychological truth. It would take the intervention of more than a generation, 1865–1894, to imagine that "peace and liberty [could be] born from the mouth of a cannon." *The Night Before the Battle* was painted without such illusions.

Susan Dodge-Peters Daiss is the McPherson Director of Education, Memorial Art Gallery.

19: Albert Bierstadt *The Sierras Near Lake Tahoe, California* (1865)

Diane P. Fischer

Featuring a pristine valley near Lake Tahoe backed by the resplendent Sierra Nevada Mountains, *The Sierras Near Lake Tahoe, California* is a classic example of Albert Bierstadt's landscapes of the mid-1860s.[1] By the time this work was created, Bierstadt was establishing himself as the foremost painter of the American West, most notably with his majestic *The Rocky Mountains* of 1863 (The Metropolitan Museum of Art).[2] Although others had depicted western scenery before him, the German-born Bierstadt, who was raised in New Bedford, Massachusetts, was the first artist with both the philosophical underpinnings of the American Hudson River School painters and impeccable European training.[3]

Like many Americans of his generation, Bierstadt had studied painting in the art center of Düsseldorf, Germany. During extensive sketching trips through the mountains of Germany, Switzerland, and Italy, the young artist mastered painting Alpine scenery in the manner of his European mentors. In the fall of 1857, after four years abroad, Bierstadt returned to New Bedford. Finding the eastern mountains of the United States uninspiring, the ambitious and adventurous artist looked westward to the relatively undocumented territory around the Rocky Mountains. In the spring of 1859, the artist-explorer embarked upon the most pivotal trip of his career. Bierstadt accompanied Frederick W. Lander's federally sponsored Survey to the Rockies, placing him on the cutting edge of western exploration. Bierstadt was delighted by the majesty of the Rocky Mountains, which he compared to the Bernese Alps.[4] Soon after returning east that September, Bierstadt moved to the fashionable Tenth Street Studio Building in New York. Applying the methods he had learned abroad, Bierstadt based his growing reputation upon his initial impressions of the West, which he rendered Edenic. He referred to sketches, photographs, and Native American artifacts amassed on the trip, which provided unique and exciting source material.

Bierstadt's *Sierras* is a prime example of a studio production for which the artist consulted on-the-spot sketches. While Bierstadt had made the preparatory sketches for the painting during his second trip to the West in 1863, the work itself was not completed until two years later in his New York studio. The 15 x 21-inch format of the painting places it somewhere between the pencil drawings Bierstadt made in pocket-sized notebooks he carried in the field and his "Great Pictures," which typically measured about ten feet in width. Some critics consider these smaller oils to be among his finest accomplishments.[5] The smaller format enabled him to retain the freshness of the *plein air* sketches, but also gave him room to add the embellishments that made his work so popular. In *The Sierras*, Bierstadt was able to blend the "facts" of his real-life experience with the "fiction" of his studio work.

Although some aspects of the painting deviate from the truth, the inspiration for it was rooted in reality. In May of 1863, Bierstadt, accompanied by the writer Fitz Hugh Ludlow, traveled to California via the Overland Stage, and then continued up the Pacific coast. *The Sierras Near Lake Tahoe, California* recalls a specific moment during the expedition, just after they had entered California along the south side of Lake Tahoe. Indeed, the mountains in the painting resemble the east side of the Sierra looking west, which coincides with their route.[6] Quite possibly, this painting was inspired by the scenery near Trout Creek of the Upper Truckee River in Lake Valley, just west of the pioneer town of Meyers.[7] As was his custom, Bierstadt used detail to enhance believability. For example, the foliage includes red Indian paintbrush, white grass of

Albert Bierstadt,
1830–1902
The Sierras Near Lake Tahoe,
California (detail), 1865
Oil on canvas, 14¹⁵⁄₁₆ x 21¹⁄₁₆ in.
Clara and Edwin Strasenburgh
Fund and Marion Stratton
Gould Fund, 92.78

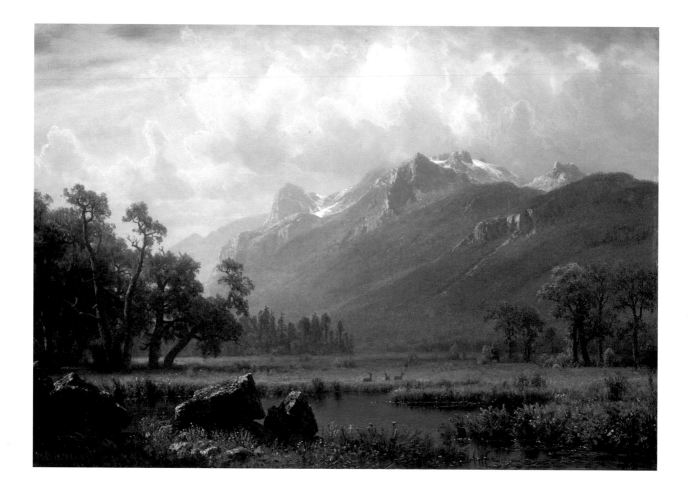

Parnassus or hyacinth, yellow monkey flower, goldenrod, and waterleaf at the edge of the stream—all indigenous to the area.[8] The cottonwood trees in the middle distance and the volcanic rock in the foreground are also characteristic of the region.

However, despite these particulars, *The Sierras* is not merely—or even really—a record of what Bierstadt and Ludlow witnessed, and can be interpreted on many levels. In one way, the painting is a celebration of survival. Recounting their experiences in the *Atlantic Monthly*, Ludlow described their trip in early July after leaving Salt Lake City as "the most frightful nightmare of my existence."[9] In inferior and often crowded coaches, they trudged "through the most horrible desert conceivable by the mind of man," witnessed death and other atrocities, and lived in abject fear of being ambushed by the Goshoot tribe until they reached Washoe [Carson City, Nevada].[10] Only their entry into California absolved them of this ghastly five hundred-mile trip through hell. According to Ludlow,

> By the mere act of crossing that ridge [the Sierra] and stepping over the California line, we came into glorious forests of ever-living green, a rainbow affluence of flowers, an air like a draught from windows left open in heaven....Here, virtually at the end of our overland journey, since our feet pressed the green borders of the Golden state, we sat down to rest, feeling that one short hour, one little league, had translated us out of the infernal world into heaven.[11]

Ludlow's language, equating the scene with heaven, was not offhand, but rather conveyed the tenor of the times.

Indeed, Ludlow's glowing remarks resound in Bierstadt's interpretation of their initial glimpse of California. Reflecting the style he had learned as a student in Düsseldorf, Bierstadt carefully orchestrated the color and composition in *The Sierras* to create a romantic, ideal conception of California as the new "Promised Land." He combined various scenes, exaggerated the mountains' cragginess, and rendered the clouds and lighting in an operatic manner. He also employed perspective to enhance the painting's symbolic meaning. With the horizon at eye-level, the viewer has the simulated experience of walking into the Promised Land of California alongside the explorers.[12] Thus, like many of Bierstadt's other works, this immaculate landscape represents a "primal vision," a landscape depicted as if it were seen for the first time by human eyes.[13]

Albert Bierstadt,
1830–1902
*The Sierras Near Lake Tahoe,
California* (detail), 1865
Oil on canvas, 14¹⁵/₁₆ x 21¹/₁₆ in.
Clara and Edwin Strasenburgh
Fund and Marion Stratton
Gould Fund, 92.78

By presenting the scene as a primal vision, Bierstadt ignores the presence of the Native Americans who had lived in the area for millennia, and who are not invited to share the paradisiacal experience. Bierstadt's attitude reflects the prevailing notion of Manifest Destiny, which maintained that certain people of European ancestry had the God-given right to inherit the North American continent.[14] Bierstadt thus depicted the scene in *The Sierras Near Lake Tahoe, California* in a way that reassured many European-Americans that westward expansion was justified.

(Facing page)
Albert Bierstadt,
1830–1902
*The Sierras Near Lake Tahoe,
California*, 1865
Oil on canvas, 14¹⁵/₁₆ x 21¹/₁₆ in.
Clara and Edwin Strasenburgh
Fund and Marion Stratton
Gould Fund, 92.78

Bierstadt's primal vision paintings also offered viewers a temporary escape from other problems, notably the Civil War then raging back east during Bierstadt's California trip of 1863 and still a factor when he completed *The Sierras* in New York two years later.[15] At this time, the ravaged land of the eastern United States could no longer symbolize America as the New

Albert Bierstadt,
1830–1902
*The Sierras Near Lake Tahoe,
California* (detail), 1865
Oil on canvas, 14¹⁵/₁₆ x 21¹/₁₆ in.
Clara and Edwin Strasenburgh
Fund and Marion Stratton
Gould Fund, 92.78

Eden.[16] However, California, which was not directly tainted by the war, represented not only a haven for escape, but also a source for the future. For a brief moment in history, Bierstadt was highly successful in perpetuating the myth of America as the new Promised Land.

In fact, before the West became truly known through photographs, Bierstadt was regarded as a reporter.[17] Then, with the completion of the transcontinental railroad in 1869, tourists and photographers had relatively easy access to what had recently been a remote region. Increasingly, Bierstadt's painted travelogues were no longer believable. This major development in transportation also coincided with a shift of taste in American art. While a number of American artists were converting to the more relaxed, intimate, and naturalistic approach of modern French painting during the 1870s, Bierstadt clung to the romantic notion of using art to transcend reality.[18] With these transformations, the once-revered artist was deemed old-fashioned, and eventually suffered financial ruin.[19]

It was not until the 1960s, corresponding with the rise in appreciation for American art, that Bierstadt's reputation began to revive.[20] Today, scholars regard Bierstadt as one of the major American artists of the nineteenth century, and his work is widely admired by museum visitors. Although the symbolic content in paintings such as *The Sierras* is inherent in the work itself, its meaning has, in effect, shifted through time. Present audiences are no longer preoccupied with geological or archaeological correctness, or with political issues such as westward expansion, Manifest Destiny, or the Civil War. And, although society now abhors our nation's prior treatment of Native Americans, today's viewers can appreciate *The Sierras Near Lake Tahoe, California* and Bierstadt's other paintings for their technical brilliance, for their evocation of a pristine wilderness now known to be fragile, as well as for their ability to transport us into a magical realm, similar to our own, but without imperfections.

Diane P. Fischer, an art historian, was Associate Curator, Montclair Art Museum, 1997-2002.

20: Mortimer Smith *Home Late* (1866)

Kerry Schauber

The little family shown in Mortimer Smith's 1866 painting *Home Late* does not at first invite a comfortable reading. The artist depicts a frozen moment when a young boy returns home on a snowy night; the father, lighting his pipe with an ember from the fireplace, has not yet noticed his son's appearance. Will the boy receive a scolding for staying out to play, or will he be warmly received? The child himself is unreadable, his face hidden by shadow; even the family pets don't react to his arrival. Still, the interior of the cabin, with its homey touches, is made to appear inviting, especially compared to the ice-blue of the snow outside. The father seems to have earned his fireside respite; his rifle hangs from the ceiling along with slabs of meat, indicating his skill at providing for his family. Other details of the interior seem to carry hidden messages—the painted china pitcher on the table indicative of a striving toward a more polished way of life, the sewing basket on a chair conjuring the absent mother.

Mortimer Smith was born in Jamestown, New York, but as an adolescent moved with his family to Oberlin, Ohio, then to Sandusky, and ultimately to Detroit. Smith's father, Sheldon, was an architect and art teacher, and the only certain source of his son's art training. By the time Smith and his family reached Detroit, in 1855, the city was booming: just a few years previously, the railroad had connected the city to Chicago, and barges had passed on the Erie Canal for some years already.

Mortimer Smith,
1840–1896
Home Late, 1866
Oil on canvas, 40 x 46 in.
Marion Stratton Gould Fund,
75.139

Mortimer Smith,
1840–1896
Home Late (detail), 1866
Oil on canvas, 40 x 46 in.
Marion Stratton Gould Fund,
75.139

Metal and chemical manufacturing provided the goods to be shipped. In addition, Detroit was a gateway for settlers making their way from the east coast, and many of them stayed instead of moving on toward the unclaimed western territories. The size of the city, in both area and population, doubled between 1850 and 1860, making the city attractive to an up-and-coming architect such as the elder Smith.[1]

Although Mortimer Smith's "home scenes" were sufficiently well known to merit a mention in his obituary, *Home Late* is the only one known today.[2] A large work by Smith with a similar subject, a five-by-eight-foot canvas called *Frontier Home* (location now unknown), was exhibited at the 1867 Michigan State Fair, and proved so popular that it was exhibited again at the next year's fair and raffled off to a fairgoer.[3] From this detail, it is evident that Smith's cabin scenes reached a large and receptive audience. Michigan was still a young state, incorporated into the Union in 1837, but immigration—both from inside the country and from Europe—was already booming. The lifestyle depicted in the genre paintings would have been left behind by thousands of city residents, or their parents, in search of work or the other opportunities offered by urban living. In this era, when settlers were still moving west, views of frontier living varied. It could be seen as an independent and authentic way of life, liberated from the social strictures of the city, or as a backward and outmoded lifestyle, soon to be superseded by civilization. Those living on the frontier were often viewed in the same broad terms, as either heroic, resourceful pioneers, or as rough, uneducated farmers, and genre paintings of this time often depicted those extremes. While Smith offers a domestic scene instead of a loaded social commentary, he makes it clear that the figures seen here are not soft Easterners who have just staked their claim. The cabin is fully stocked and furnished, laden with meat and herbs, and warm with the glow of a fire. The frontier life was not so far removed from contemporary viewers, who might have looked at such a scene with a fond nostalgia rather than distaste for its rural hardships. Smith avoids commentary on the recent Civil War, lending the scene of a family in a moment of leisure a sentimental tint.

Smith's contemporaries also depicted rustic interiors. For instance, Eastman Johnson's *The Pension Agent* (1867, California Palace of the Legion of Honor, San Francisco) and *The Boyhood of Lincoln* (1868, University of Michigan Museum of Art), as well as work by earlier American artists such as Richard Caton Woodville and William Sidney Mount, placed rural figures in stage-like interior scenes. But it seems likely that Smith's location informed his work in another way: his father—Smith's only teacher— had opened Smith's School of Design during the family's brief tenure in Sandusky. The school had shared a building with the Cosmopolitan Art Association,

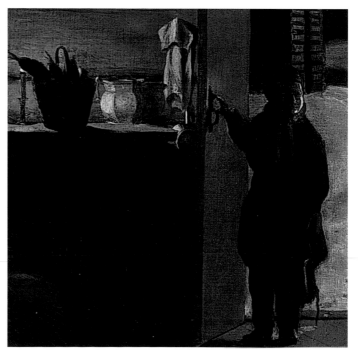

Mortimer Smith,
1840–1896
Home Late (detail), 1866
Oil on canvas, 40 x 46 in.
Marion Stratton Gould Fund,
75.139

which had an exhibition space and also organized traveling exhibitions. The Cosmopolitan was a proponent of the Düsseldorf school of painting, with its thin layers, brown tonality, and emphasis on observed details. The Düsseldorf Gallery had been opened in New York in 1849, to support and disseminate the style and its artists.[4] It seems likely that Smith would have been exposed to works from the German school as a teenager, while attending his father's school, as well as later, in Detroit, which had a large German population at the time of the family's arrival. The popularity of the style, which included an emphasis on genre painting, may have added to the acclaim awarded his early work in the Detroit newspapers.

In addition to any debt owed to the Düsseldorf school, Smith cleverly makes use of a convention from seventeenth-century Dutch genre painting in which an interior is shown with an open door at the back wall, so that the view through the doorway effectively expands the scene into the space beyond. As in *Home Late*, Dutch interiors not infrequently included a figure, often a child, peering or stepping through the open door (for a famous example, see *The Bedroom*, by Pieter de Hooch, 1658/1660).

Pieter de Hooch, Dutch, 1629–1684
The Bedroom, 1658/1660
Oil on canvas, 20 x 23½ in.
Widener Collection, ©2006, Board of Trustees, National Gallery of Art, Washington, D.C.

By 1861 Smith had followed his father into an architectural career; his training in draftsmanship is evident in *Home Late* in the ruled geometrical rhythm of the beams in the ceiling. Smith considered giving up architecture entirely to pursue a career in painting, but never did so.[5] The early interiors—MAG's is his earliest known work—gave way to snowy landscapes, an interest hinted at by the view through the cabin door here. By 1893, his moment seems to have passed; a critic describes Smith's current work with the dismissive phrase "two oil paintings of the old realistic school."[6] Smith's will mentioned forty-eight paintings; others can be added from mentions in contemporary reviews. Today less than a dozen are known.

"His pencil made him a livelihood, his brush made his life beautiful," noted Smith's obituary, describing the dovetailing of the artist's professions. "He delighted in home scenes, but his most admired paintings represent winter scenes."[7] It may be that Smith moved to such landscapes when the popularity of his paintings of the rural home had passed, along with the nostalgia of a culture at a crossroads.

Kerry Schauber is Curatorial Assistant in the Department of Paintings, Sculpture and Decorative Arts, Harvard University Art Museums.

21: Thomas Ridgeway Gould *The West Wind* (1876)

Cynthia L. Culbert

Careless and American in aspect, her pulse-beats throbbing through a belt of Western stars, the glad incarnation seems to have just cooled in the Pacific the light foot she sets on the shore of an untamed continent.[1]

So described in an 1876 review, Thomas Ridgeway Gould's *The West Wind* was the embodiment of westward expansion. The original sculpture, made in 1870, was so popular that Gould made at least seven more marble copies in two sizes, the last in 1876. The sculpture in the Memorial Art Gallery's collection, as well as personifying the American ideal of eminent domain and westward drive, also made quite a westerly journey herself. Tied to Rochester and the Memorial Art Gallery even through her creator, she took several trips and many decades to arrive at her final destination.

All the versions of *The West Wind* were carved in Florence, Italy, where Gould had resided since 1868. He had spent most of his life in Boston, working as a dry goods merchant and studying art in his spare time. After the Civil War, his business failing, he decided to try his hand at sculpture. As many sculptors before him had done, he made his way to Italy, where the old masters, the marble, and the carvers were abundant.

The West Wind's first connection to the Memorial Art Gallery was through Gould's family. He was the uncle of Marion Stratton Gould, who had died at the age of twelve and whose mother, Mrs. Samuel Gould of Rochester, created an endowment in her memory. The Marion Stratton Gould Fund is still used to this day to acquire some of the Gallery's most important works. Mrs. Gould also bequeathed her brother-in-law's marble relief *The Ghost in Hamlet* to the Gallery.

But parts of *The West Wind's* itinerary between Florence and Rochester are clouded. In 1871, the first documented *West Wind*, the original work, came to America. It was owned by Demas Barnes,[2] and according to the catalogue of the exhibition was the one that appeared in the prestigious Philadelphia Centennial Exposition of 1876, a six-month celebration of the country's founding.[3] (For this exhibition Gould had submitted, from Italy, applications for space for four sculptures: *The West Wind, The Water Babies, The Rose,* and *The Lily.*[4]) But the situation becomes confusing because another source lists the version of *The West Wind* on view at the exhibition as having been lent by "its owner, Mr. Powers, of Rochester, N.Y."[5] Unfortunately, the Centennial catalogue was known for its mistakes and inconsistencies,[6] so the question remains: which of the two versions of *The West Wind* appeared at the 1876 Exposition? Clearly, parts of the story of her journey from Florence to MAG have yet to emerge, but a good, if circumstantial, case can be made that, the catalogue aside, it was the Powers version that appeared in the Philadelphia exhibition.[7]

(Facing page)
Thomas Ridgeway Gould,
1818–1881
The West Wind, 1876
Marble, 70½ x 23 x 33¼ in.
Gift of the Isaac Gordon Estate
through the Lincoln
Rochester Trust Company,
66.18

What we do know is that "Mr. Powers"—Daniel W. Powers, a prosperous Rochester banker—bought several sculptures from the Exposition,[8] and that he had also gone art-buying in Italy in 1875. It is possible that he met Gould in Florence and placed his order for *The West Wind* there rather than risk losing it to another buyer in Philadelphia, and taking advantage of the free shipping offered by the Exposition for works by American artists living abroad.[9]

Unknown photographer
Marion Stratton Gould
(1877–1890)
Hand-colored photograph
on opaque glass, ca. 1885–90
23¼ x 19¼ in
Bequest of Mrs. Samuel Gould,
35.47

When the Centennial Exposition closed on November 10, 1876, Powers's *West Wind* would have traveled northwest to Rochester, New York, to take her place in the Statue Room in the elegant new Powers Gallery. A private art gallery in the famous fire-proof Powers Building erected in 1870, it was open to the public for twenty-five cents, seven days a week and two evenings.[10] Powers began collecting art on the previously mentioned trip to Italy in 1875. He claims to have purchased one painting and then, being so put out by the red tape he had to go through to have it shipped to Rochester, decided it would be no more trouble to send a whole case of pictures, and so bought more.[11] He commissioned many copies of old master paintings—a very popular practice at the time—but as he grew more interested in art and more skilled at identifying good pictures, he began to purchase contemporary art both abroad and in America, including work by Rochester

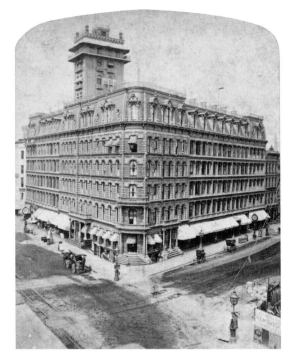

Powers Building, ca. 1878
Albumen print
Courtesy George
Eastman House
Photograph by George
H. Monroe, 1851–1916

artists Emma Lampert Cooper and Charles Gruppe.[12] His gallery grew from one room, to four, to twenty-two,[13] until it eventually occupied three floors.

Thomas Ridgeway Gould
1818-1881
The West Wind, 1870
Marble, 71 x 26 x 35 in.
Collection of the St. Louis
Mercantile Library at the
University of Missouri–St. Louis
Gift of Mrs. Demas Barnes

The Powers Gallery was known throughout the country and successfully aroused community interest in the arts.[14] Many thought it put Rochester "on the map" in the eyes of the rest of the world. But several unfortunate incidents occurred towards the end of Powers's life and after his death that stripped this valuable resource from the community. Powers, a self-made man who had gone from rags to riches in Rochester, had originally intended to leave his entire collection to the city. But when his request was denied for tax relief on the forty-thousand dollars a year it cost to maintain the gallery[15] (the city even tried to levy a tax on the gallery as a "place of amusement"[16]) Powers changed his will, leaving his entire $1.1 million to his wife and five children and nothing for Rochester or for the maintenance of the gallery.[17] The family tried to come up with some way to save the gallery, for the public outcry was fierce. Even the Rochester Art Club formed a committee dedicated to saving the gallery, with George L. Herdle, the future first director of the Memorial Art Gallery, among its members.[18] In January 1898, about a year after Powers's death, the first auction of the best works from the Powers Art Gallery was held in New York City. *The West Wind* did not make it to the sale.

Some of the very largest paintings and sculptures were left behind, though they were moved from the former art gallery to other parts of the building in

Thomas Ridgeway Gould
1818-1881
The West Wind, 1876
near telephone booth in
Powers Building, Rochester
Memorial Art Gallery
curatorial files

the spring of 1898 to make room for office space.[19] It is not known where *The West Wind* was moved to at that time, though, due to her size and weight, it is doubtful that she was moved very often.

In 1952, Memorial Art Gallery curator Isabel Herdle was putting together a show celebrating the seventy-fifth birthday of the Rochester Art Club. According to Gallery lore, she went looking for *The West Wind* at the Powers Building, along with several other large items that were known never to have left the building. Herdle found everything she was searching for except *The West Wind*. She showed photographs to the owners of the building and various tenants, but no one had seen the life-sized sculpture. Where could such a large piece of marble hide? Herdle persisted, and finally, around 1965, she showed the pictures to a woman mopping the floors who knew exactly where *The West Wind* was hiding.

Thomas Ridgeway Gould,
1818–1881
The Ghost in Hamlet, ca. 1877
Carved marble, 20½ x 24½ in.
Bequest of Mrs. Samuel Gould,
30.67

On the second floor, next to the staircase, by the phone booth, Ms. Herdle met the object of her long quest.[20] She convinced the owners of the building to donate the sculpture to the Memorial Art Gallery so that it could be cared for and again be made available to the citizenry of Rochester as Powers had intended. It was in desperate need of some attention, but after a good cleaning it looked much as it had when it graced the Statue Room on the sixth floor of the Powers Gallery.

And so, after about a ninety-year journey, from a foreign country, across an ocean, with a possible stop at a grand celebration for the young country, a stint in an impressive private gallery, and then decades of neglect and disregard, *The West Wind* arrived at the place where her maker's sister-in law had ensured she would be in good and suitable company.

Cynthia L. Culbert is Assistant Curator, Memorial Art Gallery.

22: Daniel Chester French *Bust of Ralph Waldo Emerson* (1879)

Susan Dodge-Peters Daiss

Ralph Waldo Emerson was in his seventy-seventh year when Daniel Chester French, aged twenty-nine, modeled the original clay head from which subsequent editions in plaster, marble, and bronze were made. A photograph taken of Emerson in 1879, the year that French began work on his portrait of the writer-philosopher, reveals how much the young artist had to draw on images of the elderly writer's past in the creation of his sculpture. Emerson is photographed seated at his writing desk, an open book in his hands. His head is lowered and his shoulders and posture are slumped—more an affectionate study of an elderly gentleman, dozing as he reads, than of the great man of American letters. By 1879, Emerson had all but retired from public life. His memory had started to fail and he suffered from aphasia—a humiliating and debilitating condition for one of the country's most revered orators as well as writers.[1] The public, however, did not see the aging Emerson, as his biographer Robert D. Richardson, Jr., explains: "Emerson's reputation was so great that it had a life of its own. Eventually his fame effectively concealed him, especially from his admirers."[2]

In 1879, when French proposed to Emerson that he sculpt his portrait, the request was not as forward as it might first appear. French's family had moved to Concord, Massachusetts, from New Hampshire when French was a young man and the Emerson and French families were friends. Dan—as he was familiarly called—first met with Emerson in 1869, a meeting he recalled as both cordial and daunting. "I talked with the mighty Emerson half an hour, and felt all the time like a mouse under the paw of a cat, or rather I felt exceedingly weak. He showed true politeness in talking on subjects with which I am acquainted and was as pleasant as possible; but for all that I knew he was weighing me in his mind."[3] French's skills as an artist had already been recognized and would be further encouraged by May Alcott, a member of another of Concord's leading families. His career was publicly launched in 1873 when he was awarded the commission for *The Minute Man*, a work to commemorate the centennial of the opening battle of the American War of Independence. Emerson was among the citizens who supported the selection of French for this commission, which was unveiled in 1875.

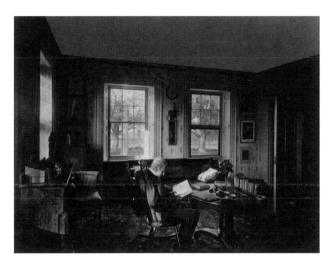

French divided the 1870s between America and Europe. After returning from Italy in 1876, he ultimately settled in Concord in 1878. His proposal to Emerson was made early in 1879, and work on the bust began in March. "I am modeling the philosopher at his own house," French wrote sculptor Thomas Ball. "I begin it with many misgivings knowing how difficult is the task & how often it has been tried before. I have an advantage over others of having known him long & well, & if I fail it will have done no harm to try."[4]

(Facing page)

Daniel Chester French,

1850–1931

Bust of Ralph Waldo Emerson, 1879

Cast after 1898

Bronze, 22 in.

Gift of the family of Alan

Underberg, in his memory, 99.2

The chronicles of Emerson's life include a range of responses to French's 1879 sculpted head—some contemporary, others retrospective. The artist seemed pleased by the response: "...my bust of Mr. Emerson is pronounced a success by those who have seen it," French wrote to his brother at the end of April.[5] Mrs. Emerson was among those satisfied. In response to receiving a plaster mold of the original clay, Emerson's daughter Ellen wrote, "We have had...a ceremonious unveiling and mounted it on a

pedestal, and there she [Mrs. Emerson] says the likeness is perfect."[6] Emerson's biographer James Elliot Cabot called the bust "the best likeness of him, I think, by any artist (except the sun)."[7] Emerson, though, wasn't certain that he appreciated the resemblance French captured, as Cabot recalls: "When the bust was approaching completion he looked at it after one of the sittings and said, 'The trouble is, the more it resembles me, the worse it looks.'"[8] Emerson's often-cited quip on seeing the completed head, "Yes, that is the face I shave," has no basis in contemporary documentation, and appears to have been "authorized" years later as the poet's "historic observation."[9]

Embedded within the first-person descriptions of the creation of Emerson's portrait is the acknowledgment and poignant regret, as Cabot wrote, that it was created "unhappily so late in his life."[10] French, writing to Cabot, explained:

> At the time I made it, as you know, Mr. Emerson had failed somewhat, and it was only now and then that I could see, even for an instant, the expression I sought. As is not uncommon, there was more movement in one side of Mr. Emerson's face than in the other (the left side), and there was a great difference in the formation of the two sides; more probably, at the time I made the bust than earlier.[11]

The Emerson French observed before him was not the Emerson he sought to represent. Capturing the likeness and essence of the figure French knew as a younger man—the Emerson the country revered—was his intent.

Emerson was a venerable figure in nineteenth-century American culture: his public life and the advent of commercial photography coincided almost perfectly, so that by mid-century his face and his writing were equally familiar. In his journal in 1841, Emerson exclaimed,

> Were you ever Daguerreotyped, O immortal man? And did you look with all vigor at the lens of the camera...& in your resolution to keep your face still, did you feel every muscle becoming every moment more rigid: ...and when at last you are relieved of your dismal duties, did you find the curtain drawn perfectly, and the coat perfectly, & the hands true, clenched for combat, and the shape of the face & head? but unhappily the total expression escaped from the face and you held the portrait of a mask instead of a man.[12]

His face and figure would be frequently recorded by this new medium over the next three decades. One photograph, among the earliest known, is reproduced as the frontispiece for the first volume of Cabot's *The Works of Ralph Waldo Emerson*.[13] "The portrait," Cabot writes in the preface, "was etched by Mr. Schoff from a photographic copy (kindly furnished by Mr. Alexander Ireland, of Manchester, England) of a daguerreotype taken in 1847 or 1848, probably in England."[14] By the 1860s, thanks to rapid changes in photographic technology, spurred by enormous popular interest, photographic images of the era's leading citizens—Emerson among them—were readily available and avidly collected.[15] In sculpting his portrait, French admits to drawing upon his own memory of Emerson. Did he also, perhaps, consult photographs that would have been accessible from the family as well as in the public domain?

The motivation behind French's request to sculpt Emerson's bust was frankly commercial. The head of Emerson as he appeared before the artist wasn't the Emerson the public would clamor to acquire. French copyrighted his portrait bust in August 1879. From his original clay model he ordered a mold, from which "an unnumbered series of plaster replicas" could be reproduced.[16] In

addition to preparing to sell plaster casts, French also began immediate conversations with carvers to issue an edition in marble, one of which was presented to Harvard University in 1883, the year after Emerson's death, another the following year to the town of Concord.[17]

The bronze edition of French's *Emerson* was undertaken as a means to provide French with a "modest income." Art historian Michael Richman tracks the first mention of casting *Emerson* in bronze in 1884 and the first production two years later.[18] Richman notes the similarities and distinctions between French's bust of Emerson in different media:

> The essential image of the Concord philosopher—the pronounced tilt of the head, the intense stare of the eyes, and the treatment of the sideburns and hair—was not altered in the new medium. The secondary elements, however, were radically changed. The chest was greatly reduced in size, the thick rim was replaced by a thin band, and the base and shaft were reworked.[19]

Other differences include two distinctive bases, "one freely worked, the other mechanically symmetrical."[20] Richman has also determined that the "Emerson sequence, produced over forty years, was not intended as a large edition....When a request was received, either an available bronze was sold and then replaced, or an order was sent to a foundry (French always used the lowest bidder)."[21] The Memorial Art Gallery's *Emerson* is mounted on the "mechanically symmetrical" base, which is inscribed "EMERSON" on the front and marked on the back, "CIRE PERDUE CAST. ROMAN BRONZE WORKS N.Y." Each casting is also signed in a different place, sometimes "on the shaft, or the foundry markings."[22] French signed the Gallery's version "D.C. French" on the back.

On several occasions, French recorded his personal reflections on sculpting Emerson's portrait. For all that the artist was aware from the outset that this work would reap him financial rewards, there resonates still in his language a sense of the privilege that it represented. "We all had the common experience of disappointment in meeting some celebrity....But Emerson seemed as great as he really was...."[23] Though French continued to rework this portrait, he consistently also included the date of the initial modeling—1879—in subsequent forms. The encounter with the great man himself is recorded in that date, as is the artist's struggle to honor the greatness that by then was visibly fading.

Susan Dodge-Peters Daiss is the McPherson Director of Education, Memorial Art Gallery.

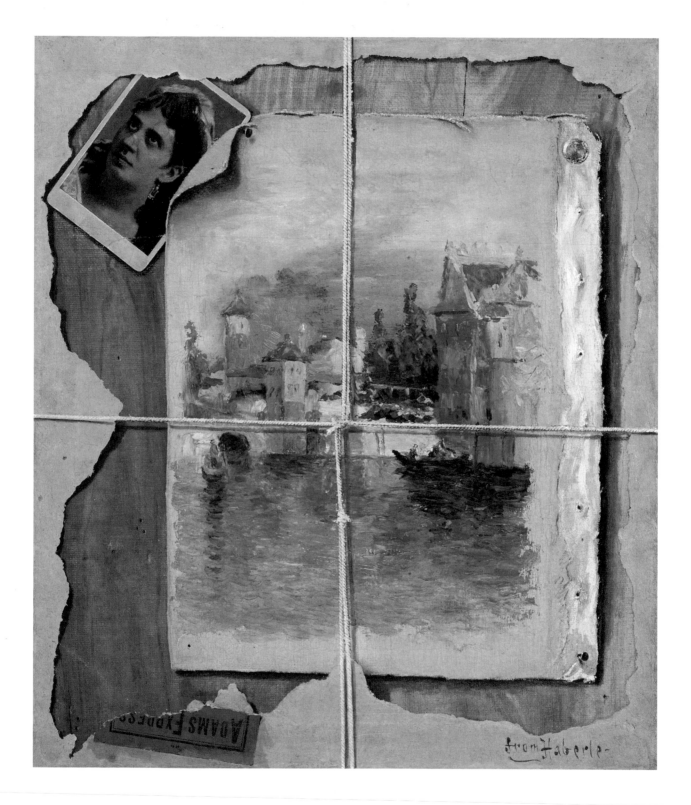

23: John Haberle *Torn in Transit* (1888-89)
John Frederick Peto *Articles Hung on a Door* (after 1890)

Marjorie B. Searl

We humans have long enjoyed being astonished by the experience of illusion, by being "taken in" by the appearance of a reality that isn't real. The most sophisticated connoisseur intent on brushing the lifelike fly or ant off the surface of a painting has gasped, at first with disbelief and then with delight, upon realizing that the creature is composed of strokes of paint. Legends about the virtuosity of artists like the ancient Greek painters Parrhasios and Zeuxis, who rivaled each other's ability to deceive, have been handed down through the generations.[1]

The "true modern Parrhasios," late nineteenth-century painter William Harnett, set the standard for his nineteenth-century American peers for hyperillusionistic painting, a style often referred to after 1800 as "trompe l'oeil," French for "fool the eye."[2] Harnett studied in Philadelphia and then traveled to Europe in the early 1880s, where he could see a variety of painting styles and subjects. Later in the decade, his celebrated work *After the Hunt*, most likely painted in Germany, hung in Theodore Stewart's Warren Street Saloon in Lower Manhattan, attracting visitors who came as much to see the painting as to drink. Much of the entertainment was generated by out-of-towners duped into placing a wager on whether or not the objects in the painting were real.[3] While interest in this type of mimetic work declined as the influence of abstraction increased, in 1940, an exhibition called Nature-Vivre at Edith Halpert's Downtown Gallery, encouraged its reexamination by *San Francisco Chronicle* art critic Alfred Frankenstein with unexpected results.[4] Frankenstein became interested in Harnett's work and decided to track it down; in the process, he revived the reputations of several of Harnett's contemporaries. While works by Harnett are not represented in the Memorial Art Gallery's collection, at least four MAG painters were indebted to him for their inspiration, and it's nearly impossible to consider them without understanding his impact on American art history.

While American artists worked in the still-life tradition and included still-life details as early as John Singleton Copley's pre-Revolutionary portraits, trompe l'oeil painting, a subset of still life, did not appear to flourish until the 1850s. Often, the work is composed in such a way that the canvas or panel itself appears to be the backdrop for one or more objects, and the eye, rather than being drawn toward the back of the painting, is only permitted to scan the details on the surface. Richard LaBarre Goodwin, for example, followed the tradition of Arthur Fitzwilliam Tait's 1850s game paintings with *A Brace of Ducks* (1885).[5] Goodwin's ducks hang heavily on a nail against a plain background where the cast shadows cause the objects to appear to project into the viewer's space. After 1885, presumably influenced by Harnett and paintings like *After the Hunt*, Goodwin's work became more complex.

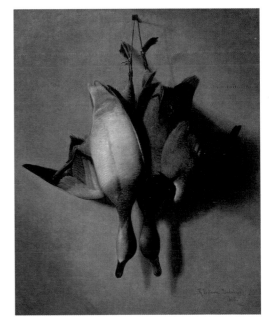

Richard LaBarre Goodwin, 1840–1910

A Brace of Ducks, 1885

Oil on canvas, 30 x 25 in.

Marion Stratton Gould Fund, 64.39

(Facing page)
John Haberle,
1856–1933

Torn in Transit, 1888–89

Oil on canvas, 14 x 12⅛ in.

Marion Stratton Gould Fund,
65.6

Goodwin was but one of Frankenstein's "finds" on the trail of Harnett.[6] Another was John Haberle, an inventive trickster who understood that part of the success of a trompe l'oeil painting depended on its ability to activate the impulse to touch it. MAG's *Torn in Transit*, one of three similar works by Haberle, is so tempting that curators keep a Plexiglas lid between the painting and the public.[7] At first glance, we are not seeing a painting at all, but a package whose wrapper has been torn open to expose the contents, a

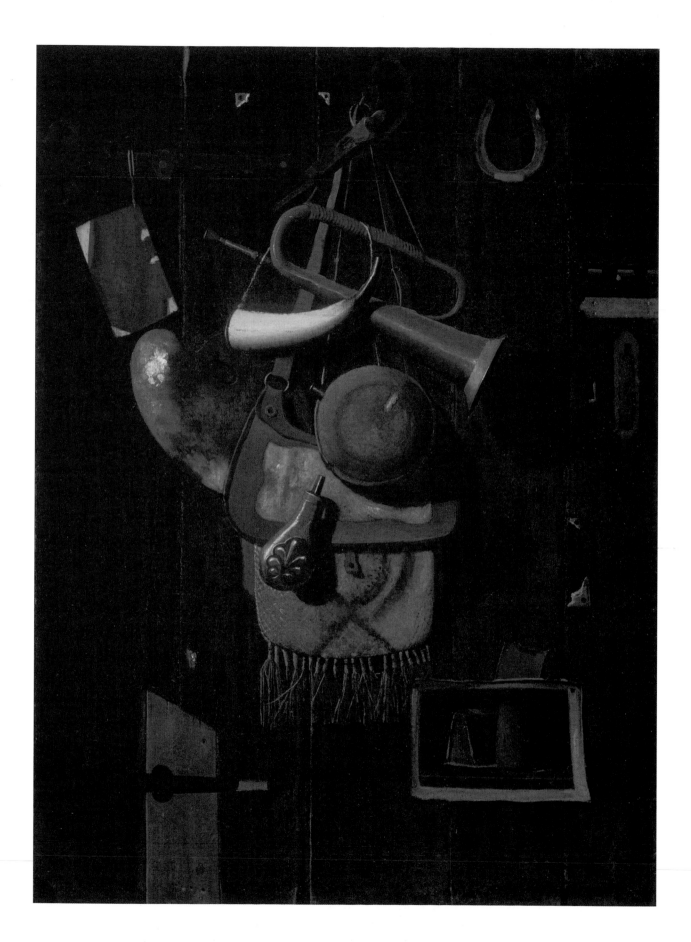

cracked board onto which a dreamy European canal scene is tacked, with a carte-de-visite of an oddly masculine-looking woman tucked in behind the painting of the painting.[8] The wrapping extends the illusion by being painted around all sides of the stretched canvas, as if it really were a package. Haberle signs his name "From Haberle," as if he were the sender. And, to make matters more questionable, the carte-de-visite has the appropriate thickness, and the string that is "tied" around the package invites the viewer to pluck it to determine whether it is real or not—hence the Plexiglas cover.

Most significantly, Frankenstein was able to identify John Frederick Peto through his census of Harnett paintings. Peto was a great admirer of Harnett, and for many years, his work was considered to be Harnett's, with forged signatures and all. Frankenstein was led to Peto's daughter's home, originally Peto's studio, as part of his sleuthing to learn more about Harnett, and found there a body of work that surprised and excited him.[9] Because Peto had been trained as a painter his work was indeed "softer," more painterly than that of Harnett and Haberle, who were originally engravers. Frankenstein now realized that the paintings he had categorized as using Harnett's "soft" technique, most of which were unsigned and undated, were actually by John Peto.[10] Her father, Helen Peto Smiley told Frankenstein, had "spoken of [Harnett] constantly–Harnett had, in fact, been Peto's ideal of perfection in still life painting." She went on to say that the two "had known each other as young men in Philadelphia but had lost contact after [Peto] had come to Island Heights in the 1880's."[11] Both had attended the Pennsylvania Academy of the Fine Arts in Philadelphia, and had exhibited in the same venues, but Harnett's work alone was acclaimed. After he moved to Island Heights, New Jersey, in 1889, Peto was largely forgotten in the larger world, but his admiration for Harnett clearly did not abate.

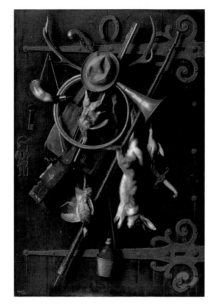

Of the four paintings considered in this essay, *Articles Hung on a Door* is the one that may be the least comprehensible to the contemporary viewer, separated by over a century from the objects depicted by Peto. It is one of a number of similar paintings by Peto done after 1889, when he moved to Island Heights. Founded by the Island Heights Camp Meeting Association, the community was a site for religious revivals, like other established gatherings organized with spiritual intent, including Oak Bluffs in Martha's Vineyard and Chautauqua Institution in Chautauqua, New York. Peto originally went to Island Heights after his marriage to earn income by playing the cornet, and subsequently became a song leader there. He had a photography studio, but continued painting, and was known to have bartered his canvases and art instruction for daily needs.[12] Both he and his buyers grew up in houses filled with the objects that he depicted hanging from realistic painted nails on weatherbeaten doors or tucked behind painted straps on a painted board. Twenty or thirty years after the Civil War, these were memorabilia that might have been found on attic shelves or in grandparents' trunks. When Frankenstein visited Helen Peto Smiley at her father's former studio, many of the objects in the paintings were still lying around.

Around the edges of the layered group in *Articles Hung on a Door* we find a horseshoe (the ubiquitous symbol of luck), a small dog-eared pamphlet, a still-life sketch held up with tacks, the remnants of other papers that have been carelessly torn, and various pieces of hardware. But it is the central group that pulls the viewer in and begs, for the sake of our postmodern brain, for explication, because until we actually understand the functions of the original objects, we can only speculate about the painting's interpretation. Because space between the door and the viewer is so compressed, the first challenge is to determine the sequence of objects in the layering.

Working from the door out, the first object is the bag, which is hanging by its leather strap. The odd arrangement of a bag within a bag has been explained by contemporary craftsman Ken Scott, who identified it as a Pennsylvania German game bag, made by German immigrants from the early 1700s through the late 1800s. The flap was made of deerskin with the hair left on. The soft, fringed pouch carried the quarry—squirrels,

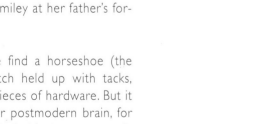

rabbits, or birds—and the leather bag stored tools and supplies for the rifle or fowler gun.[13] Hanging from the bag, in a way that is not entirely clear, is a metal powder flask that held gunpowder for loading into a musket to shoot a lead ball. Such flasks were produced as early as the 1820s and 30s, often decorated with embossed designs like the fleur-de-lis on this one; a nearly identical one was found in Peto's studio.[14] The canteen might have been used by a Civil War soldier; the bugle, as well, is a military accoutrement. Hanging from the bugle is a powder horn, which, like the powder flask, was a component of a hunter or soldier's weaponry. The final item hanging on this sturdy nail is an early nineteenth-century pistol, most likely a flintlock that was in common use during the Civil War.[15]

At first glance, the assortment of objects hanging from this single nail seems completely random and disorganized. In the words of a young man who examined this painting recently, the objects are "pieces of oldness." But as we look, we begin to see what the significance of the individual objects mean and the way they inform the broader meaning of the painting. Even in the late nineteenth century, these objects would have been understood as being from a period that had passed. All are old; some seem broken or out of use. The door itself—with repairs, missing hardware, layers of paint— is deeply weathered. The canteen lacks a stopper, the powder flask is suspended in no obvious way, and the pistol is a relic of another age.

And so, after regarding the individual objects, gaining some understanding of their history and function and mentally reuniting them, we elicit an overriding, somber message about age, incompleteness, and perhaps irrelevance. Peto has taken Harnett's beautiful, burnished, and elegant objects and replaced them with tokens of obsolescence. "Peto's still lifes," say scholars William H. Gerdts and Russell Burke, "are the most powerful reflection of post-Civil War pessimism in American still life."[16] Certainly, one can almost hear the elegiac "Taps" drifting out of the bugle, perhaps Peto's sad song for himself. The palette, off to the side, tucked behind the primary assemblage, hangs on its one nail, physically separate but visually integrated. This self-referential detail, possibly a stand-in for the artist, may be a commentary on the tension between the reflective life of the artist and the active experience suggested by accoutrements of the sporting life.

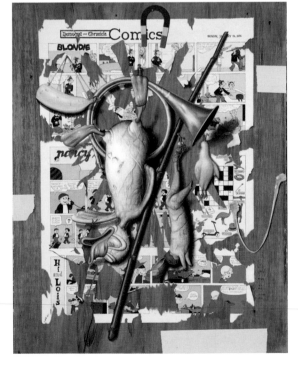

Contemporary artists continue to dwell in the in-between space where illusion and reality overlap. Kathy Calderwood's *After Harnett* takes a trompe l'oeil poke at contemporary American culture using the comic character Donald Duck as the dead bird hanging in front of a plywood board covered with remnants of the Sunday comics. A rabbit, three of whose feet have already vanished into good luck charms, hangs to Donald's right, and half a banana mocks the shape of the standard powder horn. Instead of a horseshoe there is a child's magnet. Pink bubble gum and masking tape provide the finishing sticky touches. We contemporary viewers understand Calderwood's work because of an instant familiarity with its pop culture references. By the same token, the nineteenth-century viewer would have had a greater affinity with *Articles Hanging on a Door*. We can still get a jolt of immediate pleasure from trompe l'oeil created in another era, but we have to work a little harder to unpack a deeper meaning.

Are we hard-wired to enjoy these small moments of deception? Do we marvel at an artist's skill? Yes, and more. Our enjoyment goes much deeper when we understand what we are seeing. The trick is but the first step, and if it is successful, it should move us to consider the rest for its insight into the hearts and minds of another time.

Marjorie B. Searl is Chief Curator, Memorial Art Gallery.

Christopher Clarke

The Memorial Art Gallery's arresting bronze of Nathan Hale, a diminutive but no less powerful replica of the original that stands today in New York's City Hall Park, embodies one of America's most compelling popular narratives of Revolutionary War heroism. In the fall of 1776, Hale, a young officer in the Continental Army, bravely accepted a dangerous assignment to penetrate the lines of the British Army as an undercover spy in order to discover the strength and disposition of British forces on Long Island. Unmasked as he made his way back through the British lines, Hale was captured and summarily sentenced to be hanged. In the minutes leading up to his execution, he is reputed to have uttered the words that have served for two centuries as the timeless motto of American patriotism: "I regret that I have but one life to give for my country."[1]

In 1889, Frederick MacMonnies, a young protégé of the American master Augustus Saint-Gaudens, sought and won a commission from the Sons of the American Revolution of New York State for a sculpture of Nathan Hale for City Hall Park, one of the epicenters of Manhattan's burgeoning, energetic metropolis. MacMonnies enthusiastically embraced the task of realizing Hale's heroic tale in three dimensions. The son of Scottish immigrants, MacMonnies eagerly absorbed accounts of Hale's patriotic deed and the spirit of determination and sacrifice that it expressed. The sculptor conceived a proud, determined, reserved but unbowed figure, dignified and resolute in the face of imminent death. About the Hale sculpture, MacMonnies later offered a reflection that was destined to become as oft quoted in reference to the artist as Hale's famous words were in reference to the patriot: "I wanted to make something that would set the boot-blacks and little clerks around there thinking—something that would make them want to be somebody and find life worth living."[2]

To encounter MacMonnies's *Nathan Hale* is to be persuaded that the artist fulfilled his ambition. *Hale* is a powerful work that embodies the passionate, impressionistic style of the Beaux-Arts school in Paris, where he studied in the 1880s. Its vitality, its taut yet sincere emotionalism, and the "surface bravado" with which it contrasts flickering light and shadow all combine to captivate the viewer.[3] The drama of Hale's last moments is manifest in his disheveled appearance and his bound arms and feet, and yet MacMonnies manages to reach beyond even his own realism—he leaves Hale's hands free to gesture, personifying the hero's transcendence of his immediate bonds, and his purpose and resolve as the moment of his sacrifice draws near. MacMonnies captures not just Hale's idealism but the late-nineteenth-century idealism of the American nation in an era of grand anniversaries—the Centennial of the Declaration of Independence in 1876 and of the Constitution in 1887—and lavish testaments to progress, such as the impending Columbian Exposition (1893) that marked the four-hundredth anniversary of Columbus's arrival in the New World (and for which MacMonnies would create his monumental *Columbian Fountain*).

These commemorations arrived at a moment when patriotic American heroes were much in demand, but in lamentably short supply. Decades had passed since the great national sacrifices of the Civil War (such as those soon to be enshrined in Boston on the *Memorial to Robert Gould Shaw and the Massachusetts Fifty-fourth Regiment* by Saint-Gaudens). By the end of the 1880s, especially in New York, patriotic heroism had been surpassed by the emergence of a business culture dominated by "robber barons," the politics of machine corruption and the boodle bag, labor unrest, sharp economic panics, and perceived threats to the "Americanness" of America brought on by wave after wave of foreign immigration.[4] Not surprisingly, it was a time when Americans looked with some nostalgia to the days of revolutionary idealism for their heroes.

MacMonnies's own history helps explain why he was poised to accede to the top rank of American sculptors at a time when the popular taste for celebration in bronze of heroic figures like Nathan Hale was at a peak. MacMonnies was born in 1863 into a middle-class New York City family whose once-prosperous grain business was in decline. Pursuing his evident artistic talents while of necessity working as a clerk, he had the profound good fortune at age sixteen to secure an apprenticeship in the studio of Augustus Saint-Gaudens. After five years of apprenticeship with America's premier sculptor, as well as study at the National Academy of Design and the Art Students League, he journeyed to Paris, where he entered the École des Beaux-Arts. For the next several years he moved back and forth between Paris and New York, establishing a private studio, earning a series of minor commissions, and maintaining his relationship with Saint-Gaudens, with whose assistance he secured, at age twenty-six, the *Nathan Hale* commission.[5]

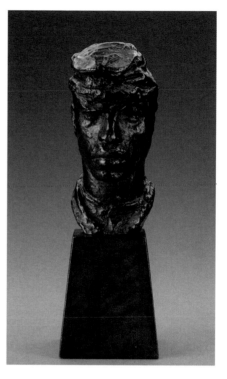

Augustus Saint-Gaudens
American (born France),
1848–1907
Shaw Memorial, Soldier's Head,
1883–1893
Bronze, 7½ x 3¾ x 5½ in.
Gift of Richard Brush and
the Maurice R. and Maxine
B. Forman Fund in honor of
Grant Holcomb's twentieth
year as director of the
Memorial Art Gallery, 2006.9

Saint-Gaudens's life-size
*Memorial to Robert Gould Shaw
and the Massachusetts
Fifty-fourth Regiment* stands
across from the Massachusetts
State House in Boston.

The erection of a monument in celebration of Nathan Hale's heroism seems more than a bit ironic at a time when American society and culture mocked so much of what Hale stood for, at least in the public mind. But the demise of American idealism under the weight of Gilded Age money and power in fact made the choice of Hale as a subject all the more compelling. In the late 1800s, Hale's stature as a first-rate American hero stood unchallenged, as it does today.

Nevertheless, celebrants of Hale's heroism must embrace the ideal version of Hale's tragic undercover misadventure. Friends who heard of the young officer's willingness to risk his life and who feared the worst tried but ultimately failed to dissuade him from his purpose. Hale undertook his mission with little support and no knowledge of the tradecraft of espionage, and met his end as a result of treachery and deceit to which he rather foolishly fell victim.[6] The recent discovery of a credible manuscript diary by a Connecticut Tory detailing Hale's lack of guile and his capture by American Loyalist Major Robert Rogers (a hero in his own right of the French and Indian War) reinforces the poignancy but also the pointlessness of Hale's sacrifice. However brave Hale was, he was not able to keep the secret of his spy mission from a fellow officer who feigned allegiance to the American cause, and then sprang the trap that led to Hale's arrest.[7]

To acknowledge the folly of Hale's quest, however, would be to question the value of Hale's sacrifice. MacMonnies boldly offers us Hale at his very best, and speaks to the power of the Hale narrative in our culture. He gives it life, passion, and three-dimensional vitality as no other Hale portraitist was able to do.[8]

(Facing page)
Frederick MacMonnies,
1863–1937
Nathan Hale, 1890
Bronze, 28⅜ x 9½ x 5¹³⁄₁₆ in.
Marion Stratton Gould Fund,
86.4

Rather like Hale's high-minded words on the gallows, MacMonnies's reported reference to Manhattan's "boot-blacks and little clerks" also demands a moment of critical reflection. A phrase oft repeated begins to take on a self-evident life of its own, and those who have written about MacMonnies's *Hale* over the past century have routinely cited the artist's words with approval. Perhaps as befits both his station in life and his celebrity at the time he is said to have uttered them, MacMonnies's words carry with them a whiff of elitism and perhaps a measure of condescension towards the crowds that he assumed would pass by his *Hale* on a daily basis. They bring

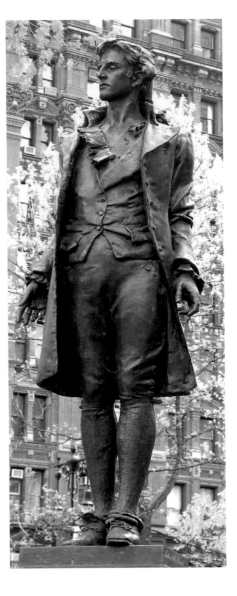

to mind the words of a more contemporary and more infamous New Yorker, the heiress and hotel maven Leona Helmsley, who observed that she thought the responsibility for paying taxes pertained only to "the little people" in America. (No doubt she would have benefited from a better acquaintance with the idealism and willingness to make a personal sacrifice that shines forth from MacMonnies's *Hale*.)

As we confront MacMonnies's own reported words, we discover that much like Hale's reputed oration, they conceal as much as they reveal, and warrant a more critical reflection than they sometimes receive. Ultimately, however, we are left with MacMonnies's ability to imbue bronze with the power of testament and to embody the unabashed idealism of a national hero. Most heroes reveal flaws if examined closely, but not so the Hale of this remarkable work, in which the pathos is genuine, the sacrifice noble, its meaning clear. Thus the artist captures the essence of the heroic narrative and returns it to us in a visual *tour de force*. For all of the contradictions in the events it embodies, MacMonnies's *Nathan Hale* shows us why heroes are necessary—and how much we miss them when they are gone.

Christopher Clarke is an independent historian and museum consultant who resides in Rochester, New York.

25: Winslow Homer *Paddling at Dusk* (1892)

David Tatham

Winslow Homer's long association with the Adirondacks began in 1870 and ended only with his death in 1910. He visited this heavily forested region of northern New York primarily to fish and to enjoy the company of other sportsmen and their families, but for many years he also took along his painting gear. From these visits came several oils and more than a hundred watercolors, including *Paddling at Dusk*.[1]

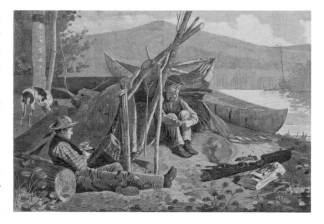

Homer's preferred Adirondack locale was a forest clearing with rustic buildings in the Essex County township of Minerva. He found subjects in the local folk, fellow sportsmen, and the surround of woods, water, and low mountains. He depicted trappers, hunters, woodsmen, and guides, all of whom he knew and respected, showing them at work or resting from their labors. He also painted fly fishermen who, like himself, had come to the Adirondacks in search of an angler's paradise.

Paddling at Dusk differs from these Adirondack works in its singular subject. The figure who paddles toward the heavy foliage of the nearby shore is neither a local woodsman nor an active angler, but rather a well-dressed young man demonstrating the worthiness of a small lightweight canoe. He was

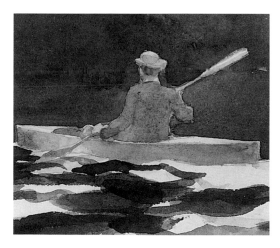

J. Ernest G. Yalden, a twenty-two year old engineering student at New York University who had himself built the canoe. Homer knew Yalden and his parents—they all belonged to the Adirondack Preserve Association. This organization (which in 1895 renamed itself the North Woods Club) had acquired the Minerva clearing, its buildings, and five thousand acres of woodland spotted with lakes and ponds.[2]

In 1936, forty-four years after Homer had rendered the scene, Yalden prepared an account of how and why the artist had painted him and his boat. He wrote:

Paddling at Dusk...was painted some time during the summer of 1892. Mr. Homer and myself were members of the Adirondack Preserve Association at the time; and this picture was made at Mink Pond on the preserve. It is a canoe built by myself which interested Mr. Homer on account of its portability for it weighed only 32 lbs. He was particularly interested in the broad flashes of light from the paddle when underway after dark; and this picture was painted when it was almost dark. The canoe built of mahogany was based on the model of a Canadian bateau, was 12 [feet] long, and 18 inches beam. It has always been a puzzle to me how he was able to get the effect he did when it was almost too dark to distinguish one color from another. I have a number of interesting photographs of Homer that I made when with him [at the club] for several summers....[3]

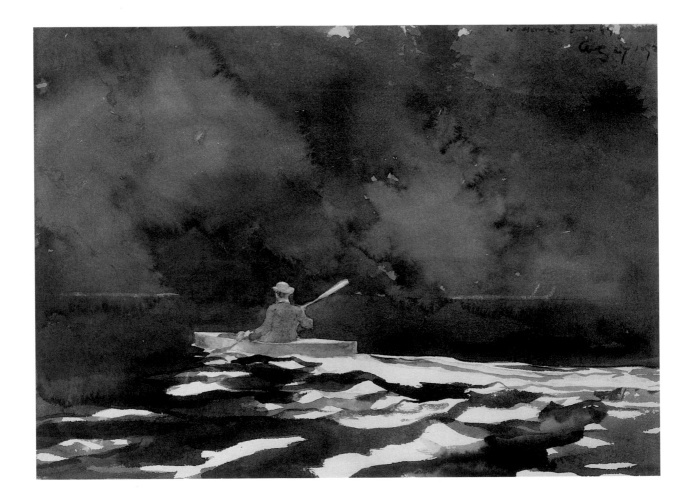

As an ardent sport fisherman well acquainted with the need for frequent overland carries from lake to lake in the Adirondacks, Homer naturally took interest in a light-weight canoe. As an admirer of skill in woodworking, he doubtless found this handcrafted boat worthy of his attention. But neither of these considerations would have moved him to paint the scene. Yalden was undoubtedly correct in recalling that what interested Homer more than anything else on this occasion was the nature of the local light at dusk—the ebbing of clarity and color and the darting reflection of what little light remained on the moving paddle and the bobbing water.

Yalden wondered how Homer had managed to capture the effects of color and light when it was nearly dark. The answer surely has something to do with Homer's sharp visual memory but it has even more to do with the fact that he typically devoted two quite different painting sessions to the creation of a watercolor. On the evening of Yalden's demonstration, Homer with very few lines sketched the figure and the boat lightly in graphite and then added local color. With broader, more vigorous strokes he captured the water's action. He began the background with freer washes. He accomplished these things in late evening on a date between June 18 and July 28, the period when both he and the Yaldens were at the preserve.[4]

On the 29th Homer returned to his studio-home at Prout's Neck on the coast of Maine. (See essay 27.) In the good light and the superior working conditions of his studio, he turned again to the watercolors he had brought from the Adirondacks. In the case of *Paddling at Dusk*, he may have touched up the figure and the canoe but he surely spent more time on the background. He brought to bear on this area a range of time-consuming techniques whose use would have been impractical or impossible in fast-fading light on a boat dock. Homer preserved the original session's spontaneity of execution while richly elaborating the subtleties of hue. In the process, he gave final balance to the composition through positioning varied intensities of color and value. When he finished, he dated the watercolor on the sheet "August 22, 1892." He was then at Prout's Neck. He inscribed the watercolor "To Ernest J. G. Yalden," confusing the sequence of the young man's initials. When Homer returned to the Adirondacks on September 17 for another three weeks of fishing, he presumably asked Yalden's father to present the painting to his son (who by then had returned to New York University) with the artist's compliments.

Beyond its distinctive subject, *Paddling at Dusk* stands as a prime example of the direction in which Homer's watercolor style had begun to move in the early 1890s. Already established as the great American master of the medium, he had over the years gradually diminished the illustrative content of his watercolors and worked more freely in a very broad range of techniques. He used his unexcelled virtuosity to create nearly nonrepresentational passages of paint, as he did in the washes of blues and greens in the background in *Paddling*. Subjects remained important, but increasingly he sought to have the educated viewer's eye linger at the painting's surface to find in his abstraction of line, shape, and color a feast of visual pleasure. Without ever being part of the movement toward modernism, Homer's late work in this way presages the aesthetic concerns of the generation of artists in Europe and America who, after the turn of the century, broke with nineteenth-century academic tradition. The marked individuality of Homer's voice as an artist, and his instinct for innovation in technique, both so evident in *Paddling at Dusk*, help explain why many within America's first generation of modernists held Homer in such high regard.

Winslow Homer,
1836–1910
Paddling at Dusk, 1892
Watercolor with graphite
on wove paper, 15⅛ x 21⁷⁄₁₆ in.
Gift of Dr. and Mrs. James
H. Lockhart, Jr., 84.51

David Tatham is Professor of Fine Arts, Emeritus, Syracuse University.

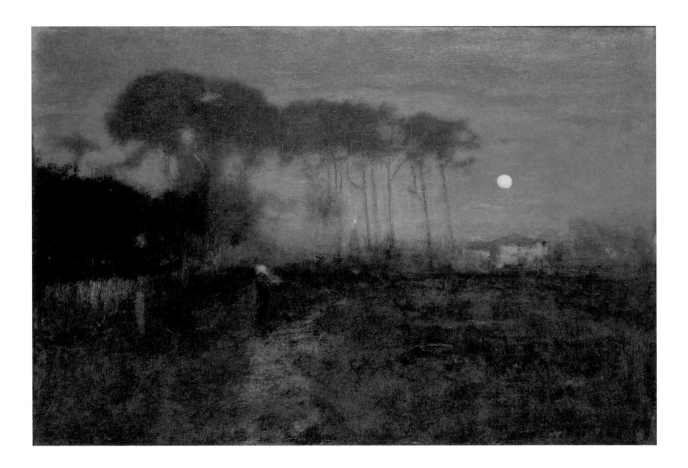

26: George Inness *Early Moonrise in Florida* (1893)

David Bjelajac

During the last decade of his life, when his primary residence was in Montclair, New Jersey, George Inness traveled extensively. The New York-born landscapist established a second home and studio in the newly incorporated city of Tarpon Springs in west-central Florida on the Gulf Coast. From 1884 until his death in 1894, Inness painted over thirty landscapes on trips to Florida and the South.[1] Like other Americans, he was encouraged to make these trips by corporate interests. Railroad companies sought to open the sunshine state for tourism and development as they rapidly laid new tracks to resort communities from St. Augustine to Palm Beach.[2] Promotional literature published during the 1880s described Florida as an ideal environment for tourists, convalescing invalids, and young settlers seeking their fortunes.

Inness chose Tarpon Springs for a winter home due to frail health. He suffered bouts of epilepsy, rheumatism, dyspepsia, and nervous exhaustion and sought seclusion and relative rest rather than dramatic scenery and oceanic adventures. Tarpon Springs was not known as a tourist resort but based its growing economy on the sponge industry, which benefited from new techniques in deep-sea diving.[3] The aging artist, whose career began during the heyday of the Hudson River School tradition of landscape painting, probably hoped that this relatively unheralded section of Florida's Gulf Coast would help him recuperate or at least avoid further maladies produced by harsh New Jersey winters.

Inness did not depict the laborious physical exertions of Tarpon Springs's sponge divers. Though he sometimes included signs of industrial activity in his later landscapes, as with the distant belching smokestack in his 1889 *Niagara* (Smithsonian American Art Museum, Washington, D.C.), the artist generally avoided scenes of economic modernization. Sympathetic critics praised him for his hostility to commercialism and the profit motive.[4] Inness had become renowned in the Gilded Age as a spiritual seeker attuned to nature as a religious resource for mining invisible, hidden truths

(Facing page)

George Inness,

1825–1894

Early Moonrise in Florida, 1893

Oil on canvas, 24⅜ x 36¼ in.

George Eastman Collection

of the University of Rochester,

36.61

Dating primarily from the 1890s, Inness's paintings of Tarpon Springs typify the artist's late style, which accentuated emotionally evocative color tones and the abstract formal elements of pictorial composition over illusionistic, precisely defined details.[5] Early in his career, during the 1860s, Inness had diverged significantly from the imaginative, romantic realism of the Hudson River School, favoring the more broadly painted style of French Barbizon School landscapes, as exemplified by Charles Daubigny's *Near Andresy* (1872, Memorial Art Gallery). Enormously popular among American collectors by the second half of the nineteenth century (including George Eastman in Rochester), these French painters impressed Inness by their quiet expression of personal, intimate moods through the freer manipulation of natural forms and tonal effects.

Charles François Daubigny

1817–1878

Near Andresy, 1872

Oil on panel, 17 x 32½ in.

George Eastman Collection of

the University of Rochester,

78.7

The French Barbizon style suited Inness's desire to transform the very act of painting into a religious exercise. By the early 1860s, Inness had moved from an early affiliation with more conventional Protestant faiths to an identification with Swedenborgianism, or the Church of the New Jerusalem, founded upon the visionary writings of the eighteenth-century hermetic philosopher Emanuel Swedenborg.[6] Unlike orthodox Christian belief, which taught that God had created the world out of nothing and that there was an essential dualistic opposition between matter and divine spirit, Christian hermetic philosophers such as Swedenborg drew upon the occult traditions of alchemy and Renaissance "pansophist" or wisdom literature to argue that God's divine light or wisdom was hidden throughout nature down to the smallest particle of matter.[7]

In harmony with this tradition, Inness interpreted painting as an alchemical process. Rather than transforming base metals into gold, the discredited goal of traditional alchemy, the American painter, following in the footsteps of the Renaissance master Titian and other great colorists, believed he could spiritually develop his own being by transmuting the humble pigments of nature into landscapes that glowed with an aerial, unifying light.[8]

Certainly, *Early Moonrise* radiates a powerful light that suggests the procreative presence of God's Word more than merely impressionistic observations of natural light effects.[9] Inness painted other moonlight scenes at Tarpon Springs in addition to early morning sunrises, evening sunsets, and twilit landscapes, all suffused by mysterious colors and powerful light-dark effects.[10]

Inness's abstract painterly style has challenged beholders, who have had difficulty in deciphering his forms. Scholars have variously interpreted the barely distinguishable figure standing on a path near the foreground.[11] The figure appears to represent a robed, religious man or, in Swedenborgian terms, a seeker of divine wisdom, who stands in profile looking upward while apparently holding an offering toward the full moon. In contrast to the softened, out-of-focus contours of the terrestrial forms, Inness's low-hanging moon possesses the geometric rigor of a distinct, perfect circle.[12] The moon dominates the picture with its radiating light and through a pictorial composition in which directional lines, formed by the curving pathway and stand of lofty trees, follow the wise man's gaze toward the lunar disc. In the background to the right, a large house with a gently sloping red roof also leads the eye upward to the silver moon floating within a luminous blue sky.

Writing in 1867 under the influence of Swedenborgian ideas, Inness referred to the moon as "the natural emblem of faith."[13] Reflecting the light of the sun, traditional symbol for God's light, the moon, Inness wrote, reassures the faithful that divine light still exists even though it is no longer directly visible in the night sky. Inness further equated the moon with the cross of Christ, symbol for the human embodiment of divine light. Elsewhere in a Swedenborgian newspaper, Inness identified blue as the color of faith.[14] Associating red with the love of God and yellow with the love of man and the natural world, Inness argued that when all three of the "primitive" or primary colors were perfectly combined, they produced harmony or a state of spiritual and aesthetic unity.

The blue of faith dominates *Early Moonrise in Florida*. Yet, Inness employed all three primaries in various ways to suggest his harmonic ideal of unity. Clouds streak across the top of the picture, their rose-tinged hue signifying God's love. Meanwhile the tall green pine trees, like the moon, also stand as traditional symbols of Christ. A combination of blue and yellow, nature's evergreens promise life everlasting.

For Inness and other Swedenborgians, death was only a small step onto a higher plane of being, one that was essentially continuous with the natural world. The reverent figure in *Early Moonrise* could be interpreted as Inness's spiritual self-portrait, painted in hopeful anticipation of his crossing through a heavenly threshold. The artist died in Scotland the next year following a tour of the European continent. This picture was displayed shortly afterward in New York at a memorial exhibition and then sold in 1895 along with several hundred other works by the estate executor. By 1915, George Eastman had acquired the painting from New York's Macbeth Gallery. Like Inness, Eastman had rejected the bright, anarchic paintings of French Impressionism, though the collector may have been more concerned that the vivid hues of the impressionist palette would clash with the interior decoration of his home.[15] An admirer of French Barbizon paintings, Eastman found their American counterpart in this southern, moonlit landscape.

David Bjelajac is Professor of Art and Human Sciences, The George Washington University, Washington, D.C.

27 : Winslow Homer *The Artist's Studio in an Afternoon Fog* (1894)

David Tatham

*I*n 1894, a decade after he had left New York City to settle at Prout's Neck on the coast of Maine, Winslow Homer painted a striking view of his studio-home. He cast the building into silhouette, enveloping it in a hazily incandescent, gold-gray, midday fog. He placed the obscured sun directly over the building, as though to suggest that a kind of divine providence favored his home. By situating the building at the center of his composition, he left little doubt that it was also at the center of his existence. It had been his home and workplace since 1884 and it would remain so for the rest of his life. After a residence of twenty-six years, he would die in this building in 1910.[1]

Homer's studio-abode (which survives little changed) and his painted depiction of it share an interesting history. The structure was originally a carriage house for the seaside cottage whose large shadowy form appears at left in the painting. Homer's father and older brother Charles built the cottage in 1882–83 as a summer residence not only for themselves and their wives, but also for the unmarried Winslow.[2] The young Portland architect, John Calvin Stevens, who designed the building, included on the second floor a north-facing studio for Winslow, who was then in the middle of a twenty-month stay in England.[3]

At some point soon after his return to the United States late in 1882, Homer chose to make Prout's Neck his permanent residence rather than a summer retreat. With his family's consent, he moved the carriage house to an adjacent lot and commissioned Stevens to convert it into a home and studio suitable for year-round occupancy. Stevens accomplished this with great skill and sensitivity,

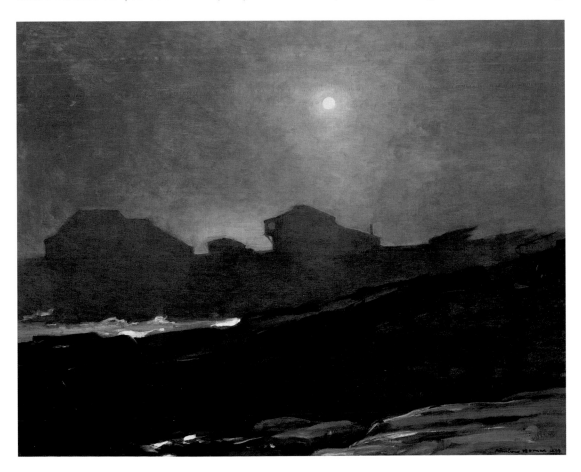

Winslow Homer,
1836–1910
The Artist's Studio in an Afternoon Fog, 1894
Oil on canvas, 24 x 30¼ in.
R.T. Miller Fund, 41.32

Winslow Homer,
1836–1910
The Artist's Studio in an Afternoon Fog, 1894 (detail)
Oil on canvas, 24 x 30¼ in.
R.T. Miller Fund, 41.32

creating a building of spartan but elegant simplicity. He added a stoutly bracketed, ocean-facing balcony and extended the building's mansard roof over it. Homer settled into his new home in 1884 and from his balcony began his study of the sea and its eternal contest with the shore. Six years later he gained more studio space when his brother Charles commissioned Stevens to add a painting room to the building. In *The Artist's Studio* Homer gives slightly sharper definition to the balcony and the painting room (through its stovepipe chimney) than to the rest of the building, perhaps to intimate the importance of these additions to the original structure.

In 1901, Stevens designed Kettle Cove, a rental cottage for Homer at Prout's Neck. As had been true with the conversion of the carriage house, the two men worked closely on the plan.[4] When Stevens submitted his bill for the job, he asked not for a sum of money but rather for a painting of Homer's choosing. Homer's reply leaves no doubt that he held Stevens and his work in high regard. He wrote: "I am very much surprised and pleased at your bill. This kind of thing occurs seldom in matters of business. The interest that you have shown in this cottage of mine, and the valuable time that you have given to it in your busy season, and your success in producing it, shows me that I can greet you as a brother artist. And, thanking you sincerely, I send you this sketch of mine that I think is appropriate and will please you."[5]

The "sketch" was in fact a finished oil painting. Stevens must have known it well. Homer had displayed it in his studio for seven years, calling it *My Studio in an Afternoon Fog*.[6] It was typical of Homer's dry humor to characterize this work as "a sketch" even though, as he knew, it displayed his powers as a painter in full measure. Later, in a letter to a friend, he referred to it as "a great work."[7]

A year following Stevens's death in 1940, the Memorial Art Gallery purchased the painting from his children. The dealer who handled the sale wrote to the museum's director, Gertrude Herdle Moore, that "the family of the late Mr. John Calvin Stevens feel very happy that [the painting] is now placed in its permanent home and so suitably and beautifully displayed."[8] Only at that point, nearly half a century after its creation, did *The Artist's Studio* take its place in the public mind as one of the masterworks of Homer's maturity.

The painting is unique in the complexity of its autobiographical content. It depicts the place where Homer resided contentedly in solitude, yet it also includes the Ark, where throughout each summer he communed regularly with members of his family.[9] It shows the Homers' buildings safe and secure on level ground, but places them at the edge of an unstable world of slippery ledges and churning water. It sets the planar, smoothly modulated, scrim-like upper half of the composition with its precise, jigsaw outline of buildings and shrubbery against a boldly brushed, impasto-laden lower half of

receding space, cyclopean rock, and white-crested water. A dark band of ledge powers its way diagonally across the lower half of the canvas to tie together contrasts of space, tension, texture, and tone.

The painting is one of several oils from the 1890s in which Homer adopted the limited palette and muted color of American tonalism, but he used those qualities in works invested with a very untonalist level of dynamic energy.[10] The monochromatic flatness of the upper part of the painting may reflect the influence of

Winslow Homer Studio,
Prout's Neck, Maine
Exterior side with rock
Courtesy Meyersphoto.com

Japanese landscape art (with whose traditions many American artists had become acquainted by the 1870s), though in an enabling rather than an imitative way.[11] *The Artist's Studio* also perpetuates something of the sense of wonderment and awe in nature that had characterized American landscape painting since the 1820s, yet with a newer, Darwinian, sense of constant struggle. Still, despite these and other possible influences from the world of art, Homer's vision and pictorial intellect are here, as everywhere in his work, uniquely his own. He trusted instinct and intuition in art more than styles and trends. A critic for *The Boston Transcript* wrote in 1899, "We watch Winslow Homer's work from season to season without being able to observe in it any trace or reflection of what other painters have done or thought."[12]

With an increasingly individualistic style, and a studio well-removed from centers of art production, Homer had gained a reputation as a distinctly independent figure among American artists. The spirit of solitude, even isolation, that pervades his portrait of his studio-home echoed the reality of his status in his profession. Great works would continue to come from this studio on Prout's Neck, but none quite so personal as *The Artist's Studio in an Afternoon Fog*.

David Tatham is Professor of Fine Arts, Emeritus, Syracuse University.

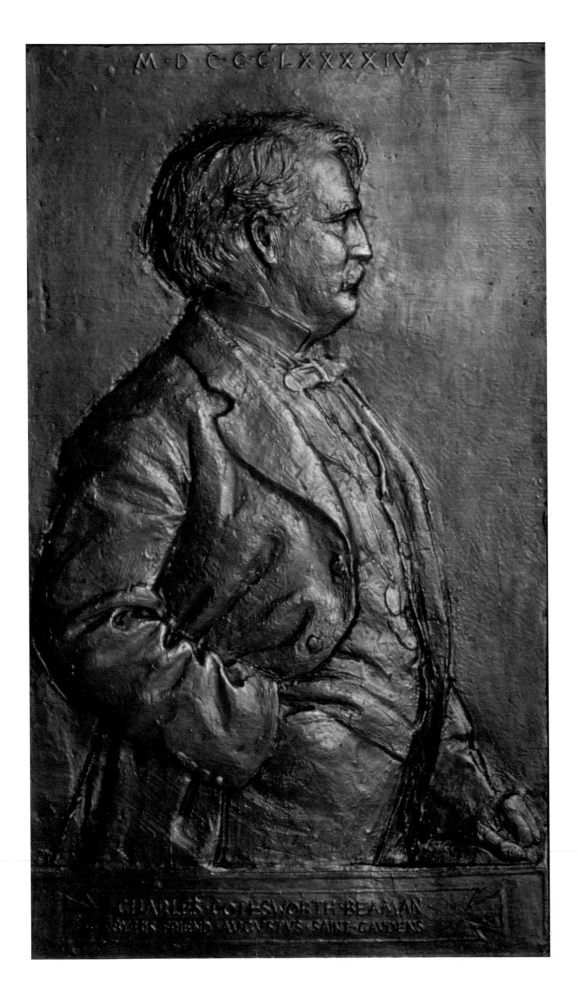

MDCCCLXXXXIV

CHARLES COTESWORTH BEAMAN
BY HIS FRIEND AVGVSTVS SAINT-GAVDENS

Henry J. Duffy

ettie Evarts Beaman (1852–1917) first met the sculptor Augustus Saint-Gaudens[1] in Rome in 1872 when she visited his studio with some friends and patrons of the young American artist.[2] Her father (Senator William Maxwell Evarts, 1818–1901)[3] ordered a marble bust of Cicero, which so pleased him that he commissioned a portrait bust of himself (completed in 1874), thus becoming one of Saint-Gaudens's first important clients.[4] Other family commissions would follow. Some twenty years later Saint-Gaudens would portray Hettie's husband, Charles Cotesworth Beaman (1840–1900), and six years after that, in 1900, Hettie Evarts Beaman herself.

Saint-Gaudens also stands at the forefront of nineteenth-century art as a creator of iconic images of Civil War heroes and as a chronicler of literary and social leaders of his time. Such monumental sculptures as the *Admiral David Farragut Monument* (New York, completed 1880), *The Puritan* (Springfield, Mass., completed 1886), *Adams Memorial* (Cambridge, Mass., completed 1891), and the *Robert Gould Shaw Memorial* (Boston, completed 1897), form the basis of his renown. But his principal artistic contribution is in the art of portraiture.

Born in Dublin of a French father and Irish mother, but raised in New York City, Saint-Gaudens received his training at the École des Beaux-Arts in Paris and in Rome, where he worked in the early 1870s. In Italy he was introduced to the art of Renaissance medals, and dreamed as a young man of one day achieving in a large-scale format what the early masters already knew in small form. Low-relief portraiture is one of the most difficult forms of sculpture to achieve, and Saint-Gaudens would become a master at the technique (notably his portrait of Robert Louis Stevenson, 1887–88).

The Memorial Art Gallery's two fine bronze portraits underscore a number of characteristic features of his work and career, beginning with the importance of Saint-Gaudens's personal relations with his subjects. In this case the Beamans were not only longtime friends and patrons, but were directly responsible for the artist's taking up residence in Cornish, New Hampshire, providing a congenial location for the creation of some of his greatest works. Saint-Gaudens created over seventy bas-relief portraits. Most are bronze, having been carved first in clay and then cast. Typically, and the Beaman portraits are no exception, they are in profile and have inscriptions. Charles Beaman's portrait is inscribed:

> CHARLES·COTESWORTH·BEAMAN
> BY·HIS·FRIEND ·AVGVSTVS·SAINT-GAVDENS

Mrs. Beaman's portrait is inscribed:

> CORNISH NEW HAMPSHIRE
> OCTOBER NINETEEN HVNDRED

and her name is contained within a classical wreath.

Charles Cotesworth Beaman was Saint-Gaudens's lawyer in New York, and became a close friend.[5] In 1883, the Beamans began construction on "Blowmedown Farm" in Cornish, New Hampshire, not far from the property owned by Mrs. Beaman's family in Windsor, Vermont. Beaman's vision for his significant property holdings in Cornish transformed the region into an inviting colony for

(Facing page)
Augustus Saint-Gaudens,
1848–1907
Charles Cotesworth Beaman, 1894
Bronze, 26½ x 15 x 3/16 in.
Gift of Mary Ellen Gaylord,
94.51

Augustus Saint-Gaudens,
1848–1907
Hettie Sherman Evarts Beaman
(detail), 1900
Bronze, 22¼ x 20⅜ in.
Gift of Mary Ellen Gaylord,
94.50

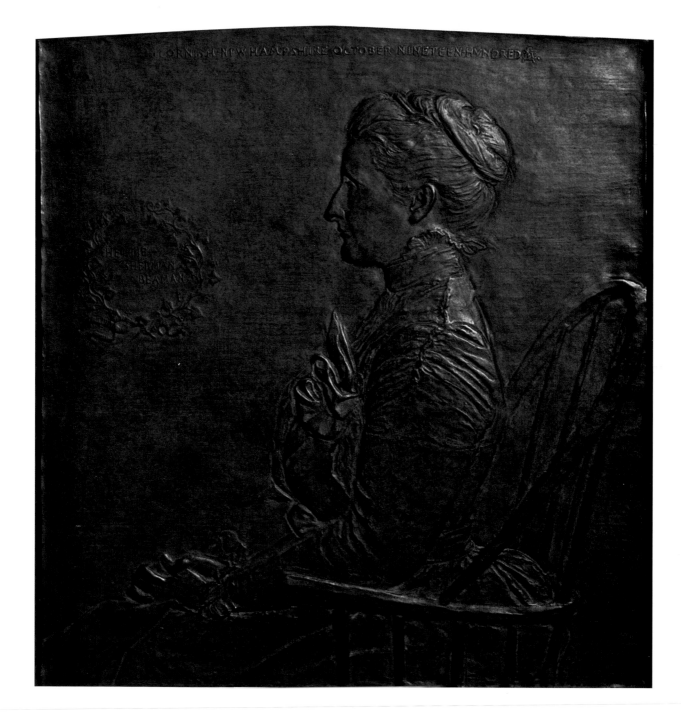

artists and writers. He first suggested Cornish as an ideal location for Saint-Gaudens to work and for the family to escape the summer heat of New York City. Beaman owned property along the Connecticut River in a beautiful valley centered on Mt. Ascutney, and he persuaded Saint-Gaudens to come see an old disused inn on the property. The Saint-Gaudenses visited the property in April, 1885.[6] At first the artist thought it looked "so forbidding and relentless that one might have imagined a skeleton half-hanging out of the window, shrieking and dangling in the gale, with the sound of clanking bones."[7] He was eventually convinced by his wife, and by Beaman's promise of "Lincoln-shaped men" in the neighborhood who could model for Saint-Gaudens's Chicago sculpture commission, to take up residence there the summer of 1885.

In the old hay-barn Saint-Gaudens, his brother Louis Saint-Gaudens, and his assistants Frederick MacMonnies and Philip Martiny completed the early sketches for the *Standing Lincoln, Seated Lincoln, Bellows Monument* and the portrait of the *Children of Jacob Schiff. Standing Lincoln,* for which, as promised, a model was found in the neighborhood—Langdon Morse, of Windsor, Vermont—was one of Saint-Gaudens's masterpieces (it was installed in Chicago in 1887). The summer was so productive that the artist changed his mind about the place, wanting to come back again. In his reminiscences, he said that country life was "the beginning of a new side of my existence."[8]

By this time, however, Beaman himself had turned reluctant, and was only persuaded by the promise of his portrait, along with some payment, to sell the property to Saint-Gaudens. The artist wrote,

> So much for the first summer. But as the experiment had proved so successful, I had done such a lot of work, and I was so enchanted with the life and scenery, I told Mr. Beaman that, if his offer was still open, I would purchase the place under the conditions he originally stated. He replied that he preferred not, as it had developed in a way far beyond his expectations, and as he thought it his duty to reserve it for his children. Instead he proposed that I rent it for as long as I wished on the conditions first named, which were most liberal. But the house and the life attracted me until I soon found that I expended on this place, which was not yet mine, every dollar I earned, and many I had not yet earned, whereas all of my friends who had followed had bought their homes and surrounding land. So I explained to Mr. Beaman that I could not continue in this way, and that he must sell to me, or I should look elsewhere for green fields and pastures new. The result was that, for a certain amount [$2500, which was five times the original asking price] and a bronze portrait of Mr. Beaman, the property came to me.[9]

Saint-Gaudens purchased the property in 1891.[10] Many artists followed Saint-Gaudens to Cornish, including painters Thomas and Maria Dewing, and sculptors James Earle Fraser and Henry Hering.

Beaman tried to negotiate at least one other portrait, perhaps that of his wife, as part of the purchase price, but was unsuccessful. Saint-Gaudens wrote that "My time is so occupied by my larger work that I am refusing to do medallions for a price that would more than pay for the entire property and I could not agree to execute for you in connection with this agreement, a portrait of anyone but yourself"—which may explain why the two portraits were not done as a pair and look so different.[11] By the time of Mrs. Beaman's portrait, the price was $2500.[12]

Hettie Sherman Evarts Beaman was the great-granddaughter of Roger Sherman, one of the signers of the Declaration of Independence, and a cousin of General William T. Sherman, whose portrait and monument Saint-Gaudens also made.[13] While she is not as publicly documented as her husband, Hettie Beaman had a lively and full life. In addition to her early European tour, Mrs. Beaman, her husband, and children took a six-month trip around the world in the 1890s. Life in

Cornish was exceedingly full with four children and all the attendant activities that the summer colony encouraged—parties, picnics, as well as the routine farming matters to be overseen. She was forty-eight years old when she began the first of twenty sittings for her portrait in October 1900.[14]

The MAG portraits[15] display Saint-Gaudens's skill in capturing not only likeness but also personality in the linear, almost-drawn technique of low-relief. While the figures barely rise above the flat surface, nuances of hair, clothing, and facial expression are beautifully delineated. The artist skillfully uses light and shadow to indicate form, depending on it to fill in details not physically present.

The portraits, in their different poses and degrees of formality, express how Saint-Gaudens saw his two friends—Charles stands upright, self-assured, in a pose befitting the public status of the man, an important lawyer with ties to government and industry. Hettie is depicted seated in a Windsor chair—perhaps in a more domestic environment—to give homage to her family's Colonial roots. The personalities are evident, reflecting Saint-Gaudens's warm understanding of his friends.[16]

In addition to his friends' portraits, Saint-Gaudens had much earlier (in 1885) depicted the Beamans' young son William in a portrait meant as a kind of payment for the use of the farm in Cornish that the artist would later purchase. William was the same age as the Saint-Gaudenses' young son Homer, and the two boys became friends. At the time of the portrait, William's health was in question, and the portrait was inscribed with words of Stoic philosophy by Seneca. It is in many ways the most personal of the three family portraits.

Through his long relationship with the Evarts and Beaman families, Saint-Gaudens achieved professional and personal goals. Early commissions for these families helped to establish his reputation and brought him into contact with other clients of means. Charles Beaman, known as a "true bon vivant,"[17] drove a hard real estate bargain but swept the Saint-Gaudens family into a bucolic and vivifying community that celebrated and nurtured artists and the arts. In his *Reminiscences* Saint-Gaudens acknowledged the important role that Beaman played in his life:

> *Much of pleasure in life has happened here in the past twenty years, but nothing so delightful and in every sense as remarkable as the Fête Champêtre, which was given on my place to commemorate the twentieth anniversary of the founding of the Colony. The real founder was Mr. C. C. Beaman; there is no doubt of this, for he subsequently brought friends here directly, and it was through him and the foresight of Mrs. Saint-Gaudens that I came.[18]*

In his career Saint-Gaudens experimented often with portraiture, trying different surface patinas and positions. He tried both high and low relief, and unusual poses—such as an arm reaching out beyond the frame. The portraits of the Beamans are not his most adventurous, but they are quiet, intimate reflections of personal friends who remained life-long companions and supporters of the artist. In the large view of Saint-Gaudens's achievement they are fine examples of the skill and sensitivity that marked his mature style.

Henry J. Duffy is Curator/Chief of Cultural Resources, Saint-Gaudens National Historic Site.

29: Frederic Remington *The Broncho Buster* (1895) *The Cheyenne* (1901)

Brian W. Dippie

*I*n 1894, Frederic Remington took up sculpting—just that casually by every indication—and within a year produced a Western masterpiece. He had watched an established sculptor, Frederick W. Ruckstull, working at a neighbor's house on a model for an equestrian monument. The neighbor, observing how Remington could turn figures around and reposition them in his drawings, commented that at heart he was a sculptor himself. The idea caught Remington's fancy, and, with Ruckstull's encouragement, he set about creating an equestrian model of his own.[1]

The audacity of his decision and of the astonishing bronze he created, *The Broncho Buster*, can only be gauged by remembering that Remington was, at the time, America's leading Western illustrator working principally in black and white wash and oils to produce linear, detailed pictures with clear

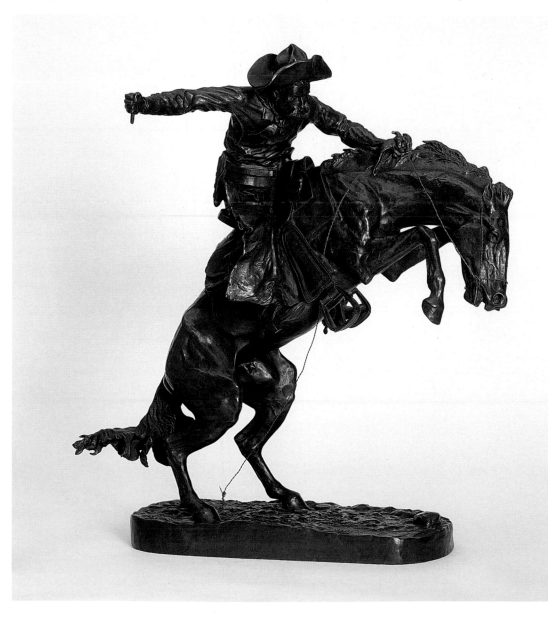

Frederic Remington,
1861–1909
The Broncho Buster, 1895
Bronze, 22½ x 20 in.
Cast 1898
Gift of a friend of the Gallery,
55.3

tonal variations that lent themselves readily to the engraver's art. He had done pen and ink drawings, but recognized his limitations in the medium. He also painted in colors, but black-and-white illustration was his bread and butter, and its requirements pounded into him the preeminence of form.[2]

Remington rapidly mastered what he needed to know in order to be a successful illustrator. The editor of *Outing* remembered that his work in 1886 was like "an electric shock," combining, as another put it in 1895, "a photographic realism" with "a vivid strength that is at times nothing less than startling." His best drawings hummed on the page, making his version of the West irresistible to contemporaries.[3] Remington's West—"*my* West," as he liked to call it—was a man's domain, replete with danger, conflict, and death. It was barren of refinement, which was precisely its appeal for his audience of refined Easterners. His confidence in expressing a way of thinking about the material at hand gave his illustrations ideological heft. The West, for him, was a testing ground—an extension of the battlefields of the Civil War as he imagined them growing up in the shadow of a father who had served in the war. Remington's generation would dwell in that shadow, but in the deserts of the Southwest and on the western plains he had found new fields of glory in the full glare of the sun.

Remington's West was a theater in which the figures he portrayed were all playing parts in the national drama of the "winning of the West." The setting for him in his major paintings was often a bare stage, reduced to horizontal bands of sky and earth. His actors were frontier "types"—"men with the bark on."[4] Illustration permitted, indeed mandated, the repetition that stamped his "types" on the public's mind. "We almost forget," an admirer wrote in 1895, "that we did not always know…the whole little army of the rough riders of the plains, the sturdy lumbermen of the forest, the half-breed canoe-men, the unshorn prospectors, the dare-devil scouts, the befringed and be-feathered red men, and all the rest of the Remingtoniana that must be collected some day to feast the eye."[5]

Through the 1890s Remington was prodigiously prolific; readers encountered his illustrations on an almost monthly basis in the leading American periodicals of the day, frequently as accompaniments to his own essays and stories, written in a savory prose describing what his pictures showed. He tossed out "theories" and prejudices and telling anecdotes that drove home the lessons his art imparted. As a writer, he was at once bellicose and sentimental, stating his views in a properly gruff, "manly" style. He wore his Americanism on his sleeve, and his art mirrored his thinking. The final phase in the winning of the West was his generation's great adventure, and he was its "pictorial historian."

As Remington prepared for his first one-man exhibition and public auction of "paintings, drawings and water-colors" in January 1893, a press report observed, "His career has been as remarkable as it has been brief."[6] In short, he was already a recognized phenomenon when, at the end of 1894, he turned his hand to sculpture.

Frederic Remington was born in the town of Canton in upstate New York in 1861, the year the nation plunged into civil war. His father's service as an officer of the cavalry explains the son's fascination with soldiers and horses, just as growing up in a land of rivers and lakes and wilderness explains his lifelong love affair with the out of doors. His artistic propensities led him to a stint at Yale's School of Fine Arts, which ended with his father's death in February 1880. The next year he made a trip to Montana that changed his life. Only one illustration resulted—a cowboy sketch that was redrawn and published in *Harper's Weekly* in February 1882—and he was back in New York after two months. But he had found his master theme, the "Grand Frontier" as he would call it, where the forces of past and present were locked in a death struggle. "I knew the wild riders and the vacant land were about to vanish forever," he recalled, and, "without knowing exactly how to do it, I began

to try to record some facts around me."[7] Going west became his substitute for war, and he was a frequent visitor as an artist/correspondent; apart from a year's residence on a sheep ranch in Kansas in 1883–84 and an even shorter sojourn in Kansas City in 1884–85, New York remained his home.

Remington's career took off when he covered the Geronimo campaign in Arizona for *Harper's Weekly* in 1886. He was also on assignment for the last, pathetic chapter of Plains Indian resistance at the battle of Wounded Knee in December 1890. By then he was illustrating regularly in *Harper's Weekly*, *Outing*, *Century*, and *Harper's Monthly* and his name had become synonymous with the West. No assignment along the way had been more important than the commission to illustrate a series of six essays on ranching and hunting life in Dakota written by another New Yorker, Theodore Roosevelt, and published in *Century* in 1888. Together writer and artist gave shape to a new American hero who oozed physical appeal. Cowboys are "as hardy and self-reliant as any men who ever breathed," Roosevelt wrote, "with bronzed, set faces, and keen eyes that look all the world straight in the face without flinching as they flash out from under the broad-brimmed hats....[T]heir appearance is striking...with their jingling spurs, the big revolvers stuck in their belts, and bright silk handkerchiefs knotted loosely round their necks...."[8] Such was the cowboy's popularity as a subject of fiction and romance by 1895, the year *The Broncho Buster* was cast, that Remington could write, "with me cowboys are what gems and porcelains are to some others."[9] Cowboys were a regular, paying proposition in his art.

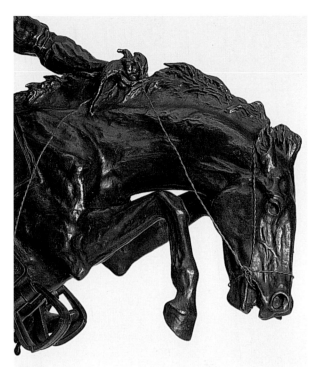

Frederic Remington,
1861–1909
The Broncho Buster, 1895 (detail)
Bronze, 22½ × 20 in.
Cast 1898
Gift of a friend of the Gallery,
55.3

Still, his venture into the three-dimensional was a daring departure. Since 1888 he had exhibited some of his major works in watercolor and oil in what would prove to be a continuing battle for critical acceptance as a "pure painter," to adopt his language, not a mere illustrator.[10] But painting raised the issue of color, which may have been a factor in his attraction to sculpture. "I am modeling," he told Owen Wister: "I find I do well—I am doing a cow boy on a bucking broncho....I have simply been fooling my time away—I can't tell a red blanket from a grey overcoat for color but when you get right down to facts—and thats what you have got to sure establish when you monkey with the plastic clay, I am *there*...."[11]

Remington described *The Broncho Buster* matter-of-factly in his copyright application: "Equestrian statue of cowboy mounted upon and breaking in wild horse standing on hind feet."[12] What is astonishing is the skill with which he had translated one of his most popular two-dimensional subjects into three dimensions. *The Broncho Buster* was an impressive achievement on aesthetic and narrative grounds, epitomizing the ideal of the "hardy and self-reliant" man. And it was a technical marvel. A cowboy, one stirrup flying free, one hand pulling on the reins while grabbing for the mane, clings to a plunging horse rising on its rear legs. The group soars with a "lift" that defies the nature of metal: How can an object made of copper, tin, zinc, and a trace of lead appear airborne? Today it is hard to recapture a sense of wonder commensurate with Remington's achievement, so many Western artists since having followed his lead in sculpting bronzes showing furious man-animal action.

Though *The Broncho Buster* appears an effortless creation, Remington admitted that it was "a long work attended with great difficulties on my part."[13] He followed it through the exacting process of sand casting at the Henry-Bonnard Bronze Co. in New York with the nervous excitement of an expectant father. In late October *The Broncho Buster* made its debut. The critics, stand-offish where Remington's paintings were concerned, rushed to embrace the new arrival. Their response was

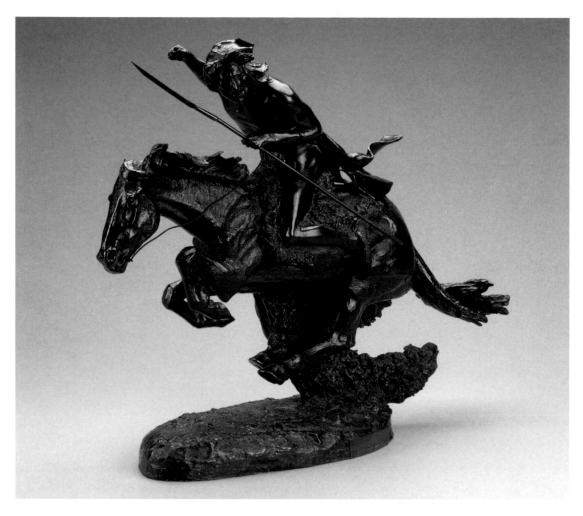

Frederic Remington,
1861–1909
The Cheyenne, 1901
Bronze, 19¾ x 21 x 7½ in.
Cast after 1907
Bequest of Mrs. Merritt
Cleveland, 2003.104

summed up by the painter and art critic Arthur Hoeber: "Breaking away from the narrow limits and restraints of pen and ink on flat surface, Remington…in a single experiment has demonstrated his ability adequately to convey his ideas in a new and more effective medium of expression."[14]

Remington loved the idea of bronze. Its solidity and durability promised immortality. "I propose to do some more," he told another critic, "to put the wild life of our West into something that burglar won't have, moth eat, or time blacken. It is a great art and satisfying to me, for my whole feeling is for form."[15] Remington had done the cowboy; other "types" beckoned—notably, the soldier and the Indian.[16] His "purpose in art" never changed. It was "to perpetuate the wild life of our American conquest of this great continent," he told a journalist while finishing *The Broncho Buster*.[17] He modeled *The Wounded Bunkie* in 1896 and *The Scalp* in 1898. In one, a soldier rescues a comrade shot in battle, in the other a warrior holds aloft his gory trophy, exulting in a momentary victory in the long struggle for mastery of "this great continent." *The Broncho Buster* and *The Cheyenne*, cast in 1901, pair up to tell the same story. Classic adversaries in the game of "cowboys and Indians," they provide a summary in bronze of Remington's overriding theme.

The copyright application for *The Cheyenne* offered another succinct description of the bronze's most challenging technical feature: "Indian on pony galloping with all four feet off the ground."[18] A trailing buffalo robe supports the entire weight of horse and rider; they skim the earth's surface, "burning the air."[19] Armed with lance and shield, this is a warrior grimly determined to resist civilization's advance; Remington portrays him as pure savage, but with a sneaking admiration. The Indians "were fighting for their land," he wrote in 1899: "they fought to the death—they never gave quarter, and they never asked it. There was a nobility of purpose about their resistance which commends itself now that it is passed."[20]

About 1900 Remington switched loyalties from the Henry-Bonnard foundry to the Roman Bronze Works in New York, which specialized in the *cire perdue,* or lost-wax process. The company took over production of *The Broncho Buster,* while *The Cheyenne* was one of Remington's first new bronzes cast by this method, and he took advantage of the flexibility it offered the artist to freely rework details. In 1907, after the edition reached twenty, he broke the original mold in the belief that the group had already lost definition, but Roman Bronze Works produced sixty-seven additional castings from another model, including MAG's cast number 53 which in 1919 was presented to William G. Stuber "from his Kodak Park Associates."[21]

As for *The Broncho Buster,* its popularity never waned, sales never slackened, and production never stopped until 1920 when Roman Bronze Works finally honored the provision in Eva Remington's will that casting end with her death, which occurred in November 1918.[22] By then nearly 340 bronzes had been cast, including the sixty-four sand casts by Henry-Bonnard, making *The Broncho Buster* "the most popular American bronze statuette of the nineteenth and early twentieth centuries."[23] The edition had reached 154 in Remington's lifetime, and perhaps in recognition of the place it had come to occupy in American art, he decided in the middle of October 1909 to create a new one-and-a-half-size version. So Remington's first model became his last model as well. He labored on the enlargement from November 20 to December 9 before declaring it "finished."

It was a cold day, but he had been warmed by good notices of his annual December exhibition at Knoedler's Gallery in New York. "The art critics have all 'come down,'" he crowed in his diary: "They ungrudgingly give me a high place as a 'pure painter.' I have been on their trail a long while and they never surrendered while they had a leg to stand on. The 'Illustrator' phase has become a background."[24] By then the issue was moot. Those who admired his bronzes had already forgotten the original basis of his fame. Indeed, writing in 1908 in praise of America's younger generation of sculptors, a critic cited as an example Remington, who went West "to model Indians and cowboys."[25]

Eleven days after finishing the new *Broncho Buster,* Frederic Remington took ill. He died on December 26, 1909, at the age of forty-eight. For him, the West was won.

Brian W. Dippie is Professor of History, University of Victoria, BC, Canada.

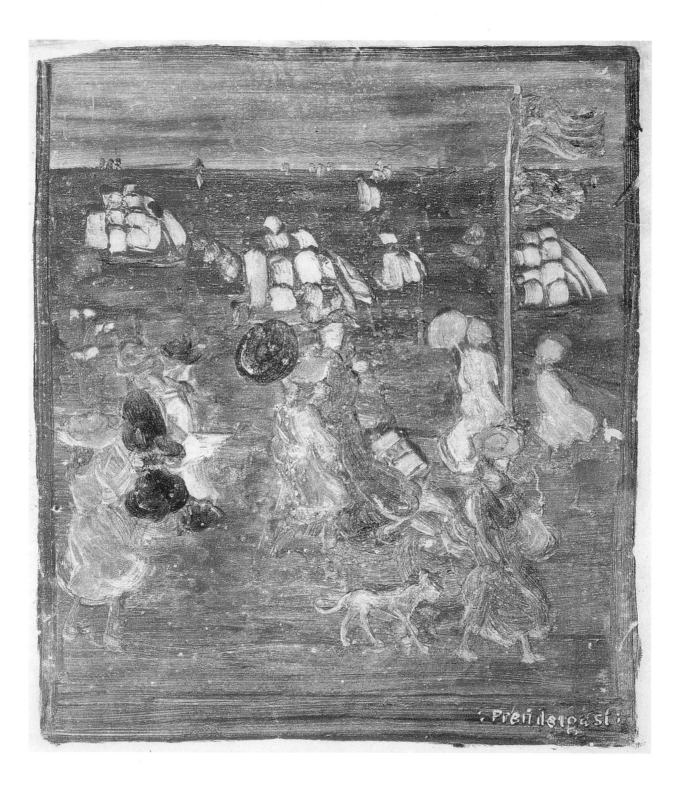

30: Maurice Prendergast *The Ships* (ca. 1895)
Woodland Bathers (1913–15)

Gwendolyn Owens

The Memorial Art Gallery has the distinction of being the first art museum in the world to welcome a work by Maurice Prendergast into its collection. *The Ships,* a monotype, was bought by Emily Sibley Watson for MAG from a summer 1919 exhibition. The artist may have never known of the acceptance of his first work into a public collection; over the years, he had exhibited at many art museums but never before had one of his works become part of a permanent holding.[1]

The Ships was made in the mid-1890s when Prendergast was first painting what would become his preferred subject matter throughout his career: people strolling along the New England shore and in city parks, in this case on Telegraph Hill near Nantasket, south of Boston.[2] Described as having "wonderful flutter, luminosity, and kaleidoscopic color-movement,"[3] Prendergast's early works were well received by local Boston critics and collectors. But in 1919, at the time of the Rochester gift, Prendergast, still active as an artist, had moved beyond his early style. He had completely stopped making monotypes—single or occasionally double-edition prints—and turned his attention primarily to making complex oils like *Woodland Bathers,* the major painting that MAG acquired in 1963. These later modernist works used the same compositional schemes as the early works, but the similarity stopped there.

Prendergast came to his modernist style of painting after a long career of artistic experimentation and innovation. Born in St. John's, Newfoundland, in 1858, he moved as a child to Boston, the home of his mother's family. He began his career as a commercial artist painting signs and showcards for businesses. In 1891, however, he made the decision to change direction and went to Paris to study art. Returning to Boston in 1894 after having studied at the Académie Julian and Colarassi's studio in Paris, he began painting oils, watercolors, and monotypes, which he exhibited in local, then regional, and finally national exhibitions. These works found favor with collectors who wanted "small bits of decorative color"[4] for the home.

In 1900, Prendergast was invited to exhibit at the Macbeth Gallery in New York, a gallery that was aggressively trying to build a market for American art. He sold a respectable eight works from his solo show at Macbeth's.[5] But rather than stick with his successful formula, the artist kept experimenting, making the figures in his beach scenes more abstract or out of scale with their surroundings. Some of these figures even stared out of the picture, challenging the viewer's gaze by seeming to stare back. In his oils, he made the colors more somber and the figures small and abstract. Unlike the earlier "small bits of decorative color," these works were more sophisticated and demanding.

As his style was developing in new directions, he was also expanding his circle of friends. Prendergast got to know two important leaders in American art who also showed at Macbeth's: Robert Henri and Arthur B. Davies. He was chosen by them to be among a group of eight artists to exhibit at the Macbeth Gallery in 1908 in a highly organized and publicized protest against the traditional art jury system. The group claimed the juries stifled innovation by making it harder for new art by younger artists to be seen in the major annual exhibitions. Prendergast's inclusion in their protest show gave the event breadth of style; his works did not resemble that of any of his fellow-protesters, the majority of whom were painting street scenes of New York.

Maurice Prendergast,
1858–1924
The Ships, ca. 1895
Monotype, 15¼ x 10¹⁵⁄₁₆ in.
Gift of Emily Sibley Watson,
19.29

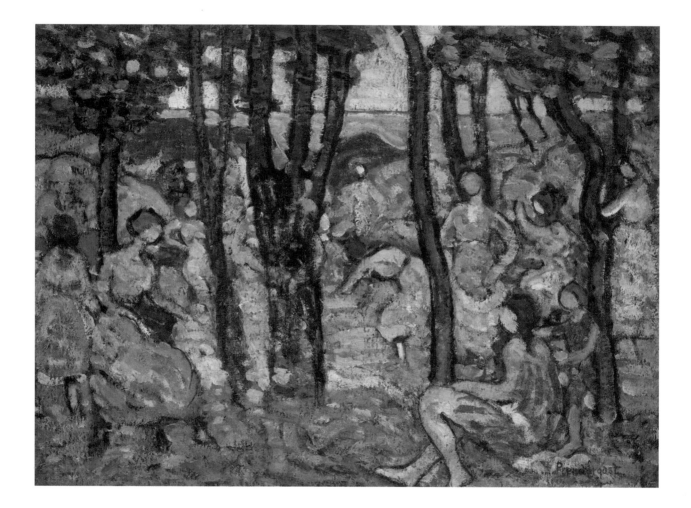

As the century progressed, Prendergast continued to follow his own path, moving even further away from the realism of his early park and beach scenes. He traveled back to Europe in 1907, revisiting Paris where he saw the newer, brighter paintings of Henri Matisse and the fauve painters,[6] and back to Venice, which he had first visited in 1898–99, in 1910–11. His palette lightened with the influence of the fauves but his commitment to his chosen subject matter never strayed.

Collectors still shunned his work and critics were confused by it. By 1911, Boston reviewers were to the point of waxing nostalgic for the luminous 1890s works.[7] This all changed in 1913, after the famous Armory Show in New York, which brought together more than a thousand works of art by modern European and American artists. At and after the exhibition, Prendergast's work was discovered by a different breed of collectors: people who were interested in modern art. Among the notable individuals who bought the artist's works were lawyer John Quinn, and three individuals who would later found museums: Albert C. Barnes, of the Barnes Collection, Lillie Bliss, of the Museum of Modern Art, and Duncan Phillips, of The Phillips Collection in Washington, D.C. And subsequently, there was a rediscovery of his earlier work, like the 1890s monotype purchased by MAG benefactor Emily Sibley Watson.

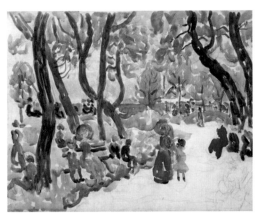

Maurice Prendergast, 1858–1924
Park by the Sea, 1922
Watercolor with graphite on paper, 17⅛ x 22⅜ in.
Gift of Mrs. Charles Prendergast, 63.28

In the later oils, the figures in Prendergast paintings had become even more schematic and out of scale with each other and the color more clearly based on theory rather than nature. The location of the specific scene, whether a park or a seashore, was no longer important. The titles reflect this change. Site-specific names like *Cohasset* or *Franklin Park* (both Boston-area locales) disappear, replaced by titles like *Picnic* or *Bathers* or *Promenade*—often interchangeable, having little to do with a place.

In essence, these works were experiments in balancing color, line, and shape. The canvas was usually layered with paint built up on the surface and the faceless figures under the trees were forms—lines and curves—that had at times only a passing resemblance to people and were never recognizable as individuals. The arrangement of the figures in the landscape and the use of both nude and clothed figures together recall the work of French artists whose work Prendergast saw in Paris, among them Puvis de Chavannes, Edouard Manet, Maurice Denis, and Paul Cézanne, all of whom experimented with the same type of composition.

In *Woodland Bathers,* the space in the work is flattened, as the sea appears not to recede. Only the outlines seem to stop the figures and trees from melding into the surface of the green lawn and the blue water. The arrangement of the scene seems deceptively simple, almost childlike; a closer look, however, reveals echoes across the canvas in color, line, and shape that can only have been deliberate. Ultimately, this painting, like all the successful paintings of this later era in the artist's life, is more about creating a sense of atmosphere on a flat canvas than trying to mirror reality.

Prendergast took a singular path to modernism; no one around him painted in a similar style. He was consistent in his own vision, taking what he saw and assimilating it into a painting style unmistakably his own. In contrast to the oils layered with paint, the late watercolors use the white of the paper and the fluidity of the medium to create his imagined world, as in *Park by the Sea* (1922), also owned by the Memorial Art Gallery.

(Facing page)
Maurice Prendergast,
1858–1924
Woodland Bathers, 1913–15
Oil on canvas, 19½ x 26½ in.
Marion Stratton Gould Fund, 63.29

Prendergast never wrote about what he was striving to achieve in his art. It seems obvious that he wanted to make the surface pattern itself the subject: a very modern idea. At their best, the patterns of line and shape are strong enough to intrigue the viewer, hold our attention, and entice us to enter into the artist's mythic world.

Gwendolyn Owens is consulting curator at the Canadian Centre for Architecture.

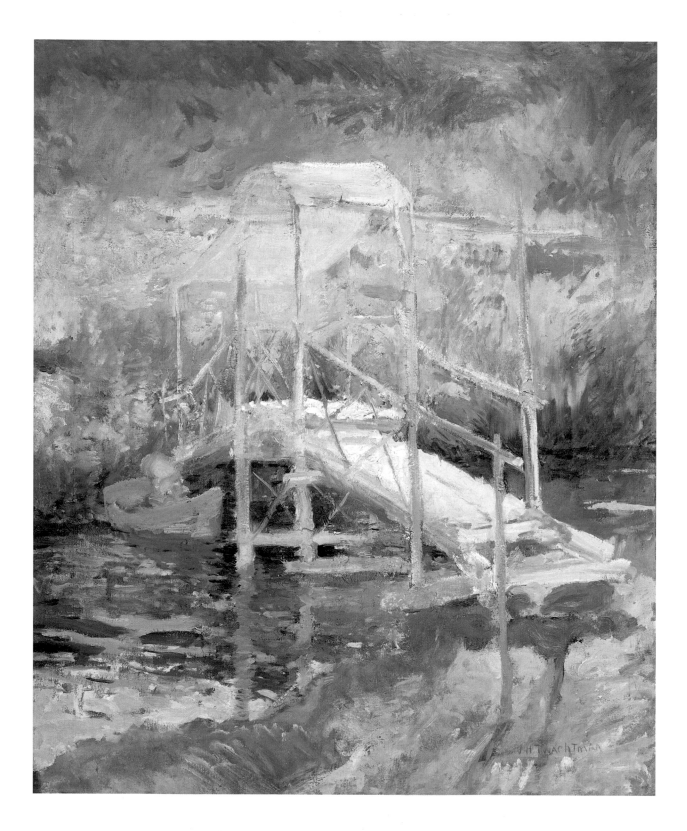

31: John Henry Twachtman *The White Bridge* (late 1890s)

Susan G. Larkin

John Twachtman settled in Greenwich, Connecticut, in the spring of 1889.[1] For the next ten years, his property on Round Hill Road—eventually totaling about seventeen acres—was the focus of his emotional and artistic life. Unlike many of his colleagues, who spent summers in the country but made their primary home in New York City, Twachtman, a Cincinnati native, lived in Connecticut year-round. "I feel more and more contented with the isolation of country life," the city-bred artist wrote to his friend J. Alden Weir in December 1891. "To be isolated is a fine thing and we are then nearer to nature. I can see how necessary it is to live always in the country—at all seasons of the year."[2] He found nearly all of his subjects on the farm where he and his wife, Martha Scudder Twachtman, reared their children. Their house was a classic fixer-upper, and Twachtman did much of the work himself, sometimes enlisting his friends' assistance. During a stay in Greenwich in 1894, Theodore Robinson noted in his diary that Childe Hassam was helping Twachtman lay the foundations for an addition.[3] Robinson also witnessed Twachtman's enthusiastic transformation of the farmland surrounding his home into an inviting garden. "Twachtman, as usual, making a trellis or porch for vines," he noted, adding a few days later that his friend was "busy engaged in gardening."[4]

Twachtman had been attracted to the place by Horseneck Brook, which ripples through a corner of the site, splashing over small cascades and collecting in wider pools as it flows to Long Island Sound. Unlike the neighboring farmers who exploited the brook to irrigate their fields and water their cattle, Twachtman enhanced its beauty and recreational value. He dammed it to make a swimming hole for his children, planted trees along the banks, and built the white wooden footbridge celebrated in the Memorial Art Gallery's painting.[5]

A bridge became a practical necessity after Twachtman acquired land on both sides of the brook in 1892.[6] The artist's neighbors crossed the stream on unadorned bridges sturdy enough to bear the weight of a laden oxcart. His children enjoyed another option: Robinson depicted two of them picking their barefoot way across the brook in *Stepping Stones* (1893, Senator and Mrs. John D. Rockefeller IV). But with his bridge, Twachtman provided a third alternative, enabling his family and friends to cross the brook dry shod, while also creating a garden ornament.

The bridge depicted in the Gallery's painting was not the first on the site. Four other canvases also depict a small covered footbridge on Twachtman's property: *The White Bridge* (Art Institute of Chicago), *The Little Bridge* (Georgia Museum of Art), *The White Bridge* (Minneapolis Institute of Art), and *Bridge in the Woods* (private collection).[7] Although none of the canvases is dated, stylistic evidence indicates that the MAG oil and *Bridge in the Woods* are the last in the series, their bold brushwork exemplifying Twachtman's return at the end of his career to the bravura paint-handling he had learned as a student in Munich. The paintings show two distinctly different structures, alike only in their white paint and latticed railings. The bridge in the Chicago and Georgia oils has a peaked roof and a flat deck, whereas that in the other canvases has a curved roof and deck. Set low over the water, the flat-decked bridge would easily have washed away in the spring flooding that is common on Horseneck Brook. In his second attempt at bridge-building, Twachtman arched the deck over the stream, thus securing greater protection from seasonal torrents and allowing his children to glide underneath in the rowboat shown in the MAG painting. (A few dabs of blue paint suggest a child's form in the boat.)

John Henry Twachtman,
1853–1902
The White Bridge, late 1890s
Oil on canvas, 30¼ x 25⅛ in.
Gift of Emily Sibley Watson,
16.9

Twachtman's ingenious design—clearly evident in the Museum's *White Bridge*—enabled him to achieve an arched effect with limited carpentry skills. He built the planking in three parts: two side sections, each set on a slant, step up to a raised central platform. (The structure seems oddly unfinished: a gap in the planking poses a hazard to strollers, and the railing is latticed only on one side.) Twachtman's inspiration may have been the myriad footbridges over the canals of Venice, where he spent a total of at least eighteen months in the 1870s and 1880s.[8] Although the more elaborate Venetian bridges, like the Ponte di Rialto, are curved on the underside, their pedestrian surface exhibits an angular three-part construction similar to Twachtman's homemade footbridge.

But if Venice informed Twachtman's design, it was only one source among several. His cosmopolitan, eclectic taste manifested itself in his living room, described by a contemporary: "plaster was thrown on the walls, which were then bronzed over with a brush, resulting in a quiet Japanese effect....The fireplace is massive with...one stone...projecting as a bracket for an Italian saint."[9] On the exterior, the classical portico (said to have been designed by Stanford White), vine-covered pergola, and standard trees in terracotta pots lent a European flavor to the Connecticut farmhouse. Similarly, the footbridge's ancestry is American in its diversity, evoking at once the Chinese-Chippendale embellishments of the Colonial Revival, the high-arched bridges of Japanese gardens, and the crisp whitewash of New England picket fences.[10]

The white paint links Twachtman to the taste of his time. Instead of leaving the wood bare, with the bark unpeeled, as the influential landscape designer Alexander Jackson Downing advised in the mid-nineteenth century, or coating it with red lacquer, as Asian garden designers preferred, he painted it white, matching his house. "He was especially fond of white in sunlight and left many impressions of white houses among green trees," one critic observed after viewing Twachtman's estate sale.[11] The white bridge enlivened the brookside landscape, making the delicate structure a worthy challenge to a painter who enjoyed exploring the chromatic subtleties of snow. Years earlier, Twachtman had expressed his admiration for the French painter Jules Bastien-Lepage's treatment of white. "What tasks the man did set himself in the painting of a white apron with which he was as much in love as the face or the person," Twachtman wrote.[12] The same might be said of his own delight in the varied colors playing over his nominally white bridge.

Besides making it the subject of his painting, Twachtman may also have used the bridge as a place from which to paint. The central platform provided a raised vantage point and the space to set an easel. The cloth canopy, arched in the center like a Palladian window, functioned like the white umbrella that was standard equipment for a *plein-air* artist. Since the bridge's exact location is only speculative, it is impossible to identify works painted from that viewpoint. However, several of Twachtman's canvases depict Horseneck Brook from an elevated position in mid-stream, suggesting that he sometimes used the bridge as an outdoor studio.

John Henry Twachtman,
1853–1902
The White Bridge (detail),
late 1890s
Oil on canvas, 30¼ x 25⅛ in.
Gift of Emily Sibley Watson,
16.9

John Henry Twachtman,
1853–1902
The White Bridge (detail),
late 1890s
Oil on canvas, 30¼ x 25⅛ in.
Gift of Emily Sibley Watson,
16.9

Twachtman moved out of his home on Round Hill Road in December 1899. For the following year and a half, while his wife and children lived in France, his primary base was the Holley family's boardinghouse in the Cos Cob section of Greenwich. He also visited his family in Honfleur and spent time in New York, Boston, Cincinnati, Chicago, and Buffalo. During the summers, he taught at Gloucester, Massachusetts, where he died on August 8, 1902. Three years later, *Country Life in America* published an article on his house and garden.[13] The author took readers on a virtual stroll along the brook, but did not mention a footbridge. That fragile structure had probably succumbed to repeated winter gales and spring floods. It catches the sunlight still in *The White Bridge*.

Susan G. Larkin is an independent art historian, specializing in American paintings and sculpture.

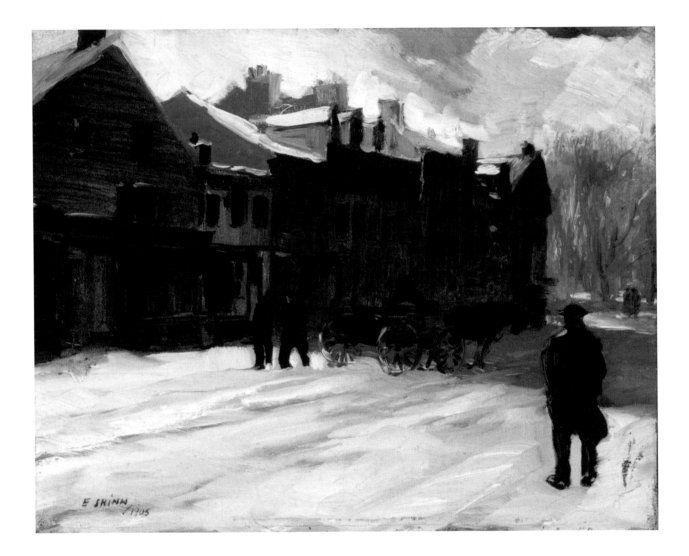

32: Everett Shinn *Sullivan Street* (1900-1905)

Marjorie B. Searl

"The Eight, by One of Them" was the intriguing title of artist Everett Shinn's talk at the Memorial Art Gallery on the occasion of a 1944 exhibition of "The Eight," the group of New York-based artists who first exhibited together at Macbeth Gallery in 1908.[1] In 1944, Shinn, along with John Sloan, was one of the last two surviving members of the group. The Eight had come together to protest the jurying practices of the Academy, and also because they admired the independent spirit of their mentor, Robert Henri, who encouraged them to seek the beauty in the world around them, liberated from conventional restraints of style or subject.

Having moved from Philadelphia in 1897 to find his fortune in New York City, Everett Shinn lived around the corner from the Greenwich Village scene that he painted with flourishing brushwork in *Sullivan Street.* The streets of lower Manhattan and its picturesque park, Washington Square, were among his most frequent subjects during the early years of his career, when he wasn't painting theater and dance scenes. His talent was quickly recognized, and fortuitous high-society contacts led to interior design commissions that were mentioned in newspapers and magazines, moving Shinn from the role of struggling artist to that of the accomplished and sought-after man about town.[2] Unlike other members of The Eight, Shinn seemed less engaged with artistic politics, and in fact actively debunked the "radical" nature of The Eight in talks and articles later in his life:

> He is amused at the legend of "The Eight." Sloan, Glackens and Luks had been newspaper-illustrator friends of his in Philadelphia. The group showed together without plan, "without anything against anyone. We just painted what we were used to drawing and seeing....Not one of us had a program....[S]ure, we were against the monocle-pictures at the Academy, but that was all. None of us had a message—and its funny now when they try to make me a "protest" painter. I wasn't....Actually, because I wasn't as interested as the others in people sleeping under bridges...I was often accused then of being a social snob. Not at all—it's just that the uptown life with all its glitter was more good-looking. The people made pictures.[3]

His comments notwithstanding, some of Shinn's most evocative paintings depict the "downtown life." *Sullivan Street* contains within it elements of the city that were cautionary—an isolated observer, ramshackle buildings, and street laborers—the very kinds of things that would earn The Eight the sobriquet of "Ashcan painters." Washington Square's trees are visible at the end of the block, but it is the texture of the street that intrigues Shinn in this particular work.

For the contemporary viewer, a Greenwich Village street conjures up romantic images of either the intellectual world of writers Henry James and Edith Wharton, or the bohemian world of social reformers John Reed and Emma Goldman. At the time that Shinn was painting, however, he would have known that Sullivan Street, and the neighborhood south of Washington Square, was peopled by immigrants, primarily Italian, and home to some of the poorest residents of New York. It also had the reputation of being one of the toughest neighborhoods in the city. In the 1890s, journalist Jacob Riis photographed areas near Sullivan Street, the "vile rookeries of Thompson Street and South Fifth Avenue" where the "old Africa [was] fast becoming a modern Italy."[4] And, "by 1900 most of [Greenwich Village's] elite residents had departed....[T]he area was known simply as the Ninth Ward, dominated by working-class Italian immigrants."[5] An Italian immigrant named Anacleto Sermolino "recalled that after standing on the corner of Bleecker and Sullivan for the first time

Everett Shinn,
1876–1953
Sullivan Street, 1900–1905
Oil on canvas, 8 x 10 in.
Marion Stratton Gould Fund,
45.45

[after his arrival in the United States in the 1890s] and seeing pushcarts loaded with Italian cheeses, pasta and vegetables and hearing women shoppers conversing in Italian, he had told his wife: 'This is not a strange land we have come to, but a little piece of Italy.'"[6]

Shinn's record book contains several references to a *Sullivan Street* title, beginning in 1901 in lists of work at Boussod, Valadon & Co., his dealer. Also, a label on the back of the frame of MAG's *Sullivan Street* gives the date as 1900. At this point, Shinn was doing primarily pastels, making it difficult to ascertain fully that the 1901 record book reference to *Sullivan Street* is the same work as the MAG painting. Contributing to the confusion is the fact that the MAG painting has a 1905 date on the lower left, the date that is assigned to it in the 1943–44 circulating exhibition from which it was purchased. Whether Shinn painted two versions of *Sullivan Street* is unknown. Further confusion arises in a physical examination of the work, for it then becomes clear that the painting extended over three of the sides wrapped around the stretcher. Had Shinn painted a larger version, and then cut it down to fit an older frame? Had it been damaged in shipping, and then cut down to its current size? Did he simply misremember the date that it was painted, or, since it was put into an exhibition about The Eight, did he choose to date the painting closer to 1908?[7]

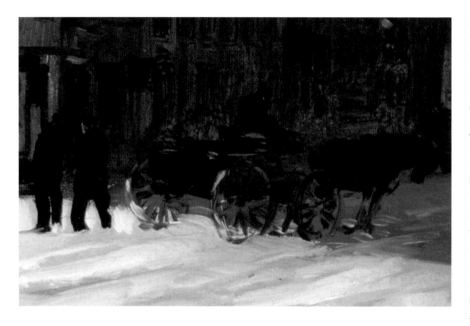

Everett Shinn,
1876–1953
Sullivan Street (detail),
1900–1905
Oil on canvas, 8 x 10 in.
Marion Stratton Gould Fund,
45.45

Following his Memorial Art Gallery lecture in 1944, Shinn and the curator, Isabel Herdle, reached an agreement about having *Sullivan Street* enter MAG's collection. A heated correspondence ensued. According to a telegram sent to Herdle from Margaret Jarden at the Museum of Modern Art, *Sullivan Street* was held back by MAG, presumably for purchase consideration, when the rest of the exhibition returned to New York in January 1945.[8] Soon thereafter, Shinn wrote Herdle to negotiate a price for the painting. "After the terrific pressure put on me in doing the 3 large murals for the Hotel Plaza new bar [the Oak Bar] is over I can get down to the sifting of the advantages and monitary [sic] losses on my pictures in case you accept my following propositions....Sullivan Street being of old New York is of more value at the moment but no better than the French street [another painting by Shinn being considered]."[9] He closed by saying, "It's nice to know that you would risk me talking again in the Museum."[10]

On March 6, 1945, Shinn contacted Isabel Herdle (whom he referred to as "Miss Hurdle") and alerted her to the fact that he had just sent her "a package containing a copy each of Rip Van Winkle for you and your sister [Gertrude Herdle Moore, MAG's director]....I sent one copy also to the sugar givers and they should get theirs about the same time....Please let me hear from you."[11] Shinn was asking $300 for the painting. Two weeks later, he implored: "Probably my hardest, most persistant [sic] and disappointing task is to get a reply to my many letters directed to you....What is the decision about the Sullivan street picture? Please let me hear from you....I feel I do deserve a reply. Yet, thanks for all your interest."[12]

Desperation sets in by April. Shinn tries a new tack:

> Please give me some sign that there is a Rochester and that I had not been in a dream state and believed that I talked in your Museum and met some delightful people and that there was some talk of purchasing one of my pictures for the museum.

Perhaps this is all imagination and there never existed "The Eight" and I am not an artist but a solicitor for a charity.

It has been months and months since my visit (if not a dream) and I do wish that you would unwind these coils of my delirium and make it definite about the painting (Sullivan Street)....

Please let me know...as I haven't the time to go to your Museum steps and wait for you.[13]

Anger soon replaces desperation: "I cannot understand why I cannot get an answer to my many letters of inquiry about 'Sullivan Street'....I have told you repeatedly that I would prefer it being in a gallery of your standing and I feel that my price is ridiculously little....Either buy it at my price or return it at once....P.S. I am not starving for recognition or money but I have a genuine hunger for getting things done that have been started."[14]

On May 1, Shinn's wish was granted. Miss Herdle wrote, deftly:

You have every right to be as annoyed as your letter sounded. It has been months since we first began negotiations about "Sullivan Street", and months since I have written you. I swore a little private oath that after this length of time had elapsed that I would not write until I could report a definite verdict on the painting. So here I am—at long last!

The delays in the Accessions Committee meeting are almost beyond belief— snow storms, Florida jaunts of committee members, illnesses, about a month ago the death of the Chairman of the Committee and the founder of the Gallery, and finally the election of new committee personnel. All this will not interest you, but it is the reason that no decision has been reached until now....

A check for $300.00 from the University of Rochester which handles our purchase funds will go to you shortly. Since this final step does not involve any member of our board or staff whom the gods of delay seem to delight to plague this year, there should be no further delay.

Again I am very sorry that you have had all this troublesome delay. Please forgive us![15]

The happy ending for both parties was that the painting, certainly one of Shinn's gems, remained at the Memorial Art Gallery to form, with other works by The Eight, the nucleus of MAG's pre-eminent Ashcan collection. And the story of Shinn at MAG continues: New York artist Ken Aptekar appropriated Shinn's image in 2001 in his painting *Everett Shinn Writes Isabel Herdle*, in which he enlarged the tiny painting by several hundred percent and invited viewers to take a closer look. Shinn would have been intrigued by Aptekar's innovative technique and probably entertained by the fact that his words were enduringly incorporated into an homage to *Sullivan Street*.[16]

Marjorie B. Searl is Chief Curator, Memorial Art Gallery.

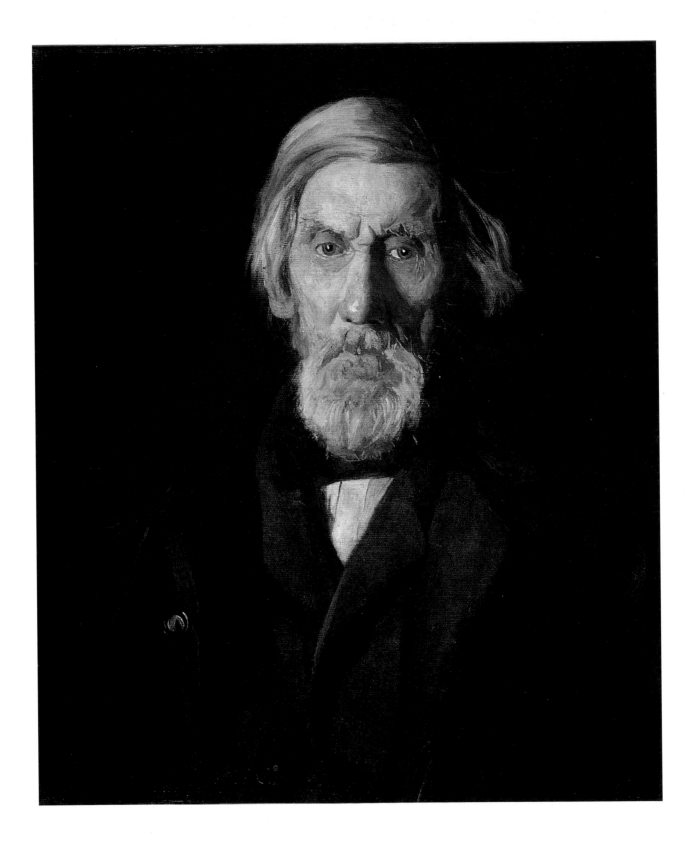

33: Thomas Eakins *William H. Macdowell* (ca. 1904)

Elizabeth Johns

When William H. Macdowell posed for Thomas Eakins in 1904, the artist had already painted six or seven portraits of him. They had known each other since at least the early 1880s, when Macdowell's three sons, his daughter Susan, and other mutual friends joined Eakins in a jaunt to the beach community of Manasquan, New Jersey, to make photographs. Taking turns with the camera, the group created idyllic scenes—reminiscent of sculpture from antiquity—of nudes walking together in friendship, posed languorously on the sand, and playing pan-pipes and other flutes near low-lying shrubs.[1]

Macdowell, known as a "free-thinker" in the tradition of his hero Thomas Paine, was surely an advocate of this venture. Not only was he something of a rebel and a learned conversationalist about ideas old and new, but, like Eakins, he lived and breathed pictures. He earned his living as an engraver and photographer, meanwhile passing on to his children his intellectual independence. His daughter Susan, who had absorbed her father's fascination with photography and had also become a highly skilled painter, married Eakins in 1884. She had first met the artist in 1876, when his *Gross Clinic* had been exhibited at the Philadelphia Centennial; subsequently she became his student.

Thus when Eakins stood at his easel to paint Susan's father in 1904, he had known Macdowell for a quarter of a century or more. That period of time had seen many changes in both their lives. In 1885, only a year after he had married Susan, Eakins had been forced to resign from his prestigious position as Director of Instruction at the Pennsylvania Academy of the Fine Arts. At issue was his use of nude models for both male and female students as well as his encouragement of his students to pose for each other in the interest of economy. The blow to Eakins was severe—professionally, economically, and emotionally. Given Macdowell's unconventionalism, one can imagine his solid support, like that of Susan, for the artist. However, the recriminations from a few of Eakins's former students were bitter, resulting in estrangements that affected him the rest of his life.

Thereafter many of his portraits seem steeped in melancholy, even regret, that seem to have emanated from the artist himself. Because he chose virtually all his sitters, asking them to pose for him because as artists or musicians or scientists they were "worthy of being remembered," he may have been drawn expressly to those who had known disappointments.

Surely in at least one respect Macdowell fits that description. Two years before Eakins painted this last portrait, Macdowell's wife (and Susan's mother) had died. The portrait photographs that Susan or others of the Eakins circle had taken of Mrs. Macdowell about 1890, when she was in her midsixties, show her to have been a small, solemn person, her face already creased with age, her hair swept back in a plain, practical style. In only one photograph, a profile, does she wear a hat, and this one quite fancy, complementing an elaborate plaid dress. As Mrs. Macdowell was some eight years younger than her husband, her death while he himself was still robust must have been a terrible blow.

Eakins's earlier images of his father-in-law present him as serious, but also as a character. In several photographs and in at least two painted portraits, Macdowell looks away from the viewer, wearing a heavy coat with collar turned up and a wide-brimmed hat somewhat rakishly set on his head. In 1904, however, in the portrait at the Memorial Art Gallery, Macdowell is formally dressed and looks directly toward the painter and viewer. He marks his unconventionalism in actually wearing two coats—his suit coat and an outer coat—with the result that the portrait reveals more than one set of buttons. He casts his eyes slightly downward, preserving the sense that it is his interior vision—

Thomas Eakins,
1844–1916
William H. Macdowell, ca. 1904
Oil on canvas, 24 x 20 in.
Marion Stratton Gould Fund,
41.26

Thomas Eakins
William H. Macdowell,
1880s
Albumen print, 3¹⁵/₁₆ x 2¾ in.
The Metropolitan Museum
of Art, Gift of Julius Ravzin,
1979 (1979.547.1)
Photograph ©2005 The
Metropolitan Museum of Art

perhaps his memories—that matter to him now. His face is narrow and long, the cheek bones made obvious and the deep lines in his forehead accentuated with Eakins's knowing modeling. Dark areas near his nose and eyes mark the ravages of age— Macdowell was then in his late eighties. Gray mixed with white, his mustache and beard seem to have been trimmed for this occasion, in contrast to their near-wildness in earlier photographs. Perhaps he and Eakins had decided that this would be the last time he would sit for Eakins. And indeed it was.

It is tempting to compare this portrait with Eakins's self-portrait of two years earlier (1902), which he presented to the National Academy of Design on his election to Associate. Only slightly larger than his portrait of Macdowell, this image, too, shows the sitter dressed formally, his hair somewhat kempt and his beard and mustache neatly trimmed. Although Eakins, born in 1844, was almost thirty years younger than Macdowell, in this self-portrait at age fifty-eight he comes close to looking as worn, as ravaged by time, as his father-in-law.

Susan kept all Eakins's portraits of her father, with the exception of one that belonged to her brother William G. Macdowell. After Susan's death in 1938, the portraits she owned passed into the hands of dealers; in 1941 the last of Eakins's portraits of Macdowell, and perhaps the most absorbing, was purchased for the Memorial Art Gallery.

Elizabeth Johns is Senior Fellow, Center for Religion, Ethics and Culture, College of the Holy Cross, and Professor Emerita of the History of Art, University of Pennsylvania.

34: Childe Hassam *The Bathers* (1904)

Margaret Bullock

his idyllic, fantastical scene of nude bathers in a landscape (on a canvas over twelve feet long) was originally part of an even larger composition by the American impressionist Childe Hassam. Hassam's friend Charles Erskine Scott Wood, a lawyer, amateur painter, writer, and patron of the arts, had hoped that paintings by Hassam and the artists J. Alden Weir and Albert Pinkham Ryder would all adorn his Portland, Oregon, home.[1] In the end, only Hassam's mural was completed.[2]

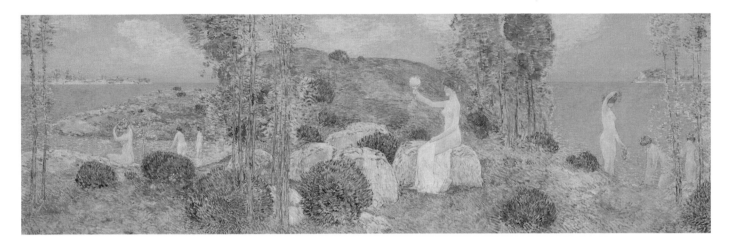

The mural commission arose from a conversation between Hassam and Wood in the fall of 1903 in which Wood mentioned his desire to tie together the eclectic collection of paintings, antiquities, sculptures, Asian art objects, and rare books in his library.[3] Hassam offered to create a decorative program for the walls of the room. He began work around November and wrote Wood on March 1, 1904, to report that the mural was complete and on view in his New York studio.[4] "A great many of the best men here have seen your decoration and they like it," Hassam proudly reported. "Of course it is too far 'up the gulch' for most people....Pinkey [Albert Pinkham Ryder] came up and was most appreciative."[5]

Childe Hassam,
1859–1935
The Bathers, 1904
Oil on canvas, 48³⁄₁₆ x 148¼ in.
Gift of Mr. and Mrs. Ogden
Phipps, 63.27

Hassam's hallmark as an artist was his versatility. His brushwork was fluent and changeable and he adapted his techniques and compositions to suit his subjects. Though his works often looked as if they were dashed off rapidly and easily, he labored over many of his canvases, working and reworking them sometimes for years. Hassam never radically departed from his impressionist style once he adopted it in the 1890s, but he did like to experiment with new stylistic elements as well as new formats, media, and painting techniques throughout his career.

In 1903 when he began work on the mural for Wood's library, Hassam was a well-established and highly successful painter, known for his impressionist views of New York's streets and the artist colonies and seaside towns of New England, particularly the Isles of Shoals off the coast of New Hampshire. His eagerness to create a mural for Wood's library and the speed with which he completed it suggest it was a format he had been considering for some time. Murals were a popular choice of decoration for American public buildings in the late nineteenth century and many of Hassam's contemporaries had received such commissions. Wood also was a supportive friend and patron, allowing Hassam freedom in his choice of subject and composition. The mural project offered him an opportunity to experiment and challenge himself in a variety of ways, including the large-scale format, extended consideration of a single motif (nudes in a landscape), and use of a modernist palette and composition.

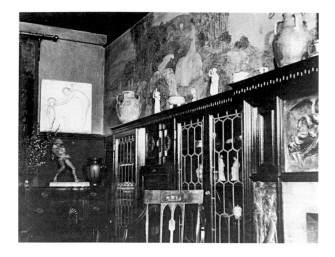

Like *The Bathers*, the other sections of the library mural depict both individual nude female figures and groups of nudes along the shore of a body of water. Hassam had painted similar scenes of nudes in landscapes prior to 1904, and they became a regular subject later in his career. In the case of the mural, it is unclear whether this motif was his own idea or Wood's. But Hassam had been using classical elements in his paintings since 1900, and the idealized female forms in *The Bathers* are certainly reminiscent of archaic and early classical Greek sculpture.[6] During this period, Hassam was also grappling with the innovations of the postimpressionists and experimenting with elements of their styles. In its dream-like arcadian setting and bright palette, the mural suggests the work of both Georges Seurat and the symbolist painter, Pierre Puvis de Chavannes, both of whose work Hassam had studied.

Library, C.E.S. Wood's House,
Portland, Oregon, ca. 1910
Oregon Historical Society,
OrHi74497#1132-A

The mural was painted as a series of individual canvases (probably for easier transport across country) but conceived as a single continuous decoration. Hassam gave the composition an overall rhythm and harmony through his repetitions of vertical accents, strategically placed rock formations, and figure groupings. The palette and brushwork are also consistent across the entire mural. Generally, the background and sky are fairly thinly painted, with the canvas showing through in spots; so too the larger landscape elements in the foreground and middleground. Landforms along the horizon are outlined with simple descriptive strokes that suggest certain shapes (a hill, the curve of a rock, etc.) without extensive detail, a form of shorthand notation Hassam used regularly. In contrast, foreground clusters of vegetation are riots of freely painted dots, dashes, drips, and strokes of color—virtuoso passages of impressionist painting. The nudes are heavily impastoed, simplified forms with touches of color to indicate details. Though he painted them regularly, Hassam's figures often feel rather wooden or awkward, particularly in contrast to his fluid landscape painting. Here, the nudes show signs of having been labored over and reworked a number of times, and were clearly the most time-consuming element of the composition.

One figure in *The Bathers* stands out among the varying clusters of nudes. She is seated just right of center, holding a mirror. Images of women holding mirrors have been a common motif in art since antiquity. They are often meant as *vanitas* emblems to suggest the fleeting nature of beauty and life. Hassam's nude, however, turns her mirror toward the world outside the mural, both acknowledging its separation from her idyllic setting and incorporating it. By reflecting Wood's world, the mirror also suggests that he is part of both the classical artistic lineage the nude represents and the half-real, half-magical world in which she resides.

Childe Hassam,
1859–1935
The Bathers (detail), 1904
Oil on canvas, 48³/₁₆ x 148¼ in.
Gift of Mr. and Mrs. Ogden
Phipps, 63.27

Pictures of Wood's library taken around 1910 show that the original mural occupied the two long walls of the room above the bookcases. Wood's grandchildren also remember it extending onto a third wall (not photographed).

When Wood later sold the house, the mural was split up into five canvases of varying sizes, one for each of his children. Over time, the pieces were sold out of the family and are now scattered across the country.[7] *The Bathers,* the largest of the canvases, was given to Wood's daughter, Nan Wood Honeyman (the first congresswoman from Oregon), who still owned it in 1953 when it was lent to the Portland Art Museum for exhibition. By 1963, it had been sold to the Hirschl & Adler Gallery in New York, where it was purchased by Mr. and Mrs. Ogden Phipps and then donated to the Memorial Art Gallery.[8]

Though Hassam was a highly prolific artist who worked in a variety of media, creating thousands of paintings, drawings, and prints during his career, the mural for Wood's library was one of only two he ever attempted. The second was a mural he painted for the Panama-Pacific Exposition in San Francisco in 1914 that also included idealized female figures. Apart from the murals, Hassam's only other large-scale work, again an image of nudes in a landscape, titled *June* (1905, 84 x 84 inches), is now in the collection of the American Academy of Arts and Letters, New York.

The Portland mural also played another significant role in Hassam's career. During his 1904 trip to Oregon to install the work in Wood's library, he was captivated by the state's rich and varied landscape, particularly the eastern desert. Hassam created sixty or more oils, watercolors, and pastels that are unique in his body of work for their western subjects, lack of reworking, and, for many, his use of pure *plein air* painting.[9] These images, and the library mural, reveal an artist secure in his ability and willing to explore new worlds, both literal and artistic.

Margaret Bullock is Curator, Harwood Museum of Art, Taos, New Mexico.

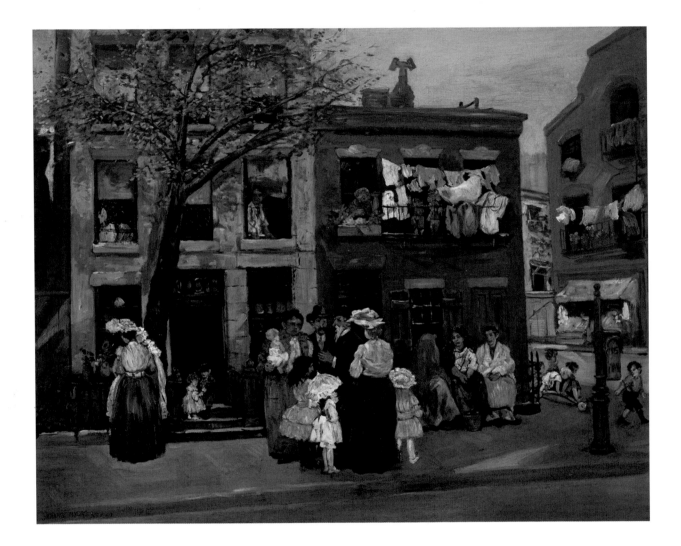

35: Jerome Myers *Sunday Morning* (1907)

Grant Holcomb

*S*unday Morning immediately shows why Jerome Myers has been called the "gentle poet of the slums"[1] for his compassionate portrayals of immigrant life on New York's Lower East Side. His entire body of work underscores a long-held tenet within the American experience, recalling Emerson's admonition to American artists to explore "the near, the low, the common" while, at the same time, echoing Whitman's optimism of spirit and the elevation of the common man.

Born in Petersburg, Virginia, in 1867, Myers grew up in poverty, which perhaps explains his affinity for the unpretentious lives of the urban poor.[2] When he moved to New York City with his family in 1886, he gravitated to the Lower East Side and immediately recognized that it "would furnish the material for his life's work" as an artist.[3] "My song in my work," he wrote, "is a simple song of the poor far from any annals of the rich."[4]

Myers's artistic vision, however, precluded any sense of the grinding poverty, the squalor, and deprivation often found and documented on the Lower East Side. "I went to the gutter for my subject," he admitted, "but they were poetic gutters."[5] His was not a world of sweatshops and street urchins but rather one where people gathered to gossip and barter in the marketplace, rest in city parks or at the end of East River piers, participate in the many religious festivals or attend the theater and outdoor concerts. Myers cherished, above all, the playful, colorful lives of the children he observed on the Lower East Side. He referred to these young boys and girls as the "little jewels who sprinkled my pictures."[6] Always clean and well-dressed, they bear no resemblance to the street urchins that haunt the photographs of Lewis Hine and Jacob Riis or paintings by George Luks. "Why catch humanity by the shirt-tail," Myers wrote, "when I could…see more pleasant things?"[7]

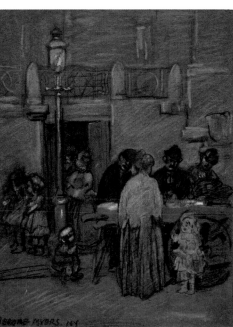

Myers painted *Sunday Morning* in 1907 when he, his wife Ethel, and one-year old daughter Virginia lived on West Twenty-third Street. In that same year his friend John Sloan painted his boisterous up-to-the-minute *Election Night*. By contrast, Myers's scene seems almost nostalgic in its peacefulness. In his autobiography, the artist recalls a quieter Manhattan as he describes the scene a couple of dozen blocks south of his studio apartment:

> *It is Sunday morning in the Italian quarter of the city.…Here are life-loving men strolling with their wives and children, all unhampered by traffic rules…no traffic signs, no safety zones, no automobile peril.*[8]

Little Italy, with its narrow streets and vibrant street life, ran from around Bleecker Street south to Canal Street in Lower Manhattan. During the first quarter of the twentieth century, many American artists captured the drama, vitality, and spirit of this section of the city but, perhaps, none more frequently than Jerome Myers.

Sunday Morning is a compendium of Myers's major motifs: tenement life on the Lower East Side where adults converse, children play, and the public nature of private lives is revealed in family laundry drying outside tenement

(Facing page)
Jerome Myers,
1867–1940
Sunday Morning, 1907
Oil on canvas, 29 x 36 in.
Marion Stratton Gould Fund,
98.74

windows. The stage-like setting is a familiar compositional device that reflects Myers's early training as a scene painter in New York theaters. Typical, also, are the clean, well-dressed children in Myers's compositions. For Myers, childhood was a period of joy and enchantment. Indeed, he wrote that "the happiness of children, their number and their well being amply made up for the parents' privation."[9] Whether playing in city parks or walking on city sidewalks, they were, in John Sloan's words, always dressed "in pinafores and pantaloons."[10] In this respect, Myers's paintings may have directly inspired the illustrations for Sydney Taylor's popular children's classic *All-of-a-Kind Family*. Published in 1951, the novel depicts an Orthodox Jewish family living, as Taylor herself did, on the Lower East Side during the early years of the twentieth century. Mary Stevens's illustrations of the five daughters certainly call to mind the images of children in paintings like *Sunday Morning*. Clean and alert, the young girls sparkle in pinafores, pigtails, and colorful ribbons and, indeed, seem close visual counterparts to Myers's paintings of youthful exuberance and joy.

Myers was at the height of his career when he painted *Sunday Morning* in 1907, and it is a mystery why he wasn't selected to participate in the historic exhibition of The Eight the following year at the Macbeth Gallery. The exhibition of The Eight was organized by Robert Henri, who personally selected the artists. That Myers was a friend of Henri's and that his work reflected, both in style and content, the basic principles of the other city realists in the exhibition makes his exclusion questionable. Indeed, ten months before the show opened, an article in *Harper's Weekly* referred to Myers as one of the strongest members of "The school of Robert Henri."[11]

Perhaps the fact that Myers had his first one-person exhibition at Macbeth's a month prior to the opening of The Eight is explanation enough. Others, however, interpret his exclusion as a deliberate rejection. William I. Homer, in his seminal study of Henri, felt that the artist found Myers's work too sentimental and, thus, excluded him on aesthetic grounds.[12] John Sloan, a close friend of both Henri and Myers, stated that Jerome "would and should have been a member [of The Eight]." But "he was too much Henri's age to adopt the position of disciple that Henri demanded" from his friends.[13] Whatever the true reason, Myers himself remained puzzled. As his wife, Ethel, later wrote, "I do know that Jerome never knew why he wasn't included."[14]

Myers, however, remained active in the New York art world. In 1910, for example, he participated in the Exhibition of Independent Artists, the first open, nonjuried exhibition ever held in America. The following year he helped organize the Armory Show, arguably the single most important art exhibition ever held in America. In fact, the very first discussions of such an exhibition were held in his studio on West Forty-second Street. Myers later called this extraordinary exhibition "the great American betrayal" as he felt that the introduction of European modern art dramatically shifted the original focus away from American realist painting. Certainly, any progressive aspects of American urban realism paled in comparison to the work of the postimpressionists, cubists, and futurists, and, after visiting the exhibition, Myers realized that "more than ever before we had become provincials."[15]

Though a disappointed Myers refrained from further active participation in the New York art world, he never abandoned his commitment to painting the Lower East Side. Friend and fellow-artist Harry Wickey wrote that this particular section of the city "struck a responsive chord in his nature and he recognized at once that here was the city whose subject matter could furnish the material for his life's work."[16] As Myers himself wrote at the end of his career, "Others saw ugliness and degradation there, I saw poetry and beauty."[17] From the time he first moved to New York in 1886 to his death in 1940, Myers never wavered from this compassionate and humane vision as an artist.

Grant Holcomb is The Mary W. and Donald R. Clark Director of the Memorial Art Gallery.

36: John Sloan *Election Night* (1907) *Chinese Restaurant* (1909)

Grant Holcomb

During his lifetime, John Sloan was often referred to as "the American Hogarth" for his robust and animated depictions of life in New York City during the early years of the twentieth century. And, shortly after his death, he was called "one of the chief creative artists of his time."[1] Today, Sloan is considered the quintessential representative of the "Ashcan" school, that group of urban realists who painted the unfashionable, unpretentious city life they found around them. Few paintings from this period better represent this tradition in American art and in the artist's total oeuvre than Sloan's *Election Night* and *Chinese Restaurant*. If tame to our eyes today, we must remember that they were considered by many to be radical and progressive, even revolutionary and vulgar, a century ago.

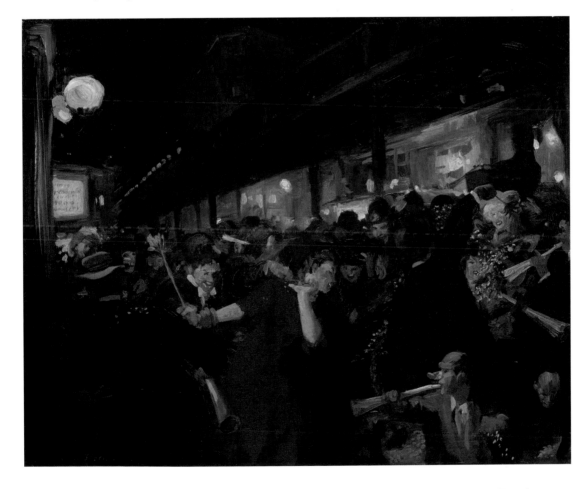

John Sloan,
1871–1951
Election Night, 1907
Oil on canvas, 26⅜ x 32¼ in.
Marion Stratton Gould Fund,
41.33

Sloan, like Walt Whitman, was an inveterate walker of the streets of Manhattan and, like the poet, could claim that "every hour of the day and night has given me copious pictures."[2] As Sloan wrote, "I saw people living in the streets and [on] the rooftops of the city and I liked their fine animal spirits."[3] His diaries of 1906–13 provide critical information as to how certain city scenes caught the artist's attention and were subsequently recorded on canvas. In his entry for November 5, 1907, he reveals how he came across the scene recorded in *Election Night:*

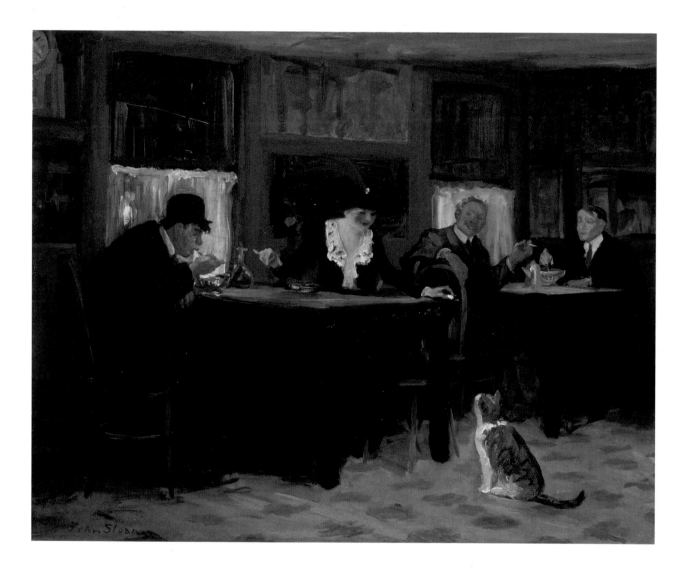

Took a walk in the afternoon and saw boys in droves, foraging for fuel for their election fires this evening....After dinner...out again and saw the noisy trumpet blowers, confetti throwers and the "ticklers" in use—a small feather duster on a stick which is pushed in the face of each girl by the men, and in the face of men by the girls. A good humorous crowd, so dense in places that it is impossible to control one's movement.[4]

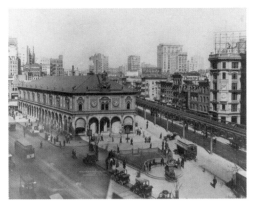

Exactly one week later, he records that he is working on the painting from memory and declares it "one of my best things."[5]

In passages like this, Sloan's diary reveals his delight in "the human comedy," in this case, the roar of the street and the raucous, lively crowd on the eve of an off-year election. The site, Sloan tells us, "was Herald Square, Sixth Avenue and 34th Street,"[6] where young and old watched the election results projected on the side of the now demolished New York Herald building.[7] A crowded composition with slashing diagonals and dramatic contrasts of light and dark convey the energy and excitement that the artist first observed on that early November evening.[8]

Irving Underhill, photographer
Herald Building and Herald Square, New York City, ca. 1910
Photograph, Library of Congress, Prints and Photographs Division, CPH3B15606

In addition to observing life on the city streets, Sloan enjoyed watching people eating, drinking, and conversing in the city restaurants, whether it was John Butler Yeats holding forth at Petitpas on West Twenty-ninth Street or male camaraderie at McSorley's Bar on East Seventh. And, certainly, the Memorial Art Gallery's *Chinese Restaurant* well represents this thematic interest of the artist.

In the winter of 1909, Sloan entered a small Chinese restaurant near his apartment on West Twenty-third Street. He was immediately taken by "a strikingly gotten up girl with dashing red feathers in her hat playing with the restaurant's fat cat." He later records in his diary (February 23, 1909) that "It would be a good thing to paint" and adds "I might make a go at it."[9] Approximately three weeks later he starts painting the scene from memory. His entry for March 18 reads, "Painted on my 'Chinese Restaurant' picture girl with red feather—and went to the restaurant for my dinner to refresh my memory of the place."[10]

Chinese Restaurant possesses the affection and good humor that typifies most, if not all, of Sloan's pictures of city life. Here an intimacy is achieved by placing the viewer in close proximity to the scene. The figures are arranged laterally across the composition and united by a rhythmical line that runs from the hand of the figure at the far left to the hand of the young woman; it continues up to her hat and down to her left hand and, finally, up and across to the hands of the two men at the far right. The narrative tension of the picture centers on the young woman with her bright red feather hat and her left hand that holds out a scrap of food for the hopeful cat.

Sloan's comment that "The girl is feeding her boy friend, before taking him home,"[11] has been interpreted by some critics to indicate that the woman depicted in *Chinese Restaurant* is a prostitute. One finds Sloan's use of the word "boy friend" a mere euphemism while others have written that "The titles of some of Sloan's pictures identify prostitutes with particular locales...."[12] Whatever the social or "commercial" situation, Sloan admired the painting's graphic expression and resonance of color.[13]

(Facing page)
John Sloan,
1871–1951
Chinese Restaurant, 1909
Oil on canvas, 26 x 32¼ in.
Marion Stratton Gould Fund, 51.12

Three years before his death in 1951, Sloan summed up his career as an artist by saying that he was interested, from the beginning, "in something about the people in a place, something about the mood, a thing John Butler Yeats called poetry."[14] Both *Election Night* and *Chinese Restaurant* possess this poetry of place and mood.

Grant Holcomb is The Mary W. and Donald R. Clark Director of the Memorial Art Gallery.

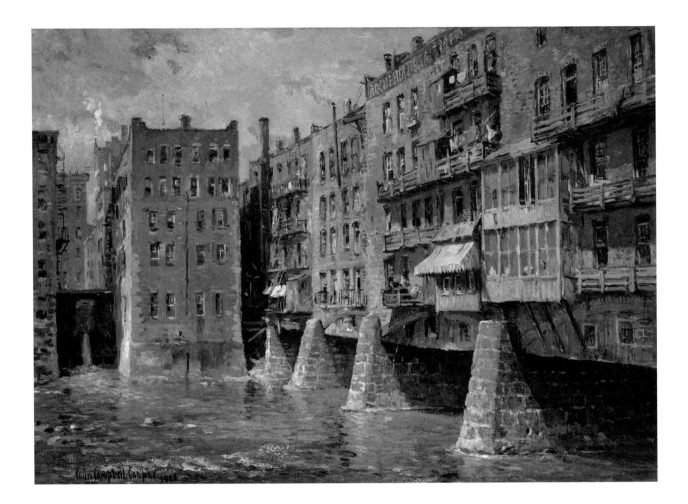

Ruth Rosenberg-Naparsteck

> *Mrs. Cooper says that the Main Street Bridge picture, whenever it has been shown at exhibitions, has attracted much attention, because people are surprised that such a foreign looking place can be found in America....People always compare it with the Ponte Vecchio at Florence, which rather proves my assertion that "any old thing" is good enough when the sun falls on it right.*
> —Colin Campbell Cooper[1]

Colin Campbell Cooper and his wife Emma Lampert were inveterate travelers in search of subjects to paint. Until Emma's death in 1920, they were based in Philadelphia and New York City, and their ties to upstate New York through Emma's friends and family often brought them to Rochester, where Cooper discovered many subjects to his liking.[2] Although he studied under Thomas Eakins at the Pennsylvania Academy of the Fine Arts, and also in Paris at the Académie Julian, it was likely the painter Childe Hassam's impressionist technique that influenced Cooper in his depiction of picturesque and colorful scenes. In the early years of the twentieth century, he was particularly interested in the buildings that were rapidly changing the Manhattan skyline, and his paintings of New York architecture were highly regarded.[3]

Cooper's Rochester visits resulted in an undetermined number of oil sketches and at least one major painting, *Main Street Bridge* (1908). Considering his interest in significant structures, it is not surprising that he chose to paint it and other Rochester landmarks, like the aqueduct and the Upper Falls.[4]

The bridge that Cooper painted remains the principal crossing of the lower Genesee River in Rochester, New York, and was the fourth construction on that site—more distinctive than its predecessors and tested by the ravages of time and the Genesee River itself. Before 1812, when Colonel Nathaniel Rochester and his partners, William Fitzhugh and Charles Carroll, first laid out the One Hundred Acre Tract on the west side of the Genesee River, the only bridge crossing was twenty miles to the south at Hartford, now Avon.[5]

A new crossing was needed to bring the recently opened Genesee Country into communication and commerce with the Niagara Region. Colonel Rochester must have noted when he purchased the One Hundred Acre Tract that the most advantageous crossing of the river was at the group of three small falls near the present Main Street Bridge. These falls together descended only fourteen feet, and while offering the necessary power to drive the waterwheels, the drop was not significant enough to hinder construction. In fact the low water made this an ideal location for a bridge.

Bridge construction began in 1810 and was completed in 1812 at a cost of twelve thousand dollars. It was constructed of wood and rested on wooden piers sunken into the stone riverbed. Since the east bank was much higher than the west bank, a ramp was required to reach the west side of the bridge floor. Farmers often stopped to water their horses where the water lapped up around the ramp. In the late fall of 1817 rushing flood water tore away at the piers and about five feet of the river's west bank were swept away. Increased travel and the threat of flood damage demanded a new, more accommodating bridge. The newly formed village of Rochesterville successfully petitioned the new County of Monroe for funding, and after a year of political bantering a contract for six thousand dollars was awarded to Elisha Johnson. The bridge was finally completed in December 1824, one year after the Erie Canal aqueduct two short blocks to the south.

Colin Campbell Cooper,
1856–1937
Main Street Bridge, Rochester,
1908
Oil on canvas, 26¼ x 36 in.
Gift of Mr. Hiram W. Sibley,
26.20

Soon enough, the new bridge began to fulfill the promise of its desirable commercial location. Within three years, two businesses crept out on the piers on the north side. Business lots were becoming scarce near the bridge, and because the rapids made this section of the river non-navigable, owners took advantage of the fact that they owned to the middle of the river and began to build out over the bridge abutments. The village itself built the first public market over the river at the northwest end. Farmers had sold their goods there for years, taking advantage of the traffic. In fact, the Main Street Bridge would be distinguished from all bridges in America and invite comparison to Ponte Vecchio in Florence.[6]

By 1830 the entire north side of the bridge was built over with wooden structures, the preferred stone buildings being too heavy. A substantial exception was the four-story stone Globe Building built to rest on the east end of the bridge. It housed small factories and, after the commercial

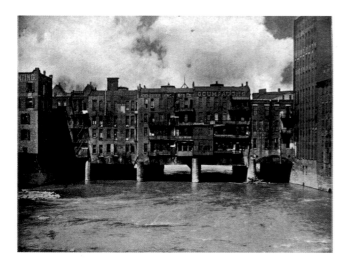

Reynolds Arcade, was the pride of the village. But building on the bridge was risky. A fire in 1834 and floods in 1835 and 1836 devastated the bridge, the market, and many of the surrounding buildings. Still the Main Street Bridge remained a preferred location for business. Rather than relocate, the city planners looked to control the river and rebuild the bridge stronger.[7]

A third bridge was built in 1837 with stone piers and an elevated east abutment to meet the rise in the road there, although plans for a cost-prohibitive all-stone bridge were abandoned. Within a short time the north side of the new bridge was lined with one- and two-story wooden buildings housing dry goods and inexpensive clothing shops, a few drug stores, and shops that advertised unusual wares. Even so, it was not an adequate crossing for the needs of the rapidly growing city.

Main Street Bridge Over
the Genesee River
ca. 1890s
Courtesy Rochester
Public Library

Agitation for the fourth generation of the Main Street Bridge, which appears in Colin Campbell Cooper's painting and upon which we walk and ride today, was precipitated by the need for a stronger and wider bridge that would replace the deteriorated wooden floor and sidewalks with substantial stone. For two decades the thousands of horses' hooves and heavily laden wagons had taken their toll on the bridge and rendered it dangerous. *The Daily Union* remarked that if people knew the condition of the bridge under the planks only the stout-hearted would cross.[8]

Work on the bridge began in September of 1855 after long, heated discussions over the number and shape of the arches, and the number and placement of the supports. Much had been learned over the years about the toll the river's flooding could take on the piers as well as the need to allow for clear passage of the river under the arches. Millers and commercial lot owners complained that any further construction of supports in the river impeded the river's flow and endangered their businesses. It was decided to rest the bridge on five rounded stone arches with piers adequate to support buildings on both the north and south sides. The cost soared as contractors found that Elisha Johnson had compromised the new bridge's soundness by using dirt instead of stone when he reinforced the east abutment in 1824. The controversies and changes of personnel delayed the start of construction so that the annual fall flooding swept away the work that had been done the month before. After eight thousand dollars invested, the city had nothing but a stack of stone waiting to be placed.[9] Construction delays, flood damage, changes in design, and cost overruns further plagued the project. Though the keystone set July 29, 1857, was celebrated that weekend, the Medina stone pavement was not finished until the following summer and the temporary wooden sidewalk served much longer.[10] Like the third bridge, the fourth bridge, painted by Cooper, was soon filled with buildings that housed businesses ranging from the Rochester Printing Company that printed the *Democrat and Chronicle*, to clothing and shoe stores and one store listed in the 1907–1908 City Directory as selling "kodaks."

Colin Campbell Cooper's depiction of the Main Street Bridge is the image most popularly held. This fourth bridge over the Genesee River holds the same attraction as the first—it is the heart of commerce, the connection between east and west, and the place everyone wants to be. When Cooper set out to paint the bridge around 1908, he selected an interesting vantage point— the back of the bridge buildings, from the south. This might seem odd at first, but it was a fortunate choice, because it also gave him the opportunity to paint the light on the river, the bridge's raison d'être. To paint from this angle, he must have had access to a room in the Post Express Building, on South Water Street. Current visitors to the site would be standing on the terrace at the Rochester Convention Center.

Main Street Bridge Railings
by Albert Paley, 1989
Photograph by Bruce Miller
Courtesy Paley Studios Ltd.

Cooper captures the power of the river, its shallow, quiet current as it moves under the bridge around the heavy stone piers that support the buildings. Across the river a tailrace spills water back into the river after having generated power to the mills. Cooper's dramatic use of the bridge as a strong diagonal is consistent with the composition of some of his other urban scenes (*Wall Street, New York Cityscape*). While it was probably inadvertent, he leads the eye to the very spot that Nathaniel Rochester had determined would be a good location for water-powered mills, expanding the painting's already substantial role as an icon of local history. The mid-day sun casts shadows under the awnings that shade and cool the riverside apartments and back rooms of the businesses. After more than half a century, the ravages of time sag the balcony floors and rails. This rear view contrasts with the bustle of people, carriages, and bicycles that frequent the presentable, public front of the businesses.

Cooper implies the humanity that drew people to the businesses on the Main Street Bridge. Darkness between the buildings across the river draws the viewer to look closer for other glimpses into life in 1908—a freeze-frame from one sunny afternoon. The movement in the sky is imperfectly reflected in the river below. The smoke moving slowly over the rooftops, carried by a gentle northward breeze, tells of life as usual on this day. Nothing out of the ordinary. The painting is a complex joining of long-gone buildings, each with its own story.

The bridge as Cooper shows it to us in 1908 has changed significantly over the years, although its stone arches and piers remain. Flood control studies blamed the constriction of the river's flow partly on the Main Street Bridge, but not until 1913 was a flood wall built on the west side and the arch obstructions removed on the east end. From 1915 to 1919 a river-deepening project further enabled the river to safely pass through the downtown. Since then, the Main Street Bridge surface has been repaved and improved a number of times. The buildings that once lined its sides obstructing the view of the Genesee River were removed in the urban renewal projects of the 1950s and 1960s. Today iron rails wrought by noted sculptor Albert Paley grace the sides of the bridge. The Main Street Bridge, still the mainstay of the city's commerce and traffic, has changed since Colin Cooper's memorable view of it in 1908, but remains in some ways the same: always functional, always beautiful.

Ruth Rosenberg-Naparsteck is the city historian of Rochester, New York.

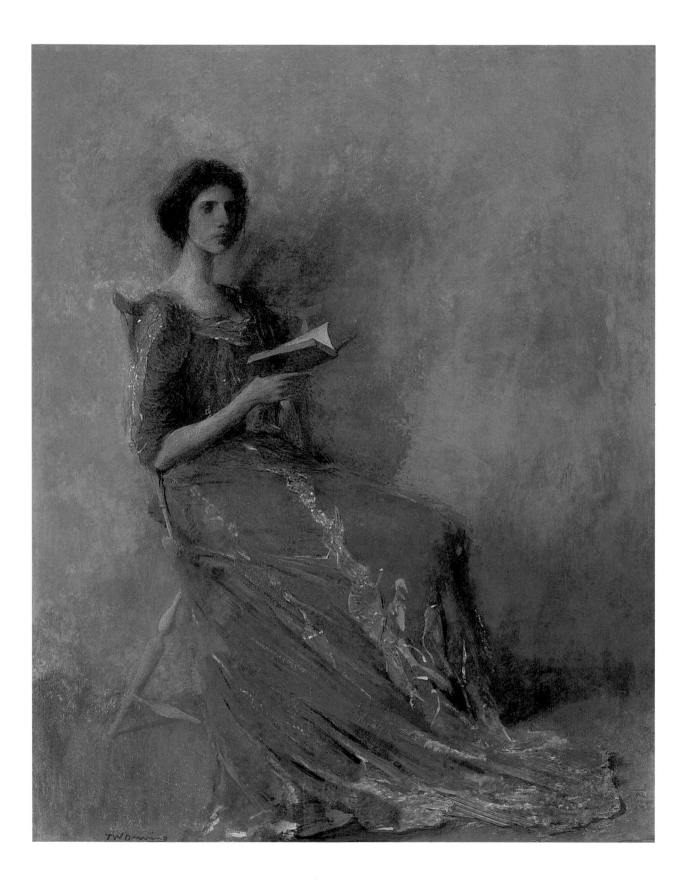

38: # Thomas Wilmer Dewing *Portrait in a Brown Dress* (ca. 1908)

Susan Hobbs

Thomas Wilmer Dewing uniquely wove together some of the most profound painterly influences of his time, especially those of James McNeill Whistler's profile figures, the flattened patterns of Japanese prints, and the richly rendered interiors of the recently rediscovered old master, Jan Vermeer. *Portrait in a Brown Dress* reveals this legacy in its utilization of unadorned, abstract space, its shimmering and complex brushwork, and in the classic seated pose employed by a generation of American artists who were inspired by Whistler. Dewing provided an individual interpretation of these themes in a manner unlike that of any other painter of his time. Employing his own inimitable brushwork, he explored the enigmatic psychology of womanhood in works that are subtly beautiful and inscrutably provocative.

Dewing was born in 1851 in Boston to a school teacher and a millwright who died of alcoholism when Dewing was twelve.[1] After grammar school he apprenticed with a lithographer from whom he learned the basics of draftsmanship, and then, like many of his peers, worked under the artist-physician Dr. William Rimmer, who taught his students drawing and anatomy at the Lowell Institute. In July 1876, after drawing chalk portraits of local notables in Albany, New York, he sailed for Europe, where he studied at the Académie Julian and developed an interest in the exotic, enigmatic themes that appeared in his own work when he returned to Boston a year later and continued when he moved to New York in 1880. He took a job teaching at the Art Students League and in 1881 married the well-known portrait and flower painter Maria Richards Oakey.

Dewing began to exhibit at the National Academy of Design, where his Pre-Raphaelite-inspired work called *The Days* garnered him the coveted Clarke prize in 1887. As a result, he immediately became an Associate of the Academy, and the following year he was elected to full Academician. He also began to spend time at the growing art colony in Cornish, New Hampshire. There, he and Maria purchased a house where, along with their only child, Elizabeth, they lived for eighteen summers before moving to a wooded retreat near the border with Maine. The verdant Cornish setting inspired his dozen or so landscapes with small figures placed in indistinct and billowing foliage.

For many years Dewing was also a featured exhibitor with the Society of American Artists, but in 1897 he resigned from that group to join the newly formed Ten American Painters. These artists had grown dissatisfied with the Society's crowded exhibitions and wanted more controlled settings in which to show their works. Most of them were already Dewing's close friends, and had begun to employ the broken brushwork associated with the impressionism movement abroad. Therefore, "The Ten," as they came to be called, were the foremost American impressionists of the day, Dewing included.[2]

By the mid-1890s Dewing was well known for his elegantly gowned women in carefully appointed interiors. In 1894–95, his patron, the Detroit railroad-car builder Charles Lang Freer, funded his study and travel to England and France. Freer even arranged for him to meet the American expatriate artist James McNeill Whistler, with whom Dewing worked briefly in London before moving on to Paris, where he shared a studio with the sculptor Frederick MacMonnies. Despite such beneficial associations, Dewing was, for the most part, disappointed with his time abroad and returned home earlier than expected. He was determined to paint in his own distinct manner, and was uninterested in following the latest trends in painting. Unlike the other members of The Ten, many of whom painted freely in vibrant colors, Dewing was by now a tonalist, an artist who worked in closely related hues with relatively solid modeling. His impressionist colleagues produced scenes depicting open windows and blowing curtains. He, by contrast, utilized environments illuminated by an artificial light

Thomas Wilmer Dewing,
1851–1938
Portrait in a Brown Dress,
ca. 1908
Oil on wood panel, 20 x 15½ in.
Gift of Mr. and Mrs. Alexander
Millar Lindsay III, in
memory of Jesse Williams
and Grace Curtice
Lindsay and their daughter,
Carolyn Lindsay White, 57.79

source. This sort of cloistered and ambiguous setting provided the perfect context for the unique, meditative themes that are distinctly Dewing's.

In 1900 the artist staged his first solo exhibition of twenty-one paintings at the Montross Gallery in New York City. Now fully established as an important figure in American painting, he produced just a few paintings a year for a select group of clients. Many of them were noted industrialists of the era, men who purchased a Dewing for their home, perhaps, as a respite from the rugged challenges they faced in their place of business. Not coincidentally, the well-known architect Stanford White also provided intricately patterned and gilded frames for artist-friends such as Dewing.[3] White's clients often were also Dewing's customers and his richly embossed borders enhanced the layered surfaces of the artist's works, enabling them to fit perfectly into the architect's ornate Beaux Arts interiors.

Dewing's upward spiral of success was crowned when he captured a first-class medal and a lucrative monetary prize of $1,500 at the 1908 annual exhibition of American paintings held at the Carnegie Institute in Pittsburgh. His winning painting, *The Necklace* (1908, Smithsonian American Art Museum) features the same model shown here in *Portrait in a Brown Dress* (also known as *Portrait, Portrait in Brown Dress, and Girl with a Book*) done the same year. The Memorial Art Gallery's painting, therefore, caps Dewing's career as a high-style work rendered in his mature style, embodying the special quality of mystery that marks his best efforts. Although her name is not known, the model is distinctive, possessing a long-limbed physique, a soft halo of brown hair, and a slightly aquiline nose. She was the quintessential "Dewing type," not quite pretty, but supremely aesthetic with her long lines and small head. The painter liked to keep his subjects ambiguous, and therefore open to various interpretations. Viewers attached a range of meaning to a work such as *Portrait in a Brown Dress*. For some she typified the vaunted New Woman whose intellect and sophistication would lead the nation. Others perceived the sitter as a passive, inward-looking, but serene symbol of culture.[4] A recent study has suggested that the quiet demeanor of the Dewing lady indicated the period's need to retreat from the noise, stress, and unwanted complexity of industrialization.[5]

Indeed, when in February 1908, the artist displayed *Portrait in a Brown Dress* at the Montross Gallery for the first time in a joint exhibition with his friend, the landscapist Dwight Tryon, he entitled it simply, *Portrait*. The artist seemed indifferent "to the human element in his picture," declared critic Charles de Kay, writing in the *New York Evening Post*.[6] Dewing displayed this picture along with another version of the same model in a slightly changed pose and in an alternate range of colors (*Green and Rose*, 1908, private collection). The identical sitter may have also sat for *The Print* (1908, Dallas Museum of Art), which was also on view. The noted critic Royal Cortissoz preferred *Portrait in a Brown Dress* and wrote about it in his *New York Daily Tribune* column.[7] An admiring Cortissoz thought that Dewing "has wreaked himself...on the painting of her tawny dress. It is in great measure the exquisite color he extorts from the fabric that justifies the work; you are attracted by the figure but you linger most appreciatively over the beautiful painting that the artist gives you, the subtly manipulated surface. This is a perfect example of art existing in and for itself." Dewing's own daybook shows that the dress was indeed as important to him as Cortissoz suggested. He indicates that the sitter wore an "aspinwall brown dress."[8] This material was thin and gauzy and perhaps imported from India. This garment appears in a number of pastels, possibly because

Dewing appreciated the manner in which the revealingly transparent fabric draped across the sitter. The dress is not actually brown, but only appears so due to the optical mixture of freely applied complementary colors that the painter layered one on top of the other. Viewed up close, the dress shimmers with gold. This effect derives in large part from the first application of an orange pigment, over which Dewing placed long sweeping motions of muted olive gray-green and taupe. From afar these colors blend and the viewer sees an unusual shade of brown. Wrote Charles de Kay of the picture in 1910, "the color wraps around the form like a garment, a diaphanous fabric of faint dyes;...the painter's style is so individual and extraordinary [that] the classic quality persisting through the nervous elegance of modern technique frequently is overlooked."[9]

As de Kay implies when he speaks of "the classic quality" of the work, Dewing did employ a traditional method in building up his intricate layering of pigment. For *Portrait in a Brown Dress*, he began work on a prepared Winsor Newton mahogany panel that was manufactured with a smooth surface of lead white. A beige tint followed, one that ultimately peeps through the layers of the finished painting. He then laid in the freely painted orange-colored dress, eventually subduing its vivid hue with long, tangled strokes of olive green and bluish taupe. These brush marks drift downward toward the lacy, lemon-colored flounce at the sitter's feet. The multidirectional, seemingly unpremeditated strokes lend the dress volume and energy. Such freedom finds a contrast in the

Thomas Wilmer Dewing,
1851–1938
Portrait in a Brown Dress (detail),
ca. 1908
Oil on wood panel, 20 x 15½ in.
Gift of Mr. and Mrs. Alexander
Millar Lindsay III, in
memory of Jesse Williams
and Grace Curtice
Lindsay and their daughter,
Carolyn Lindsay White, 57.79

small quill-like lines that define the pouched front of the model's gown. The flesh of her arm is suffused with tiny dots of pink and green that extend to the sitter's long, perfectly formed fingers and the crisp, delicate book that she holds.

For *Portrait in a Brown Dress* Dewing may have borrowed from Whistler and Vermeer, but his work is uniquely his own, less patterned than Whistler's, and with an airy touch quite unlike the solid handling of the Dutch master. This quality of uniqueness emanated from the almost imperceptible tensions that run through his compositions, as well as the intricacy of their painted surfaces. Only Dewing would have echoed the spindly projections of a Windsor chair in the bony limbs of his sitter. And the quality of unease derives from the ominous shadows that suffuse the floor and move upward on the curtain behind the model, where they mimic the shape of her head. The resulting, dark shape may only serve to balance the sweep of her skirt, as do the sitter's preternaturally long thighs and a chair with impossibly splayed legs. Nevertheless, such artistic license effectively suggests foreboding and a certain psychological tension. The shadow seems to echo the lady's serious, even ponderous thoughts, thereby effectively drawing us into a realm that is gently, but sadly beautiful.

Susan Hobbs, an independent scholar, is presently a guest curator at the Freer Gallery of Art, Smithsonian Institution, and is compiling the T.W. Dewing catalogue raisonné.

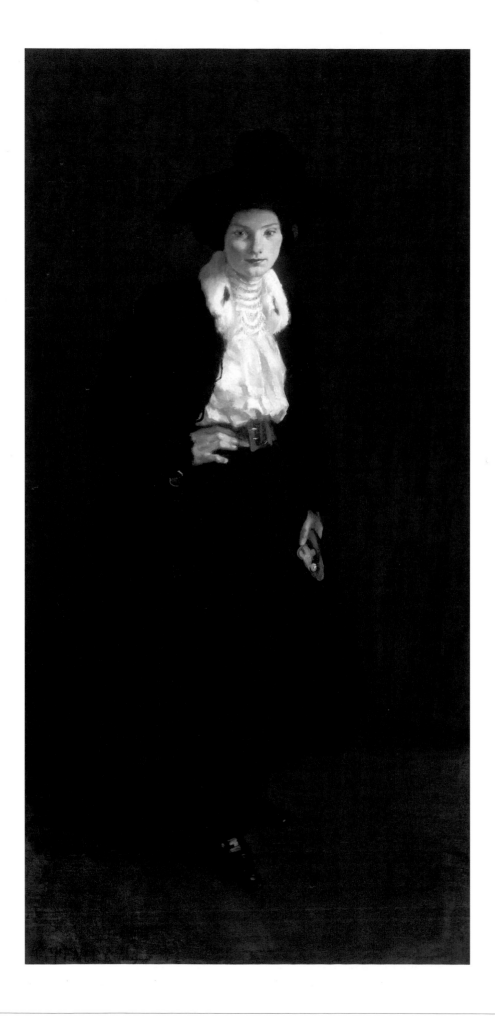

39: Kathleen McEnery Cunningham *Woman in an Ermine Collar* (1909)

Jessica Marten

The striking immediacy of the early twentieth-century realist painting *Woman in an Ermine Collar* continues to engage modern viewers. The limited palette and shadowy, plain background allow the viewer to become absorbed in the full-length figure. A young woman dominates the canvas. She wears a stylish ensemble of 1909: a large hat adorned with ostrich feathers, an ermine coat, an embroidered, high-necked shirtwaist, a flared, floor-length skirt, and shoes with metal buckles. Bravura brushstrokes capture the textures of fur, cotton, and leather. The finely detailed, exotic features of the woman's face repeatedly draw the viewer's eye, yet the impassive expression provides little clue as to what she is thinking. Although the model stands still for her portrait, the artist has created a dynamic figure. The languid *contrapposto* stance and exaggerated S-curve are enhanced by two gestures: her right arm sweeps back her jacket as she places her hand on her hip, and her left hand gathers up her skirt. Both gestures project vitality, action, and worldly confidence.

Kathleen McEnery was in her early twenties and living in Paris when she painted *Woman in an Ermine Collar*. Raised in Great Barrington, Massachusetts, McEnery moved to New York to study art—first at the Pratt Institute and then under Robert Henri at the preeminent New York School of Art.[1] In the summer of 1908, she traveled to Madrid with Henri's class, spending her mornings copying from Velázquez at the Prado and her afternoons in the studio. At the conclusion of the Madrid class McEnery moved to Paris to continue her studies, and it was during this period that she completed this arresting painting.[2]

After eighteen months in Paris, McEnery returned to New York in 1910 to immerse herself in that city's thriving artistic environment. Between 1910 and 1914, she kept a very active exhibition schedule, including shows at the Pennsylvania Academy of the Fine Arts, the Corcoran Biennial Exhibition, and the prestigious MacDowell Club. Most notably, she had two paintings in the famous Armory Show of 1913, *Dream* (Family of Peter Cunningham) and *Going to the Bath* (Smithsonian American Art Museum). These two works, both female nudes, are representative of the direction her style had taken upon her return from Paris: incorporating the New York emphasis on realism and the figure with the postimpressionist use of expressive color, space, and line. As evident in her circa 1929 portrait of Rochester artist Fritz Trautmann, McEnery's mature style was a further exploration of the expressive potential of uniting the opposing tenets of realism and modernism.[3]

Kathleen McEnery Cunningham,
1885–1971
Portrait of Fritz Trautmann,
ca. 1929
Oil on canvas, 36 x 30 in.
Anonymous gift, 71.82
Printed by permission of the
Estate of Kathleen McEnery

Although her star was rising on the New York art scene in the early 1910s, McEnery was to dramatically change her life, moving from Manhattan to Rochester, New York, in 1914. Her connection to Rochester is rooted in a friendship she began in Madrid with the siblings Leora and Rufus Dryer of Rochester, who were classmates and fellow artists. The Dryers introduced McEnery to Francis E. (Frank) Cunningham of the Cunningham Car Company of Rochester, to whom she was married in September of 1914. By November, McEnery was settled in Rochester, the city she was to call home until her death in 1971. In addition to her new focus on raising a family, McEnery managed to continue to paint and exhibit her work, participate in the lively and erudite Rochester society of artists, writers, and musicians, and become deeply involved in the then fledgling Memorial Art Gallery (opened in 1913). Her involvement at MAG included lifetime membership on the Board of Managers beginning in 1926, lifetime membership on the Art Committee starting in 1945, lifetime membership on the Women's Council starting in 1952, and a teaching position in MAG's Creative Workshop. Through her role in the Art Committee, McEnery had a dramatic influence on the legacy of the

(Facing page)
Kathleen McEnery Cunningham,
1885–1971
Woman in an Ermine Collar, 1909
Oil on canvas, 76⅞ x 38⅜ in.
Gift of Joan Cunningham
Williams, Peter Cunningham,
and Michael McEnery
Cunningham, 83.13
Printed by permission of the
Estate of Kathleen McEnery

Robert Henri,

1865–1929

Young Woman in Black, 1902

Oil on canvas, 77 x 38½ in.

Friends of American Art

Collection, 1910.317,

The Art Institute of Chicago.

Photograph ©The Art Institute

of Chicago.

Memorial Art Gallery and its collection. As then-director Harris K. Prior wrote in the foreword to the catalogue for her 1972 Memorial Exhibition, "Her judgment and discrimination are evident in many of the finest items in the permanent collection."[4] In addition, McEnery's own oeuvre is now represented at MAG by seven of her paintings. Her role as one of Rochester's most distinguished artists has been celebrated in two major solo exhibitions: the retrospective organized by the Memorial Art Gallery a year after her death in 1972 and, after a long hiatus of thirty-one years, a show at the Hartnett Gallery of the University of Rochester organized by Janet Wolff in 2003, The Art of Kathleen McEnery.

McEnery's artistic imprint in Rochester is undeniable and enduring, yet in the early years of the twentieth century the path of her career was yet to be determined. She was a young, ambitious artist eager to hone her skills and forge her future as a portrait painter. Despite the initial reservations of her parents and her teacher, Henri, she was convinced of her need to move to Paris to study painting. In a letter to her mother after arriving in Paris from Madrid, the artist's steely determination is evident: "[H]ere is Mr. Henri's advice. He says that it would be foolish for me to go to a school here…. He said that long before he was as advanced in painting as I am he had left the schools….You might think that a studio in NY or GB [Great Barrington] might do just as well….But that's rather foolish because one hasn't the advantages of seeing pictures and meeting artists there, that one has here….Now what do you think of the plan? I shall take a studio I think…."[5]

As the art capital at this time, Paris provided ample opportunities for McEnery to immerse herself in a culture of art. Not long after her arrival in 1908 she was living and painting on her own in an atelier at 17 Rue Campagne-Première adjacent to the Montparnasse area of the city. Speaking of her neighborhood on the Left Bank McEnery said, "Over here everybody carries portfolios under their arms."[6] In fact, the center of modern art in Paris was just then shifting from Montmartre to Montparnasse. Around her swirled the early strains of twentieth-century modernism in the flourishing movements of the cubists and fauves, but these trends had yet to capture McEnery's artistic interest. It wasn't until her return to the United States in 1910 that she began to apply a modernist sensibility to her painting. In response to the Salon d'Automne of 1908 she wrote, "Spent the afternoon at the Salon….Many frightful pictures belonging to what is called the Neo-impressionistic School. They are quite impossible, at first they made me laugh but afterwards *mad*….I feel all the time that I could do much better, so now I'm going to confine myself to the Louvre where I'm troubled by no such foolish thoughts."[7]

At the time she painted *Woman in an Ermine Collar* in 1909, McEnery's style was still primarily influenced by realist masters Diego Velázquez, Frans Hals, Edouard Manet, and her American mentor Robert Henri. The full-length portrait was a format adopted and mastered by Henri from the precedent set by Velázquez and Hals, both of whom he greatly admired—minimal background, dark, almost monochromatic tones, bright white highlights, and primary focus upon the face of the subject rendered with sensitive realism. Henri's own success with this format, and early acclaim for his painting *Young Woman in Black,* 1902 (Art Institute of Chicago) would not have been lost on his young student seeking to jump-start her own career. Despite her proximity to the pervasive modernity in Paris of 1909, it is clear McEnery's commitment to the American realist style remained firm. Her training with Henri drew McEnery to depictions of her time and place—the human condition as it exists in the modern world. Hence, the insistent modernity evident in *Woman in an Ermine Collar* is borne not of style, but of subject matter.

Although McEnery was seeking out portrait commissions while in Paris, there is no evidence in her correspondence of a commission for a full-length portrait of a young woman. It is more likely that this painting was intended by McEnery for exhibition: a painting in the grand manner with a hired artist's model as subject.[8] In her letters she gives often amusing bits of information on her many French models: "Enter my model Jeanne who is fifteen and says of smoking *'C'est ma plus grande passion.'* She arrives red of nose and I must hold her over the fire to see if we can restore its (her nose) natural color. Winter is not a good season for models they always come red nosed and red handed."[9] The hands of the figure in MAG's painting do indeed appear rather ungraceful, rugged, and reddened.[10]

McEnery preferred models over amateur sitters or commissioned portraits because of their malleability and lack of demands. While McEnery and this model were probably close in age, their social and cultural distance allowed the artist to manipulate and construct the image we see here. As Janet Wolff has observed of her later portraits of Rochester women, McEnery "captures the moment and the personality in a style which unambiguously registers the sitter as a 'modern' woman."[11] Although we do not know this person's identity, her modern persona has been skillfully created. Her reddened nose and hands, her hat, opened jacket, gloves, and upswept skirt all indicate that she has just come in from the cold. This is no fin-de-siècle hothouse flower. As opposed to the paintings of decorative, passive females in interior settings by American artists like William Merritt Chase and Thomas W. Dewing, this young woman's casual vibrancy is more appropriate to the public domain.

The figure in *Woman in an Ermine Collar* is an embodiment of the New Woman—a cultural phenomenon associated with the growing women's rights movement. The New Woman, who would eventually transform into the infamous flapper of the 1920s, had her genesis in the 1890s as epitomized by the Gibson Girl, the famous illustrated character by Charles Dana Gibson. The Gibson Girl rejected the constraining attire of her mother's generation and instead often wore a white high-necked shirtwaist, a flared skirt, and a large hat atop voluminous hair. She rebelled against traditional gender roles and was independent, spirited, and physically active. The Gibson Girl was the standard of beauty and womanhood in America during McEnery's formative years, an influence notable in her artistic ambitions and in her unabashed love of dancing, riding horses, playing sports like tennis and golf, and even smoking on occasion. Kathleen McEnery was a passionate supporter of the women's rights movement throughout her life.[12] It is no surprise then to see the strength of character and physical characteristics of this new model of womanhood reflected in both the artist and the figure she chose to paint. McEnery's commitment to the American realist creed to depict with honesty the conditions of modern life resulted in this woman's unapologetic presence.

Charles Dana Gibson,
1867–1944
Untitled, ca. 1904
Reproduced in
*The Gibson Book: A Collection
of the Published Works
of Charles Dana Gibson*, vol. 2
(New York: Charles
Scribners Sons, 1906)

Woman in an Ermine Collar speaks volumes about the intrepid young woman who moved to New York and traveled to Madrid and Paris on her own to pursue her artistic passion. The model's composure reflects the artist's own fearlessness. Her gaze, both casual and intense, is unquestionably that of a twentieth-century woman, asserting her right to be young, confident, ambitious, and independent.

Jessica Marten is Assistant Curator, Memorial Art Gallery.

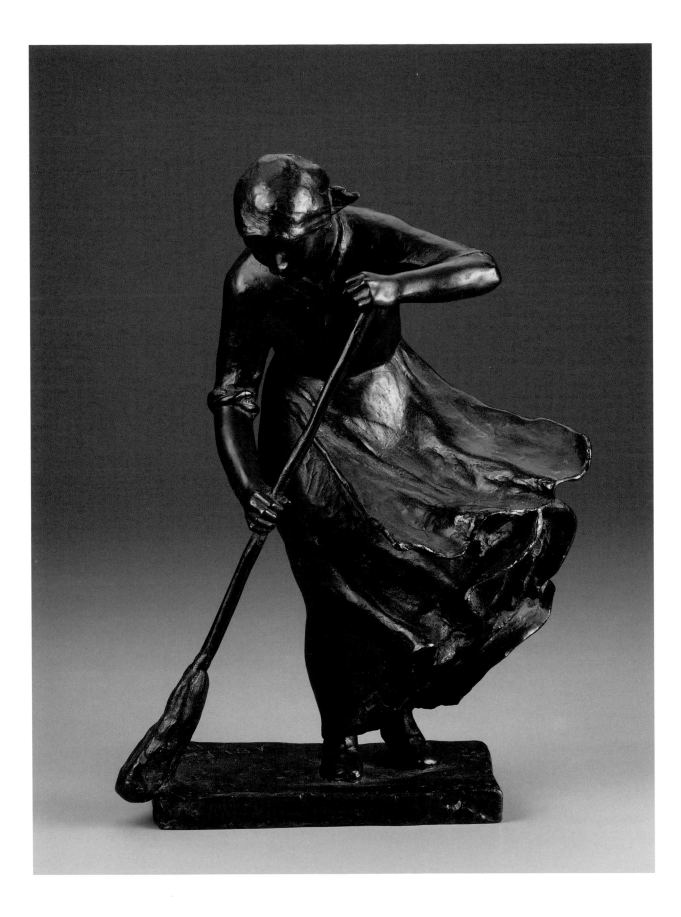

40: Abastenia St. Leger Eberle *Windy Doorstep* (1910)

Pamela W. Blanpied

The woman sweeping the windy doorstep is vigorously engaged in her task. She grips the broom purposefully, leaning into her work. This is no romantic ideal of domesticity. It is an image of one mature young woman, thoroughly involved in the work of a familiar, useful task. The high-cheek-boned face, the fingers, the worn stone slab are specific. She has her sleeves rolled to her elbows; she's wearing sturdy boots. Her head, her skirt, her back, and the broom flare beyond the doorstep. The wind blows the tails of the kerchief tied around her head and lifts the corners of her apron away from the skirt. It presses her dress against her side and back, revealing the body: the half-crouch, the musculature of the back, the force of the shoulders, the shapes of the legs as they carry the weight from the lifted right heel to the ball of the left foot.[1]

Abastenia Eberle[2] created this piece at her cottage in Woodstock, New York, in 1910, using a local woman as a model. "I remember thinking about the idea [of sweeping] continually when walking about New York and later I modeled it in Woodstock. Every farmer's wife I knew was arguing about how to sweep properly."[3] In time she came to understand that this statue "was the expression of a subjective reality—though I myself was not aware of it at the time. Later I realized why the idea of 'sweeping something out' had been so insistent."[4]

By 1910 Eberle was well along in a personal transition that in some ways mirrored the large forces moving in the art community and in the world beyond it. She had come to New York in 1899, alone, with few funds, and twenty years old. She had very little art background; she was in training to be a professional musician. Until she was in her teens the only sculptures she had seen were cemetery monuments that "didn't fill the bill."[5] Until she came to New York her only formal work had been two years of classes at the Canton, Ohio, YWCA, where she had personally rounded up the requi-site ten students so there could be a sculpture class. During the Spanish-American War, when her father was stationed as physician to the military in Puerto Rico, she modeled portraits of the life she saw around her in the streets there. When she could manage it, she moved to New York and enrolled at the Art Students League.

At the League, sculpture and life classes were segregated by sex, the first-year students drew and sculpted from Greek and Roman classics in the academic style, and her teachers and her mentor, George Grey Barnard,[6] were all rigorously traditional. Eberle obviously thrived on this fare, paying her fees in prizes and scholarships. But she remembered, "in those early lonely years in New York I would often stroll around the lower parts of town—losing my loneliness in the consciousness of all the pulsing throbbing life around me."[7]

With Anna Vaughn Hyatt (later Huntington)[8] she collaborated on at least three major pieces, Eberle doing the people and Huntington the animals. Gutzon Borglum, Huntington's teacher, urged them to submit their *Men and Bull* for the 1904 Society of American Artists exhibit, where it was greeted with enthusiasm by the jury, including Augustus Saint-Gaudens.[9] Their *Boy and Goat Playing* was featured prominently at the Society's exhibition the following year. They caused a stir partly for the novelty of their collaboration and partly because they were Americans. "Art students are wont to go to Europe for 'atmosphere,' to study what others have done, to try to learn to feel and think as others have felt and thought," observed Bertha H. Smith in *The Craftsman*.[10] The debate over European tradition versus "modern" American work was in full swing.

Abastenia St. Leger Eberle,
1878–1942

Windy Doorstep, 1910

Bronze, 13¾ in. high

Maurice R. and Maxine B.
Forman Fund, 2004.14

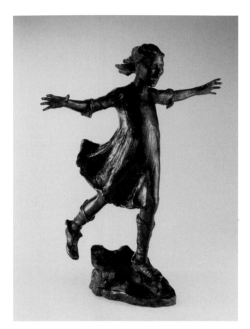

Abastenia St. Leger Eberle,
1878–1942
Roller Skating, ca. 1906
Bronze, 12¹³⁄₁₆ x 11¼ x 6½ in.
Whitney Museum of American
Art, Gift of Gertrude Vanderbilt
Whitney, 31.15

Within two years, echoing the divisions in the art world, the two careers went different ways. Huntington went to Paris to study,[11] Eberle remained in New York. "I do not regret the time I spent with the past," Eberle said, "for it gave me a firm grip on form, and was of great benefit to me technically. It did not, however, stir me to individuality but held me within the confines of what was strictly traditional and academic."[12] She continued to model traditional subjects, often in small, useful pieces that sold well, but her original interest in the ordinary people around her persisted and began to take on a life of its own. She had shown her Puerto Rican sculptures to New York galleries. They "were not accepted by dealers etc because they were not American—but no one suggested to me to do the same thing only of Americans and it took me five years to come to it myself."[13]

The breakthrough came as she began to find interest for her small figures of the life of the streets in lower Manhattan. *Roller Skating* (1906), a wildly happy, poor girl, stockings falling down her legs, arms outstretched in joy as she flies downhill on one, crude skate, was acquired by the Metropolitan Museum of Art.[14] It was followed by the bent figure of the *Old Woman Picking Up Coal* and the exuberant *Girls Dancing*. These three began a flood of work modeled from life amid the poor in lower Manhattan. "I broke away from the archaic and realized at last that right here and now, there was too much to be lost to my art for me to pass it by."[15]

In 1906 Eberle was elected to the National Sculpture Society, only one of seven women since its founding. In 1907 and again in 1908 she went to Naples, where she could cast her work more inexpensively. The Italian foundry, never having handled the work of a woman artist before, had to be convinced that the work was hers and that she knew what she was doing.[16]

Eberle's return from Italy reinforced her interest in America and especially in the immigrant communities she had known and found so inspiring. She lived at the Music School Settlement on East Third Street for the summers of 1907 and 1908, and then in a small studio on West Ninth Street, in the midst of the immigrant community there. In her newly invigorated work, her subjects were increasingly women and children. She became active in the suffrage movement, organizing a show at the Macbeth Gallery to raise funds, and leading a contingent of women sculptors in the women's suffrage parade.

Though they showed their art at the same galleries and worked in the same city, even in the same neighborhoods, there is no record that Eberle came to her subject matter in company with or because of the group of painters known as "The Eight," in the sensational 1908 exhibit at the Macbeth Gallery, the core of what later came to be called the "Ashcan" school of urban realism.[17] Like her contemporaries Jerome Myers and Mahonri Young,[18] she seems to have made her own way into her true interest and to have worked independently. Though she was an admirer of Jane Addams, and was eager "to give help when I could and where I felt the need,"[19] Eberle's work does not concentrate on that need. Most often her people are lively, vigorous, and unsubdued by their living conditions. Alexis L. Boylan suggests that Eberle's work was not principally "part of the socially progressive agenda pursued by Ashcan school artists....Her challenge as an artist, Eberle held, was to harness the beauty and the thirst for life that was hidden behind the shabby facades of her neighborhood."[20] The woman who was the unwilling model for *Old Woman Picking Up Coal* (1907)[21] was poor, no doubt, and lived in conditions no reformer would tolerate, but Eberle's figure is about the bulky form and the reaching gesture. The role of the artist, Eberle told *The Survey,* is to be "the specialized eye of society, just as the artisan is the hand, and the thinker the brain....The artist must see for the people—reveal them to themselves."[22] According to the *New York Evening Sun*, "This is her way of helping combat the injustices and evils of our system. She does not preach, she makes us see."[23]

In 1909 Eberle built a small studio in the burgeoning artist colony in Woodstock, New York. There in 1910 she modeled *Windy Doorstep*, the woman sweeping with the wind so all the accumulated debris is blown far away. It became one of her most successful pieces. At the National Academy of Design exhibition in 1910 it won the Helen Foster Barnett Prize for the best sculpture by an artist under thirty-five. It was purchased by four museums.[24] By April 1917, fifteen copies of the edition of twenty had been sold.[25]

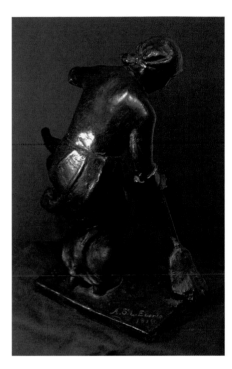

During the ten years following the success of *Windy Doorstep* Eberle's career flourished. She had two pieces in the groundbreaking Armory Show, *Girls Wading* (a group of three also called *Coney Island*) and *White Slave*, an adolescent, naked girl, cringing, clutched by a grotesque, gesticulating old man who is auctioning her into prostitution. She had worked on this piece in 1909, but set it aside, thinking it would be received "as an unwelcome effort toward sensationalism."[26] It was passed by in the general melée of the show but later, when *The Survey* pictured this sordid scene on the cover of the May 13, 1913, volume, it caused an outrage.[27]

In 1920 she was elected to the National Academy of Design and a year later the Macbeth Gallery gave her a one-artist show. But by this time, the ill health that had begun to plague her in 1915 took hold and her heart was too weak to continue. At forty-three, she was forced to retire, working only when she had the strength and the means to hire help for the heavy work sculpture demands. She died in 1942.

Abastenia St. Leger Eberle,
1878–1942
Windy Doorstep, (back) 1910
Bronze, 13¾ in. high
Maurice R. and Maxine B.
Forman Fund, 2004.14

In 1913 when her work and health were thriving, a friend gave her a teacart to commemorate many pleasant afternoons in the studio. The next day, certain she was getting too comfortable, Eberle moved to the heart of the Lower East Side, taking two rooms on the top floor of a tenement on Madison Street under the Manhattan Bridge. One room was a studio strewn with toys and music for the neighborhood children who came to listen to her stories. She sketched them in clay as they played. These figures of neighborhood life are the work that has begun to be rediscovered in the last twenty years: *Ragtime, Yetta and the Cat Wake Up, Unemployed, Shy, Dance of the Ghetto Children*. The energy and beauty of these small figures show what she admitted to Robert McIntyre in 1913: "I have always had a strong taste for life."[28]

Pamela W. Blanpied is an independent writer and artist in Rochester, New York.

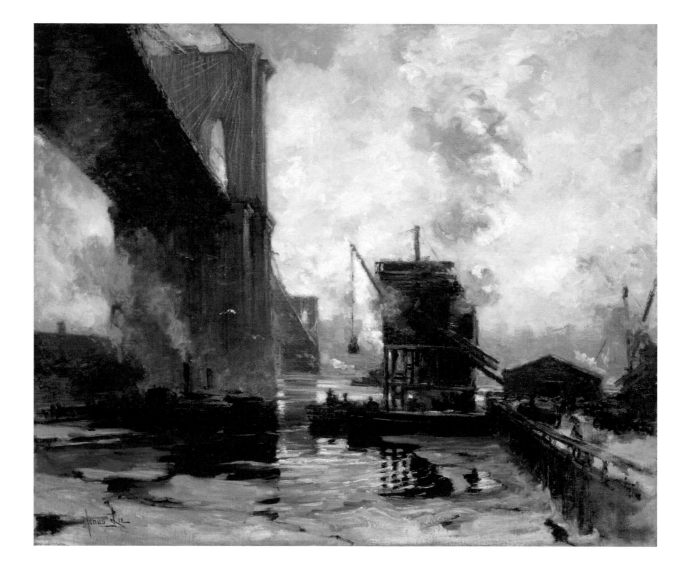

41 : Jonas Lie *Morning on the River* (ca. 1911-12)

Barbara Dayer Gallati

Jonas Lie's *Morning on the River* is a prime example of the artist's mature work, in which his love of depicting chill winter landscapes merged with his delight in strong, architectural forms. Here, in a finely calibrated composition, Lie juxtaposed the powerful bulk of the Brooklyn Bridge with the brilliant effects of early morning light as it reflects from the cloud- and steam-filled atmosphere above the icy waters of the East River. Lie's emerging penchant for the visual drama provided by the contrast of the man-made and the natural world did not go unnoticed and soon after its execution, the painting was widely recognized as one of the artist's most compelling productions. Writing in 1915, critic Lorinda Munson Bryant described her reaction to the painting: "We feel almost under the power of some titanic monster, only that the pale light creeping in lifts us as it follows the straight columns of smoke reaching skyward and glints the scuttling clouds with ever-varying tints."[1]

Although views of New York docks and the Great East River Bridge, as the bridge was officially known, had constituted a significant subgenre in the American arts for decades, Lie astonished the critics when he first showed urban scenes such as this at New York's Folsom Galleries in 1911.[2] Reviewers noted that the exhibition marked a new stage in the young painter's artistic development. Though he had initially gained attention for his timeless depictions of the wild, frozen landscapes of his native Norway, Lie had suddenly turned to a contemporary and quintessentially American subject. The alteration in his art prompted one writer later to claim that his "brush gives new poetry to modern urban life and aspiration, and fresh power and significance to latter-day industrial effort."[3]

To be sure, *Morning on the River* and other paintings of this series may be characterized as expressions of the urban sublime, a mode in which the modern cityscape replaced the untamed wilderness in the visual catalogue of national progress as it was articulated in early twentieth-century American art. The Brooklyn Bridge—itself a positive symbol of America's destiny from its inception—here becomes an even more formidable image, whose ponderous weight is contrasted with the metaphorical language of light that had long been central to the iconography of spiritual sublimity in Western art.[4] Unlike many of his contemporaries, Lie eschewed what had become the familiar, picture-postcard rendition of this engineering marvel. Rather than exploiting the aesthetic potential of the elegant, rhythmic sweep of its cables or the full extent of its Gothic-manner towers, Lie presented the bridge from the vantage point of the dockside laborer, whose view is anchored by the dark, irregular forms of the sheds and machinery dwarfed by the hulking, radically foreshortened span. The painter's emphasis on the unglamorous aspects of the bridge and its surroundings betrays his close affiliation with the painters of the so-called Ashcan group, yet his focus on the structure of the city itself separates his art from the more anecdotal visions of such artists as John Sloan, George Luks, or Jerome Myers, who often concentrated on the denizens of the streets. Indeed, Lie's *Morning on the River*—so operatic in scale and concept—conveys the sense of the ineluctable energies that brought the nation to the dawn of its economic and industrial priority.

Morning on the River was an apt choice for display at the Rochester Memorial Art Gallery's inaugural exhibition. Its progressive mood corresponded with the regional optimism of upstate New York and simultaneously evoked associations linking Rochester's history with that of the glittering urban gem at the mouth of the Hudson to which it was connected by the Erie Canal. Rochester viewers undoubtedly appreciated the mutually beneficial relationship of the two cities, recognizing that just as New York City's rise to preeminence had depended partly on the transport of goods on the canal, their local economies had also flourished as a result. Purchased from the exhibition

Jonas Lie,
1880–1940
Morning on the River,
ca. 1911–12
Oil on canvas, 50 x 60 in.
Gift of Ruth Sibley Gade in
memory of James G. Averell,
13.6

with funds provided by Mrs. John A. Gade, the painting immediately entered the Gallery's collection. Under such circumstances the painting was destined to be a constant reminder of local progress, for its donor was the former Ruth Sibley, a member of one of Rochester's most illustrious families, whose presence in the area stretched back to the 1838 arrival of Hiram Sibley. Hiram Sibley's rise from humble origins to a position of great wealth reads like the archetypal American rags-to-riches narrative, particularly with regard to his role in founding the Western Union Company, a move that bears witness to his own ingenuity and belief in advancement through technological innovation. The Sibley fortune, as it passed from one generation to the next, was directed to a wide variety of philanthropic causes, including the cultural improvement of the Rochester community and, of course, the founding of the Memorial Art Gallery by Ruth Sibley Gade's aunt, Emily Sibley Watson.

ON THE JOB FOR VICTORY

UNITED STATES SHIPPING BOARD EMERGENCY FLEET CORPORATION

ALSO IN THE MAG COLLECTION:

Jonas Lie,

1880–1940

On the Job for Victory, ca. 1917

Color lithograph, 30 x 38¾ in.

Gift of Dr. and Mrs. E. Henry

Keutmann, 73.170

Almost certainly, the well-publicized romance of Lie's foreign birth and climb to success reconfirmed the truth of the American dream as it was exemplified by the Sibley family and thereby augmented the painting's appeal.[5] Noting Lie as one of New York's most promising artists, writers had enjoyed tracing and retracing the outlines of his biography, which eventually took on the shape of a grand, fairy-tale odyssey from the Old World to the New. Born in Norway to a Norwegian civil engineer and an American mother, Lie reportedly spent an idyllic childhood that closed abruptly with the death of his father. The twelve-year-old was then sent to Paris, where he lived with the famous novelist uncle for whom he was named. After a year, he rejoined his mother, who had since returned to the United States. Published accounts emphasized Lie's triumph over life's obstacles, glorifying his attendance at evening classes at the National Academy of Design and the Art Students League while he worked by day as a textile designer, and citing the rewards of his talent and diligence by listing the honors he had accrued.

Thus, at the moment of the painting's purchase, both *Morning on the River* and its painter already possessed respected pedigrees rooted in the ideal of America's promise. The painting's aesthetic worth had been validated the previous year by its showing at the National Academy of Design, to which Lie had also been elected an associate member at the time. Ultimately, however, the painting's popularity rested in the universality of its message that declared in spiritual and material terms America's triumphant advancement.

Barbara Dayer Gallati is Curator of American Art, Brooklyn Museum of Art, and Lecturer, Department of Art History, School of Visual Arts, New York.

42: George Bellows *Evening Group* (1914) *Autumn Brook* (1922)

Ronald Netsky

When considering the paintings of George Bellows our thoughts may first turn to images of brutal boxing matches or teeming New York City tenements. Works like *Stag at Sharkey's* (1909) and *Cliff Dwellers* (1913) have become iconic images, capturing the zeitgeist of early twentieth-century American life. But there was another side of Bellows's oeuvre, a more serene body of works that constitute an antidote to the bustle and brutality of city life.[1]

Bellows painted his family and friends and the pastoral scenery that surrounded him during his respites away from the city. *Evening Group* and *Autumn Brook*, the two Bellows paintings in the Memorial Art Gallery collection, are in many ways quintessential examples of Bellows's lesser-known works. Painted on Monhegan (an island off the coast of Maine), and in Woodstock, New York, the two rural locales where Bellows was most productive, both works deal with Bellows's reaction to the landscape. *Evening Group* also focuses on Bellows's family.

In his rural works viewers can almost feel Bellows's need for more open spaces and a retreat to a quieter location. The action of the streets, the angles of the buildings, and the plight of the city's people are replaced by the rustle of trees, the flow of water, and the drama of the mountains. Bellows reacted with immediacy to the landscape, producing paintings with expressionistic brush strokes and vibrant color.

In July 1911, when Bellows first traveled to Monhegan at the behest of his mentor and friend Robert Henri, he was awed by the drama of the island, a rock rising from the sea. "The island is only a mile wide and two miles long, but it looks as large as the Rocky Mountains," Bellows wrote. "My head is full of millions of great pictures which I will never have time to paint."[2] When he made his final trip to Monhegan in the summer of 1914, Bellows brought his wife, Emma, and their two-year-old daughter, Anne. Among the works Bellows painted that summer were two of the earliest images portraying his family, a major theme of the last half of his career: *Fisherman's Family* and *Evening Group*.

While *Fisherman's Family* (the first version of which was completed in 1915) offers an idealized, symbolic treatment of this theme, with the family based on Bellows, his wife, and daughter, *Evening Group* is a more accurate depiction of Bellows's family along with two other children. They are shown in a slice-of-life scene behind the house where the family was residing, against a dramatic landscape falling off to the sea. In the background sailboats pass between the island and Nigh Duck Rock, which rises from the sea like a great whale. The late-day light strikes the figures, illuminating them against surrounding darker tones. Emma sits on a chair with arms crossed, while Anne gazes at a red flower in the left foreground. Her playmates occupy the opposite corner. Bellows himself is in the center carrying a cat in his arms. A washer-woman, barely visible in the background, hangs clothes on a line while a lone sailor occupies a small boat in the distance.

The Memorial Art Gallery also owns the preliminary drawing Bellows executed for *Evening Group*, providing a fascinating glimpse of Bellows's working methods. Bellows was interested in compositional and color systems from the beginning of his career, as evidenced by the triangular structure of early compositions like *Stag at Sharkey's*. The embrace of these systems was common early in the twentieth century and Bellows was enthusiastic about the work of several prominent theorists.

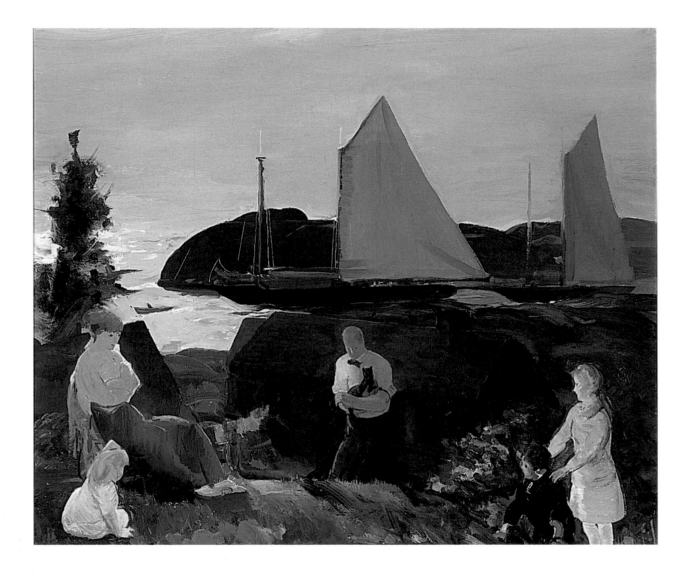

Many of his later paintings were influenced by Jay Hambidge's theory of Dynamic Symmetry, a system based on structures found in nature. However, *Evening Group* demonstrates his experimentation with the compositional ideas of Hardesty Maratta and the color systems of Denman Ross.[3]

Evening Group's preliminary drawing is done on paper crisscrossed by 1½-inch-high watermarked diamonds. Using this subtle grid, Bellows planned his composition to be subliminally pleasing by undergirding it with a dominating equilateral triangle. The painting, Bellows noted in his record book, is done with a palette from Ross's 1912 book, *On Drawing and Painting*. The "Rubens Palette," named for a color range observed by Ross in the paintings of old masters, offered a complex arrangement of hues of primary colors red, blue, and yellow in seven sets of values from light to dark.

In the drawing, the largest sail of a background boat aligns with the roof of a middleground house; other compositional lines carry over into the shapes of children at bottom right and left. The central figure—clearly not Bellows—is most likely a Monhegan fisherman standing in for the artist while he composed the image. In the drawing this figure carries a lamb instead of a cat. The background washerwoman is more distinct in the drawing, the cat is on ground, and additional islands are visible in the distance. The drawing is, in general, more realistic than the painting, with a horizon line between the sea and the sky. In the painting, sea and sky are merged in the hazy background.

There are also differences between the final painting and an earlier stage of it that was reproduced in the August 1915 issue of *Arts and Decoration* magazine.[4] In the reproduction, the Bellows figure directs his attention at his wife, Emma. The white cat is not cradled, but held more precariously in his arms. In the finished painting, Bellows gazes downward as he strides up the hill. The marks indicating the changes Bellows made are visible under the current brush strokes surrounding the self-portrait figure. The completed painting is both the product and depiction of a great city painter's idyll in the country.

By the time Bellows arrived in Woodstock, the Catskill Mountains had attracted painters—notably those of the Hudson River School—for over a century. In 1912 Bellows had visited Onteora, an artists' colony in the mountains about twelve miles north of Woodstock, where he produced ten small oil-on-panel landscape studies. During the years before he revisited the region in 1920, the world around him had changed. When he read about the atrocities of World War I in "The Bryce Report," published in the *New York Times* in 1915, Bellows was deeply shaken. In the following years he created a group of paintings and lithographs known as *The War Series*. Over the next several years Bellows seemed to be in search of a secure life for his family in an atmosphere less hectic than that of New York City.

Bellows had visited Santa Fe in 1917 and Middletown, Rhode Island in 1918 and 1919. He created wonderful paintings at each of these locations, but did not choose to stay. It was not until he visited Woodstock, at the suggestion of his friend, painter Eugene Speicher, that he found a landscape intriguing enough, and an artists' community culturally rich enough, to inspire him to settle there. *Autumn Brook* is a lovely vignette, emblematic of his relationship to the landscape around Woodstock, where Bellows painted most of his major works from 1920 until his untimely death early in 1925.

No small part of the attraction of Woodstock to Bellows was the full-blown community of artists he found when he arrived. Many of them also lived and worked in Manhattan, about one hundred miles to the south. An arts colony, called Byrdcliffe, had been built in 1902, luring a steady stream of artists,

writers, and intellectuals to Woodstock. By the 1920s residents included his friend Leon Kroll, Peggy Bacon, Alexander Brook, Yasuo Kuniyoshi, and many more established artists.

During the summers of 1920 and 1921 Bellows rented the Shotwell House, which possessed one of the most beautiful mountain views in Woodstock. He felt at home in the town. He had been an athlete all his life and in Woodstock he managed the baseball team. The local Maverick Festival was a wild Bacchanal with costumes and stage productions; Bellows was an enthusiastic participant. And nothing beat the company of artists. Bellows would often drive into the countryside with Speicher, searching the landscape for scenes to paint. In the evening there were poker games during which the artists sketched caricatures of one another. In 1921 Bellows, Kroll, Speicher, and Henri taught a class in painting the figure out-of-doors at the Art Students League's summer program in Woodstock.

ALSO IN THE MAG COLLECTION:
George Bellows,
1882–1925
"Happy New Year":
from George, Emma, and Anne
Bellows to Robert Henri,
ca. 1913
Pen and ink on paper,
4½ x 2¾ in.
Marion Stratton Gould Fund
and Ackerman Foundation,
by exchange, 2005.32

When Bellows spent "summers" in Woodstock he did not just stay through July and August. He would sometimes arrive in April and stay until November. During the summer of 1922, the year he painted *Autumn Brook,* Bellows made a commitment to his new, rural surroundings. In a little cul-de-sac, already occupied by the homes and studios of Speicher and Charles Rosen, he designed (according to the principles of Dynamic Symmetry) and built his own home in Woodstock. The street where the house still stands is now called Bellows Lane.

(Facing page)
George Bellows,
1882–1925
Autumn Brook, 1922
Oil on panel,
16½ x 24 in.
Bequest of Murial Englander
Klepper and Marion Stratton
Gould Fund, 2001.27

Autumn Brook depicts a lone cow surrounded by layer upon layer of natural splendor. From the foreground stream, through rolling hills, to the background mountains topped with wispy clouds—all painted energetically in heightened color—*Autumn Brook* contains all of the natural elements that drew Bellows from the city to his new country home.

Ronald Netsky is Professor of Art, Nazareth College, Rochester, New York.

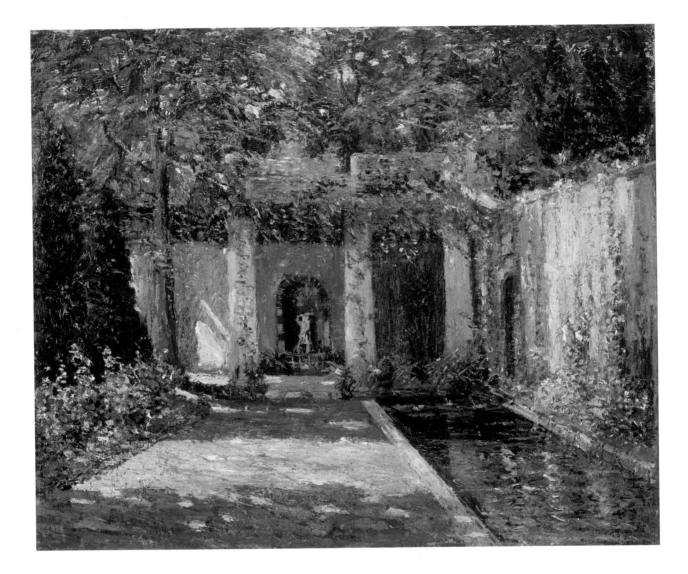

43: Ernest Lawson *The Garden* (1914)

Deirdre F. Cunningham

When Emily Sibley Watson, founder of the Memorial Art Gallery, saw Ernest Lawson's *The Garden* at the Gallery in 1916, and was moved to acquire it for her personal collection, she probably responded to Lawson's dazzling "palette of crushed jewels."[1] That palette is consistent in other works of Lawson, but the subject is not. Best known for his urban landscapes, Lawson on this singular occasion has painted an individual, partially enclosed Italian-style garden, built into the side of a hill overlooking a lake, with a rectangular reflecting pool alongside a central lawn panel and a teahouse at one end, complete with a garden sculpture, where guests might socialize, drink, and enjoy the panoramic view.

An American born in Nova Scotia in 1873, Lawson worked as a draftsman and studied part-time at the Santa Clara Art Academy while living in Mexico as a teenager. He moved on to the Art Students League in New York in 1891 and studied at the Cos Cob, Connecticut, summer school with American impressionists John H. Twachtman and J. Alden Weir. In 1893 he attended Académie Julian in Paris,[2] but left after a short time to develop his own personal impressionistic style. His American career began in 1894 with his "Harlem River period," which lasted for a decade or more, during which time he painted various landscapes around the New York City region.

Although he depicted many aspects of the urban fabric, he focused on river views, which included human-made intrusions such as bridges, shipping vessels, and industrial sites. He was a member of "The Eight" that formed in 1908 to mount an exhibition of their work in protest against the current trends in art that failed to depict the harsh realities of urban life.[3] It was unusual for Lawson to affiliate himself with a particular group because he believed that a true artist must have a unique vision and way of working. In his personal credo, entitled "The Power to See Beautifully and Idealistically," he formulated his theories about art and painting, which coincide with those of the French artist Gustave Courbet, by stating, "It is the individual who counts with me, not the school of painting he works in."[4]

Because Emily Sibley Watson donated *The Garden* to the Memorial Art Gallery in 1951, it was long believed that the painting depicted Mrs. Watson's own garden at 11 Prince Street in Rochester, New York. Then in 1990 a letter arrived at the Memorial Art Gallery from a professor at the Troy State University System in Alabama. The letter asked for "a color slide of Ernest Lawson's *The Garden* (the lower terrace of the H. H. Rogers garden at Tuxedo) for use in my research."[5] A little sleuthing in the James Sibley Watson, Jr. papers in the Motion Picture Collection at George Eastman House revealed through photographs that Mrs. Watson's garden was typically Victorian. It consisted of island plantings of perennials and bedding plants that formed an embroidered pattern on the lawn in the backyard, which was open to the adjacent property owned by her family on East Avenue. The flower beds surrounded a sunken seating area accessed by a set of steps. In no way did her garden resemble the garden in Lawson's painting, which in fact depicts the Rogers garden in Tuxedo Park, New York. That garden, as represented in the painting, offers us a good example of an outdoor space designed during the Country Place Era.

The American Country Place Era (1894–1940) represents a period of unprecedented wealth in the United States due to the shift from an agriculture-based economy to one that was industry-based. The World Columbian Exposition held in Chicago in 1893, laid out by Frederick Law Olmsted's landscape architecture firm, was based on French formalism, or the Beaux Arts style. This event is generally accepted as the catalyst for a proliferation of Country Place estates. Outside of

Ernest Lawson,
1873–1939
The Garden, 1914
Oil on canvas, 20 x 24 in.
Gift of the Estate of Emily
and James Sibley Watson, 51.36

major metropolitan regions, along river valleys and surrounding mountains as in the Hudson River area north of New York, large privately owned tracts of land were subdivided and sold, often to people who had grown newly wealthy through land speculation, agriculture, and industry. With the advent of the railroad, which encouraged commuter travel, large country place estates and new suburban communities, such as the privately developed Tuxedo Park in the Hudson Highlands, were developed outside of urban centers.

Tuxedo Park, the location of *The Garden,* was established in 1886 sixty miles west of New York. One of the first planned communities in the United States, the mountain village was developed by P. R. Lorillard, an heir to a tobacco fortune, and laid out by architect Bruce Price and landscape architect Ernest Bowditch. Lorillard invited several friends who were part of New York's exclusive "Four Hundred" to join his Tuxedo Club and buy land on which to build a country estate. Tuxedo Park was primarily inhabited during the fall for hunting and fishing. The annual Autumn Ball, where the tuxedo dinner jacket originated, kicked off New York's debutante season. Invited to join this illustrious group, H. H. Rogers and his wife were coming to Tuxedo Park as early as 1904, and sometime before 1916 may have hired the firm of Walker & Gillette, Architects to design the garden for their Tuxedo estate.[6]

Often built and designed collaboratively between architects, landscape architects, and home owners, American country estates typically featured an eclectic mix of formal Italian and French landscape design with a naturalistic English pastoral or picturesque style, or an Asian-influenced design. Formal gardens were constructed adjacent to the house with garden paths mirroring its architectural lines. Utilitarian (vegetable, cut-flower) gardens were placed out of view of the house and informal, park-like lawns dotted with trees were installed along the property perimeter. These extensive residences reflected the wealth of owners such as the Vanderbilt and Rockefeller families. They had the means to travel abroad extensively and collect furniture, art work, and ideas to incorporate into the design of their new estates. During this time, a proliferation of books and magazines in the United States and Europe encouraged Americans to travel abroad and promoted interest in garden and landscape design. Gertrude Jekyll, a well-known British garden designer who partnered with architect Edwin Lutyens, wrote extensively about her gardens and planting designs. Her late nineteenth- and early twentieth-century publications continue to enjoy popularity in this country and Britain.[7]

The newly emerging profession of American landscape architecture drew its primary inspiration from Italian Renaissance villa design. This was due in no small part to an 1894 publication entitled *Italian Gardens,* by Charles Platt. The book was a contemporary photographic record of centuries-

Pool, H. H. Rogers, Jr.,
garden, 1917
From "A Hillside Garden,"
The Architectural Forum 27,
no. 3, p.73

old villa landscapes. Ten years later in 1904, novelist Edith Wharton published *Italian Villas and their Gardens*. Illustrated by Maxfield Parrish, the book was immensely popular and influential among the well-heeled who used it as a travel guide. Several magazines also played an important role in developing more sophisticated home grounds, including *Country Life in America*[8] and *The Architectural Forum*.[9] Both publications featured articles about the H. H. Rogers Italian-style garden and helped to solve the mystery of whose garden was portrayed in Lawson's impressionistic painting, *The Garden*.

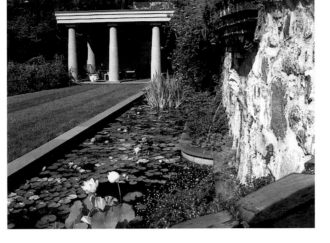

Henry Huddleston Rogers, Jr. was heir to the Standard Oil fortune amassed by his father, H. H. Rogers. Colonel Rogers, as he was called, was, himself, an industrialist. He had a lifelong interest in the military, from his involvement as a youth in the Twelfth Regiment of the New York National Guard to his service with the American Expeditionary Force in World War I. In addition to his Tuxedo Park "cottage," he owned an estate in Southampton, Long Island, designed by Walker & Gillette. Until 1929, Rogers was married to Mary Benjamin Rogers, whose friendship with Mark Twain has been preserved in the book "Mark Twain's Letters to Mary." Twain also spent time in Tuxedo Park at a cottage near the Rogers home.

Garden, Tuxedo Park,
New York, 2005
Courtesy of
Mr. and Mrs. Allen Yassky

Ernest Lawson's depiction of the Rogers garden is a literal rendering of the descriptions of the garden found in contemporary publications. In *A Terrace Garden for Mr. H. H. Rogers at Tuxedo Park New York* the caption states: "The terrace is formed by a twelve-foot retaining wall of stucco which runs in color from deep orange to a soft gray-pink, and has a coping of brownish red tile. The vines on the wall are English ivy and blue morning glories which repeat the blue of the flowers on the other side of the grass path." The caption under another photograph says: "A blue-tile-lined pool runs the whole length of the retaining wall, and on the outer edge of the terrace is a ten-foot wide flower bed planted with blue and mauve flowers interspersed with black cedar trees."[10]

So close is Lawson's rendering of the garden scene to the published photographs that one wonders if he had actually seen the garden himself or if someone gave him a photograph to copy. His relationship with the Rogers estate remains a mystery. Although he was well-respected as a landscape painter and won several awards for his work during his lifetime, he did not reap much in the way of financial reward. He was impoverished most of the time and depended on the good will of wealthy art patrons, sometimes staying at their homes.[11] Possibly this was the situation in Tuxedo Park. However, if the painting originated as a commission, there may have been a falling-out between artist and patron, since *The Garden* came to Rochester for an exhibition courtesy of Daniel Gallery in 1916, was available for sale at that time, and was purchased out of the exhibition by Mrs. James Sibley Watson.

The Rogers "cottage" has long since disappeared, but happily the current owners of the property are aware of the adjoining garden's importance and have begun to restore it to its original formal beauty.

Fountain in tea house,
H. H. Rogers, Jr.,
garden, 1917
From "A Hillside Garden,"
The Architectural Forum 27,
no. 3, p.74

Deirdre F. Cunningham, former Nancy R. Turner Landscape Curator, George Eastman House in Rochester, New York, is currently Manager of Gardens and Grounds, MacKenzie-Childs, Inc. in Aurora, New York.

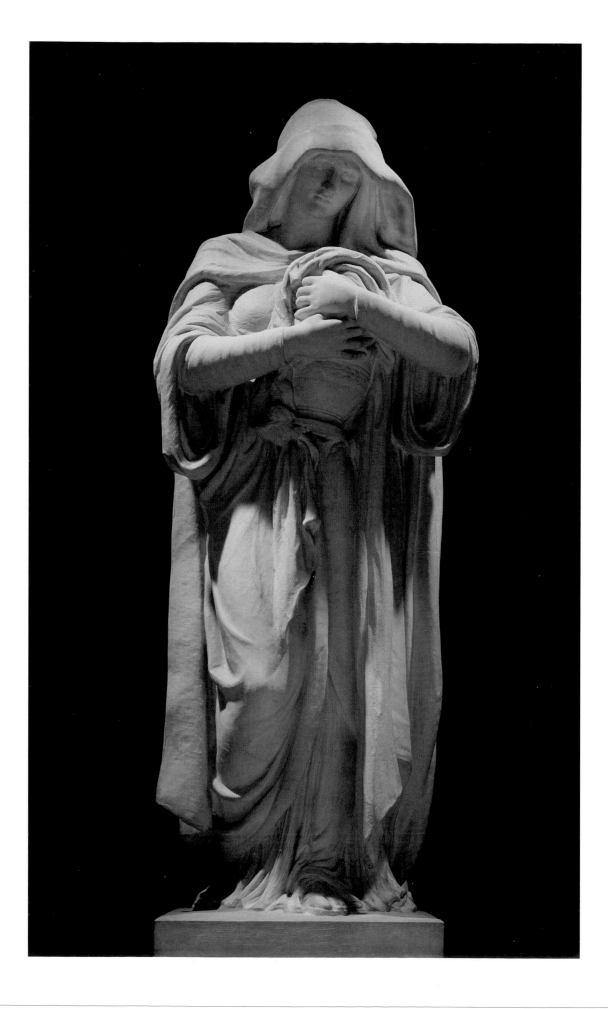

44: William Ordway Partridge *Memory* (1914)

Marie Via

"James George Averell Dead: Well-Known Polo Player Succumbs to Typhoid Fever," announced a headline in *The New York Times* of November 21, 1904. Today, visitors to the Memorial Art Gallery may not realize that it owes its existence to the death of a twenty-six-year-old socialite, or that the hooded marble figure now tucked into an alcove on the museum's second floor is the expression of his mother's grief.

Averell, born in 1877, was the product of the unhappy union of Isaac S. Averell, the unambitious heir to a railroad fortune, and Emily Sibley, the daughter of the wealthy founder of the Western Union Company. In 1875, Isaac inscribed Emily's autograph book: "When looking over these pages in the years to come, will you not sometimes linger kindly over this signature?"[1] They wed a year later but the marriage ended in divorce when their son was six.

Averell attended St. Paul's, an Episcopal boarding school in Concord, New Hampshire, and graduated from Harvard in 1899. He subsequently decided to pursue a career in architecture and took a three-year course of advanced study at Harvard. In the spring of 1904, after enjoying a European tour, he joined the firm of Herbert D. Hale in Boston. That autumn, he contracted typhoid fever and died without having built a single project. His estate included railroad stock, five horses, and a note for the loan of $2,500 from his employer.[2]

William Ordway Partridge,
1861–1930
James G. Averell, 1914
Marble, 22 x 14½ in.
Gift of Mrs. James Sibley
Watson, 13.13
This relief is located on the
base of *Memory.*

By that time, Averell's mother had remarried and was a fixture in Rochester society. Emily Sibley Watson and her husband James were said to have one of the finest private collections of art in the country. A woman of means in her own right, Mrs. Watson approached President Rush Rhees of the University of Rochester with her intention to build an art museum dedicated to the memory of the son she had lost at such an early age. Crews broke ground on the University Avenue campus in May of 1912, and in early 1913 she commissioned the eminent sculptor William Ordway Partridge to create a memorial statue that would dominate the main gallery.

Partridge had been born in Paris to American parents in 1861. Later he moved to New York City, where he studied at Columbia University. He flirted briefly with a stage career and wrote several books of poetry, but sculpture was his true calling. Among his most famous works are the equestrian sculpture of General U. S. Grant (1895) in Brooklyn's Grant Square and the heroic *Pieta* (1905) at St. Patrick's Cathedral in New York.

(Facing page)
William Ordway Partridge,
1861–1930
Memory, 1914
Marble, 82½ x 26¾ x 29⅝ in.
Gift of Emily Sibley Watson,
13.12

How Mrs. Watson came to select Partridge for the memorial commission is unclear. It may have been a recommendation from her son's former employer, Herbert D. Hale, whose own father, the author and clergyman Edward Everett Hale, had been the subject of a Partridge bust in 1891. The contract[3] directed Partridge to create a life-size sculpture in fine Carrara marble, as well as a portrait relief of young Averell for its base. He was to be paid

$8,000 for his work in four installments of $2,000: upon the approval of the sketch models; upon the completion of the life-size clay version; when the sculpture was pointed up in marble and half the work on the pedestal was completed; and upon completion of the entire project.

As the date for the opening of the new gallery approached, it became clear that the sculpture would not be ready in time for the dedication ceremonies. Partridge had not been well over the summer, and he was also working on a sculpture of Thomas Jefferson for Columbia University (the model for which is in the Memorial Art Gallery collection) and a memorial for Joseph Pulitzer's gravesite. Unable to get back on schedule, he proposed making a plaster cast from the life-size clay model of *Memory* to stand in until the marble version could be completed. Rochester sculptor Thillman Fabry, later celebrated for his wood and plaster carvings in Kilbourn Hall and St. Paul's Episcopal Church on East Avenue in Rochester, was called upon to create a temporary plaster base.[4] Thus it was that on the afternoon of October 8, 1913, when the Memorial Art Gallery opened its doors for the first time, a reproduction of *Memory* stood in the main gallery while the partly finished original remained at Partridge's studio on West Thirty-eighth Street in New York City.

In December of that year, the sculptor requested photographs of the cast in situ to assist him in his work. Correspondence between Partridge and Gallery director George Herdle is incomplete,[5] but in a letter dated March 11, 1914, Herdle expressed his polite hope that "we will soon have the pleasure of seeing the finished marble in our gallery." The pedestal had become a problem; Partridge explained on March 14 that there had been a bad flaw in the first block they attempted to cut and that a new one had to be started. He expected delivery to take place no later than April 1 and must have been more or less on schedule because on April 23, Herdle informed him that a Rochester craftsman had carved the inscription[6] on the base. He also assured Partridge that some of the light entering through the skylight had been deadened, resulting in "a vast improvement over the former garish illumination." Four days later, Herdle sent a formal letter of thanks, lauding the sculpture's "tenderness of feeling" and calling it "a source of constant surprise and joy to us all."

Although Partridge pronounced "exorbitant" the Rochester Carting Company's charge of $90 to set the heavy sculpture in place, he paid the bill and asked to have the plaster cast shipped back to him. Sadly, in August of 1922, an enormous amount of coal was mistakenly dumped into the cellar where the artist had stored about 250 casts, models, and death masks. According to the *New York Times*, "General Grant's head was smashed in....President Roosevelt's body was crushed and his

nose was broken off, and other famous men…were mutilated, while group figures of religious and patriotic scenes were irreparably damaged."[7] In all likelihood, the plaster cast of *Memory* was among the victims.

In a book titled *Technique of Sculpture,* Partridge advised artists that "the continuous striking upon the marble dulls the delicate sense of touch and feeling, and stiffens the muscles."[8] He suggested that the sculptor do his own finishing work, or supervise it closely, but entrust the initial carving to an assistant, the best of which "has no creative genius of his own."[9] In 1889 he had persuaded an Italian carver named Giovanni (John) Rapetti to accept employment in his studio. Rapetti had been one of the sculptors who assisted Frederic Bartholdi in creating the Statue of Liberty and, in all likelihood, it was he who chiseled the basic form of *Memory* after the block of white marble had been pointed up from the clay model. One art historian has written that "most of Partridge's marble pieces appear dull by comparison with the initial clay models"[10] and suggests that Partridge may not have always done the finishing work himself. In the absence of the model for *Memory,* it is impossible to compare the sculpture against it.

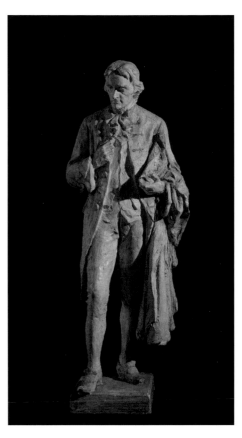

William Ordway Partridge
1861–1930
Thomas Jefferson, ca. 1914
Painted plaster
20 in. high
Gift of Lily Lawlor, 23.8

To twenty-first-century eyes, *Memory's* flowing drapery and the funeral urn she clutches to her breast create a classical impression. However, Partridge was considered an impressionist sculptor at this stage of his career, and the marks of the chisel that are so apparent in the figure's robe make it a work very much of its own time. When a dealer from the Metropolitan Art Association in New York City tried to interest the Gallery in acquiring similar work, University of Rochester president Rush Rhees responded: "I doubt whether the Art Committee desires to enter the field of modern sculpture. The memorial piece by William Ordway Partridge is likely to remain an exception for many years to come."[11]

Marie Via is Director of Exhibitions, Memorial Art Gallery.

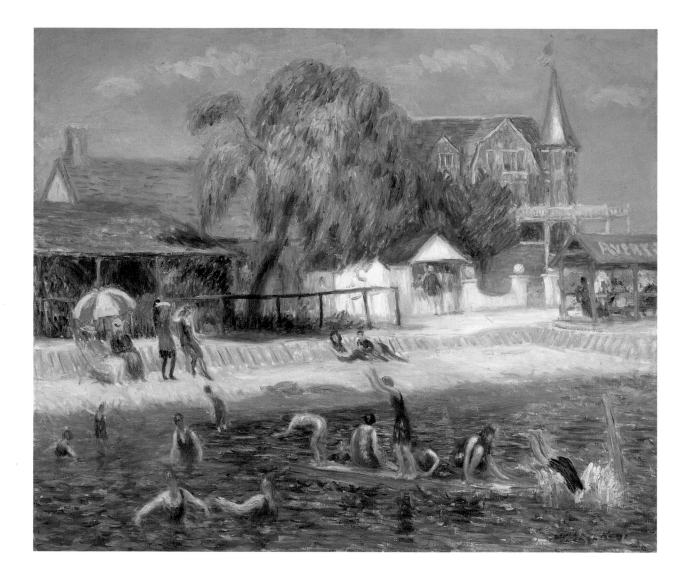

45: William Glackens *Beach at Blue Point* (ca. 1915)

Grace Seiberling

In *Beach at Blue Point* William Glackens presents a moment out of time. People relax in the soft light and warmth of a summer's day. In the blue-green water, divers, rafters, and bathers are forever stopped in mid-motion. A man and a woman buy refreshments at a window while other people lounge in an open shed with "Avery" on the roof.[1] Two women lounge under a yellow and orange umbrella with their straw hats tilted down while others relax along a sea wall. This scene is an idyll but it also lets us know some things about Blue Point and what summer was like on the relatively sheltered waters of Long Island's Great South Bay in the early teens.

Beach at Blue Point is part of an extended group of paintings Glackens did between 1911 and 1916 when he and his family spent summers in the town of Bellport on Long Island.[2] He painted many views of beaches at Bellport and nearby Blue Point. Although the Atlantic beaches on Fire Island could be reached by ferry, Glackens preferred the protected waters of Great South Bay.

These works represent a change for Glackens, who had previously concentrated on New York scenes as a painter and illustrator. A member of the group called The Eight, he had shared their predilection for urban subjects emphasizing the grittier side of city life. The impressionist-inspired landscapes showing middle-class outdoor recreation suggest a different way of living. Glackens was about forty-five when he painted *Beach at Blue Point*. His marriage to Edith Dimock, daughter of a wealthy textile manufacturer, had brought an end to immediate financial pressures, and allowed him to focus more on painting, although he would continue producing illustrations until 1919. His children, Ira, born in 1907, and Lenna, born 1913, provided one impetus for renting a cottage near the seashore. Summers at Bellport provided an opportunity to explore a new range of subjects and develop his sense of color. "Color should be as expressive as drawing," he said in 1913; "it should be as closely connected with life."[3]

Glackens's contact with modern European painting had been renewed when he went to Paris in 1912 to buy pictures for the collector Albert Barnes, and again in 1913 when he headed the committee to select American works for the Armory Show. Although he appreciated works of Matisse and others, the challenge he had set himself of painting figures in action and in changing scenes with varied textures and shifting light was closer to that of the impressionists. He acknowledged the influence of Renoir, then the most admired impressionist in America, asking a critic, Forbes Watson, who complained of the connection, "Can you think of a better man to follow than Renoir?"[4] Glackens's colors—emerald green, yellows, dark blues, and crimson lake—do call to mind Renoir, as does the soft, feathery brushwork in some parts of the painting.

While the scene in the Memorial Art Gallery's painting may appear to be detached, it is connected in many concrete ways to its milieu in the teens. Glackens's earlier career as an illustrator continued to inform his work, both in his ability to present scenes of many people with individual characterizations and in his sensitivity to social issues and nuances of behavior.

He was aware that these scenes of summer recreation had their counterpart on the city streets. *Far from the Fresh Air Farm,* a drawing Glackens did in 1911, shows crowds of people shopping and carrying on their business beneath a banner advertising an annual beach outing, while children play ball in the street or are nearly run over by a delivery wagon. Like George Bellows in his 1913 lithograph *Why don't they all go to the country for vacation?,*[5] Glackens in his drawing presents the lives of a group of people who can't afford to get out of the city. They might spend an afternoon on the beach at Coney Island, but not the long days of leisure evoked by Glackens's scenes at Bellport and nearby Blue Point.

William Glackens,

1870–1938

Beach at Blue Point, ca. 1915

Oil on canvas, 25¼ x 30⅛ in.

Elizabeth R. Grauwiller Bequest,

73.12

Seaside recreation had become a prominent feature of life in the late nineteenth and early twentieth centuries. The Industrial Revolution had increased leisure time for middle-class people, and improved transportation allowed greater mobility. The Long Island Railroad had made the Atlantic beaches readily accessible to vacationers. As early as the 1880s summer resorts and hotels like those at Blue Point were built in the coastline villages. By the time Glackens went to Bellport, its beaches were already crowded. Not only a wish to escape the heat of city summers, but also a concern for health had led to the development of Long Island. Popular magazines advised families to avoid the threat of infectious diseases by leaving the city for the summer.[6] Fears of the polio epidemic in 1916 even led the artist to move his family away from Bellport to a more rural location in the middle of the summer.[7]

Unlike Renoir's timeless nudes, Glackens's bathers are participants in a social scene of their time. The majority of people in the Bellport and Blue Point paintings are women. This may very well suggest the life of a seaside resort where wives and children spent the weekdays, escaping the heat and health dangers of the city, to be joined on the weekends by men who worked in New York.

Glackens's paintings of Bellport and Blue Point contrast both with the elegant views of Long Island in the works of William Merritt Chase and the rowdier, more working-class scenes of Coney Island that Glackens and John Sloan had done earlier.[8] Chase's scenes at Shinnecock show a bucolic land-

scape of fields inhabited by women and children, far from the workaday world. Bellport, according to Ira Glackens, was an unspoiled town without any large estates. "Near the beach," he writes, "stood a huge barnlike 'Vacation Home' for New York shopgirls."[9] A recent commentator has remarked on the accord between the improvisatory aspect of the landscape around Bellport and Glackens's subjects: "This shoreline was punctuated by rickety gazebos, jetties, rafts and water slides, and dressing sheds and seems extremely commonplace in comparison with the elegant beaches that Boudin depicted at Deauville and Trouville or that Chase recorded at Shinnecock. The liveliness of his figures' poses and of his paint application is entirely consistent with the casual energy and spontaneous activity associated with the young people whom Glackens pictures."[10]

This spontaneous activity links the beach scenes with Glackens's urban scenes and his illustrations. He could characterize individual figures yet give a sense of the activity of the whole. Wattenmaker remarks that the figures frolic and pose in specific attitudes like actors on a stage, which, in a sense, they are.[11] Women drying or dressing their hair appear in the middle ground in *The Beach at Blue Point* but neither they nor the bathers—in different variants of swimwear, with and without sleeves, with and without stockings—suggest the extent to which women's freedom of behavior at the beach was a matter of controversy at the time.

Appropriate standards for swimwear were one focus for debate about the boundaries of women's behavior in public.[12] Glackens's illustration of a beach scene, "Vacations," appeared in a 1913 issue of *Harper's Weekly* that also contained an article on champion swimmer Annette Kellerman, depicted in her controversial one-piece bathing suit. It began, "Most persons would perhaps agree that a

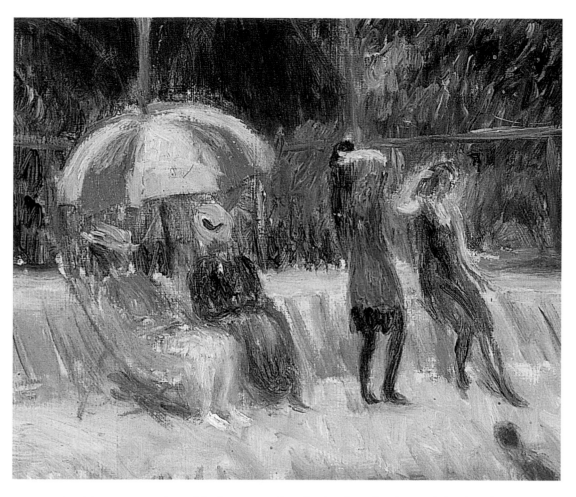

William Glackens,
1870–1938
Beach at Blue Point (detail),
ca. 1915
Oil on canvas, 25¼ x 30⅛ in.
Elizabeth R. Grauwiller
Bequest, 73.12

woman should not appear in public in a state of nudity, but how far short of that happiness propriety makes it necessary for her to stop seems to be an undecided question."[13] Unlike their faceless counterparts in his painting, the women in Glackens's illustration pose provocatively.

Nevertheless the Bellport and Blue Point pictures draw back from overt social commentary. Glackens was realist enough to notice the contemporary aspects, but he addresses an audience beyond the immediate, beyond the readers of illustrated magazines. The pleasurable aspects of his work remain fresh.

Albert Barnes wrote about Glackens's beach scenes: "He shows with detachment the essential picturesqueness and humanity of the events represented, and his only comment upon life is that it is pleasant to live in a beautiful world."[14]

Grace Seiberling is Associate Professor of Art and Art History, University of Rochester.

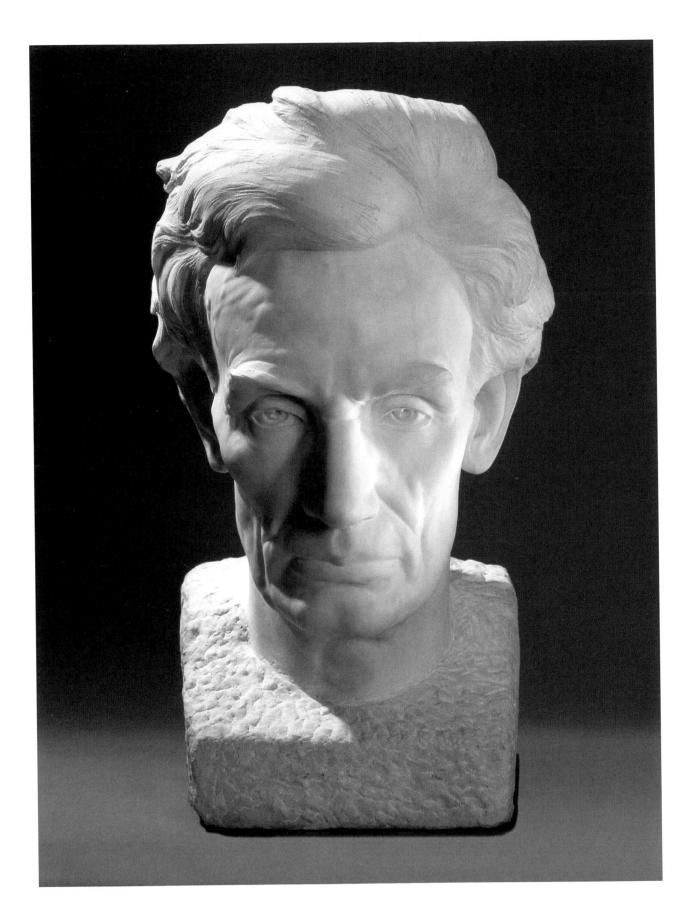

46: George Grey Barnard *Abraham Lincoln* (ca. 1918)

Grant Holcomb

George Grey Barnard was one of the many American artists directly influenced by the work of Leonard Volk. He referred to Volk's cast of Lincoln as "the most wonderful face left to us"[1] and, indeed, felt "there was enough in [the casts] to make a human religion."[2] Lincoln, in fact, became both artistic and religious icon for Barnard. "This face," he proclaimed, "is infinitely nearer an expression of our Christ character than all the conventional pictures of the 'Son of God.'"[3] Barnard's many portraits of Lincoln, two of which are entitled "Lincoln as Christ," reflect the profound impression that Lincoln's life made on the artist.

Barnard was born the son of a minister in Bellefonte, Pennsylvania, and spent his early years living in the Midwest, primarily in Kankakee, Illinois. At the age of seventeen, he moved to Chicago and enrolled in evening classes at the Chicago Academy of Design. Here he first met and studied with Leonard Volk, founder of the Academy, and Leonard's son Douglas. Thanks to a commission he received while studying in Chicago, he was able to travel to Paris in 1883 and study at the École des Beaux-Arts. Indeed, he would spend twenty of the next twenty-eight years working and studying in Paris (1883–1894 and 1902–1911) where he produced many of his most monumental works. These include *Struggle of the Two Natures of Man* (1894, The Metropolitan Museum of Art), *The Great God Pan* (1899, Columbia University) and the heroic grouping of figures *Love and Labor: The Unbroken Law* (1910, Pennsylvania State Capitol, Harrisburg)—until that time, the largest commission ever received in the U.S.[4] All reflect the artist's mastery of materials (especially marble) and his proficient training in classical sculpture.[5]

George Grey Barnard,
1863–1938
Abraham Lincoln, ca. 1918
Marble, 21 x 11⅞ x 14⅞ in.
Marion Stratton Gould Fund,
86.5

Upon his return to New York City, he began to focus his lifelong interest, one might say his obsession, on the life and the legacy of Abraham Lincoln. In 1912, former United States President William Howard Taft commissioned Barnard to create a monumental bronze sculpture of Lincoln for the citizens of Cincinnati, Ohio. Barnard sought to capture a "Lincoln of the People," or, in his words, "the mighty man who grew from our soil and the hardships of the earth."[6] When unveiled in 1917, it met with scathing derision and ridicule. If the public referred to it as "The Tramp with the Colic" or "The Stomach Ache Statue," most damning of all was the criticism by Lincoln's eldest son Robert who, in a letter to Taft, called the sculpture "a monstrous figure which is grotesque as a likeness of President Lincoln and defamatory as an effigy."[7]

Barnard was undeterred by such criticism and continued to create many portrait busts of the martyred president. The majority range in size from approximately eighteen inches to a colossal fifteen-foot high bust. Together, they depict a variety of "Lincolns" from the clean shaven to bearded, youth to adulthood, and melancholy to romantic. The Memorial Art Gallery bust is part of this series and evokes, much like its counterpart at the Metropolitan Museum of Art, a contemplative young man with smooth face and full sensuous lips, the hair massed and tousled, and the base pitted and textured. The series of marble and plaster busts reflects the artist's abiding interest in discovering the many aspects of Lincoln's personality whether serious or comic, romantic or spiritual. Barnard truly "sought the secret of his face,"[8] which he described as "the triumph of God through man and of man through God....Lincoln, the song of democracy written by God."[9]

Grant Holcomb is The Mary W. and Donald R. Clark Director of the Memorial Art Gallery.

47: Charles Burchfield *Cat-Eyed House* (1918)
Springtime in the Pool (1922)
Telegraph Pole (1935)

Nancy Weekly

Two of the paintings by Charles Ephraim Burchfield in the Memorial Art Gallery's collection aptly illustrate the stylistic extremes that frame an intense period of transition in the painter's work and life, and a third serves as an early environmentalist's statement against the pollution of industrial America. *Cat-Eyed House,* coming at the end of World War I, marks his early ventures into fantasy and anthropomorphism. *Springtime in the Pool,* coming at the end of this process, is one of only three paintings he completed in 1922,[1] but stands among Burchfield's most buoyant and evocative works. Also known as *Sun Reflected in Pool,* it is a glorious homage to spring that ushers in the radical personal changes taking place in Burchfield's life, as well as a transition in his painting style and subject matter.[2]

To understand the importance of *Springtime* in Burchfield's oeuvre, we need to digress briefly to consider his career and education. Six years earlier, in 1916, he had graduated from the Cleveland School of Art, having concentrated in design, illustration, and painting. His early works were imaginative, stylized landscapes and rural Ohio scenes. During this time of artistic development, Burchfield sketched incessantly and started all watercolor paintings with a graphite sketch of simple outlines that he filled in with color. During his student years he had been influenced by Chinese landscape scroll paintings, Japanese artists Hiroshige and Hokusai, illustrators such as Aubrey Beardsley, and Russian ballet designs by Léon Bakst. These led him to a style that capitalized on flat patterning and limited modeling for three-dimensional mass. In a retrospective exhibition in 1965, he recalled his favorite Cleveland teacher, Henry G. Keller, saying that his "inability to see form" and his "virtually complete concentration on two-dimensional pattern, amounted almost to genius."[3]

After a truncated visit to New York City in the fall of 1916 to attend the National Academy of Design on a scholarship Burchfield returned to his small home town of Salem, Ohio. There, far from painting in a merely decorative style, he began in 1917 to depict childhood emotions and visualizations of sound through linear distortions and symbols. In doing so, he created a personal, visual language that he used throughout his career. His vocabulary included distinctive repetitious patterns for cicadas, crickets, spring peepers, and other wildlife, animation marks to suggest the effect of wind rustling through trees, and inventive motifs he called "Conventions for Abstract Thoughts," which symbolically characterized extreme emotions such as "Fear," "Morbidness," "Melancholy," "Dangerous Brooding," "Imbecility," and "Insanity." These conventions he used as anthropomorphic tools to suggest personality flaws of residents through the exterior of their buildings. By 1918, when he painted *Black Houses* (private collection) and *Cat-Eyed House* (now owned by MAG), he abandoned the specific menacing fantasy forms of the "Conventions" and instead exaggerated porch shadows, cornices, curtained windows, sagging clapboard and rooflines to make the houses themselves appear as gargantuan beings. Not a single right angle can be found in *Cat-Eyed House,* transforming it from an engineered architectural structure in Washingtonville, Ohio, into a lurking feline caught in the sun's glare off snow. He considered these paintings "'portraits' of individual houses....[M]any were social or economic comments...to express the ingrown lives of solitary people."[4]

Charles Burchfield,
1893–1967
Cat-Eyed House, 1918
Watercolor with graphite
on paper, 18¼ x 22¼ in.
Marion Stratton Gould Fund,
44.53

Inducted into the U.S. Army in July 1918, Burchfield traveled to Camp Jackson, South Carolina, where he first served in the field artillery, and later was relieved to be transferred to the camouflage corps. The return to his previous life after the war was difficult. Regrettably, he destroyed a fanciful series of paintings depicting life from a bird's perspective after being discouraged from publicly showing them.[5] During his modest output that year, he also painted abandoned coal mines, trains, and beleaguered houses in Ohio's small towns. Then, having floundered in finding appropriate subjects at the beginning of 1919, Burchfield reached a pivotal point after reading the newly published *Winesburg, Ohio* by Sherwood Anderson, although he preferred the settings over the characters in these stories that conveyed an atmosphere of disillusionment, boredom, and desperation in midwestern America. He considered Anderson to be one of America's best writers of their generation. The book sent him "back to the human scene" and his paintings took on an analogous look of despondency. A number of national critics recognized the connection between Burchfield and Anderson.[6] Carl Bredemeier in Buffalo thought that Burchfield painted

> truthfully, directly, brutally, and without apology, as he saw it....What Carl Sandburg and Edgar Lee Masters do for us in verse, what Sherwood Anderson did for us in "Winesburg, Ohio," and what Sinclair Lewis did in "Main Street," Burchfield does with water color. Nature sees to it that we have every generation, our uncompromising realists, clear-eyed, fearless men who tear aside the sham of our lives and show us some of the dross.[7]

Burchfield took pride in their comparisons, saving in a scrapbook the articles that declared him "the Sherwood Anderson artist."[8]

Literary works continued to fuel Burchfield's interest in American subjects. He was drawn to the work of Zona Gale and Sinclair Lewis, and especially favored Willa Cather's "epic grandeur of postpioneer life."[9] After the sale of some works from his first exhibition at the Kevorkian Gallery in 1920, Burchfield used the income to take a three-month summer leave from his office job in Salem to travel and paint. In New York, Mrs. Mary Mowbray-Clarke, a bookstore owner who had become his first art dealer during his original brief visit to the city, introduced him to Arthur B. Davies, who showed Burchfield his own experimental techniques with oil tempera. Burchfield tried using it for a couple of paintings, including *Late Afternoon Twilight* (Burchfield-Penney Art Center).[10]

Back in Salem in 1921, with the American economy in a postwar depression, Burchfield lost his job at the W. H. Mullins Company, where he had worked since childhood. At first he painted full time and was encouraged when The Brooklyn Museum acquired *February Thaw* (1920)—his first work purchased by a museum. During the summer he worked at Elias Kenreich's farm in Greenford, Ohio, where he became attracted, and soon engaged, to Bertha Kenreich. Wanting to earn a living using his artistic talent, Burchfield, on the advice of his former teacher Henry Keller, applied to M. H. Birge & Sons Company, one of the nation's most prominent and artistic wallpaper companies. After head designer Edward B. Sides hired him as his assistant designer, Burchfield moved in November to a small apartment close to the plant in Buffalo, New York.

The year 1922 signifies a major change in Burchfield's life. On April 13 Mary Mowbray-Clarke wrote to Burchfield about his current group exhibition at the Montross Gallery and how she "begged them to cut out the tiresome blurb about your supposed hatred of Salem." She offered poignant advice on his approaching marriage, and importantly, observed: "...only you and Sherwood Anderson seem to have direct power to use American experience pure and simple. You can both infuse into the verities of the powerful seeing eye the verities of another world than that of the eye. An avenue to the subconscious in both of you is at times opened and you achieve considerable power of statement."[11] Such validation of his current and future abilities may very well have sparked Burchfield's creative drive, sending him to Spring Brook to paint *Springtime in the Pool.*

Charles Burchfield,
1893–1967
Springtime in the Pool, 1922
Watercolor and gouache
on paper, 21 1/8 x 18 5/8 in.
Gift of Mrs. Charles H. Babcock,
45.68

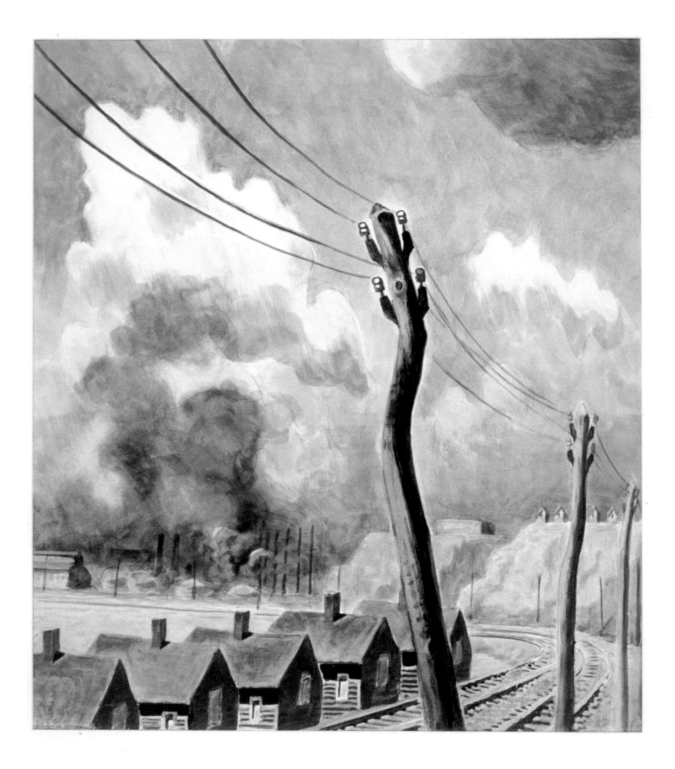

The courting period that spring was filled with anticipation of the imminent wedding, their separation tolerated as a necessity of preparation. Burchfield changed apartments twice, settling in May at 170 Mariner Street, where a two-room apartment would become the newlyweds' first home. Sprucing up the new apartment, Burchfield wrote enthusiastically:

> It is May! The buckeye trees are almost fully out, and hang loosely with great masses of vivid emerald foliage—there is nothing to equal this brilliant color of green—the sun shines on it in a subdued silvery highlight & the partly cloudy sky beyond is composed of pale violets—a cool breeze comes out of the sunlit south—Maple trees are speckled with twin leaves that form horizontal dashes across their branches—The shadows under porches suddenly become intensified & full of poetry—It is the kind of day that should have its lawnmower going.
>
> At evening to my new quarters—to the place where Bertha & I will start life together—Mariner street is lined with buckeyes & elms, and I felt a wave of joyousness come over me as I walked up under those brilliant green trees, splotched with yellow in the late afternoon sunlight....[12]

Four days later he wrote:

> In the afternoon I went out to Hamburg & beyond to walk, & get some wild flowers plants to decorate the rooms for when Bertha comes—I felt as I used to when as a small boy I gathered plants for my grape-arbor garden....The virgin freshness of the new trees gives the woods a feeling of sacredness— A plowed field, dried in the sun gleamed intensely hot white thru openings— Mosquitoes abounded but their humming belonged to the general summer scheme....[13]

Charles Burchfield,
1893–1967
Telegraph Pole, 1935
Watercolor, charcoal and
graphite, 23⅜ x 20⅞ in.
Gift of Mrs. Charles H. Babcock,
47.105

On May 20, Charles and Bertha were married on her family farm. Their trips into the Western New York landscape began shortly after they returned. Before the end of the month they took a Saturday walk along the Niagara River, experiencing the flush of the season with the optimism of newlyweds. Burchfield sustained new confidence in taking his artwork in a different direction. "[I]t came over me all at once how proud & glad I was that I was 'I'—that my conception of nature was all sufficient to me—that nature in all its raw harsh uncouth beauty was worth more to me than all the sophisticated art of the world—that I am a pioneer, and that I must retain the courage to present nature in all its harshness & not soften it to the vulgar taste of sophistication...."[14]

Springtime in the Pool quite likely was painted just before Burchfield's marriage, since the bare trees indicate that the weather was still cool enough for pockets of snow to linger. In Volume VII of his Painting Indexes,[15] Burchfield recorded this singular painting for 1922. Its "location or subject" was noted as "Cazenovia Creek, near Northrup Rd, Spring Brook, N.Y." The rural setting was perfect for a blissful evocation of nature, emblematic of the elation in his personal life that he needed to express through earthly, yet metaphysical symbols. Wandering through the same region on weekend forays with Bertha later, Burchfield wrote about how their laughing, enjoying the sounds of robins and towhees, the smell of the earth, or a chance visit to an old farm, sometimes made them feel transported in time to "romantic pastoral scenes of hundreds of years ago."[16] Indeed, the painting depicts a timeless scene rendered in a palette of seasonal colors and brilliant light. The primordial land of lavender gray hills rises behind horizontal bands of rich black and ochre earth, a melting trough of snow, and a taupe shore with pink accents. Open, limitless space in the pale aqua sky is accentuated by delicate leafless trees whose branches dissolve in the air like water ripples, drawing the eye toward the sun's presence at its zenith, suggested by subtle gradations of white gouache. Its pure light dances in shades of pastel blue, green, and gray, becoming whitest at the center, while ripples on the placid pool undulate in the palest hues of gray, lavender, and salmon. The painting

taken whole is a paradigm for new life and growth, a new direction with more complex concerns, a personal identification with nature. It stands as a transcendental turning point in Burchfield's work and life, a hint of the remarkable, mythical works that were to come.

Fast forward to the mid-1930s and Burchfield's painting changes dramatically. For eight years he had grown increasingly disenchanted with the demands on his time at the wallpaper factory, yet he worried about the ability to support his wife and five children. In February 1929, art collector Edward Wales Root introduced him to the New York gallery owner Frank Rehn, who began to sell his work. Yearning for an alternative that would give him the freedom to paint, Burchfield agonized over making the right decision. After six months' association with Rehn, he resigned from Birge in August, only weeks before the stock market crash triggered the Great Depression. Nevertheless, Burchfield managed to maintain his artistic independence for the rest of his career. He began to seek new subject matter in Buffalo's harbor and urban landscape, near his suburban home in Gardenville where he had moved in 1925, and further into the countryside. His work reflected greater realism in larger compositions. Finding an odd beauty in industrial pollution and weathered houses, Burchfield chose the unglamorous side of America during the 1930s in order to call attention to both the "sinister darkness" of a man-made environment and the romantic retreat into domestic simplicity or rural purity.

Telegraph Pole, painted in 1935, is a perfect example of a lingering thought reemerging in a contemporary context. He wrote that the composition was "built around a telegraph pole found near Beech Creek, Penn[sylvani]a,"[17] discovered during his trip home from the Army in 1918. Merged with details from other sites, the pole became a remarkable metaphor. Clearly it had been a tree in its earlier life. Cut down in its prime, stripped of its bark and limbs, it is now imprisoned by wires along tracks leading to an industrial inferno. The battered tree seems still alive, writhing to escape from the belching smokestacks, daunting factories, and lifeless row of workers' huts. Soot-filled blue-black smoke builds into thunderheads certain to carry ash and, as we now know, acid rain to a scorched earth. Ironically that telegraph pole is relaying its own message: a call for humanity to reverse its misguided destruction of the land. It points the way to the later, even grander masterworks that reflect Burchfield's increasingly personal reverence for nature.

Nancy Weekly is the Head of Collections and the Charles Cary Rumsey Curator, Burchfield-Penney Art Center at Buffalo State College.

48: Harold Weston *Three Trees, Winter* (1922)

Rebecca Foster

> I stopped beside a big hemlock tree and reached around the great trunk to feel its vigor, its reality, its life existing essence. My ear, laid against the wet bark, seemed to hear the pulse, the flow of life-creating sap....[R]oots plunged into the soil, made it one with the earth and gave it life. As a primitive pagan I bowed before the mystery of that world spirit that giveth life to nature and to man.[1]
>
> —Harold Weston, 1922

With a staff to support his half-paralyzed leg, Harold Weston walked on snowshoes through the Adirondack wilderness on nights when the moon reflected bright light on the snow. He wanted to know the woods in every mood and every season, even at night. He hiked the hills and rowed the lakes, chopped his wood and howled at the moon. He lunged, hopped, and swung himself with powerful arms and climbed elevations to see and study every change in the light, colors, and forms. If he embraced the mountains, if he listened to their inner pulse, he thought, perhaps he could paint them. And perhaps he could become a painter.

He had built a one-room studio near his family's summer home in St. Huberts, New York, in the spring of 1920. An heir to the American transcendentalists through his father, a radical, intellectual theologian who led the Society for Ethical Culture movement in Philadelphia, Weston believed that nature embodied the spiritual and the aesthetic. He shut out all concerns but paint with the vigorous discipline of an autodidact. "If I have anything vital to say I must work it out with this great and ever changing source of inspiration about me,"[2] he wrote to his former teacher Hamilton Easter Field. He packed a knapsack with a tin sketch box containing paints, pencils, and small pieces of cardboard. Vigorously, expressionistically, ecstatically, he daubed and smeared paints on field sketches that Weston said came from "without."

The oils on canvas Weston painted in the studio, by contrast, are interpretive, symbolic, and write the inner world of the artist's living—a living defined by "mystical nature worship."[3] To look at the canvas *Three Trees, Winter* is to experience the place as he did, looking out from the woods and their soft shadows to the top of a moonlit hill where there is nothing more triumphant than...air. The painting is not about a single objective—a mountaintop, a view, a tree—it is about being surrounded by snow and light. It is more meditative than some of his other paintings of this period. *Three Trees* is about reaching the transcendent through the immanent, through unremarkable, tangible moments. His uncharacteristically quiet appreciation allows Weston to focus on the rhythm—or pulse—of the scene. At least one critic agreed: "There is so much rhythm in some of these forest scenes that one well believes the trees can 'clap their hands together,' and indeed, make any gesture of joy and abandon."[4]

Historically, large stands of trees served as inspiration for cathedrals, but over time the referent inverted itself and trees came to be seen to resemble cathedrals. Cloisters of trees and altars of mountaintops make up the house of pagan worship before which Weston bowed. The uninhabited landscapes he painted reach back to something primal, to a time "before anything had a soul / While life was a heave of matter, half inanimate," as D. H. Lawrence wrote in a poem that Weston clipped from a magazine.[5] Weston was discovering the birth of the world in the aerial optimism and snow-frozen forms of his winter canvases. Painters of the northern romantic tradition, such as Caspar David Friedrich, often used blue—the color Wassily Kandinsky called spiritual, infinite, heavenly—to

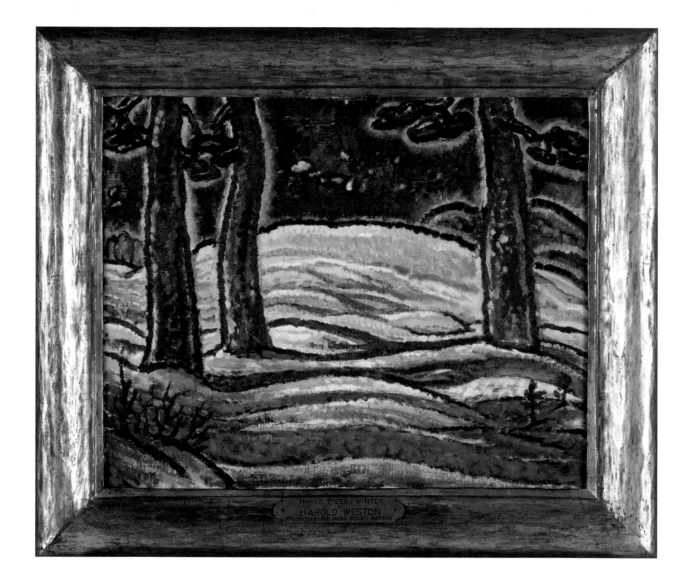

paint landscapes in lieu of religious iconography. The blue in *Three Trees* makes Weston a descendant of this tradition, but with a "joy and abandon" that are not often found in a Friedrich, Ferdinand Hodler, or Edvard Munch.

He had succeeded in finding something "vital to say," and the dealer Newman Montross was astute enough to realize it. Upon being offered a show at the Montross Galleries in New York City, one of the few venues for modernist works in 1922, Weston was so excited, and perhaps so anxious, about his first show that in the evenings he carved frames for the canvases. Each frame echoed the "emotional purport" of the painting it surrounded.[6] Not only does the frame for *Three Trees* mimic the curved form of the painting's tree trunks, but it also reflects the contemplative, peaceful mood of the picture. The hand-carved and gilded frames around the sixty-three canvases hung at Montross in November 1922 helped earn Weston the uniformly high critical praise that was his introduction to the art world.

Henry Tyrrell from the *New York World,* whom Weston called one of the few progressive critics, lingered for two and a half hours at the gallery, telling Weston that his work was the "biggest thing of its kind to hit the New York art world in the last two years."[7] Critics for the *New York Evening Post, American Art News, Art Review,* and *Vanity Fair* agreed that Weston's paintings were highly personal, not of any one school, and certainly not academic.[8] Most important was the critical approval of Henry McBride, the longtime champion of modernist work, in the *New York Herald.* Accustomed to making and breaking careers, he anointed Weston "likely to have a career." He called Weston heroic for pursuing his wilderness solitude, claiming that most great American artists, such as Thomas Eakins and Winslow Homer, had been recluses, too.[9]

The Memorial Art Gallery exhibited Weston's early landscape paintings in January 1925. The museum director, Gertrude Herdle, admitted that "the literal-minded among our gallery visitors cannot put themselves in tune with your cosmic rhythms because they look upon nature and the world with the eye of a camera."[10] "Like Blake, [Weston] will find a small number of kindred natures whose emotions toward nature spring from similar sources," wrote one Rochester critic. "He is merely a stray poet whom a few will listen to thankfully."[11] He had strayed to the mountains from the throngs of artists exploring the sophisticated speed and power of the city with cubist, futurist, and surrealist techniques. The stray poet no more took on the affectations of the "lost generation" than he did the economic plenty of the "roaring twenties." Even so, in Rochester he was dubbed "one of America's most significant living artists."[12] Herdle, who felt that Weston's work, "as an instance of spiritual intuition" was a "remarkable event,"[13] made sure that one of the landscapes was purchased for the permanent collection—*Three Trees, Winter.*

(Facing page)
Harold Weston,
1894–1972
Three Trees, Winter, 1922
Oil on canvas, 16 x 20 in.
Wood frame carved
by the artist
Gift of Emily Sibley Watson,
25.33

Over the next fifty years Weston lived and worked in France and New York City as well as the Adirondacks, and he even stole time from his painting for humanitarian causes.[14] His career changed radically over the decades but it had a fundamental integrity. In 1932 an *Art News* review noted that in spite of his continually evolving style Weston had "remained curiously and courageously himself." The explanation, the review concluded, was his early contact with nature.[15] Until the end he put "a full living into vital expression,"[16] a living whose creative foundation was the Adirondacks and the idea of wilderness that had plunged its roots into him at an early age and given life to his passion for paint.

Rebecca Foster is Weston's biographer and president of the Society for the Preservation of American Modernists.

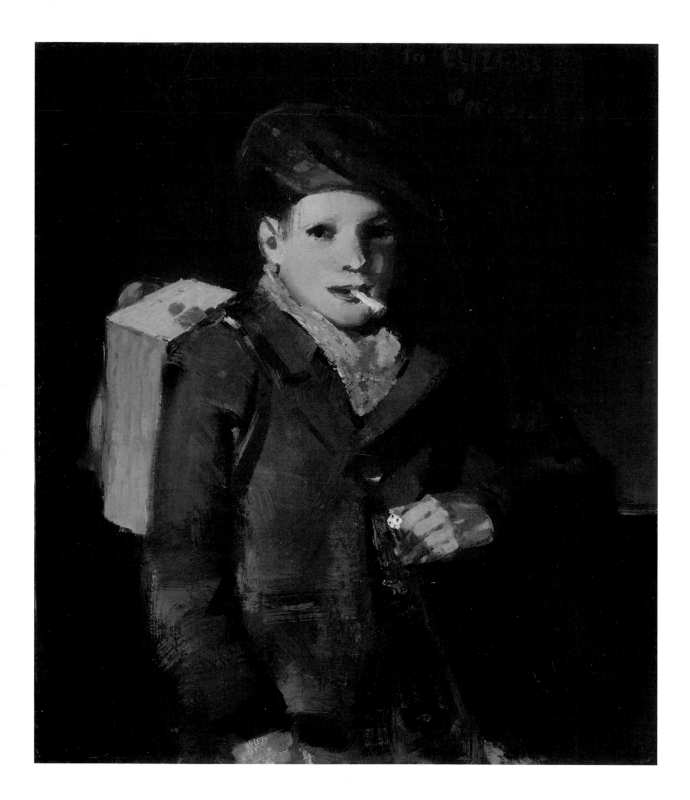

49: George Luks *Boy with Dice* (ca. 1923-24)

Bruce Weber

George Luks depicted children throughout his career. His interest in the subject began in earnest in 1896, when, after moving to New York from Philadelphia and joining the staff of the *New York World,* he temporarily took over drawing the comic strip *The Yellow Kid* from its originator Richard F. Outcault (1863–1928). *The Yellow Kid* was set in an Irish slum on the Lower East Side of Manhattan and dealt with the devilish adventures of the scrawny, toothless urchin Mickey Duggan and his Irish, Jewish, Italian, African American, and Chinese cronies. In keeping with his new assignment, Luks began to frequent the Lower East Side and, in 1899, he commenced painting the immigrant Jewish and Italian children who flooded the streets of the neighborhood—as well as the children of the longer-established Irish and Germans. Luks portrayed the children of this lively but impoverished area with tenderness, warmth, dignity, and humor. He believed that a "child of the slums [made] a better painting than a drawing-room lady gone over by a beauty shop."[1]

The Spielers (1905, Addison Gallery of American Art) is the best known of Luks's early paintings of children. The work was originally titled *Hand Organ Music* and ranks as his most jubilant celebration of childhood. The canvas, which portrays a German girl and an Irish girl whirling about the pavement to the tune of an Italian organ grinder, captures one of the most popular forms of entertainment on the Lower East Side. Many writers of the day commented on the type of scene pictured here. In 1904, Columbia University graduate student Bella Mead wrote a study about Lower East Side social life in which she related that

> No pleasure...is more generally indulged in than that of dancing. From the children to the mothers, it is enjoyed according to the individual capacity. The sound of the hurdy-gurdy on a warm spring evening is the signal for all the children in the neighborhood to assemble and to turn the side-walk into an impromptu dance-hall.[2]

In style, the painting reflects the influence of Robert Henri. Under Henri's influence in the 1890s, Luks began to create works in a dark earth-toned palette with a dramatic chiaroscuro technique, and developed an interest in the art of the seventeenth-century Dutch and Spanish Old Masters. Over the course of his career the artist enjoyed painting quickly, liked to combine house paint with conventional oils, and adopted his own unorthodox methods of applying pigment—including using his fingers.

George Luks, 1867–1933
The Spielers, 1905
Oil on canvas,
36⅛ x 26¼ in.
1931.9
Addison Gallery of American Art, Phillips Academy, Andover, Massachusetts.
All Rights Reserved.

Luks also painted pictures that suggest the harsher side of life on the Lower East Side. In *The Little Madonna* (ca. 1907, Addison Gallery of American Art), a child mothers her doll on a dark and dilapidated street. Luks appears to be alluding to a major social problem at the turn of the century: many little girls in the immigrant community were entrusted with the responsibility of looking after their infant brothers and sisters while their mothers were at work. Such girls were referred to as "Little Mothers," and their harrowing predicament led to the formation of the Little Mother's Aid Association and the Little Mother's League.

(Facing page)
George Luks,
1867–1933
Boy with Dice, ca. 1923–24
Oil on canvas, 30⁵⁄₁₆ x 26⁵⁄₁₆ in.
Gift of Mr. and Mrs. Thomas Hawks, in honor of Harris K. Prior, 74.103

From 1912 until 1924–25, Luks had a home and studio in upper Manhattan at Edgecomb Road and Jumel Place, one block east of Amsterdam Avenue and West 170th Street. While living there he often painted scenes featuring children of the neighborhood playing in High Bridge Park, a five-minute

walk from his residence. These works mark a major departure from the artist's earlier dark depictions of the downtown slums. They are distinguished by their vivid color, modified impressionist style, and solid compositional structure. While living uptown, Luks often befriended the children of the neighborhood and used them as models. In 1920, the art writer Mary Fanton Roberts recounted a conversation she overheard near Luks's house and studio: "'George Luks ain't a goin' to paint you!' 'Why ain't he goin' to paint me? My mama dressed me all nice.' 'Huh, that's why—he ain't a goin' to paint no kids what's clean.' I passed this group of excited children on my way to talk with George Luks about his work....You could see at a glance that these children knew and liked George Luks. He was their pal."[3]

In the early and mid-1920s, Luks painted several portraits of working boys, including the Memorial Art Gallery's *Boy with Dice*.[4] This work reveals the artist's greater concern now with form and volume, and his new incorporation of brighter and livelier color. His works of the period are also often distinguished by a broader and more bravura handling of paint than is seen in his earlier pictures. At this point in his career Luks felt that "Color, that's personal. It's something every artist must feel and develop, I like citron colors, pinks and watermelon rind green, blues like velvet to offset the yellows and browns."[5] The young bootblack carries a "kit" on his back with the rags and brushes of his trade, as well as dice for gambling on the streets. Luks, himself, sometimes enjoyed gambling with the children he encountered. The artist Gifford Beal (1879–1956) recounted an overnight stay that he and his sons made to Luks's summer home in Rockport, Massachusetts: "My boys were quite young at the time and he had never seen them before, but when I woke up rather early Luks already had both kids outside of the house pitching pennies on the sidewalk. He had a way with kids."[6]

The ethnic background of the bootblack is difficult to identify. He may be one of the many children of Italian heritage who worked in the shoeshine trade in New York in the early decades of the twentieth century. In the early 1920s, Luks's associate John Sloan pictured young Italian-American bootblacks in several of his etchings of Washington Square Park, a popular area of congregation for the shoeshine boys. As early as 1897 social reformer William I. Hull had noted that becoming a bootblack was often "the easiest entry into the world of business for the poorest boys."[7]

In *Boy with Dice*, Luks conveys the sense of hope and optimism he often felt in the presence of working class children. In 1921 he related:

> *Children seem to have in their eyes a definite glimpse of something, a wonder, a half-awakened expectancy. This is at once one of the most engaging and most elusive things an artist may try to catch....To paint children is to approach the historical!...I try to pick out children who give signs of meaning something to the community in the future....Some show the vitality and individuality that are almost certain to take them somewhere. This one may become a pugilist and that one an idealist. It doesn't matter. Each will be worthwhile, a leader, a voice. This little girl may be a madonna, and that a celebrated courtesan. It is not possible to say in what direction the energies of the child will drive it. One can only try to get those who promise to go far or high, whatever their path.*[8]

Bruce Weber is Director of Research and Exhibitions, Berry-Hill Galleries, New York.

50: Mahonri M. Young *Right to the Jaw* (ca. 1926)

Roberta K. Tarbell

In 1926, Mahonri Young was best known for his statuettes of urban and rural laborers, which he had exhibited internationally for twenty-five years.[1] *Right to the Jaw* was the first of his series of professional fighters. While precedents for Young's works include paintings by Thomas Eakins and George Bellows,[2] the depiction of the ancient sport of boxing in art had been relatively rare.

Mahonri Young was born and raised in Salt Lake City, a theocracy founded in 1847 in the Utah Territory by his grandfather, the Mormon patriarch Brigham Young.[3] As a youth the artist regularly sketched farmers and the workers who were building the transcontinental railroads.[4] He was inspired by other western artists—the brothers Gutzon and Solon Borglum and Cyrus E. Dallin—who also studied in Paris. Young's interest in sculpture was probably kindled by Dallin's important Salt Lake City sculptures of the Angel Moroni and Brigham Young.

Intermittently, between 1894 and 1901, Young studied art and worked as a sketch artist and engraver for the *Salt Lake Herald,* the *Salt Lake Tribune,* and the *Deseret News.* This experience remarkably parallels that of four Philadelphia artist/reporters—John Sloan, George Luks, Everett Shinn, and William Glackens—who came to be known as the "Ashcan" painters in New York City. Like these urban realists, who later became his friends, Young favored genre subjects and realist stances and gestures. But unlike them, he also retained the anatomical correctness and beautiful bodies of the academic tradition.[5] Although Young's style invariably is labeled realism, his images are not documentary, but rather are subjected to his strong bias for idealized naturalism.

Later, Young studied life drawing, anatomy, and illustration at the Art Students League in New York in 1899.[6] In Paris, from 1901 to 1905, he was a student of drawing, painting, and sculpture at the Académies Julian, Colarossi, and Delécluse. There he began to model clay figures of rugged muscular French workers whose indomitable spirits sustained them through protracted manual labor. Young had in mind both the social types of the sculptures of miners by the Belgian artist Constantin Meunier and the classical monumentality of the peasants of the French realist Jean-François Millet, though in Young's work, his consummate craftsmanship and serene compositions contradict the agony of the idealized muscles and the harsh conditions of these laborers' lives. He was particularly intrigued and influenced by Millet, whose paintings he first had seen in 1899 in Chicago and New York. Young visited Millet at his studio, acquired several of his drawings and etchings, collected and read books about him, and compiled five scrapbooks of reproductions of and articles about him and his work.[7] Later Young recollected:

> Since those early days when Millet discovered for me form, space, light and movement, I have never ceased to love and admire his work and the more I have studied it and the more I have seen of it the greater and more profound it has become. Though I studied him, I did not try to imitate him. He sent me to nature. I understood that, though I must get my material from nature, it was my job as an artist to make of it an ordered, composed work of art no matter in what medium I worked.[8]

Artists and critics recognized the quality of these bronze statuettes when he exhibited them in 1902 at the American Art Association in Paris. When he showed them in New York in 1912, J. Lester Lewine wrote that one figure, *Bovet Arthur–A Laborer,* had "the virility of masculine prime" and that others were "types of vital energy in action and repose." In 1918, Guy Pène du Bois observed:

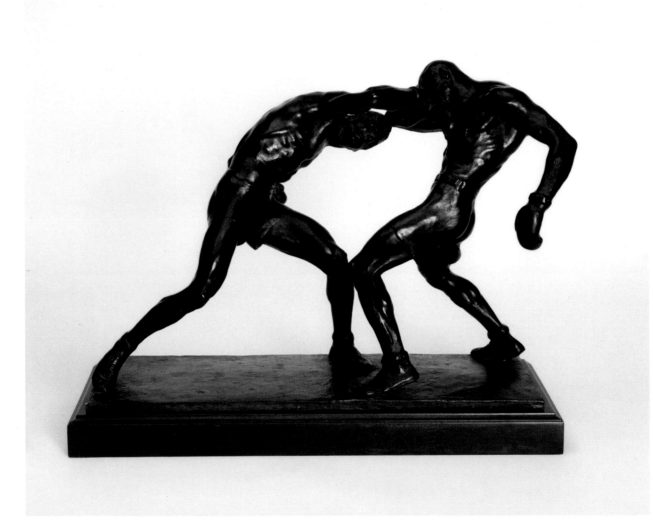

"Mr. Young's laborers exist as men rather than as symbols of a downtrodden class." In 1924, Young said that these figures were his "tribute to honest toil" and represented years of sympathetically observing, sketching, and modeling "the long procession of unskilled labor that has been the means of changing the face of the earth in the first quarter of the twentieth century."[9] Although his figures do not appear to proselytize for a political point of view, Young honored the dignity possible for workers and athletes in democratic countries.

From his bronzes it was a short step to Young's monuments honoring frontier and Mormon heroes. In 1913 his granite and marble *Sea Gull Monument* was erected in Temple Square, Salt Lake City. In 1947, he was commissioned to create for the U.S. Capitol Rotunda the marble seated portrait of Brigham Young. In the same year another of his monumental sculptures, *This is the Place,* was dedicated in Emigration Canyon in the Utah desert valley. The American Museum of Natural History in New York commissioned Young to create plaster sculptures for their dioramas of the habitats of the Hopi, the Apache, and the Navajo. For this project Young spent months in the Southwest sketching Native Americans, models for the thirty-five life-size figures he sculpted in a studio in the museum. His training as an artist/reporter helped him to record details accurately, but other artists' interpretations of the subjects and countless images from popular culture also shaped the forms he created.[10] Throughout his life, Young avoided traditional Roman and Greek mythological iconography, and celebrated instead the intensely physical people found in the West of his youth or in international modern society.

From August 1925 to January 1928 Young lived in Paris, where he created his first extant sculptures of prizefighters, *Right to the Jaw, On the Button,* and *Groggy* (adapted from one of the two figures in *Right to the Jaw*).[11] A combination of factors probably led him to this subject. Trained athletes of various races increasingly had become modern heroes, admired for their disciplined, skillful performances. Young had attended boxing matches in Utah, New York, and Paris, and loved to discuss the sport with his brother, Wally Young, a sportswriter. He admired the iconic power of the taut prizefighters in action painted by his friend George Bellows.[12] Leo Stein and Young reminisced about their student years in Paris when they had attended matches together and Young had broken his thumb sparring with Stein.[13] Although boxing had started for Young as physical exercise and a spectator sport, *Right to the Jaw* and the other prizefight sculptures established him as the premier creator of the genre. In *Right to the Jaw* one of the muscular athletes is poised precariously, deciding whether to succumb to unconsciousness or to resume the bout instants after his opponent has landed a right overhand blow to his chin.[14] It is a climactic moment of intense interaction between the belligerents, and a clear addition to Young's well-known vocabulary of solo active workers and contrapposto figures in repose. With such a "pas de deux" he has choreographed geometric forms and volumes of space—a hallmark of Bellows's boxing pictures—the tense action balanced by the structure's gentle undulating planes.

Before he left Paris, Young modeled two other boxing scenes—*Da Winnah!* (featuring the Madison Square Garden announcer Joe Humphries, the winner Jack Dempsey, and an anonymous loser) and *The Knockdown,* which depicts the Jack Dempsey/Luis Firpo heavyweight title fight of September 1923 that Bellows had painted in *Dempsey and Firpo* (1924, Whitney Museum of American Art). Young's interest in boxing rode the crest of a wave of popularity for the sport that culminated in the organization of intramural and collegiate athletic associations and, in 1928, the American national

amateur championships, the "Golden Gloves Tournaments." He exhibited his new sculptures of prizefighters at Rehn Gallery in New York in 1928 to universal acclaim. In his review, Royal Cortissoz celebrated Young's "clairvoyancy" and "the warm human tie" between the artist and his subjects.[15]

In Hollywood in 1929 Young created a portrait of African American lightweight champion Joe Gans and wax effigies of five other notables for Twentieth Century Fox Studio's "Seven Faces," one of the earliest talking pictures, which starred Paul Muni as the elderly caretaker of a Parisian wax museum. Young's life-sized bronze cast of Gans was prominently displayed in the main entrance of New York's Madison Square Garden and later moved to its Hall of Fame Club.[16] In 1932 Young won the gold medal at the Olympic Games Exhibition in Los Angeles for *The Knockdown.*

Throughout his career, Young consistently honored the power of hardworking people. *Right to the Jaw* and his other fine and original images of boxers remain the most varied set of sculptures of prizefighters ever created. Together with the work of Thomas Eakins and George Bellows they elevate the modern athlete to heroic stature.

ALSO IN THE MAG COLLECTION:

Mahonri M. Young,

1877–1957

Riggers/Riveters Medal, 1943

Bronze, 2⅞ x 2⅞ in.

Gift of Edward G. Miner, 45.37

Roberta K. Tarbell is Associate Professor, History of Art, Rutgers University, Camden, New Jersey.

51: Gaston Lachaise *Fountain Figure* (1927)

Cynthia L. Culbert

For many years, the idealized, serene, partially draped *Fountain Figure* by Gaston Lachaise occupied a central space in a jewel of a garden in Rochester, New York. The commission was the result of the landscape designer Fletcher Steele's search for good garden sculpture and a series of relationships and events that led the artist to a group of patrons, including Charlotte Whitney Allen and her husband Atkinson Allen, in Rochester. A beautiful sculpture and quite fitting in the garden, it bears little relation to the work that Lachaise is best known for—ample, fecund, earth goddesses—that earned him the place in the history of art as the sculptor of the monumental woman. That well-deserved title recognizes the power, heart, and soul that he poured into every work that fits that description. But *Fountain Figure* does not fit that description, and as illustrated by the letters between artist and patron, the circumstances surrounding its creation were strained, at best.[1]

Lachaise fell madly in love with an older, married American woman whom he met while she was visiting France around 1901. He followed her to America in 1906 and, following her divorce, married her in 1917. Of that first meeting he wrote: "I met a young American person who immediately became the primary inspiration which awakened my vision and the leading influence that has directed my forces....I refer to this person by the word 'Woman.'"[2] Her name was Isabel Nagle. She was ten years Lachaise's senior, with a son from her first marriage. Her voluptuous figure informed his work throughout his career (indeed, he modeled every uncommissioned sculpture since he met her on her form) and her luxurious life-style drained his wallet. In 1923, after they'd purchased a summer home in Georgetown, Maine, Lachaise started to seek commissions in order to supplement his earnings.

Through acquaintance with a group of his stepson's friends at Harvard University, Lachaise became the benefactor of very positive free press from the *Dial* magazine, a publication devoted to promoting the best in the visual and literary arts. Among Edward Nagle's peers and those involved with the *Dial* were e.e. cummings, Scofield Thayer, Gilbert Seldes, Marianne Moore, and Rochesterian James Sibley Watson, Jr.,[3] whose mother had founded the Memorial Art Gallery. The whole group became staunch Lachaise supporters, offering praise, encouragement, positive reviews, purchases, and eventually commissions.

Commissions became a point of tension for Lachaise. He could do them rather easily technically, as he spent his early career apprenticed to jewelry and glass designer René Lalique in France doing modeling and design work, then assisted Henry Hudson Kitson in Boston, where he focused on the details of Civil War monuments, and later, in New York, found work with the Art Deco sculptor Paul Manship. He spent about fifteen years polishing his skills as a sculptor with these artists, all of whose individual styles differed greatly from Lachaise's personal style. Around 1920 he stopped working for Manship and focused more on his personal work and a commission that he received in 1921 for a frieze for the American Telephone and Telegraph Building in New York.

Lachaise had his first one-man show in 1918 at the Bourgeois Gallery, where Charlotte Whitney Allen and her husband purchased a small bronze called *Pudeur*. Mrs. Whitney Allen likely saw the first work that Lachaise exhibited in New York when she attended the Armory Show in 1913. His second one-man show was also at the Bourgeois Gallery in 1920, around the same time the *Dial* started to showcase his work. The public reaction to the personal work Lachaise exhibited in these shows was mixed. Many felt that his ample nudes were shocking, even obscene, but the art critics' sensibilities were not so delicate and Lachaise received some rave reviews. Thereafter his career seemed to be thriving. But after the purchase of the summer property in Maine in 1923, the Lachaises were unable to keep up with their finances.

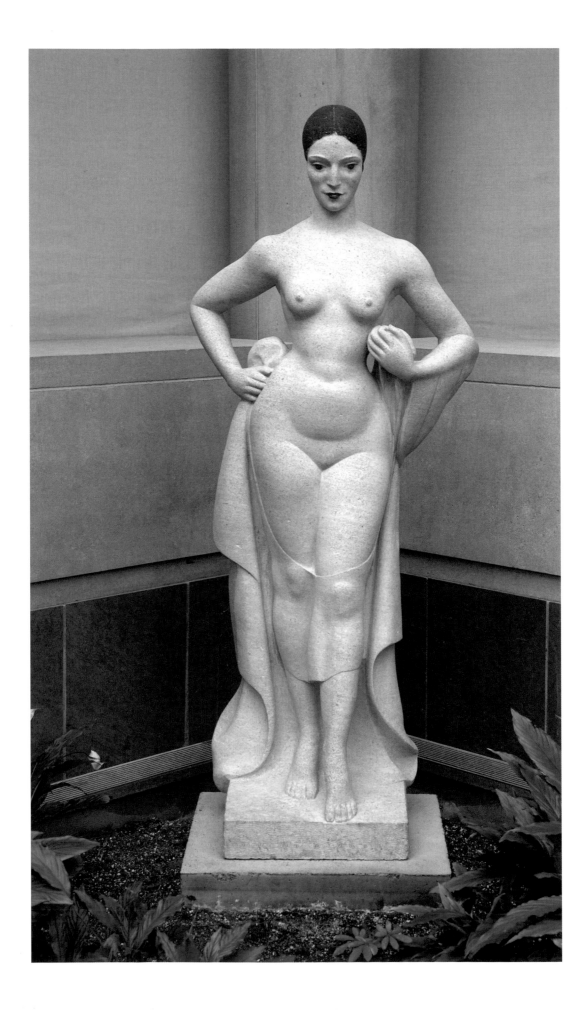

In search of more commissioned work, Lachaise turned to his friends and supporters at the *Dial*. Scofield Thayer had a portrait bust done in 1923–24, Marianne Moore in 1924, and e.e. cummings in 1927. James Sibley Watson, Jr. commissioned a statuette of his wife, Hildegarde, in 1925 and they had a portrait head of Mr. Watson done in 1927. A portrait head of Urling Sibley Iselin in 1927, commissioned by her and her husband O'Donnell, was followed in 1928 by a life-size bronze female figure. Urling, though she now lived in New York, had been born in Rochester. Both she and her cousin Watson were clients and friends of Fletcher Steele's and so had many connections to the Rochester scene, whose elite, in turn, were well connected with New York. In 1924 the Memorial Art Gallery held a show from *The Dial Portfolio of Living Art* (the *Dial* had amassed a collection of art illustrated in the publication), showcasing the work of Lachaise along with Picasso, Matisse, and Marin. The Allens, though already familiar with Lachaise's work through the exhibitions they attended, were likely caught up in the Lachaise fever of the *Dial* and their friends the Watsons.

A group of letters housed at Kenyon College in Gambier, Ohio, chronicles the working relationship between Lachaise and the Allens. The first letter dated from September 26, 1925, indicates that the Allens had already decided they would commission a sculpture from Lachaise for the garden that Fletcher Steele had been working on since 1915.[4] In a letter from October 8, 1925, Lachaise describes what he has in mind for the sculpture's size (life-size), attitude (about to step into the pool), and material (light pink Tennessee marble),[5] and he carefully lays out the price (five thousand dollars), payment plan, and a completion date of June 1926. Things appeared to be on track until June of 1926 when Lachaise informed the Allens that the sculpture would not be ready until late July. By July 1, he had only just received the piece of stone from which he would carve the sculpture (he had already worked out the design in clay and cast it in plaster). He also asked for his first advance payment at that time. Two weeks later he asked for $300, and two weeks after that, he was asking for more money. The letters that follow become more desperate and continue to ask for more money while apologizing for the fact that the statue is taking longer than he expected. A letter from August 2, 1926, reads: "I find I must have more time to finish your statue as I wish....There is considerable more work than I expected, to make it the complet beautifull [sic] work that I wish....This will make it imperative for me to have more money to be able to continue the work without difficulty[.] I trust you may understand my position and that you will send me a further payment."[6]

By January of 1927, the sculpture was complete enough for the Allens to see it in New York and they agreed to let Lachaise include it in its only exhibition before it entered the collection of the Memorial Art Gallery. This was at Alfred Stieglitz's Intimate Gallery from March 7 to April 3, 1927. By late February, after paying Lachaise a thousand dollars[7] more than originally agreed upon, Atkinson Allen wrote Lachaise: "We have now done a great deal more than we had planned to do or had any right to do from the point of view of our finances....[I]f you still need more money it will not be possible for you to look to us for it."[8] On the bottom of a further letter by the Allens, again refusing to give him any more money, is scribbled the word

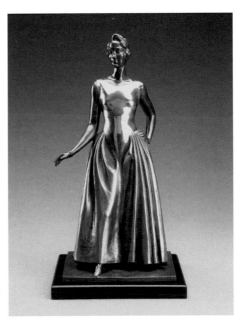

"anxiety."[9] Alfred Stieglitz then wrote to the Allens on Lachaise's behalf describing the reactions to the sculpture in the exhibition. He told how almost every artist who saw it felt it was one of the "grand bits of work that has come out of America"[10] and that John Marin broke down in front of it. He claimed that the average price viewers placed on the statue was twenty thousand dollars. By May 1929, Stieglitz was writing Lachaise his own letters refusing to lend him any more money, and his predictions of the statue's place as an icon of American art failed to come true.

In 1928, Lachaise wrote "A Comment on My Sculpture," in which he expressed his feelings about working for patrons: "One of the reliable pitfalls in the way of achievement is the society man or society woman seeking playtoys and prestige, publicity for their vanity in exchange for their frivolous or whimsical patronage."[11] Lachaise's biographer, Gerald Nordland, Lachaise's wife Isabel, and even their friends knew of Lachaise's distaste for working for others. Marguerite and William Zorach wondered about "'compromised' standards for reasons of money."[12] It is clear from comparing Lachaise's work for patrons with his own private work based on his reverence for Isabel that there was something missing from the commissioned work—the execution is flawless, the forms are pleasing to the eye, but they are also cold. They lack the spark and vitality that makes the rest of Lachaise's oeuvre deserving of its place in the annals of American art.

Fortunately, despite the drama over money and the greatness of a statue that Stieglitz shuddered to think would be hidden away in a garden, the Allens and Fletcher Steele were very happy with how it worked in its intended place. Steele's criteria for garden sculpture were met—the pink Tennessee marble contrasted nicely with the foliage surrounding it and blended with the brick and cast stone of the architecture, and the silhouette was animated without appearing blocked in by the arch that framed it. The Rochester weather surely took its toll on the sculpture, but Charlotte Whitney Allen had a box made to cover it in the winter, and on it she had a friend paint a likeness of the statue. At her death, she bequeathed *Fountain Figure* to the Memorial Art Gallery, where today it graces the Vanden Brul Pavilion.[13]

Cynthia L. Culbert is Assistant Curator, Memorial Art Gallery.

52: Thomas Hart Benton *Boomtown* (1928)

For a decade after his return to America from Paris, in 1908, Thomas Hart Benton was generally regarded as a modernist painter whose work reflected European influences of Cézanne, constructivism, futurism, and synchromism. In the early 1920s, however, a variety of factors pushed Benton towards an interest in the American scene. On Martha's Vineyard he began making portraits of his neighbors, which soon developed into studies of American character. At the same time, his readings of American history led him to make plans for a mural program, which would present a "people's history" of the United States, from the earliest settlers to the present.

In emotional terms, however, the greatest factor in turning Benton's attention towards American life was the death of his father from throat cancer in 1924. Maecenas Benton, a Missouri lawyer and congressman, had never approved of his son's choice of an artistic career, and they had not seen each other for some fifteen years. But as the artist sat beside the dying man, these differences dissolved. Benton felt a new compassion for his father and for the midwestern culture he espoused.[1]

After his father's death, Benton felt an urge to pick up again the threads of his childhood. In 1926, with some money he had made from decorating a sportsman's den, he made a sketching trip through northwest Arkansas and southwest Missouri, the same area he had traveled through as a boy on political tours with his father. In 1928 he made a longer excursion, accompanied by a student, Bill Hayden. Traveling in an old Ford, he started in Pittsburgh, made his way through the coal fields and hardscrabble farms of the Smoky Mountains, down into the cotton belt of the Deep South. There he turned inland, first exploring the Delta of the Mississipi River and then pushing westward as far as the ranches and oil fields of New Mexico and Texas.

During these journeys Benton made hundreds of sketches—of steel mills, hillbilly shacks, cotton pickers, river boats, railroad trains, sleepy streets, cowboys, and oil towns—which he would draw upon for the remainder of his career. An exhibition of work based on his journeys—held at the Delphic Galleries in New York, just after his return in 1928—immediately established him as a leading chronicler of American life. In 1930 he created the work that made him famous—a sprawling mural for the New School for Social Research in New York entitled *America Today*.

The Memorial Art Gallery's painting, *Boomtown*, plays a prominent role in this saga, since it was the most important painting to result from Benton's 1928 sketching trip, and the highlight of his exhibition at the Delphic Galleries that year. Indeed, *Boomtown* was Benton's first regionalist masterpiece—the instance in which he distilled his distinctive, humorous, raucous vision of American life into a large-scale painting.

The canvas records the boomtown of Borger, Texas, a town that sprouted from empty ranchland with astonishing speed. On Monday, January 11, 1926, the Dixon Creek Oil and Refinery Company hit a gusher that produced five thousand barrels of oil a day. This set off a frantic search for more. Within days a real-estate promoter from Missouri, "Ace" Borger, purchased two hundred and forty acres of ranch land just west of this gusher and created a town, whose population, in just ninety days, zoomed from zero to thirty thousand. Borger went on to create four other boomtowns in Texas and Oklahoma, but his career ended abruptly in 1934 when a vengeful county clerk gunned him down in the Borger Post Office, in front of a crowd of spectators.[2] Benton devoted four colorful pages of description to Borger in his autobiography, *An Artist in America*. As he noted there:

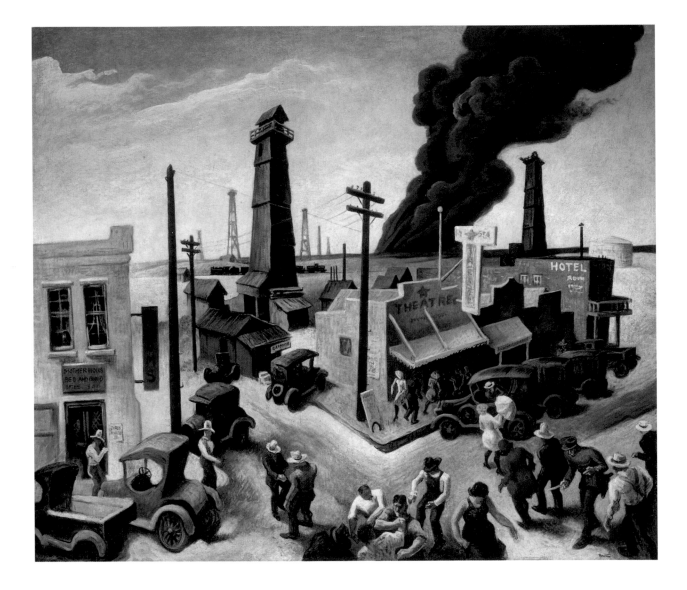

I was in the Texas panhandle when Borger was on the boom. It was a town then of rough shacks, oil rigs, pungent stinks from gas pockets, and broad-faced, big-boned Texas oil speculators, cowmen, wheatmen, etc. The single street of the town was about a mile long, its buildings thrown together in a haphazard sort of way. Every imaginable human trickery for skinning money out of people was there. Devious-looking real-estate brokers were set up on the corners next to peep shows. Slot machines banged in drugstores which were hung with all the gaudy signs of medicinal chicanery and cosmetic tomfoolery. Shoddy preachers yowled and passed the hat in the street. Buxom, wide-faced, brightly painted Texas whores brought you plates of tough steak in the restaurants....The hotels that had bathtubs advertised the fact.... Out on the open plain beyond the town a great thick column of black smoke rose as in a volcanic eruption from the earth to the middle of the sky. There was a carbon mill out there that burnt thousands of cubic feet of gas every minute, a great, wasteful, extravagant burning of resources for monetary profit.... Borger on the boom was a big party—an exploitative whoopee party where capital, its guards down in exultant discovery, joined hands with everybody in a great democratic dance.[3]

Benton's painting records the view from the second-floor window of Don Dilley's apartment in Borger, which was located at 518 Jackson, just above Dilley's American Beauty Bakery. "I can still remember Benton standing at the window sketching," Mrs. Dilley told a journalist in 1976. "He was an interesting person but I didn't know that he was to become so famous. He dressed very casually and his cousin, Patty Oles, did not approve of his attire. Larry, Patty, and Thomas Hart Benton were our guests for lunch. Then Benton did his sketching while we talked about Kansas."[4]

Benton's painting closely corresponds with his description of the place. Men and women stroll on the boardwalk in front of false-front buildings labeled "Theatre" and "Hotel." To the left two men in Stetsons stand in the center of the street, shaking hands over a deal; just in front of them a fistfight, probably caused by the girl leaving the vicinity, is about to be broken up by a Texas Ranger. Signs reading "Midway Dance" and "Mother Holl's, Bed and Board, Baths 50 cents, Girls Wanted," allude to the sleazy morality of the town. In the distance are telephone poles and a line of oil rigs, as well as a great plume of black smoke, which suggests the wasteful, exploitative spirit of the place.

Borger Street Scene, 1926
Postcard
Courtesy Ken Sharpe
Photography Collection

Photographs of Borger taken in the same year as Benton's painting confirm the general accuracy of his picture, with its swarms of cars and forest of advertising billboards. But they also show that he exaggerated the vertical elements of the composition, endowing the scene with an increased sense of energy and optimism.[5]

The artist's on-the-spot sketch, which happily survives, is remarkably close to the final design, but in developing it into a painting Benton enlivened the picture in several ways. He transformed an unidentified storefront into a theatre, added provocative signage on the hotel at the left, and introduced new figural groupings, such as the hand-shakers and fighters in

the foreground. Perhaps most notably, he added the ominous funnel of black smoke in the background, which he had recorded in another drawing, taking some liberties with its actual location.[6]

Critics of Benton's work have often dismissed him as a "realist" and assumed that he had no interest in modern art. But in fact the tipped-up viewpoint, the angular shapes of the buildings, and the cacophony of signs and letters are all devices that Benton borrowed from cubism. With generous open-mindedness, however, Benton also seems to have been inspired by Hollywood films (appropriately, a movie palace sits in the center of the painting). Early movies often displayed high horizons like those of Benton's painting (in part because non-panchromatic film did not register clouds), and the figures on the street are characterized in a fashion reminiscent of John Ford features: a dark suit indicates a businessman, a Stetson and a red bandana a cowboy. The unusual high viewpoint of the painting has the feeling of an introductory tracking shot, which sweeps over the town, quickly introducing us to the main characters.

We can find many of the features that appear in *Boomtown* in an earlier painting by Benton, *The City* (1920, private collection), executed eight years earlier, which shows the juncture of Broadway and Fifth Avenue at Twenty-third street, overlooking Madison Square in New York.[7] This also has a tipped-up perspective, faceted buildings, clusters of cars, and deftly characterized figures. Compared to *Boomtown,* however, the painting lacks emotional impact. Just what differentiates the two raises fascinating questions, but essentially the New York painting feels like a well-observed vignette, the Texas painting like a mythic statement. Something about Borger resonates with our deepest fears and hopes about American life. In the frenzied energy, can-do-spirit, wastefulness, corruption, and sheer manic exuberance of Borger, Benton found a potent symbol for the dynamism and complexity of America as a whole.

Henry Adams is Chair of the Art History Department, Case Western Reserve University.

53: John Marin *Marin Island, Small Point, Maine* (1931)

Elizabeth Hutton Turner

In 1914 John Marin discovered Maine as a summer retreat and immediately resolved to own a piece of it.[1] Recently married, his wife pregnant, he used an annuity provided by his dealer and friend Alfred Stieglitz to purchase a small uninhabited island off the coast of Small Point, not far from Portland. The site lacked fresh water and was useful only for camping, fishing, and painting, but the artist proudly dubbed it "Marin Island."

> There's that–Island–that–Island of mine–beautiful little island–with all its trees the sense of being mine….I suppose there are now a thousand trees on it….The other day–me–with my brood–went over to the Island I carrying an ax and I chopped down trees–I who love trees–but when you cannot see trees for trees–something has to be done about it–…and even though I never build a house on it–I can still see a house on with–Groups of trees and vistas…and this is all right I guess it's all right–a trifle sentimental–but then I wonder–am I not a trifle sentimental–and then a bit.[2]

Between 1914 and 1919 Marin probably painted most of his seascapes from Small Point. In 1917, with his wife and his son, John IV, he spent the entire summer in a modest hotel there.[3] In July he wrote Alfred Stieglitz, exclaiming, "Wonderful days, Wonderful sunset closings. Good to have eyes to see, ears to hear the roar of the water. Nostrils to take in the odors of the salt sea and the firs."[4] Nevertheless, although Marin Island was a regular stop on his annual drives north, Marin did not spend another summer there or nearby for the next fourteen years.

Born in Rutherford, New Jersey, on December 23, 1870, John Marin initially trained as an architect at the Stevens Institute of Technology in Hoboken, New Jersey, and was recognized early on as a superb draftsman. He swiftly developed a fluency and range of technique in the graphic arts by balancing the movement of calligraphic line with luminosity of color wash. These elements were later liberated into abstraction through Marin's exposure to Cézanne and cubism at Stieglitz's Gallery 291. In 1912 Marin became the first to transpose the new sounds, rhythms, and heights of New York with his Brooklyn Bridge series. In the 1920s he became equally known for deciphering the conflicts among earth, sun, wind, and water in his landscapes. Marin was among the first of his generation honored with a retrospective at the Museum of Modern Art in 1936.

Marin traveled seasonally if not extensively, making watercolors for most of his life. Between 1905 and 1910 he spent much of his time abroad. After 1920 he settled into the pattern of spending most winters in Cliffside, New Jersey, and most summers in northeastern rural locations. From 1914 until 1933 Marin summered in either Small Point or Deer Isle, Maine, before looking further up the coast.

During the summers of 1931 and 1932 Marin returned to Small Point. The familiar view with its adjacent island and inlet suitably exorcised the arid light and heat that had filled his renderings of Taos, New Mexico, the previous year. Returning to a setting where he knew every stone and tree and shoreline left Marin free to renew and interweave his powers of observation and improvisation.

Initially *Marin Island, Small Point, Maine* seems to make a predictable inventory of the setting. Marin's brushstrokes readily translate a record of "The solemn restful beautiful firs…the border of the sea" just as he first described them to Stieglitz in 1917. The modest description permits us to know the artist's position in the landscape. But landscape to Marin meant something more than mere description

or even transcription. Landscape was something to be performed *en plein air*. With a brush in each hand Marin moved rapid-fire as if conducting a symphony with the elements. The boldly fragmented diagonals launch a soaring trajectory out and over the inlet bordered by distant trees. Viewed through these angles the landscape presents itself kaleidoscopically, opening up in the center like the prow of a flying ship. The eye ricochets off high contrasts and strong effects of sharp light. Each break in contour, every shift in texture from graphite to color, every movement from saturated surface to empty paper lyrically connotes the sounds of wave against rock acting in concert with sea breezes swaying the juniper. The disposition of light and line in the sky, so perfectly reflected upon the water, achieves a soothing harmony.

The images from the 1931–32 summers in Maine, among them that of the Memorial Art Gallery, are now considered to be among the best, most abstract, and compositionally inventive watercolors of his career, but critical reception at the time was also significant. Paul Rosenfeld wrote in *The Nation* that 1931 was "Marin's year." And in *Art News* Ralph Flint wrote:

> I no longer have any compunction about stating my findings about Marin....He is a master way beyond his time—possessing an almost scriptural solemnity and grandeur in his pictorial approach to the world about him.[5]

In his later years Marin began re-exploring earlier styles but also experimented with new, expressionist forms. He died on October 2, 1953, at Cape Split, Maine (just north of Bar Harbor), his summer residence since 1933. As Lewis Mumford observed at the time, "Were I writing a history of American civilization and did I want a symbol of the utmost economy and organization we had achieved, I should select not a Ford factory but a Marin water color."[6]

Elizabeth Hutton Turner, Senior Curator of The Phillips Collection, is a specialist in early twentieth-century modern art.

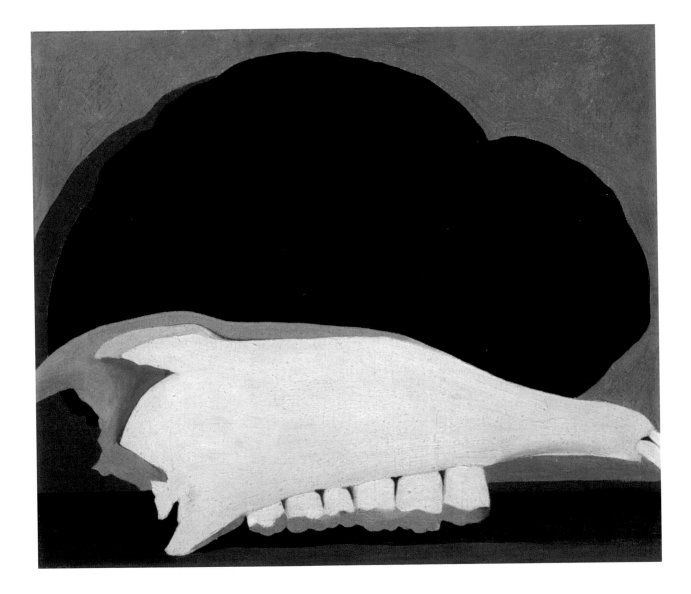

54: Georgia O'Keeffe *Jawbone and Fungus* (1931)

Sarah Whitaker Peters

Georgia O'Keeffe's search for containers from nature that could hold and express her feelings and desires with paint has rarely turned up an odder pairing than the two in *Jawbone and Fungus* (1931). We can only speculate about the intentions behind its form and content. O'Keeffe never helped her paintings with words, but she did say (in her late eighties) that, "I find...I have painted my life—things happening in my life—without knowing."[1] Perhaps this is the most useful key we have.

What did she actually put here? The upper part of an animal's jawbone fills the foreground, and nearly all of the canvas's lower half. O'Keeffe did not identify the jawbone in her title, but it is generally considered to be that of a mule. (In the later 1930s she would paint several complete mule skulls.)

Directly behind the bleached bone is an unnervingly large black fungus. Cropped at its base by the bone, it appears to be levitating rather than growing properly out of the ground. There is a carefully calibrated balance between these two forms, with tactile interplays between the colors, between hard and soft, sharp and round, alive and dead—to name the most obvious ones.

What were bones to O'Keeffe? She found them "beautiful," she said in 1939, and "keenly alive."[2] By the time *Jawbone and Fungus* was painted, she had come to regard New Mexico as her psychic homeland, a place where "I felt as grateful for my largest hurts as I did for my largest happiness."[3] In Taos, she had often gone to Indian dances, "sings," and other sacred ceremonies with Tony Luhan, the Navajo husband of her hostess Mabel Dodge Luhan. And she began to have an intense interest in the still-functioning Anasazi-Pueblo culture of New Mexico. It therefore seems unlikely she wouldn't have known that shamans in primitive societies the world over believed bones to be sacred. (They were not only placed in graves as regenerative symbols, they were used in divination and healing practices as well.)

The choice of a jawbone from the ass family may be significant for the artist's personal meaning. A beautiful shape to be sure. But with O'Keeffe abstract design is always a means, not an end in itself. As a symbolist painter, she never intends what you see to be all of what you get. Therefore we should probably be alert to the fact that the mule, the hinny, and the donkey are famous within the animal kingdom for being durable, sure-footed, obstinate, and hardy—traits that belong memorably to the artist (who lived to ninety-eight).

As to the fungus, O'Keeffe has juxtaposed it with the jawbone in a peculiarly threatening way. It towers over the bone like an ominous black cloud. The fungus is a plant of abnormal, spongy growth which has time-honored connections with morbidity.

Any meaning we glean from this picture must, of course, include the colors: variations on black, brown, and white. It should perhaps be stressed that white always held a specific meaning for O'Keeffe. Her husband, the great photographer Alfred Stieglitz, often referred to her as white. ("Georgia is a wonder....if ever there was a whiteness she is that."[4])

Could the white jawbone be one of O'Keeffe's abstract self-portraits, and the black fungus one of Stieglitz? There is some context to suggest that this is so. The abstract portrait was a Stieglitz circle specialty. Inspired by New York Dada during World War I, Stieglitz encouraged the artists around him to analyze one another's personalities (including his own) by abstract means in order to create new forms and abstract symbols. O'Keeffe wrote a friend in 1915 that she was crazy about this stuff—that it just took her breath away.[5] But she never admitted to doing it herself.

Georgia O'Keeffe,
1887–1986
Jawbone and Fungus, 1931
Oil on canvas, 17 x 20 in.
Marion Stratton Gould Fund,
51.11a
©2006 The Georgia O'Keeffe
Foundation/Artists Rights
Society (ARS), New York

Why would she want to image Stieglitz as a black fungus? For one thing, by 1931 she had come to the sad recognition that working alongside him at Lake George, New York, as she'd done for over twelve years, was a dead-end for her art. There was, as well, an acute crisis in their marriage—caused largely by Stieglitz's infidelity. Her distress was such that she would suffer a nervous breakdown between 1932 and 1933 and be unable to paint for nearly two years.

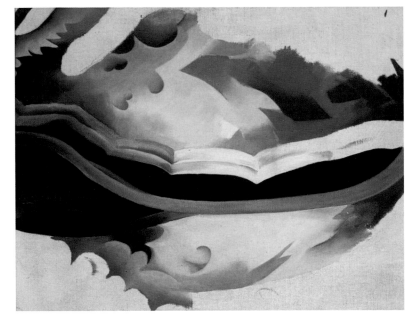

In 1918, their first summer together, Stieglitz had photographed O'Keeffe at Lake George wearing his familiar black cape (in effect, his mantle). The unmistakable implication is that she was under his protection (he had already become her dealer as well as her lover). It may not be too fanciful then to suggest that the cape/mantle had now become a threatening, engulfing black fungus to her, one which she had to shed and, ultimately, destroy in order to preserve and nurture her own identity.

We know from her biographers that O'Keeffe had a life-long history of depression. It could be that this low-colored painting is a kind of drastic portent of her severe nervous breakdown a year later. It should also be noted that on the verso is a high-colored unfinished abstraction (ca. 1923), about which almost nothing is known—only that the artist discarded it for reasons of her own.

There is wonderfully original painting in *Jawbone and Fungus*. Consider the complex visual ambiguity: is this a studio still life or a landscape? The shadow cast by the fungus suggests the former, but the low horizon line and the horizontal strips of sepia, nut brown, and gray beneath make it read equally easily as a bare desert landscape. There are some photographic qualities in the work as well. The distance between bone and fungus is artificially compressed, as if by a lens, for emotional effect. And the isolated magnification we see in these forms had become a notable feature of her work after 1924, especially with flowers.

All of O'Keeffe's paintings are susceptible to multiple interpretations and meanings. Most often, the subjects she chose suggest the universal and spiritual transitions in a woman's life cycle. Unlike *Jawbone and Fungus*, which is exceptional in O'Keeffe's oeuvre, her New Mexico bones of the 1940s will dance cheerfully in the sky like angels on the wing.[6]

O'Keeffe adored secrecy for its own sake. Her art, and her life, are full of the maneuvers of concealment. Was secrecy the engine of her imagination? A good, forever unanswerable, question.

Sarah Whitaker Peters is the author of *Becoming O'Keeffe: The Early Years.*

55: Charles Sheeler *Ballet Mechanique* (1931)

Karen Haas

*I*n the fall of 1927, on the occasion of Ford's introduction of the new Model A automobile, Charles Sheeler was commissioned by the N. W. Ayer advertising firm to photograph the Ford Motor Company plant outside Detroit. During Sheeler's six-week stay at the River Rouge plant, popularly known as the Rouge, he wrote to his good friend Walter Arensberg: "[W]hat wouldn't I give for the pleasure of showing you through this unbelievable establishment. It defies description."[1] The largest such industrial complex in the world at the time, the Ford factory was a daunting subject, and its immense scale, deafening noise, and bustling activity were a challenge to an artist known for his carefully composed and painstakingly rendered works. As a result, Sheeler told Arensberg, he planned to focus his camera on "details of the plants and portraits of machinery" rather than try to capture an impression of the whole vast enterprise, in which every stage of automobile manufacturing was carried out, from the production of raw materials—steel, glass, and rubber—to the fabrication of actual car parts.[2] In the end, the more than thirty photographs that resulted from the commission became some of Sheeler's most critically acclaimed images and were widely reproduced in Ford Motor Company publications, as well as in art magazines in the United States and Europe.

Ballet Mechanique is one of three conté crayon drawings Sheeler made in 1931 that were based on his photographs taken at the Ford plant four years earlier. In fact, two of the three Rouge drawings—*Ballet Mechanique*, with its unusual, almost square format, and the more standard vertical *Smokestacks* (William H. Lane Collection)—appear to share the same source in a now-lost photograph.[3] Both depict the network of ducts and pipes that connected the factory's massive blast furnaces and powerhouse, but *Ballet Mechanique*, which represents the lower part of the overall image, is the more striking and unconventional of the two. *Smokestacks* centers on the eight soaring stacks of Powerhouse No. 1 (which also appear in two other photographs in the series),[4] while the truncated view in *Ballet Mechanique* features the contrasting dark and light shapes of the large pipes and the maze of slender supports below. An unprepossessing subject with little sense of scale or context, *Ballet Mechanique* is a fascinating example of Sheeler's tendency to use the camera to tease the simple geometry and underlying structure out of what would have been a much larger and more complex view. Employing a technique that he had first experimented with more than a decade earlier (in a series of views of New York skyscrapers), Sheeler created increasingly abstract images by closely cropping his photographs under the enlarger and printing smaller and smaller parts of the negative.[5] Often these photographic details then became the basis of drawings like this one, with its emphasis on architectonic form and graphic composition rather than recognizable aspects of the factory, its famous assembly line, or its workers.

Never one to work *en plein air*, Sheeler's practice, at this stage in his career, was to use photographs as source material for nearly all of his paintings and drawings. The artist likened his working methods to that of a squirrel gathering nuts for the winter and described the often protracted process of "digesting" an unwieldy subject like the Rouge, by saying: "I was out there…on a mission of photography….And when I got there, I took a chance on opening the other eye and so then I thought maybe some pictures could be pulled out."[6] "Opening the other eye" was Sheeler's way of explaining that he first approached his subjects through the monocular "eye" of the camera, with its built-in one-point perspective. Only having done that could he discover potential pictures that might be translated into other media, in some instances "pulled out" even several years later. Thus, the camera became an important intercessor for Sheeler, who always seemed most comfortable initially working out his compositions in black and white.

Conté crayon was a favorite medium for the artist beginning in 1929 and continuing well into the 1930s. With its velvety blacks and subtle gradations of tone, it was also the medium that most closely rivaled the graphic qualities of his photographs. Meticulously drawn using an extremely sharp crayon, pictures like *Ballet Mechanique* were created by projecting the photographic image onto a piece of paper using an opaque or overhead projector and then rendering the subject with nearly invisible, feathery strokes. The obvious connection between his photography and these works is significant, because

Sheeler took up conté crayon at about the same moment that his dealer, Edith Halpert of the Downtown Gallery in Manhattan, began actively discouraging him from making and exhibiting photographs, which she felt took time and attention away from his paintings and drawings. Halpert later claimed that she simply did not want to have to reorient Sheeler's artistic career, but it is also true that drawings like these—in which the technique so beautifully complements the subject—were acceptable even to those who otherwise criticized the close relationship between photography and his work in other media.[7]

Sheeler often gave his works musical titles and, in this case, the reference is not simply to the elegant, balletic forms of the large pipes and their delicate network of supports, but to George Antheil's "Ballet Mécanique," an avant-garde piece of music which had its highly publicized American debut in New York in 1927, the same year that Sheeler first visited the Rouge. Originally written in 1924, as the score for a modernist film of the same title by Fernand Léger and Man Ray, the two parts were never actually performed together during Sheeler's lifetime and the film itself was little known in the United States. Antheil's composition, which called for a percussion orchestra, synchronized player pianos, electric bells, sirens, and airplane propellers, was performed with much fanfare at Carnegie Hall in the spring of 1927, and seems the most likely inspiration for the title of the drawing. The paint-

Charles Sheeler,
1883–1965
Ballet Mechanique (detail), 1931
Conté crayon on paper,
10½ x 10¼ in.
Gift of Peter Iselin and
his sister, Emilie Iselin Wiggin,
74.96

(Facing page)
Charles Sheeler,
1883–1965
Ballet Mechanique, 1931
Conté crayon on paper,
10½ x 10¼ in.
Gift of Peter Iselin and
his sister, Emilie Iselin Wiggin,
74.96

ed backdrop for the production depicted a variety of machines and machine parts—from whistles to spark plugs, and riveters to excavators—in front of a panoramic image of futuristic skyscrapers, and some of the notices of the show in New York newspapers were accompanied by cartoons that set the musical program on an imaginary construction site complete with jackhammers, backhoes, and steam shovels.[8] Whether or not he attended the actual performance, Sheeler would certainly have been aware of Antheil, the young American expatriate who was the *succès de scandale* of Paris, and his

infamous "Ballet Mécanique," which, Ezra Pound suggested in his review, allowed the audience to imagine "the possibility of organising the sounds of a factory."[9] Also, Antheil's contention in his program notes—that the aesthetic purity of his "Ballet" had more to do with the mechanical perfection of the automobile than any other art form—would surely have resonated with Sheeler who, that same year, described the subject of the Ford plant as "incomparably the most thrilling I have had to work with."[10]

Karen Haas is Curator of The Lane Collection, Museum of Fine Arts, Boston.

56: Stuart Davis *Landscape with Garage Lights* (1931-32)

Karen Wilkin

*I*f one were to choose a paradigmatic Stuart Davis painting of the early 1930s, *Landscape with Garage Lights* might well be it. Its angular, loose-jointed structure of flat planes, its intense color, its vernacular theme, even its gasoline pumps and industrial light fixtures, are all emblematic of the artist's concerns of the time. Broadly speaking, *Landscape with Garage Lights* exemplifies the early pictures, dating from the mid-1920s through the early 1930s, in which Davis developed a personal, idiosyncratic language of form and color—"Color-Space-Logic," as he called it—informed equally by his understanding of cubist structure and his acute perceptions of the specific. *Landscape with Garage Lights,* at once inventively abstract and particular, announces Davis's double identity as an uncompromising modernist who claimed descent from the European avant-garde, and as an American painter of uniquely American experience.

If *Landscape with Garage Lights* is a typical Davis of its period, it is also surprising, since its point of departure is recognizably the streetscape and harbor of a small New England town, while its author's reputation is bound up with his evocation of urban themes. Davis spent virtually his entire working life in New York City (almost all but his last decade south of Fourteenth Street), delighting in the visual chaos, the cacophony, energy, and speed of modern city life. He insisted that his paintings were not abstractions, but rather distillations of his emotional and perceptual responses to his surroundings, captured in drawn "configurations" and made dynamic by color contrasts. In a famous description of "things which have made me want to paint, outside of other paintings," written in 1943, Davis itemized such twentieth-century urban phenomena as "skyscraper architecture" and "electric signs," as well as taxicabs, storefronts, and "fast travel by train, auto, and aeroplane." Jazz, also inventoried, was a lifelong passion, its uninhibited rhythms and unpredictable harmonies obviously reflected in Davis's brash palette and syncopated compositions. Yet he also listed "the landscape and boats of Gloucester, Mass."[1] —the setting for *Landscape with Garage Lights*.

It is significant that Davis named Gloucester, on Cape Ann, north of Boston, specifically. Although an artists' center since the nineteenth century (with varying degrees of relevance), Gloucester is not a traditionally picturesque or pretty seaside town like its neighbor Rockport, but a gritty working fishing port set in an austere, rocky landscape deeply penetrated by fingers of sea. The town's steep hills are lined with no-nonsense clapboard houses, punctuated by the occasional extravagant turret or church tower, with everything bathed in brilliant light. Davis first came to Gloucester in 1915 at twenty-two and returned almost every summer until 1934. His first years there were formative, following as they did upon his first serious exposure to modernist art at the great international exhibition of 1913, the Armory Show. That experience convinced him that he "would quite definitely have to become a 'modern' artist."[2] As the precocious star pupil of the anti-academic school run by the Ashcan school realist, Robert Henri, Davis had already learned to express feelings about modern life by employing heightened color and free drawing.[3] The young painter had even had several watercolors included in the Armory Show's juried American section, but seeing them in proximity to European avant garde work made him question his direction. Davis entered a decade-long self-imposed apprenticeship to the Europeans he admired, first trying out the implications of Van Gogh, Gauguin, and Matisse, then attempting to come to grips with Picasso, Braque, and Picabia, among others.

The clear light, rocky landscape, and economical architecture of Gloucester and Cape Ann probably shaped Davis's development into a "Modern artist." He found justification there for the tipped space and geometric dissection of forms encouraged by his study of European modernism; his

earliest experiments with cubism were, in fact, Gloucester images, painted about 1916, in which he "discovered" overlapping planes in rows of houses, narrow alleys, and crowded tombstones. Davis's work of the late teens and early 1920s is characterized by its variousness as he tested possibilities, painting the cornfields of Pennsylvania as if aspiring to be Van Gogh, depicting the balconies of Havana as if taking advice from Matisse, and tackling tabletop still lifes as if competing with Braque. His elegant "portraits" of lightbulbs and percolators, like his fictive collages—meticulously painted facsimiles

of oversized cigarette wrappers—seem to anticipate both his own late paintings and pop art. These multivalent themes notwithstanding, by the mid-1920s, Gloucester images had become major motifs in Davis's work. He continued to explore a variety of approaches, even flirting with abstractness in the *Eggbeater* still lifes of 1927 and 1928. But as the 1920s progressed, his pictures increasingly came to depend, as *Landscape with Garage Lights* would, on schematic evocations of the streetscapes and harbors of Gloucester and nearby Rockport, treated like stage sets where gas pumps and the occasional tree, mast, or hoist become surrogate figures enacting casual dramas.

By the late 1920s, however, despite the persistence of Gloucester themes in his work, Davis had begun to spend less time on Cape Ann, definitively interrupting his summers there with a sojourn in Paris in 1928 and 1929.[4] In Paris, as in Gloucester, he painted streetscapes, translating them into inventive two-dimensional structures and even more inventive orchestrations of jazzy color, enlivened by shorthand renderings of details that struck him as uniquely Parisian: railings, shutters, mansards, café furniture, and more. After his return to the United States, his eye refreshed by absence and stimulated by his first-hand encounters with adventurous French painting, Davis continued to work in this mode, enhancing economical compositions of colored planes with sharply observed details of place, this time of wholly American places. Some sketchbooks of the early 1930s itemize New York subway entrances, El stations, and the Empire State Building, still under construction; others record the paraphernalia of Gloucester docks. In the *New York-Paris* pictures of 1931, Davis conflated observed American motifs and remembered French fragments in illogical but provocative relationships, like dream images. *Landscape with Garage Lights*, painted a year later, reveals both Davis's rediscovery of Gloucester and the effects of his Paris stay. Such Gloucester landmarks as the coal derrick, the fish processing plant, and the gasoline pumps that appear in this painting had all played important roles in earlier works; the clear

geometry, shifting scales, unstable space, and above all, the exuberant patterns and full throttle hues, demonstrate a new, perhaps European-inspired audacity, while the seductive drape and scalloped edge of the awning, like the delicately drawn, ambiguous bottles below it, recall images in Davis's drawings of French cafés.

Another component must be considered: the popularity of "American Scene" social realist painting, as exemplified by Thomas Hart Benton's or Grant Wood's idealized images of rural life. Davis loathed such work, finding it sentimental in mood and

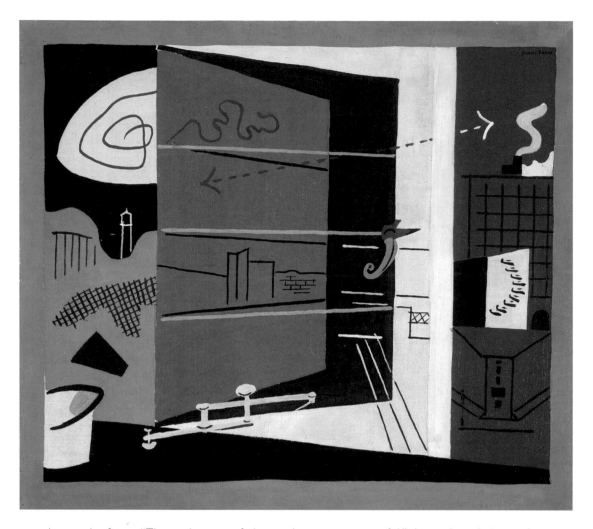

reactionary in form. "The only corn-fed art that was successful," he quipped, "was the pre-Columbian."[5] Davis was a politically engaged, passionate activist who espoused progressive positions and helped found and run important artists' organizations during the Depression years. But he always separated his social activism from his work in the studio, insisting that aesthetic concerns and propaganda were incompatible. "Art is not politics nor is it the servant of politics," he wrote in 1936. "It is a valid, independent category of human activity."[6] For practical reasons, however, Davis's dealer, Edith Halpert, urged him to take a more sympathetic view of the social realist painters' concerns. He responded to the challenge with the exhibition Stuart Davis: American Scene, held at Halpert's Downtown Gallery in March 1932. The show, which included *Landscape with Garage Lights*, was his demonstration of how images could be rooted in the specific American experience without compromising formal daring or inventiveness. Davis's close observation and affection for Gloucester are palpable; so are his thorough understanding of the achievements of Picasso, Miró, Matisse, and Léger, and his ability to express unexpected, evocative visual ideas in a native, colloquial dialect of cubism.

Landscape with Garage Lights embodies all these concerns and more. Davis himself, though, would have cautioned against over-interpretation. "Too much is expected of Art," he wrote, "that it mean all kinds of things and is the solution to questions no one can answer. Art is much simpler than that. Its pretensions more modest. Art is a sign, an insignia to celebrate the faculty for invention."[7]

Karen Wilkin is the author of *Stuart Davis* and the curator of the touring exhibition The Drawings of Stuart Davis: The Amazing Continuity.

57: Alexander Calder *Untitled Mobile* (1935)

Cynthia L. Culbert

When Alexander Calder created the elegantly restless assemblage of rods and colorful disks known simply as *Untitled* or *Untitled Mobile* he had just started experimenting with the form that would make him an internationally sought-after artist. The mobile became Calder's signature piece and one that he would return to for the rest of his life. During the formative period of the early 1930s, however, Calder had to seek out commissions. *Untitled* was one of his first of these following his return to America from an extended stay in France, as well as one of his first works meant for the out-of-doors anywhere.[1]

Calder's *Untitled Mobile* occupied a specific site in a private garden in Rochester, New York, for about forty years before it came into the collection of the Memorial Art Gallery. The owner, Charlotte Whitney Allen, who regularly hosted Rochester's avant-garde at her "chilled glass hour,"[2] served for sixty-two years on the board of managers of the Memorial Art Gallery, where the library bears her name. With a little prompting from her landscape architect, Fletcher Steele, and from the artist himself, she commissioned the sculpture for a secluded spot at the end of an allée. Steele, a Rochester native whose garden designs include Naumkeag, Mabel Choate's fanciful estate in the Massachusetts Berkshires, had met Alexander Calder in 1932 at one of the first exhibitions of his "mobiles" in Paris.[3] Three years later, he introduced Calder to Mrs. Whitney Allen.

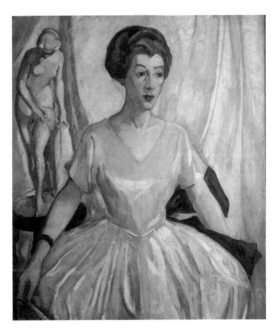

Kathleen McEnery Cunningham,
1885–1971
Portrait of Charlotte Whitney Allen,
after 1914
Oil on canvas, 41¾ x 35¾ in.
(framed dimensions)
Courtesy of the David Hochstein
Memorial Music School,
3.94L
Printed by permission of the
Estate of Kathleen McEnery
and Hochstein School

Steele started working on Mrs. Whitney Allen's garden in 1915 and he would continue to do so until 1968. They became the best of friends and Steele often referred to the garden on Oliver Street, off fashionable East Avenue, as one of his finest works. Mrs. Whitney Allen was very particular about what she wanted in her garden. She did not like flowers, disapproving of the mess they made when they died, so Steele had to work with the other elements of the garden to create interest.[4] In 1926, he arranged for Gaston Lachaise to create the sculpture (now also a part of the Memorial Art Gallery's collection) that provided the focal point of the garden.[5] It stood above a swimming pool and was framed by an arch made of brick and a brick wall. This addition served as a major mile-

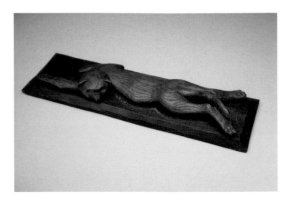

stone in the completion of the garden but there were still several ideas to be realized: a chain-mail Saracen tent filled the "drinking pit" to the left of the pool in 1938 and a teahouse was planned for the end of the hidden allée that ran behind the garage. The teahouse idea was abandoned in 1935 when Calder enigmatically mentioned, in a letter to Mrs. Whitney Allen: "Fletcher Steele wrote me that the visit that that thing of mine paid Rochester left you in a mood to permit me to prescribe something for a certain corner of your garden."[6]

ALSO IN THE MAG COLLECTION:
Alexander Calder,
1898–1976
Very Flat, 1926
Oak, 19 x 5½ x 1½ in.
Gift of Charlotte Whitney
Allen, 64.26
©2006 Estate of Alexander
Calder/Artists Rights Society
(ARS), New York

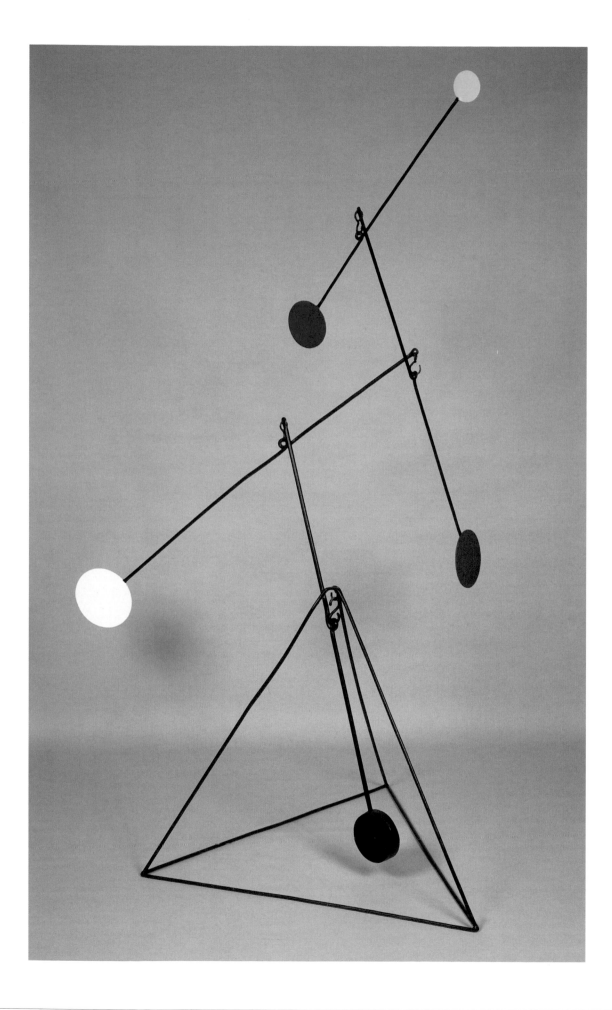

Steele was always searching for exciting garden sculpture—works with interesting silhouettes and substantial mass.[7] He was quite taken with the work of Calder's he had seen in Paris, which, with its ability to move, met and exceeded his criteria for outdoor sculpture. The silhouettes were not only interesting, but were constantly changing, creating mass out of air. Unfortunately, mobiles were a bit more modern than most of his clients' tastes. But there was a place in one client's garden where it just might work. Bringing an example of Calder's sculpture with him to Rochester, he was able to entice Mrs. Whitney Allen into considering the idea, and then Calder followed up with a series of entertaining letters, which fortunately were saved and housed at Kenyon College in Gambier, Ohio.[8]

Calder and his wife Louisa returned from an extended residence in France in 1933. Having bought an old farmhouse in Roxbury, Connecticut, and expecting their first child, Calder was anxious to sell some work. He was subtle but persistent with Mrs. Whitney Allen and after nine months she agreed to have a standing mobile made for her garden. During that time, they developed a mutual friendship based on a steady correspondence and Calder's occasional visits to Rochester. Their friendship lasted for many years, resulting in more sales for Calder and some quirky gifts for Mrs. Whitney Allen, including jewelry and a "Happy Birthday" mobile. In a letter that Calder dated in his characteristically whimsical manner "April 1½, 1935," he expressed his thoughts about a mobile for the garden: "I saw Fletcher Saturday....He seemed to think that I ought to make you an object...that one might displace, and then watch it seek to regain its original calm, equilibrium, and peace of mind. I think so too."[9] In August he gently nudged her again with: "Have you ever decided about the mobile for your garden?"[10] And later that month he wrote: "As to your having one of my things, nothing would please me more, and I would be very glad to do it for any sum you felt you could afford. I think I mentioned a stiff price to Fletcher because I felt he would make me do it over again and again, he seemed so stern in the first letter he wrote me about it. But what if Louisa and I came and visited you for a few days...and I designed it *under your eye,* and made it right in Rochester?"[11] The Calders were in Rochester by late September and they brought the famous *Circus,*[12] now owned by the Whitney Museum of American Art, which Calder performed in Mrs. Whitney Allen's basement to his wife's accompaniment on the concertina.[13] Over the course of a week, Calder designed the mobile, searched for materials, and found some suitable iron disks in a blacksmith's shop.[14] These he took home to Roxbury to fabricate the mobile, asking Steele deliver it to Mrs. Whitney Allen on his next trip west.[15] Calder had painted it in his typical primary colors, and Mrs. Whitney Allen got her wish: there were no flowers in her garden. The only colors were the green of the foliage, the red of the brick wall and arch, the robin's egg blue of the pool and the bright splashes of the mobile's red, blue, and yellow disks as they gently swayed in the breeze at the end of the allée.

Alexander Calder,
1898–1976
Happy Birthday Mobile, 1935
Brass wire and cotton string,
16 x 13 in.
Gift of Charlotte Whitney
Allen, 68.50
©2006 Estate of Alexander
Calder/Artists Rights Society
(ARS), New York

Alexander Calder,
1898–1976
Earrings, ca. 1930s;
Comb, undated;
Bracelet, undated; *Ring,* undated
Silver, 2 x 2⅜ in. each;
brass, 7 x 8¼ in.;
brass, 3⅜ x 2¼ x 2¼ in.;
brass, 1 x 1¼ x 1¼ in.
Gift of Charlotte Whitney
Allen, 60.52.1-.2; 78.49; 78.48;
78.50
©2006 Estate of Alexander
Calder/Artists Rights Society
(ARS), New York

(Facing page)
Alexander Calder,
1898–1976
Untitled Mobile, 1935
Iron, steel and paint,
105½ x 72 x 41 in.
Gift of Charlotte Whitney
Allen, 64.27
©2006 Estate of Alexander
Calder/Artists Rights Society
(ARS), New York

Calder *Mobile* in Charlotte
Whitney Allen Garden on
the occasion of MAG Gallery
Council's Art in Bloom
Garden Tour, June 17, 2000
Photograph by James Via

In his autobiography, Calder remembers Mrs. Whitney Allen's mobile as "the first object I made for out of doors."[16] This, along with the fact that it was one of his first commissions upon his return to the United States, makes *Untitled Mobile* a key work in Calder's oeuvre, as well as a treasured piece in MAG's collection. It serves as a precursor to the monumental outdoor standing mobiles that would make Calder one of the most influential artists of the twentieth century.

In a rare opportunity for a museum object, the mobile returned for a day to its intended place. On Saturday, June 17, 2000, several members of MAG's staff brought Calder's mobile back to the hidden allée on Oliver Street for the biennial Art in Bloom garden tour. The event highlights area gardens and in the summer of 2000 it featured the city oasis designed by Fletcher Steele. Several friends of Mrs. Whitney Allen's came out to see the garden again and to share old memories. For the staff, it was magical to see an object they were used to looking at in the middle of a room under artificial light take its original place out in the sun against a backdrop of European beeches. It seemed to come alive. It was just as mesmerizing in the garden when you saw it move as Calder imagined it would be in his early letters to Mrs. Whitney Allen: "that one might displace, and then watch it seek to regain its original calm, equilibrium, and peace of mind."[17]

Cynthia L. Culbert is Assistant Curator, Memorial Art Gallery.

58: Arthur G. Dove *Cars in a Sleet Storm* (1938)

Elizabeth Hutton Turner

Arthur G. Dove began *Cars in a Sleet Storm* in the fall of 1937 and completed it in the winter of 1938.[1] He installed and photographed it on a sixty-foot wall of his apartment along with some twenty-five other paintings finished that season, including *Motor Boat, Flour Mill,* and *Old Boat Works.* At the time Dove was living in a huge third-floor space of a commercial block built by his father near Seneca Lake in Geneva, New York, Dove's boyhood home. He had only reluctantly returned five years earlier to settle his family's estate. In April 1938, soon after finishing *Cars in a Sleet Storm,* the fifty-eight-year-old artist left Geneva for good.

The region was familiar to Alfred Stieglitz and his circle of American modernists in New York City, where Dove was known as America's first abstract artist. The story of how Dove, after his return from Paris in 1910, had gone camping in the Geneva woods, was often told around Stieglitz's American Place gallery.[2] This seminal experience had caused Dove to limit his palette and improvise with the simple shapes and earth tones that resulted in distinctively nonrepresentational works. (Stieglitz kept the small paintings at the gallery as proof positive of Dove's early conversion to abstractionism.) Dove's unflinching demand for authenticity in nature led him to abhor and for the most part abandon his lucrative career as illustrator and to work with perfect integrity as an impoverished farmer or waterman while painting as a modern artist.

The Dove Block,
Geneva, New York
Photograph courtesy of the
Archives of American Art,
Smithsonian Institution

Until his death in 1946, Dove continued to develop an abstract rhythmic vocabulary—rotating saw-toothed triangles, swelling circles, and soaring diamonds of color—while stimulated by a direct contact with nature. Dove himself deemed the process "not abstraction but extraction," believing the artist to be especially equipped to apprehend patterns of seen and unseen forces in the universe. This decidedly unconventional outlook was matched by an equally experimental approach to medium and method. For a time in the 1920s, Dove gave up painting altogether to work with found objects. In so doing he effectively shed the last vestiges of descriptive pictorialism and thereafter constructed compositional space with a new awareness of the relationship of shape and texture to color field and frame. By July 1933, when Dove returned to Geneva, he had reconciled with easel painting but continued to research unusual oil mixtures.

Initially Dove and his wife Helen Torr ("Reds," also a painter) set up their studios in a house without electricity or running water on farmland bordering Exchange Street just north of the Geneva city line. The physical demands of handling his father's estate—repairing, inventorying, and ultimately liquidating the highly mortgaged properties—were mitigated by the the luxury of a large studio within which to foster new ideas about painting. In 1935 he bought a copy of Max Doerner's *The Materials of the Artist* and began grinding his own colors, mixing his own medium, and preparing his own canvases. In particular he was drawn to the properties of wax emulsion and tempera to enhance the depth and vibrancy of his surfaces and colors.

Dove and his wife lived for four years in the old farmhouse before moving, in the fifth, to the large third-floor apartment near Seneca Lake where he painted *Cars in a Sleet Storm*.[3] During his years in Geneva Dove developed a seasonal rhythm of work to accommodate his restless and inductive approach. During the spring and summer, whether walking in the Loomis woods or fishing to the northwest of Holbrook's Bridge, he scouted for images to commit to watercolor. Late in the year when storms rolled in from the north these watercolors became records of what he called "a condition of light" from which to build up the color of his compositions. In the winter, snowed in on the farm, he concentrated on easel painting. In March and April there remained the physical chores of framing and packing the paintings for shipment to New York.

Having grown up fishing and hunting in and around the waterways that feed Seneca Lake, Dove knew every highway and byway and was no stranger to the elements. Visual incidents and accidents of location and weather in particular—so evident in *Cars in a Sleet Storm*—had always excited him. Checklists of Dove's annual exhibitions at Stieglitz's American Place reveal the range of his discoveries each year. For example, in *Electric Peach Orchard* (1935) the open wiry branches of spring trees march like so many telephone poles across the banded colors of Geneva's landscape. Wet and shiny foliage emerge dolphin-shaped in the midst of a composition called *Summer* (1935). *Autumn* (1935) stretches a rhythmic score of elastic bubbles and commas into a variegated panorama of ecstatic color. Such animistic portrayals defied categorization in the eyes of most reviewers, leading Elizabeth McCausland, for instance, to locate Dove somewhere near a crossroads of Mark Twain and Miró:

> *Gaity, spontaneity, big hearty jokes are in Dove's character, as they are in the American character, witness Mark Twain's jumping frog....As far as we can find out, Dove never saw a Picasso, though he has seen some reproductions. Probably he never saw many surrealist canvases, though we seem to remember that he has expressed a liking for Miró....The Mirós seen the past winter at the Pierre Matisse gallery had this vibrating color; but they did not seem to be articulated to have a skeleton under their skin of color. In this Dove there is all the madness of the best surrealist view of the world; but with a strength and vigor...that redeems the picture from decadence. A superb clairvoyance into the structure of matter and the function of light seems to operate in this painting.*[4]

Cars in a Sleet Storm derives from this misunderstood aspect of Dove's imagination and humor. What Dove saw along the highway in Geneva is part poetry, part mechanomorphic fantasy. Dove's vision of three gritty awkward diamond-shaped cars with headlight- and windshield-eyes piercing the gloom came to life in his usual watercolor way, as the preparatory sketch of the finished painting demonstrates.[5] Fluid lines of gouache loop around to suggest a clutch of reptilian shapes side by side and variously head to tail.

Suffering the strains of ill health on leaving Geneva in 1938 and relocating with his wife to a deserted post office in Centerport, Long Island, Dove abandoned his playful manner and gravitated toward a cooler, cleaner geometry. That earlier aspect of his art had, after all, been close to caricature and seemingly distant from abstraction. Did he have misgivings about the work of this phase? Dove once privately confessed to Stieglitz that, in fact, "Weather shouldn't be so important to a modern painter—maybe we're still 'too human.'"[6] Nevertheless what Duncan Phillips recognized in Dove's 1938 show at An American Place (which included MAG's painting)[7] and noted with appreciation was "the bliss of a boy in his first liberties with nature's elements....[To] enjoy his art it is only necessary to have something of that first ecstasy left in one's heart and head."[8]

Arthur G. Dove,
1880–1946
Cars in a Sleet Storm, 1938
Oil on canvas, 15 x 21 in.
Marion Stratton Gould Fund,
51.4
©Estate of Arthur G. Dove

Elizabeth Hutton Turner, Senior Curator of The Phillips Collection, is a specialist in early twentieth-century modern art.

59: Reginald Marsh *People's Follies No. 3* (1938)
Ice Cream Cones (1938)

Kathleen Spies

Deemed an American Hogarth by contemporary critics, Reginald Marsh is best known for his lively scenes of modern urban life. Throughout his career, he paid particular attention to the earthy, the vulgar, and the lowbrow, and two of his favorite locations for finding such qualities are depicted in *People's Follies No. 3* and *Ice Cream Cones*.

In *People's Follies*, Marsh portrays a 1930s burlesque performance with all its bawdy energy. His palette of heated reds, tarnished golds, and dingy browns suggests a lustful, tawdry atmosphere, and his jam-packed detail and condensed space create an active, if somewhat chaotic, composition. Marsh painted this scene in his preferred medium of tempera, which dried quickly and allowed him to layer brushstrokes, a technique adding to the overall restless effect. The artist devoted roughly one-third of his output to burlesque subjects, and would often make several different paintings and etchings of the same scene, as is the case with this work. He was drawn to the topic, he said, because "You get a woman in the spotlight, the gilt architecture of the place, plenty of humanity. Everything is nice and intimate...."[1]

Alternating between comic skits and strip acts, burlesque in the 1930s was widely considered the lowest form of live entertainment, employing strippers and dancers not talented or attractive enough for Hollywood or Broadway. At the time Marsh painted *People's Follies*, burlesque was a particularly newsworthy topic. The urban reforms spearheaded by Mayor Fiorello LaGuardia led to widely publicized court hearings which gave burlesque more exposure than ever. But it also irrevocably linked the theaters and their performers to degeneracy, vice, and decay.[2]

As with many of his burlesque images, Marsh bifurcates this composition, devoting the left to the scantily-clad female chorines, and the right to the all-male audience. Wearing ridiculously frilly, gaudy costumes, the voluptuous performers are frozen in varied poses—one is in the midst of dancing, one appears in mid-stride, another has her feet firmly planted on the ground—indicating the unrehearsed, ad-lib character for which burlesque was known. As in the shows themselves, these female figures are indistinguishable from one another. With their identical bleached blonde hairstyles and almost caricatured bodies, Marsh depicts them as little more than sex objects. Indeed general public opinion held that burlesque performers were one step removed from prostitutes, selling their bodies for a paying public.

Burlesque audiences often fared just as poorly in the public eye, and were thought to consist primarily of bums and derelicts. But in *People's Follies* Marsh records a different faction: the suited "baldhead" patrons who could afford season tickets closest to the stage. These burlesque "connoisseurs" reveal a variety of reactions to the sight before them: one leans forward eagerly in his seat, one inspects the women with a sophisticated reserve, and another sits back and slyly grins. Visually separated from the audience by a vertical column and the horizontal band of the stage, the women are viewed by these men as if they are in a storefront window display, objects of desire for consumption and possible purchase.

The emphasis that Marsh places on the audience members and their reactions reveals that it was not just female sexuality that interested him, but also the desire, lust, and consumption of that sexuality —in other words, the act of viewing. While the actual burlesque show distinguished itself from other forms of entertainment by encouraging interaction between performers and audience members

Reginald Marsh,
1898–1954
People's Follies No. 3, 1938
Tempera on composition board,
25⅞ x 39 in.
Marion Stratton Gould Fund,
43.1
©2006 Estate of Reginald
Marsh/Art Students League,
New York/Artists Rights Society
(ARS), New York

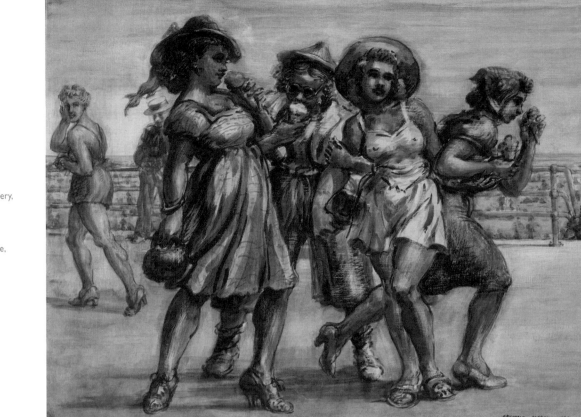

(through invitations via song to powder one's back, for example), Marsh shows us a world in which there is a lack of connection, in which the modern relation of the sexes is purely visual, a fantasy based on commercial exchange.

But Marsh was hardly a mere cynic or moralist about this sort of exchange. He infuses his images with a liveliness that suggests he relished, rather than condemned, the tawdry vulgarity of burlesque, and celebrated its lack of pretense. While his images communicate his awareness of the deep subtleties and ironies of such interactions, they are hardly critical statements.

In fact, Marsh was one of numerous artists, writers, and intellectuals drawn to burlesque between the wars, a prestigious group including e. e. cummings, Jean Cocteau, Edward Hopper, and Thomas Hart Benton. For this group, accepting or celebrating burlesque was a means of breaking from Victorian prudery, and marking oneself as modern in thought. With its open attitudes toward sex and the public display of female flesh, burlesque pushed aside all Victorian limits. More broadly, many artists and intellectuals of this period saw the "vulgar" as distinctly American. Rather than look down at popular culture as did previous generations, Marsh celebrated it, and revered what others may have called grotesque or lowbrow as unique Americana.

Further, burlesque was a popular downtown site for slumming uptowners, and like the audience members he portrayed, the artist himself was part of this trend. Educated at Yale, Marsh was described by his lifelong friend and biographer Lloyd Goodrich as a confirmed, if reluctant, member of the upper classes.[3] Like many aspiring moderns, Marsh saw the working class as authentic and uninhibited, as opposed to the wealthy elite still bogged down by Victorian constraints and values. "People of wealth spend money to disguise themselves, but these people live in the open.... [R]eality is exposed and not disguised," he once said.[4]

It is not surprising that Marsh devoted so much of his oeuvre to burlesque, since as his teacher Kenneth Hayes Miller once told him, "Sex is your theme."[5] Marsh was sure to include young buxom blondes in nearly all of his images, even when representing less openly prurient locales. These women became such a stock, identifiable part of Marsh's art that critics dubbed them "Marsh girls."

Apart from the burlesque theater, one of Marsh's favorite sites for locating the "Marsh girl" was Coney Island. At the time the artist completed his 1938 *Ice Cream Cones,* Coney Island had changed significantly from its turn-of-the-century origin as a respectable middle-class destination into a largely working-class area of recreation, replete with freak shows, amusement park rides, and striptease acts. Most burlesque theaters were closed during the summer, and Coney Island allowed Marsh the opportunity to record many of the same themes he sought in burlesque: sex, consumption, vulgarity, and the public display of the female body.

In *Ice Cream Cones,* we see several "Marsh girls" eating cones and evocatively posing for prospective others passing by. Coney Island was known as a place where young men and women could meet and date, and many of the rides promised the potential of physical interaction between strangers of the opposite sex. Unlike the dark and dingy palette of *People's Follies,* the color scheme here is one of pastels, of sunny days at the beach and confectionary delights. Nonetheless, these girls differ little from Marsh's burlesque chorines; their clinging clothes reveal more than conceal their exaggerated anatomy, and their ice cream cones seem little more than props of erotic suggestion.

Yet, typical of Marsh's work, *Ice Cream Cones* injects this outright portrayal of sex with an element of humor. Behind the two coy, attractive women stands a third, who awkwardly leans over and gorges her ice cream cone, oblivious to any onlookers. And, at the right, a fourth woman rushes past with a singularity of focus that is comically out of place in such a leisurely setting. Humor here perhaps served for the painting's viewers, as it did for the patrons of burlesque, to alleviate sexual tension or the guilt of desire, and to place it in the realm of innocuous fun. Marsh often showed people ungracefully shoving food in their faces in Coney Island scenes, a strong parallel to the insatiable appetite the burlesque audience shows toward the strippers and chorines. In these and many of his other images, Marsh defines modern urban society, for all its vitality, as one that is decidedly occupied by the act of consuming rather than producing.

On a more basic level, the indecorous behavior and awkward pose of the third girl balances, and even subverts, the pinup beauty of the two women in front of her. After all, despite his fascination with feminine perfection, Marsh also admitted that he liked Coney Island because "it stinks of people and is earthy and real."[6] And, by the 1950s, he was complaining that the Coney Island he once knew was vanishing: "The bunions and varicose veins and flat chests are gone. Now there are only Marilyn Monroes."[7] Like the ogle-eyed and gaping-mouthed spectators in his burlesque scenes, the third girl provides the "plenty of humanity" Marsh was sure to include in all his works, and through which he comically reminds us of our own.

Kathleen Spies is Associate Professor of Art History, Birmingham-Southern College.

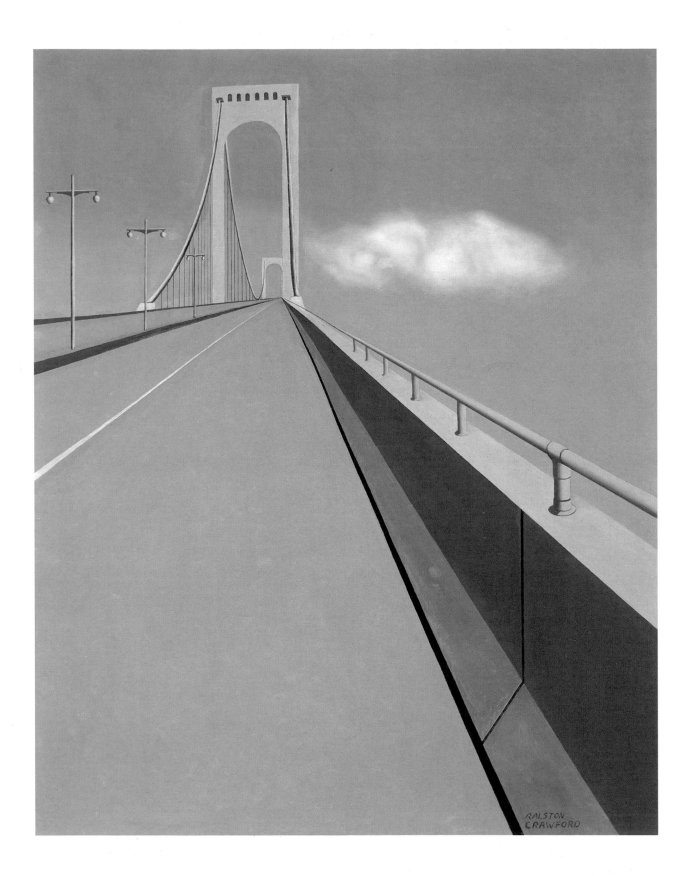

Seeing America: Painting and Sculpture from the Collection of the Memorial Art Gallery

Marjorie B. Searl

Shocking to me: the solitary man
perched high on a girder of the Whitestone Bridge,
until his yellow hard hat bolts
into sight, his wind-burned face,
legs that ride a wedge between sky and sea. Closer,
and more startling still:
grasping a tiny whisk broom, he dusts the ledge
with a motion delicate and precise—
a jeweler brushing a watch's gears.
—From "Gulls and the Man" by Maria Terrone[1]

On April 29, 1939, a brand-new New York City icon was dedicated—the Bronx-Whitestone Bridge. The bridge, itself heralded by many as a work of art, has inspired or figured in artistic creations in many genres, from the poem above to an exhibition of artworks related to Alfred Hitchcock's films, an exhibition that included Ralston Crawford's painting, *Whitestone Bridge.*[2]

Fittingly, the spare and elegant bridge is also a metaphor for a transitional period in Crawford's career, coming just as he moved from the painterly and peaceful landscapes and still lifes of the early 1930s to more austere works whose bridges, industrial elevators, roofs, and barns were created with a limited palette and linear style, linking him with precisionists like Charles Sheeler (1883–1965) and Charles Demuth (1883–1935).

Ralston Crawford's life and career were characterized by change.[3] From California, where he worked as an illustrator for Walt Disney Studios, he moved to Philadelphia in 1927, where he became acquainted with modern art at the Barnes Foundation, and from there to New York City, which became his home base. Study in Europe, married life in Bucks County, and trips to Florida and New Orleans happened in quick succession. By 1938, he had completed some of his most muscular paintings, and the next year saw the creation of the surrealistic and much-acclaimed *Overseas Highway* (Thyssen-Bornemisza Collection, 1939), a sibling to *Whitestone Bridge* in its illusionistic pull of the viewer into deep space, with no certainty of a safe landing at the other end, and only a cloud to reach for.

Whitestone Bridge was finished in 1940, the year following the bridge's completion. Given Crawford's interest in the industrial landscape the Bronx-Whitestone Bridge was a natural subject for him: a manmade structure of significant proportions, with startling visual impact and, viewed from the right angle, the potential for psychic unease. The bridge unfolds before the viewer like a fan, with carefully creased pleats made up of narrow slivers of guard rail, roadway, and median.

Using a severely restricted palette of blues, grays, black, and white, Crawford eliminates all but the most essential components of the composition. There is no meandering from foreground to middleground to background—the exaggerated diagonal lines leave the viewer no choice but to zoom ahead, as if one were in reality traversing the bridge by car. The surreal absence of land on the other side of the bridge—in effect, a suspension bridge suspended in space—suggests the memory of an anxiety dream, made dreamier by the cottony cloud drifting by, a counterpoint to the hard-edged surfaces of the painting.

Ralston Crawford,
1906–1978
Whitestone Bridge, 1939–40
Oil on canvas, 40¼ x 32 in.
Marion Stratton Gould Fund,
51.2
Ralston Crawford Estate

By 1936, traffic on the East River bridges, including the new Triborough Bridge, had become insupportable, and one powerful man, Robert Moses, was convinced that a new bridge would solve the problem. A crossing from Whitestone, Queens, to Ferry Point, the Bronx, had been proposed since early in the century, but not until Moses advanced his plan in 1930 was the vision for the complex roadway system that included the Whitestone Bridge fully articulated:

> *If the Marginal Boulevard, the Ferry Point-Whitestone Bridge and the Hutchinson River Parkway Extension were built…motorists would be able to leave Manhattan Island on the Brooklyn Bridge and then proceed over broad modern roads, unhindered by a single traffic light, all the way around Brooklyn to the Long Island parkways and parks. In addition, Manhattan and Brooklyn motorists would be presented with a through route to the Bronx, Westchester and New England—and so would motorists from Nassau and Suffolk counties.*[4]

Resistance was strong: New York City's Regional Plan Association insisted that no traffic solution would be acceptable unless mass transit or the potential for mass transit were included as part of the structure. Moses was equally adamant that this not happen, possibly due to his concern that "undesirables" might overrun Long Island. Or, he may have been concerned that the budget would prove inadequate to the project.

As was nearly always the case, Moses had his way, but the city's much-anticipated traffic relief never materialized. Notwithstanding traffic woes, the bridge's design was widely praised. One reporter commented: "The bridge's freedom from heavy structural lines and ornamentation gives a breath-taking grace to the 2,300-foot center span and 3,770-foot overall length."[5] At the ribbon-cutting, Robert Moses described it as "architecturally the finest suspension bridge of them all, without comparison in cleanliness and simplicity of design, in lightness and absence of pretentious ornamentation. Here, if anywhere, we have pure, functional architecture."[6] Forty years later, Moses was still smitten with the bridge's beauty, as he described the "'airy, gossamer lightness' of the original structure."[7]

Ralston Crawford,
1906–1978
Study for Fortune Magazine,
ca. 1945
Pen and ink with watercolor
on paper, 7¹⁵⁄₁₆ x 5 in.
Gift of Edith Holden Babcock,
Peter Iselin, Dr. Ben Shenson,
Dr. A. Jess Shenson, Emilie
Wiggin, and Marion Stratton
Gould Fund, by exchange, 95.50
Ralston Crawford Estate

Ralston Crawford,
1906–1978
Study for "Whitestone Bridge,"
ca. 1940
Pen and ink with graphite
on paper, 7⁵⁄₁₆ x 5 in.
Gift of Edith Holden Babcock,
Peter Iselin, Dr. Ben Shenson,
Dr. A. Jess Shenson, Emilie
Wiggin, and Marion Stratton
Gould Fund, by exchange, 95.48
Ralston Crawford Estate

New York City viewers in 1940, for whom the bridge was a symbol of innovation and progress, brought an entirely different set of associations to Crawford's painting than their 2005 counterparts. The streamlined Art Deco style of the Whitestone Bridge was a perfect entrée for visitors crossing the East River to the futuristic fairgrounds, whose theme—"Building the World of Tomorrow"—was expressed in its architecture and, especially, in its "Trylon and Perisphere" logo. On April 30, 1939 (in a feat of good planning, the day after the dedication of the Whitestone Bridge), Franklin Roosevelt made the first live television broadcast from Flushing Meadow Park, Queens, in which he declared the 1939 World's Fair officially open.[8]

Crawford's *Whitestone Bridge,* too, excited great interest and functioned as a benchmark against which his future work was often com-

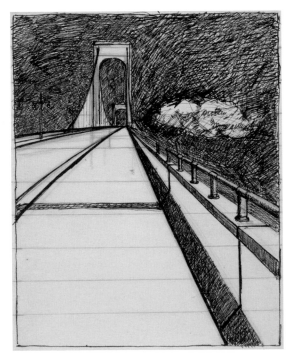

pared. The celebratory atmosphere of the openings of the bridge and the World's Fair may have also given Crawford reason to believe that the bridge would be a well-received subject. He recalled that "The production of the painting 'Whitestone Bridge' was preceded by a series of direct visual stimuli related to this bridge and similar forms.[9] In this painting I have tried to express the sensations and thoughts about the sensations that I have had while driving over such bridges. The simplifications and distortions aim at a distillation of these experiences. Some of the people who have gotten satisfaction from the painting tell me that it clarifies and enlarges their reaction to similar experiences."[10]

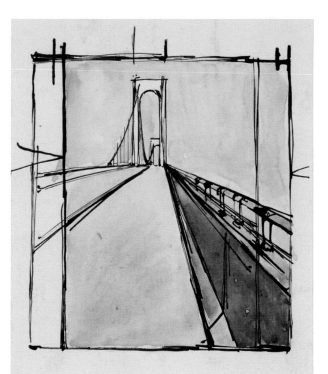

Ralston Crawford,
1906–1978
Study for "Whitestone Bridge,"
ca. 1940
Pen and ink with watercolor
on paper, 7¹⁵/₁₆ x 5 in.
Gift of Edith Holden Babcock,
Peter Iselin, Dr. Ben Shenson,
Dr. A. Jess Shenson, Emilie
Wiggin, and Marion Stratton
Gould Fund, by exchange, 95.49
Ralston Crawford Estate

The first published reference to the painting appears to have been in Edward Alden Jewell's review of the 1940 Whitney annual exhibition of contemporary American painting, which includes in an informal list of work "Ralston Crawford's severely simplified perspective device, 'Whitestone Bridge.'"[11] In January 1944, Dorothy Grafly, reviewing the Pennsylvania Academy of the Fine Arts salon, described the "cool, precise, engineering emphasis in Ralston Crawford's 'White Stone Bridge.'"[12] In 1943, the dynamic art dealer Edith Halpert of the Downtown Gallery began to represent Crawford[13] and a year later she sold *Whitestone Bridge* to the Encyclopedia Britannica Collection:

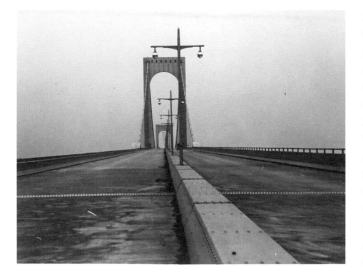

Incidentally, did you know that we sold your "Whitestone Bridge" to Encyclopedia Britannica just before we closed for the summer. Because of the split commission (on which we charge 40%), I raised the price (and this is confidential) to $850.00, so that you won't have to take a cut. They are assembling a pretty good collection, slightly on the conservative side, but have been breaking loose lately. I tried to put over a later example, but the committee couldn't quite take it. However, they got a swell picture, and everyone was happy.[14]

Ralston Crawford,
1906–1978
Whitestone Bridge, ca. 1940
Gelatin silver print,
2¹¹/₁₆ x 3¹⁵/₁₆ in.
Gift of Edith Holden Babcock,
Peter Iselin, Dr. Ben Shenson,
Dr. A. Jess Shenson, Emilie
Wiggin, and Marion Stratton
Gould Fund, by exchange, 95.52
Ralston Crawford Estate

Crawford answered her from Washington, D.C., on July 23, 1944:

> *I am terribly glad about WHITESTONE BRIDGE and I am more than pleased that you were able to arrange the price so effectively. I very well understand their choice of this picture rather than a later example. I also appreciate your effort to provide them with a later example. This procedure of selecting the earlier ones is, I am sure, an old story in your experience and it is becoming*

an old one in mine. There is no doubt that the productive painter paints faster and develops faster than the public eye can absorb. This, I presume, is for the simple reason that the painter thinks about his work for longer periods than the average gallery visitor. Therefore this lag does not seem disturbing to me, provided the public keeps moving.[15]

These sentiments echoed a critic's comment in the January 15, 1944, issue of *Art News*, in response to an exhibition of Crawford's work at Halpert's Downtown Gallery: "There are people who will regret the passing of what he did so well, remembering *Whitestone Bridge* where not alone the vanishing perspective but the infinitely remote blue sky created a tremendous sense of suction....But Crawford must pursue his direction. That direction has resulted in a group of work which now represents one of the milestones of American abstract art."[16] Halpert understood as well that the public had been conditioned to expect a certain "look" from Crawford; he, however, was hoping to interest people in his developing style. About a possible commission for a factory in Buffalo, she wrote to him: "I am sure that what she [the factory decorator] has in mind is 'The Whitestone Bridge', but you can decide for yourself whether you want to bother with the matter at all."[17] He wrote back: "I am slightly disappointed in the development of this project [the Buffalo commission]. And then, "The Fortune Commissions, and needless to say, the Encyclopedia Britannica sales have been swell. But what do you think can be done with these pictures now in existence?"[18]

"These pictures" represented the beginning of a shift in Crawford's approach to painting, from a type of ultra-clarified representation toward abstraction. *Whitestone Bridge's* controlled classicism gave way after World War II to explosive bursts of color and line. This was due in no small part to one of Crawford's most intense experiences: being witness to the 1946 nuclear tests at Bikini atoll for a *Fortune* magazine commission.[19]

The Whitestone Bridge also experienced changes and modifications. In November 1940, a little more than eighteen months after the opening of the Whitestone Bridge, the Tacoma Narrows suspension bridge collapsed into Puget Sound after experiencing vibrations due to high winds. In spite of reassurances by engineer and designer Othmar Ammann that the New York bridge was safe, Robert Moses mandated that precautions be taken to increase its structural strength, which included adding diagonal stiffening cables running from the tower tops to the plate girders. As Darl Rastorfer wrote: "Lost forever were the pure and simple lines of the original structure and unobstructed views its roadway afforded travelers."[20] Fortunately, thanks to the availability of stronger and lighter materials, the bridge is undergoing renovations intended to bring it back to its original form. Belying Rastofer's dire description, the lines of the bridge will once again correspond closely to "the original structure and the unobstructed views" in Ralston Crawford's painting.

Marjorie B. Searl is Chief Curator, Memorial Art Gallery.

61: Marsden Hartley *Waterfall, Morse Pond* (ca. 1940)

Margaret MacDougal

Marsden Hartley's *Waterfall, Morse Pond*[1] demonstrates the synthesis of styles, spirituality, and personal expression that Hartley was able to achieve in his late painting. It is part of a body of work, painted by Hartley on his return to his native Maine in 1937, that celebrates the state's natural beauty, as well as its historical and cultural importance.

The painting was in the personal collection of Hudson D. Walker, Hartley's art dealer, promoter, and close friend, when Harris K. Prior, director of the Memorial Art Gallery, contacted Walker, searching for a "first rate example" of Hartley's work.[2] Walker, who had vigorously encouraged and promoted the artist, believed that the work Hartley did from 1935 until his death in 1943 was "monumental and American," and he was convinced that Hartley's return to his native Maine was pivotal in his ability to paint with emotion and "universal expression."[3] Part of Hartley's genius was his ability to capture a natural setting, and to portray the spirit of the place by reinterpreting it, using the expressionist tools of a modernist.

Hartley painted the waterfall in the late autumn when rich, red colors contrast sharply with the black rocks and cascading water. The artist uses a close-up focus, and crops and eliminates much of the surrounding forest, resulting in an intimate portrait of the waterfall. He captures the reverent stillness and vital energy simultaneously by using strong, stable, geometric lines to outline the rocks and trees, in contrast to the turbulent water, which is formed by thick, white, curving brush strokes. It is a private scene of nature, located ostensibly far from civilization, but Hartley includes cut logs

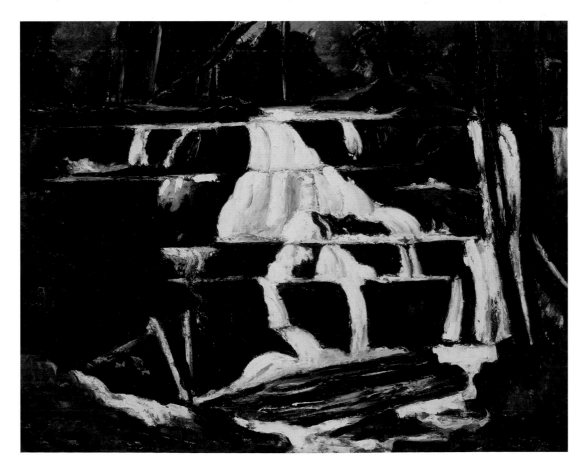

Marsden Hartley,
1877–1943
Waterfall, Morse Pond, ca. 1940
Oil on board, 22 x 28 in.
Marion Stratton Gould Fund,
65.59

at the base of the waterfall, perhaps making reference to the use of this waterway as transportation to the saw mills of Maine's lumber industry. The small glimpse of blue sky gives perspective to the modernist, flat surface and, in contrast with the dark, earthy tones of the water and woods, hints at the artist's connection with the spiritual.[4]

Morse Pond is located deep in the Maine woods,[5] accessible only by a four-wheel drive vehicle, and is part of a tributary to the Kennebec River, one of the largest rivers in Maine. The waterfall looks today much as it might have sixty-five years ago when Hartley visited it. It is a horizontal rather than vertical waterfall, with churning water spilling around several large, moss-covered boulders, which step down to the stream below. The woods frame the waterfall, and one tree still stands exactly in the middle of the background with blue sky visible behind it.

Hartley's method of painting his late landscapes was to visit a site, either on foot or by being driven (he did not operate a vehicle), and remain at the location for hours, even days, in order to absorb the total essence of the natural setting. He would then, at a later date, paint from memory, drawing on his own interpretation and personal, spiritual connection to the place.[6] It is not difficult to imagine that he was entranced by the waterfall below Morse Pond. In a poem entitled "Water from the Rock," he describes his attraction and affinity for moving water:

> O—lead me there
> To where the pure water gushes forth
> From rock made bountiful
> With faith.
>
> ...Cool be thy mercy's flow
> river beneath the glowing rock
> obstructing not the silver show.
> I would not be slow
> To sense wonder.[7]

Hartley loved waterfalls and rushing streams, and would actually immerse himself in the stream under a waterfall and let the water pour over him, delighted by the "old baptism of nature and the hypnosis of water."[8]

Along with *Waterfall, Morse Pond,* Hartley painted other waterfalls, views of the coast, a series of Mt. Katahdin, and a number of remarkable character paintings of lumberjacks, fishermen, and lobstermen. While artists from Fitz Hugh Lane to Winslow Homer chiefly painted the coast of Maine, Hartley searched inland for remote locations that exhibited the beauty of the land but also acknowledged the hardworking natives and their culture. The painting of the waterfall below Morse Pond particularly fits in with a series that Hartley did in reference to the logging industry,[9] celebrating Maine's natural resources, yet at the same time seeming to warn about exploitation.[10] Lush forests, for instance, are contrasted in the same painting with chopped trees and barren stumps in *Wood Lot, Maine* (1938). Hartley titles one painting of logs which have washed down the Kennebec River, *Ghosts of the Forest, Georgetown* (1937–38).[11]

Marsden Hartley was originally a Yankee from Lewiston, Maine, who spent much of his restless and peripatetic life outside of New England. When he was studying and painting in New York, he came to the attention of Alfred Stieglitz who, as a great promoter and supporter of young, avant-garde artists, exposed him to the modern art of Matisse and Cézanne. "He knew that I was a traveler," Hartley said, "and that my education lay out in the open free areas of the world—and that I must go wherever my education called for me to go."[12] In 1912, with the financial help of Stieglitz, Hartley went to Paris, met Gertrude Stein, and frequented her home at 27 rue de Fleurus, where he grew excited by modernist ideas and paintings. "They seemed to burn my head off," he remarked in his autobiography.[13]

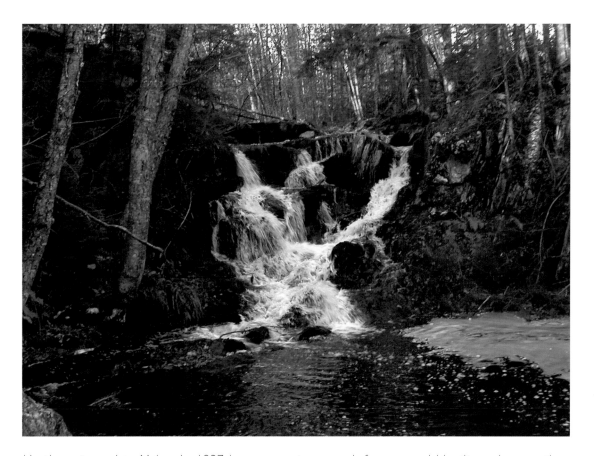

Waterfall, Morse Pond,
November 4, 2002
Photograph by the author

Hartley returned to Maine in 1937 in response to a search for personal identity and connection, but he was also reacting to emerging nationalism in post-World War I American culture and art.[14] The artists and writers in the Stieglitz group, who showed at the New York gallery An American Place, were determined to define and distinguish American culture from that of Western Europe.[15] In order to appeal to the public, an artist's identity—associated with a particular location, such as Georgia O'Keeffe's with New Mexico—became an important ideological as well as economic goal. In New England there was a strong regionalist movement, much like that in the Midwest, exemplified in art by the seascapes of John Marin, lumberjacks of Waldo Pierce, and the stalwart granite sculptures of William Zorach and Robert Laurent.[16] The expatriate Hartley began a strong bid to become a New England painter, and wrote an essay in which he proclaimed, "I wish to declare myself the painter from Maine."[17] In his essay, Hartley distinguishes himself as a native "Maine-iac" in contrast to Winslow Homer, whom he greatly admired, but who had been "born in Boston,"[18] and John Marin, who had recently been celebrated as a great American painter and a Maine painter after an exhibition at the Museum of Modern Art.[19] Neither Marin nor Homer was a Maine native, and Hartley began a relentless campaign to claim his right to be "painter laureate" of the state. He wrote numerous letters to the state, to his friends, and to Hudson Walker outlining his intentions.

Yet for all his desire to be "the painter from Maine," a lifetime seeking the transcendent meaning of *place* meant that Hartley's strongest spiritual connection as an artist was to the American mystical painter, Albert Pinkham Ryder, whose *Moonlight Marine* he had seen in 1909. "All my essential Yankee qualities were brought forth out of this picture....It had in it the stupendous solemnity of a Blake mystical picture and it had a sense of realism besides that bore such a force of nature itself as to leave me breathless."[20] Hartley, who always derived inspiration from nature, labored to paint the mysticism he found in the work of Ryder, whose spirit is evident in the dark, thick textures of the waterfall at Morse Pond.

Waterfall, Morse Pond is relatively unknown, primarily because it remained in the private collection of Hudson Walker until 1965, but it was part of Hartley's bid to be known as Maine's premier painter. The intimate portrait of the waterfall, painted with the realism of a modernist, incorporates Hartley's spiritual connection to nature and his admiration for the hardworking Yankee character, and exemplifies the extraordinary work he did at the end of his life.

Margaret MacDougal is an art historian who currently resides in Harpswell, Maine.

62: Douglas Warner Gorsline *Bar Scene* (1942)

Marie Via

The Rochester-born artist Douglas Gorsline burst upon the art scene with fireworks.

The first time he ever submitted work for consideration was to the Memorial Art Gallery's Annual Exhibition of Work by Rochester Artists and Craftsmen in 1935. Not only was the painting *Girl's Head* accepted for inclusion but it was awarded the first purchase prize ever offered at the Gallery. "I was still trying to recover from the amazement of winning the prize in your exhibition when I heard you had purchased it for the gallery," he wrote to director Gertrude Herdle Moore. "I assure you that put the finishing touches upon my stupefaction!"[1] A month later, the twenty-two-year-old Gorsline was selected as one of ten artists of special promise enrolled at the Art Students League in New York, and in 1938 was included in the Whitney Museum's prestigious annual exhibition of contemporary art. By 1940, *Art Digest* was following his "steady progress,"[2] and in 1942 his portrait titled *My Better Half* took the Walter Lippincott Prize for best figure painting at the Pennsylvania Academy of the Fine Arts.

It was at this heady juncture that the Memorial Art Gallery acquired its third Gorsline painting. *Bar Scene* had been selected for inclusion in the 1942 Rochester-Finger Lakes Exhibition (the annual juried show of regional art) and was subsequently purchased for the permanent collection through the Art Patrons Fund. Depicting a beefy saloon patron draping his arm over the shoulder of an auburn-haired beauty in a yellow blouse, it was a brilliant example of the genre upon which Gorsline was building his solid reputation: scenes from everyday life in New York City.

Elisabeth Perkins Gorsline ("Zippy"), ca. 1936
Photograph
Courtesy John Gorsline

As he so often did, Gorsline used his wife as his model. Elisabeth "Zippy" Perkins, the daughter of famed Charles Scribner's Sons editor Maxwell Perkins, was the ideal Gorsline "type"—one part "buxom working gal"[3] and one part "lost soul."[4] She too had studied at the Art Students League, and her marriage to the handsome Gorsline in 1936 marked the beginning of a fruitful artist/model collaboration.

Gorsline incorporated two of his signature devices into *Bar Scene*. First, his subjects, like the woman here, often wear coats or wraps that have been allowed to hang open, revealing the drapery of the blouse or dress underneath. Indeed, he was so captivated by the details of clothing that many of his portraits now serve as documents of mid-century dress.[5] Second, he had a penchant for the far-away gaze. Seldom do his models make eye contact with the viewer, effectively distancing themselves behind an invisible barrier. The woman in *Bar Scene* turns away from the casual possessiveness of her cigarette-smoking companion. Despite her fur jacket and décolletage, she seems less glamorous than wistful.

The critics were quick to recognize Gorsline's talent and potential. One acknowledged his "keen sense of characterization,"[6] which is fully realized in works like *Bar Scene*. Another noted that his portraits were "complete statements equipped with an aesthetic subject, predicate and period."[7] In 1939, *Art News* praised his work as that of "a young artist whose draughtsmanship has real distinction, and who handles his colors with ease."[8]

Likewise, reviewers commented on the influence of the old masters in Gorsline's work. Although his subject matter was completely up-to-date, his time-consuming technique was based on that of Titian and Rubens, in which successive layers of semi-transparent oil glazes were layered over egg tempera that he mixed himself, creating the illusion of depth and inner light. By 1945, he had streamlined his methods a bit. That year, identified as "one of the younger brilliant painters recent-

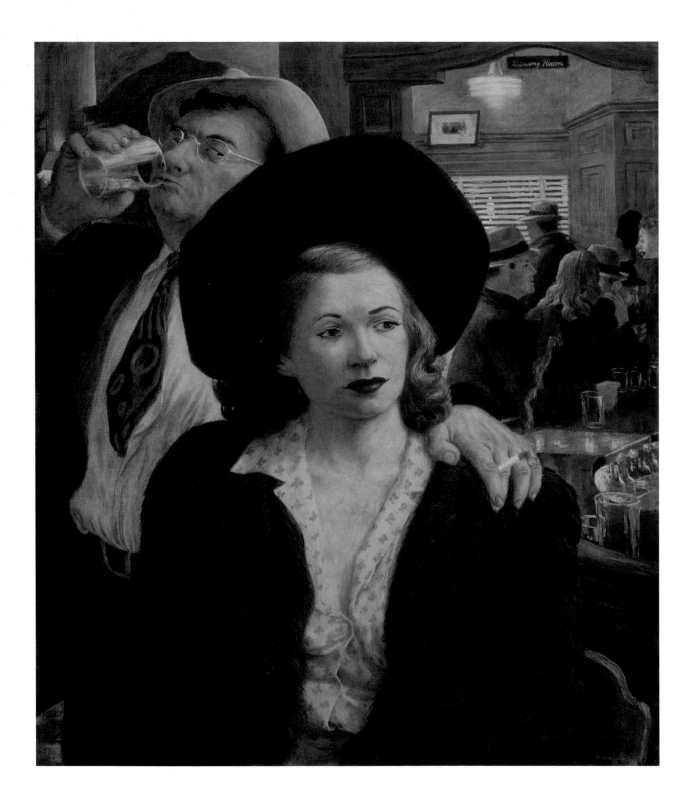

ly honored by the National Academy," he endorsed Grumbacher oils in a national ad campaign: "After seeking the most permanent colors for years, I have come to the conclusion that Grumbacher Finest Oil Colors are my answer, and I always use them."[9]

The setting of the painting has always been a mystery. Clearly, it was a bar set slightly below street level (as indicated by the legs of figures seen through the window) and there was also a dining room (the sign appears on the back wall). But was it an actual place or a generic spot concocted in Gorsline's imagination? The discovery of a creased and faded photograph of a lost Gorsline painting titled *Costello's Bar* suggests that this was also the location depicted in *Bar Scene,* painted in the same year. This supposition is confirmed by a surviving copy of the menu that Gorsline designed for Costello's, illustrated with lively vignettes of the establishment's staff and patrons, one of the original sketches for which is also dated 1942.[10]

Costello's was the legendary home away from home for writers at *The New Yorker, The Daily News, United Press International,* and *Associated Press* and served as "forward editorial headquarters"[11] for *Yank Magazine* during World War II. Located at Third Avenue and East Forty-fourth Street in New York City, the Irish bar and grill was decorated with murals by James Thurber, one of its regulars, and made famous in John McNulty's *This Place on Third Avenue.* Its habitués were "truck drivers, horseplayers, glamour girls, draftees, has-beens, never-weres, dreamers and despairers,"[12] exactly the sort of characters that captured Gorsline's fancy. In *Costello's Bar,* which hung in the establishment until about 1947, proprietor Tim Costello leans against the mahogany bar while, in the background, an archetypal "Gorsline Girl" chats with a man in a fedora. The artist eventually reacquired the canvas; around 1957, while developing a new, "splintered" visual style, he painted a different portrait of Costello on top of it.[13]

Douglas Warner Gorsline,
1913–1985
Tim Costello, before 1947
(no longer extant)
Courtesy Musée Gorsline,
Bussy-le-Grand, France

Fortunately, *Bar Scene* has remained undisturbed in the Memorial Art Gallery's collection, still an outstanding example of urban genre painting. In recent years, it has been included in a number of exhibitions: A Rochester Retrospective (1980), The Art of Douglas Gorsline (1990), Out of the Drawing Room (1995), and Eye Contact: Paintings by Ken Aptekar (2002). It also appeared in Amerika: Traum und Depression, 1920–1940, which was on view in Berlin and Hamburg in 1980–81.

Even as Gorsline was receiving accolades from the critics, he was urged by them to emancipate himself from discipleship to Kenneth Hayes Miller, his former teacher and also a master of the urban scene. "His vocabulary of night clubs, restaurants and subways could be broadened," counseled one.[14] "It will be interesting to see whether this young painter…will be able to dominate a felicitous technique or whether his skill will stand in the way of more mature emotional growth," mused another.[15]

(Facing page)
Douglas Warner Gorsline,
1913–1985
Bar Scene, 1942
Oil on canvas, 29½ x 25¼ in.
Art Patrons' Purchase Award,
1942 Rochester-Finger Lakes
Exhibition, 42.19
Courtesy Musée Gorsline,
Bussy-le-Grand, France

Although he never fully rejected realism, by the late 1950s Gorsline had begun wedding it to a cubist sensibility. Inspired by the photographs of Étienne-Jules Marey, his new work was visually fragmented—an exploration of movement and the passage of time. In 1965, he moved to a remote farm in the Burgundy region of France with his third wife, Marie, who had been his artist's representative. Mrs. Gorsline now directs the museum she created to house his work in Bussy-le-Grand, where examples of both his early and late paintings are on view to the public.

Marie Via is Director of Exhibitions, Memorial Art Gallery.

Douglas Warner Gorsline,
1913–1985
Menu, Costello's Bar (recto),
ca. 1942
Courtesy Musée Gorsline,
Bussy-le-Grand, France

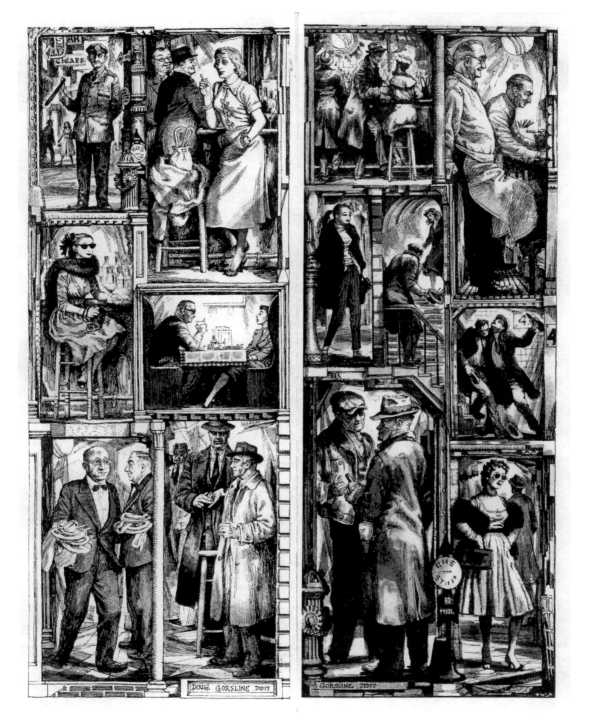

Douglas Warner Gorsline,
1913–1985
Menu, Costello's Bar (verso),
ca. 1942
Courtesy Musée Gorsline,
Bussy-le-Grand, France

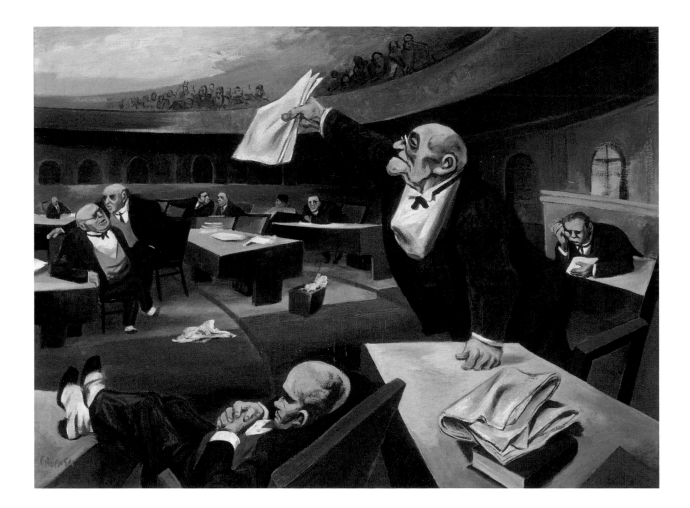

63: William Gropper *The Opposition* (1942)

Roberta K. Tarbell

Williom Gropper's satirical interpretations of United States senators and other prominent political figures were memorable and inventive invectives.[1] In 1967, he recalled his first-hand experiences in Washington, D.C.:

> A long time ago, I was assigned by Vanity Fair to cover the Senate. I stayed two or three weeks and painted the Senate as I saw it. I think the United States Senate is the best show in the world. If people saw it, they would know what their government is doing. The painting that I did [The Senate, 1935] was rejected by every show I tried to get it into. Then it was brought back and the Museum of Modern Art had it and now it is in every show. I get bored, so I did one or two Senates, and now I will do a Senate only when a Senator makes a speech that makes me mad.[2]

In 1934, Frank Crowninshield, editor of *Vanity Fair*, sent Gropper to the Senate to sketch legislators in action and printed the resulting caricatures as the "Sowers of the Senatorial Winds."[3] ("Those who agree with Disraeli that 'With words we govern men,'" Gropper wrote, "may take comfort, during this age of dictatorship, in the United States Senate, where phrases rather than deeds are still the rule."[4]) By 1942, when he painted *The Opposition*, Gropper had exhibited and published dozens of drawings, paintings, prints, and cartoons of senators, and the descriptive portraits of 1934 had evolved to iconic anonymous caricatures—ancient orators, side-bar negotiators, recumbent dozers, and so on.

For thirty years, Gropper supported himself by executing—almost daily—political cartoons, satirical drawings, and illustrations, most of which pointed out how the burdens of global social dislocation were borne by the lower classes. As one of the most-traveled, best-informed, and most-published radical artists, Gropper clearly was not an isolationist or a regionalist. Nevertheless, his large Senate series, depicting a place shared by all citizens, contributed to the chauvinism and the nationalist spirit that dominated American art during the second quarter of the twentieth century. He filled his political cartoons with his passion for democratic and socialist solutions to world problems and created satirical images easily decoded by the average citizen. He joined international partisan and progressive organizations and journals while simultaneously staying aloof from the styles of the Eurocentric avant-garde in art.

Born in a Lower East Side ghetto in 1897, William Gropper lived all of his life in New York City and its environs. He dropped out of high school because his Russian Jewish immigrant family needed his wages, but managed to study part time at the Ferrer School. His mentors there, realist painters Robert Henri and George Bellows, were philosophical anarchists more interested in individuals' freedom of expression than in the organized anarchist movement. They created art that was true to life, but not explicitly political. Although Gropper, like avowed socialist John Sloan, adopted the liberal, intellectual, and Marxist belief that art could induce political change, he did not embrace the revolutionary politics of the Russian Bolsheviks and never joined the Communist party.[5]

In 1917, *The New York Tribune* hired Gropper as a feature artist, and from 1918 to 1924 he was a regular contributor to *The Liberator*, successor to *The Masses*, the radical magazine that fearful federal officials had banned from the mails in 1917.[6] When *The New Masses* published its first issue in May 1926, Gropper was an executive board member and a contributor. He remained active in various leftist political organizations throughout his life, was one of the founders of the John Reed Club, and actively supported the purpose of the National Committee of the American Artists

William Gropper,
1897–1977
The Opposition, 1942
Oil on canvas, 28 x 38 in.
Marion Stratton Gould Fund,
51.5
Courtesy of ACA Galleries,
New York

Congress "to achieve unity of action among artists of recognized standing in their profession on all issues which concern their economic and cultural security and freedom, and to fight war, Fascism and reaction, destroyers of art and culture."[7]

Gropper often depicted victims of racism, war, economic depradations, and the hypocrisy of offending leaders. In 1937, for example, he dedicated his second, annual solo exhibition (at the ACA Gallery) of paintings of the protagonists in the Spanish Civil War to the defenders of democracy in Spain; the catalogue for the seventh ACA show in 1942, which included *The Opposition*, "was published for the benefit of the Russian War Relief."[8] Ten of the twenty-five paintings on view involved the European theater of war. For these, Gropper deliberately adopted the dark humor of Francisco de Goya and Honoré Daumier who, a century earlier, also courageously depicted war, death, and social injustice in politicized prints and paintings. All of them satirized men who abused power. Gropper was optimistic that his art could provoke social and political change.

William Gropper, 1897–1977
The Opposition, 1942
Lithograph, 12¹⁄₈ x 17 in.
Gift of the Print Club of
Rochester, by exchange, 89.59
Courtesy of ACA Galleries,
New York

ALSO IN THE MAG COLLECTION:
William Gropper, 1897–1977
John Henry, from the *American
Folklore* portfolio, 1953
Color lithograph, 17 x 11 in.
Gift of Emille Allen, Nancy
Buckett, Grant Holcomb,
Robert Hursh, and Earl Kage
in memory of Sylvan Cole,
2005.239.10
Courtesy of ACA Galleries,
New York

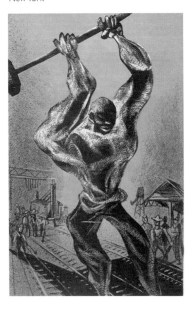

Gropper wrote about *The Opposition*:

> I have portrayed the type of representative that is opposed to progress and culture. The U.S. Senate and the House of Representatives have had such an influence on American life, good and bad, that it has even affected the artist and the cultural development of our country. No matter how far removed from politics artists may be, it seems to strike home. Only recently one blasting speech of a reactionary representative resulted in not only doing away with the Section of Fine Art, but also dismissing the Graphic Division of the OWI [Office of War Information] and nullifying art reportage for the War Department.[9]

Central to Senate debates in 1942, when Gropper painted *The Opposition*, was the demise of the largest-ever federal programs in support of the arts. Instead of concentrating on the pathos of the unemployed artists, Gropper chose to depict the well-fed, conservative legislators who imperiously decided to eliminate relief programs for artists. Although *The Opposition* at first appears to celebrate the importance to democracy of vigorous debate, one soon notices that most of the very few senators present in chambers are either asleep or inattentive. A Christian cross appears innocently as the mullions of a small medieval-style window (very little fresh light penetrates the darkened Senate), symbolizing Gropper's belief that organized religion was more political than beneficent. In 1934, Gropper had caricatured Senator McKellar haranguing with a paper in his lower, left hand and with his right fist raised and Huey Long energetically filibustering with both arms in the air. The unidentified, emaciated, and apparently senile ancient in *The Opposition* is neither of these vigorous polemical politicians.[10] (In 1949, Senator Guy M. Gillette from Iowa asked Gropper to identify the senator depicted in *Opposition*; unfortunately, we do not have Gropper's reply.[11])

Gropper's mastery of color and abstracted composition in such paintings as *The Senate* and *The Opposition* are unexpected. He usually drew in black and white, and although he had painted since 1920 he did not have a solo show of oil paintings until 1936. In *The Opposition*, Gropper juxtaposes the hard-edged segmental arch of burnt orange with the Prussian blue suits of the senators, setting into motion the visual vibrations of simultaneous contrast. He also skillfully establishes a modernist tension between interpenetrating geometric planes, biomorphic figures, and ambiguous space. Gropper's lithograph,

A New Bill (1940), and his painting and lithograph both entitled *The Opposition* (both 1942), demonstrate his habit of developing similar subjects and compositions in a series. In these three works (all in the collections of the Memorial Art Gallery), the sweeping horizontal curve of the Senate Gallery is bisected by a standing orating senator surrounded by his mostly disinterested colleagues. In the painting, Gropper retained relatively normal anatomical proportions of people to each other and to their ambient architecture. In the lithographs, however, he exaggerated the physiognomy and size of the senators—especially of the protagonist—in the manner of the superb political cartoonist that he was. In the graphic version of *The Opposition*, the artist moved away from representation toward caricature by delineating the aging bald and toothless orator with a hawk-like nose, deeply furrowed wrinkles, and an enormous arm that grips a heavy book. In the painting, *The Opposition*, and in *A New Bill* the speaker raises a less threatening

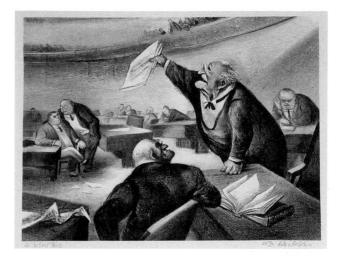

William Gropper,
1897–1977
A New Bill, 1940
Lithograph,
13⅞ x 19³/₁₆ in.
Gift of Betty Dennis Burt, Alfred Crimi and Sister Magdalen LaRow, by exchange, 96.31
Courtesy of ACA Galleries, New York

sheaf of papers in his right hand, which intersects the flat segmental curve of the gallery positioned near the top of the pictorial space. In the print of *The Opposition*, the more pronounced curve of the balcony runs like a speeding train through the Senate chamber. This dynamic arc and the colossal proportions and exaggerations of the speaker loom over and dominate not only his smaller colleagues but the hall itself. By reducing the number of senators and increasing the empty space, Gropper amplified the visual and ideological impact.

Gropper's Senate paintings and prints entered major museums and became familiar American icons. In 1949, because of the oppressive politics of the Cold War and the persecution of liberal artists by Senator McCarthy, Gropper ended his career as a regularly published political cartoonist and concentrated on further developing his paintings and prints, many with Senate iconography.[12]

Gropper's loyalty to the United States was challenged in 1949 by Congressman George Dondero and in 1953 by Joseph McCarthy's Senate Committee. In response, an angry Gropper drew *Capriccios*, a suite of fifty lithographs "inspired by the Caprichos of Goya who exposed the brutal inquisitions of his time."[13] In 1943, he had tried unsuccessfully to go abroad to see first hand the destruction of the war,[14] and in 1948 was a delegate to the international Congress of Intellectuals for Peace in Wroclaw, Poland, which Pablo Picasso and Paul Éluard also attended. Around this time Gropper had solo exhibitions in Paris, Moscow, and Prague, and he had frequent exhibitions at several galleries in New York and California. During the third quarter of the twentieth century, although realist art was in disfavor, Gropper's work sustained interest. His passionate messages ring true in our post-9/11 twenty-first century world:

> There are moments in the course of our daily life when even the hardiest
> spirits are assailed by doubt, dismay, and despair as they watch what looks
> like an insane and precipitous march of mankind to collective suicide.[15]

Informed by his keen intellect, Gropper communicated his anger at this state of affairs by the exaggerated stances and gestures and the fluid contour lines of his caricatures. Gropper is as important to the history of American cultural (especially political) identity, as he is to the history of art.

Roberta K. Tarbell is Associate Professor, History of Art, Rutgers University, Camden, New Jersey.

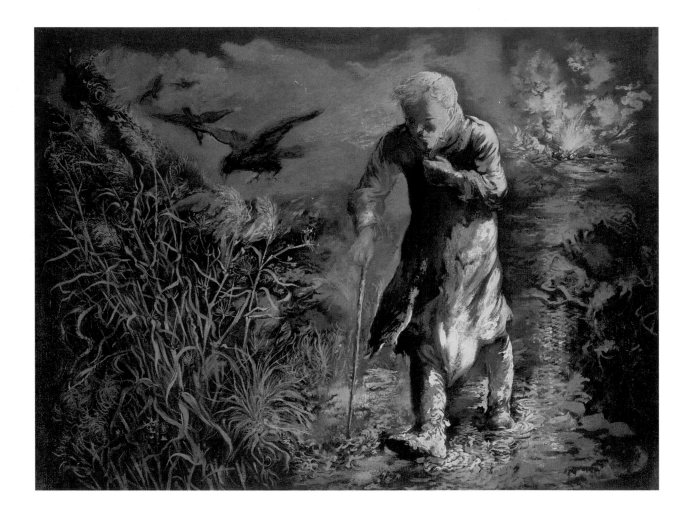

64: George Grosz *The Wanderer* (1943)

Nancy Norwood

I left because of Hitler. He is a painter too, you know, and there didn't seem to be enough room for both of us in Germany.[1]

On the eve of Hitler's rise to power in 1933, George Grosz emigrated to the United States from Germany. A decade later, he painted *The Wanderer*, a work that belongs to a group of paintings that Grosz himself called "apocalyptic, prophetic, or just hell-pictures."[2] They share a characteristic and recurring imagery, both haunting and disturbing: landscapes with rocks, reeds, and earth that appear as living tentacles and mire, flames on the horizon, nightmarish birds, and man's struggle for survival through flight and despair. *The Wanderer's* lone figure, huddled in his overcoat, leans heavily on a walking stick as he trudges through swamp-like mud. The quagmire, smoke-filled sky, and malevolent reeds that reflect the blazing inferno behind him guide his path of escape and illuminate the accompanying horror. Large black ravens hover nearby, seeking carrion in the dense landscape. In total, the nightmarish images that unite the painting create both the backdrop and subject of desolation and impending doom.

The Wanderer was purchased by the Encyclopedia Britannica as part of its collection of contemporary American paintings. Along with the august company of artists such as Thomas Hart Benton, Georgia O'Keeffe, and William Gropper,[3] the advisory board chose Grosz as one representative of the "frame of an idea—to tell the story of American painting since 1900."[4] In the catalogue of the collection published in 1948, Grosz provided an enlightening though incomplete commentary on his painting:

> *"The Wanderer" is real and and yet unreal at the same time. The old man is the everlasting human spirit....here once more he goes through a dark world—through an apocalyptic landscape—tireless and in deep, maybe grim, thought he wanders on until the dark day changes into a light and sunny day...the bird and the thicket of reeds and brambles symbolizing his thought. So he, the old man, is just a lonely reed, too.*[5]

George Grosz,
1893–1959
Illustration to Brothers Grimm's
"Hansel and Gretel," ca. 1934
Pen and ink drawing,
19 x 24 1/6 in.
Art ©Estate of George Grosz/
Licensed by VAGA,
New York, New York

(Facing page)
George Grosz,
1893–1959
The Wanderer, 1943
Oil on canvas, 30 x 40 in.
Marion Stratton Gould Fund,
51.6
Art ©Estate of George
Grosz/Licensed by VAGA,
New York, New York

In letters, conversations, and interviews, Grosz explained *The Wanderer* and his hell pictures in terms less optimistic but more personal, in ways equally compelling and disturbing. In an undated letter to a Mr. Schück, Grosz writes:

I work a lot—it is as if I have lost too much time with worthless things. I have so little contact with my former self....I painted a little picture—The Wanderer—myself of course....The resonance of explosion and destruction often shakes me bodily. Maybe all this will one day form itself into greater things. I do not want to survive only as a Callot.[6]

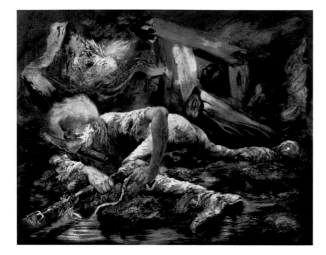

George Grosz,
1893–1959
The Survivor, 1944
Oil on canvas, 31 x 39 in.
Collection of
The Robert Gore Rifkind
Art Collection, Beverly Hills,
California
Art ©Estate of George Grosz/
Licensed by VAGA, New York,
New York.

Many of the apocalyptic pictures, though primarily painted in the 1940s, were anticipated by drawings from the 1930s, in particular some that Grosz created in 1936 for his first American volume, *Interregnum*. Intended as a commentary on German life from 1928 to 1932, several of the works, though not intended as studies or preparatory drawings for the later paintings, are directly related to the hell pictures through both composition and imagery.[7] Some of his visual vocabulary emerged even earlier, particularly the peculiar and tortured reeds and dense quagmire of his landscapes. His earlier illustration for the Brothers Grimm fairytale *Hansel and Gretel* (ca. 1934), as one of many examples, almost eerily predicts the composition of *The Wanderer* and its related 1936 *Interregnum* drawing *Even Mud Has an End*.[8]

The almost obsessive visual motifs in the hell pictures as well as the earlier drawings—the muddy swamps, the tortured and withered landscapes, infernos, and ravens—emerge from the not-quite buried memories of Grosz's German military experience and his despair over the rising power of Hitler and Nazi Fascism. The larger-than-life birds of *Hansel and Gretel* and *The Wanderer*, perhaps, emerged during his institutionalization in a military mental hospital in 1915, when he described the darkness that surrounded him, the approach of death, and his fellow sufferers: "Above the beds hang black birds; the nameplates of the sick animals."[9] Grosz claimed a premonition of World War I, for example, when he noticed that, marching toward Belgium, the flowers soldiers placed in their rifles withered and died. He knew Fascism was coming because "ordinary walking sticks had become quite heavy."[10] Regarding the heavy quagmire seen in many of his apocalyptic pictures, a root can be found in his experience of the German army: "They crush you. They humiliate you. They break you....Then the mud...I don't know why soldiers are always in the mud."[11] His visceral response to the image of mud erupts during a conversation with the writer John dos Passos in 1948 about the struggling figure in *The Survivor*: "It's the last survivor," he says "The mud itself becomes alive to kill."[12]

George Grosz was a complex, tormented and contradictory man. In 1943, the year of *The Wanderer*, Richard O. Boyer wrote a series of three *New Yorker* profiles that explored the painter's daily life, his American dreams, and his darkest fears. Respectively titled "Demons in the Suburbs," "The Saddest Man in all the World," and "The Yankee from Berlin," the profiles present the portrait of a man torn between two very conflicting worlds—America and Germany, his present and his past.[13] Grosz had always idealized America and idolized Americans—in a 1927 symposium in Berlin, for example, he responded to the question "Where is paradise?" with the answer "In the Rocky Mountains."[14] He thought of America as a place of the pioneer and the innocent, far distant from his own personality: "The Americans have something bold in them, something of big, innocent boys. It must be nice to be with them. They have a better attitude toward life."[15]

Grosz's only real difficulty with America was the critics, many of whom found his "American" paintings uncompelling, preferring instead the German Dada works and the scathing satirical drawings that had made him famous. Others, though—even if they preferred the earlier satire or the later nudes and still lifes—acknowledged his American efforts and the roots from which the hell pictures emerged, especially on the occasion of the exhibition where *The Wanderer* was first exhibited.[16] The reviewer of the *New York Sun* wrote:

Although he laid the foundations of his international reputation by his bitter satires of war...[and his] scathing attacks on the beginnings of Nazism, George Grosz is an artist who more and more concerns himself with purely a painter's problems. But the old horror will not down, and his present exhibition...shows him still dwelling in part on the nightmare of war in canvases that are at once symbolical and realistic. Among these are "The Mighty One Meets Two Poets," "I Woke up One Night and Saw a House," "The Wanderer" and others that must be seen to get their bitter message. But it is that other side of Grosz's art that one prefers to dwell on now. We find enough of the rest around us daily, over the air and in the press. So Grosz the painter, as revealed in his various nudes, his landscapes and still life subjects, presents the more inviting theme.[17]

George Grosz,
1893–1959
Even Mud Has an End,
plate 4 from the *Interregnum*
portfolio, 1936
Photolithograph, 8⅜ x 10³/₁₆ in.
Art ©Estate of George Grosz/
Licensed by VAGA,
New York, New York

Grosz well realized the extent of his obsession with the hell pictures and understood its derivation. On the one hand, he treasured it: "The darkness that surrounds me is not just fear and terror....It is very sustaining."[18] On the other hand, he was tormented by it: "Like Goya, I am torn in two....It is like living in a haunted house. You can't escape it and you can't forget."[19] His own evaluation of his hell pictures of the 1940s, however, is unambiguous:

> *Maybe it was in reality only a thunderstorm, one of these odd American thunderstorms, that suddenly appears and becomes a monstrous hailstorm. Then it disappears again, and is monstrous. But for me it became a symbol....The war was in the air. A man who lived through the first world war feels that....That's why I use the example of a walk on the beach [before the war], just to clarify the root from which the memories and thoughts that are a part of my last paintings originated.*[20]

In 1945, *The Wanderer* was used as the illustration for "A Poet's Anti-Fascist Melodrama," the *New York Times* review of Frederic Prokosch's *Age of Thunder.*[21] The painting was curiously but perhaps appropriately captioned "'The Wanderer' in an Age of Thunder." In one of the crucial and most poignant moments in the book, Ulysse whispers to his fellow-traveler Amedée, "It's a troubled kind of night....Motionless. Unreal. Like a dream." "All of life nowadays," responds Amedée, "has that torpor, that unreality. Life has become a dream." Ulysse replies: "It is the war, Amedée, which is the dream. Some day we shall wake up. The dream will crumble, and even the memory of the dream will crumble....Happiness will return."[22]

The Wanderer is to all accounts a desolate and disturbing image of flight, exile, and the struggle for survival. As manifest in his hell pictures, Grosz was filled with the despair of Prokosch's Amedée: "This war will last the rest of our lives. Even when the killing has stopped...the war will live on; no one can rebuild the ruined nerves."[23] Perhaps, though, like Ulysse, Grosz's protagonist—the old man, the everlasting spirit—retains a modicum of hope for the crumble of the dream and the end of the recurring nightmare.

Nancy Norwood is Curator of European Art, Memorial Art Gallery.

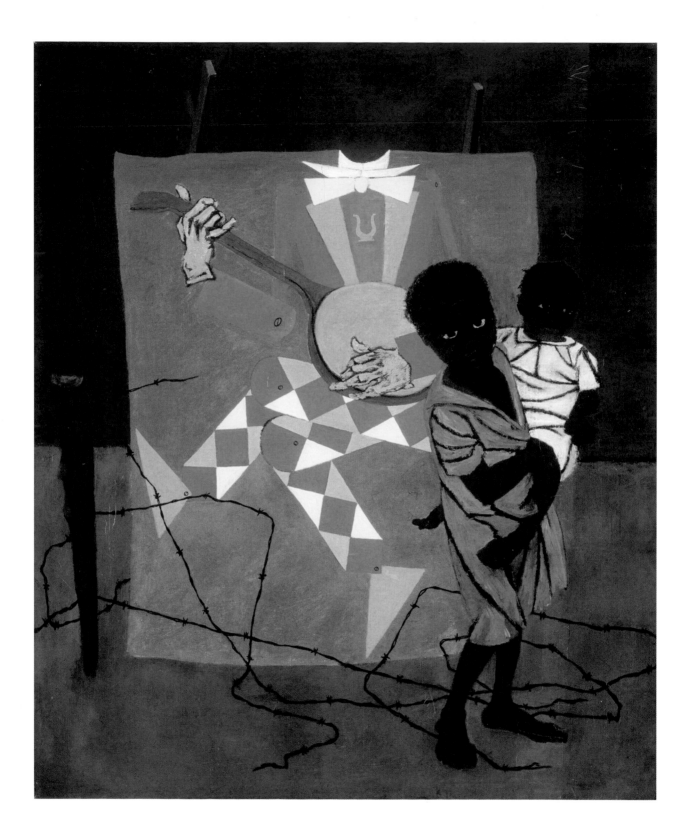

65: Robert Gwathmey *Non-Fiction* (1943)

Michael Kammen

Born in Richmond, Virginia, Robert Gwathmey never lost his Tidewater drawl and colloquialisms. Married for fifty-three years to a North Carolinian he met in Philadelphia, where they both studied at the Pennsylvania Academy of the Fine Arts, Gwathmey came of age in the South when segregation and the economic oppression of African Americans remained a harsh reality. Gwathmey learned about the debilitating life of sharecroppers first-hand in 1944 when he lived on a farm in Rocky Mount, North Carolina, and worked alongside tenant farmers in the sun-blazed fields where he became familiar with the daily hardships of their lives. His deep and abiding concern for social justice, however, dated back more than a decade to his days as an art teacher and political activist in Philadelphia and Pittsburgh.[1]

By the end of the 1930s Gwathmey had destroyed most of what he painted during the previous decade because it seemed so derivative from the work of his teachers. He then began to develop his own distinctive style: deliberately two-dimensional and flat, using vivid (often clashing) colors, ignoring chiaroscuro on the grounds that the flatness of his "native region" tended to obscure such shadows and perspectives, and preferring light and dark contrasting color planes for his backgrounds. The artists he most admired served him well, and they are all reflected in *Non-Fiction*. The influence of sharp social satire from Honoré Daumier is plain to see. The bold (and controversial) inclination of Jean-François Millet to highlight peasant life in nineteenth-century France made it more acceptable for Gwathmey to focus his attention on humble sharecroppers and their families. Picasso's bold colors and love of harlequin costumes with their diamond-shaped patterns had particular appeal for the emerging American artist.

At least six years prior to the profound experience of working on that Tar Heel farm, Gwathmey decided to depict African American life as he had observed it in both town and country, and he did so with figural realism rather than romanticization. He knew full well that long days and years in the fields caused debilitating arthritis and rheumatism, and he knew that when both parents worked extended hours in the fields, children were obliged to help look after younger siblings. Although some of the images he painted during the 1940s were caustic satires combined with caricature, like *Non-Fiction*, more often than not he simply painted "colored people" (as they were called then) at home, mending clothes while singing songs, gathering for church on Sundays or mingling "in town" on a sociable Saturday afternoon.

In terms of productivity, finding his own metier, and achieving national recognition, 1943 was quite clearly Gwathmey's breakthrough year. He had recently found a sympathetic dealer in New York, Herman Baron of the ACA Gallery (American Contemporary Artists), who was happy to feature his work and provide some financial support. Two of the works Gwathmey painted that year won prizes. His *Rural Home Front*, a color silkscreen (a technique in which he was a pioneer), received first prize in the Artists for Victory exhibition that was part of the National Graphic Arts Competition sponsored by a wartime association of leading arts organizations. His large and panoramic *Hoeing* won the $700 second prize at an exhibition, Painting in the United States, sponsored by the Carnegie Institute of Technology in Pittsburgh, which swiftly purchased the painting for its permanent collection. It featured a larger-than-life black man leaning on his hoe and wiping the sweat from his forehead. To his right there are poor white workers taking a break while black laborers to his left continue to toil at various rural tasks.

Robert Gwathmey,
1903–1988
Non-Fiction, 1943
Oil on canvas, 29 x 24 in.
Marion Stratton Gould Fund,
51.7
Art ©Estate of Robert
Gwathmey/
Licensed by VAGA,
New York, New York

In the lower right hand corner of *Hoeing* a young black girl holds a child on her hip. Those same two figures become prominent rather than incidental in *Non-Fiction*. The barbed wire, Gwathmey's customary symbol of segregation and entrapment in the vicious cycle of sharecropping, surrounds the grown man in *Hoeing* but entangles both the girl and the painting-within-a-painting in *Non-Fiction*. The stark contrast between the ghostly minstrel and the two stoic children make the image compelling. The headless figure at which we gaze is unreal, whereas the girl staring so intently at us is all too real. His race is unclear because he wears gloves the color of patinated copper, whereas her race is entirely evident. We know that only a few years earlier the Gwathmeys had accidentally come upon an all-black minstrel show in rural North Carolina, and we know from a lithograph by Thomas Hart Benton that whites were still attending rural minstrel shows as recently as the mid-1930s. Racial caricaturing was very much alive in the 1930s and 1940s. The most popular radio program of the era was "Amos 'n' Andy," in which two white writer-performers fascinated the nation with comic narratives mocking the lives of blacks who had recently migrated from rural fields to urban factories.

Robert Gwathmey,
1903–1988
Non-Fiction (detail), 1943
Oil on canvas, 29 x 24 in.
Marion Stratton Gould Fund,
51.7
Art ©Estate of Robert
Gwathmey/
Licensed by VAGA,
New York, New York

Gwathmey's composition of *Non-Fiction* is exceedingly careful—he always remained a meticulously deliberate designer. One might ordinarily assume that it was painted as a preliminary study that eventually became one small part of the more ambitious *Hoeing*. But Gwathmey did not work that way. Most of the time if he liked one or two figures in a large and complex painting he had completed, he would then isolate them and make a separate smaller version, or in the case of *Non-Fiction* they could become the basis for a variant image. He may very well have worked on both pictures simultaneously; but the most likely pattern for this artist would have been *Hoeing* first, followed directly by *Non-Fiction* because he felt pleased with the image and had a "follow-up" idea that he wished to execute.

The baby rests on the girl's left hip while the banjo rests on the minstrel's left hip. The minstrel actually holds an unreal banjo that has no strings. Their absence only serves to highlight the sinuous snare created by the cruel barbed wire entangling the girl, by calling up ideas of black music and mocking humor so prominent in American popular culture ever since the 1840s, when minstrel shows and "blacking up" became a national craze. Above all, the intensity of the girl's gaze contrasts with the disturbing absence of the minstrel's gaze. We are seeing through him though not beyond him, while she is staring so intently at us. "His" unreality makes her presence all the more poignant and stressful.

Why the upturned horseshoe below the minstrel's big bow-tie? As it happens, Robert Gwathmey loved to play horseshoes. (So his grim narrative of the South's black past thereby embodies a highly personal aside, as so many provocative paintings covertly do.) Ultimately, for purposes of this iconic image, we see an unsubtle symbol of good luck ironically placed. Neither the children nor the minstrel are fictional. The cut-out minstrel confronts us absent a face but with merely a sur(face) instead—thereby exposing the superficiality of its entertainment genre. The American minstrel show was a historical reality. Gwathmey's allusive "fiction" can be found in what the storied minstrel show had done by distorting African American realities into ludicrous travesties.

Michael Kammen is the Newton C. Farr Professor of American History and Culture, Cornell University.

66: Norman Rockwell *Soldier on Leave* (1944)

Karal Ann Marling

On August 12, 1944, when this painting by Norman Rockwell appeared on the cover of the *Saturday Evening Post*, there was reason to hope that the end of World War II might be in sight. During August, U.S. fliers had conducted a daring bombing raid on the Japanese city of Nagasaki. On the European front, Patton's army was driving toward Paris; before the end of the month, the City of Light would be liberated by Allied troops. Perhaps more telling for the average American, Washington had finally allowed manufacturers to resume production of household appliances— a sure sign that combat operations were on the wane.

It was in this moment of optimism—before the bloody Battle of the Bulge, before the epochal flight of the Enola Gay—that Rockwell painted another of his intimate, domesticated explorations of life on the homefront, a work variously known as *Soldier on Leave, Lovers on a Train,* or *Voyeur.* In a railroad car crowded with servicemen and their best girls, a young flier has lowered the balky window shade as far as it will go and used his coat as a curtain to create a cozy space where he can cuddle with his sweetheart in whatever privacy the situation affords. Sailors framing the picture at the top and the bottom have the same idea. Somewhere in a war-torn world there must still be room for courtship, for tenderness, for whispered goodbyes.[1]

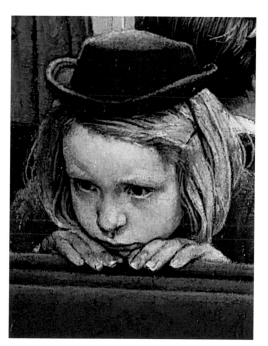

Although he was the nation's best-loved artist of World War II, Rockwell did not earn his stripes with scenes of conflict and mayhem. Instead, he took for his theme the folks back home: the armchair generals, the planters of Victory Gardens, the tattooist at work on a much-traveled sailor, the G. I. home on leave.[2] His most famous wartime cover for the *Post* was probably *Rosie the Riveter* (May 29, 1943), a Michelangelesque redhead posed in her dungarees before the Stars and Stripes to represent all the women who had gone to work in the factories that made the planes flown into battle by the young airman on the train.[3]

The sense of intimacy, of our close proximity to the couple, is reinforced by the almost preternatural degree of detail with which the scene has been observed. Every lock of hair, every grommet, every stitch appears in closeup, as if there were no air in that parlor car, no impediment of distance to block a perfect godlike apprehension of plush upholstery, polished leather, canvas, dull metal. The result is a kind of magic realism that is both personal and a little unsettling, like the intense gaze of the child peering over the back of her seat, or the single omniscient eyeball staring fixedly from the upper right corner of the image. Homegrown surrealism, Rockwell style: the burning glances add a poignant urgency to the longing of the soon-to-be-separated lovers.

The radical angle of vision, plunging down suddenly upon the denizens of the train, suggests a fleeting moment in time. It also suggests the use of the camera. In the 1940s, it was Rockwell's practice to dress his scenes with the care of a movie director and to have them photographed by his long-time assistant, Gene Pelham (Pelham's is the hand of the conductor, at the right edge of the picture). Then, using a Balopticon projector, he transferred the major lines of the photo to canvas. This procedure, which Rockwell discussed openly, had been surreptitiously used by illustrators since the artist was a novice.[4]

Norman Rockwell,

1894–1978

Soldier on Leave (detail), 1944

Oil on canvas, 22 x 20 in.

Gift of Dr. and Mrs. Robert

M. Boynton, 74.98

Printed by permission of the

Norman Rockwell Family

Agency/Copyright ©1944

the Norman Rockwell

Family Entities

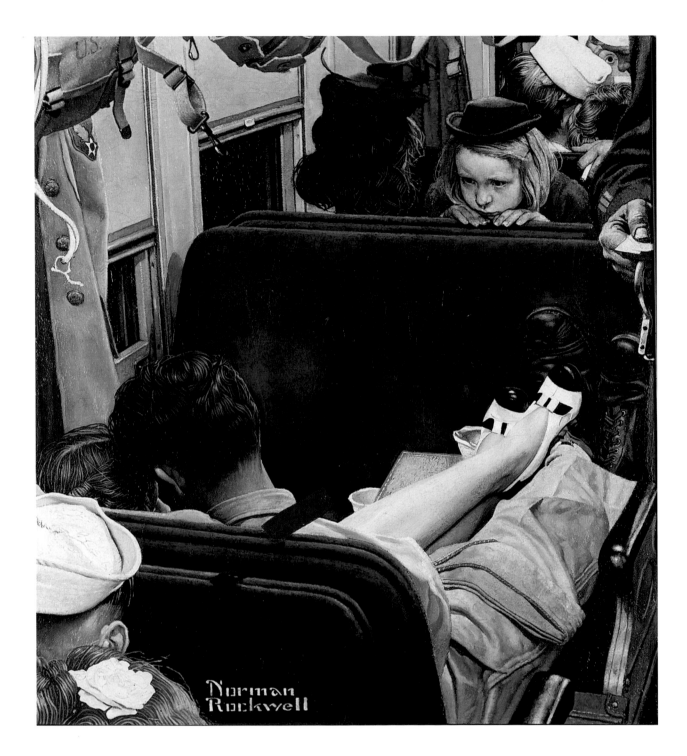

Seeing America: Painting and Sculpture from the Collection of the Memorial Art Gallery

As professional models disappeared with the coming of modernism, photography let the illustrator use rank amateurs, who were required to hold a pose only for as long as it took to adjust the f-stop. In this instance, Clara Edgerton, the mother of the farm family who lived next door to the Rockwells in Arlington, Vermont, played the minor role of the blonde head in the foreground. Other Arlington neighbors also obliged. Odd-job boy Roy Crofut, a handsome kid whose relatives were members of Rockwell's stable of amateur models, was the airman. Gladys Cross and her daughter Yvonne were the mother and the spooky little girl seated in front of the lovers.[5]

Just as Rockwell's covers strongly appealed to the general public because of their real-life situations and down-to-earth narratives, Rockwell's neighbors were delighted to be enlisted in the unfamiliar cause of art-making—especially when his pictures reexamined the war on a familiar, grassroots level. For a later, postwar cover showing raucous skiers on their way to Vermont's wintertime resorts by train, Rockwell managed to have a real set of coach seats sent from Albany. For *Soldier on Leave,* he got a whole car, left by the Rutland Railroad on a siding outside Arlington for two days at his behest. Once detached from the train, of course, the car was without light. And heat. Over two exceedingly cold winter days, nonetheless, various Crofuts and Crosses and Edgertons came and went in the name of art for folks like themselves.[6]

Norman Rockwell,
1894–1978
Soldier on Leave (detail), 1944
Oil on canvas, 22 x 20 in.
Gift of Dr. and Mrs. Robert
M. Boynton, 74.98
Printed by permission of the
Norman Rockwell Family
Agency/Copyright ©1944
the Norman Rockwell
Family Entities

The most dramatic of Norman Rockwell's wartime works came in the Four Freedoms series of 1943, or what the artist called his "BIG pictures." Originally intended as paintings without commercial sponsorship, the four images wound up on inside pages of the *Post* when Washington bureaucrats failed to recognize their value as posters. It was only after the public had adopted the pictures as their own that the government saw the wisdom of using Norman Rockwell's *Freedom from Want, Freedom from Fear, Freedom of Speech,* and *Freedom of Worship* to sell war bonds. As posters, the pictures were eventually reproduced by the millions and remain today among the most revered of all American works of art—precisely because they capture universal moments in the lives of average Americans. In the persons of Rockwell's fellow citizens, they share a Thanksgiving meal, put their children to bed, speak up at a town meeting, and pray as each one chooses. They belong, on a grander scale, to the world of the anonymous, ordinary couple on the train, seeking one last moment of comfort and closeness in the uncertainty of global chaos.[7]

(Facing page)
Norman Rockwell,
1894–1978
Soldier on Leave, 1944
Oil on canvas, 22 x 20 in.
Gift of Dr. and Mrs. Robert
M. Boynton, 74.98
Printed by permission of the
Norman Rockwell Family
Agency/Copyright ©1944
the Norman Rockwell
Family Entities

The anonymity of the lovers in *Soldier on Leave,* their faces averted from the viewer, enhances the universality of the sentiment. Rockwell's popular Willie Gillis series of eleven *Post* covers, featured between 1941 and 1946, followed the adventures of a slight, open-faced recruit from boot camp to the week he finally enters college on the celebrated G. I. Bill. Although Willie's face is distinctive, the charm of his adventures came in the ability of the reader to see a son, a brother, a father, a boyfriend in his un-extraordinary progress through the war. Willie gets parcels from home. He peels potatoes on K. P. duty. He basks in the attentions of pretty girls at the U.S.O. Willie, in short, is anybody, or everybody—the American Everyman in the service. He could, indeed, be that young airman on the train.[8] By his attention to the sights and the feelings we share, Norman Rockwell helps us to see and to feel more acutely, to empathize more fully, to share in the life of an America at war in the summer of 1944.

Karal Ann Marling is Professor of Art History and American Studies, University of Minnesota.

67: Guy Pène du Bois *Jane* (ca. 1946)

Betsy Fahlman

During a career that spanned the first half of the twentieth century, Guy Pène du Bois established himself as one of America's leading realists. His first works date from 1904, when he was still an art student, and his last were executed fifty years later. As the son of an art critic, a profession Guy would also pursue, he enjoyed an aesthetic advantage reinforced by family heritage and European travel. His paintings blended American urban realism with a distinctly French flavor.[1]

Enrolling at the New York School of Art in 1899, Pène du Bois first took classes from William Merritt Chase. Chase impressed his students with his combination of an art-for-art's-sake philosophy combined with the agile realism of his style. But it was the legendary and charismatic painter, Robert Henri, who began teaching there in 1902, who most strongly affected the young artist. Among his fellow students were several who would have notable careers, including Edward Hopper, Patrick Henry Bruce, Rockwell Kent, Walter Pach, and George Bellows. Together, they learned to be men first, and artists second, and to take their inspiration from the life they knew around them. Years before Henri became famous as the leader of the anti-academy group known as The Eight,[2] he was urging Pène du Bois and his contemporaries to execute gritty urban themes in a darkly toned, painterly style. Although Pène du Bois's style changed with each succeeding decade, Henri's lessons remained the foundation of his art for the rest of his career.

In 1905, after three years of study with Henri, Pène du Bois departed for Europe, spending most of his time in Paris, where he took classes at the Colarossi Atelier. Intense exposure to French art exerted a deep influence on him, and he honed his skills as a sharp observer of social exchanges, a characteristic theme he would continue to explore—he was especially intrigued by the interactions between men and women. Returning to New York in 1906, while he continued to paint, he took up writing criticism as a means to support himself. He began to actively exhibit his work, and astute collectors, including Chester Dale, Albert Barnes, and Gertrude Vanderbilt Whitney, purchased his paintings. In 1920, he began teaching at the Art Students League, where his students included some of the next generation of urban artists, such as Isabel Bishop and Raphael Soyer.

His move to France in 1924 for a six-year sojourn marked the beginning of the mature phase of Pène du Bois's work. Liberated from the wearying cycle of teaching and criticism, and supported by steady sales from the Kraushaar Gallery, which had given him a solo show in 1922, he could now devote himself full-time to painting. His style became broader and more stylized, his palette lighter, his paintings larger, and his vision more distinctly individual. Pène du Bois's paintings from this period are stylish and sophisticated, depicting the social theater he saw around him with a sharp wit.

The stock market crash ended Pène du Bois's time in France, forcing his return to America in 1930 and, out of economic necessity, to take up writing and teaching once again. In his painting he continued to pursue many of the themes that had interested him throughout the teens and twenties. Now, however, his figures have gained in solidity and breadth, his humor has become more subtle, and many of his compositions have taken on an impressive new monumentality. Like many artists during the Depression, Pène du Bois sought government support through Post Office mural competitions: he did three. Whether as cause or effect of this work—but again like many artists at that time—he discovered a renewed interest in the human figure, and emerged as a strong portrait painter.

Guy Pène du Bois,
1884–1958
Jane, ca. 1946
Oil on canvas, 30 x 24 in.
Gift of Thomas and Marion
Hawks by exchange, 98.36
Courtesy James Graham &
Sons, and the Estate of Yvonne
Pène du Bois McKenny

He published his autobiography in 1940, but otherwise, the forties proved to be difficult years for the artist. Heart attacks in 1940 and 1941 limited the time he was able to be active in his studio; in 1947 he broke with Kraushaar Gallery, after twenty-five years. Sales generally were slow, and the art market was further strained by World War II. As the larger art world changed, many representational artists like Pène du Bois found themselves increasingly out of touch with contemporary developments, and the rise of abstract expressionism would soon eclipse his generation of Henri-trained realists.

Jane is a typical work of Guy Pène du Bois's later years. A woman whose blond hair has been carefully arranged and who wears an elegant long sleeveless evening dress with a plunging neckline, accented by a glittering necklace and bracelet, enters an undefined space alone. Her body is partially obscured by the dark shadow that stretches diagonally across the lower right third of the canvas. The artist has used the striking contrast of light and dark to create a suspenseful mood, and his figure pauses momentarily before proceeding further. The eerie blue tonality is typical of Pène du Bois's palette during this period, as is the somewhat ominous atmosphere. Whether she is meeting someone else or is exiting from a previous encounter is not clear, but her solitude adds an element of anxiety and tension worthy of a suspenseful movie scene. The artist often presented his subjects in pairs, but in this case the other participant is only implied. Nor is the precise nature of the space through which she passes clear. It might be the courtyard of a city apartment or townhouse, or it could be the entry of a nightclub or elegant restaurant for which her attire would be appropriate. Pène du Bois often employed such ambiguity in his depictions of character types (which he favored over individuals), who perform highly structured roles within the social theatre of their economic class.

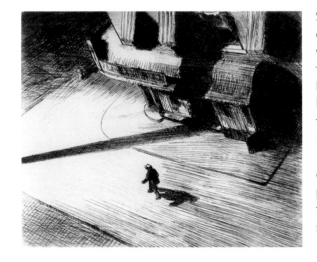

ALSO IN THE MAG COLLECTION:
Edward Hopper
1882–1967
Night Shadows, 1921
Etching, 10⅝ x 13³/₁₆ in.
Gift of Sister Magdalen LaRow in honor of Robert Gianniny,
89.52

Stylistically, *Jane* evokes the spirit of Guy Pène du Bois's lifelong friend, Edward Hopper, whom he had first met in Henri's class. The two had early on shared an enthusiasm for Paris, which Hopper had visited twice by 1910. Further, both had depicted elegant themes in the 1920s, as seen in Hopper's *Two on the Aisle* (1927, Toledo Museum of Art). But by the 1940s, Hopper's interest in depicting sophisticated and urbane themes had waned. His paintings from that period have become emotionally arid, whereas Pène du Bois's figures still retain some of the visual snappiness of his 1920s flappers.

By 1950 the active career of Guy Pène du Bois was at an end. He experienced increasing health problems, and his wife Floy, to whom he had been married for nearly forty years, died. With his daughter Yvonne, also a painter, he spent the years between 1953 and 1956 in Paris, where he painted his last dated significant canvas, *The Café Flore* (1954, private collection), four years before his death in 1958.

Betsy Fahlman is Professor of Art History at Arizona State University.

Lowery Stokes Sims

Certainly one of the foremost American artists of the twentieth century, Jacob Lawrence not only was the principal chronicler of the transitions in the African American community, but also a stylistic innovator whose contributions are still to be fully recognized. *Summer Street Scene* is an exuberant, abstracted depiction of a highly animated street in Harlem during the late 1940s.[1] In the foreground a group of seven boys attempt all at once to ride a scooter undoubtedly fabricated from a wooden box and some cast-off wheels. In midground at the right a man leans into a block of ice to scrape off refreshing scoops that will be flavored from the bottles of syrup on the cart. Three small very expectant children can be seen behind the cart, their faces partly obscured by the syrup bottles. One lucky child is already enjoying this cool treat behind the man in a green shirt and striped pants, who leans on a crutch. In the most distant plane of the composition promenading adults—who occasionally stop to greet one another against intimations of urban architecture—form a background to these vignettes.

The subject is an extension of Lawrence's body of work in the late 1930s and 1940s chronicling the Great Migration of African Americans from the South to the North between 1913 and the outbreak of World War II. This protracted social upheaval may be considered the pivotal event in the history of African Americans in modernism. As art historian Sharon Patton has written, there was "a sense of optimism, a revolt against traditional values and an exploration of new ideals." With that change of locale, not only were African Americans able to ameliorate their economic, political, and social condition, but they could also create new lifestyles from their clothes, their speech, their living spaces, and the way they worshiped. These "new Negroes" expressed a "renewed racial pride, expressed in economic independence, cultural and political militancy"[2]

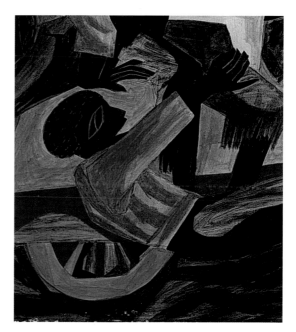

Lawrence himself was part of this migration, relocating to Harlem with his mother from Atlantic City in 1930 around the age of thirteen. As *Summer Street Scene* clearly indicates, he was particularly sensitive to the condition of the African American working class as an important societal force and subject matter. This is evident in his work from the beginning of his mature career in the mid 1930s. In addition to the epic stories of black freedom fighters such as Toussaint L'Ouverture (1938), Frederick Douglass (1939), Harriet Tubman (1940), and John Brown (1941), Lawrence also dealt with the more immediate and local political and economic backdrop for black American life in Harlem in works such as *Street Orator's Audience* (1936, Tacoma Art Museum). His Harlem Paintings of 1942 deal with the dire conditions of tenement living, high rents, fire hazards, latch key kids, as well as the will to work, go to school, and find solace in religion. In the post-World War II era the determination of African Americans to avail themselves of educational and economic opportunities is seen in compositions such as *Shoemaker* (1945), *The Seamstress, Watchmaker, Cabinet Maker, Steelworkers, Radio Repairs,* and *Stenographers,* all of 1946.[3] Lawrence would continue to chronicle both symbolically and anecdotally the state of African Americans in the building trades, which he captured in an ongoing series of paintings entitled *Builders* (1946–98).

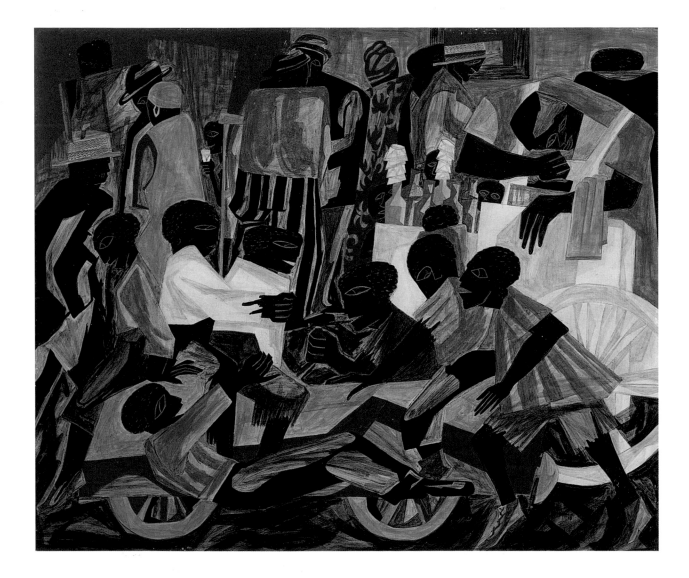

In *Summer Street Scene in Harlem* Lawrence captures the recreational aspects of life in Harlem; such images are important vehicles for humanizing, even normalizing the perception of black life. Usually the raucous, dissolute life of back-room juke-barrel houses and urban after-hours blues and jazz joints is a favorite and familiar image of black life (as, for instance, in Lawrence's *Gamblers*, ca. 1954, also in the Memorial Art Gallery's collection). Lawrence, like his slightly older contemporary Romare Bearden, reminds us of the more intimate, private joys and heartbreak of black life. *Summer Street Scene* demonstrates the easy fluidity that Lawrence had reached with regard to organizing color, form, and pattern in his work during the second half of the 1940s. This facility evolved from his practice as a young student of making pictures inside cardboard shipping boxes,[4] which would explain the sense we have in his paintings of each scene occurring within the imaginary box that characterizes perspectival studies in Western painting particularly since the Renaissance. He would hold steadfast to his first media—gouache and tempera—ascribing his continued use of these to the physical qualities of gouache that he thought complemented the "hard, bright, brittle" aspects of Harlem during the Depression.[5]

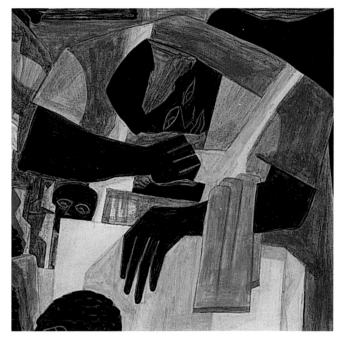

Lawrence eschews atmospheric effects—for instance, the perception that colors pale in the distance (or the back of the box)—for flat color shapes. Space is conveyed through a network of overlapping flat shapes and forms that exist like cut-outs or props in a real-life tableau. Their strong rectangular and ovoid shapes express solidity. Suggestions of volume or modeling (such as the folds of clothing) are conveyed in discrete, simplified colors and shapes: the darker green shades of the shirts of the boy at the left and of the man on crutches; the grey shades in the white shirts and in the cart and wheel of the ice seller; and the variegated browns and blacks of the clothing on other figures. Lawrence began to manifest these signature stylistic elements in his late teens.

Because Lawrence's artistic career was incubated in Harlem outside of the nexus of vanguard circles in lower Manhattan, it is not easy to pinpoint the source of his style. Certainly it can be catalogued along with several anti-academic technical strategies employed by modernist artists. These include the geometric symbolism of tribal arts and the unselfconscious fluidity and aberrant approach to space and proportion seen in the art of self-taught/folk/outsider artists. In fact the skill Lawrence developed in exploiting rhythmic repetition in form and color derived directly from his awareness of "similar patterns in the [Harlem] cityscape around him."[6] He has noted the "endlessly fascinating patterns" of "cast-iron fire escapes and their shadows created across the brick walls,"

the "variegated colors and shapes of pieces of laundry on lines stretched across the back yards [and] the patterns of letters on the huge billboards and the electric signs,"[7] "fraternal and social organizations marching in the streets of Harlem in resplendent uniforms of all colors and lavishly trimmed with gold,"[8] and home decorations of "brightly colored 'Oriental' rugs covering the floors," so that, Lawrence observed, "you'd think in terms of Matisse."[9] All of these elements are present in *Summer Street Scene*, as golden yellows, reds, greens, and purples are set off against browns, blacks, and whites. These in turn are balanced within the composition, each color serving as a punctuation point leading the eye through this sensuous, cacophonous composition: the green shirt of the boy laying off the scooter at the bottom of the composition leads to his cohort at the left and then to the man on crutches off center at the back of the composition, thence to the ice man at the right.

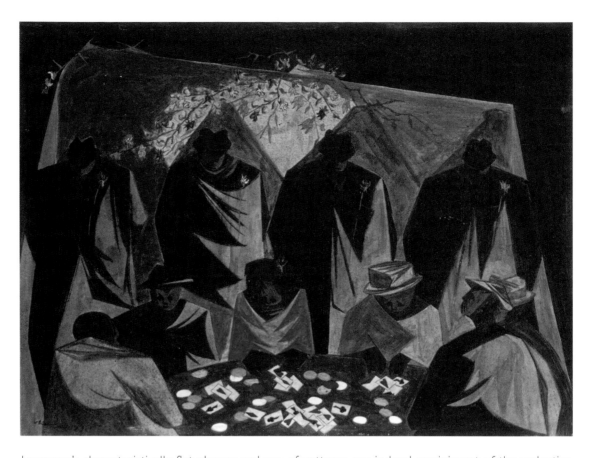

Jacob Lawrence,
1917–2000
Gamblers, ca. 1954
Tempera on gesso panel,
9 x 12 in.
Marion Stratton Gould Fund,
74.1
©2006 The Jacob and
Gwendolyn Lawrence
Foundation, Seattle/Artists
Rights Society (ARS), New York

Lawrence's characteristically flat shapes and use of patterns are indeed reminiscent of the reductive figuration of Henri Matisse or late cubist compositions by Picasso.[10] Like many of his contemporaries Lawrence was also schooled in African art following the prescription of Alain Locke, who in his influential essay, "The Legacy of the Ancestral Arts," published in the 1925 anthology *The New Negro*, urged black visual artists to look to African art for inspiration and guidance in their search for an art connected to their African heritage. He singled out qualities such as "a classic background," "discipline," "style," and "technical control" as qualities to be emulated, noting that artists could profit from the "almost limitless wealth of decorative and purely symbolic material" in African art. "The African spirit...is at its best in *abstract* decorative forms,"[11] he concluded. Jeffrey Stewart has written that Lawrence's work demonstrated a "use of African design principles and ornamentation to create surface tensions,"[12] and as seen in *Summer Street Scene in Harlem* he used not only the convention of African art, but also the adaptations of those conventions in Western modernism to capture the dramatic elements of any activity of any one of his figures.

Lowery Stokes Sims is president of the Studio Museum, Harlem.

69: John Koch *Interlude* (1963)

Susan Dodge-Peters Daiss

*D*etail by detail, we are drawn into John Koch's painted world, lured into the carefully cultivated life of art and music that he and his wife, musician and teacher Dora Zaslavsky, led in New York City from the 1930s to 1970s. Their apartment on Central Park West, on the tenth floor of the El Dorado, served both as their home, their studios—they owned two adjoining apartments—and as the setting for legendary parties that brought together distinguished artists, musicians, critics, and patrons.[1] Like Rubens and Mozart, who through their art had access to the most powerful people of their time, the Kochs entered the New York City world of affluence and influence thanks to their individual artistic gifts.[2] At a time in the City's history when it was fast becoming the center of the international avant-garde, the Kochs were committed to the practice of art forms with the most historical of pedigrees—Dora, classical music; John, portraiture, still life, and interiors. Those who knew them speak of their shared dedication to their work and to each other, of lives dedicated to the mastery of their art that was both their identity and a means to another end: access to people and resources so they could fashion a way of life that was, itself, "a work of art."[3]

Writing about Koch in *Esquire* in 1964—when he was at the height of his artistic powers and reputation—Dorothy Parker speaks of the "nostalgia" that his work evokes, "nostalgia for those rooms of lovely lights and lovelier shadows and the loveliest people....[I]t is the sort of nostalgia that is only a dreamy longing for some places where you never were."[4] Perhaps the one who most longed for the reality implied in these paintings was the artist himself. In the great tradition of the old masters who were his only teachers—the painter trained himself over four years of looking at and copying masterpieces in the Louvre—Koch paints with extraordinary verisimilitude that easily seduces his audience into believing that he has painted precisely what was before him. But as he readily admitted, "this is far indeed from the truth....I am intensely concerned with the believability of my painted world. Again and again I invent objects, people, and even places that do not exist."[5] Koch's painted world is an artful balancing act of realism and artifice, of ease and effort. His interiors are no more painted lies than stage sets for the theater. The models are actors, the objects are props, the room is the convincing backdrop where the drama unfolds.

The drama of *Interlude* is actually an entr'acte—a familiar subject in Koch's work—when artist and model are taking a break. Those familiar with his art would recognize several of the characters immediately: in the background, seated on a sofa, looking off to the viewer's right—the painting's "stage left"—is the artist himself. Drink in hand—a habitual gesture for many of the actors in Koch's paintings—he gazes intently at the canvas in process. In the middle-ground, dressed in a brilliant red robe, is Koch's wife, Dora Zaslavsky, another stock figure in Koch's work. The model in the foreground is Rosetta Howard, who appeared in at least two other Koch paintings: *Studio—End of Day* (1961) and *Two Artists and a Model* (1965).[6] The essential action of *Interlude*—this scene—is Rosetta's reaching for a cup of tea, extended toward her by Dora, whose downcast eyes suggest deference to the model's nudity as well as thoughtful handling of the hot liquid. The model's beauty and the power of her presence—though seen only in her back—recalls a comment the artist once made: "I find the back of a human being as eloquent and expressive as a face."[7]

Props, like figures, also recur in Koch's work, taking on a supporting role in his narratives. These objects—some associated with affluence, others with a workaday reality—are set amidst spacious surroundings, and eloquently tell the story of the Kochs' complex world. The Queen Anne chair on the left, which echoes in shape and tonalities the contour and colors of the model's back, is a familiar object in many of his paintings. The small serving table—here, with a teapot and martini

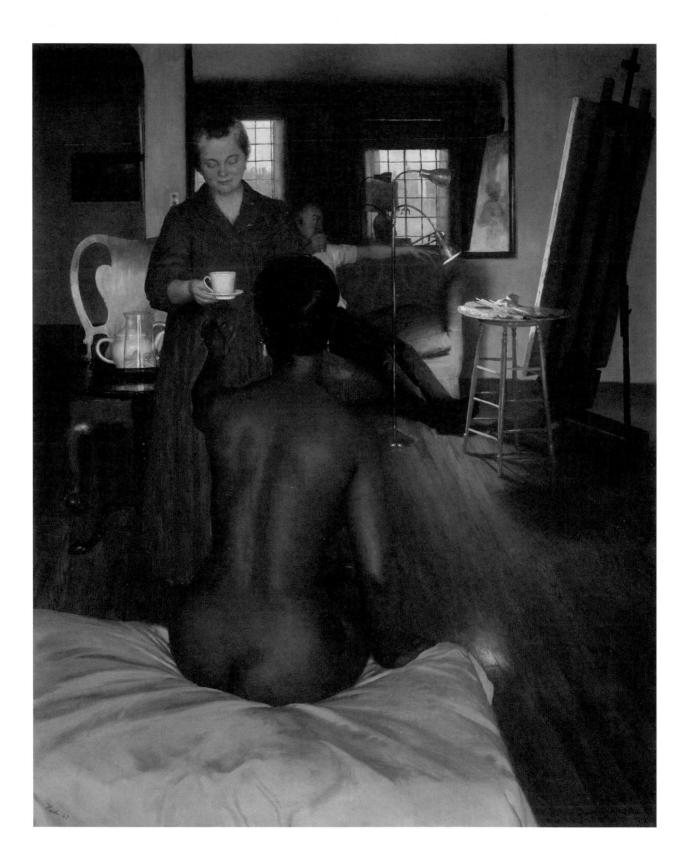

pitcher—makes multiple appearances, as do the easel, the yellow stool supporting the palette, the gooseneck lamp, the daybed, the tufted and fringed sofa, and the black-framed mirror. Mirror? What appears at first glance to be a bank of windows behind the artist—an architectural detail and not another prop—is revealed as a mirror when "real" elements in the room—a corner of the canvas in process and the repetition of the gooseneck lamp—are finally seen as reflections. Koch has played the well-known decorating trick, placing a mirror on a wall to enlarge the sense of a room. The effect here is not simply the expansion of interior space, though he does include the breadth of Central Park in the view to the east out the Kochs' tenth-floor windows. The illusion is more complex: a technical *tour de force* making his viewers pay close attention to details and appreciate how initial appearances may be deceiving.

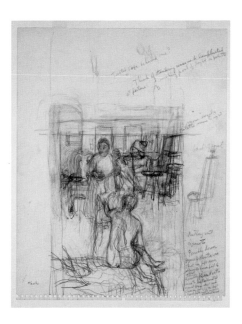

As was his usual practice, Koch made multiple sketches before painting *Interlude*, three of which are known, two now in the Gallery's collection.[8] The overall com position is already set in the three extant drawings. Koch appears to be adjusting the precise placement of the three overlapping figures in the room: will they be in the center of the canvas or off to one side? (He finally places Dora and Rosetta slightly to the left.) He plays with the placement of Rosetta's right arm and her legs. (He finally positions the model's legs in front of her—not off to the side—and places her right arm by her side, pressing her weight into her right palm on the very edge of the daybed.) He experiments with ideas for lighting and cropping, and sketches particular details—the back of the easel, the line of Rosetta's right side—while trying out different positions for her hand. (He finally decides to angle Rosetta's fingers to the right.)

John Koch, 1909–1978
Study for "Interlude" (I), 1963
Graphite on paper, 14 x 11 in.
Gift of the artist, 65.63.1
Courtesy Kraushaar Galleries,
New York

Perhaps the most significant decision developed through these drawings is the physical distance portrayed between Dora's and Rosetta's two extended hands. Should the gesture of the extended cup of tea be consummated or not? Koch determined in the end to leave a critical gap between the two women's hands. The dynamic gap that includes a white tea cup, an older woman's white hand and forearm, and the opening hand of the young African American model is the most articulate and poignant moment in the entire painting. In this intimate world of the artist's studio—ten stories above the streets of New York—two women are engaged in an historic reversal: a young black model is being served by an older white woman.

John Koch, 1909–1978
Study for "Interlude" (II), ca. 1963
Graphite on paper, 14 x 11 in.
Gift of the artist, 65.63.2
Courtesy Kraushaar Galleries,
New York

Interlude is signed and dated on the painting's lower right: "Koch 1963." Is it a coincidence that this was painted at the height of the Civil Rights movement? Koch had painted African Americans in his work earlier and would do so again, but never, before or after, with the implied narrative of the changes at work in contemporary American society. *Interlude* in many ways is a painting like all the others: a beautifully crafted insider's glimpse into the Kochs' enchanted, even rarified, world, complete with its familiar figures, objects, and setting—down to the often-repeated deception of the mirrored windows. But in this single gesture, first glimpsed perhaps in the course of a working day, Koch has captured a moment—an interlude—that takes on a level of contemporary meaning rarely, if ever, achieved elsewhere in his work.

(Facing page)
John Koch,
1909–1978
Interlude, 1963
Oil on canvas,
50⅛ x 39⅞ in.
Gift of Mr. and Mrs. Thomas
H. Hawks, 65.12
Estate of John Koch, Courtesy
Kraushaar Galleries, New York

Susan Dodge-Peters Daiss is the McPherson Director of Education, Memorial Art Gallery.

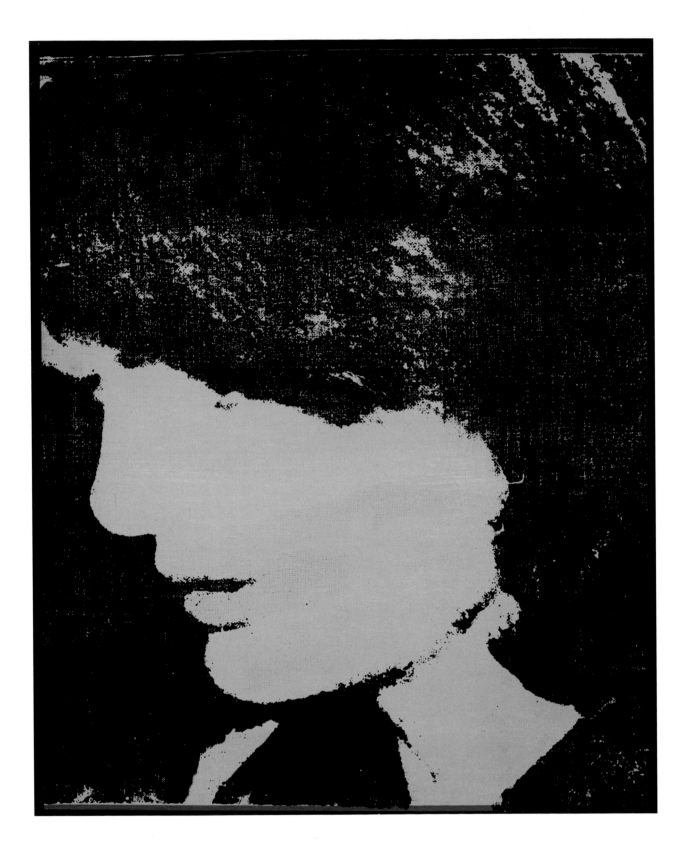

70: Andy Warhol *Jackie* (1964)

Marjorie B. Searl

"Where were you when Kennedy was shot?"

Lee Harvey Oswald's was, truly, the shot heard round the world.[1] Quite possibly, the news of John Fitzgerald Kennedy's assassination was known and felt by more people around the world than any event in recorded history: "In what amounted to a poignant demonstration of the newly emerging concept of the Earth as a global village, spontaneous gatherings of mourners assembled in public plazas throughout the world, east and west, with lit candles, solemn faces, and photographs of the slain president framed in black bunting."[2]

In part because Kennedy was really the first "television president," his life opened up before us on a regular basis. No doubt the first televised presidential debates won the election for him, and his televised inauguration was made memorable by these unforgettable lines: "And so, my fellow Americans: ask not what your country can do for you—ask what you can do for your country." His wife and children were regulars on our TV screen, as if they were our royal family; when he died, we watched his funeral—and family—as if they were our own.

Because the assassination was captured on film by dressmaker Abraham Zapruder, who was recording for himself and his family the moment when the president's open-air limousine drove by on that sunny November day in Dallas, those images have also been the most studied bits of photography to date. Many still living can recall, from seeing them on television or published in *Life Magazine,* the hundreds of images that came after the assassination itself: Mrs. Kennedy, still in her bloodied pink Chanel suit, standing by Lyndon Johnson while he was sworn in as president on Air Force One; the stoic, veiled Mrs. Kennedy with her children, Caroline and John, as the casket proceeds past them and John John salutes; the black riderless horse.

The pop artist Andy Warhol heard the news at the same time as everyone else.[3] He said:

> When President Kennedy was shot that fall, I heard the news over the radio when I was alone painting in my studio. I don't think I missed a stroke. I wanted to know what was going on out there, but that was the extent of my reaction....I'd been thrilled having Kennedy as president; he was handsome, young, smart—but it didn't bother me that much that he was dead. What bothered me was the way the television and radio were programming everybody to feel so sad....John Quinn, the playwright...was moaning over and over, "But Jackie was the most glamorous First Lady we'll ever get."[4]

Not long after the assassination, Warhol recognized that the images of Jacqueline Bouvier Kennedy, or Jackie, as she is now known for all time, had become a commodity much like his ubiquitous Campbell Soup can. In his book *Dangerous Knowledge: The JFK Assassination in Art and Film,* Art Simon writes: "Indeed, the assassination as a consumer good, mass produced and sold on newsstands not far from the soup cans in grocery stores, is one of the inevitable messages of the Jackie portraits."[5] Her image had been repeated so many times that it was fairly imprinted in the minds of all Americans, if not all of humanity with access to television and print media. Warhol's relentless repetition of her image positioned Jackie as another American icon, the co-star of "the most powerful man in the Western world," ironically as visually memorable as Marilyn Monroe, who was romantically linked with JFK.[6]

Andy Warhol,
1928–1987
Jackie, 1964
Ink on canvas, 23⅞ x 23¼ in.
Marion Stratton Gould Fund,
65.7
©2006 Andy Warhol Foundation
for the Visual Arts/Artists Rights
Society (ARS), New York

The Memorial Art Gallery's painting, *Jackie*, is one of the many images that Warhol and his studio created in 1964. It is derived from a detail of a photograph by Cecil Stoughton, a captain in the army signal corps, taken on Air Force One when Lyndon Johnson was taking the oath of office and Jackie, still in her stained clothing, looked on.[7] Lady Bird Johnson described it this way:

> On the plane, all the shades were lowered. We heard that we were going to wait for Mrs. Kennedy and the coffin....It was decided that Lyndon should be sworn in here as quickly as possible, because of national and world implications, and because we did not know how widespread this was as to intended victims....Mrs. Kennedy had arrived by this time, as had the coffin. There, in the very narrow confines of the plane—with Jackie standing by Lyndon, her hair falling in her face but very composed, with me beside him, Judge Hughes in front of him, and a cluster of Secret Service people, staff, and Congressmen we had known for a long time around him—Lyndon took the oath of office.[8]

According to David Lubin, Jackie had not wanted to be in the photograph, but President Johnson insisted that she be there lest "the ceremony, without her presence, would lack legitimacy in the eyes of the public." Stoughton "wedged himself against the bulkhead as far forward as possible, and a phalanx of witnesses squeezed into every available spot in the cramped, overheated sixteen-foot-square stateroom of Air Force One (which sat on the runway sealed tight and without air conditioning) while crew and passengers waited for Mrs. Kennedy to appear."[9] Again, according to Lubin, "Jacqueline Kennedy grasped the importance of formality, especially in the midst of crisis, and that is why she consented to stand beside Lyndon Johnson as he raised his hand in oath. She lent a dignity to the occasion that could not have obtained without her."[10]

Warhol used a commercial silkscreening technique to produce this image. In his words,

> In August '62 I started doing silkscreens. The rubber-stamp method I'd been using to repeat images suddenly seemed too homemade; I wanted something stronger that gave more of an assembly line effect. With silkscreening you pick a photograph, blow it up, transfer it in glue onto silk, and then roll ink across it so the ink goes through the silk but not through the glue. That way you get the same image, slightly different each time. It was all so simple quick and chancy. I was thrilled with it.[11]

Appropriately, Warhol used a mass-production technology for his work, whose subjects are statements about mass production and market saturation. Warhol's "Factory" at 231 E. Forty-seventh Street housed an artistic production line where Warhol and his assistants produced the work by day and films were shot by night. For his *Jackie* series, Warhol used a handful of images that he configured in multiple ways—singly, as a pair, and up to sixteen and more, in shades mainly of blue and black.[12]

Jackie Kennedy was born in 1929 and died in 1994. Her life was tumultuous, thrilling, and tragic, and Warhol's gift was to understand her potential as the heroine of a powerful visual narrative. Through his images of her, we relive the events of November 22, 1963. We see the beautiful wife stepping off the plane, the smiling Jackie in the motorcade, the stunned Jackie of the MAG painting, the veiled Jackie looking beatific, all taken from photojournalistic sources. The tightness of the shots, the way in which the contrast of lights and darks are heightened and the resulting loss of detail control the way in which we understand the images. Nonetheless, Warhol's Jackie haunts us like a grieving Madonna, or a desolate Guinevere, the Queen of a Camelot that she began to construct in the weeks following the "King's" death.[13]

Andy Warhol,
1928–1987
Jacqueline Kennedy III, 1966
Serigraph, 40 x 30 in.
Mr. and Mrs. Daniel
G. Schuman, 76.132
©2006 Andy Warhol
Foundation for the Visual
Arts/Artists Rights Society
(ARS), News York

Marjorie B. Searl is Chief Curator, Memorial Art Gallery.

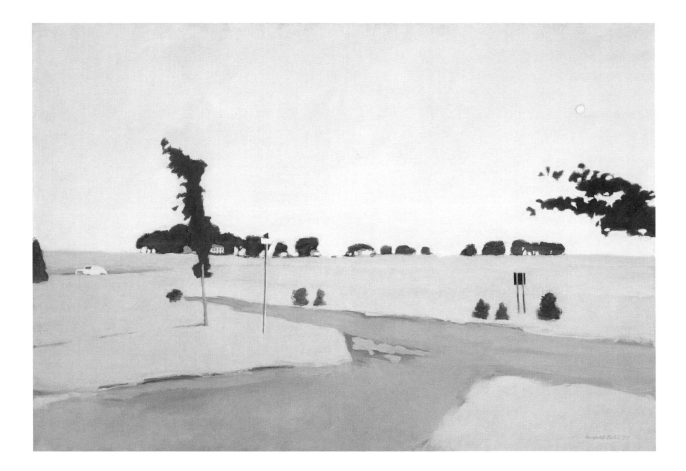

Joan Ludman

The Beginning of the Fields is a tour de force with a special place in Fairfield Porter's oeuvre.[1] He did not paint space, he said, he painted air, and that certainly seems true of this dazzling creation, one of many beautiful works from the last two years of his life. An homage to his beloved Long Island landscape, it displays the qualities that have earned Porter recognition as one of the major American artists of the twentieth century. It is also a superb example of the realist tradition that he upheld throughout his career, despite the ascendance of abstract expressionism. When he died in 1975, at the height of his powers, Porter left behind an oeuvre of light-filled, sun-dappled landscapes, intimist interiors, lyrical still lifes, and insightful portraits. This body of work, as well as his teachings and writings, influenced an entire generation of figurative artists.

Porter was born in 1907 into a large, prosperous, and highly accomplished family in Winnetka, Illinois. Cultural pursuits and travel were encouraged and nurtured, exposing him to a diverse range of art and thought that shaped and inspired his own unique style. A family trip to Europe when he was fourteen showed him the work of Leonardo, Titian, Veronese, and J. M. W. Turner. A trip to Moscow while still a student at Harvard influenced his philosophy, his politics, and his art; another to France in 1927 enhanced his enthusiasm for Romanesque and Renaissance art and architecture; a return trip to Italy in 1931 sparked a lifelong interest in Giotto's frescoes.

In 1928, after Harvard, he moved into a wholly different milieu among modernists and literati in New York, studying with Thomas Hart Benton and Boardman Robinson at the Art Students League and growing acquainted with Alfred Stieglitz and the work of John Marin. During the Depression years, he embraced the socialist leanings and ideals of the 1930s' intelligentsia, provided illustrations for a socialist periodical called *Arise*, and painted modernist murals in the social realist tradition.

Porter attended exhibitions in the 1930s and 1940s of the works of Bonnard and Vuillard, notably at New York's Museum of Modern Art, and these artists joined the eclectic web of influences from which Porter was to fashion his distinctive style. At the Parsons School of Design during World War II, he studied with the Louvre restorer Jacques Maroger, who instructed him in the use of a rediscovered Flemish painting medium that caused the paint to dry slowly, making possible an easier reworking of the canvas. The dazzle of Bonnard's color and the intimism and patterning of Vuillard, along with Porter's interest in the Maroger technique and feel of the paint, became hallmarks of his landscapes, interiors, and still lifes from then onward.

In 1949 Porter moved with his poet wife, Anne Channing Porter, and their five children to Southampton on Long Island, the site of *The Beginning of the Fields*, where he appreciated the rural atmosphere and the proximity to the sea, while still maintaining a connection to the art world of New York City. He was the first of many artists, notably Jackson Pollock and Willem de Kooning, to make their homes and set up their studios in the Hamptons (which in the 1940s was not the posh area it later became). De Kooning, whose work Porter was among the first to admire, became a close friend, as did the painters Alex Katz, Jane Freilicher, Neil Welliver, and Jane Wilson. The "New York School of Poets"—Frank O'Hara, James Schuyler, John Ashbery, and Kenneth Koch—also welcomed Fairfield into their circle. In the early 1950s, this group often met at the Cedar Bar in Greenwich Village and read each other's poems. Porter, who had always enjoyed reading and writing poetry, experienced a burst of creativity in both his painting and his poetry. His art became more fluid and lyrical.

Fairfield Porter,
1907–1975
The Beginning of the Fields, 1973
Oil on canvas,
52 x 76⅛ in.
Marion Stratton Gould Fund,
86.132
©Estate of Fairfield Porter
and Hirschl & Adler Modern,
New York

During this period, he began to have a series of successful shows of his paintings at New York's Tibor de Nagy Gallery and at prestigious venues including the Whitney and the Cleveland museums. He simultaneously embarked upon another highly regarded career as an art critic, writing for *Art News* and *The Nation*. His reviews of contemporary painters and sculptors were finely written, forthright, and eminently readable. But as his shows became more successful and his reputation grew, he quit writing art criticism in order to devote full time to painting.

Over the following decades, into the 1960s and 1970s, Porter's paintings evolved into luminous, color-saturated canvases, his subject matter reflecting his and his family's daily life—domestic interiors and still lifes of the family dinner table, portraits of family members and friends, and perhaps most specially, landscapes depicting the countryside around his homes in Great Spruce Head Island in Maine and in Southampton, Long Island.

The Beginning of the Fields is a depiction of the wide-open, flat, uncluttered landscape in Southampton, near where Porter and his family lived from 1949 until the end of his life. In its powerful sense of place, its particular evocation of the Long Island atmosphere, its sea air and the light that he felt was the finest anywhere, better even than the famous light of the south of France, it pays an emotional homage to his cherished home as he hoped it would remain, green and unspoiled.

Porter often proclaimed that he saw the "extraordinary in the ordinary" and he "painted things as they are." If this seems to describe a representational artist, it is also true that he believed in the reality of the paint. The place depicted is "real," but so are the "paint" and the painting. For all his classical realism, Porter was a great admirer of the abstractionists, especially of de Kooning, and their influence is apparent in his gestural handling of the paint. *The Beginning of the Fields* is an image of both realism and abstraction—inconsistent shadowing, a disappearing roadway, an unusual perspective, and a powerfully atmospheric use of color in capturing the feel of the air that suffuses the entire composition. Large, flat planes of pure fluid color, rather than line, define borders. Porter has balanced his love of the medium, the feel of the paint, the handling of the paint, with his interest in visual reality.

In Porter's late paintings, he seems to have arrived at that distinctive individual style, simultaneously realistic, impressionistic, and abstractionist, toward which all his diverse training and experience appears, in hindsight, to have been leading. In 1974, the art critic Hilton Kramer wrote that Porter's "greatest strength is to be found in a painting such as *The Beginning of the Fields*, a dazzling, simplified construction of light."[2] Kenworth Moffett, writing in the catalogue for the Boston Museum's 1983–84 retrospective, noted that "in certain very late pictures, Porter started to cross the border between Impressionism and Fauvism, between a reaction to natural light and a search for invented color."[3] "In *The Beginning of the Fields*, says art critic Michael Brenson,

> We seem to be looking at heat. The trees are like flames. The sun is a little white ball. The car on the road is an explosion of white. Only the blue of the signposts and road bring some relief, and the road is shaped like a cross. There is almost a Biblical quality to the light here. It is the light of revelation, but it is also fire, with its potential for purification and redemption. As cool, objective and American as Porter can seem, he is sometimes not far from Van Gogh.[4]

ALSO IN THE MAG COLLECTION:

Elaine de Kooning

American, 1918–1989

John Ashbery, 1975

Oil on board, 34 x 30 in.

Marion Stratton Gould Fund,

99.3

Courtesy the estate.

Salander-O'Reilly Galleries

Porter, who died in Southampton in 1975, was a man of strong opinions in politics and art. He was also a passionate environmentalist, and an avid critic of encroaching development and technological intrusions like the Shoreham Nuclear Power Station planned for eastern Long Island, sullying the natural landscape and threatening his idyllic home.[5] His art reviews, poetry, and especially his paintings, are, says Justin Spring,

> an essentially diaristic project in which the artist perpetually sought to
> define for himself his relation to the world. Only when that project has
> been appreciated in its literary, critical and artistic entirety will Porter be
> given the recognition that he is due as—in his friend [the poet] John
> Ashbery's words—"perhaps the major American artist of this century."[6]

Joan Ludman, art historian and independent scholar, is the author of the catalogues raisonnés.

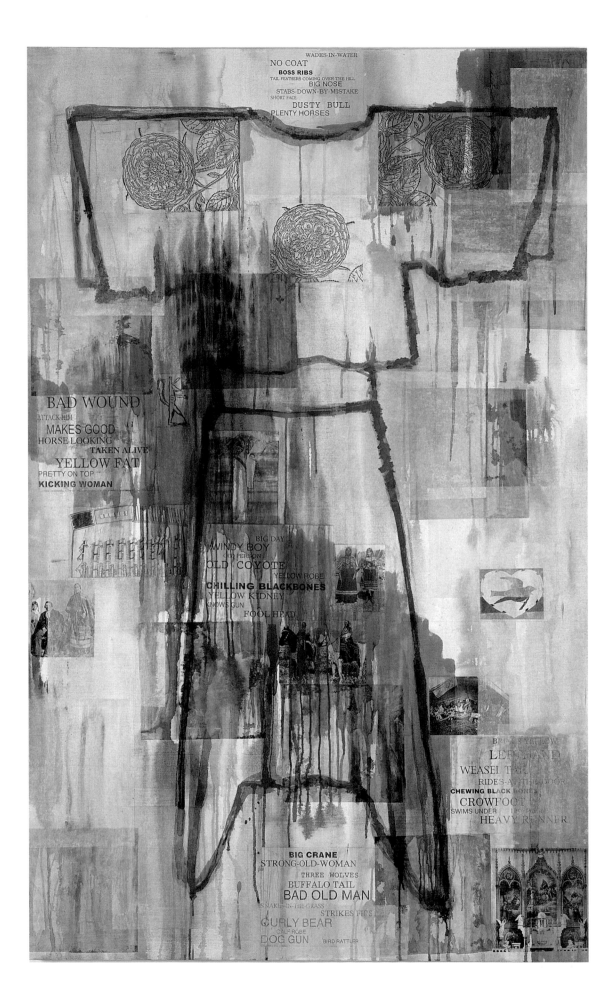

G. Peter Jemison

*We Indians are a paradox in this land of paradox. We are members of
sovereign tribal nations, but we are also Americans.*

—Joy Harjo[1]

Jaune Quick-to-See Smith's large and remarkable body of work—paintings, drawings, collages, and prints—challenges simple notions about Native Americans and Native American art. Her success at bridging the traditions of her inherited past and those of modern Euro-American culture has made her a highly admired contemporary artist and a much sought-after spokesperson.[2]

Born in Montana, an enrolled member of the Confederated Salish and Kootenai Tribes of the Flathead Indian Reservation, Quick-to-See Smith traveled as a child around the West with her father, who was a horse trainer and trader as well as an amateur painter. In her thirties she started painting seriously, and was already earning a living at it when she went to the University of New Mexico for an M.F.A. degree. While in Albuquerque, she met younger Native American artists with whom she formed a group in 1977, Grey Canyon, named for the skyscraper-lined city streets. After several exhibitions the loosely organized collective dissolved, but some strong artists emerged, Quick-to-See Smith among them.

Recently she has made her home in Corrales, New Mexico, where her studio is surrounded by the high desert landscape whose colors are reflected in much of her work. But there is nothing passively picturesque about that work, which is highly charged by Quick-to-See Smith's activist values. She is a staunch supporter of Native American rights, of women's rights in both the larger world and the art world, and of the environmental movement. She is also a tireless educator, of both Native and non-Native people, about the values and meanings of her traditions.

In MAG's *Famous Names*, what appears to be a simple form—the outline of a woman's dress—is actually a layering of materials whose complexity becomes clear only as we continue to regard the work. Names, old photos, art historical images, decorative forms and details are glued, stencilled, and painted onto the canvas in bewildering detail and variety, emerging from the background as we look. The whole work is overlaid with a viscous acrylic, predominantly of desert reds and browns that appear to drip or flow down the middle of the work.[3]

The form of the dress itself speaks to the role of women in Native American society, since it is they who traditionally raise the children and then perhaps remain most keenly aware of kinships, maintaining family ties to a Native community even if they are living far away. Dresses of this type—made of buckskin, commonly called a cut wing—are today worn for powwows and other ceremonial gatherings. Those from the Flathead or Plateau country are often decorated with beaded designs that illustrate the camas or bitterroot flowers. Quick-to-See Smith has used the traditional dress form, but has decorated the painted dress to express her own message. Her flowers, collaged onto the canvas, resemble the beadwork designs but also suggest European printed fabric—another instance of Western form applied to Native tradition. Other images in the painting include a bird, a number of old photographs, a Christian triptych, a Native Madonna and Child (the child on the mother's back, both with haloes), a coyote branded with Quick-to-See Smith's Native registration number 7137,[4] an array of rifles and bayonets, and several seemingly faded patches where the "dripping" paint has eerily resolved into landscape effects. It is quite evident that Quick-to-See Smith wishes to confuse the eye with a mixture of familiar and unfamiliar images, forcing us to ponder and "reassemble" the montage into a meaningful whole.

Jaune Quick-to-See Smith,
1940–
Famous Names, 1998
Oil, acrylic, collaged photographs,
and mixed media on canvas,
80 × 50 in.
Gift of Thomas and Marion
Hawks by exchange, 98.39
Courtesy of Jaune Quick-
to-See Smith

Recently Quick-to-See Smith remarked that "The dress, men's shirts, vests, buffalo, canoes, horses, coyotes (creation story) and rabbits (also a trickster)—all Salish cultural icons—began to appear in my work after 1992."[5] Many of these icons are apparent in the 1994 lithograph, *Horse Sense,* also in MAG's collection. But she is circumspect when asked about their meanings. In the lower right corner of *Famous Names,* for instance, one also finds of all things a medieval Christian triptych physically imposed upon the canvas. When asked about this puzzling detail, Quick-to-See Smith responded: "I'll say what I think it might mean. The Christian churches were sent by the U. S. government to 'civilize' us and used whatever means possible to decimate our cultures."[6] Similarly, the Madonna and Child may suggest the aggressive missionary tactic of "nativizing" Christian stories to make them more appealing.

That same sense of outrage is surely at work in one of the painting's most prominent features, the "famous names" that appear to be stencilled or glued onto the canvas in various sizes, fonts, and styles. Like the whole variety of images in the painting, some of the names are familiar from Westerns and popular culture (PRETTY ON TOP, TAKEN ALIVE, PLENTY HORSES, OLD COYOTE); some seem mysterious (CHILLING BLACKBONES, YELLOW KIDNEY, HORSE LOOKING); some may strike us as mocking (KICKING WOMAN, FOOLHEAD, BIG NOSE, BAD OLD MAN). Some of the names are historical, some contemporary; one (BUFFALO TAIL) belongs to her son.[7] But however exotic-sounding, the "famous" names Quick-to-See Smith has focused on were in the first place attempts to give in English the meaning found in Native American languages. In the interest of converting Native Americans to various faiths, churches needed names they could spell and pronounce for proper registry. The army also needed names when foods were being distributed to those visiting a fort for rations when hunting was outlawed.

Thus, BAD WOUND, TAKEN ALIVE, CURLY BEAR, LEFTHAND and the others are not the names of the founding fathers of America, but the record of people with ancient ties to the land and of the often-bungled attempts of English-speaking writers to capture what a translator related. Sometimes this

translation and recording process was done with the same haste implied in the seemingly slap-dash painted image, yet the results remain with us until today. Quick-to-See Smith gets the names from basketball and baseball rosters as well as council members, medicine people, and artists whose names appear in her tribal newsletter, *Char-Koosta,* from the Flathead community.[8] "My 'Famous Names' dress," she commented, "proves that we still retain many of our original names, either because they've lasted or because our families took them back (as in my case)."[9] By reappropriating them for her painting she has reclaimed their ownership. As she says:

I've used large identifiable Indian icons that have been romanticized by movies, novels and the media. But up close the viewer gets a reading of a different story about Indian life on and off the reservation. Clippings from my tribal newspaper (the Char-Koosta), newspapers, books, magazines tell a story that deals with the reality of Indian life....Even though the government and the Christian churches banned our ceremonies, dancing, drumming, religions and languages all the way through the 1950's, our elders retained our cultural knowledge and are revitalizing our cultural ways.[10]

Aside from the icons and names, the photographs play a crucial role in the painting's work of "reassembling" our prejudices and expectations. In the nineteenth century there was a lusty commercial appetite in the East for photographs of western scenes and exotica, including of course

Native Americans. Behind the natural fascination with the "other," the photographs were also another way for the dominant non-Native culture to define, trivialize, and neuter the Native culture. Quick-to-See Smith's photos, vintage 1870–80, range from depictions of individuals in their Native attire to those with European hair styles and dress. By using them here, literally gluing them onto the form of the Native dress, she again inverts the historical record, reclaims the images as she has the "famous names," allows us to "gaze" at the images once again, but this time in a wholly reconfigured context.[11]

Jaune Quick-to-See Smith, 1940–
Famous Names (detail), 1998
Oil, acrylic, collaged photographs, and mixed media on canvas, 80 x 50 in.
Gift of Thomas and Marion Hawks by exchange, 98.39
Courtesy of Jaune Quick-to-See Smith

Clearly Quick-to-See Smith's work is about preservation of the traditions her Flathead Salish relatives handed down to her, and about earning respect for them, through teaching and lecturing as well as in her art. But it would be a mistake for us to see her work only in terms of a specific Plateau cultural tradition. She is an artist of the twenty-first century with a gallery in New York City. She is well aware of the art world, and has integrated the major influential currents of twentieth-century modernism (from Klee, to Kandinsky, to Picasso, to Matisse, to Pollock) into her work. And a recent trip to China suggests that the scope of her influences and interests also extends beyond the West to the art of the world.[12]

G. Peter Jemison is a Heron Clan member of the Seneca Nation of Indians, an artist, and the Historic Site Manager of Ganondagan State Historic Site in western New York.

the failure of sylvester octoroon two old women minnie woman holding a jug self portrait troubadour self portrait
self portrait artist's life no. 1 nude john brown mom and dad i've been in some big towns constance jeannie
mable two girls family no.9 wanted poster no.3 man standing on his head wanted poster no. 17 harriet
willy j

73 : Lorna Simpson *Untitled (The Failure of Sylvester)* (2001)

Gretchen Sullivan Sorin

Lorna Simpson, though trained as a traditional photographer, is now widely known for exploring African American identity through highly innovative techniques of conceptual imaging.[1] Her black and white photographs evoke influences of paintings, literature, cinema, and other sources, and often are realized through printing processes such as photogravure and silkscreen. Mostly they confront viewers with images of African American women juxtaposed with provocative text. The faces of the black women in Simpson's compositions are never seen. Their backs are turned or their torsos exposed only to the neck or to the nose, but the incomplete yet arresting forms raise questions and spark ideas about the roles, stereotypes, and experience of black women in western society, and encourage questions about such issues as exclusion, invisibility, and race. The women are proud and strong—black sculptures—without names or identities. Their otherness is clear. Dressed in plain gowns and without ornamentation, their femininity is certain, but their sexuality is diminished.

In *The Failure of Sylvester* we view multiple photographic images of a single anonymous African American woman. Sometimes a cameo-like oval frames her head. Sometimes she appears within a rectangle. She faces to the left in several of the images, and in others to the right. In a few she is completely in shadow. As viewers, we must confront this anonymous woman and also our own prejudices. Is this the woman who cleans the house, or cares for the children, or does the laundry? Do we know her? After all, "they all look alike." Americans dislike being reminded of the persistence of racial discrimination and inequality. Such painful ideas—such painful art—makes us uncomfortable, but *The Failure of Sylvester* forces us to see them. How do historical stereotypes of black women persist today? How do they affect the roles in which we place them?

The Failure of Sylvester (and the photographic series of which it is a part) makes use of a traditional American form—the silhouette—to connect viewers with past events and present perceptions. Before photography, silhouette artists, both fine artists and carnival cutters, created detailed images of their sitters through a variety of techniques. The most skillful silhouette cutters were able to capture their sitters' personalities in the flat profiles. After sketching, the image was then snipped, usually out of black paper, mounted on a contrasting background, and framed. Although inexpensive, these paper cuts were extremely popular with affluent families, offering them an easy method of forever preserving their likenesses, and costing significantly less than a painted portrait. Often identified by name, the figures portrayed in the silhouettes displayed their middle-class aspirations—top hats and ruffles, fancy collars, frills, and jewelry set them apart as people of means. They were individuals to be remembered.

Lorna Simpson, 1960–
Untitled (The Failure of Sylvester)
(detail), 2001
Archival gelatin prints under
Plexiglas with black vinyl
lettering, 61 x 41 x 1 in.
Marion Stratton Gould Fund,
2003.4
©Lorna Simpson, Courtesy Sean
Kelly Gallery, New York

(Facing page)
Lorna Simpson, 1960–
Untitled (The Failure of Sylvester),
2001
Archival gelatin prints under
Plexiglas with black vinyl
lettering, 61 x 41 x 1 in.
Marion Stratton Gould Fund,
2003.4
©Lorna Simpson, Courtesy
Sean Kelly Gallery, New York

Silhouettes were wildly popular art forms during the late eighteenth and the first half of the nineteenth centuries. They adorned walls and were shared with friends as personal mementoes. But at the time when white Americans posed for their "shadow pictures," as they were also known, African Americans were held in slavery. Lorna Simpson takes this nineteenth-century art and turns it around using mainstream culture—the customers of the silhouette cutter—as her foil. Her work thus represents women both in the past and in the present.

The traditional silhouettes of the nineteenth century appear in perfect profile, with the eyes, nose, mouth, and chin clearly delineated to specifically distinguish the individual. Text also accompanies many silhouettes, further confirming the identities of the sitters. In the most desirable cuttings the names both of sitters and artists as well as dates and locations are included. In contrast, Simpson's silhouetted woman in *The Failure of Sylvester* averts her face just enough to prevent us from seeing her features. She is not identified by name. Instead, she appears as the white slave owner, or the overseer, or the owner of a house in the middle of the white suburbs might view her—faceless and anonymous. The accompanying text, instead of naming her, raises questions about her identity.

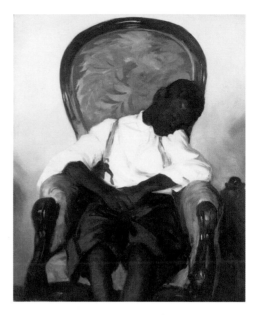

African American writers and tradition inspired Lorna Simpson to integrate provocative narrative elements in her art. The text, which draws from familiar sources, creates challenging new meanings that address issues of personal and collective identity, gender, language, and African American history. "When I was in school, I read a lot of literature that had a profound effect on me," Simpson told photographic historian Deborah Willis in 1992. "I was really amazed by black writers like James Baldwin, Ntozake Shange, Alice Walker, and Zora Neale Hurston....These writers related black experiences in such interesting ways and for them language became a slippery object. I was really amazed by how much they said in silence."[2] The carefully chosen text in *The Failure of Sylvester* employs words reminiscent of captions in a family album—"mom and dad," and "Minnie"—as well as disturbing reminders of slavery and racism like "octoroon," "wanted poster no. 3," and the abolitionist John Brown. In fact, according to Simpson, "the references within the work are titles of paintings from the 1790s to about 1970, and of films from about 1910 to the 1970s."[3] *Wanted Poster No. 3, Octoroon,* and *Mom and Dad,* for instance, are all works by African American artists,[4] while "Minnie" evokes any number of popular-cultural references, many specifically African American.[5] The title of Simpson's work itself comes from a painting by Robert Henri (*The Failure of Sylvester,* 1914) in which a young African American boy, supposedly modeling, has fallen asleep in his chair.

Lorna Simpson was born in the Crown Heights section of Brooklyn, New York, in 1960, growing up and attending high school in the Borough of Queens. She studied documentary photography at the School of the Visual Arts in Manhattan, earning a B.F.A. in 1982. She broadened this traditional education by moving to San Diego to pursue an M.F.A. Her master's work at the University of California focused on conceptual photography. Now a leading member of the younger generation of African American artists, Simpson has work in over forty major public collections and has exhibited in many international venues.

Photographic portraiture can be a particularly accessible form of art, as it connects subjects and viewers through their shared humanity. Understanding this, Lorna Simpson continually redesigns and reshapes this relationship between subject and viewer, turning her subjects away from the camera, and replacing the expressiveness of the face with gesture, symbol, and text. Her viewers must work hard to interpret the messages of her portraits—messages that can be both ambiguous and controversial. But her aggressive images challenge us to reconsider how easily we stereotype one another, and may lead us to see through the flat, featureless silhouettes to the three-dimensional persons behind them. In so doing they may coax us to re-explore our own identities.

Gretchen Sullivan Sorin is the director of the Cooperstown Graduate Program and professor of museum studies.

Notes

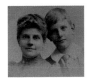

Introduction

1 Peter Finley Dunne, *Observations of Mr. Dooley* (New York, 1902), 21, 24.

2 Given the daughters' training in the history of art, and their personal predilections for certain forms of medieval art, the European side of the collection hardly suffered under their stewardship, which lasted until 1972. An important exhibition in the winter of 1964–65, entitled In Focus, a Look at Realism in Art, included European as well as American art, highlighting in the process both continuities as well as discontinuities. That show also concluded with examples of pop art, making MAG one of the earliest American museums to feature this new development and stimulate viewers to form their own opinions about the relationship of works by Andy Warhol and Roy Lichtenstein to earlier forms of "realism."

3 In 1951, MAG acquired fourteen paintings from the Encyclopedia Britannica collection, including Thomas Hart Benton's *Boomtown* (1928), Ralston Crawford's *Whitestone Bridge* (1939–40), Stuart Davis's *Landscape with Garage Lights* (1931–32), Arthur Dove's *Cars in a Sleet Storm* (1938), William Gropper's *The Opposition* (1942), George Grosz's *The Wanderer* (1943), Robert Gwathmey's *Non-Fiction* (1943), Walt Kuhn's *Clown* (1945), George Luks's *London Bus Driver* (1889), John Marin's *Marin Island, Small Point, Maine* (1931), Georgia O'Keeffe's *Jawbone and Fungus* (1931), John Sloan's *Chinese Restaurant* (1909), Max Weber's *Discourse* (1940), and Karl Zerbe's *Troupers* (1943).

4 For a representative example of this theme, see Virgil Barker, "The Search for Americanism," *The American Magazine of Art* 27 (February, 1934): 51–2. For judicious observations on the historical complexity of stylistic distinctiveness in American art, see Dore Ashton, *The Unknown Shore: A View of Contemporary Art* (Boston: Little, Brown, 1962), chap. 3, "Locating the American Note: A Digression."

5 See Elizabeth Johns, *Winslow Homer: The Nature of Observation* (Berkeley: Univ. of California Press, 2002), 129–32, 137–40, and plates 25–27.

6 George Grosz, quoted by Grace Pagano in *Contemporary American Painting: The Encyclopedia Britannica Collection*, entry 48 (New York: Duell, Sloan and Pearce, 1948), xxvii.

7 See Annie Cohen Solal, *Painting American: The Rise of American Artists, Paris 1867–New York 1948* (New York: Knopf, 2001).

John Singleton Copley
Unfinished Portrait of Nathaniel Hurd
(ca. 1765)

1 For the most recent overview of Copley's life and career, see the exhibition catalogue *John Singleton Copley in America,* by Carrie Rebora and Paul Staiti (New York: The Metropolitan Museum of Art, 1995).

2 The most recent investigation of the Memorial Art Gallery's portrait of Nathaniel Hurd by John Singleton Copley was the exhibition About Face: Copley's Portrait of Nathaniel Hurd, Colonial Silversmith and Engraver, which was on view at the Gallery from November 1999 through May 2003. Papers from the symposium in April 2000 were published in the Gallery's scholarly journal, *Porticus* 20 (2001). Hurd scholarship includes Hollis French's publication *Jacob Hurd and His Sons Nathaniel & Benjamin, Silversmiths, 1702–1781* (Cambridge, Mass.: The Walpole Society, 1939; repr. New York: Da Capo Press, 1972) and Patricia E. Kane's exhaustive study of Colonial silversmiths, *Colonial Massachusetts Silversmiths and Jewelers: A Biographical Dictionary Based on the Notes of Francis Hill Bigelow and John Marshall Phillips* (New Haven, Conn.: Yale Univ. Press, 1998).

3 Lawrence W. Kennedy, *Planning the City Upon a Hill* (Amherst: Univ. of Massachusetts Press, 1992), 255.

4 Warren (1728–1814) was a distinguished writer and articulate defender of the Revolutionary cause.

5 John Singleton Copley and Henry Pelham, *Letters & Papers of John Singleton Copley and Henry Pelham, 1739–1776* (Boston: Massachusetts Historical Society, 1914), 31.

6 Regarding the relationship between Benjamin Hurd and Copley, see William Whitmore, *The Heraldic Journal,* vol. 4 (Boston, 1865), 192; regarding Nathaniel Hurd and Pelham, see Patricia E. Kane, "Nathaniel Hurd: The Life of a Colonial Silversmith and Engraver," in *Porticus* 20 (2001): 12.

7 While the miniature is documented, its current owner has not been determined. See Jules Prown's *John Singleton Copley* (Cambridge, Mass.: Harvard Univ. Press, 1966), 1: 220.

8 Because the creation of the paintings would seem to be linked to Copley's commission of the mezzotint of Reverend Joseph Sewall, which is dated 1765, the paintings are dated ca. 1765.

9 Carrie Rebora Barratt, "Oriental Undress and the Artist," *Porticus* 20 (2001): 22. Barratt's article discusses the iconography of the costumes of the two Hurd paintings.

10 See Sandra L. Webber, "The Discovered Hand: John Singleton Copley's Underdrawing Techniques," *Porticus* 20 (2001): 48–58.

11 Entry for Wednesday, November 27, 1776, Journals of the House of Representatives of Massachusetts, Vol. 52, Pt. 2, 1776–1777 (Boston: Massachusetts Historical Society, 1986), 173.

12 Nathaniel Hurd, will, docket no. 16448, Suffolk County Judicial Archives, Boston, Mass. Hurd signed his will on December 8, 1777, and the will was probated shortly after, on January 23, 1778.

13 Ibid.

Thomas Chambers
View of West Point (after 1828)

1 O. L. Holley, ed., *The Picturesque Tourist: Being a Guide Through the Northern and Eastern States and Canada; Giving an Accurate Description of Cities and Villages, Celebrated Places of Resort, etc.* (New York, 1844), 29-30.

2 *The New York State Tourist* (New York, 1842), 23.

3 Chambers's paintings held by other museums include: *The Constitution and the Guerrière* (The Metropolitan Museum of Art), *Looking North to Kingston* (Smith College Museum), *Niagara Falls From the American Side* (Wadsworth Athenaeum), *Staten Island and the Narrows* (The Brooklyn Museum), *View of the Hudson Near Weehawken* (Fenimore Art Museum), and *Upper Falls of the Genesee* (Albright-Knox Art Gallery).

4 Nina Fletcher Little's articles are: "T. Chambers, Man or Myth?" *Antiques* 53 (March 1948): 194, "Earliest Signed Picture by T. Chambers," *Antiques* 53 (April 1948): 285, and "More About T. Chambers," *Antiques* 60 (November 1951): 469.

5 Chambers's last signed painting was of the *Harriet Lane,* commemorating a naval action involving the ship in January 1863. See John K. Howat, *The Hudson River and Its Painters* (New York: Viking, 1972).

6 Howard Merritt, "Thomas Chambers—Artist," *New York History* 37, no. 2 (April 1956): 212. Professor Merritt associated twenty-two of Chambers's paintings with prints: nine by Bartlett, seven by Milbert, and three by Durand. Bartlett's work was published in Nathaniel Parker Willis's *American Scenery* (London, 1840).

7 Merritt went on to conclude that Durand, in turn, copied his view of the Delaware Water Gap from a print by Thomas Doughty.

8 *Itinéraire pittoresque du fleuve Hudson et des parties latérales de l'Amérique du Nord* (Paris, 1828–29). See *Antiques* 36, p. 21, for a photograph of Milbert's original oil painting, then in the possession of Joe Kindig, Jr. of York, Pa.

9 Julia D. Sophronia Snow, "Delineators of the Adams-Jackson American Views," *Antiques* 36, no. 1 (July 1939): 21.

10 All of these buildings were subsequently razed to make way for new construction. The dating of Milbert's original painting to the early 1820s is based upon his known return to Paris in 1824.

11 Holley, ed, *The Picturesque Tourist,* 57. The author later describes the convenience and ease of travel up and down the Hudson by steamship and the unique combination of history and beauty to be found at West Point:

No stranger should leave this place without visiting the public buildings, Kosciusko's monument, and a wild and romantic retreat near the water's edge called "Kosciusko's Garden," the ruins of old Fort Putnam, which commands a view of West Point, the Hudson River, and the surrounding mountain scenery….

If the visitor tarries through the day at this attractive place, any time during the summer months, when the hotel usually is thronged with fashionable people from every section of the Union, he will have an opportunity to view West Point in all its loveliness. (58–9)

Kathleen Foster, curator of American Art at the Philadelphia Museum of Art, notes in recent correspondence with the Memorial Art Gallery the existence of similar views in the Albany, Minneapolis, and Shelburne art museums and describes having seen photographs of many others, either lost in the market or held in private collections (e-mail communication from Kathleen Foster to Marjorie Searl, March 18, 2005).

12 Holley, ed, *The Picturesque Tourist,* 57. Another guide book puts the traveler up front on the morning boat for the best of all views:

[The traveler is] kept in agreeable suspense for a few minutes while near the Caldwell landing…gazing up at the stupendous elevation close at hand, that the steamer almost brushes or grazes in its panting and rapid course….

When at about fifty miles from New-York, we catch the first glimpse of the ruins of *Fort Putnam,* in a northwest direction, five hundred and ninety-eight feet above the river, peering over the brow of the hill on the left, and soon after, of the out-works and buildings attached to the United States military academy at West Point…one hundred and eighty-eight feet above the river….(*The New York State Tourist,* 22–3)

13 On the evidence of contemporary municipal directories "portraiture," for instance, was offered only after 1830.

Unknown American Artist
3 Portrait of Colonel Nathaniel Rochester
(before 1831)

1 Multi-focal glasses of the type worn by the sitter were invented and patented by the English optician John Richardson in 1797 and were in relatively common use in the nineteenth century. Charles E. Letocha, M.D., "The Invention and Early Manufacture of Bifocals," *Survey of Ophthalmology* 35, no. 3 (November–December 1990): 232.

2 Since the provenance is murky, it can't be known when the attribution was made. The painting was acquired in 1934 from the estate of Emilie Jane Logan, Rochester's grand-niece, by Thomas J. Watson, through the auspices of Mrs. Chester Dale. (See MAG curatorial files.) But MAG's records are inconsistent about the provenance. The original ownership information was provided by the curator of the Burlingham Collection from which the painting was sold in 1934, Fleetwood Brownridge. He provided the genealogical information that was made available when the painting was acquired by Hiram Burlingham in 1928. This has been confused with provenance information, leading to an assumption that the painting went originally to Nathaniel's brother John, then to John's daughter Artemisia, then to her daughter Emilie Jane Logan. But this is based on speculation, for as yet there has been no adequate documentation proving that the painting was in the hands of either John Rochester or Artemisia.

On another note, further research is needed into the possibility of Nathaniel Rochester having sat for a portrait while in Kentucky managing business interests, especially in light of the fact that Emilie Jane Logan lived in Kentucky.

The Nathaniel Rochester family papers are preserved in the Department of Rare Books, Rush Rhees Library, the University of Rochester. A good source of information about Col. Rochester is Blake McKelvey, "Colonel Nathaniel Rochester," *Rochester History* 24, no. 1 (January 1962): 1–23.

3 The information regarding Audubon's career comes from Edward R. Foreman, "Discovery of an Audubon Portrait of Col. Nathaniel Rochester," The Rochester Historical Society Publication Fund Series, vol. 7 (1928): 1–5, and, more recently, from Richard Rhodes, *John Jay Audubon: The Making of an American* (New York: Knopf, 2004).

Nearly fifty portraits have been attributed to Audubon, almost all of them unsigned. The style of these paintings varies widely. Most contain obvious "primitive" elements and only a few, including a signed self-portrait from 1822 and a painting of Daniel Boone from the same period, even begin to approach the confident and accomplished technique so evident in MAG's portrait of Colonel Rochester. A 2005 exhibition at the Portland Museum in Louisville, Kentucky, called "If Not Audubon, Who?" suggests that in the Kentucky region alone there are many portraits presenting similar attribution challenges. MAG would like to thank Nathalie Andrews of the Portland Museum, Louisville, Kentucky, for her insights, as well as Dr. Linda Dugan Partridge of Marywood University, Scranton, Pennsylvania.

4 Foreman, "Discovery of an Audubon Portrait," 3-4.

5 Mary M. Burdick noted this information in a paper, "Audubon and the Portrait of Nathaniel Rochester," written for a museum course at the University of Rochester, February 20, 1942, p. 14. The paper is housed in MAG's curatorial files.

6 A January 8, 1984 article in the Rochester *Democrat and Chronicle* questioned the identity and painter of the Memorial Art Gallery's portrait, citing Shepard's criticisms voiced a decade and a half earlier. Shepard, however, refused to be interviewed for the article.

7 Rood and his brother are also the owners, by inheritance, of a portrait of one of Rochester's sons, Nathaniel Thrift Rochester, which is painted from a similar perspective and whose subject bears a considerable resemblance to the sitter for the Memorial Art Gallery's painting.

8 Sketches related to the Rochester Historical Society's portraits of Nathaniel and Sophia were purchased in the 1990s by a Rochester descendant. A recent examination has revealed that they are copies, possibly made by V. Payson Shaver in connection with Henry O'Reilly's *Sketches of Rochester,* published in 1838. Another Historical Society version exists in the same collection signed "J. Gauntt." Jefferson Gauntt, an itinerant portrait painter from New York City, recorded in his journal starting a portrait of "Old Mrs. Rochester" on September 2, 1830.

Writing about the engraving of the Historical Society version of Nathaniel Rochester's portrait, which is reproduced in *Sketches of Rochester,* O'Reilly states that this image, which became the most popular view of the Colonel, was taken "from a painting made by Harding a few years before Colonel Rochester's death" (p. 383). O'Reilly could have been referring to either Horace Harding or his more distinguished brother, Chester, as both practiced portraiture from time to time and made limited visits to the area. It is also quite possible that Jefferson Gauntt painted Colonel Rochester as well as Sophia, but so far the family has not made that painting accessible.

9 Helen Rochester Rogers, the descendant who insisted that the inscription on the back of the MAG portrait was in her ancestor's hand (see note 5 above), was the owner of the "Hagerstown Bank" pastel portrait, which had been given to her just prior to World War II by the then bank president. She took a great interest in promoting the Rochester family and its legacy to the City. The portrait hangs at the Campbell-Whittlesey House, which is a part of the Landmark Society complex in Corn Hill, Rochester.

10 Sophia Rochester's will, dated April 29, 1842 (Monroe County Surrogate's Court, File No. 1846-40), makes specific reference to the "family pictures" which she bequeathed to her then unmarried daughter, Luisa. Sons Thomas, Henry, and Nathaniel T. Rochester were named as her executors. According to Hart Rogers, a great grandson of the Colonel, a portrait set of Nathaniel and Sophia (the Rochester Historical Society version) once in his possession also bore a reverse legend, "Colonel Nathaniel Rochester. Taken 1822, aged 70." These are now in the possession of Rochester descendants.

11 For three years, beginning in 1821, Nathaniel Rochester had led a group of local businessmen in seeking a charter from the State of New York for Rochester's first bank. This was to be Rochester's last significant financial endeavor, his health sliding into a steady decline thereafter. Nineteenth-century American banks were frequently founded on a local businessman's reputation and, as in the case of the Hagerstown Bank, a portrait of the founder was often commissioned for a prominent place in the lobby. The Memorial Art Gallery's strong rendering of Colonel Rochester would have suited this requirement admirably.

12 For Harding, see note 8 above. Gilbert's candidacy was presumably based upon stylistic comparisons and his long career as a Rochester portrait painter. However, a fairly encyclopedic retrospective of Gilbert's work near the close of his life fails to list any portrait of Nathaniel Rochester in its catalogue. For additional information on Gilbert, see Clifford M. Ulp, "Art and Artists in Rochester," *Rochester Historical Society Publications* 14 (1936): 30–32.

13 There is no record of what reply, if any, was given to Mrs. Russell, but she cannot be referring to MAG's painting, which was acquired in 1934. However, given the demand in the nineteenth century for Rochester's portrait, which led to copies of other versions, there may be multiples of the MAG portrait as well.

4 Ammi Phillips
Old Woman with a Bible (ca. 1834)

1 Much of what we know today about Ammi Phillips's oeuvre comes from the work of Barbara and Lawrence B. Holdridge, "Ammi Phillips," *Art in America* 48, no. 2 (1960): 98–103 and "Ammi Phillips, 1788–1865," *Connecticut Historical Society Bulletin* 31, no. 1 (1966); and their catalogue for the 1968 exhibition of his works, *Ammi Phillips: Portrait Painter 1788–1865*, Museum of American Folk Art (New York: Clarkson N. Potter, 1969), as well as from the introduction to the catalogue by Mary Black, the first director of the Museum of American Folk Art. A catalogue was also published for a second exhibition held at the museum in 1994: *Revisiting Ammi Phillips: Fifty Years of American Portraiture,* ed. Stacy C. Hollander, with an essay by Mary Black in association with Barbara and Larry Holdridge (New York: Museum of American Folk Art, 1994).

2 The exhibit opened in November 1930 at the Newark Museum of Art in Newark, N.J. curated by Holger Cahill. Excerpts from the original exhibition essays were used in the Memorial Art Gallery brochure. A subsequent exhibition, also curated by Cahill, American Folk Art: The Art of the Common Man in America 1750–1900, opened at MoMA in 1932. Cahill went on to become head of the Index of American Art during the 1930s.

3 Although MAG's portrait is unsigned, it bears marks noted during its 1983 conservation that are consistent with Phillips's unique way of building his wooden stretchers, i.e., joining the corners in a blind mortise with tenon. (Conservation report from Intermuseum Laboratory, Allen Art Building, Oberlin, Ohio, December 9, 1983, by Michael Heslip, Acting Chief Conservator.) According to Patricia Anderson, "Ammi Phillips's *Old Woman with a Bible:* Expanding the Definition of American Naïve Art," *Porticus* 8 (1985): 27:

> Although nothing is known of the history of the Gallery portrait, attribution to Phillips is easily made on stylistic and technical grounds. Moreover, we can place the portrait fairly confidently within Phillips's career by comparing it with other works. The painting is said to have been found in Ontario, New York, east of Rochester, but comparison shows that it clearly belongs to the body of work Phillips produced as an itinerant in a region encompassing Kent, Connecticut, and Amenia, New York, in the 1830s.

Anderson notes: "It was purchased from a Caledonia, N.Y., art dealer [in 1984] who could provide no information on the portrait's history [other than that he'd found it in Ontario, New York]."

4 Gerald C. Werkin, "Foreword," in Stacy C. Hollander, *Revisiting Ammi Phillips: Fifty Years of American Portraiture,* exhibition catalogue (New York: Museum of American Folk Art, 1994), 7. The biblical source of the name is Hosea: 2:1; it means "my people."

5 The Holdridges (see note #1 above) were the first to combine known works by Phillips with works by the so-called "Border Limner" and the Kent Portraitist. The Border Limner was so named for the number of portraits done in the area of the borders of New York, Massachusetts, and Connecticut from 1812 to 1819. The Kent portraits, from 1829 to 1838, were named for Kent, Connecticut, where many were first found. See Holdridge and Holdridge, "Ammi Phillips," and Mary Black, "Ammi Phillips: Portrait Painter," in Hollander, ed., *Revisiting Ammi Phillips.* Also see Anderson, "Ammi Phillips's *Old Woman with a Bible,*" 30.

6 Stacy C. Hollander, "Introduction," in Hollander, ed., *Revisiting Ammi Phillips,* 11.

7 Ibid., 12.

8 Anderson, "Ammi Phillips's *Old Woman with a Bible,*" 29, 30.

9 Black, "Ammi Phillips: Portrait Painter," 16.

10 Ibid., 13-14.

11 Ibid., 16.

12 See Holdridge and Holdridge, *Ammi Phillips: Portrait Painter 1788–1865* for examples (e.g.: Phillips's *Cornelius Allerton,* ca. 1817, #32, Art Institute of Chicago; *William Cantyne De Witt,* ca. 1823, #79, private collection; and, late in his career, *Elizabeth Harris Husted,* 1862, #277, private collection).

13 R. Turner Wilcox, *The Mode in Costume* (New York: Charles Scribner's Sons, 1942), 262.

14 *Lady in White* (ca. 1820, National Gallery of Art).

15 Anderson, "Ammi Phillips's *Old Woman with a Bible,*" 30.

16 Linda Baumgarten, *What Clothes Reveal: The Language of Clothing in Colonial and Federal America* (Williamsburg, Va.: The Colonial Williamsburg Foundation with Yale University Press, 2002), 176.

17 Anderson, "Ammi Phillips's *Old Woman with a Bible,*" 34.

18 Holger Cahill, *American Primitives* (Newark, N.J.: The Newark Museum, 1930), 9.

19 E-mail, September 6, 2005, from Virginia Mecklenberg, senior curator at the Smithsonian American Art Museum, Washington, DC, to Marjorie Searl, chief curator at MAG.

Milton W. Hopkins
5 *Pierrepont Edward Lacey and His Dog, Gun* (1835-36)

1 Jacquelyn Oak, et al., *Face to Face: M. W. Hopkins and Noah North,* exhibition catalogue, Museum of Our National Heritage, Lexington, Mass., 1988, 94–96. Pierrepont's grandfathers, farmers Isaac Lacey (b. 1780) and William Pixley (1784–1853), also participated in the anti-Masonic movement and Whig politics in the Rochester area. Pixley and Hopkins testified at the same trial of an alleged anti-Masonic conspirator in 1828. See Edward Evans Pixley and Franklin Hanford (compilers), *William Pixley of Hadley, Northampton, and Westfield, Mass. and Some of His Descendants* (Buffalo, N.Y.: P. Paul and Co., 1900), 34–35.

2 Pixley, *William Pixley of Hadley...,* 63.

3 Oak, *Face to Face,* 23–4. Hopkins's portrait painting advertisement in the Albion newspaper, *The Orleans Advocate and Anti-Masonic Telegraph,* in 1833, states that "Lessons will be given to pupils who may desire, for a few weeks." North, who lived in Alexander, some twenty miles south of Albion, may have started to study painting with Hopkins at this time.

4 Ibid., 39–54. Research subsequent to the publication of Oak, *Face to Face* has revealed that Hopkins was a leader in the underground railroad in Ohio and traveled extensively in the south. In an 1842 letter (privately owned by the family) to his wife, Hopkins writes as he comes north from Mississippi: "I have barely escaped with my life….a number of rowdies…agreed to reek their vengeance against the abolitionists on me….[they] followed me in order to get up a mob and lynch me before I could get on a steamboat….I will write again if I live to get into a free state…."

Notes

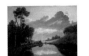

6 George Harvey
Pittsford on the Erie Canal (1837)

1 "Low Bridge, Everybody Down (The Erie Canal)" by Thomas S. Allen, 1905 (http://www.eduplace.com/ss/hmss/8/unit/act4.1.2.html).

2 David E. Nye, *American Technological Sublime* (Cambridge, Mass: The MIT Press, 1994), 34–35.

3 Ibid., 37, 39.

4 "The Erie Canal," Rochester Images, Central Library of Rochester and Monroe County, N.Y. (http://www.rochester.lib.ny.us/rochimag/4thmain.html).

5 It is not known when, exactly, George Harvey was in Pittsford. He may have come during the two years he claims to have traveled to the "far west," 1820–1822. This would have corresponded with the period of time during which the canal was being built.

6 Robert Corby, mayor of Pittsford Village, generously gave his opinion about the buildings in the painting, and Audrey Johnson, Pittsford Town Historian, has provided important help in determining the location of this scene. Thomas Grasso, President of the Canal Society of New York State, also suggests the location as being a view from what is now Jefferson Road, or from the Monroe Avenue bridge at the west end of the village (e-mail to the author, March 31, 2006). The painting is related to a watercolor in the collection of the Fenimore Museum in Cooperstown, New York (*Pittsford on the Erie Canal*) although the village buildings in the distance are quite different. It may be assumed that the artist took liberties with some of the details in one or both paintings. In fact, if the painting is compared with the image of the *Village of Rochester* on p. 31, it might be inferred that Harvey placed the steeples and cupola from Captain Basil Hall's 1827–28 sketch in the background of his oil painting while retaining the Pittsford terrain in the foreground.

7 A good source for research on George Harvey is Christine Huber Jones, "George Harvey's Atmospheric Landscapes: Picturesque, Scientific and Historic American Scenes" (master's thesis, University of North Carolina, 1989).

8 George Harvey, *Harvey's Scenes in the Primeval Forests of America…* (London, 1841), 9.

9 Hastings was not far from Washington Irving's home, Sunnyside, in Tarrytown, for which Harvey provided design assistance.

10 N.A., *The Anglo-American* 2, no. 10 (December 30, 1843): 239. This type of portfolio had been produced by a number of other entrepreneurial artists. One example is *Picturesque View of American Scenery*, 36 aquatint engravings by John Hill after watercolors by Joshua Shaw (1835). There seemed to be a European market for these in response to the belief that the American wilderness was unique and, also, ironically, fast-disappearing—not unlike the trips to Alaska that are being promoted in the twenty-first century ("see the glacier before it melts").

11 George Harvey, *A Descriptive pamphlet of the Original Drawings of American Scenery…* (London, 1850), 24.

12 "Exhibition of the National Academy of Design," Editor's Table, *The Knickerbocker* 9 (June 1837): 618. The MAG oil painting has been called: *Dead Calm, Afternoon View near Pittsford on the Erie Canal*; *Afternoon—Dead Calm: Pittsford on the Erie Canal*; and *Late Afternoon—Calm on the Erie Canal*. The National Academy of Design records indicate that the original owner was Moses Grinnell, a wealthy merchant active in Republican politics, who also had a distinguished art collection and whose wife was a niece of Washington Irving (see note 9 above). In 1854, seven years following the National Academy of Design exhibition that included the canal painting from Grinnell's collection, he backed an amendment to the New York State constitution to expand the Erie Canal.

13 George Harvey, "Introduction to the Eight Lectures…Before… The Royal Institution of Great Britain, in 1849," in *Harvey's Illustration of the Forest Wilds & Uncultivated Wastes of Our Country…* (Boston, 1851), 3.

14 Ibid., 6.

15 David Nye, *America as Second Creation: Technology and Narratives of New Beginnings* (Cambridge, Mass.: MIT Press, 2003), 1.

16 A similar case is made by Christine Huber Jones about Harvey's *Atmospheric Landscape, Afternoon Rainbow–The Boston Common from Charles Street Mall*: "Harvey's painting is about harmony among citizens and between people, the landscapes, religion and government" ("George Harvey's Atmospheric Landscapes," 91).

17 An 1831 minister's journal gives us a glimpse of the canal experience through the eyes of a traveler:

> Friday July 8: After spending another night on the canal, and having passed through many thriving villages I landed at Pittsford….
>
> Saturday July 9th.—After an uncomfle. breakfast at the Inn, set off for the residence of Mr. Billinghurst….They lived in a good brick house, the old log one having been removed….The weather chill & I ill.
>
> Sunday July 10th: Preached two sermons to very att. congregns.—There are in this neighbourhd. Many Universts. or call them Unitarians if you will…
>
> Tuesday July 12th: Still very unwell but induced to visit the village 2 1/2 miles distant to deliver an evening lecture. had a large and an attentive congn….In the morning of this day visited several individuals, and found them all liberally inclined
>
> Wednesday July 13th. Left Pittsford for Rochester, a busy town of the great Erie Canal—a popn. Of 11,000—and 16 years since there was not one house on the site of this now flourishg. town.—
>
> There is an abundance of water power here, the Genessee, a considerable river, having a considerable fall—on the NE of the town, one of these cataracts assumes an appearance of the sublime. The whole body of this river falls 96 feet in one unbroken sheet, over a ledge of rocks stretching across the river. A waterfall however looks sadly out of place in the midst of a populous town.

From *An Englishman's Journey along American's Eastern Waterways: The 1831 Illustrated Journals of Herbert Holtham's Travels*, ed. Seymour I. Schwartz (Rochester: Rochester Museum and Science Center and the Univ. of Rochester Press, 2000). Thanks to Dr. and Mrs. James Stewart for bringing this volume to my attention.

18 Frances Trollope, *Domestic Manners of the Americans*, ed. Donald Smalley, with a history of Mrs. Trollope's Adventures in America (New York: Alfred A. Knopf, 1949), 334.

19 "The Great Water Highway through New York State, 1829" (http://www.history.rochester.edu/CANAL/BIB/1829). This account is not technically a travel "book," for it was published in a Philadelphia periodical, *The Ariel*, in 1829–30 under the title, "Notes on a Tour through the Western Part of the State of New York."

20 Nathaniel Hawthorne, "The Canal Boat." This sketch originally appeared in the *New-England Magazine* 9 (December 1835): 398–409 (http://www.history.rochester.edu/CANAL/BIB/hawthorne/canalboat.htm).

21 Nye, *The American Sublime*, 39.

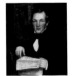

7 Asahel Lynde Powers
Portrait of a Dark-haired Man Reading the "Genesee Farmer" (ca. 1839)

1 Although there is an example of Powers's including a newspaper in the editor's portrait—*Benjamin Clarke*, 1840 (Fogg Art Museum, Harvard University), editor of the *Fort Covington Gazette*— it is unlikely that the MAG work is a portrait of Luther Tucker. There is no evidence that Powers was anywhere near the Rochester area in 1839; in fact all evidence points to him living and painting in Vermont and northern New York. In addition, Luther Tucker's age of thirty-seven years in 1839 does not match the exceedingly youthful appearance of this man.

2 *The Genesee Farmer*, January 1, 1831, vol. 1, no. 1.

3 Letter from Thomas Loraine McKenney to unknown recipient dated June 12, 1826, in his *Sketches of a Tour to the Lakes, of the Character and Customs of the Chippeway Indians, and of Incidents Connected with the Treaty of Fond du Lac* (Baltimore, 1827), 85–86.

Notes

4 *The Genesee Farmer*, October 12, 1839, vol. 9, no. 41.

5 For an in-depth exploration of Asahel Powers see Nina Fletcher Little, *Asahel Powers: Painter of Vermont Faces*, exhibition catalogue, Abby Aldrich Rockefeller Folk Art Collection, Williamsburg, Virginia (Williamsburg, Va.: Colonial Williamsburg Foundation, 1973).

6 Ibid., 40, no. 41. The only concrete piece of evidence of this endeavor is an oil on cardboard painting believed to be a copy of a European engraving, *Study of a Nude* (1837, Shelburne Museum, Vermont).

7 Similar sketches are on the verso of another Powers's painting from this period, *Boy Studying Geometry*, October 1839. See Little, *Asahel Powers*, 41, no. 43. Also inscribed on the verso of the MAG portrait are "Painted by AL Power" and "1839." Beginning around 1836, Powers began excluding the "s" from his signature.

8 *Plattsburgh Republican*, November 7, 1840.

9 Little, *Asahel Powers*, 11. Powers's success in New York made for a prosperous period, during which he married, though when he later moved to Olney, Illinois, to join his parents, his wife remained in Plattsburgh for unknown reasons. No evidence exists of Powers painting in Illinois. When he died at the age of thirty-three on August 20, 1843, no painting equipment was listed among his modest estate.

8 DeWitt Clinton Boutelle
The Indian Hunter (1846)

1 James Fenimore Cooper. *The Last of the Mohicans*, pt. 2 of *The Leatherstocking Saga*, ed. Allan Nevins (New York: Pantheon, 1954), 295–96.

2 U.S. census figures: 1830—12,866,020; 1850—23,191,876. Figures taken from *Measuring America: The Decennial Census from 1790 to 2000* (U.S. Census Bureau, 2002), Appendix A.

3 For a thorough discussion of the topic as it pertains to the visual arts, see Julie Schimmel's essay, "Inventing 'the Indian,'" in *The West as America: Reinterpreting Images of the Frontier* (Washington, DC: Smithsonian Institution, 1991), 149–89.

4 The British poet Eliza Cook (1818–1889) wrote these words, which became the lyrics to the English parlor song "The Indian Hunter," published ca. 1835. The American sheet music associated with this song was issued at New York by Jas I. Hewitt & Co., ca. 1836–37. (MAG curatorial files.)

5 William Cullen Bryant (1794–1878), lawyer, poet, editor, and abolitionist, was one of the most influential American literary figures of the nineteenth century. Bryant wrote a number of poems with the "disappearing race" as the central theme.

6 For the Erie Canal, see essay 6 in this volume on George Harvey.

7 Not much is known of the particulars surrounding Boutelle's life or career. The facts and dates stated here are taken from "DeWitt Clinton Boutelle," *M. and M. Karolik Collection of American Paintings, 1815 to 1865* (Boston: Harvard University and The Museum of Fine Arts, 1949), 137.

8 See essays in this volume on both Cole and Durand.

9 Cooper, *Last of the Mohicans*, 462.

9 Thomas Cole
Genesee Scenery (ca. 1846–47)

1 Much of Cole's biographical information is taken from an early published source, *The Life and Works of Thomas Cole*, written by Louis Legrand Noble, Cole's pastor, friend, and first biographer. It was first printed in 1853 under the title *The Course of Empire, Voyage of Life, and other Pictures of Thomas Cole, N.A., with Selections from his Letters and Miscellaneous Writings: Illustrative of his Life, Character, and Genius*. The title was shortened by the third printing in 1856.

2 Noble, *Life and Works of Thomas Cole*, 35, 314–15. John Trumbull (1756–1843) and Asher B. Durand (1796–1886) were well-respected and successful painters by this time. For Durand, see the essay in this volume.

3 I am indebted throughout this article to the scholarship of Howard Merritt, professor emeritus of art history, University of Rochester. His work on Cole, especially in regard to the history behind *Genesee Scenery*, was invaluable. Most helpful was his exhibition catalogue *The Genesee Country*, published in 1975 by the Memorial Art Gallery. It was through the generosity of Howard and Florence Merritt that *Genesee Scenery* entered the collection of the Memorial Art Gallery.

4 *Rochester History* 56, no. 4 (Fall 1994): 3.

5 Ibid., 4. Due to financial strain, construction on the canal was delayed between 1842 and 1848. The canal was officially abandoned in 1878, and the canal banks were sold off as railroad beds.

6 Letter from Samuel Ruggles to Thomas Cole, July 29, 1839, Collection of the New York State Library, Albany, ALS, 29 July 1839, SC10635, box 2, folder 9.

7 Letter from Thomas Cole to Maria Cole, August 3, 1839, quoted in Noble, *Life and Works of Thomas Cole*, 204.

8 Professor Merritt puts the construction date of Hornby Lodge at 1837–38, although in most publications it is given as 1840. I have not found any documentation that proves the 1840 date is correct. Documentation of Cole's visit to the area exists in the form of a letter home to his wife dated August 3, 1839 (see note 7 above). Cole's sketches of Hornby Lodge from that visit date Hornby Lodge to at least August 1839. Elisha Johnson moved to the Genesee to begin overseeing construction of the Canal around 1837, and in all likelihood would have moved quickly to build a home there for his family.

9 This quote from Cole appears in his hand as a caption on a 1839 pencil drawing, *Hornby Lodge* (The Detroit Institute of Arts, William N. Murphy Fund). The blasting of the rock cliffs underneath Hornby Lodge for the canal damaged the structure beyond repair. It was torn down in 1849.

10 *On the Genesee* (pencil; Detroit Institute of Arts, William N. Murphy Fund).

11 *Genesee Scenery (Mountain Landscape with Waterfall)* (1847, Museum of Art, Rhode Island School of Design).

12 *Portage Falls* came into the Seward House in 1841. Thanks to Peter Wisbey, Director, Seward House, Auburn, New York, for his assistance on this project.

13 Thanks to Leonora K. Brown, Historic Site Assistant, New York State Office of Parks, Recreation and Historic Preservation, located at Letchworth State Park, for her assistance on this project.

14 The existence of a camp stool and portable sketch box belonging to Cole is evidence of the artist painting directly from nature. See Eleanor Jones Harvey, *The Painted Sketch: American Impressions from Nature, 1830-1880* (New York: Dallas Museum of Art in association with Harry N. Abrams, 1998), 120.

15 "I think that a vivid picture of any object in the mind's eye is worth a hundred finished sketches made on the spot—which are never more than half true—for the glare of light destroys the true effect of colour & the tones of Nature are too refined to be obtained without repeated paintings and glazings." Thomas Cole to Baltimore art patron Robert Gilmor, undated draft of a letter after May 10, 1835; quoted in Harvey, *The Painted Sketch*, 30.

16 Letter from Thomas Cole to Asher B. Durand, January 4, 1838, cited in Noble, *Life and Works of Thomas Cole*, 185.

10 Lilly Martin Spencer
Peeling Onions (ca. 1852)

1 To date the most extensive study of Spencer's life and career is Robin Bolton-Smith and William H. Truettner, *Lilly Martin Spencer 1822–1902: The Joys of Sentiment* (Washington, DC, National Collection of Fine Arts, 1973). For a shorter overview, see Elsie Freivogel, "Lilly Martin Spencer," *Archives of American Art Journal* 12 (1972): 9–14.

2 Spencer depicted this theme and gesture in similar extant images: *Peeling Onions*, pencil on paper (ca. 1848–52, Munson-Williams-Proctor Institute); *The Young Wife: First Stew*, oil on canvas (1854, private collection); *The Young Wife: First Stew*, oil on board (ca. 1856, Ohio Historical Society).

3 Mrs. [Elizabeth Fries] Ellet wrote that Spencer uses "the highly-finished German style," in *Women Artists in All Ages and Countries* (New York: Harper & Bros., 1859), 325. Also see Donelson F. Hoopes, *The Düsseldorf Academy and the Americans* (Atlanta: High Museum of Art, 1972), and Henry Nichols Blake Clark, "The Impact of Seventeenth-Century Dutch and Flemish Genre Painting on American Genre Painting, 1800–1865" (PhD. diss., Univ. of Delaware, 1982), 3, 57–87.

4 For more about the social and legal limitations of women in the American work force, see Julie A. Matthaei, *An Economic History of Women in America: Women's Work, the Sexual Division of Labor, and the Development of Capitalism* (New York: Schocken Books, 1982), 102.

5 Bolton-Smith and Truettner, *Lilly Martin Spencer*, 11–12; Wendy Jean Katz, *Regionalism and Reform: Art and Class Formation in Antebellum Cincinnati* (Columbus: The Ohio State Univ. Press, 2002), 60–62; Parke Godwin, *A Popular View of the Doctrines of Charles Fourier*, 2nd ed. (New York, 1844; repr., New York: AMS Press, 1974), 58.

6 For an exploration of Spencer's formative years, see chap. 2 in Katz, *Regionalism and Reform.*

7 Bolton-Smith and Truettner, *Lilly Martin Spencer*, 19–28.

8 Ibid., 25–27; Katz, *Regionalism and Reform*, 78.

9 Ellet, *Women Artists*, 317.

10 Letter from LMS to her parents, December 1859; quoted in Bolton-Smith and Truettner, *Lilly Martin Spencer*, 55.

11 For excellent explorations of the genre tradition in the nineteenth-century United States, see Elizabeth Johns, *American Genre Painting: The Politics of Everyday Life* (New Haven & London: Yale Univ. Press, 1991) and Patricia Hills, *The Painters' America, Rural and Urban Life, 1810–1910* (New York: Praeger, 1974).

12 Contemporary reviewers did not hesitate to outline Spencer's marketing and financial difficulties—or to suggest that they stemmed from her gender. See Ellet, *Women Artists*, 322–26; Henriette A. Hadry, "Mrs. Lilly M. Spencer," *Sartain's Magazine* 9 (August 1851): 152–54; and "Editorial Etchings," *Cosmopolitan Art Journal* 1 (July 1856): 27.

13 For discussions of Spencer's depictions of her household employees, see chap. 3 in Elizabeth L. O'Leary, *At Beck and Call: The Representation of Domestic Servants in Nineteenth Century American Painting* (Washington, DC: Smithsonian Institution Press, 1996). Recent studies, while acknowledging Spencer's use of her servant as model, interpret her images of working women more broadly as housewives. See Johns, *American Genre Painting*, 163–64, 239n39; David Lubin, *Picturing a Nation: Art and Social Change in Nineteenth-Century America* (New Haven: Yale Univ. Press, 1994), 180–83.

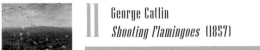

11 George Catlin
Shooting Flamingoes (1857)

1 *New York Morning Herald*, November 28, 1837, p. 1, on the occasion of Catlin's departure for Europe with his initial Indian Collection, which included three hundred individual portraits.

2 Joseph Harrison ultimately preserved Catlin's collection, but not before the artist undertook the enormous task of replicating it from cartoons and sketches of the original works. The collection is now in the Smithsonian.

3 *Shooting Flamingoes*, the Memorial Art Gallery's painting, was acquired in 1941 from the collection of Mrs. E. Sanderson Cushman. It had descended in the Colt family through Elizabeth Hart Jarvis Colt's sister's family (Hetty Jarvis Robinson) to her great granddaughter, Mrs. Cushman, who is thought to have owned nine Catlin paintings from this series; they originally hung in Colt's billiard room at Armsmear, his Hartford mansion. William Hosley, author of *Colt: The Making of an American Legend* (Amherst: Univ. of Massachusetts Press, 1996), was most helpful in providing this information. Elizabeth Mankin Kornhauser, Chief Curator and Krieble Curator of American Paintings and Sculpture, Wadsworth Athenaeum, confirmed that the Catlin paintings hung in Colt's billiard room at Armsmear (e-mail communication with the editor, February 28, 2005). The numbers of paintings produced by Catlin for Colt varies depending on the source. A letter in the MAG curatorial file from the Peabody Museum of Natural History refers to the "original Colt Arms Collection…of 10 paintings: The collection was broken up in 1940 and only four remain to a member of the original family, Mrs. E. Sanderson Cushman of New York City" (letter to MAG, May 29, 1962, from Diana L. Ross, Public Relations Dept., Peabody Museum of Natural History, Yale University). According to Western scholar Brian Dippie:

> Eager to make the case for their adoption [Colt guns] he [Colt] had Catlin paint a series of twelve pictures showing Colts being employed in the field. The terms of their agreement are unclear, but Catlin completed the order by 1857, and the Colt's Patent Fire-Arms Manufacturing Company subsequently used the paintings in its advertising. (*Catlin and His Contemporaries: The Politics of Patronage* [Lincoln: Univ. of Nebraska Press, 1990], 347)

Hosley (the author of the Colt book cited above) also says that there were twelve paintings.

4 The Gallery's painting is signed "G. Catlin 1857" and is inscribed on the back of the stretcher: "Geo. Catlin Buenos Ayres 1857 View of Etretat, a bathing [place?] 20 miles from Havra [Le Havre]." Since Etretat is in France, twenty miles from Le Havre, this inscription suggests that Catlin either reused this stretcher or stretched another canvas over the original. The conservation report in the MAG curatorial files indicates that when the painting was treated at the Intermuseum Laboratory at Oberlin College in 1967, two canvases were attached to the stretcher.

In South America Catlin painted on easily transportable paper and bristol board, producing his finished work in the studio. Memorial Art Gallery communications suggest the existence of other versions of *Shooting Flamingoes*, including a gouache and water color painting in the collection of the Museum of Fine Arts, Houston. In 2000 yet another version was offered for sale to the public by M. Knoedler & Co.

5 George Catlin, *Last Rambles Amongst the Indians of the Rocky Mountains and the Andes* (1868), chap. 7. During the nineteenth century, flamingo feathers and meat were prized, and the implied relationship between the Colt rifle and more successful flamingo hunting would have been understood by gun buyers.

6 Catlin's continuing loyalty to his Colt would have made his now-deceased friend proud: "I…with 'Sam' in hand and a six-shot revolver in my belt, was considered equal to a war party," he wrote in *Last Rambles* (p. 262). Catlin was not the only artist to paint Sam Colt's products. William Harnett's *The Faithful Colt* (1890) is a prized holding of Hartford's Wadsworth Athenaeum collection.

7 "But, before picking up my birds, I had been obliged to pick up my negro Indian boy; he had had no idea of my firing more than once, and my agitation and somewhat of confusion in turning to fire right and left, and withed up in a bunch of bushes filled with smoke, the sharp breech of my rifle had struck him on the temple, and knocked him helpless down, without my knowing it. He had fallen backwards, entangled in his bushes, and was lying on his back, imploring me to be merciful. He thought I had shot him, and that I was going to shoot him again" (*Last Rambles*, 284–5).

8 In describing his preparations for the flamingo hunt, Catlin notes that "My cylinders, which my friend Colonel Colt had shaped expressly for shot and ball, I had filled with duck shot, and we began to move forward...."(*Last Rambles*, 282).

9 Catlin associated with and tried to learn from some of the better-known artists of his day including Rembrandt Peale, Thomas Sully, and John Neagle, but had difficulty in producing a competitive product. William Truettner, *The Natural Man Observed: A Study of Catlin's Indian Gallery* (Washington, DC: Smithsonian Institution Press, 1979), 86.

10 Despite his well-deserved reputation as a preserver of Indian culture and defender of their rights, Catlin has been the subject of revisionist attacks, owing to his underlying desire to profit from the enterprise. In a recent essay ("Green Fields and Red Men," in *George Catlin and His Indian Gallery*, ed. George Gurney and Therese Thau Heyman, exhibition catalogue, The Smithsonian Washington, DC, 2002, 30), Brian W. Dippie observed that "Catlin's mission was never simply altruistic. Indians, a contemporary noted, were for him 'a new path to fame and fortune, and while he leaves a memorial to the true Indian uncorrupted native character, he makes a lasting name for himself.'" (Dippie is quoting from an article in the *Philadelphia Evening Post*, reprinted in George Catlin, *Catlin's Notes of Eight Years' Travels and Residence in Europe with His North American Indian Collection*, 2 vols. [London, 1848], 1:225.)

11 An experienced intercontinental traveler, Catlin was obsessed with the rapid development of transatlantic passenger ships and anxious to find a way to profit from it. According to Christopher Mulvey, "George Catlin in Europe," in Gurney and Heyman, eds., *George Catlin and His Indian Gallery*, 78, Catlin "published a pamphlet entitled *Steam Raft: Suggested as a Means of Security to Human Life on the Ocean*."

12 "George did not linger long in London. He went on to Germany to see the Baron von Humboldt, and tell him of geological discoveries he had made in the mountains during his travels. This was a subject of much interest to both men, and made Catlin decide on a second trip to South America and the West Indies" (Marjorie Catlin Roehm, ed., *The Letters of George Catlin and His Family: A Chronicle of the American West* [Berkeley: Univ. of California Press, 1966], 327).

13 Colt arranged to have six lithographs from Catlin's commissioned works published in England by J. M. Gahey. These color prints, measuring 18.5 by 25 inches, are now extremely rare. See the bibliography from *George Catlin and the Old Frontier* (New York: Harold McCracken, 1959), 214. According to Ellsworth S. Grant ("Gunmaker to the World," *American Heritage* 19, no. 4 [1968]: 5–17, 86–89), Catlin's depiction of *Shooting Flamingoes*, described there as "Texas" flamingos, was not among the six images chosen for advertising lithographs by the Colt Mfg. Co.

14 Paul Mellon was one of the purchasers (Cartoons 486 and 487).

15 See Theresa Thau Heyman in "George Catlin and the Smithsonian," in *George Catlin and His Indian Gallery*, 249–71.

16 Since Catlin's time, many of the world's flamingo colonies have been threatened by overhunting and disturbance of nesting areas. Protective legislation and action by conservation groups have begun to minimize the risk of extinction.

Rubens Peale
12 *Still Life Number 26: Silver Basket of Fruit* (1857–58)

1 An excellent source of information on all the Peale family and the interrelationships of the generations is Lillian B. Miller, ed., *The Peale Family: Creation of a Legacy 1770–1870* (New York: Abbeville Press, 1996). See the website for the exhibition, January 25–April 6, 1997, at the San Francisco Fine Arts Museum, http://www.tfaoi.com/aa/1aa/1aa124.htm.

2 Rubens's brothers were Raphaelle (1774–1825), Rembrandt (1778–1860), and Titian (1799–1885).

3 After 1801, the centerpiece was a mastodon exhumed from an Ulster, New York, farm and immortalized in a large painting by Charles Willson Peale, perhaps the first painting of a paleontology dig: *Exhumation of the Mastodon* (1805–08, The Peale Museum, Baltimore City Life Museums).

4 Rubens took over management of The Peale Museum in Philadelphia in 1810 upon his father's retirement. When Charles returned as director in 1822, Rubens took over his brother Rembrandt's failing museum in Baltimore. While a much more inventive showman, he was unable to satisfy the financial backers of the museum, who expected profits from their investments. Rubens added a new museum in New York City to the Peale enterprise in 1824 and left the Baltimore museum to creditors in 1830. In 1837, the Great Crash brought financial ruin to many, including Peale's museum, and he was forced to sell much of the contents to his competition, P.T. Barnum. Most were lost in a subsequent fire. See Wilbur H. Hunter, Jr., "Peale's Baltimore Museum," *College Art Journal* 12, no. 1 (Fall 1952): 31–36.

5 Rubens was proud of his ability to overcome a fragile physical nature in early life and, through experimentation, create a pair of glasses to aid his vision. "It was always thought that I required concave glasses and every degree of concavity was tried in vain. At last I happened to take a large burning-glass and placed it to my eye and to my great astonishment I saw at a distance everything distinctly" ("Memorandum of Rubens Peale," Peale-Sellers Papers, American Philosophical Society, Philadelphia, reel P33, pp. 413–77).

6 See Rubens Peale, "Journal of Woodland Farm," Archives of American Art, Smithsonian Institution, reel D10: 1881–2259.

7 Ibid., entry Monday [March] 2 [1857]: "I painted all day on N.15 and N. 26 as it has been very stormy today, nothing going on out doors...." There is no mention of painting until Tuesday [March] 24: " I arranged my painting apparatus and commenced soon after sunrise and painted all day on N. 26 and 27."

8 Ibid., entry Tuesday [February] 3 [1857]: "George commenced a silver basket with fruit and dead coloured it. N. 26."

9 Charles Coleman Sellers, "Rubens Peale: A Painter's Decade" *Art Quarterly* 23 (1960): 143.

10 See Patricia Anderson, "Rubens Peale's Still Life Number 26: The Chronicle of a Painting," *Porticus* 6 (1983): 35n11.

11 Miller, *The Peale Family*, 177, plate 83.

12 For more on Matthew Boulton, see Eric Delieb, *Matthew Boulton: Master Silversmith 1760–1790* (New York: Clarkson N. Potter, 1971). The basket is illustrated on p. 41. While owning an English-made silver bread basket would not be out of the question for the Peales, there is a possibility that it was procured for them by their friend Benjamin Franklin, who also knew Matthew Boulton in England. As yet, however, there is no evidence to support this enjoyable speculation.

13 William H. Gerdts, *Painters of the Humble Truth: Masterpieces of American Still Life 1801–1939* (Columbia, Mo., and London: Philbrook Art Center with the University of Missouri Press, 1981). See chap. 5, "An Abundance of Still Life, The Still Life of Abundance," esp. p. 83, on changing American tastes, and pp. 88–89, on the impact of the Düsseldorf "school" where many American artists went to study and work. The still lifes of Severin Roesen are a good example of the large scale and overly lush trend in this genre (84–88).

John Frederick Kensett
13 *A Showery Day, Lake George* (ca. 1860s)

1 For a complete discussion of Adirondack prints, see Georgia B. Barnhill, *Wild Impressions: The Adirondacks on Paper: Prints in the Collection of the Adirondack Museum* (Boston: David Godine; Blue Mountain Lake, N.Y.: The Adirondack Museum, 1995).

2 Willis, an American correspondent for the *New-York Mirror* assigned to London from 1831 to 1836, met Bartlett in 1835. Together they convinced the London publisher George Virtue to publish a travel book of American scenery, which was published in two parts in June 1837 and November 1839 in London. Bartlett's sketches were made on his first trip. This large number of highly picturesque views all around the lake document tourists, recreational pastimes, steamboats, hotels, and the lake as a resort.

3 The lake simultaneously epitomized nineteenth-century artistic concepts of the "sublime," the "beautiful," and the "picturesque." Its dramatic vistas and rugged mountains stirred feelings of awe and wonder in viewers, thus endowing nature with the divine characteristics defining the sublime. The lake's pure and limpid waters expressed peace and harmony, thus exemplifying the characteristics of the beautiful. Its aesthetic juxtaposition of mountains, water, islands, trees, and rocks provided the memorable view so eagerly sought by travelers "touring in search of the picturesque." See Sue Rainey, *Creating Picturesque America: Monument to the Natural and Cultural Landscape* (Nashville and London: Vanderbilt Univ. Press, 1994), 26–45. For a discussion of Adirondack art, see Patricia C. F. Mandel, *Fair Wilderness: American Paintings in the Collection of the Adirondack Museum* (Blue Mountain Lake, N.Y.: The Adirondack Museum, 1990), and Caroline M. Welsh, "Paintings of the Adirondack Mountains," *The Magazine Antiques* 155, no. 1 (July 1997): 78–88.

4 *Appleton's Journal of Literature, Science and Art* 1, no. 17 (July 24, 1869).

5 Asher B. Durand Papers, Manuscript and Archives Division, New York Public Library.

6 Kensett made sketching tours every summer between 1841 and 1872, leaving New York City in early July and going back in late October. He made his first trip to the West in 1848 after his return from an extended stay in Europe. He traveled at various times with Durand, Casilear, Benjamin Champney, Jasper Cropsey, Frederic Edwin Church, Thomas P. Rossiter, Sanford Gifford, Regis Gignoux, Worthington Whittredge, and others. See John Paul Driscoll and John K. Howat, *John Frederick Kensett: An American Master* (Worcester, Mass.: Worcester Art Museum; New York and London: W. W. Norton, 1985), 42, 63, 70, 91, 123.

7 Kensett to his uncle, J. R. Kensett, March 30, 1854, as quoted in Andrew Wilton and Tim Barringer, *American Sublime: Landscape Painting in the United States, 1820–1880* (Princeton: Princeton Univ. Press, 2002), 134.

8 See entries on this painting by Tim Barringer in Wilton and Barringer, *American Sublime*, 134–36, and by Carol Troyen in John K. Howat, ed., *American Paradise: The World of the Hudson River School*, exhibition catalogue, The Metropolitan Museum of Art, New York, 1987, 156–57.

9 Alexander Wyant and Roswell Morse Shurtleff, both of whom purchased summer homes in Keene Flats, were particularly influenced by Kensett's personality and art. Shurtleff wrote: "In those days Wyant, and in fact everyone else, looked upon Kensett as our greatest landscape painter." See "Recollections of Keene Valley by R. M. Shurtleff," unpublished manuscript in the Keene Valley Free Library, as quoted from notes in Margaret O'Brien artist files, Adirondack Museum Library.

10 Notations for sixty-five paintings and studies, identified in the Adirondack Museum artist files from the exhibition records of the National Academy of Design; The Brooklyn Academy of Art; auction records from the Robert Somerville auction sale after Kensett's death in March 1873 and the Somerville sale of the Robert M. Olyphant Collection in December 1877; and modern auction sale records and museum exhibition or permanent collection catalogues substantiate the importance of the Adirondacks as a subject for the artist. Of those Adirondack paintings, thirty or more are of Lake George.

Other contemporaries depicting the region included William Trost Richards, who, like Kensett, was principally recognized as a painter of marine and coastal subjects. Richards explored New York State and the Adirondack region on several trips from 1855 to 1868, and from studies made on these forays produced a series of paintings that figure among the most beautiful and significant records of the region produced at mid-century. See Linda S. Ferber and Caroline M. Welsh, *In Search of a National Landscape: William Trost Richards and the Artists' Adirondacks, 1850–1870* (Blue Mountain Lake, N.Y.: The Adirondack Museum, 2002).

After the Civil War, artists came in greater numbers to Lake George and Adirondack sites. Alfred Thompson Bricher's views of Lake George result from two sketchbooks surviving from an 1867 visit. David Johnson's Lake George paintings and drawings of the 1870s are among his finest. Nelson Augustus Moore was one of the earliest photographers in this country, maintaining successful galleries in New Britain and Hartford, Connecticut, before becoming a landscape painter. Combining art and camping, he spent twenty-five summers in the Adirondacks, primarily at Lake George, beginning in 1866.

Most artists came to Lake George for the summer or for shorter visits to fill sketchbooks with subjects for full-scale paintings to be executed in their studios during the winter. However, John Henry Hill, grandson and son of American artists, lived year-round on Phantom Island in Lake George from 1870 to 1874. In a diary now in the collection of the Adirondack Museum, Hill recorded his daily life, the weather, and the art he made.

11 Quoted in Executors' Sale, *The Collection of Over Five Hundred Paintings and Studies, by the Late John F. Kensett* (New York, 1873), 4.

14 Leonard Wells Volk
Life Mask and Hands of Abraham Lincoln (1860/1886)

1 Walt Whitman, "When Lilacs Last in the Dooryard Bloom'd," (second stanza) in *Walt Whitman: Complete Poetry and Collected Prose* (New York: The Library of America, 1982), 459.

2 Mark Van Doren, *The Last Days of Lincoln: A Play in Six Scenes* (New York: Hill and Wang, 1959), x.

3 Leonard Volk, "The Lincoln Mask and How It Was Made," *Century Magazine* 23 (December 1881): 223.

4 Ibid., 226.

5 Ibid.

6 Phillip B. Kunhardt, Phillip B. Kunhardt III, and Peter W. Kunhardt, *Lincoln: An Illustrated Biography* (New York: Knopf, 1992), 119.

7 John Hay, "Life in the White House in the Time of Lincoln," *Century Magazine* 41 (November 1890): 37.

8 Volk, "The Lincoln Mask," 227.

9 Ibid.

10 Ibid.

11 Woodruff's study was submitted for a competition for the Registry of Deeds Building in Washington, DC. The subject was a hypothetical meeting of Frederick Douglass, Abraham Lincoln, and Lincoln's cabinet, based on the engraving by Frances Bicknell Carpenter, *The First Reading of the Emancipation Proclamation Before the Cabinet* (ca. 1866). Woodruff's insertion of Douglass into the scene was an appropriate evocation of the African American leader's role in encouraging Lincoln to sign the Emancipation Proclamation, and also Douglass's position as the first African American Recorder of Deeds for the District of Columbia, to which he was appointed in 1881 by President Garfield.

12 See essay 28 on Saint-Gaudens in this volume.

13 Avard Fairbanks, "The Face of Abraham Lincoln," in *Lincoln for the Ages*, ed. Ralph G. Newman (New York: Pyramid Books, 1960), 162.

15 Asher B. Durand
Genesee Oaks (1860)

1 Like many artists of his generation, Durand was influenced by the poetry of William Cullen Bryant (1794–1878), the paintings of Thomas Cole (1801–1848), and a belief system that directly linked Christianity to an appreciation of natural beauty. David B. Lawall discusses Durand's work at length with regard to the "theological, philosophical, and aesthetic ideas current in his time" in "Asher Brown Durand: His Art and Art Theory in Relation to His Times" (PhD diss., Princeton Univ., 1966).

2 White oaks typically grow 70 to 100 feet tall, with diameters usually exceeding four feet and often continuing to more than seven feet. An excellent article on these native trees and their history in the Genesee Valley was written by Carl Wiedemann, "The Genesee Oaks," *The Conservationist* (September–October 1983): 7.

3 Thanks to Dr. Gregg Hartvigsen, Assistant Professor, Department of Biology, State University of New York, Geneseo, for making these identifications.

4 Ibid.

Notes

5 A. B. Durand, "Letters on Landscape Painting, IX," *The Crayon* 2 (July 11, 1855): 16.

6 Built by Wadsworth in 1835, Hartford House still stands in Geneseo. A commanding view of the valley, as seen in *Genesee Oaks*, is clearly visible from behind the main house. While there is no documentation to prove that this is the site where Durand stood, it is the most plausible.

7 Thanks to Dr. Judith Hunter, Senior Research Scholar in History, SUNY Geneseo, and Liz Argentieri, Special Collections Librarian, SUNY Geneseo, for their help with research on the Wadsworth family.

8 Wiedemann, "The Genesee Oaks," 8.

9 Ibid.

10 Lease signed between James Wadsworth and Charles F. Isham and Josiah Chadwick of Avon, New York, February 20, 1843. Wadsworth Family Papers, SUNY Geneseo, box C1.hj.

11 The drawings are catalogued and in the collection of the New York Historical Society, numbers 1918.156–159; 1918.242.

12 Asher B. Durand Papers, New York Public Library, Archives of American Art, Smithsonian Institution, microfilm N20.1072–1073. With thanks to Howard Merritt, Professor Emeritus, University of Rochester, for providing direction to this citation, and his early and insightful writings on Durand in various sources.

13 Listed in The National Academy of Design Exhibition Record for 1861 as "#184. Genesee Oaks. *J. S. Wadsworth.*"

14 Thanks to Corrin Strong for his assistance and access to the land surrounding Hartford House. Thank you to Harry Wadsworth for information on the painting as it hung in Hartford House. The painting was sold to Lake View Galleries, Lake View, N.Y., and purchased by the Memorial Art Gallery in 1974.

15 Durand, "Letters on Landscape Painting, IX," 16.

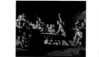

16 Martin Johnson Heade
Newbury Hayfield at Sunset (1862)

1 "Didymus" [Martin Johnson Heade], "Taming Hummingbirds," *Forest and Stream* 38n15 (April 14, 1892): 348. The dedicated lifetime work of Theodore E. Stebbins, Jr., of the Fogg Art Museum at Harvard University has illuminated and classified the oeuvre of Martin Johnson Heade. I would like to acknowledge his generous discussion with me about the Memorial Art Gallery painting and this essay, as well as his publications that have led the way in Heade studies. Chronological and biographical references in this essay are keyed to Stebbins's book, *The Life and Work of Martin Johnson Heade: A Critical Analysis and Catalogue Raisonné* (New Haven, Conn.: Yale Univ. Press, 2000).

2 "Art Items," *Boston Evening Transcript,* December 1, 1859, p. 2, cited in Theodore E. Stebbins, Jr., *Martin Johnson Heade,* with contributions by Janet L. Comey, Karen E. Quinn, and Jim Wright, exhibition catalogue, Museum of Fine Arts, Boston, 1999.

3 Stebbins, *Life and Work of Martin Johnson Heade,* 117.

4 Ibid., 24.

5 Ibid., 172–73.

6 Stebbins identifies some of these friends as the Reverend James Cooley Fletcher, who had important connections to poets John Greenleaf Whittier and Henry Wadsworth Longfellow, and Harvard scientist Louis Agassiz; as well, Fletcher had important Brazilian contacts that no doubt encouraged Heade's interest in traveling there. See Stebbins's essay, "Painter of the Tropics," in *Life and Work of Martin Johnson Heade.* Stebbins also suggests that the Newburyport link was originally Reverend Bishop Thomas March Clark, whom he met in Providence and whose portrait he painted ca. 1856 (16). Clark hailed from Newburyport, where his mother owned significant property in the region, including marshlands (28–29).

7 Stebbins, *Martin Johnson Heade,* 29.

8 Bruce Johnson, "Martin Johnson Heade's Salt Marshes and the American Sublime," *Porticus* 3 (1980): 34–39.

9 Betsy H. Woodman, *Salt Haying, Farming and Fishing in Salisbury, Massachusetts: The Life of Sherb Eaton* (1900–1982), *Essex Institute Historical Collections,* 119n3 (July 1983): 165–81. While Eaton's recollections are of his life in Salisbury, the processes that he describes are essentially those used by all farmers in the region, and the methods used had been handed down for generations.

10 John Wilmerding, *American Views: Essays on American Art* (Princeton: Princeton Univ. Press, 1991), 61.

11 *Journal of John Winthrop,* ed. Richard S. Dunn, James Savage, and Laetitia Yeandle (Cambridge, Mass.: The Belknap Press of Harvard Univ. Press, 1996), 35.

12 Estate of Thomas Smith of Newbury, Essex County (Mass.) Probate Docket #25779. Probate Records of Essex County, Mass., 1635–1681, The Essex Institute, Salem, Mass., 1916, 42-43.

13 John R. Stilgoe, *Alongshore* (New Haven, Conn.: Yale Univ. Press, 1994), 116. Stilgoe's essay "Salt Marsh" offers important analyses of the cultural impact of the salt marsh.

14 Ibid., 123.

15 http://www.8tb.org

16 Heade's letters appeared in *Forest and Stream* from 1880 to 1904: "The Plume Bird Traffic," 44 (July 27, 1895): 71; "Disappearing Ducks," 55 (November 10, 1900): 370; "Save the Woodcock," 59 (October 18, 1902): 310.

17 David Gilmour Blythe
Trial Scene (Molly Maguires) (ca. 1862–63)

1 Bruce Chambers, "David Gilmour Blythe (1815–1865): An Artist at Urbanization's Edge" (PhD diss., Univ. of Pennsylvania, 1974), 150–51. In the first in-depth biography of Blythe, the author, Dorothy Miller, describes the painting as "one of the Molly Maguire trials" but later mentions that there was "some doubt that such societies existed in the middle 1800's." See Dorothy Miller, *The Life and Work of David G. Blythe* (Pittsburgh: Univ. of Pittsburgh Press, 1950), 54–55. Indeed, it was not until the 1870s that the Molly Maguires targeted the Philadelphia and Reading Railroad mining subsidiary to which Miller refers. More recent scholarship into the Molly Maguires has shown that there were several waves of violence, one of which began as early as 1862. For this new interpretation see Kevin Kenny, *Making Sense of the Molly Maguires* (New York: Oxford Univ. Press, 1998).

2 The assassination of one mine owner in November of 1863 made national news, as did accounts of worker beatings and intimidation in early 1864. Soon afterwards, federal troops arrived and stayed to maintain order until the end of the Civil War. Kenny, *Making Sense,* 71, 96–102. Chap. 3 of this book discusses the first wave of Molly Maguire violence, which was distinct from later activity in the 1870s.

3 *Miners' Journal,* October 3, 1857; cited in Kenny, *Making Sense,* 79.

4 For more about Bannan's background see Kenny, *Making Sense,* 76. For more analysis of Blythe's politics see Bruce Chambers, *The World of David Gilmour Blythe (1815–1865),* exhibition catalogue, Smithsonian Institution, Washington, DC, 1980, 78–79.

5 Blythe portrayed a mob on at least one other occasion. An unlocated work titled *Illustration of a Mob by the Figure of a Woman* was mentioned in an 1879 article about Blythe (Chambers, *The World of David Gilmour Blythe,* 184, cat. no. 228).

6 Artists such as George Caleb Bingham, William Josiah Brickey, and Tompkins Harrison Matteson portrayed frontier courts of law. Although artists often poke fun at participants in the legal process, they are benign in comparison to Blythe, who chose to depict the absurdities of the law more than any other nineteenth-century artist. Between 1859 and 1863 he painted the subject at least five times. The other works by Blythe that take up the theme of jurisprudence are *Justice* (ca. 1859–62, De Young Museum, Fine Arts Museums of San Francisco), *Courtroom Scene* (ca. 1860–63, private collection), *The Lawyer's Dream* (1859, Museum of Art, Carnegie Institute, Pittsburgh), and *The First Mayor of Pittsburgh* (ca. 1860–63, Museum of Art, Carnegie Institute, Pittsburgh).

7 Bruce Chambers, who was curator and acting director of the Memorial Art Gallery of the University of Rochester in the 1970s, has written the most thorough biography of Blythe and his work. Biographical information about the artist that follows is taken from Chambers's important work, "David Gilmour Blythe (1815–1865)" and *The World of David Gilmour Blythe.*

8 On occasion Blythe's late paintings were commissioned. Chambers suggests that Captain Charles W. Batchelor of Pittsburgh might have commissioned some of Blythe's political paintings executed during the Civil War. Blythe's last paintings, a pair of still lifes titled *Youth* and *Old Age,* were commissioned by Christian H. Wolff of Pittsburgh in March 1865. See Chambers, *The World of David Gilmour Blythe,* 79–80, 103.

James Henry Beard
The Night Before the Battle (1865)

1 "The Exhibition of the National Academy," *Harper's Weekly* 9 (May 13, 1865): 291.

2 Excerpt from a speech by Abraham Lincoln to the Sanitary Commission in Philadelphia, June 16, 1864, cited in James M. McPherson, *Battle Cry of Freedom: The Civil War Era* (New York and Oxford: Oxford Univ. Press, 1988), 742. Lincoln is borrowing from the funeral lament for Henry V in the opening line of Shakespeare's *Henry VI, Part I:* "Hung be the heavens with black, yield day to night!"

3 Daniel Carter Beard, *Hardly a Man is Now Alive: The Autobiography of Dan Beard* (New York: Doubleday, Doran, 1939), 167.

4 Ibid. Wallace in 1880 wrote *Ben Hur* at his home in Crawfordsville, Indiana.

5 Photographs and descriptions of gabions can be found in *Touched by Fire: A Photographic Portrait of the Civil War,* vol. 2, ed. William C. Davis (Boston and Toronto: Little, Brown, 1986), 152–53.

6 Dean S. Thomas, *Cannons: An Introduction to Civil War Artillery* (Gettysburg, Pa: Thomas Publications, 1985), 53–54.

7 For comparison with Beard's painting of a cannon carriage, see photograph of *Battery of Parrott Guns Manned by Company C, 1st Connecticut Heavy Artillery, Fort Brady, VA 1864,* available on the "Civil War Home Page" at http://www.civil-war.net/cw_images/files/images/214.jpg.

8 Andrew Berg, "The Best Offense," *Smithsonian* 36, no. 6 (September 2005): 42. Thanks to Civil War scholar Professor James Ramage, Northern Kentucky University, for his generous e-mail correspondence in September 2005 in response to inquiries about his research on the defense of Cincinnati, Covington, and Newport.

9 John F. Graf, *Warman's Civil War Collectibles* (Iola, Wisc: Krause Publications, 2003), chap. 18, "Uniforms," 480–94, esp. 489, 490, 491.

10 E-mail correspondence between Professor James Ramage and the author, September 13, 2005.

11 George Henry Preble, *History of the Flag of the United States of America* (Boston, 1880), 459–60.

12 Beard, *Hardly a Man is Now Alive,* 149.

13 Graf, *Warman's Civil War Collectibles.* The tin cup appears to be "typical" of those "carried by many soldiers" (335). The dark inkwell might be made of gutta-percha, a material popular at the time (337). Though possibly only a fragment of a tobacco twist, its inclusion would certainly be in keeping with a display of "typical soldier belongings" (342).

14 "The Soldier's Respite: Civil War Gambling, How to Play Faro, Monte, & Dice." Cited on http://www.shasta.com/suesgoodco/respite/, accessed 6/30/2005. Monte had been learned by soldiers in the Mexican-American War earlier in the century, and Beard's depiction is faithful to many characteristics of the game. Thanks to Mary Mathews, Education Department of the Memorial Art Gallery, for her valuable research into this game.

15 An engraving in the July 22, 1865, issue of *Harper's Weekly* based on Timothy O'Sullivan's photograph of a field of corpses was titled *The Harvest of Death.* Even the year before, Beard could still paint a sentimental domestic scene of a wounded soldier teaching his young son (no more than three years old) to stand at arms, the mother proudly looking on (*Back from the War* [1864, location unknown]). Documented in Smithsonian American Art Inventory, Control No. IAP 70620014, accessible through the Smithsonian's archival website, http://siris-artinventories.si.edu.

In a lecture delivered on October 19, 1978, Bruce W. Chambers, assistant director for curatorial services of the Memorial Art Gallery, proposed a biblical interpretation based on Italian Renaissance paintings, which, he argued, evoked the Garden of Gethsemane and the sleeping disciples. (Transcript in MAG curatorial files.)

16 In her study of Apocalyptic visions in mid-nineteenth century painting, art historian Gail Husch writes that Beard, unlike many of his contemporaries, "does not deny disturbing realities" in his work. "Beard recognized that westward expansion visited grave injustices on Native Americans, opened a new field for the spread of slavery and for sectional conflict, and encouraged rootlessness and dislocation." Gail E. Husch, "Poor White Folks and Western Squatters: James Henry Beard's Images of Emigration," *American Art* 7, no. 3 (Summer 1993): 37–38.

17 Lyrics by Robert Morris Esq., "The Night Before the Battle" (Philadelphia: Lee and Walker, 1865), plate no. 5162.4.

18 Cara Montane, "Another Woman's View of the New Academy of Design," *New York Leader,* June 3, 1865 (np); "Exhibition of the National Academy of Design," 291. Cited in David Dearing, ed., *Rave Reviews: American Art and Its Critics, 1826–1925,* exhibition catalogue, National Academy of Design, New York, 2000, 205–6.

19 Three of Frank Beard's illustrations from the war front in Tennessee were published in *Harper's Weekly* in early 1863: January 10, 31, and February 7. Additionally, twenty-five drawings were published in *New York Illustrated News.* (Cited in *The Civil War: A Centennial Exhibition of Eyewitness Drawings* [Washington, DC: National Gallery of Art, 1961], 107.)

20 Illustration by Frank Beard, in Jesse Bowman Young, *What a Boy Saw in the Army: A Story of Sight-Seeing and Adventure in the War for the Union* (New York, ca. 1894), 399, illus. no. 100.

Albert Bierstadt
The Sierras Near Lake Tahoe, California (1865)

1 For a thorough analysis of this painting, see Laurene Buckley, "*The Sierras Near Lake Tahoe* by Albert Bierstadt," *Porticus* 14–16 (1991–93): 42–51. See also "New Acquisition Fills Major Gap in American Collection," *Gallery Notes* (Memorial Art Gallery of the University of Rochester, N.Y., March–April 1993): 6, and *American Paintings IV* (New York: Berry-Hill Galleries, 1986), 36. For the most extensive study on Bierstadt to date, see Nancy K. Anderson and Linda S. Ferber, *Albert Bierstadt: Art and Enterprise* (New York: Hudson Hills Press with the Brooklyn Museum, 1990); *The Sierras Near Lake Tahoe, California* is reproduced on p. 202.

2 *The Rocky Mountains,* which measures 73¼ x 120¾ inches, made its debut in Bierstadt's New York studio in February of 1863, and was subsequently exhibited in Boston that spring. During Bierstadt's seven-month trip west beginning in May of that year, the painting traveled to New Bedford, New York, Portland, Maine, and Boston, and continued to be exhibited after he returned east in mid-December. In 1866, Bierstadt sold *The Rocky Mountains* to an English collector for $25,000, breaking the record for the highest price ever paid for an American painting. For details, see Anderson and Ferber, *Albert Bierstadt,* 177 ff.

3 See Nancy Anderson's entry on Bierstadt in Jane Turner, ed., *The Dictionary of Art,* vol. 4 (London: Macmillan, 1996), 43.

4 Albert Bierstadt, "Letter from the Rocky Mountains," letter dated 10 July [1859], *Crayon* (September 1859): 287; cf. Anderson and Ferber, *Albert Bierstadt,* 145. For a documentation of Bierstadt's early trips to the West see Gordon Hendricks, "The First Three Western Journeys of Albert Bierstadt," *Art Bulletin* 46, no.3 (September 1964): 333–65. See also Gordon Hendricks, *Albert Bierstadt* (Fort Worth, Texas: Amon Carter Museum, 1972).

5 For a discussion of this, see Buckley, "*The Sierras Near Lake Tahoe,*" 46, who cites S. G. W. Benjamin, *Art in America: A Critical and Historical Sketch* (New York: Harper & Brothers, 1880), 98, as well as Oliver Larkin, *Art and Life in America* (New York: Rinehart, 1949), 210.

6 I would like to thank James B. Snyder, Yosemite Research Library, Yosemite National Park, and Laurel Ames, Sierra Nevada Alliance, for their insights.

7 The spot that may have inspired Bierstadt to paint *The Sierras Near Lake Tahoe* is located just southwest of Meyers along what is now Highway 89, near the Pioneer Trail (present-day Route 50), which Bierstadt and Ludlow followed to Placerville. I am indebted to Katy Coulter, Assistant Heritage Program Manager of Eldorado National Forest, who was especially helpful in consulting a number of park officials on my behalf.

8 Buckley, "*The Sierras Near Lake Tahoe,*" 46. Although Bierstadt has been known to take liberties by including non-native vegetation in his paintings, all of the foliage depicted here is indigenous to the area, according to Coulter.

9 Fitz Hugh Ludlow, "Among the Mormons," *Atlantic Monthly* (April 1864): 479–95. The public had access to accounts of the 1863 expedition through Ludlow's articles, which were published serially in the *Atlantic Monthly, Evening Post* (New York), and the *Golden Era* (San Francisco). Ludlow also wrote a book about the excursion, entitled *The Heart of the Continent: A Record of Travel Across the Plains and in Oregon, with an Examination of the Mormon Principle* (New York: Hurd and Houghton, 1870).

10 Ludlow, "Among the Mormons," 493–94.

11 Ibid., 494–95.

12 Buckley, "*The Sierras Near Lake Tahoe,*" 46–7.

13 For a discussion about Bierstadt's "primal visions," see Diane P. Fischer, "The Story of the 'Plainfield Bierstadts': Shifting Perspectives, Changing Times," in *Primal Visions: Albert Bierstadt "Discovers" America*, exhibition catalogue, Montclair Art Museum, Montclair, N.J., 2002, 11–31.

14 Ibid., 12.

15 Bierstadt himself escaped the horrors of the Civil War by traveling west. While visiting Yosemite in August of 1863, the artist was drafted for service in the Union Army. However, through an agent in New York Bierstadt paid a commutation fee and was excused from service. See Anderson and Ferber, *Albert Bierstadt,* 178–79

16 Buckley, "*The Sierras Near Lake Tahoe,*" 46.

17 Fischer, "The Story of the 'Plainfield Bierstadts,'" 15; Anderson and Ferber, *Albert Bierstadt,* 76.

18 Fischer, "The Story of the 'Plainfield Bierstadts,'" 15, 17.

19 For an account of Bierstadt's waning reputation and bankruptcy, see Ibid., 16–25.

20 Ibid., 28.

20 Mortimer Smith
Home Late (1866)

1 For general information on Detroit of the period, see Melvin G. Holli, *Detroit* (New York: New Viewpoints, 1976), esp. the appendix from the U.S. Census Bureau.

2 Obituary, *Detroit Journal,* January 19, 1896.

3 The *Detroit Free Press* of February 2, 1868, discusses seven of Smith's works exhibited in the 1867 fair as well as the raffle for *Frontier Home.*

4 In fact, after the Smith family left Sandusky, the Cosmopolitan bought out the Düsseldorf Gallery, and continued its programming. See Walter Sutton, "The Derby Brothers: 19th Century Bookmen," *University of Rochester Library Bulletin* 3, no. 2 (Winter 1948).

5 Quoted in Jacqueline K. Adams, "Mortimer L. Smith, 1840–1896," *Porticus* 1 (1978): 34. Smith wrote to his son Fred L. Smith on March 7, 1881, that the prices he was making from his paintings "will clear me more than architecture. I'm thinking seriously of closing up the office."

6 *Detroit Journal,* April 18, 1893, p. 4.

7 *Detroit Journal,* January 20, 1896, p. 5.

21 Thomas Ridgeway Gould
The West Wind (1876)

1 Edward Strahan, *The Masterpieces of the Centennial International Exhibition,* vol. 1: *Fine Art* (Philadelphia: Gebbie & Barrie, 1876), 296.

2 *New York Times,* February 16, 1871, p.2.

3 Centennial Catalogue Company, International Exhibition, *1876 Official Catalogue, pt. 2: Art Gallery, Annexes, and Outdoor Works of Art* (Philadelphia: John R. Nagle and Co., 1876), 38.

4 United States Centennial Commission Records, 1876–1879, Archives of American Art, Smithsonian Institution, microfilm reel 3603. Though on the application Gould claims all four were his own original work, the *1876 Official Catalogue* lists *Water Babies* as done by "M.S. Gould," his son, Marshall, also a sculptor, who often assisted with his father's work later in Gould's life.

5 Strahan, *Masterpieces,* 296.

 The Barnes *West Wind* was donated by his wife to the St. Louis Mercantile Library in 1890. (Thanks to Julie A. Dunn-Morton, Curator of American Art at the Mercantile Library, for this information.)

 The Barnes version has the title carved into the marble base, whereas the Powers does not. A recent search among the vast photographic archives of the Centennial in the Archives of American Art, the Free Library of Philadelphia, the Historical Society of Pennsylvania, and others, has so far not turned up a photograph of the exhibited version of *The West Wind* that would definitively determine which statue was in the show, the one with the title carving (Barnes) or the one without (Powers).

6 See Pennsylvania Board of Centennial Managers, *Pennsylvania and The Centennial Exposition,* vol. 2, pt. 3 (Philadelphia: Gillin & Nagle, 1878), x.

7 Barnes (1827–1888) was a former U.S. congressman from Brooklyn and a still-active public figure. *The New York Times* covered the arrival of his *West Wind* from Italy and announced an intended public showing in 1871. It seems possible that someone on the Centennial committee, knowing he owned the statue, and perhaps not realizing there were several other copies in existence, assumed he had lent it to the exhibition, especially since he had also lent other works.

8 *[Rochester, N.Y.] Union Advertiser,* December 12, 1876. At least one work that Powers bought at the Exposition is in MAG's collection—Nicola Cantalamessa-Papotti's *Love's Mirror* (1875), and another the gift from his children in his memory, Edward W. Redfield's *River Hills* (ca. 1920). Scrapbooks of newspaper clippings about Daniel Powers are at the Landmark Society of Western New York and the Rochester Historical Society.

9 The Exposition sent American inspectors to Rome, Paris, and Munich, and offered free shipment from Europe aboard a Navy vessel to encourage American artists living abroad to submit entries to the exhibition. Pennsylvania Board of Centennial Managers, *Pennsylvania and The Centennial Exposition,* vol. 1, pt. 1, 172.

10 A good succinct account of Powers's life, his gallery, and his collections can be found in Jean Merrell Dinse, "Private Art Collections in Rochester," *Rochester History* 7, no. 3 (July 1945): 11–17. It can also be accessed on the website http://www.rochester.lib.ny.us/~rochhist/v7_1945/v7i3.pdf.

11 Alphonso A. Hopkins, *The Powers Fire-Proof Commercial and Fine Art Buildings* (Rochester, N.Y.: E. R. Andrews, 1883), 85.

12 Powers's building housed studio space for Rochester artists as well, among them Emma Lampert Cooper.

13 Hopkins, *Powers Fire-Proof Commercial and Fine Art Buildings,* 86.

14 More information about the Powers Art Gallery can be found in Blake McKelvey, "The First Century of Art in Rochester—to 1925," *Rochester History* 17, no. 2 (April 1955), and in Virginia Jeffrey Smith, "The Powers Art Gallery," *Scrapbook* [Rochester Historical Society] 2, no. 1 (1951). In addition, a series of catalogues authored by C. C. Merriman and James Delafield Trenor was published between 1885 and 1897.

15 McKelvey, "The First Century of Art in Rochester," 13.

16 Smith, "The Powers Art Gallery," 12.

17 Betsy Brayer, *Brighton [N.Y.] Pittsford Post*, February 3, 1999.

18 [Rochester, N.Y.] *Democrat and Chronicle*, January 9, 1898.

19 Ibid., March 19, 1898.

20 Recently, a woman who worked in the Powers building around 1945 recalls seeing it next to the staircase on the second floor near the phone booth and the George D. B. Bonbright Brokerage. (Ann Stear, interview by the author, Rochester, N.Y., October 11, 2005.)

22 Daniel Chester French
Bust of Ralph Waldo Emerson (1879)

1 Robert D. Richardson Jr., *Emerson: The Mind on Fire* (Berkeley: Univ. of California Press, 1995), 569.

2 Ibid., 524.

3 Daniel Chester French, cited in Michael Richman, *Daniel Chester French: An American Sculptor* (New York: Metropolitan Museum of Art for the National Trust for Historic Preservation, 1976), 51.

4 Ibid.

5 Ibid.

6 Ellen Emerson, cited in Richman, *Daniel Chester French*, 51-52

7 James Elliot Cabot, *A Memoir of Ralph Waldo Emerson*, Vol. 2 (Boston: Houghton, Mifflin, 1887), 678.

8 Ibid., 679.

9 Adeline Adams, *Daniel Chester French, Sculptor* (Boston: Houghton Mifflin, 1932), 9.

10 Cabot, *Memoir*, 678.

11 Daniel Chester French, cited in Cabot, *Memoir*, 679.

12 From Emerson's October 24, 1841 journal entry, cited in The Daguerreian Society website: http://www.daguerre.org/resource/texts/emerson.html, accessed 10/16/2005.

13 James Elliott Cabot, ed., *The Works of Ralph Waldo Emerson* (Boston: Houghton, Mifflin, 1883), frontispiece.

14 Ibid., iv.

15 There are nine images of Ralph Waldo Emerson in the archives of the George Eastman House, Rochester, New York.

16 Richman, *Daniel Chester French*, 52.

17 Ibid., 52–53.

18 Ibid., 53.

19 Ibid.

20 Ibid., 53–54.

21 Ibid., 54.

22 Ibid. The Roman Bronze Works was founded in Brooklyn in 1899.

23 Ibid., 54.

23 John Haberle *Torn in Transit* (1888–89)
John Frederick Peto
Articles Hung on a Door (after 1890)

The primary references for work on Harnett and Peto are Alfred Frankenstein's *After the Hunt: William Harnett and Other American Still Life Painters* (Berkeley and Los Angeles: Univ. of California Press, 1953) and John Wilmerding, *Important Information Inside: The Art of John F. Peto and the Idea of Still-Life Painting in Nineteenth-Century America*, exhibition catalogue, National Gallery of Art, Washington DC, 1983.

1 Sybille Ebert-Schifferer, "Trompe l'Oeil: The Underestimated Trick," in Sybille Ebert-Schifferer, ed., *Deceptions and Illusions: Five Centuries of Trompe l'Oeil Painting*, exhibition catalogue, National Gallery of Art, Washington, DC, 2002, 19.

2 Harnett was called the "true modern Parrhasios" by a Munich art critic (Frankenstein, *After the Hunt*, 69, quoting from *Handelsblatt* [Munich, 1884]). Louis-Leopold Boilly was apparently the first to use the phrase "trompe l'oeil" when he titled one of his works "Un trompe l'oeil at an exhibition in Paris in 1800" (Susan L. Siegfried, "Boilly and the Frame-Up of Trompe l'Oeil," *The Oxford Art Journal* 15, no. 2 [1992], quoted in Arthur Wheelock, "Illusionism in Dutch and Flemish Art," in Wilmerding, *Important Information Inside*, 78).

3 Frankenstein, *After the Hunt*, 78–80.

4 Olive Bragazzi, "The Story Behind the Rediscovery of William Harnett and John Peto by Edith Halpert and Alfred Frankenstein," *American Art Journal* 74, no. 1 (Spring 1984): 53.

5 Like Harnett's *After the Hunt*, this work hung in a commercial venue, Rochester Stationery Company, where it was one of a pair admired by Professor Howard Merritt of the University of Rochester. He inquiried about the paintings' availability for purchase, and bought them for his collection. Director Harris Prior subsequently recommended the purchase of one of them for the MAG's permanent collection (author's conversation with Professor Merritt on October 8, 2005). The Memorial Art Gallery remains indebted to Professor Merritt for his scholarly and material contributions to the American collection.

6 Frankenstein, *After the Hunt*, 115.

7 The painting was acquired for the Memorial Art Gallery from Haberle's daughter, Vera Haberle Demmer. According to Frankenstein, it was one of three that were left in the Haberle house in New Haven, Connecticut. This seems unclear based on correspondence between Mrs. Demmer and MAG's director, Harris Prior, which suggests that she had a group of her father's paintings available to sell (Alfred Frankenstein, "Haberle: or the Illusion of the Real," *Magazine of Art* 41, no. 6 [October 1948]: 226–27).

8 A July 22, 1965, letter from Haberle's daughter to MAG director Harris Prior included the following comment about the carte-de-visite: "I think you will be interested in the reason why this museum [another museum that was considering purchasing the painting] did not purchase *Torn in Transit*. They said that 'though interesting and the quality is excellent from the point of view of trompe l'oeil the face of the woman in the upper left hand corner is unfortunate and presents an aesthetic obstacle which becomes a real eye-stopper.'" Apparently MAG did not have any such qualms and acquired it in 1965 (MAG curatorial files).

9 When Peto died of Bright's disease, many of his canvases remained at his studio with varying degrees of finish. The Memorial Art Gallery's painting is signed on the back by Helen Peto Smiley. Comparison with other works by Peto of this period suggests that this painting may be somewhat unfinished.

10 Frankenstein, *After the Hunt*, 10, 15.

11 Ibid., 14

12 Wilmerding, *Important Information Inside*, 33n3 (photo studio), and 62.

13 Ken Scott is a craftsman in Indianapolis, Indiana, who makes hunting pouches. I am indebted to him for his assistance in identifying the origin of this object (e-mail correspondence, August 10–11, 2005). Also, see other "game paintings" that include fringed hunting bags, including John Marion Shinn's *The Old Barn Door*, 1927 (Frankenstein, *After the Hunt*, plate 70) and Adophe Braun's photograph *Trophy of the Hunt* (1867, The Cleveland Museum of Art).

14 Frankenstein, *After the Hunt*, plate 12; this may also be at the Archives of American Art, Smithsonian Institution (recent donation, uncatalogued).

15 This is similar to the Model 1836 Flintlock Pistol made by Asa Waters of Millbury Massachusetts and Robert Johnson of Middletown Connecticut from 1836 to 1844 and in common use during the Civil War ("Ron Ruble Enterprises" [http://www.ruble-enterprises.com/johnson1836.htm], last accessed March 19, 2006). Thanks, too, to Jeremy Greaves and Dan Knerr for pointing me in the right direction.

16 William H. Gerdts and Russell Burke: *American Still-Life Painting* (New York: Praeger Publishers, 1971), 144.

Notes

24 Frederick MacMonnies
Nathan Hale (1890)

1 Hale's bravery and exploits receive detailed attention in Henry Phelps Johnson, *Nathan Hale, 1776: Biography and Memorials* (New Haven, Conn.: Yale Univ. Press, 1914), and William Ordway Partridge, *Nathan Hale: The Ideal Patriot* (New York: Funk and Wagnalls, 1902). For a contemporary account with more critical balance, see Barnet Schecter, *The Battle For New York: A City at the Heart of the American Revolution* (New York: Walker and Co., 2002), 210–16.

2 The MacMonnies quotation is cited as having been heard personally by artist and author Lorenzo Taft in Taft, *The History of American Sculpture* (New York: Macmillan, 1903), 339.

3 Some critical appraisals of Nathan Hale are found in Taft, *History of American Sculpture*, 336, 339; Judith A. Barter, et al., *American Arts at the Art Institute of Chicago: From Colonial Times to World War I* (Chicago: The Art Institute of Chicago, 1998), 279–80; Mary Smart, *A Flight with Fame: The Life and Art of Frederick MacMonnies* (Madison, Conn.: Sound View Press, 1996), 87–88, 99–100; and Hildegard Z. Cummings, "Cast as Hero: Frederick MacMonnies' Nathan Hale," *Porticus* 17–19 (1994–1996): 26–31. The phrase "surface bravado" appears in reference to the work of Saint-Gaudens in the online essay "Augustus Saint-Gaudens" by Thayer Tolles, Associate Curator of American Paintings and Sculpture for the Metropolitan Museum of Art, located at http://www.metmuseum.org/toah/hd/astg/hd_astg.htm.

4 A detailed and fascinating analysis of later nineteenth-century New York City is found in Edwin G. Burrow and Mike Wallace, *Gotham: A History of New York City to 1898*, pts. 4 and 5 (New York: Oxford Univ. Press, 1999), 929–1208.

5 Smart, *Flight with Fame*, 85–87; Taft, *History of American Sculpture*, 334–35.

6 Schecter, *Battle For New York*, 210–16.

7 James Hutson, "Nathan Hale Revisited: A Tory's Account of the Arrest of the First American Spy," in *Library of Congress Information Bulletin* (July/August 2003), available at http://www.loc.gov/loc/lcib/0307-8/hale.html.

8 The most common point of comparison is the statue of Hale by Bela Lyon Pratt, executed for Yale University in 1912 (Cummings, "Cast as Hero," 28, 30). It should be noted that no genuine likeness of Hale was available to any of the artists who undertook to sculpt him, as no portrait of Hale has ever been identified.

25 Winslow Homer
Paddling at Dusk (1892)

1 For a record of Homer's visits, see David Tatham, *Winslow Homer in the Adirondacks* (Syracuse: Syracuse Univ. Press, 1996), 137; for a list of his Adirondack oils and watercolors, see 138–42. In addition to his stays in Minerva, Homer visited another Adirondack locale, Keene Valley, in 1870, 1874, and 1877. For a further discussion of *Paddling at Dusk*, see David Tatham, "Paddling at Dusk: Winslow Homer and Ernest Yalden," *Porticus* 9 (1986), 16–19.

2 For the history of the clearing, originally the Baker farm, and its later development as the North Woods Club, see Leila Fosburgh Wilson, *The North Woods Club, 1886–1996* (Minerva, N.Y.: privately printed, 1996). Homer first visited the clearing in 1870.

3 Yalden to Robert McDonald, 30 September 1936 (MAG curatorial file). None of Yalden's photographs of Homer have been located. Yalden's letter was presented to the Memorial Art Gallery with the watercolor in 1984 by Dr. and Mrs. James H. Lockhart, Jr. Yalden's own interest in light took the form of expertise in the technology of sundials.

4 The inclusive dates of Homer's visits, and those of the Yaldens, are recorded in the North Woods Club Register, Adirondack Museum, Blue Mountain Lake.

26 George Inness
Early Moonrise in Florida (1893)

1 *George Inness in Florida, 1890–1894 and the South, 1884–1894*, exhibition catalogue, Cummer Gallery of Art, Jacksonville, Fl., 1980.

2 Ruth K. Beesch, "Introduction," *Florida Visionaries: 1870–1930* (Gainesville: Univ. of Florida, 1989), 6.

3 Writer's Program of the Work Projects Administration in the State of Florida, *A Guide to Key West*, rev. 2nd ed. (New York: Hastings House, 1949), 58.

4 Sarah Burns, *Inventing the Modern Artist: Art and Culture in Gilded Age America* (New Haven: Yale Univ. Press, 1996), 43.

5 On Inness's stylistic development, see Nicolai Cikovsky, Jr., *George Inness* (New York: Harry N. Abrams, 1993) and Nicolai Cikovsky, Jr. and Michael Quick, *George Inness* (New York: Harper & Row, 1985).

6 On Inness and Swedenborgianism, see especially Sally M. Promey, "The Ribband of Faith: George Inness, Color Theory, and the Swedenborgian Church," *The American Art Journal* 26, nos. 1–2 (1994): 44–65.

7 On the hermetic and alchemical traditions in American art, see David Bjelajac, "William Sidney Mount and the Hermetic Tradition in American Art," in *The Visual Culture of American Religions*, ed. David Morgan and Sally M. Promey (Berkeley and Los Angeles: Univ. of California Press, 2001), 176–90; David Bjelajac, *Washington Allston, Secret Societies, and the Alchemy of Anglo-American Painting* (Cambridge and New York: Cambridge Univ. Press, 1997).

8 Inness's devotion to Titian (1485/90–1576) was well publicized by admiring critics. Inness even made a pilgrimage to Pieve di Cadore, the birthplace of Titian, while on a tour of Europe during the 1870s. (Cikovsky, *George Inness*, 74–75.) On Anglo-American artists' pursuit of the Titianesque "Venetian Secret" of color, see Bjelajac, *Washington Allston*, 32–65.

9 The painting is signed and dated 1893, but it is unclear when precisely it was painted during that year. In fact, the painting has also been listed with the title of *July Moonrise in Florida*. While it is highly unlikely that Inness would have been in his Tarpon Springs studio during the summer months, it is possible that he painted the landscape from memory in his Montclair, New Jersey, studio. However, the Memorial Art Gallery painting was more likely executed sometime during the months of January through March, 1893. (*George Inness in Florida*, 25, cat. no.20.)

10 For other moonlight scenes at Tarpon Springs, see *George Inness in Florida*, cat. nos.16, 19, 25 and 34.

11 Leroy Ireland identified the figure as "a woman on a path carrying a basket" in *The Works of George Inness: An Illustrated Catalogue Raisonné* (Austin: Univ. of Texas Press, 1965), 377, cat. no.1450. But it actually appears to represent a "monk-like figure," who presents "an offering to the rising moon." Beesch, *Florida Visionaries*, 19.

12 Gwendolyn Owens and John Peters-Campbell, *Golden Day, Silver Night: Perceptions of Nature in American Art 1850–1910*, exhibition catalogue, Herbert F. Johnson Museum of Art, Cornell University, Ithaca, N.Y., 1982, 66.

13 Inness article, *New York Evening Post*, May 11, 1867, quoted in Promey, "The Ribband of Faith," 53.

14 George Inness, "Color and Their Correspondences," *New Jerusalem Messenger* 13 (November 13, 1867) is reprinted in its entirety in Promey, "The Ribband of Faith," 59–60.

15 Candace J. Adelson, "Frits Thaulow's *The Stream*: George Eastman and Impressionism," *Porticus* 17–19 (1994–96): 46.

Winslow Homer
27 *The Artist's Studio in an Afternoon Fog* (1894)

1 For an account of Homer's years at Prout's Neck, see Philip C. Beam, *Winslow Homer at Prout's Neck* (Boston: Little Brown, 1966). See also the same author's entry for *The Artist's Studio in an Afternoon Fog* in Philip Beam, et al., *Winslow Homer in the 1890s: Prout's Neck Observed,* exhibition catalogue, Memorial Art Gallery, Rochester, N.Y. (New York: Hudson Hills Press, 1990), 126–29. See also entries on Prout's Neck subjects in Nicolai Cikovsky, Jr. and Franklin Kelly, *Winslow Homer,* exhibition catalogue, National Gallery of Art, Washington, DC, 1995.

2 The youngest of the three brothers, Arthur Homer, designed and built a nearby summer cottage of his own, El Rancho, also in 1882: Patricia Junker, "Expressions of Art and Life in *The Artist's Studio in an Afternoon Fog,*" in Beam et al., *Winslow Homer in the 1890s,* 41. Junker's essay remains the essential source for the history of the cottages the Homers built at Prout's Neck.

3 Steven's plan showing the studio is reproduced in Junker, "Expressions," 43.

4 Junker, "Expressions," 47.

5 Homer to John Calvin Stevens, June 26, 1901. Winslow Homer Papers, Bowdoin College Museum of Art. The passage in quoted in full in Junker, "Expressions," 47. For its present appearance, Homer's punctuation has been regularized

6 This was the title by which Stevens and his family knew the painting (MAG curatorial files).

7 Homer's comments about the painting are known from an undated clipping from an unidentified newspaper preserved in the Winslow Homer Papers, Bowdoin College Museum of Art. The comments, dealing primarily with a critic's misinterpretation of the painting as a moonlit scene, are reproduced in Cikovsky and Kelly, *Winslow Homer,* 327–28.

8 Neal Allen to Gertrude Herdle Moore, December 27, 1941 (MAG curatorial files).

9 The question has been raised by art historian Trevor Fairbrother about the season represented in this painting. In his annotated checklist in *Winslow Homer in the 1890s,* Philip Beam comments: "The fog he [Homer] recorded frequently enshrouds the coast of Maine during the summer months. The filtering of the rays of the sun as it descends over Saco Bay to the west and softens the scene with a yellowing hue is a display Homer must have witnessed numerous times as he returned from his late afternoon walks above the cliffs" (126). On the other hand, fog is a constant phenomenon on the coast of Maine, albeit more frequent in summer; lacking any documentation, it is difficult to determine the exact season, as Homer lived in Prout's Neck year-round.

10 Other of Homer's tonalist-like works are *The West Wind* (1891, Addison Gallery of American Art, Andover, Mass.) and *The Wreck* (1896, Carnegie Museum of Art, Pittsburgh), both reproduced in Junker, "Expressions," 60–61.

11 A possible Japanese influence is proposed in Albert Ten Eyck Gardner, *Winslow Homer, American Artist: His World and His Work* (New York: Clarkson N. Potter, 1961), 206–7.

12 *Boston Evening Transcript,* March 17, 1899. The critic was probably William Howe Downes, later Homer's first biographer.

Augustus Saint-Gaudens
28 *Charles Cotesworth Beaman* (1894)
Hettie Sherman Evarts Beaman (1900)

1 The standard reference for Augustus Saint-Gaudens is John H. Dryfhout, *The Work of Augustus Saint-Gaudens,* catalogue raisonné (Hanover, N.H.: The University Press of New England, 1982). The most recent publications are: Henry J. Duffy and John H. Dryfhout, *Augustus Saint-Gaudens, American Sculptor of the Gilded Age* (Washington, DC: Trust for Museum Exhibitions, 2003) and Thayer Tolles, "Augustus Saint-Gaudens, His Critics, and the New School of American Sculpture 1875–1893" (PhD diss., City Univ.

of New York, 2003). Saint-Gaudens's own reminiscences are also a valuable resource: *The Reminiscences of Augustus Saint-Gaudens,* ed. Homer Saint-Gaudens, 2 vols. (New York: The Century Company, 1913).

2 Montgomery Gibbs and his family. Gibbs was one of Saint-Gaudens's most enthusiastic early patrons. Hettie Evarts's family was accompanying her father, Senator Evarts, in Geneva, Switzerland, where he was participating in an international tribunal representing U. S. interests. That same year in Geneva, Charles Cotesworth Beaman was Solicitor for the United States before the Arbitration Tribunal (John H. Dryfhout, *This Land of Pure Delight: Charles C. Beaman and Blowmedown Farm* [Cornish, N.H.: Trustees of the Saint-Gaudens Memorial, 2000], 8). This provided the opportunity for Charles and Hettie to meet; they were engaged by 1873 (11) and married in 1874 (17). Beaman became associated with Evarts's law firm by 1879 (21).

3 William Maxwell Evarts (1818–1901) was a prominent attorney and politician. He was Secretary of State for President Rutherford B. Hayes in 1877–81, a U.S. Senator (1885–91) and Attorney General for President Ulysses S. Grant (1868–69). He was the chief defense counsel for President Andrew Johnson in his impeachment trial. Saint-Gaudens well understood the importance of Evarts as a patron and acquaintance. He describes his work for Evarts in his *Reminiscences,* 1:113, 123, 129, 143, 173, and 2: 167. See also: Henry Duffy "American Collectors and the Patronage of Augustus Saint-Gaudens," *Augustus Saint-Gaudens (1848–1907): A Master of American Sculpture* exhibition catalogue, Musée des Augustins, Toulouse, 1999.

4 Dryfhout, *The Work of Augustus Saint-Gaudens,* 74.

5 The Beaman family is discussed in detail in Dryfhout, *This Land of Pure Delight.* Saint-Gaudens's own account is in his *Reminiscences* 1: 274, 311, and 2: 167, 352.

6 Dryfhout, *This Land of Pure Delight,* 23.

7 Saint-Gaudens, *Reminiscences,* 1: 312.

8 Ibid., 311.

9 Saint-Gaudens, *Reminiscences,* 2: 315–16. The reference for the $2500 is Burke Wilkinson, *Uncommon Clay: The Life and Work of Augustus Saint Gaudens* (New York: Harcourt Brace Jovanovich, 1985), 167.

10 Dryfhout, *The Work of Augustus Saint-Gaudens,* 11.

11 Tharp, *Saint-Gaudens and the Gilded Era,* 246. Wilkinson, *Uncommon Clay,* uses a shorter quote and cites a letter from Augustus Saint-Gaudens to Charles Cotesworth Beaman, January 1891, in the Saint-Gaudens collection, Baker Library, Dartmouth College Library, Hanover, N.H.

12 John Dryfhout, *Augustus Saint-Gaudens: The Portrait Reliefs,* exhibition catalogue, The National Portrait Gallery, Washington, DC, 1969, No. 48.

13 The portrait bust of General Sherman was made in 1888. To counter his initial reluctance at sitting for his portrait, the general was promised a meeting with Robert Louis Stevenson, whom he admired for *Dr. Jekyll and Mr. Hyde.* The story of the meeting is told in Saint Gaudens's *Reminiscences,* 1: 378–83. The portrait was immediately understood by critics to be the most truthful depiction of the general. The bust later served as a model for Saint-Gaudens's full-scale monument to Sherman unveiled in New York City in 1903.

14 Her husband died on December 15, 1900 (Dryfhout, *This Land of Pure Delight,* 53) at which time he held over one thousand acres of land in the Cornish region. Saint-Gaudens died in Cornish in 1907. Mrs. Beaman survived until 1917, and continued to spend her summers in Cornish. She supported the Discussion Club and also the 1913 "Bird Masque" (70).

15 Several versions of these pieces have been made. The two in Rochester have an important local provenance, having been given to MAG by the Shumway family. They were donated in 1994 by Mary Ellen Gaylord, great-granddaughter of the Beamans and daughter of Frank Ritter and Hettie Beaman Lakin Shumway (named for her grandmother, Hettie Beaman). John Dryfhout describes in a letter of February 23, 2000, his reasons for believing that these two examples may be original casts. The question is interesting, as there are many examples in public and private hands. See the MAG curatorial files.

16 The presentation of the inscriptions as well are different, more formal and static in his portrait and more relaxed and casual in hers.

17 *Augustus Saint-Gaudens 1848–1907: A Master of American Sculpture,* exhibition catalogue, Musée des Augustins, Toulouse, 1999, 192.

18 Saint-Gaudens, *Reminiscences,* 2: 352.

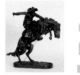

Frederic Remington
29 *The Broncho Buster* (1895)
The Cheyenne (1901)

1 Augustus Thomas, "Recollections of Frederic Remington," *Century Magazine* 86 (July 1913): 361, and *The Print of My Remembrance* (New York: Charles Scribner's Sons, 1922), 326–27. Two excellent studies of Remington's bronzes examine the variant quality of castings: Michael Edward Shapiro, *Cast and Recast: The Sculpture of Frederic Remington* (Washington, DC: Smithsonian Institution Press for the National Museum of American Art, 1981), and Michael D. Greenbaum, *Icons of the West: Frederic Remington's Sculpture* (Ogdensburg, N.Y.: Frederic Remington Art Museum, 1996). For Remington's flat art, Peter H. Hassrick and Melissa J. Webster, *Frederic Remington: A Catalogue Raisonné of Paintings, Watercolors and Drawings* (Cody, Wy.: Buffalo Bill Historical Center, in association with Univ. of Washington Press, Seattle, 1996), is indispensable. The standard biography is Peggy and Harold Samuels, *Frederic Remington: A Biography* (Garden City, N.Y.: Doubleday & Company, 1982). The commentary here also draws on my book *The Frederic Remington Art Museum Collection* (Ogdensburg, N.Y.: Frederic Remington Art Museum, distributed by Harry N. Abrams, New York, 2001).

2 Frederic Remington to Owen Wister [before February 1, 1896], in Allen P. Splete and Marilyn D. Splete, *Frederic Remington—Selected Letters* (New York: Abbeville Press, 1988), 280–81.

3 Poultney Bigelow, *Seventy Summers* (1925), quoted in Harold McCracken, *Frederic Remington: Artist of the Old West* (Philadelphia: J. B. Lippincott, 1947), 50; and Philip Rodney Paulding, "Illustrators and Illustrating," *Munsey's Magazine* (May 1895), typescript in the Helen Card Scrapbooks, Metropolitan Museum of Art Library, New York, Archives of American Art, , Smithsonian Institution, microfilm roll N 68-26. It should be noted that Remington's "photographic realism" was often enough the result of a close reliance on photographs, a subject that has been fully explored in Remington scholarship.

4 Remington published an illustrated account of his adventures in 1900: *Men With the Bark On* (New York: Harper & Bros.).

5 Julian Ralph, "Frederic Remington," *Harper's Weekly,* February 2, 1895, p. 688.

6 *Catalogue of a Collection of Paintings, Drawings and Water-Colors by Frederic Remington, A.N.A.* (New York: The American Art Galleries, 1893); "Painting the West Many Colors," unidentified clipping (New York, January 1893), Box 18B, Frederic Remington Art Museum, Ogdensburg, N.Y.

7 Frederic Remington Diary, 1909, entry for July 30, Frederic Remington Art Museum, Ogdensburg, N.Y.; "A Few Words from Mr. Remington," *Collier's Weekly* 34 (March 18, 1905): 16.

8 Theodore Roosevelt, "Ranch Life in the Far West: In the Cattle Country," *Century Magazine* 35 (February 1888): 502.

9 Frederic Remington, "Cracker Cowboys of Florida," *Harper's Monthly* 91 (August 1895): 339.

10 Frederic Remington Diary, 1909, entry for December 9.

11 Frederic Remington to Owen Wister, [January 1895], in facsimile in Ben Merchant Vorpahl, *My Dear Wister--: The Frederic Remington–Owen Wister Letters* (Palo Alto: American West Publishing Company, 1972), 160–61. Remington had begun illustrating Wister's stories in *Harper's Monthly* the previous year.

12 *The Broncho Buster* copyright application statement in McCracken, *Frederic Remington,* 155.

13 William A. Coffin, "Remington's 'Bronco Buster,'" *Century Magazine* 52 (June 1896): 319. Remington possibly chose the Henry-Bonnard Bronze Company on the recommendation of Ruckstull. See Shapiro, *Cast and Recast,* 40.

14 Arthur Hoeber, "From Ink to Clay," *Harper's Weekly,* October 19, 1895, p. 993. For European precedents for Remington's bronzes see, for example, Shapiro, *Cast and Recast,* 42–43.

15 Coffin, "Remington's 'Bronco Buster,'" 319. Remington was echoing the Gospel according to St. Matthew: "But lay up to yourselves treasures in heaven: where neither the rust nor moth doth consume, and where thieves do not break through, nor steal." He repeated the sentiment in letters to Owen Wister, [January 1895], October 24, [1895], in Splete and Splete, *Frederic Remington—Selected Letters,* 263, 275.

16 C. M. Fairbanks, "Artist Remington at Home and Afield," *Metropolitan Magazine* 4 (July 1896): 448, 450, observes that before Remington went west, "No one had ever before told us so truly what manner of man was the cowboy, no one else had so literally brought us face to face with the poor Indian, and never before had we of the East had such a realistic view of the lives of our soldiers in camp and in action….In a word, he has fixed on the dial of time types that are disappearing from our Western borders…."

17 Paulding, "Illustrators and Illustrating."

18 *The Cheyenne* copyright application statement in McCracken, *Frederic Remington,* 155.

19 Frederic Remington to Owen Wister, [late April 1901], in Splete and Splete, *Frederic Remington—Selected Letters,* 296 (the letter is misdated 1900).

20 Frederic Remington, "How Stillwell Sold Out," *Collier's Weekly,* December 16, 1899, in Peggy and Harold Samuels, eds., *The Collected Writings of Frederic Remington* (Garden City, N.Y.: Doubleday & Company, 1979), 397.

21 The Memorial Art Gallery received *Cheyenne* as a bequest from Marjorie S. Cleveland, the granddaughter of William G. Stuber, who was hired by George Eastman at Eastman Kodak in 1893. In 1919, Stuber became vice president in charge of photographic quality, presumably the occasion for the gift of the Remington sculpture. He rose to the positions of president of the company and chairman of the board.

 Broncho Buster was a gift in 1955 to the Memorial Art Gallery from Hildegarde Watson, the daughter-in-law of MAG's founding family.

22 Last Will and Testament of Eva A. Remington (probated December 23, 1918), copy, Frederic Remington Art Museum, Ogdensburg, N.Y. The will permitted only one exemption: "The models must be broken, but before they are broken I want one made from each model, (not already in the Frederic Remington Collection) and added to the Frederic Remington Collection to be paid for out of my estate."

23 Shapiro, *Cast and Recast,* 43.

24 Frederic Remington Diary, 1909, entry for December 9.

25 Giles Edgerton [Mary Fanton Roberts], "Bronze Sculpture in America: Its Value to the Art History of the Nation," *The Craftsman* 13 (March 1908): 617.

Maurice Prendergast
30 *The Ships* (ca. 1895)
Woodland Bathers (1913-15)

1 The three works by Prendergast in the Memorial Art Gallery are recorded in Nancy Mowll Mathews, Carol Clark, and Gwendolyn Owens, *Maurice Brazil Prendergast, Charles Prendergast: A Catalogue Raisonné* (Williamstown, Mass.: Williams College Museum of Art, and Prestel, 1990). They are listed as follows: *Woodland Bathers,* no. 491, *Park by the Sea,* no. 1337, and *The Ships,* no. 1676. Another important source on the artist is Richard J. Wattenmaker, *Maurice Prendergast* (New York: Harry N. Abrams, 1994).

2 Although Telegraph Hill is near Nantasket, Massachusetts, one of Prendergast's watercolors is titled *Telegraph Hill, Nahant* (private collection; catalogue raisonné, 617), which has led to some confusion about the location of the inspiration for his series of watercolors and monotypes called Telegraph Hill.

3 William Howe Downes, "Exhibition of Mr. Prendergast's Water Colors," *Boston Evening Transcript,* April 27, 1899, p. 8.

Notes

4 "Collection of Decorative Drawings Shown at Hart & Watson's,"
 The Sunday Herald, December 19, 1897, p. 30

5 Gwendolyn Owens, "Prendergast Among His Patrons," in
 Mathews, Clark, and Owens, *Maurice Brazil Prendergast,* 51.

6 Fauvism, so-called because a critic in 1905 felt that the expressive
 quality of the paintings reminded him of wild beasts, was a move-
 ment that used bright colors and bold brushstrokes. See, for
 example, John Elderfield, *The "Wild Beasts": Fauvism and Its
 Affinities* (New York: The Museum of Modern Art, 1976).

7 See Dominic Madormo, "The Butterfly Artist: Maurice Prendergast
 and His Critics," in Mathews, Clark, and Owens, *Maurice Brazil
 Prendergast,* 59–69, for the history of criticism of Prendergast's
 work.

31 John Henry Twachtman
The White Bridge (late 1890s)

1 In researching and writing this essay, I benefited from the gracious
 assistance and expert insights of Elizabeth Boone, David Gardiner,
 Mac Griswold, John Nelson, and Lisa N. Peters.

2 John H. Twachtman (Greenwich) to J. Alden Weir (New York),
 December 16, 1891. Quoted in Dorothy Weir Young, *The Life and
 Letters of J. Alden Weir* (1960; repr. New York: Kennedy Graphics,
 and Da Capo Press, 1971), 189–90.

3 Theodore Robinson's diary (Greenwich), May 30, 1894.
 Robinson's diary from March 29, 1892, to March 30, 1896, can be
 consulted at the Frick Art Reference Library, New York.

4 Robinson's diary (Greenwich), May 16 and 19, 1894.

5 The dam, swimming pool, and plantings are mentioned in Alfred
 Henry Goodwin, "An Artist's Unspoiled Country Home," *Country
 Life in America* 8 (October 1905): 629–30.

6 See Susan G. Larkin, *The Cos Cob Art Colony: Impressionists on the
 Connecticut Shore* (New York and New Haven: National Academy
 of Design and Yale Univ. Press, 2001), 191–96.

7 Another painting, *Summer Afternoon* (Edward Evans collection),
 depicts an unroofed bridge. All five paintings are illustrated in
 Lisa N. Peters, "The Suburban Aesthetic: John Twachtman's *White
 Bridge,*" *Porticus* 17–19 (1994–96): 50–56.

8 Twachtman visited Venice in 1877–78 with Frank Duveneck and
 William Merritt Chase, spending about a year; in 1881 on his
 wedding trip, spending two or three months; and in 1885, spend-
 ing about three months. He depicted one of the bridges, the
 Ponte Longo, in his etching *Venice* (ca. 1880–85). For a useful
 chronology, see Lisa N. Peters, "John Twachtman (1853–1902)
 and the American Scene in the Late Nineteenth Century: The
 Frontier within the Terrain of the Familiar" (PhD. diss., City
 University of New York, 1995), 527–30.

9 Goodwin, "An Artist's Unspoiled Country Home," 628.

10 Colonial Revival garden structures were more "solid, regular
 and symmetrical" than Twachtman's bridge, according to garden
 historian Mac Griswold (e-mail to the author, June 30, 2003). She
 concurs, however, that the white paint and latticed railing suggest
 the influence of that taste.

11 Katharine Metcalf Roof, "The Work of John H. Twachtman," *Brush
 and Pencil* 12 (July 1903): 244.

12 John H. Twachtman (Paris) to J. Alden Weir (New York), January 2,
 1885; transcript in Lisa N. Peters, "John Twachtman," 542.

13 Goodwin, "An Artist's Unspoiled Country Home," 625–30.

32 Everett Shinn
Sullivan Street (1900-1905)

1 The exhibition at MAG was from November 10 to December
 26, 1944. Michelle Harvey, associate archivist at the Museum of
 Modern Art, writes that "This exhibition was assembled and
 circulated by MoMA in cooperation with the Brooklyn Museum.
 (The exhibition was never shown at MoMA.) According to
 MoMA's Department of Circulating Exhibition Records, it traveled
 to seven venues from February 8 [to] December 8, 1944, and
 was organized by John I. H. Baur, Curator of Paintings at the
 Brooklyn Museum" (e-mail to the author, June 20, 2005). The
 MAG venue was the last one and may have been extended. The
 Eight comprised Robert Henri, Arthur B. Davies, John Sloan,
 Everett Shinn, William Glackens, Maurice Prendergast, Ernest
 Lawson, and George Luks.

2 Shinn worked with architects Walker & Gillette and interior
 designer Elsie deWolfe. For more information on Shinn, see Edith
 De Shazo, *Everett Shinn: 1876—1953* (New York: Clarkson N.
 Potter, 1974).

3 Aline R. Louchheim, "Last of 'The Eight' Looks Back," *New York
 Times,* November 2, 1952, sec. X, p. 9. John Sloan echoes Shinn's
 lack of commitment in this undated quote: "What a paradox that
 we two should be the last of The Eight, Shinn who was in the
 group by accident, clinging on Glackens' shirttails…." De Shazo,
 Everett Shinn, 166.

4 Rick Beard and Leslie Cohen Berlowitz, eds., *Greenwich Village:
 Culture and Counterculture* (New Brunswick, N.J.: Rutgers Univ.
 Press, 1993), 98.

5 George Chauncey, "Long-Haired Men and Short-Haired Women,"
 in Beard and Berlowitz, eds, *Greenwich Village,* 152.

6 Gerald W. McFarland, *Inside Greenwich Village: A New York City
 Neighborhood, 1898–1918* (Amherst: Univ. of Massachusetts Press,
 2001), 34.

7 Shinn was known to have made dates more "convenient," accord-
 ing to his biographer (De Shazo, *Everett Shinn,* 156). The notion
 that Shinn reused a frame from an earlier work was broached by
 Dr. Janay Wong, whose dissertation focused on Shinn's early work.
 Wong also suggested a relationship between the MAG painting
 and two other small works, *Paris Street Scene I* (Vose Gallery,
 Boston) and *Paris Street Scene II* (New Britain Museum of Art).
 Additionally, Wong cited Shinn's first exhibition of oils at Gimpel-
 Wildenstein in 1905, where he intended to exhibit a painting
 called *New York Street* but withdrew it. This could perhaps have
 been MAG's *Sullivan Street.* The author would like to thank Dr.
 Wong for her contribution.

8 MAG curatorial files.

9 Letter from Everett Shinn to Isabel Herdle, January 25, 1945,
 MAG curatorial files.

10 Ibid.

11 Ibid., March 6, 1945. Presumably, the "sugar givers" were wealthy
 patrons whom Shinn had met during his time in Rochester. A
 signed copy of *Rip Van Winkle,* the book referred to in this letter,
 is in the collection of the Memorial Art Gallery's Charlotte
 Whitney Allen Library.

12 Ibid., March 20, 1945.

13 Ibid., April 24, 1945.

14 Ibid., April 30, 1945.

15 Letter from Isabel Herdle to Everett Shinn, May 1, 1945, MAG
 curatorial files. The reference to the death of the chair of the
 accessions committee and the founder of the Gallery likely is
 to one and the same person, Emily Sibley Watson, who died
 on February 8, 1945.

16 In 2001, Ken Aptekar was invited to mount an exhibition of his
 work at the Memorial Art Gallery, during which he conducted
 focus groups with gallery visitors and staff, from which he gleaned
 text that he sandblasted onto glass and bolted to his paintings of
 appropriated imagery. In *Everett Shinn Writes Isabel Herdle* Aptekar
 quoted from the previously cited correspondence.

Notes

33 Thomas Eakins
William H. Macdowell
(ca. 1904)

1 The following sources were used for this essay:

Kathleen A. Foster and Cheryl Leibold, *Writing about Eakins: The Manuscripts in Charles Bregler's Thomas Eakins Collection* (Philadelphia: Univ. of Pennsylvania Press, 1989).

Kathleen A. Foster, *Thomas Eakins Rediscovered: Charles Bregler's Thomas Eakins Collection at the Pennsylvania Academy of the Fine Arts* (New Haven and London: Yale Univ. Press, 1997).

Lloyd Goodrich, *Thomas Eakins*. 2 vols. (Cambridge: Harvard Univ. Press, 1982).

Elizabeth Johns, "An Avowal of Artistic Community: Nudity and Fantasy in Thomas Eakins's Photographs," in Susan Danly and Cheryl Leibold, *Eakins and the Photograph: Works by Thomas Eakins and His Circle in the Collection of the Pennsylvania Academy of the Fine Arts* (Washington and London: Smithsonian Institution Press, 1994).

Patricia Junker, "William H. Macdowell," in Susan Dodge Peters, ed. *Memorial Art Gallery: An Introduction to the Collection* (New York: Hudson Hills Press, 1988), 202–3.

Sylvan Schendler, *Eakins* (Boston: Little, Brown, 1967).

David Sellin, *Thomas Eakins, Susan Macdowell Eakins, Elizabeth Macdowell Kenton*, exhibition catalogue, North Cross School, Roanoke, Va., 1977.

John Wilmerding, ed. *Thomas Eakins (1844–1916) and the Heart of American Life* (London: National Portrait Gallery, 1993).

34 Childe Hassam
The Bathers (1904)

1 Hassam had met Wood through their mutual friend Weir in 1890.

2 "I suggested him [Hassam] for my study, you for my dining room, and Pinkey [Albert Pinkham Ryder] for the hall, as the largest of all." C. E. S. Wood to J. Alden Weir, May 23, 1904, in Dorothy Weir Young, *The Life and Letters of J. Alden Weir* (New Haven, Conn.: Yale Univ. Press, 1960), 222.

3 Hassam "whirled in and painted me a whole wall for my studio, and they tell me it is beautiful. I am anxious to see it. It grew out of a remark of mine that I was tired of my bric-a-brac house, like a dealer's shop, and wanted to get back to Greek simplicity." Ibid. See also Childe Hassam to C. E. S. Wood, March 1, 1904, Charles E. S. Wood Papers, 1884–1920, The Bancroft Library, University of California, Berkeley, Banc Mss 72/28.

4 Childe Hassam to C. E. S. Wood, March 1, 1904, Wood Papers, Banc Mss 72/28.

5 Ibid., April 13, 1904.

6 H. Barbara Weinberg, "Hassam in New York, 1897–1919," in Weinberg, et al., *Childe Hassam, American Impressionist*, exhibition catalogue, Metropolitan Museum of Art, New York, 2004, 203. Numerous other Hassam scholars have also noted Hassam's interest in motifs from antiquity.

7 The other four sections of the mural are now titled *Marine View, Isles of Shoals* (48 × 40 in.); *Inlet, Monhegan* (48 × 40 ½ in.); *Nudes at the Cove* (48 × 63 in.); *The Bather* aka *Nude Bather* (45 × 52 in.). All are in private collections.

8 Document file on *The Bathers*, MAG curatorial files.

9 Hassam's Oregon paintings were the subject of a recent exhibition and catalogue titled *Childe Hassam: Impressionist in the West*, at the Portland Art Museum, December 11, 2004–March 6, 2005.

35 Jerome Myers
Sunday Morning (1907)

1 Lloyd Goodrich and John I.H. Baur, *American Art of Our Century* (New York: Praeger, 1961), 27.

2 Jerome remembered little of a father who essentially abandoned the family when he was quite young. They moved often in search of steady employment. Jerome (one of five children, including a brother, Gustavus, who grew up to be an influential historian during the muckracking years in American literature) grew up in Petersburg and moved with his family to Philadelphia when he was ten. Two years later he dropped out of school in order to help with the family finances. In 1881, the Myerses moved to Baltimore, where Jerome first worked in a fruit market before becoming a sign painter with his older brother, Harry. In 1885, they moved to New Orleans; there Jerome and Harry printed posters for advertising agencies and, a year later, moved to New York City, where Jerome became the primary designer in Harry's advertising business and also began a brief career as a scene painter (a hotel interior on Broadway, the Old Opera House in New Haven, Connecticut). More signficantly, he soon began his serious study of art, first at Cooper Union and later the Art Students League. (Jerome Myers Papers, Delaware Art Museum, Wilmington, Delaware.)

3 Harry Wickey, *Jerome Myers Memorial Exhibition*, exhibition catalogue, New York, Whitney Museum of American Art, 1941, 3.

4 Jerome Myers, Unpublished manuscript, Jerome Myers Papers.

5 Ada Rainey, "Work of Jerome Myers, Street Scene Painter, On Display at Corcoran," *The Washington Post*, December 14, 1941, sec. L, p. 7.

6 Myers, Unpublished manuscript, Jerome Myers Papers.

7 Jerome Myers, *Artist in Manhattan* (New York: American Artists Group, 1940), 30.

8 Ibid., 132.

9 Myers, Unpublished manuscript, Jerome Myers Papers.

10 Quoted in Grant Holcomb, "The Forgotten Legacy of Jerome Myers (1867–1940): Painter of New York's Lower East Side," *The American Art Journal* 10, no. 1 (May 1977): 91.

11 Samuel Swift, "Revolutionary Figures in American Art," *Harper's Weekly* 51 (April 13, 1907): 533.

12 William I. Homer, *Robert Henri and His Circle* (Ithaca, N.Y.: Cornell Univ. Press, 1969), 129.

13 Van Wyck Brooks, *John Sloan: A Painter's Life* (New York: Dutton, 1955), 88.

14 Ethel Myers to Bennard Perlman, undated letter, Jerome Myers Papers, Delaware Art Museum, Wilmington, Delaware.

15 Myers, *Artist in Manhattan*, 36.

16 Wickey, *Jerome Myers Memorial Exhibition*, 3.

17 Ethel Myers, *A Memorial Exhibition of the Work of Jerome Myers, Virginia-born Master*, exhibition catalogue, Virginia Museum of Fine Arts, Richmond, Va., 1941–42, 9.

36 John Sloan
Election Night (1907)
Chinese Restaurant (1909)

1 Lloyd Goodrich, *John Sloan: 1871–1951*, exhibition catalogue, Whitney Museum of American Art, New York, 1952, 77.

2 Walt Whitman, "Pictures," *Leaves of Grass*, in *The Collected Writings of Walt Whitman* (New York: New York Univ. Press, 1965), 649.

3 John Sloan, Unpublished notes, 1950, John Sloan Papers, Delaware Art Museum, Wilmington, Delaware.

4 Bruce St. John, ed., *John Sloan's New York Scene: From the Diaries, Notes, and Correspondence, 1906–1913*, with an introduction by Helen Farr Sloan (New York: Harper & Row, 1965), 164.

5 Ibid., 165.

6 John Sloan, *Gist of Art: Principles and Practice Expounded in the Classroom and Studio,* recorded with the assistance of Helen Farr (New York: American Artists Group, 1939), 213.

7 Robert W. Snyder and Rebecca Zurier, "Picturing the City," in *Metropolitan Lives: The Ashcan Artists and Their New York* (Washington, DC: National Museum of American Art, 1995), 143.

8 Herald Square, the location of this painting, was one of New York's liveliest neighborhoods. It was named for the New York Herald newspaper whose building, designed by the firm of McKim, Mead and White in 1894, may be on the left in Sloan's painting. The Sixth Avenue Elevated Railroad, built in 1878 with waiting rooms designed by architect/painter Jasper Cropsey, frames the painting on the right. Nearby, Macy's and Gimbel's department stores were popular shopping destinations for New Yorkers.

9 St. John, *John Sloan's New York Scene,* 292.

10 Ibid., 300.

11 Sloan, *Gist of Art,* 221.

12 See Suzanne L. Kinser, "Prostitutes in the Art of John Sloan," *Prospects* 9 (1984): 243, and Snyder and Zurier, "Picturing the City," 187.

13 Sloan, *Gist of Art,* 221.

14 John Sloan, Typescript manuscript, 1948 interview, John Sloan Papers.

 37 Colin Campbell Cooper
***Main Street Bridge, Rochester* (1908)**

1 *The Common Good: An Independent Magazine of Civic and Social* Rochester 5, no. 1 (October 1911): 16.

2 Emma Lampert Cooper (1855–1920) was born in Nunda, New York, a small village fifty miles south of Rochester. She attended Wells College in Aurora, New York, Cooper Union, and the Art Students League. She taught at the Mechanics Institute in Rochester, and was an officer of the Rochester Art Club. She was the recipient of a number of distinguished prizes and awards for her paintings. She was the aunt of another famous Rochester artist, landscape architect Fletcher Steele. (See essays 51 and 57.)

3 Cooper taught at Drexel Institute in Philadelphia, and moved to New York City in 1902. He and his wife, Emma, exhibited at the National Academy exhibitions in New York during the 1890s, where Hassam's impressionist work was also on view, giving Cooper the opportunity to see the work and also to meet the artist. Cooper was a member of the National Academy of Design and, after his wife died, he moved to California where he became the dean of painting at the Santa Barbara Community School of Arts.

4 Colin and Emma Cooper exhibited their work in Rochester, where local patrons had the opportunity to acquire it. In 1911, works by both Coopers, including *Main Street Bridge,* were exhibited at the 28th Annual Exhibition of the Rochester Art Club at Exposition Park in Rochester, New York. It is likely that Hiram W. Sibley (brother of Emily Sibley Watson, MAG's founder), who donated the painting to the Memorial Art Gallery, bought it from that exhibition.

5 On Rochester history, see Ruth Rosenberg-Naparsteck and Edward P. Curtis, *Runnin' Crazy* (Virginia Beach, Va.: Donning Company, 1996); Blake McKelvey and Ruth Rosenberg-Naparsteck, *Rochester: A Panoramic History* (Sun Valley, Cal.: American Historical Press, 2001).

6 Blake McKelvey, "Names and Traditions of Some Rochester Streets," *Rochester History* 27, no. 3 (July 1965): 3.

7 The fire of January 25, 1834, spread so quickly through the wooden buildings that the firefighters had no chance to extinguish it before it caught the wooden staircase of the stone Globe Building and gutted it too. The village market where the fire began was destroyed, but the site was so popular that the farmers sold their goods among the charred ironwork and ashes. Butchers and retailers rented space on the bridge and built their businesses there, but in October 1835 the flooding Genesee River swept them away. It tore away the western abutment and collapsed the buildings resting upon it into the river. The market ground was swept clean and other businesses on the east side collapsed. In the midst of repairs the following March, high water brought its own renewed assault on the bridge's businesses.

8 Rochester *Daily Union,* April 8 and September 15, 1854.

9 The stone was salvaged from the federal government project that called for stone piers at the mouth of the river at Charlotte eighteen years earlier.

10 Construction on the north side began as soon as the bridge was completed. Construction delays on the south side spared the owners when Rochester experienced the worst flood in its history in March 1865. The river tore out stores on the lower west end, filled the Genesee Valley and Erie Canal beds, and ran through the city with a current so swift that no one could even enter a boat to salvage their property. Properties on both sides of the bridge were severely damaged or torn out. The basements of bridge buildings suspended over the bridge were washed away. Still the hardy businessmen held flood-damage sales only days after the waters receded. And the bridge, whose west end had been submerged under eight feet of swirling flood water, had proved its durability. Businesses promptly repaired themselves, and by the mid-1870s both the south and north sides were so thickly occupied that visitors might not know they were on the river.

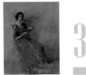 **38 Thomas Wilmer Dewing**
***Portrait in a Brown Dress* (ca. 1908)**

1 For general information on Dewing's life and career, see Susan A. Hobbs, "Beauty Into Art: The Life of Thomas Wilmer Dewing," in *The Art of Thomas Wilmer Dewing, Beauty Reconfigured,* exhibition catalogue (Washington, DC: Brooklyn Museum and Smithsonian Institution Press, 1996).

2 The Ten American Painters included Edmund Tarbell, Frank Benson, Joseph DeCamp, Thomas Dewing, Childe Hassam, Willard Metcalf, Robert Reid, Edward Simmons, John H. Twachtman, J. Alden Weir, and William Merritt Chase, who was elected to membership in 1904 upon the death of Twachtman.

3 The frame for MAG's *Portrait* was designed by White ca. 1908.

4 Catherine Beach Ely, for example, writing a few years later, could have been speaking of this work when she said, "[H]is women have character, brains and the mature point of view; they have chosen their route, they know why and whither. In this they are modern." See Ely, "Thomas W. Dewing," *Art in America and Elsewhere* 10 (August 1922): 225; Charles de Kay, "Rare Paintings in New Galleries," *New York Times,* February 10, 1910, p. 6, is a more typical review in that it views the picture as a vehicle for beautiful painting technique. For more information on the contradictory interpretations of Dewing's work see Hobbs, "Beauty Into Art," 1.

5 Zachary Ross, "Rest for the Weary," quoting Dewing's friend Royal Cortissoz, in *Women on the Verge: The Culture of Neurasthenia in Nineteenth-Century America* (Palo Alto, Cal.: Stanford Univ. Press, 2004), 27.

6 Charles de Kay, "Two Figure and Landscape Men," *The New York Evening Post,* February 19, 1908, p. 5

7 de Kay, ibid.; and Royal Cortissoz, "Art Exhibitions," *New York Daily Tribune,* February 19, 1908, p. 26.

8 Dewing Daybook (private collection). This record is contained in a small ledger and includes an entry on the painting discussed here.

9 de Kay, "Rare Paintings in New Galleries," 6.

Notes

39 Kathleen McEnery Cunningham
Woman in an Ermine Collar (1909)

1 I want to thank Professor Janet Wolff, formerly of the University of Rochester and now at Columbia University, for her seminal scholarship on McEnery's work and for her generous support of further research on the artist. Much of the factual information on McEnery's life is based on Janet Wolff's "Questions of Discovery: The Art of Kathleen McEnery," in *AngloModern: Painting and Modernity in the United States* (Ithaca and London: Cornell Univ. Press, 2003), and *The Art of Kathleen McEnery*, exhibition catalogue, Hartnett Gallery, University of Rochester, 2003.

2 To judge from letters to her family, McEnery was in Paris from around September 1908 to March 1910, when she left to tour Italy before returning to the United States (Kathleen McEnery correspondence, on loan to the Memorial Art Gallery from the artist's descendants, MAG archives). While in Paris, McEnery studied under Lucien Simon and Anglada-Camarasa.

 Thanks to the artist's descendants for their ongoing support of the Memorial Art Gallery and scholarship on Kathleen McEnery.

3 For a more in-depth discussion of McEnery's later style, see Wolff, "Questions of Discovery."

4 *Memorial Exhibition: Kathleen McEnery Cunningham*, exhibition catalogue, Memorial Art Gallery, Rochester, N.Y., January 10–30, 1972.

5 Letter dated September 6, 1908, Kathleen McEnery correspondence.

6 Undated letter to family, Kathleen McEnery correspondence.

7 Undated letter to family, Kathleen McEnery correspondence.

8 McEnery had two paintings in the Salon of 1909, *Riante Rosario* and *Portrait de Paulette*. Research has proved inconclusive as to whether *Woman in an Ermine Collar* is either of these paintings.

9 Letter dated October 31, Kathleen McEnery correspondence.

10 Despite these intriguing details, an exact identification of the model for *Woman in an Ermine Collar* has yet to be determined.

11 Wolff, "Questions of Discovery," 48.

12 In 1915 McEnery participated in the Exhibition of Painting and Sculpture by Women Artists for the Benefit of the Woman Suffrage Campaign held at the Macbeth Gallery in Manhattan. See Mariea Caudill Dennison, "Babies for Suffrage: The Exhibition of Painting and Sculpture by Women Artists for the Benefit of the Woman Suffrage Campaign," *Woman's Art Journal* 24, no. 2 (Fall 2003/Winter 2004).

40 Abastenia St. Leger Eberle
Windy Doorstep (1910)

1 I have relied on these resources for Eberle's life and work: Janis Conner and Joel Rosencrantz, *Rediscoveries in American Sculpture: Studio Works, 1893–1939* (Austin: Univ. of Texas Press, 1989); Macbeth Gallery Records, 1838–1968, Archives of American Art, Smithsonian Institution; Louise Noun, "Introduction," *Abastenia St. Leger Eberle, Sculptor (1878–1942)*, exhibition catalogue, Des Moines Art Center, Des Moines, Iowa, 1980; R.G. McIntyre, "The Broad Vision of Abastenia Eberle: The Increasing Interest in Humanity Shown in This Sculptor's Work," *Arts and Decoration* 3 (August 1913): 334–37.

2 Eberle was christened Mary Abastenia St. Leger Eberle, but she did not use "Mary" in her professional work. In New York, where her career began in earnest, her friends called her "Stennie." Abastenia was her maternal great grandmother's name. She signed her correspondence "Abastenia" or "AStLE," and often used those initials on her sculpture. (Noun, "Introduction," 2.)

3 Eberle, letter to Beatrice Gilman Proske, 1937, quoted by Noun, "Introduction," 8.

4 Beatrice Gilman Proske, ed., *Brookgreen Gardens: Sculpture*, printed by order of the trustees, Brookgreen, S.C.,1943, 158.

5 Eberle, letter to McIntyre, 1913, Macbeth Gallery Records, microfilm reel NMc44, Correspondence with Artists, Collectors, Sellers, Institutions and Other Galleries, etc. 1911–1933, frame 255.

6 See essay 46 on Barnard in this volume.

7 Macbeth Gallery Records, reel NMc44, frame 256.

8 Eberle shared lodging with Huntington and two other women who were musicians. Huntington said of those days, "Stennie of course was studying very hard, and she studied both piano and cello as well as her own work so that she was a very busy person" (interview with Anna Hyatt Huntington, conducted by Dorothy Seckler in Connecticut, December 14, 1964, Oral History Interviews, Archives of American Art, Smithsonian Institution).

9 The jury recommended that *Men and Bull* be shown at the Louisiana Purchase Exposition in St. Louis, where it won a bronze medal. For Saint-Gaudens, see the essay in this volume.

10 Bertha H. Smith, "Two Women who Collaborate in Sculpture," *The Craftsman* 8 (August 1905): 623.

11 Huntington's career prospered with sculptures and monuments on traditional heroic and mythological themes like her 1921 *Joan of Arc* on Riverside Drive in New York. The Memorial Art Gallery owns a small bronze model of this sculpture.

12 McIntyre, "The Broad Vision of Abastenia Eberle," 337.

13 Macbeth Gallery Records, reel NMc44, frame 257.

14 "Mary Abastenia St. Leger Eberle (1878–1942)," *American Sculpture in the Metropolitan Museum of Art, Volume 2: A Catalogue of Works by Artists Born between 1865 and 1885*, ed. Thayer Tolles (New York: Metropolitan Museum of Art, 2001), 627–29.

15 McIntyre, "The Broad Vision of Abastenia Eberle," 336.

16 Eberle's experience at the Naples foundry was written up in the *New York Sun* (Noun, "Introduction," 6).

17 McIntyre, "The Broad Vision of Abastenia Eberle," 336–37.

18 See essays on Young (50) and Myers (35) in this volume.

19 McIntyre, "The Broad Vision of Abastenia Eberle," 336.

20 Alexis L. Boylan, "'The Spectacle of a Merely Charming Girl': Abastenia St. Leger Eberle's *Girl Skating*," in The Metropolitan Museum of Art Symposia: Perspectives on American Sculpture before 1925, ed. Thayer Tolles (New York: The Metropolitan Museum of Art, 2004), 116.

21 This figure was exhibited at the National Academy of Design in 1907. Noun, "Introduction," 5.

22 Christina Merriman, "New Bottles for New Wine: the Work of Abastenia St. Leger Eberle," *The Survey* 30 (May 3, 1913): 196.

23 Noun, "Introduction," 14.

24 *Windy Doorstep* was bought by the Carnegie Institute, the Newark Museum, Peabody Institute, and the Worcester Art Museum. The Newark Museum's casting was done in 1910, the same year as MAG's. (Thanks to Mary Kate O'Hare, curator at the Newark Museum.)

25 Macbeth Gallery Records, reel 2588, frames 285–86. The Memorial Art Gallery's *Windy Doorstep* is marked "S. Klaber & Co/Founders, NY" indicating an early casting of this piece, according to Joel Rosencrantz (see MAG curatorial files).

26 Merriman, "New Bottles for New Wine," 198.

27 "White Slave" was exhibited in plaster and Eberle never cast it. Later she did have the figure of the girl carved in marble, *Pinioned*. Noun, "Introduction," 9–10.

28 Macbeth Gallery Records, reel NMc44, frame 256.

41 Jonas Lie
Morning on the River (ca. 1911–12)

1 Lorinda Munson Bryant, *What Pictures to See in America* (New York: John Lane Company, 1915), 211.

2 "The Presentation of Jonas Lie's Development in Painting at the Folsom Galleries," *The Craftsman* 21 (January 1912): 455.

3 Christian Brinton, "Jonas Lie: A Study in Temperament," *American-Scandinavian Review* 3, no. 4 (July–August, 1915): 205.

4 For a history of the Brooklyn Bridge and a survey of its representation in art, see *The Great East River Bridge, 1883–1983*, exhibition catalogue, The Brooklyn Museum, New York, 1983.

5 See, for instance, "Jonas Lie of Norway and America: A Painter Who Has Found the Secret of Suggesting on Canvas Nature's Manifold Moods," *The Craftsman* 13 (November 1907): 135–39; and "A Norwegian Artist-Interpreter of America," *Current Literature* 52 (February 1912): 222–24.

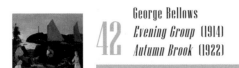

George Bellows
42 *Evening Group* (1914)
Autumn Brook (1922)

1 Information about Bellows and his work can be found in, among other places, Charles Morgan, *George Bellows: Painter of America* (New York: Reynals & Co., 1965), and Michael Quick, et al., *The Paintings of George Bellows*, exhibition catalogue (New York: Harry N. Abrams, 1992). For a full bibliography, and particular attention to Bellows's Woodstock years, see Marjorie B. Searl and Ronald Netsky, eds., *Leaving for the Country: George Bellows at Woodstock*, exhibition catalogue, The Memorial Art Gallery of the University of Rochester, Rochester, NY, 2003.

2 Letters to Emma Bellows, Summer 1911, George Wesley Bellows Papers, Archives and Special Collections, Amherst College Library, as quoted in Morgan, *George Bellows*, 135, 136, 139.

3 See Jay Hambidge, *Dynamic Symmetry in Composition: As Used by the Artists* (New York: Brentano's, 1923). For more on Bellows's use of color and compositional systems see Michael Quick, "Technique and Theory," in Quick, *The Paintings of George Bellows*, esp. 33–38, 63–65, with a discussion and diagram of *Evening Group* on 47–48.

4 Bellows, "Evening Group," in *Arts and Decoration* (August 1915): 399.

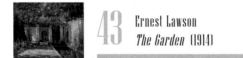

Ernest Lawson
43 *The Garden* (1914)

1 Henry and Sidney Berry-Hill, *Ernest Lawson, American Impressionist, 1873–1939* (Leigh-on-Sea, England: F. Lewis, 1968), 29.

2 In Paris he became friends with Alfred Sisley, and shared a studio with Somerset Maugham, becoming the inspiration for the artist Frederick Lawson in Maugham's 1915 novel *Of Human Bondage*.

3 Other members of The Eight, along with the leader Robert Henri, included John Sloan, William Glackens, George Luks, Everett Shinn, Maurice Prendergast, and Arthur B. Davies.

4 Berry-Hill, *Ernest Lawson*, 22.

5 Richard G. Kenworthy, Associate Professor of History at The Troy University System, in Troy, Alabama, to MAG, September 16, 1990.

6 Walker & Gillette was a prominent architectural firm whose designs for skyscrapers and country estates were equally impressive. While the firm had a presence in Tuxedo Park and designed at least four houses there, it is not known if the Rogers home was by Walker & Gillette or just the gardens. Christopher Sonne, the Tuxedo Park historian, has been generous with his responses to questions about the Rogers property, as have the Yassky family, the current owners. Sonne confirmed that the Rogers family owned the Tuxedo Park property from 1906 to 1935. While the Tuxedo Park connection between the Rogerses and Walker & Gillette is not clearly defined, it is well established that the firm continued to be employed by the family. In 1918, the firm designed a lavish home for Rogers's sister, Mae Rogers Coe, on the north shore of Long Island. Originally called Coe Hall, the estate is now called Planting Fields Arboretum State Historic Park. Walker & Gillette designed at least eleven other Long Island homes, one of which belonged to H. H. Rogers, Jr.

7 Some of Jekyll's popular publications were *Gardens for Small Country Houses* (1912), *Wood and Garden* (1899), *Wall, Water and Woodland Garden* (1901) and *Colour Schemes for the Flower Garden* (1908).

8 John Wallace Gillies, "A Terrace Garden for Mr. H. H. Rogers at Tuxedo Park, New York," photographic essay, *Country Life in America* 29 (November 1915–April 1916): 36–37.

9 Walker & Gillette, Architects, "A Hillside Garden," *The Architectural Forum* 27, no. 3 (September 1917): 73–76.

10 Gillies, "A Terrace Garden," 36–7.

11 A letter from Lawson to the painter Everett Shinn on November 27, 1906, sheds light on this situation: "My dear Shinn, If there is any chance of that friend of yours looking at some of my work could you try and get him before Friday. I have to raise some money by Friday at the latest….I am in a bad hole and it would be awfully kind of you if you could see what you could do…." (Everett Shinn Papers, Archives of American Art, Smithsonian Institution). In 1906, Shinn was hobnobbing with wealthy New Yorkers. By 1914, he was doing decorative work for clients of Walker & Gillette, and he went on to do murals for Rogers's sister at Coe Hall on Long Island. It is not hard to imagine that Shinn might have tried to help his friend obtain a commission from another Walker & Gillette client, H. H. Rogers, Jr. (Also see essay 32 on Shinn's *Sullivan Street* in this volume.)

William Ordway Partridge
44 *Memory* (1914)

1 Autograph book, Watson Family Papers, Department of Rare Books & Special Collections, Rush Rhees Library, University of Rochester, box 2, folder 2.

2 Hiram Sibley Papers, Department of Rare Books & Special Collections, Rush Rhees Library, University of Rochester, box 8, folder 23.

3 Watson Family Papers, box 2, folder 4.

4 Photographs of the temporary plaster base show that it was much more decorative than the permanent marble version, reflecting Fabry's own aesthetic.

5 Existing correspondence is housed in the MAG curatorial files.

6 "J. G. Averell—1877–1904. He loved life, beauty and honor. His mother dedicates this building to his memory."

7 *New York Times*, January 23, 1923, p. 1.

8 William Ordway Partridge, *The Technique of Sculpture* (Boston, 1895), 91–92.

9 Ibid., 92.

10 Marjorie Pingel Balge, "William Ordway Partridge (1861–1930): American Art Critic and Sculptor" (PhD. diss., University of Delaware, 1982), 113.

11 MAG Correspondence, Department of Rare Books & Special Collections, Rush Rhees Library, University of Rochester, box 1, folder S.

William Glackens
45 *Beach at Blue Point* (ca. 1915)

1 In 1752 Humphrey Avery purchased property in this region, where his descendants then settled. See Gene Horton, *Blue Point Remembered*, 2nd ed. (Blue Point, N.Y.: Searles Graphics, Inc., 1998). Thanks to Gary Kerstetter of the Bayport-Blue Point Public Library for providing this reference.

2 The best source of information on Glackens's Long Island paintings is Richard J. Wattenmaker, "William Glackens's Beach Scenes at Bellport," *Smithsonian Studies in American Art* 2, no. 2 (Spring 1988).

3 "The American Section: The National Art, An Interview with the Chairman of the Domestic Committee, Wm. J. Glackens," *Arts and Decoration* 3 (March 1913): 164, cited in Wattenmaker, "William Glackens's Beach Scenes," 84.

4 William H. Gerdts, *William Glackens: Life and Work* (New York: Abbeville Press, 1996), 94, also quotes Guy Pène du Bois in 1914: "Of the impressionists, the most admired man in modern circles today is Renoir."

Notes

5 Both illustrated in Rebecca Zurier, Robert W. Snyder, Virginia M. Mecklenburg, *Metropolitan Lives: The Ashcan Artists and Their New York,* exhibition catalogue, Smithsonian, National Museum of American Art, Washington, DC, 1995, figs. 14, 108.

6 A. W. Greenley, "Where Shall We Spend Our Summer," *Scribner's Magazine* 3, no. 4 (April 1888): 481–88, cited in Ronald G. Pisano, *Long Island Landscape Painting 1820–1920* (Boston: Little, Brown, 1985), 154.

7 Ira Glackens, *William Glackens and the Ashcan Group: The Emergence of Realism in American Art* (New York: Crown Publishers, 1957), 177.

8 See *Fruit Stand, Coney Island* (ca. 1898) and the drawing *The Beach, Coney Island* (1902), in Zurier, *Metropolitan Lives,* figs. 184, 50.

9 Glackens, *William Glackens and the Ashcan Group,* 170.

10 H. Barbara Weinberg, Doreen Bolger, David Park Curry, "The Country Retreat and the Suburban Resort," *American Impressionism and Realism: The Painting of Modern Life, 1885–1915,* exhibition catalogue, The Metropolitan Museum of Art, New York, 1994, 121.

11 Wattenmaker, "William Glackens's Beach Scenes," 87.

12 Angela J. Latham, "Packaging Woman: The Concurrent Rise of Beauty Pageants, Public Bathing, and Other Performances of Female 'Nudity,'" *Journal of Popular Culture* 29, no. 3 (Winter 1995): 149–67.

13 Francis R. McCabe, "Modesty in Women's Clothes," *Harper's Weekly* 58 (August 30, 1913): 10. "Vacations" appears on p. 17.

14 Albert Barnes, *The Art in Painting* (Merion, Pa.: Barnes Foundation Press, 1925), 297, quoted in Wattenmaker, "William Glackens's Beach Scenes," 88.

46 George Grey Barnard
Abraham Lincoln (ca. 1918)

1 Harold Holzer, "The Many Images of Lincoln," *Antique Trader* (April 1995) and in the Abraham Lincoln Art Gallery (http://www.abrahamlincolnartgallery.com/referenceholzerpg2.htm), 2.

2 Frederick Moffatt, *Errant Bronzes: George Grey Barnard's Statues of Abraham Lincoln* (Newark: Univ. of Delaware Press, 1998), 61.

3 "George Grey Barnard: American Sculptor Sculptor & Artist, 1863–1938," Kankakee County Historical Society (www.kankakeecountymuseum.com/exhibits/barnard/barnard3.html), 2–3.

4 The Harrisburg Capitol commision was received in 1902; Barnard then returned to Paris to do the work.

5 In addition to making sculptures, Barnard was also an avid collector, especially of medieval art, and indeed much of the sculpture and stonework now at The Cloisters in New York had been gathered by Barnard during his stay in France before World War I. In 1925 John D. Rockefeller acquired the museum and its contents, which were to form the nucleus of the present Cloisters on a sixty-six-acre parkland north of Barnard's original site. ("Introduction to the Cloisters," The Metropolitan Museum, http://www.metmuseum.org/Works_Of_Art/introduction.asp?dep=7)

6 Merrill D. Peterson, *Lincoln in American Memory* (New York: Oxford Univ. Press, 1994), 209.

7 Moffatt, *Errant Bronzes,* 33.

8 "George Grey Barnard," Kankakee County Historical Society, 1.

9 Ibid., 2.

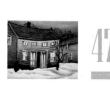

Charles Burchfield
Cat-Eyed House (1918)
47 *Springtime in the Pool* (1922)
Telegraph Pole (1935)

1 Joseph S. Trovato, who in 1970 published the closest to a catalogue raisonné of paintings to exist on the artist with his volume, *Charles Burchfield: Catalogue of Paintings in Public and Private Collections,* memorial exhibition, April 9–May 31, 1970, Munson-Williams-Proctor Institute, Utica, N.Y., lists only three works from 1922. This information is borne out in the Frank K. M. Rehn Gallery photographic records at the Burchfield-Penney Art Center. Surprisingly, Burchfield himself only lists one in his Painting Index: *Sun Reflected in Pool* (see note 15).

2 MAG's three Burchfield paintings were acquired between 1944 and 1947. However, the first mention of Burchfield's work is in *Gallery Notes,* November-December, 1941, when *Telegraph Pole* illustrated an article on page 6 entitled *The Lending Library of American Art.* This remarkable program was initiated by the Women's Council of the Gallery "in an effort to bring contemporary American art closer to the American public in this grave period of national emergency and to present to the Gallery membership the opportunity of securing excellent average-priced paintings by outstanding American artists." One hundred eighty paintings were made available for rental, the initial group having been selected by a committee of the Council with staff members. Ninety artists were asked to contribute paintings, including Burchfield, John Steuart Curry, and Rockwell Kent. Three years later, correspondence from 1944 with Rehn Gallery in New York City indicates that *Cat-Eyed House* and *Springtime in the Pool* were being considered for acquisition (it isn't known if they were also part of the Library), but only *Cat-Eyed House* was purchased (the inscription on the back says "Snow-lit House, Jan. 5, 1918, Washingtonville, Ohio"). The following year, a letter from director Gertrude Herdle Moore to Mrs. Charles E. Babcock, long-time Gallery patron and board member, suggests that Mrs. Babcock had purchased *Springtime in the Pool* (called at that point *Sun Reflected in the Pool*) for herself, perhaps with the intention of donating it to MAG:

> September 22, 1945
>
> Dear "Lady B", Ackers brought in today your beautiful "Sun Reflected in a Pool" with your sweet note that it was to be a birthday present to the Gallery. How like you to celebrate your birthday with a most generous gift to our "MAGgie"! We shall surely treasure it always
>
> You remember what a difficult decision the Art Committee had last year in choosing between it and the "Cat-Eyed House". Now they will hang happily side by side, and once again I am trying to find words to tell you how grateful we are. Bless you and many, many "Happy Birthdays" from all of us at the Gallery.

In a "P.S.," she continued: "Ackers is taking the little 'Telegraph Poles' back to you so you will have at least one Burchfield at Berkeley Street!"

Perhaps Mrs. Moore had a hunch that lending *Telegraph Pole* to Mrs. Babcock, which must have still been part of the Lending Library, might result in yet another contribution of a Burchfield painting—which it did, as that painting entered the Gallery's collection in 1947.

3 Charles Burchfield, "Fifty Years as a Painter," *Charles Burchfield: His Golden Year—A Retrospective Exhibition of Watercolors, Oils and Graphics,* organized by William E. Steadman (Tucson: Univ. of Arizona Press, 1965), 16.

4 Ibid., 23.

5 In later years, 1959-63, Burchfield recreated some of these destroyed 1919 drawings and paintings from memory, such as *New Life.*

6 "[H]is visual reactions to the scenes he depicts are of the same mental substance as the literary reactions of Sherwood Anderson. Read 'Winesburg, Ohio' and then look at Burchfield's pictures; the prevailing mood is the same, but the pictures have greater carrying power than the book." Virgil Barker, "Notes on the Exhibitions," *Arts Magazine* 5 (April 1924): 219.

7 Carl Bredemeier, "The Art of Charles Burchfield," Art Chat, *Buffalo Saturday Night* 2, no. 98 (January 27, 1923): 4.

8 The quotation (from an article in *The Buffalo Times*, "Call Buffalo Artist 'Sherwood Anderson',") is reprinted in Carl Bredemier, "Charles Burchfield: The Honest," *Buffalo Arts Journal* 8 (June–July 1923): 15.

9 Burchfield, "Fifty Years as a Painter," 36.

10 He painted a larger version in oil in 1931–34, titling it *November Evening*, and it was purchased by The Metropolitan Museum of Art.

11 Letter from Mary Mowbray-Clarke to Charles E. Burchfield, April 13, 1922, Charles E. Burchfield Archives, Burchfield-Penney Art Center, Buffalo State College, Buffalo, New York.

12 Charles E. Burchfield, *Charles E. Burchfield's Journals*, vol. 35 (May 11, 1916): 50–51. The *Journals* are part of The Charles E. Burchfield Archives at the Burchfield-Penney Art Center at Buffalo State College in Buffalo, New York.

13 Ibid. (May 15, 1922): 54.

14 Ibid. (entry following May 15, 1922 and preceding May 30, 1922): 55.

15 Burchfield created twelve volumes of Painting Indexes to document works from 1914 to 1954, which are part of the Charles E. Burchfield Archives at the Burchfield-Penney Art Center, Buffalo State College.

16 *Charles E. Burchfield's Journals*, vol. 35 (May 30, 1922): 57.

17 Charles E. Burchfield, Painting Index, vol. 9, no. 17.

48 Harold Weston
Three Trees, Winter (1922)

1 Harold Weston to Faith Borton, May 4, 1922, Harold Weston Manuscript Collection, Harold Weston Foundation, West Chester, Pa.

2 Harold Weston to Hamilton Easter Field, transcribed in Diary, Nov. 25, 1920, Harold Weston Manuscript Collection.

3 Harold Weston to Gertrude R. Herdle, December 16, 1924, Harold Weston papers, 1916–1972, Archives of American Art, Smithsonian Institution.

4 Margaret Breuning, "Galleries Show Many Phases of Modern Art," *New York Evening Post*, November 18, 1922, p. 11.

5 D. H. Lawrence, "Humming-Bird," *New Republic*, ca. 1921, Harold Weston papers, 1916–1972.

6 Harold Weston to Gertrude R. Herdle, December 2, 1924, Harold Weston papers, 1916–1972.

7 Harold Weston to Faith Borton, November 5, 1922, Harold Weston Manuscript Collection; Henry Tyrell, "A Roundabout Modernist," *New York World*, November 12, 1922.

8 Breuning, "Galleries Show Many Phases of Modern Art," 11; "Weston's Persian and American Views," *American Art News*, November 11, 1922, pp. 2, 6; "Harold F. Weston: An Adirondack Painter," *Art Review*, November 1922, p. 21; Ruth de Rochemont, "Notes on Painting and Sculpture: Comments on the Current Exhibitions in New York," *Vanity Fair* 19, no. 3 (November 1922): 29.

9 Henry McBride, "Art News and Reviews: Attractive Shows in Many Galleries," *New York Herald*, November 12, 1922, sec. 7, p. 7.

10 Gertrude R. Herdle to Weston, January 14, 1925, Harold Weston papers, 1916–1972.

11 Ernest A. Weiss, "Art in Rochester," *Rochester (N.Y.) Herald*, January 25, 1925, p. 11.

12 Ibid., January 18, 1925, p. 9.

13 Gertrude R. Herdle to Weston, July 6, 1925, Harold Weston Manuscript Collection.

14 During World War II Weston founded and ran a citizens' organization—Food for Freedom—that advocated for famine relief for victims of the war. "[Weston], more than anyone else—as Mrs. Eleanor Roosevelt has written me—was responsible for the original conception and carrying through of UNRRA [United Nations Relief and Rehabilitation Administration]" (Lewis Mumford, statement of support, June 5, 1952, Harold Weston papers, 1916–1972). During the 1950s and 1960s Weston led

the artists' lobby for government support of the arts through the National Council on Arts and Government. He played a key role in writing and securing legislation favorable to artists and the arts, including the law that established the National Endowments for the Arts and Humanities in 1965.

15 Ralph Flint, "Exhibitions in New York: Harold Weston, Montross Gallery," *Art News*, December 3, 1932, p. 5.

16 Harold Weston to Gertrude R. Herdle, December 16, 1924, Harold Weston papers, 1916–1972.

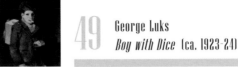

49 George Luks
Boy with Dice (ca. 1923-24)

1 Luks is quoted in Bennard Perlman, *The Immortal Eight* (Westport, Conn.: North Light Publishers, 1979), 78.

2 Bella Mead, "Social Pleasures of the East Side Jews" (master's thesis, Columbia University, 1904), 5–6.

3 Mary Fanton Roberts, "Painting Real People is the Purpose of George Luks' Art," *Touchstone* 8 (October 1920): 32.

4 Luks dedicated and gave the painting to the artist Elizabeth Olds (1896–1991). Olds had attended Luks's painting class at the Art Students League from early October 1920 through the end of May 1921, and again from early December 1922 through the end of January 1923. She formed a long-term friendship with Luks, and two years after his death she authored an article about her association with him. See Elizabeth Olds, "'The Old Man Hatter' Found Art in the Slums (The Story of Artist George Luks, Told by One of His Pupils)," *Omaha World-Herald*, Sunday Magazine Section, 27 January 1935, pp. 7–8. Information pertaining to Olds's study with Luks was generously provided by Stephanie Cassidy, Archivist, Art Students League.

5 Luks is quoted in Walter H. Vanderburgh, "The Three Top Sergeants," Walter H. Vanderburgh Papers, Archives of American Art, Smithsonian Institution, reel 3480, frame 456.

6 Gifford Beal, "George Luks," unpublished recollection, copy in William H. Gerdts Library, New York.

7 Professor William I. Hull, "The Children of the Other Half," *The Arena* 17 (June 1897): 1045.

8 Luks is quoted in Edward H. Smith, "'Kids' That Luks Paints," *The [New York] World*, 13 February 1921, magazine sec., p. 9.

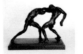

50 Mahonri M. Young
Right to the Jaw (ca. 1926)

1 Published biographies include "Mahonri Young, Sculptor, Dead. Grandson of Mormon Leader Was Noted for Bronzes—Taught Students Here," *New York Times*, November 3, 1957, p. 88; Roberta Tarbell, "Mahonri M. Young," *Dictionary of American Biography*, Supplement 6, 1956–60 (New York: Charles Scribner's Sons, 1980), 719–21; Janis Conner and Joel Rosenkranz, *Rediscoveries in American Sculpture: Studio Works, 1893–1939* (Austin: Univ. of Texas Press, 1989), 177–88; Thomas E. Toone, *Mahonri Young: His Life and Art* (Salt Lake City: Signature Books, 1997); and Norma S. Davis, *A Song of Joys: The Biography of Mahonri Mackintosh Young, Sculptor, Painter, Etcher* (Provo, Utah: Brigham Young Univ., 1999). An extensive collection of Young's papers and works of art have been deposited at Brigham Young University, Provo, Utah.

2 Young habitually researched and filed images of works by other artists and knew American prizefighter iconography. Artists of his generation boxed for recreation. In 1866 Eakins wrote to his father about art students wrestling in Jean-Léon Gérôme's Paris atelier and that Max Schmitt had taught him about boxing (Gordon Hendricks, *The Life and Work of Thomas Eakins* [New York: Grossman, 1974], 32). Eakins executed oil sketches, photographs (1883), and three major paintings of boxers: *Taking the Count* (Yale University Art Gallery, 1898), *Salutat* (Addison Gallery of American Art, 1898), and *Between Rounds* (Philadelphia

Museum of Art, 1899). Bellows's six large oil paintings of boxers (1907–09 and 1923–24) are his signature works. See E. A. Carmean, Jr., John Wilmerding, Linda Ayres, and Deborah Chotner, *Bellows: The Boxing Pictures* (Washington, DC: National Gallery of Art, 1982), a catalogue of forty-six different works about boxing by Bellows; and Jane Myers and Linda Ayers, *George Bellows: The Artist and His Lithographs, 1916–1924* (Fort Worth, Texas: Amon Carter Museum, 1988).

3 Utah became the forty-fifth state in 1896, when Mahonri Young was nineteen.

4 "Town Builders of Today as interpreted by Mahonri Young," *The Survey* 52: 7 (July 1, 1924). The American transcontinental railroad had been connected at Promontory, Utah, in 1869, ending the pioneer phase of Utah's history. Young wrote, "I was thrown into the company of a number of workmen of many occupations and trades, at the Factory [his father owned the Deseret Woolen Mills and the family lived on a nearby farm until 1884], besides men and women working in the mill itself, there was a comp[l]ete farm with all the animals, horses, cows, chickens, that go with a working farm and besides an orchard. I was exposed to the influence of all these different and varied activities and occupations from my most impressionable years." Mahonri M. Young, "Millet, J. F.," Mahonri Young Collections, Brigham Young University, box 6, folder 35.

5 In 1911, for *Bovet Arthur—A Laborer*, Young won the Helen Foster Barnett Prize, and, in 1932, for *Emil Carlsen*, the Maynard Portrait Prize at the annual exhibitions of the National Academy of Design. He was elected an Associate member in 1912 and a full member in 1923. Young was a fellow of the National Sculpture Society, was elected to the National Institute of Arts and Letters, and was a member of the Society of American Etchers.

6 Young returned many times to the Art Students League between 1916 and 1943 to teach sculpture, printmaking, illustration, and painting, according to his *New York Times* obituary ("Mahonri Young, Sculptor, Dead…").

7 See Roberta Tarbell, "Mahonri Young's Sculptures of Laboring Men, Walt Whitman, and Jean-François Millet," *Walt Whitman and the Visual Arts*, ed. Geoffrey M. Sill and Roberta K. Tarbell (New Brunswick, N.J.: Rutgers Univ. Press, 1992), 142–65, and Elizabeth B. Hopkin, "A Study of the Philosophical and Stylistic Influence of Jean-François Millet on Mahonri M. Young from 1901–27" (master's thesis, Brigham Young University, 1990), 8.

8 *Mahonri M. Young: Retrospective Exhibition*, exhibition catalogue, Addison Gallery of American Art, Phillips Academy, Andover, Mass., 1940, 50.

9 J. Lester Lewine, "The Bronzes of Mahonri Young," *International Studio* 47 (October 1912): 55; Pène du Bois, in "Mahonri Young—Sculptor," *Arts and Decoration* 8 (February 1918): 169; Young in "Town Builders…by Mahonri Young," 1924.

10 See Alex Nemerov, "'Doing the "Old America"': The Image of the American West, 1880–1920," *The West as America: Reinterpreting Images of the Frontier, 1820–1920* (Washington, DC: Smithsonian Institution Press, 1991), chap. 6.

11 Other bronze casts of *Right to the Jaw* are found at Brigham Young University Fine Arts Museum Collection, Provo, Utah; the Brooklyn Museum, Brooklyn, N.Y.; Smithsonian Museum of American Art, Washington, DC; and Columbus Museum of Art, Columbus, Ohio (posthumous cast). *Sculpture, Drawing and Paintings by Mahonri Young* (New York: The Sculptors' Gallery, 1918) lists *Prizefighters* (location unknown) as one of the fifty-five sculptures Young exhibited, documenting his claim that he had been using athletes as subjects throughout his career.

12 John Wilmerding, "Bellows' Boxing Pictures and the American Tradition," in Carmean, et al., *Bellows: The Boxing Pictures*. Wilmerding's conclusions for Bellows's work rings true for Young—it came "at the confluence of several elements in earlier American art: the inherent love of narrative in the genre tradition, the Eakins style of direct recording and strong realism, the broad impact of popular illustration, and the sense of immediacy made possible by photography" (20). See *Men Boxing* (1887, Library of Congress, Washington, DC), a stopped-action photograph of boxers by Eadweard Muybridge and Muybridge's *Animal Locomotion*, 1887, plate 336.

13 Toone, *Mahonri Young*, 133.

14 *New York Times*, February 19, 1928, p. 123. "Prize Ring Sculptures by Mahonri Young," *Vanity Fair* 31 (September 1928): 41, and Royal Cortissoz, "Mahonri Young's Recent Sculptures and the Subject in Art," *New York Herald Tribune*, February 21, 1928, p. 17, are other reviews of the exhibition Mahonri Young: Prize Fight Groups and Other Recent Bronzes, Frank K. M. Rehn Galleries, New York, 1928.

15 Royal Cortissoz, "Mahonri Young's Recent Sculptures," 17.

16 Toone, *Mahonri Young*, 140.

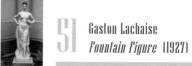

51 Gaston Lachaise
Fountain Figure (1927)

1 For further information on Lachaise, see Sam Hunter, *Lachaise*, with photography by David Finn (New York: Cross River Press, 1993), and Cynthia Lynn Campbell (Culbert), "Charlotte Whitney Allen, Fletcher Steele, Gaston Lachaise, and Alexander Calder: A Look at a Garden and Its Makers" (masters thesis, Syracuse University, 1996).

2 Gaston Lachaise, "A Comment on My Sculpture" (1928), Gaston Lachaise Archive, Beinecke Rare Book Library, Yale University, New Haven, Connecticut.

3 Scofield Thayer was the *Dial's* founder and editor, James Sibley Watson its cofounder and publisher, Gilbert Seldes its managing editor, 1920–1923, Marianne Moore its acting editor, 1925–1927, and editor after 1927, and e.e. cummings was a regular contributor.

4 For more information about the garden and other sculpture in it, see essay 57 on Alexander Calder's *Untitled Mobile* in this volume.

5 All through the letters, Lachaise refers to the material as "Tennessee marble," but at some point after the sculpture came into MAG's collection the medium was changed to "cast stone." After several years of pondering, research, and expert opinions, a conservator at Williamstown Art Conservation Center has determined the material to be a type of limestone, quarried in Tennessee, and often referred to as "Tennessee marble."

6 Gaston Lachaise to Charlotte Whitney Allen, August 2, 1926, Charlotte Whitney Allen Papers, Greenslade Special Collections and Archives, Kenyon College, Gambier, Ohio. Used by permission.

7 In 2005 dollars, the agreed upon price would equal about $55,000, and the additional payments about $11,000.

8 Atkinson Allen to Gaston Lachaise, February 24, 1927, Gaston Lachaise Archive.

9 Ibid., March 15, 1927.

10 Alfred Stieglitz to Allens, March 26, 1927, Charlotte Whitney Allen Papers.

11 Gaston Lachaise, "A Comment on My Sculpture."

12 Marguerite and William Zorach, interview by Donald B. Goodall, transcript, August 28, 1961, Gaston Lachaise Archive.

13 Recent conservation of all the Lachaise sculptures at MAG, including *Fountain Figure*, was made possible by grants from the Institute for Museum and Library Services, and the Lachaise Foundation.

52 Thomas Hart Benton
Boomtown (1928)

1 Thomas Hart Benton, *An Artist in America*, 4th ed., rev. (Columbia and London: Univ. of Missouri Press, 1983), 75–77.

2 For an account of Borger and Benton's painting see Henry Adams, *Thomas Hart Benton: An American Original* (New York: Alfred A. Knopf, 1989), 138–39 and 151–53.

3 Benton, *An Artist in America*, 201–3.

4 *Borger New-Herald*, October 5, 1976. Benton may well have visited Borger earlier, during his sketching trip of 1926, but Mrs. Dilley's account establishes that the sketch for *Boomtown* must have been made in 1928, since the Dilleys came to Borger in February 1927.

Notes

5 For an extensive discussion of the iconography of the painting, see Karal Ann Marling, "Thomas Hart Benton's 'Boomtown': Regionalism Redefined," in Jack Salzman, ed., *Prospects: The Annual of American Material Cultural Studies* 6 (1981): 73–137.

6 Henry Adams, *Thomas Hart Benton: Drawing from Life* (New York: Abbeville Press, 1990), 108–10.

7 For a discussion of *The City* (1920), see *American Art*, auction catalogue, Phillips, de Pury & Luxembourg, December 3, 2002, p. 94. The painting is also reproduced in Matthew Baigell, *Thomas Hart Benton* (New York: Abrams, 1974), 61.

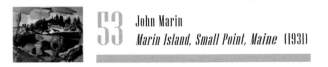 **53 John Marin**
Marin Island, Small Point, Maine (1931)

1 Major primary sources for Marin include: John Marin Archives, National Gallery of Art, Washington, DC; John Marin File, New York Public Library Papers, Archives of American Art [AAA]; John Marin Papers, AAA; Sheldon Rich papers on Catalogue Raisonné of John Marin, AAA; Alfred Stieglitz Archives, Beinecke Rare Book and Manuscript Library, Yale University, New Haven, Conn.; and at The Phillips Collection, Washington, DC: Phillips-Marin correspondence, 1930–53, Foxhall correspondence, Phillips-Stieglitz correspondence, 1926–1946.

The major published sources (in chronological order) on Marin's life include: John Marin, "John Marin, By Himself," *Creative Art* 3 (Oct. 1928): 35–39; MacKinley Helm, *John Marin* (Boston: Pellegrini & Cudahy), 1948; Dorothy Norman, ed., *The Selected Writings of John Marin* (New York: Pellegrini & Cudahy), 1949; Cleve Gray, ed., *John Marin by John Marin* (New York: Holt, Rinehart and Winston), 1970; Sheldon Reich, *John Marin: A Stylistic Analysis and Catalogue Raisonné*, 2 vols. (Tucson: Univ. of Arizona Press), 1970; Ruth E. Fine, *John Marin*, exhibition catalogue, National Gallery of Art, Washington, DC, 1990.

2 Gray, ed., *John Marin by John Marin*, 24.

3 Probably the Aliquippa House. See Helm, *John Marin*, 38.

4 Marin to Stieglitz, July 31, 1917, *Letters of John Marin*, ed. with an introduction by Herbert J. Seligmann (New York: An American Place, 1931), n.p.

5 *The Nation*, January 27, 1932, pp. 122–24, *Art News*, October 17, 1931, p. 3, both cited in Helm, *John Marin*, 67–68.

6 Lewis Mumford, "The Art Galleries: Resurrection and the Younger Generation," *The New Yorker*, May 13, 1933, pp. 42, 44, quoted in Sarah Greenough, "Alfred Stieglitz and His New York Galleries," in *Modern Art and America*, ed. Sarah Greenough (Boston: Bulfinch Press, 2000), 345.

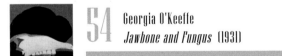 **54 Georgia O'Keeffe**
Jawbone and Fungus (1931)

1 Georgia O'Keeffe, *Georgia O'Keeffe* (New York: Viking Press, 1976), opposite catalogue no. 52.

2 Georgia O'Keeffe in *Georgia O'Keeffe: Exhibition of Oils and Pastels*, exhibition catalogue, An American Place, New York, 1939, n.p.

3 O'Keeffe to Mabel Dodge Luhan, September 29, in Jack Cowart, Juan Hamilton, and Sarah Greenough, *Georgia O'Keeffe: Art and Letters*, exhibition catalogue, National Gallery of Art, Washington, DC, 1987, 196.

4 Alfred Stieglitz to Sherwood Anderson, September 18, 1923, Sherwood Anderson Papers, Newberry Library, Chicago. For a discussion of the symbolist aesthetic behind Stieglitz's photography and O'Keeffe's paintings, see Sarah Whitaker Peters, *Becoming O'Keeffe: The Early Years* (New York: Abbeville Press, 1991; 2nd ed., 2001), 63–79.

5 O'Keeffe to Anita Pollitzer, in Anita Pollitzer, *A Woman on Paper: Georgia O'Keeffe* (New York: Simon and Schuster, 1988), 12.

6 A perfect example of this is *Pelvis with Moon–New Mexico* (1945; Collection of the Norton Museum of Art, West Palm Beach, Florida).

 55 Charles Sheeler
Ballet Mechanique (1931)

1 Charles Sheeler to Walter Arensberg, 25 October 1927, Correspondence Series, Arensberg Archives, Philadelphia Museum of Art, Archives.

2 Ibid.

3 Carol Troyen and Erica E. Hirshler, *Charles Sheeler: Paintings and Drawings*, exhibition catalogue, Museum of Fine Arts, Boston, 1987, 124.

4 *Criss-Crossed Conveyors and Powerhouse No. 1*, 1927, reproduced in Theodore E. Stebbins Jr., Gilles Mora, and Karen E. Haas, *The Photography of Charles Sheeler: American Modernist* (Boston: Bulfinch Press, 2002), 145, 157.

5 For a more detailed discussion of this process, see Karen E. Haas, "Charles Sheeler and Film," *Antiques* (November 2002): 122–29.

6 "For many years now, I've never worked on location. I always gather the nuts and bring them home and chew them over there and arrive at a picture." Interview by Martin Friedman, June 18, 1959, Archives of American Art, sound tape transcript, Smithsonian Institution, 11. Garnett McCoy, "Charles Sheeler—Some Early Documents and a Reminiscence," *Archives of American Art Journal* 5, no. 2 (April 1965): 4.

7 "It took me years and years to change the public attitude which was built up many years ago, indicating that he merely transferred one medium to another." Edith Halpert to Musya Sheeler, April 11, 1967, Downtown Gallery Papers, Archives of American Art, Smithsonian Institution, reel 5554, frame 550.

8 See Donald Friede, *The Mechanical Angel: His Adventures and Enterprises in the Glittering 1920s* (New York: Alfred A. Knopf, 1948), 49; and Carol J. Oja, "George Antheil's Ballet Mécanique and Transatlantic Modernism," in Townsend Ludington, ed., *A Modern Mosaic: Art and Modernism in the United States* (Chapel Hill: Univ. of North Carolina Press, 2000), 195. For a reproduction of one of these cartoons in *The World*, see Wanda Corn, *The Great American Thing: Modern Art and National Identity, 1915–1935* (Berkeley: Univ. of California Press, 1999), 114, 115.

9 Review by Ezra Pound in *The New Criterion* 4, no. 4 (October 1926): 695–99, quoted in Robert M. Crunden, *Body and Soul: The Making of American Modernism* (New York: Basic Books, 2000), 330.

10 See Hugh Ford, *Four Lives in Paris* (San Francisco: North Point Press, 1987), 56. Sheeler to Arensberg, 25 October 1927, Arensberg Archives.

 56 Stuart Davis
Landscape with Garage Lights (1931–32)

1 Stuart Davis, "The Cube Root," *Art News* 41, no. 18 (February 1–14, 1943): 34.

2 Diane Kelder, ed. *Stuart Davis* (New York: Praeger, 1971), 23–24.

3 Davis's father, as art editor of the *Philadelphia Press*, employed John Sloan, William Glackens, George Luks, and Everett Shinn as illustrators. They and other members of the Ashcan school, notably Robert Henri, were family friends of the Davises.

4 Davis spent summers in Gloucester with his family, who, after renting for many years, acquired a house on Mount Pleasant Avenue in 1925. His sculptor mother, Helen Davis, established a studio nearby and became a nearly year-round Gloucester resident. (Davis maintained a painting studio in the family house until the mid-1930s and participated in many local exhibitions.) From the late 1920s on, Davis's companion was Bessie Chosak, a native of Brooklyn, who accompanied him to Paris, where they were married before returning to the U.S. in 1929. Davis's parents disapproved, so it is not surprising that between the couple's return to New York and Ms. Chosak's tragic death in 1932, Davis spent less time on Cape Ann than he had previously.

5 Stuart Davis, 1934, in Karen Wilkin, *Stuart Davis* (New York: Abbeville Press, 1987), 36. For more on the truly vitriolic quarrel between Davis and Benton, see editorials, articles, and letters in *The Art Digest* 9, nos. 11–14, 17 (March 1–June 1, 1935), esp. "Davis' Rejoinder" in no. 13 (April 1, 1935): 12.

6 Stuart Davis Papers, Harvard University Art Museums, on deposit Houghton Rare Book Library, Harvard University (microfilm reel 1, 1936; no frame numbers; some pages are dated, some not).

7 Stuart Davis Papers, reel 14, November 27, 1956.

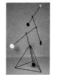

57 Alexander Calder
Untitled Mobile (1935)

1 Alexander Calder and Jean Davidson, *An Autobiography with Pictures* (New York: Pantheon, 1966), 154.

2 Mrs. Whitney Allen had an open cocktail hour every day at 4 p.m. where she and her guests would have martinis in the "drinking pit," which was eventually filled with a chain-mail Saracen tent. Various local residents and out of town guests were often in attendance. The Sibley Watsons were probably involved, as well as Tom and Hilda Taylor of Bausch & Lomb, Fletcher Steele when he was in town, the newspaperman Henry Clune, Frank and Kathleen McEnery Cunningham (whose painting *Woman in an Ermine Collar* is the subject of essay 39 in this volume), the painter Ralph Avery, and other local artists and musicians. The guests were always changing, as the tradition spanned decades. It was known to be a quiet, informal gathering for stimulating conversation among intellectuals.

3 Fletcher Steele was the nephew of Emma Lampert Cooper, wife of Colin Campbell Cooper, whose painting *Main Street Bridge, Rochester* is the subject of essay 37 in this volume.

4 Robin Karson, *Fletcher Steele, Landscape Architect: An Account of the Gardenmaker's Life, 1889–1971* (New York: Harry N. Abrams/Sagapress, 1989), 33.

5 For artist Ralph Avery's watercolor rendition of the garden and Fletcher Steele's garden plan, see essay 51 on Gaston Lachaise's *Fountain Figure* in this volume.

6 Alexander Calder to Charlotte Whitney Allen, January 25, 1935, Charlotte Whitney Allen Papers, Greenslade Special Collections and Archives, Kenyon College, Gambier, Ohio. Used by permission (hereafter cited as KC).

7 Cynthia Campbell, "Charlotte Whitney Allen, Fletcher Steele, Gaston Lachaise, and Alexander Calder: A Garden and Its Makers" (master's thesis, Syracuse University, 1996), 11.

8 Ibid., 27.

9 Calder to Allen, April 1½, 1935, KC.

10 Calder to Allen, August 2, 1935, KC.

11 Calder to Allen, August 27, 1935, KC.

12 Calder created *The Circus* in Paris between 1926 and 1931 with wire, cloth, wood, metal, yarn, paper, and many other found objects. Most of the characters were articulated. Calder would send out invitations, provide seating and peanuts, and have a performance while his wife helped with the sound effects.

13 Robert Henning, Jr. to Joan M. Marter, March 21, 1974, MAG curatorial files.

14 Calder, *Autobiography*, 154.

15 Calder to Steele, n.d., Fletcher Steele Papers, Manuscript Division, Library of Congress, Washington, DC.

16 Calder, *Autobiography*, 154.

17 Calder to Allen, April 1½, 1935, KC.

58 Arthur G. Dove
Cars in a Sleet Storm (1938)

1 Ann Lee Morgan, in preparing a catalogue raisonné of Arthur Dove's work to be published for the *American Art Journal*, requested permission for a photograph of *Cars in a Sleet Storm*. She suggested that the painting be dated 1938 rather than the 1925 date that had been assigned to it by the Encyclopedia Britannica Collection. Ms. Morgan wrote,

> [A]ll the evidence points to a 1938 date for your painting. Stylistically, it just doesn't look like anything Dove was doing in 1925. The painting was first exhibited in 1938, and it was Dove's standard procedure to show each year all the paintings he had completed since the previous year. So far as I know, he never did a watercolor based on an oil. The photograph referred to in the last of the "References" on the information sheets you sent me shows the painting in the company of one painting from 1933, one from 1937, and the rest from 1938; so far as I know, at this point in his life, he didn't have anything from the early part of his career with him. Finally, in the diaries kept by the artist's wife, there are two references that I presume must refer to your painting. One, in October 1937, mentions that Dove started a painting of "3 Cars." The other, in January 1938, mentions him working on "Automobiles in Rain." (Ann Lee Morgan to Janet Otis, MAG archivist, July 13, 1982, MAG curatorial files.)

The painting was acquired from Dove by Encyclopedia Britannica, Inc., by 1945; by Senator William Benton by 1948; and by the Memorial Art Gallery in 1951. The title has varied over the years. In the 1938 American Place show (see note 8) it was titled *Cars in Sleet and Storm;* in the Encyclopedia Britannica Collection catalogue it was *Cars in Sleet Storm;* MAG correspondence in 1951 lists the work variously as *Cars in Sleet Storm* and *Cars in a Sleet Storm*. For MAG's acquisitions from the Encyclopedia Britannica collection see Introduction in this volume, note 3.

2 Dove tells the camping story in the context of an unpublished, undated, ca. 1930 autobiographical statement, beginning and ending with recollections of his mentor Newton Weatherly, who taught him how to paint and camp. See Dove papers, reel 4682, frame 0172, Archives of American Art. He wrote: "In writing about ideas I can claim no background except perhaps the woods, running streams, hunting, fishing, camping, the sky etc. The first ideas were gained from a fine man who is still living, Newton Weatherly. He taught me fishing hunting the woods, his life in fact. That was at the age of nine. He painted landscape[s] and supported himself by…raising plants in hot houses. I got to like the earth and sky and water and thinking about it. High School and University—whatever came later was nothing as compared to those few years….[Dove next mentions his career in illustration in New York City, next his trip to France, painting landscape in the South of France and his return to Geneva, and then says:] "Then back home again homesick—camping for a month or so—Waking up here looking in the woods for motifs, studying butterflies beetles, flowers—The 1-2-3 thing—condition of light, then the condition of shape. Conic sections as triads. Found that they were invented by Maenechaena a Greek sculptor. There was a series done from planes chosen from hillsides, sails of boats, horses— several different paintings expressing through rhythm of these shapes and choice of colors the spirit. After that it was reduced to line. Watching a waterfall the line had more speed and/therefor sticks, sand, canvas and all,—which probably date back to Mr. Weatherly."

3 "To their surprising assortment of improbable dwellings the Doves then added the top floor of an old block of commercial buildings erected by his father and used subsequently as an auditorium (Paderewski once performed there), drill hall, and skating rink.…Dove's sense of the extraordinary possibilities of things transformed it. Neon signs cast colored patterns on the stencilled Victorian ceiling and fire trucks clanged by, but by painting the one wall without windows white and hanging it with paintings, the room became quite as liveable as their previous lodgings." Dorothy Johnson, quoted in "The Art of Arthur Dove," *Cornell Alumni News* 78, no. 9 (May 1976).

4 Elizabeth McCausland, "Authentic American is Arthur G. Dove,"
 Springfield [Mass.] Union and Republican, May 5, 1935, sec. E, p. 6.

5 Arthur G. Dove, *Cars in a Sleet Storm,* 5 x 7 inches, watercolor
 (1938; collection Herbert F. Johnson Museum, Cornell University).

6 Dove to Stieglitz, October 24, 1936, quoted in Elizabeth Hutton
 Turner, "Going Home: Geneva, 1933–1938," in *Arthur Dove: A
 Retrospective,* ed. Deborah Bricker Balken (Cambridge, Mass.: The
 MIT Press, 1997), 106.

7 The show was "Arthur G. Dove: Exhibition of Recent Paintings,
 1938," March 29–May 10, 1938, An American Place, New York.

8 Duncan Phillips, "The Art of Arthur G. Dove," introduction to
 Arthur G. Dove: Exhibition of Recent Paintings, 1938, exhibition cat-
 alogue, An American Place, New York, 1938 (Vertical File, The
 Phillips Collection Library and Archives, Washington, DC).

Reginald Marsh
59 *People's Follies No. 3* (1938)
Ice Cream Cones (1938)

1 Reginald Marsh, quoted in Norman Sasowsky, *The Prints of
 Reginald Marsh* (New York: Clarkson N. Potter, 1976), 10.

2 For more on burlesque, see Robert Allen, *Horrible Prettiness:
 Burlesque and American Culture* (Chapel Hill: Univ. of North
 Carolina Press, 1991) and Rachel Shteir, *Striptease: The Untold
 History of the Girlie Show* (Oxford: Oxford Univ. Press, 2004).
 For more on Marsh and burlesque, see Kathleen Spies, "'Girls
 and Gags': Sexual Display and Humor in Reginald Marsh's
 Burlesque Images," *American Art* 18, no. 2 (Summer 2004): 32–57.

3 Lloyd Goodrich, *Reginald Marsh* (New York: Abrams, 1972), 24.

4 Reginald Marsh, quoted in *Yale Record* 64 (September 25, 1935):
 15.

5 Kenneth Hayes Miller, quoted in Marilyn Cohen, *Reginald Marsh's
 New York: Paintings, Drawings, Prints and Photographs,* exhibition
 catalogue (New York: Whitney Museum of American Art in
 conjunction with Dover, 1983), 24.

6 Douglas Gilbert, "Camera Craze Has Made American Artists Feel
 Inferior," *New York World Telegram,* October 5, 1938, p. 3.

7 Dorothy Seiberling, "Reginald Marsh: Swarming City Scenes by
 'U.S. Hogarth' Go on a Year Long Tour of the Country," *Life,*
 February 1956, p. 88.

60 **Ralston Crawford**
Whitestone Bridge (1939–40)

1 Excerpt from *Gulls and The Man* by Maria Terrone, 1998, reprinted
 here with the kind permission of the author. ©Maria Terrone,
 from *The Bodies We Were Loaned* (The Word Works, 2002).

2 Dominique Païni and Guy Cogeval, eds., *Hitchcock and Art: Fatal
 Coincidences,* exhibition catalogue, The Montreal Museum of Fine
 Arts, Montreal, Quebec, 2000.

3 Crawford was born in St. Catherine's, Ontario, Canada in 1906,
 and died in New York City in 1978. Two publications are useful
 references for information about Crawford's life and art: William
 C. Agee, *Ralston Crawford* (Pasadena, Cal.: Twelve Trees Press,
 1983) and Barbara Haskell, *Ralston Crawford,* exhibition catalogue,
 Whitney Museum of American Art, New York, 1985.

4 Robert A. Caro, *The Powerbroker: Robert Moses and the Fall of
 New York* (New York: Alfred A. Knopf, 1974), 341.

5 *New York Times,* April 27, 1939.

6 Sharon Reier, *The Bridges of New York* (New York: Quadrant Press,
 1977), 136.

7 Leslie Maitland, "Moses, 90, Nostalgic About Whitestone Bridge,
 40," *New York Times,* April 30, 1979, p. B1.

8 "Fair on the Air," *New York Times,* April 30, 1939, p. 186.

9 Here, Crawford may have been referring to preliminary studies
 that he did of the bridge.

10 Grace Pagano, *Encyclopaedia Britannica Collection of Contemporary
 American Painting* (Chicago: Encyclopaedia Britannica, Inc., 1946),
 n.p. For MAG's acquisitions from the Encyclopedia Britannica
 collection, see Introduction in this volume, note 3.

11 Edwin Alden Jewell, "Art in American Life: Whitney Annual,"
 New York Times, December 1, 1940, p.X9.

12 Grafly's quote is in "Painting Field Broadened," a review of the
 Pennsylvania Academy of the Fine Arts salon of American paint-
 ings and sculpture, *Christian Science Monitor,* January 29, 1944,
 p. 10

13 Edith Halpert was a remarkable dealer whose gallery represented
 American modernists such as Charles Sheeler, Stuart Davis, and
 Jacob Lawrence. Her passion for folk art and establishment of a
 dedicated gallery, the American Folk Art Gallery, elevated this
 genre from a nostalgic curiosity to a high art phenomenon.

14 Edith Halpert to Crawford, July 12, 1944, Downtown Gallery
 papers, Archives of American Art, Smithsonian Institution, reel
 5546. The Encyclopedia Britannica collection was created by the
 Encyclopedia Britannica Corporation. In the words of E. H.
 Powell, President, in the April 1, 1945, issue of *The Art Digest*
 (Encyclopedia Britannica Special Number), "A few years ago
 our editor, Walter Yust, in his quest for more original and potent
 illustrations for our various publications, began to buy paintings
 and to commission artists to paint certain subjects for him....It
 seemed a fine thing to do—and a right thing for Encyclopedia
 Britannica to sponsor. Inevitably, the Britannica collection began to
 take shape" (43). In 1951, the Memorial Art Gallery acquired
 fourteen outstanding paintings from this collection, including
 Whitestone Bridge.

15 Crawford to Edith Halpert, July 23, 1944, Downtown Gallery
 papers, reel 5546, frame 298.

16 *Art News,* January 15, 1944, p. 20.

17 Edith Halpert to Crawford, April 26, 1945, Downtown Gallery
 papers, reel 5546, frame 349.

18 Crawford to Halpert, April 30, 1945, ibid., reel 5546, frame 351.

19 *Fortune,* December 1946; Crawford saw (correctly) a market for
 his work in *Fortune.* The Memorial Art Gallery owns two studies
 for *Fortune* covers, the subject of one being the Whitestone
 Bridge, although neither actually was used. Crawford's covers
 appear on the November 1944 issue and the April and October
 1945 issues (Daniel Okrent, *Fortune: The Art of Covering Business*
 [Salt Lake City: Gibbs-Smith Publisher, 1999]).

20 Darl Rastorfer, *Six Bridges: The Legacy of Othmar H. Ammann*
 (New Haven: Yale Univ. Press, 2000), 124.

61 **Marsden Hartley**
Waterfall, Morse Pond (ca. 1940)

1 Hudson D. Walker wrote in his sales order of October 4, 1965 to
 the Memorial Art Gallery, "This is the only oil painting I ever saw
 Marsden Hartley work on. He finished it in our gallery at 38 East
 57th Street in 1940" (MAG curatorial files).

2 Harris K. Prior to Hudson D. Walker, June 22, 1964 (MAG
 curatorial files).

3 Hudson D. Walker, "Marsden Hartley," *The Kenyon Review* 9, no. 2
 (Spring 1947): 256, in Elizabeth McCausland Papers, Archives of
 American Art, Smithsonian Institution, reel 273, frame 483.

4 Hartley was an avid reader of the transcendentalists Emerson,
 Thoreau, and Whitman.

5 Morse Pond is located on Mahoney Hill near Bingham, Maine.

6 Gail Scott, *Marsden Hartley* (New York: Abbeville Press, 1988),
 151.

7 Marsden Hartley, *The Collected Poems of Marsden Hartley,
 1904–1943,* ed. Gail R. Scott (Santa Rosa, Cal.: Black Sparrow
 Press, 1987), 190.

8 Hartley, "Hypnosis of Water," Marsden Hartley Papers, Archives
 of American Art, Smithsonian Institution, reel 1369, frame 1297.

9 *Woodlot, Maine* (1938), *Ghosts of the Forest, Georgetown*
 (1937–38), *Abundance* (1939–40), *Backwaters Up Millinocket
 Way* (1939–40), *Log Jam, Penobscot Bay* (1941).

10 Celeste Connor, *Democratic Visions: Art and Theory of the Stieglitz Circle, 1924–1934* (Berkeley: Univ. of California Press, 2001), 137.

11 Elizabeth McCausland Papers, reel 270, frame 250.

12 Marsden Hartley, *Somehow a Past: The Autobiography of Marsden Hartley,* ed. Susan Elizabeth Ryan (Cambridge, Mass.: MIT Press, 1997), 62, 64.

13 Ibid., 77.

14 Donna M. Cassidy, "Localized Glory: Marsden Hartley as New England Regionalist," in *Marsden Hartley,* ed. Elizabeth Mankin Kornhauser (New Haven, Conn.: Wadsworth Atheneum Museum of Art in association with Yale Univ. Press, 2002), 175.

15 Connor, *Democratic Visions,* 24.

16 John I. H. Baur, "The Beginnings of Modernism 1914–1940," in *Maine and Its Role in American Art 1940–1963,* ed. Elizabeth F. Wilder (New York: The Viking Press, 1963), 122.

17 Marsden Hartley, "On the Subject of Nativeness—a Tribute to Maine," in *Marsden Hartley: Exhibition of Recent Paintings, 1936,* Elizabeth McCausland Papers, reel 273, frame 89.

18 Ibid., frame 85.

19 Cassidy, "Localized Glory," 176.

20 Ibid., 67.

62 Douglas Gorsline
Bar Scene (1942)

1 Letter from Douglas Gorsline to Gertrude Herdle Moore, undated, probably May 1935 (MAG archives).

2 "Douglas Gorsline Continues to Advance," *Art Digest,* December 15, 1940, p. 6.

3 "Our Cover," *American Artist,* September 1945, p. 6.

4 "Gorsline's Art to be Featured in Exhibition," *Rochester Democrat & Chronicle,* March 21, 1948.

5 Gorsline's *What People Wore: A Visual History of Dress* (New York: Viking, 1952), continues to be one of the standard references for artists, costume designers, etc.

6 "Gorsline Exhibition," Rochester *Democrat & Chronicle,* May 5, 1936.

7 Paul Bird, "The Fortnight in New York," *Art Digest,* March 1, 1939, p. 19.

8 J. L., "Serious Painting by a Young Artist of Promise, Douglas Gorsline," *Art News,* March 4, 1939, p. 12.

9 Advertisement, *Art Digest,* March 15, 1945. Paint analysis has not been performed, so it is difficult to say with certainty whether *Bar Scene* includes tempera or is done completely in oil.

10 The menu was first drawn to our attention by Virginia Cordner. Photograph, menu, and sketch are in the archive of the Musée Gorsline, Bussy-le-Grand, France. We wish to thank Marie Gorsline, director of the museum and widow of Douglas Gorsline, for making them available to us.

11 Herbert Mitgang, "O, What a Lovely War," *New York Times,* September 1, 1968, p. BR6.

12 John McNulty, *This Place on Third Avenue* (Washington, DC: Counterpoint, 2001), book jacket blurb.

13 This second version is currently in the collection of the Musée Gorsline.

14 J. W. L., "Gorsline," *Art News,* March 15–31, 1942, p. 26.

15 J. L., "Serious Painting by a Young Artist of Promise, Douglas Gorsline," 12.

63 William Gropper
The Opposition (1942)

1 Basic resources for Gropper include August L. Freundlich, *William Gropper: Retrospective* (Los Angeles: Ward Ritchie Press and the Joe and Emily Lowe Art Gallery of the University of Miami, 1968); J. Anthony Gahn, "William Gropper—A Radical Cartoonist: His Early Career, 1897–1928," *The New-York Historical Society Quarterly* (April 1970): 111–44; Louis Lozowick, "William Gropper," *William Gropper: Fifty Years of Drawing, 1921–1971,* exhibition catalogue, ACA Galleries, New York, 1971; Louis Lozowick, *William Gropper* (New York: Abrams, 1973 and Associated University Presses, 1983); Norma S. Steinberg, "William Gropper: Art and Censorship from the 1930s through the Cold War Era" (PhD diss., Boston University, 1994); and "William Gropper Papers," Archives of American Art, Smithsonian Institution, microfilms 3501–04.

2 Freundlich, *William Gropper,* 29. *The Senate* was based on "Norris, of Nebraska, in a frenzy; and Johnson, of California, in doubt," *Vanity Fair* 42 (May 1934), 31. A letter from Alfred H. Barr Jr., Director, Museum of Modern Art, to William Gropper, Mt. Airy Road, Croton-on-Hudson, New York, December 2, 1936 (Gropper Papers, 3501:559) announced the museum's purchase of *The Senate* with monies from the (A. Conger) Goodyear Fund.

3 *Vanity Fair* 42 (May 1934), 31–32.

4 Ibid., 31.

5 Allan Antliff, *Anarchist Modernism: Art, Politics, and the First American Avant-Garde* (Chicago: Univ. of Chicago Press, 2001).

6 Gropper's sketches and cartoons appeared in the *New York Tribune* between October 1917 and June 1919. See Harry Salpeter, "William Gropper: Proletarian," *Esquire* (September 1937): 10, 105–06, 156, 159, and Gahn, "William Gropper."

7 Raphael Soyer, *Self-Revealment: A Memoir* (New York: Random House, 1967), 79.

8 In October 1927, William and Sophie Gropper, Sinclair Lewis, Theodore Dreiser, and Scott Nearing traveled to Moscow as delegates to the tenth-anniversary celebration of the Bolshevik Revolution. Gropper spent eight months in the U.S.S.R., drawing for Soviet publications, and five months in the Near East and western Europe.

9 Quoted in Grace Pagano, *The Encyclopaedia Britannica Collection of Contemporary American Painting,* 2nd ed. (Chicago: Encyclopaedia Britannica, 1946). The exhibition traveled from April 1945 to May 1950. Gropper referred to the U.S. Treasury Department's "Section of Fine Arts" program that had commissioned him, after peer review, to create a mural for the new Department of the Interior in Washington, DC. He had executed murals for the Schenley Corporation in Detroit, Michigan, in 1934 and 1935 and, in 1936, a mural for the Post Office at Freeport, Long Island, under the WPA. For MAG's acquisitions from the Encyclopedia Britannica collection, see Introduction in this volume, note 3.

10 Tentative identities of some of the senators portrayed in Gropper's ten lithographs of senators, first exhibited at ACA Gallery in 1941, can be made. The senators in his paintings are less representational.

11 Letter, Senator Guy M. Gillette to Gropper, Gropper Papers, 3501: 614. Gillette wrote that *Opposition* "is said [by Gropper] to portray the type of representative who is opposed to progress and culture" and "I am informed that it is a portrayal of a member of the House or Senate who is speaking against the fine arts and the graphic division of the Office of War Information."

12 Oil paintings with Senate themes that Gropper exhibited in 1989 at Sid Deutsch Gallery in New York include: *Roll Call* (n.d.), *The Senate Hearing* (ca. 1948), *Eternal Senator* (1956–72), *The Caucus Room* (ca. 1959), and *Senate Committee* (1961). Other paintings of congressmen include *Point of Order, The Probers, Senate Debate, The Untouchables, The Investigatory Committee, Three Senators,* and *The Un-American Committee.*

13 Gropper, handwritten and typed notes, n.d. Gropper Papers, 3501: 359, 376–7.

14 Gropper applied for an application to go to Europe in 1943 as a war correspondent, but was not able to leave the country until 1948, when he went to Poland. (E-mail correspondence, February 19, 2005, with Charlotte Sherman of Heritage Gallery, Pacific Palisades, California, and Gropper's son, Gene Gropper. e-mail correspondence with Norma Steinberg [see n. 1], Feb. 22, 2005, confirms this.)

15 Louis Lozowick, "William Gropper," n.p.

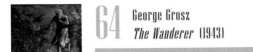

64 George Grosz
The Wanderer (1943)

1 From Grosz's 1942 lecture *Art Under Hitler* on the radio program "Living Arts," a joint broadcast of CBS and The Metropolitan Museum of Art. Cited by Ralph Jentsch in the chronology included in the exhibition catalogue *George Grosz: Berlin-New York* (Nationalgalerie Berlin, 1994), 551.

2 George Grosz, letter to Emily Genauer, April 29, 1947. Cited in Hans Hess, *George Grosz* (New York: Macmillan, 1974), 211n45.

3 For MAG's acquisitions from the Encyclopedia Britannica collection, see the Introduction to this volume, note 3.

4 Daniel Catton Rich, Preface, *Contemporary American Painting: The Encyclopaedia Britannica Collection* (New York: Duell, Sloan and Pearce, 1948), xxvii.

5 George Grosz, ibid., entry 48. Grace Pagano, the author of the Britannica catalogue, had a more optimistic view of *The Wanderer*, which she expressed in her article "The War—As Seven Artists in the Britannica Collection See It," *Art Digest*, April 1, 1945, p. 36:

> In Grosz' *The Wanderer* a vivid imagination can read many subtleties. His figure—the everlasting human spirit once more wanders through a dark world, an apocalyptic landscape—but his face is grim, rather than despairing....This figure still seeks a sunnier day, a brighter world.

6 Cited in Hess, *George Grosz*, 217n258. Hess suggests that the letter was written in November or December 1940; it seems more likely, though, that it dates nearer to 1943, the year that Grosz painted *The Wanderer*.

7 The significance of the *Interregnum* drawings to the later paintings was discussed by John I. H. Bauer in the exhibition catalogue *George Grosz* (London: Thames and Hudson, 1950), 28. The portfolio is illustrated in its entirety in the catalogue *George Grosz: Berlin-New York*, 479–87.

8 The 1940 painting *No Let-Up* closely follows the drawing of the same title, also from *Interregnum*. With its image of a lone man, his back to the viewer and carrying a lantern, trudging through brambles and mud, it is the nearest in theme to *The Wanderer*. The 1944 *Cain, or Hitler in Hell*, echoes his 1936 drawing *So Cain Killed Abel*, while the 1948 painting *The Survivor* is almost an exact derivative of the *Interregnum* drawing. The association of the drawings *Even Mud Has an End* and *No Let-Up* with the flight of exiles from Nazi Germany is demonstrated by the use of both as the illustrations for the German poet and fellow-immigrant Walter Mehring's powerful anti-Nazi epic *No Road Back* of 1944.

9 Hess, *George Grosz*, 68.

10 Richard O. Boyer, "Profiles, Artist: 1. Demons in the Suburbs," *The New Yorker*, November 27, 1943, p. 33.

11 Richard O. Boyer, "Profiles, Artist: 2. The Saddest Man in All the World," *The New Yorker*, December 4, 1943, p. 39.

12 John Dos Passos, Introduction, *George Grosz* (London and Brussels: Nicholson and Watson, 1948), 10.

13 Boyer, "Profiles, Artist: 1," 32–43; "Profiles, Artist: 2," 39–48; "Profiles, Artist: 3. The Yankee from Berlin," *The New Yorker*, December 11, 1943, pp. 37–44.

14 Boyer, "Profiles, Artist: 3," 37.

15 Ibid.

16 As far as can be determined, *The Wanderer* was first exhibited in the Grosz exhibition in February 1943 at the galleries of Associated American Artists, Grosz's representative, in New York City.

17 Review of the exhibition from the *New York Sun*, February 12, 1943.

18 Boyer, "Profiles, Artist: 1," 41.

19 "Grosz Paints What He Can't Forget," review, *Art Digest* 17, no. 10 (February 15, 1943), front page.

20 George Grosz, 1954 interview (origin unknown), as cited by Lothar Fischer in his entry on *The Wanderer* in the exhibition catalogue *Die Nibelungen. Bilder von Liebe, Verrat and Untergang* (Munich: Prestel-Verlag, 1987), 271. (Author's translation from the German.)

21 Robert Gorham Davis, "A Poet's Anti-Fascist Melodrama," *The New York Times*, March 18, 1945, Book Review, 4.

22 Frederic Prokosch, *Age of Thunder* (New York and London: Harper & Brothers, 1945), 25.

23 Ibid., 25-26.

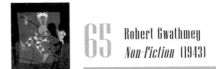

65 Robert Gwathmey
Non-Fiction (1943)

1 For more information on Gwathmey's life, see Michael Kammen, *Robert Gwathmey: The Life and Art of a Passionate Observer* (Chapel Hill: Univ. of North Carolina Press, 1999). Also see Robert Gwathmey and Charles K. Piehl, "Art for Art's Sake?" *American Art* 7 (Winter 1993): 99–103; Charles K. Piehl, "The Southern Social Art of Robert Gwathmey," *Transactions of the Wisconsin Academy of Sciences, Arts and Letters* 73 (1985): 54–62; and Charles K. Piehl, "A Southern Artist at Home in the North: Robert Gwathmey's Acceptance of His Identity," *The Southern Quarterly* 26 (Fall 1987): 1–17.

66 Norman Rockwell
Soldier on Leave (1944)

1 Karal Ann Marling, *Norman Rockwell* (New York: Harry N. Abrams, 1997), 90–109, 116.

2 Norman Rockwell, *My Adventures as an Illustrator* (New York: Harry N. Abrams, 1994), 328.

3 Susan E. Meyer, *Norman Rockwell's World War II: Impressions from the Homefront* (n.p.: USAA Foundation, 1991), 42–3; Marling, *Norman Rockwell*, 101.

4 Arthur L. Guptill, *Norman Rockwell Illustrator* (New York: Watson-Guptill, 1946), 199–203. The Balopticon projector, much like a modern slide projector, allowed the artist to see a photograph on the surface of his canvas. The main lines of the composition could then be traced as a starting point for the picture.

5 Susan E. Meyer, *Norman Rockwell's People* (New York: Harry N. Abrams, 1987), 109.

6 Ibid., 108–9, 122.

7 Rockwell, *My Adventures*, 312-17; Marling, *Norman Rockwell*, 98–105.

8 Marling, *Norman Rockwell*, 90–96.

$\mathcal{N}otes$

67 Guy Pène du Bois
Jane (ca. 1946)

1 For information on Pène du Bois's life and career, see: Betsy Fahlman, "Guy Pène du Bois: Painter, Critic, Teacher" (PhD diss., University of Delaware, 1981); *Guy Pène du Bois (1884–1958): Returning to America,* exhibition catalogue, James Graham and Sons Gallery, New York, 1998 (*Jane* was included as no. 20); "Imaging the Twenties: The Work of Guy Pène du Bois," in *Guy Pène du Bois: The Twenties at Home and Abroad,* ed. Stanley Grand (Wilkes-Barre, Pa.: Sordoni Gallery, Wilkes University, 1995); and *Guy Pène du Bois: Artist About Town* (Washington, DC: Corcoran Gallery of Art, 1980). Also, Guy Pène du Bois's autobiography, *Artists Say the Silliest Things* (New York: American Artists Group, 1940) remains a useful period source. His papers are at the Archives of American Art, Smithsonian Institution.

2 The Eight included Robert Henri, John Sloan, William Glackens, George Luks, Everett Shinn, Ernest Lawson, Maurice Prendergast, and Arthur B. Davies. Their paintings of city life represented a revolution in subject matter. Their landmark show took place at the Macbeth Gallery in New York in 1908.

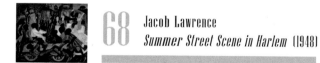

68 Jacob Lawrence
Summer Street Scene in Harlem (1948)

1 This painting was acquired in 1991 in conjunction with the exhibition of Lawrence's Frederick Douglass and Harriet Tubman Series of Narrative Paintings, loaned by Hampton University Museum. Jacob and Gwendolyn Lawrence visited the Memorial Art Gallery for the exhibition opening, and they returned in 1994 when Jacob was given an honorary degree by the University of Rochester.

2 Sharon F. Patton, *African American Art* (Oxford and New York: Oxford Univ. Press, 1998), 110.

3 *Shoemaker* (1945; Metropolitan Museum of Art), *The Seamstress* (Southern Illinois University Museum at Carbondale), *Watchmaker* and *Cabinet Makers* (Hirshhorn Museum and Sculpture Garden, Washington, DC), *Steelworkers* (Collection of Edith and Emil Oxfeld), *Radio Repairs* (Collection of Mr. and Mrs. Julius Rosenwald), and *Stenographers* (current collection unknown), all of 1946.

4 Elizabeth Hutton Turner, "The Education of Jacob Lawrence," in Peter T. Nesbitt and Michelle DuBois, eds., *Over the Line: The Art and Life of Jacob Lawrence* (Seattle and London: Univ. of Washington Press in association with Jacob Lawrence Catalogue Raisonné Project, Seattle, 2000), 99.

5 A. Jacobowitz, transcript of tape-recorded interview with Jacob Lawrence, March 21, 1968, part I, p. 11, Archives of American Art, Smithsonian Institution.

6 Charles Alan, unpublished manuscript, ca. 1973, courtesy Harry N. Abrams, New York, 13. Archives of American Art, Smithsonian Institution.

7 Ibid., 12.

8 Ibid. These scenes were also captured by James VanDerZee (1886–1983) in his contemporary photographs of Marcus Garvey and the members of his Universal Negro Improvement Association.

9 Paul Karlstrom, interview with Jacob Lawrence and Gwendolyn Knight Lawrence, part I, p. 77, November 18, 1998, Archives of American Art, Smithsonian Institution.

10 Lowery Stokes Sims, "The Structure of Narrative: Form and Content in Jacob Lawrence's Builder Paintings, 1946–1998," in Nesbitt and DuBois, eds., *Over the Line,* 201.

11 Alain Locke, "The Legacy of the Ancestral Arts," in Alain Locke, ed., *The New Negro,* intro. by Arnold Rampersad (New York: Atheneum Books, 1992), 256, 267.

12 Jeffrey Stewart, "(un)Locke(ing) Jacob Lawrence's Migration Series," in Elizabeth Hutton Turner, ed., *Jacob Lawrence: The Migration Series,* exhibition catalogue (Washington, DC: Rappahannock Press in association with The Phillips Collection, 1993), 48.

69 John Koch
Interlude (1963)

1 Mina Rieur Weiner, "Reminiscences," in *John Koch: Painting a New York Life,* exhibition catalogue, ed. Mina Rieur Weiner (New York and London: New-York Historical Society and Scala Publishers, Ltd., 2001), 44–45.

2 Biographical details of the Kochs' lives come from Grady T. Turner, "Enigmatic Intimacy: The Interior World of John Koch" and "Biography," in Weiner, ed., *John Koch: Painting a New York Life.* John Koch was born in Toledo, Ohio, and raised in Ann Arbor, Michigan (13, 108). Dora Zaslavsky, of Jewish descent, was born in the Ukraine and immigrated to the United States, where her musical talents were discovered and promoted by Janet D. Schneck, founder and director of the Manhattan School of Music (30, 60). In 1956 and 1966, Koch painted the Malcolm S. Forbes family (cat. nos. 9, 10, pp. 56–57). In 1973, he was commissioned to paint Henry Luce III (cat. no. 14, p. 60). These are reproduced in Weiner, ed., *John Koch: Painting a New York Life.*

3 Felicity Dell'Aquila, cited in Weiner, "Reminiscences," 44.

4 Dorothy Parker, "New York at 6:30 PM: John Koch and his Glorious People," *Esquire,* November 1964, cited in cat. entry no. 56 in Weiner, ed., *John Koch: Painting a New York Life,* 94.

5 Interview with John Koch in *John Koch in New York, 1950–1963* (New York: Museum of the City of New York, ca. 1963), 9–10. (Interviewer unnamed.)

6 *Studio—End of Day* (1961) reproduced in *John Koch,* exhibition catalogue, the New York Cultural Center in association with Fairleigh Dickinson University, New York, February 21–April 1, 1973, cat. no. 23; *Two Artists and a Model* (1965) reproduced in Weiner, ed., *John Koch: Painting a New York Life,* cat. no. 32, p. 75. The model's identity first became known to the Memorial Art Gallery through a series of e-mails with her husband Jerome Morgan, beginning in April 2003. Born Rosetta Brooks in 1926, in Clarkston, Mississippi, she worked in New York from approximately 1954 to 1967 as a professional model, also serving during that time as a secretary at the United Nations for Congo-Brazzaville. In 1967 she moved to California and began an acting career under the stage name Rosetta Howard. According to her husband, she often spoke about her experiences as a model, remembering how kind John and Dora Koch were, about frequently eating with the Kochs, and about how cordial Mrs. Koch had been. She died in 2003, before she and her husband were able to make the trip to see *Interlude* at the Gallery. (Notes from author's telephone conversation with Jerome Morgan on July 5, 2005.)

7 Turner, "Enigmatic Intimacy," 38.

8 In the Gallery's collection, given by the artist, are two drawings: *Study for "Interlude" I* and *Study for "Interlude" II.* Both are graphite on paper and were torn from Koch's sketch book; both have the uneven edges of paper ripped from a spiral binding. A third drawing for this painting, *Study for Interlude,* was published in *Models and Moments: Paintings and Drawings by John Koch,* exhibition catalogue (Hamilton, N.Y. and University Park, Pa.: Picker Art Gallery, Colgate University and Museum of Art, Pennsylvania State University, 1977), 21. At the time of this publication, the drawing was owned by Kraushaar Galleries in New York, which has represented John Koch's work since 1939.

Koch's painting was featured in MAG's fiftieth anniversary exhibition entitled "In Focus: A Look at Realism in Art," 1965, and was then purchased for the Gallery by Mr. and Mrs. Thomas Hawks.

Notes

70 Andy Warhol
Jackie (1964)

1 John Fitzgerald Kennedy, the thirty-fifth President of the United States, was assassinated on November 22, 1963 in Dallas, Texas, by Lee Harvey Oswald.

2 David Lubin, *Shooting Kennedy: JFK and the Culture of Images* (Berkeley: Univ. of California Press, 2003), ix; Lubin cites Bradley S. Greenberg and Edwin B. Parker, eds., *The Kennedy Assassination and the American Public: Social Communication in Crisis* (Stanford, Cal: Stanford Univ. Press, 1965).

3 Pop art, an ironic movement that flourished in the 1950s and 1960s, attempted to devalue the precious and privileged objects created as High Art and promote subjects taken from the popular culture. Andy Warhol, who originally specialized in images of mass produced goods, was one of the leaders of the movement.

4 Andy Warhol and Pat Hackett, *POPism: The Warhol '60s* (New York and London: Harcourt Brace Jovanovich, 1990), 60.

5 Art Simon, *Dangerous Knowledge: The JFK Assassination in Art and Film* (Philadelphia: Temple Univ. Press, 1996), 114.

6 Lubin, *Shooting Kennedy*, 35-6. Lubin's insightful observations about the relationship between the Kennedys and Hollywood pop culture shed important new light on the reasons why Warhol might have been drawn to images of Jackie.

7 Ibid., 198

8 Lady Bird Johnson, *A White House Diary* (New York: Holt, Rinehart and Winston, 1970), 5–6.

9 Lubin, *Shooting Kennedy*, 195.

10 Ibid., 198.

11 Warhol, *POPism*, 22.

12 "All that summer [1964] a young English kid named Mark Lancaster…was coming to the Factory every day.…People would come over to talk to him as he helped me stretch…the small black and blue Jackies, the funeral image, and some big square Marilyns with different-color backgrounds, and one Jackie-Liz-Marilyn combo" (Warhol, *POPism*, 70).

13 While it seems as though "Camelot" and the Kennedy White House have been linked from the beginning, in reality the idea was not put into public discourse until after the assassination. In an interview a week after the assassination with Theodore H. White, historian and author of *The Once and Future King*, Jackie Kennedy described how the president listened to Lerner and Loewe's *Camelot* before going to sleep every night, and "had more than once expressed the hope that his era would be remembered like King Arthur's" (Lubin, *Shooting Kennedy*, 94).

71 Fairfield Porter
The Beginning of the Fields (1973)

1 General information on Porter, his life and works, can be found in Joan Ludman, *Fairfield Porter: A Catalogue Raisonné of the Paintings, Watercolors, and Pastels* (New York: Hudson Hills Press, 2001), and *Fairfield Porter: A Catalogue Raisonné of His Prints* (Westbury, N.Y.: Highland House Publishing, 1981); Justin Spring, *Fairfield Porter: A Life in Art* (New Haven, Conn.: Yale Univ. Press, 2000); and Ted Leigh, *Material Witness: Selected Letters of Fairfield Porter* (Ann Arbor: Univ. of Michigan Press, 2005).

2 Hilton Kramer, "Art: Fairfield Porter," *New York Times*, March 9, 1974, p. 25.

3 Kenworth Moffett, *Fairfield Porter: Realist Painter in an Age of Abstraction* (Boston, Mass.: Museum of Fine Arts, 1982), 38.

4 Michael Brenson, "Porter Paintings on Display," *New York Times*, September 13, 1985, p. C24.

5 The Shoreham plant at Brookhaven, L.I., was fought by local citizens for twenty-five years beginning in 1969. It was finished in 1983, then decommissioned in 1994 without ever having produced a kilowatt of commercial power. See Dan Fagin, "Lights Out at Shoreham," http://www.newsday.com/community/guide/lihistory/ny-history-hs9shore,0,563942.story?coll=ny-lihistory-navigation.

6 Spring, *Fairfield Porter*, 351.

72 Jaune Quick-to-See Smith
Famous Names (1998)

1 Joy Harjo, "Creation Story: The Jaune Quick-to-See Smith Survey," in Anreus, ed., *Subversions/Affirmations*, 68. (See note 2 below.)

2 A good brief source of information on Quick-to-See Smith's life and work is Alejandro Anreus, ed., *Subversions/Affirmations: Jaune Quick-to-See Smith: A Survey*, exhibition catalogue, Jersey City Museum, N.J. In particular see the essays there by Lucy R. Lippard, "Jaune Quick-to-See Smith's Public Art: Generosity With an Edge," 79–92, and Alejandro Anreus, "A Conversation with Jaune Quick-to-See Smith," 108–113. Another useful reference is Linda Muehlig, "The Red Mean: Self Portrait, 1992," in *Masterworks of American Painting and Sculpture from the Smith College Museum of Art*, ed. Linda Muehlig (New York: Hudson Hills Press in assoc. with Smith College Museum of Art).

3 In a telephone conversation with the author in August, 2005, Quick-to-See Smith explained that acrylic paint has been applied to the surface of *Famous Names* in a very viscous state, so that the dripping that results lends an appearance of rapid application. In fact, she experiments with many ways to apply the paint, for instance by laying plastic on the canvas to see how different washes work in the space and which wash best preserves the collaged elements underneath. What appears haphazard and fresh on the canvas is thoroughly contemplated before it is applied.

4 According to Linda Muehlig, "the artist's registration number, assigned to her at birth,…not only records her identity as an enrolled member of her tribe but 'qualifies' her as a Native American artist under the 1990 Indian Arts and Crafts law enacted by the U.S. Congress. The legislation…was originally intended to protect the market for art and artifacts produced by Native Americans against forgeries made by non-Native fabricators, but a number of artists and craftspeople who were not enrolled or registered members of a tribal group were placed in the anomalous position of risking a large fine or jail term for producing and selling their work because they lacked the required proof of their ethnic identity" (Muehlig, "The Red Mean," 240).

5 E-mail from Jaune Quick-to-See Smith to the author, August 2005.

6 Ibid.

7 Buffalo Tail's name was given him by Molly Kicking Woman, whose name also appears in the painting, and Mike Swims. Quick-to-See Smith's cousin, Three Wolves, and her grandmother, Strong Old Woman, also appear, as well as a distant relation, Big Crane. (E-mail from Jaune Quick-to-See-Smith to the author, October 2, 2005.)

8 *The Char-Koosta News* is the newsletter of The Confederated Salish and Kootenai Tribes of the Flathead Indian Reservation (http://www.charkoosta.com/). The name "Char-Koosta" comes from the names of the last traditional leaders of the Salish and Kootenai people—Chief Charlo of the Salish people, and Chief Koostatah of the Kootenai people.

9 E-mail from Jaune Quick-to-See Smith to the author, August 2005.

10 "Quotes from the Artist," Artist Spotlight, Jan Cicero Gallery, Chicago, Ill. http://www.galleryguide.org/ArtistPortfolios/Cicero/Smith/smith.asp (accessed Sept. 12, 2005).

11 A good source of information on Native American photographs is Alfred L. Bush and Lee Clark Mitchell, *The Photograph and the American Indian* (Princeton, N.J.: Princeton Univ. Press, 1994). In the introduction, Lee Clark Mitchell asks the same question Quick-to-See Smith implicitly raises about the photographs in her painting: "Is the photographer a passive recorder or someone who alters what he finds, sympathetic participant or rude intruder, preserver or thief?" (xv).

12 Author's phone conversation with Jaune Quick-to-See Smith, August 23, 2005.

Notes

73

Lorna Simpson
Untitled (The Failure of Sylvester)
(2001)

1 Some good sources of information on Simpson are: Deborah Willis, *Lorna Simpson* (San Francisco: The Friends of Photography, 1992); *Lorna Simpson,* exhibition catalogue (Salamanca, Spain: Centro de Arte de Salamanca, 2002); Beryl J. Wright and Saidiya V. Hartman, *Lorna Simpson: For the Sake of the Viewer* (Chicago: Museum of Contemporary Art, 1992); and Kellie Jones, Thelma Golden, and Chrissie Iles, *Lorna Simpson* (New York: Phaidon, 2002).

2 Willis, *Lorna Simpson,* 56.

3 "Interview: Thelma Golden in conversation with Lorna Simpson," in Jones et al., *Lorna Simpson,* 20–21. Simpson's full statement is of interest: "This body of work contains oval and square images, and they're all of a woman's head, slightly out of focus. There's a little bit of her revealed, but not much; we kind of see her face, but the photographs lie just beneath a translucent material and become silhouettes or are clouded or glossed, so you can only just make her out. The references within the work are titles of paintings from the 1790s to about 1970, and of films from about 1910 to the 1970s. Formally, the ovals point to turn-of-the-century photographs and daguerrotypes—photographs that people would carry around, images of their loved ones. The four-by-five, rectangular images represent modern photography and art. I mix those up in a kind of incomplete grid, so that it's somewhat fallen apart and not completely filled in, but the grid structures each individual piece."

4 *Wanted Poster No. 3,* 1969, painting by Charles White (1918–1979); *Octoroon (Study for a Lithograph),* ca. 1930s–40s; pencil sketch by Dox Thrash (1893–1965); *Mom and Dad,* 1944, painting by William H. Johnson (1901–1970).

5 Minnie was a well-known character in Cab Calloway's all-black musical revue as well as the subject of his famous song "Minnie the Moocher." Minnie Evans (1892–1987) was a self-taught African American painter (see http://www.antonart.com/bio-evan.htm). In 1994, three novels by the nineteenth-century African American poet and social advocate Frances E. W. Harper were unearthed: *Minnie's Sacrifice, Sowing and Reaping, Trial and Triumph: Three Rediscovered Novels,* ed Frances Smith Foster (Boston: Beacon, 1994), http://www.amazon.com/gp/reader/080708333X/ref=sib_dp_pt/104-4744400-5152743.

Acknowledgments

Our life is an apprenticeship to the truth, that around every circle another can be drawn; that there is no end in nature, but every end is a beginning; that there is always another dawn risen on mid-noon, and under every deep a lower deep opens.

—Ralph Waldo Emerson, *Essays, First Series, X. Circles,* 1841

The "apprenticeship to the truth" that a catalogue of this size represents could only happen through contributions that are nearly impossible to fully acknowledge. Scores of institutions—libraries, other museums and galleries, historical societies, colleges and universities—have assisted with locating images and information. Many individuals have done the same, and contributed at least as much with their good-will efforts to support this publication. The following list is an inherently imperfect effort to thank publicly all those who made *Seeing America* a significant contribution to the field of American art and culture. Any omissions are unintentional and are my responsibility. I offer apologies in advance.

First, thanks go out to the staff of the Memorial Art Gallery. Grant Holcomb, The Mary W. and Donald R. Clark Director, has been supportive from the first, and it was his passion for the American collection that helped to secure the key initial funding from the Henry Luce Foundation's American Collections Enhancement initiative. Christine Garland worked long, hard hours over several years to put the funding puzzle together with support from her colleagues in the MAG advancement department. Lu Harper and Susan Nurse have gathered untold reels of microfilm, interlibrary loans, and rights and reproductions permissions. Colleen Griffin-Underhill provided valuable insight into production-related questions. Carol Acquilano, Cynthia Culbert, Jessica Marten, Emily Pfeiffer, and Monica Simpson in the curatorial department have kept the project afloat by attending to authors and managing photoshoots, images, and budgets, as well as the many incidental details generated by a project of this size. Hardworking colleagues added the task of essay-writing to their already full days: Cynthia Culbert, Susan Dodge-Peters Daiss, Marlene Hamann-Whitmore, Grant Holcomb, Susan Nurse, Jessica Marten, Nancy Norwood, and Marie Via.

Special recognition goes to Cynthia Culbert, who joined the Gallery staff in the first phase of the *Seeing America* project as coordinator of the Henry Luce Foundation American Collections Enhancement grant. She has patiently and painstakingly tended the project through its completion in the form of this publication.

Of course the authors listed in the Table of Contents are all deserving of our thanks, particularly for their cooperation with revisions and their patience with the publication schedule. And again, our thanks to Michael Kammen for his introduction.

Photographers James M. Via and Andy Olenick were responsible for the majority of the beautiful images of artwork from the permanent collection of the Memorial Art Gallery. Donald Strand's management of the images contributed to the smooth work flow from photographer to designer.

John Blanpied, editor nonpareil, held the project together over more years than I like to think about. Kathryn D'Amanda, with the assistance of Amy Holowczenko, has contributed intelligently and sensitively to the aesthetics of the printed page with her visionary design services. Tony Harris and

Monroe Litho, Rochester, New York, were consistently supportive of the project and contributed generously to its production. And thanks to the University of Rochester Press and its staff who have collaborated with us in the distribution of the publication.

Memorial Art Gallery interns were diligent factcheckers. They include: Rebekah Biss, Erin A. Buch, Rebecca Merritt, Molly Searl, Lisa Szkolnik, and Erin Train. Multiple libraries in the region played a part in locating books, journals, and microfilm. In particular, Rush Rhees Library of the University of Rochester, and its Department of Rare Books, Special Collections and Preservation, as well as Interlibrary Loan Services, provided important support to its sister department, the Charlotte Whitney Allen Library at the Memorial Art Gallery. Also, the Rochester Public Library System and the State University of New York at Geneseo's Milne Library were valuable resources for our intrepid team. The Archives of American Art of the Smithsonian Institution is a national treasure for which I and my fellow researchers give thanks.

I also want to thank the following individuals and institutions for their cooperation, and recognize that this ambitious undertaking happened only with their assistance and generous contribution of time, energy, and in some cases financial resources:

> Nathalie Andrews, Portland Museum, Louisville, Kentucky; Tim Barnes; Edwin Bingham; James Bishop; Jean Bellows Booth; Elizabeth Bouvier, Massachusetts State Archives; Elizabeth Brayer; David Burnhauser, The New-York Historical Society; Virginia Cordner; Margaret R. Dakin, Amherst College Library Archives and Special Collections; Daria D'Arienzo, Amherst College Library Archives and Special Collections; Julie A. Dunn-Morton, Ph.D., St. Louis Mercantile Library at the University of Missouri-St. Louis; Pamela Erwin; Trevor Fairbrother; Jennifer Fauxsmith, Massachusetts State Archives; Dr. William Gerdts; John Gorsline; Marie Gorsline, Musée Gorsline, Bussy-le-Grand, France; Jeremy Greaves; Gene Gropper; Jack Gumbrecht, The Historical Society of Pennsylvania; Erika Holmquist-Wall, The Minneapolis Institute of Fine Arts; the late Donelson Hoopes; Kathleen Houston; Nathan Johnson; Karl Kabelac; William Keeler, Landmark Society of Western New York; Gary Kerstetter, Bayport-Blue Point (New York) Library; Marion Kolisch; Elisabeth Mankin Kornhauser, Wadsworth Athenaeum; Dr. M.S.A. Kumar, Cummings School of Veterinary Medicine at Tufts University; Frances Lennie; Nancy Martin, Rare Books, Special Collections and Preservation, Rush Rhees Library, University of Rochester; Dr. Howard Merritt; Jerome and Sandy Morgan; Dr. Kevin Nibbe; Mary Kate O'Hare, The Newark Museum; Dr. Linda Dugan Partridge; Rochester Historical Society; Professor James Ramage, Northern Kentucky University; Wilson Rood; Frank Sadowski; Ken Scott; Brian J. Scriven, Historic Site Manager, Letchworth State Park; Rebecca Searl; Charlotte Sherman, Heritage Gallery, Pacific Palisades, California; Christian Sonne, Town Historian, Tuxedo Park, New York; Dr. Theodore Stebbins, Fogg Art Museum, Harvard University; Dr. Norma S. Steinberg; David Svahn, Christ Church, Cooperstown, New York; Maria Terrone; Judy Throm, Archives of American Art; Yale University Beinecke Rare Book and Manuscript Library; and Mr. and Mrs. Alan Yassky.

It has been my honor and MAG's to have received the benefit of working with so many people and institutions, both known to us and anonymous, in the compilation of this catalogue. Their contributions will lead, we hope, to additional discoveries about, and deeper insights into, this rich collection of art.

Marjorie B. Searl

Index

Subjects of essays (**artists** and ***works***) are given in **boldface type**. Page numbers in **boldface** indicate images in the book. Page numbers in *italics* indicate essays in the book.

A